"The birth of modernism a century ago was one of history's greatest moments of creative disruption, including Einstein's physics, Stravinsky's music, and the writings of Joyce and Proust. One major spark was an astonishing painting by Picasso, and Miles Unger brings us both the drama and brilliance of that creation in this thrilling book."

—Walter Isaacson, author of *Leonardo da Vinci*

"Riveting. . . . This engrossing book chronicles with precision and enthusiasm a painting with lasting impact in today's art world."

—*Publishers Weekly* (starred review)

"Bohemian Montmartre comes brilliantly to life, as do the artist's struggles."

—*The New Yorker*

"An engrossing read. . . . Unger draws not just from his own wide knowledge and considered taste but from an imposing array of journals, memoirs, biographies and periodicals. From these he offers a historically and psychologically rich account of the young Picasso and his coteries in Barcelona and Paris."

—Alexander C. Kafka, *The Washington Post*

"Illuminating."

— Barbara Spindel, *The Christian Science Monitor*

"[A] vibrant biography. . . . Unger succeeds in making *Les Demoiselles d'Avignon,* the book's titular painting, accessible. Heady modern art is made over as approachable and exciting."

—*Booklist*

ALSO BY MILES J. UNGER

Michelangelo: A Life in Six Masterpieces

Machiavelli: A Biography

Magnifico: The Brilliant Life and Violent Times of Lorenzo de' Medici

The Watercolors of Winslow Homer

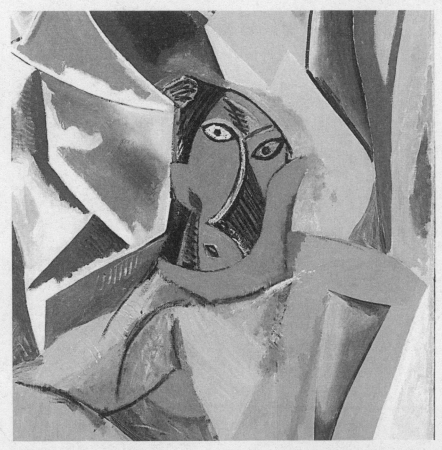

Detail from *Les Demoiselles d'Avignon*. © *The Museum of Modern Art/Licensed by SCALA / Art Resource, NY.*

PICASSO

and the

PAINTING

That Shocked
the World

MILES J. UNGER

SIMON & SCHUSTER PAPERBACKS

New York London Toronto Sydney New Delhi

To my brothers, Brooke and Paul

———

Simon & Schuster Paperbacks
An Imprint of Simon & Schuster, Inc.
1230 Avenue of the Americas
New York, NY 10020

First Simon & Schuster trade paperback edition March 2019

SIMON & SCHUSTER PAPERBACKS and colophon are registered trademarks
of Simon & Schuster, Inc.

For information about special discounts for bulk purchases,
please contact Simon & Schuster Special Sales at 1-866-506-1949
or business@simonandschuster.com.

The Simon & Schuster Speakers Bureau can bring authors to your
live event. For more information or to book an event, contact the
Simon & Schuster Speakers Bureau at 1-866-248-3049 or visit our
website at www.simonspeakers.com.

Interior design by Lewelin Polanco

Manufactured in the United States of America

10 9 8 7 6 5 4 3 2

The Library of Congress has cataloged the hardcover edition as follows:

Names: Unger, Miles, author.
Title: Picasso and the painting that shocked the world / Miles J. Unger.
Description: First Simon & Schuster hardcover edition. | New York : Simon & Schuster,
2018. | Includes bibliographical references and index.
Identifiers: LCCN 2017022812 | ISBN 9781476794211 | ISBN 1476794219
Subjects: LCSH: Picasso, Pablo, 1881–1973—Criticism and interpretation. | Picasso,
Pablo, 1881–1973. Demoiselles d'Avignon.
Classification: LCC ND553.P5 U56 2018 | DDC 759.4—dc23 LC record available at
https://lccn.loc.gov/2017022812

ISBN 978-1-4767-9421-1
ISBN 978-1-4767-9422-8 (pbk)
ISBN 978-1-4767-9423-5 (ebook)

Contents

In Search of Lost Time

We will all return to the Bateau-Lavoir. We were never truly happy except there.

<div align="right">

—PICASSO TO ANDRÉ SALMON, 1945

</div>

P ablo Picasso stood on the threshold of his apartment bundled against the autumn chill, his hat pulled low about his ears, a brown knit scarf tossed carelessly across his shoulders. A shapeless coat engulfed his stocky frame. Shabbily dressed, not so much anonymous as invisible beneath the layers, he hardly looked the part of the world's most famous artist.

There was something incongruous in the scene, something about the man and the place that didn't quite match. If the elegant address— a seventeenth-century apartment building on the rue des Grands-Augustins, in the genteel Left Bank neighborhood of Saint-Germain-des-Prés— proclaimed his worldly success, his rumpled outfit suggested an indifference to the trappings that came with it. With his stained pants, worn at the cuff, and felt cap "whose folds had long since given up the struggle for form," Picasso showed the same disregard for convention he had as a struggling painter living from hand to mouth in a squalid Montmartre tenement. It was a quirk of his personality that his first wife had tried hard to correct. She often complained that no matter how much money he made,

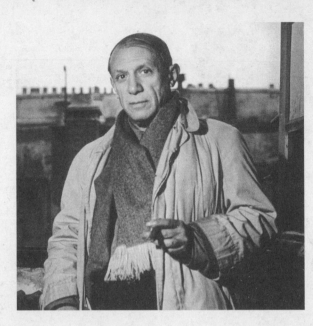

Picasso in the rue des
Grands-Augustins. ©
*RMN-Grand Palais / Art
Resource, NY.*

he insisted on dressing like a bum. In fact, the wealthier he became, the
more determined he was that money would not define him. "One has to
be able to afford luxury," he once explained to the writer Jean Cocteau, "in
order to be able to scorn it."

In any case it was not his wife he was waiting for this Tuesday after-
noon in the fall of 1945. Olga had long since fallen by the wayside, a casu-
alty of her unsuccessful battle to groom him for a life in high society. For
a time he'd submitted to her strict regime, attending costume balls hosted
by the decadent Count Étienne de Beaumont, posing pipe in hand for the
photographers, and generally playing the part of a debonair man-about-
town. But he eventually tired of the cocktail parties and elegant soirees,
reverting to the haphazard ways he'd enjoyed before the smart set claimed
him as one of their own. The Hungarian photographer Brassaï, who met
Picasso in 1932, was on hand to observe the process: "Those who thought
that he had put his youth behind once and for all, forgotten the laughter
and the farces of the early years, voluntarily abandoned his liberty and
his pleasure in being with his friends, and allowed himself to be 'duped'
by the pursuit of 'status,' found that they were mistaken. *La vie de bohème*
regained the upper hand." In truth, it had always been an unequal battle:
while Olga tried to make him into a gentleman, he took revenge in his art

by putting the former ballerina through a set of pictorial transformations, each more grotesque than the last.

Rather than Olga—or the voluptuous Marie-Thérèse Walter or the brooding Dora Maar, former mistresses who were both still part of Picasso's extended harem—the woman he was expecting this afternoon was his latest conquest, the twenty-four-year-old, auburn-haired Françoise Gilot.

Perhaps *conquest* is not quite right. For once, it seemed, this relentless seducer had met his match. It's true that after a strenuous campaign Françoise had agreed to share his bed, but his attempts to possess her body *and* soul had been frustrated by her infuriating streak of independence. Her ability to parry his advances only increased his determination to have her, but her inscrutable ways drove him to distraction. Brassaï testified to the "raw state of his nerves." With Françoise, this usually self-confident man (particularly when it came to the war between the sexes) was reduced to a gelatinous state. "When I see Picasso, looking a little upset, shy as a college boy in love for the first time," Brassaï recalled, "he

Rue des Grands-Augustins.
Courtesy of the author.

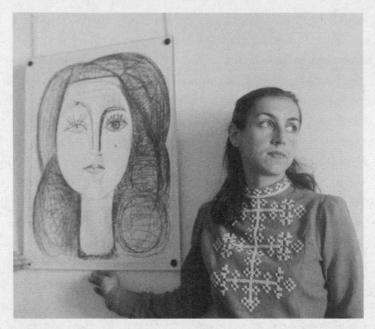

Françoise Gilot. © *Ministère de la Culture / Médiathèque du Patrimoine, Dist. RMN-Grand Palais / Art Resource, NY.*

gestures slightly toward Françoise, and says, 'Isn't she pretty. Don't you think that she is beautiful?'"

There's no doubt that Françoise Gilot—barely out of college and with little experience of the world in general, even less of men in particular—managed to throw him off balance. After more than a year of on-and-off wooing, Picasso was still unsure where he stood. "I don't understand you," he grumbled. "You're too complicated for me." In her most recent display of rebellion, Françoise had spent the last few months in the south of France, not exactly ending the relationship but making it clear that she wasn't ready to commit to him. And when she finally returned, showing up unexpectedly on his doorstep, he couldn't hide his hurt feelings. "I thought you weren't coming back," he sulked, "and that put me in a very black mood." Though she was here now, Picasso knew she might just as easily slip away.

Since her return to Paris in late November, Picasso had assumed a role that had often worked before on star-struck young women, playing the older master to the eager pupil. Françoise had still not agreed to

move in with him, but she visited his apartment almost every day. "Over the weeks that followed," she recorded, "I began to do just what Pablo advised me to do: to study Cubism more in depth. In the course of my studies and reflections I worked back to its roots and even beyond them to his early days in Paris, between 1904 and 1909." Being initiated into the mysteries of the twentieth century's most important movement by its founder was a rare privilege for a budding artist, and Picasso was happy to oblige. These lessons drew them closer, their intimacy heightened by the sense of a shared voyage. At the same time they measured an unbridgeable gap: while she had her future in front of her, he belonged to history.

An older man—Picasso had turned sixty-four this past October—taking a young woman under his wing can generate a powerful sexual charge, and he was not above exploiting his fame to lure impressionable girls into his bed. But with Françoise it was different; he felt a kinship with her that went beyond mere sexual appetite. Each responded to the loneliness in the other, a sense of isolation that culminated in Picasso's fantasy that his lover would live in the rafters beneath the rooftop of his studio where, together, they could shut out the world. When Jaime Sabartés—the childhood friend who now served as his personal secretary and gatekeeper at the rue des Grands-Augustins—warned him that the relationship was bound to end badly, Picasso turned on him angrily. "You mind your business, Sabartés," Picasso shouted. "[W]hat you don't understand is . . . the fact that I *like* this girl." They were kindred spirits, he insisted, tormented souls who could find comfort only in each other's arms.

Françoise was drawn to Picasso against her better judgment. Along with his famous charm, which he could turn on and off like a switch, he was bathed in the dazzling aura that surrounds all famous men. But there was more to his magnetism than this. Françoise was moved by Picasso's vulnerability, a vulnerability that showed through the hard shell of mistrust that served to shut out a world that had wounded him. He could be arrogant, insufferable, too certain of his genius, and merciless to anyone he thought was preventing him from realizing his destiny. There was also a desperate neediness, a sadness that played on her maternal instincts,

instilling an almost irresistible urge to fix what was wrong, to make whole what had been broken.

Still she held back, understanding instinctively that a relationship built around his all-consuming need was bound to be destructive. "I could admire him tremendously as an artist," she remarked, "but I did not want to become his victim or martyr."

Despite her youth, Gilot was no ingenue to satisfy the lust and prop up the vanity of an aging satyr (though as always in Picasso's case those two most compelling of human motives were never completely absent). Indeed, when he'd spotted her two years earlier across the darkened room of his favorite restaurant, sitting with her childhood friend Geneviève, she'd been introduced to him as "the intelligent one" to distinguish her from her "beautiful" companion.

Of course, that was part of the problem. Françoise had a mind and a life of her own before she met Picasso. In May 1943 she had just made her professional debut with a show of paintings at the fashionable Madeleine Decré gallery (in sharp contrast to Picasso himself, who had been labeled "degenerate" by the Nazi occupiers and whose work was banned from public exhibition). Noticing the two attractive women in the company of an actor he knew, Picasso sauntered over to their table bearing a bowl of ripe cherries, a luxury in wartime Paris that carried more than a faint erotic whiff. When Geneviève told him that she and her friend were painters, he burst out laughing. "That's the funniest thing I've heard all day," he snorted. "Girls who look like that can't be painters."

Still, he'd been sufficiently intrigued to pay an incognito visit to the gallery, and the following week, when Françoise took him up on his invitation to visit him in his studio, he remarked, "You're very gifted for drawing. . . . I think you should keep on working—hard—every day."

Françoise was flattered by the great man's attention, but she had few illusions as to the nature of his interest. At first Picasso opted for the direct approach. On one occasion he pulled her roughly to him and planted a kiss on her lips; on another, he casually cupped her breasts like "two peaches whose form and color had attracted him." Assuming he was

merely trying to provoke her, Françoise determined that the best way to knock him off his game was by failing to play the role of the outraged virtue he expected. "You do everything you can to make things difficult for me," he complained, dropping his hands. "Couldn't you at least *pretend* to be taken in, the way women usually do? If you don't fall in with my subterfuges, how are we ever going to get together?"

When Françoise finally relented, then, it was with eyes open, and even after they became lovers she was careful to retain room for maneuver, rebuffing his increasingly urgent pleas that she move in and tormenting him with what he described as her "English reserve."

Withholding a part of herself was an act of self-preservation. Françoise knew it was almost impossible to be intimate with Picasso without losing oneself entirely. Stronger women than she had been consumed in the furnace of his passion, an obsession whose intensity inevitably turned to disillusionment. "For me," he told her, "there are only two kinds of women—goddesses and doormats." The idol inevitably fell, the object of worship becoming the focus of rage when she failed to vanquish the demons that haunted him. After the end of the wartime occupation he became increasingly unpredictable, lashing out angrily or wallowing in self-pity as his growing celebrity increased his sense of isolation. "[H]e was very moody," Françoise recalled, "one day brilliant sunshine, the next day thunder and lightning."

For an older man, a consuming passion for an attractive woman young enough to be his granddaughter inevitably stirred up morbid thoughts of lost time, of the yawning chasm between his own vanished past, the inadequate present, and the uncertain future. As Picasso aged, the women he chose tended to get younger. His success in that arena reassured him that he retained the vital spirit that made him a force of nature, and any stumble conjured up the specter of his own mortality. In love, as in art, there were many pretenders to the throne, and if so far he had managed to stay on top, it remained a constant war against not only a host of rivals but also a more remorseless foe.

When Françoise arrived at the rue des Grands-Augustins that Tuesday afternoon, she was surprised to find Picasso already waiting on the front

steps. Usually he kept an eye out for her seated at the second-floor window, one of his pet pigeons perched familiarly on his shoulder.

"I'm going to take you to see the Bateau Lavoir," he announced, summoning like a talisman the name of the ramshackle tenement where he had spent his early years in Paris and where he had transformed himself from a young unknown to the acknowledged leader of the modern movement. "I have to go see an old friend from those days who lives near there."

Before long, a car squeezed through the wrought-iron gate and inched into the courtyard, a jet black monstrosity—half hearse, half royal chariot—driven by a chauffer in white gloves and livery. This was Marcel at the wheel of Picasso's famous Hispano Suiza Coupe de Ville. The car was a relic from the days before the war, one of the few reminders Picasso allowed himself of his life with Olga: a souvenir of Parisian seasons filled with society balls and summers on the Riviera with Ernest Hemingway and the Fitzgeralds. Among the anachronistic touches were multiple interior mirrors for making the final adjustments to one's evening wear and crystal vases filled with cut flowers.

It was a strange possession for someone who called himself a Communist, as odd as the grand and gloomy apartment that recalled a vanished aristocracy of minuets and powdered wigs. Since his headline-making announcement the year before that he was joining the "People's Party," the chauffeured limousine had become something of an embarrassment, a visible symbol of hypocrisy. But for Picasso (who never learned to drive) the car was more than a luxury. It was a means of escape when the routines and the people associated with a particular place grew too burdensome. During the war years, with gasoline rationed and movement restricted by the Germans, he'd been forced to abandon his peripatetic ways. Now, after years of claustrophobia and paranoia, he could once again travel at will, a necessary balm for his restless soul.

The restlessness had always been there, but his kinetic energy used to take a different form. As a young man he had prowled Paris on foot, feeding his inspiration by feeding off the excitement of the vibrant city, wearing holes in shoes he couldn't afford to mend. It was not simply the last resort of a poor man; walking was a form of epistemology, a way of

knowing. It provided the essential textures and materials of his art. The woman who lived with Picasso during his years of poverty remarked, "[I]t is good to walk when you are young and carry hope in your heart." In meandering journeys through the neighborhoods of his adopted city he had time to think, to tease out the tangled skeins of his vision and explore new vistas and uncharted alleyways of the mind. And while he wandered, he absorbed the sights and smells of the great capital, its hectic rhythms so different from those of his native Spain, its jarring dislocations and cacophony finding their way in the fractured surfaces of his canvases. Now his face was plastered on magazine covers on every corner newsstand, and as the world crowded in, he withdrew, increasingly alienated, unmoored.

With Marcel at the wheel, Picasso and Françoise watched the city unspool in silence, the noise and dust shut out by glass and chrome. They rolled across the Pont Neuf and over the Île de la Cité. They watched the twin towers of Notre Dame looming dark against the clear blue sky, skirting the eastern edge of the Louvre, where as a young man he had spent hours warding off the winter cold and grappling with the masters of the past. In that great labyrinth he had tested his youthful ambition against millennia of human achievement, seeking to possess the secrets of the ages so that he might storm the battlements armed with the weapons of the enemy.

They navigated the Marais, its streets haunted by the missing Jews who had fled or been rounded up and sent to the east, buildings scarred by bullet holes made when Parisians finally rose up against their jailers. Picasso had almost been one of the casualties when a stray projectile whizzed past his head and lodged in the windowsill as he peered out to see what was happening.

At the base of Montmartre they crossed the boulevard de Clichy with its bars and seedy nightclubs, including the tawdry, tacky Moulin Rouge, made famous by Toulouse-Lautrec. It was in these low-end dives that the teenage Picasso and his Catalan friends had received their first education in the liberated sexual mores of the French capital and the mysteries of the liberated French woman.

Then the climb up the southern face of Montmartre, the engine of

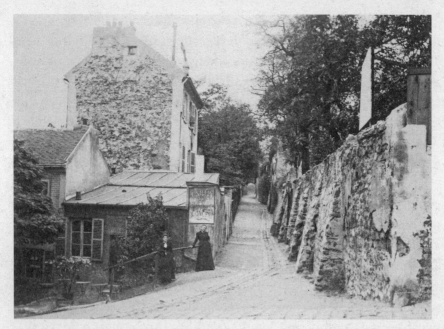

Montmartre, c. 1900. *Adoc-photos / Art Resource, NY.*

the Hispano Suiza grumbling with the effort to negotiate the steep slopes. As they rose through Montmartre's clotted byways, Marcel carefully maneuvering the oversized car through the narrow passages, the years seemed to slip away. "I would have thought we had made a long journey through time and space to reach this faded corner of the past," Françoise wrote. As the weight of the present lifted, Picasso grew visibly more relaxed, his eyes gleaming hopefully as he surveyed the scene of his youthful triumph.

Stepping out of the car at the summit of the hill, they found themselves in another world, a neighborhood of rustic houses and overgrown gardens that still carried the memory of the village it had once been. When Picasso had first arrived, at the beginning of the century, Montmartre was already joined to Paris as its Eighteenth *Arrondissement*, but the Butte, as locals called it, continued to defeat the best efforts of urban planners who hoped to transform a medieval metropolis into the City of Light, a beacon of modern rationality. Mystery clung to the neighborhood's rubble-strewn slopes, forgotten pockets of an earlier time, dark corners of the human psyche that reproached the image Parisians had of

themselves as a people in the vanguard of civilization. Here were relics of a past that had vanished elsewhere: windmills, quarries, and vineyards,* tumble-down lean-tos—home to impoverished workers displaced by Baron Haussmann's ruthless demolitions—and high stone walls behind which virginal sisters lived in cloistered isolation.

Montmartre was the "Hill of Martyrs," the place where Saint Denis, the eighth-century miracle worker, proclaimed his faith and lost his head. But even as it clung to its medieval spirituality, the Butte was also a site of unbridled libido: of taverns and opium dens, cabarets, dance halls, and bordellos, far enough from the city center to escape the strict attention of the authorities but close enough to lure seekers of illicit pleasures.

It was contested territory, between country and city, between the world of the spirit and the world of the flesh, pitting radical atheists against black-robed priests. Here the Commune of 1870—the world's first socialist government—made its bloody stand against the forces of reaction, and here, too, in an attempt to expiate the sins of godless communism, Catholic reactionaries raised the Basilica of Sacré-Coeur in virginal white travertine as a monument to their ancient faith.

Like all sites of ambivalent authority, Montmartre had always attracted more than its share of the discontented and dispossessed. Even before the turn of the century, it served as a haven for artists as well as anarchists—which often amounted to the same thing, as each group asserted as its ultimate goal the freedom to live without rules. Renoir had taken up residence on the rue Cortot before he became rich and complacent, as had, briefly, Cézanne and van Gogh, sharing the neighborhood with the radical *L'Anarchie* and *Le Libertaire*, published out of cramped offices in the rue d'Orsel. Picasso himself had heard tales of the neighborhood's fevered nightlife and colorful characters while still a regular at Els 4 Gats, the Barcelona tavern that was itself modeled on a Montmartre original, so that lurid dreams of bohemian Paris fueled in his imagination long before he ever set foot in its crooked streets. Ultimately, Picasso would do more than anyone to promote the romantic legend of Montmartre, but

* Most of the windmills are gone, but Montmartre is still home to the only vineyard within the city limits.

when he first made the journey he was treading a well-worn path, following in the footsteps of compatriots who had already set up an unofficial Catalan artist colony in the Eighteenth *Arrondissement*.

In the fall of 1945, the journey proved more difficult. Navigating time is necessarily more fraught than navigating space, since the dimension defined by the elastic stuff of memory is inherently treacherous. As they walked arm in arm, Picasso conjured up a world that had disappeared decades before Gilot was born, a world of ghosts who had passed into legend and grizzled survivors who had managed to salvage something from the wreckage of the past. "There's where Modigliani lived," said Picasso, pointing to a dilapidated shed barely visible on a slight rise behind the street. Modigliani's was a classic Montmartre tale. Handsome, talented, and doomed, he had arrived in Paris in 1906 seeking to tap into the vital energy of the avant-garde. Drawn like a moth to the brilliance of Picasso and his companions, he hovered just outside that charmed circle, too unsure of himself to hold his own in that boisterous crowd. In the end, he lacked the hard instinct that allowed the Spaniard to negotiate the gauntlet bordered by poverty on one side and dissipation on the other and that destroyed so many of his contemporaries, succumbing to a lethal combination of drugs, alcohol, and tuberculosis before his fortieth birthday.

Picasso paused in front of a narrow, gray building. "That was my first studio, the one straight ahead," he said, gesturing to the fifth-floor attic, where a wall of north-facing windows indicated the presence of a painter's atelier. Here the eighteen-year-old Picasso and two of his Spanish friends had stayed during his first visit to Paris, spending a delirious couple of months wallowing in the decadent glamour of Montmartre, its allure infinitely enhanced by the fact that the studio came fully furnished with three pretty (and compliant) models. For Picasso, that first taste of Paris was exhilarating; for his friend, the brooding Carles Casagemas, that initial confrontation with the sexually adventurous Montmartrois female would bear tragic fruit.

"A little farther along," Gilot recorded, "we reached a sloping paved square, rather pretty and a little melancholy. Ahead of us was the Hôtel

Paradis and beside it, a low, flat, one-story building with two entrance doors, which I recognized, without his telling me, as the *Bateau Lavoir*. Pablo nodded toward it. 'That's where it all began,' he said quietly."

Where it all began . . . how much is conveyed by that wistful phrase! A line dropped into a dark pool, a beacon sent out across the gulf of years on the off chance it will fetch back some faint reflection. There's a fierce pride here, but also regret, a recognition that, for all that was achieved, much was lost along the way. Those words measured the distance between desire and consummation, and in making the calculation Picasso discovered—like many who've made the journey from obscurity to fame, from poverty to wealth—that dreams, in coming true, lose much of their luster. A few months earlier, shortly after the Liberation of Paris, Picasso's thoughts had inevitably turned to those halcyon days, before darkness fell. "We will all return to the Bateau-Lavoir," he told his old companion the poet André Salmon. "We were never truly happy except there."

What, precisely, began here? What vision sustained those who called the former piano factory on the rue Ravignan home and tried to wring some deeper meaning from that particular time and place, something to compensate them for the cold and hunger, the suicides and betrayals, something dimly perceived through the opium haze and nights of despair, some glimmer in the dark to ease their doubts, a signpost guiding them toward a limitless future?

Some insisted that it was nothing less than the modern world that was born here, that unique mix of infinite potential and unspeakable horror that characterized the twentieth century: an impulse to innovate at any cost, to transform every aspect of life whose benign aspect we call progress but whose malignant twin led to Dachau and the Gulag. Often compared to a laboratory—its inhabitants likened to alchemists who brewed strange potions for inscrutable purposes—the tenement known as the Bateau Lavoir has gone down in history as one of those sites of cosmic convergence, a gravitational vortex where random motes seemed to coalesce, to in-spiral in heated clouds, creating novel and hitherto unimagined forms of matter and radiating bursts of unpredictable energy.

Place Ravignan. *Courtesy of the author.*

To those of a more spiritual bent, the Bateau Lavoir was sacred ground, "the Acropolis of Cubism,"* a temple to that uniquely modern creed known as the avant-garde. Though it proclaimed itself the enemy of organized religion, the avant-garde was nonetheless a form of worship, a mystery cult where the sacred stuff of life was extracted according to formulas known only to initiates, a faith that gained in power as it wrapped itself in obscurity, with its own rites, customs, hierarchies, and keepers of the flame. Here vestal virgins came disguised as women of easy virtue, the ceremonies were conducted beneath heavy clouds of opium and hashish, and the high priests were poets, painters, and sculptors of equally dubious morals, scruffy avatars of a civilization addicted to lurid tales of its own demise.

* The phrase originates with Picasso's friend the poet Max Jacob, who, according to legend, was also the first to name the old piano factory the Bateau Lavoir, "The Wash Boat," due to its supposed resemblance to the barges on the Seine to which Parisians took their dirty laundry.

Like all religions this one had a prophet. He was a stranger, a young Spaniard just arrived from Barcelona, crude of tongue (at first he could barely communicate with the natives, whose language he did not speak) and of gloomy countenance, who through some otherworldly power drew about him a circle of brilliant men and women, disciples who would soon proclaim the gospel they had learned at his feet to the far corners of the earth.

Viewed from the chestnut-shaded place Ravignan, the Bateau Lavoir is a modest structure, presenting only a low stucco wall to the square. But the squat facade is deceptive. Like many of the buildings set into the steep sides of the Butte, it tumbles down the slope in back in a kind of slapdash architectural landslide,[*] so that, like Mary Poppins's purse, it contains far more interior space than its exterior dimensions would seem to allow.

As Picasso led Gilot through the low door, they were plunged into darkness. The place was dank, with oozing walls and stagnant air, bitter with decay. The days when Montmartre, and the Bateau Lavoir in particular, had been the center of all that mattered had long since passed, and the building had the silent, musty feel of a tomb. As they wandered along mazelike corridors, groping their way forward in the grudging light, Picasso tried to make the building come alive by telling her stories of the old days: of the farcical Max Jacob with his top hat and monocle, his funny dances and barbed songs improvised on the spot; of the brilliant Guillaume Apollinaire hunched over his plate like a stray dog guarding a meat bone, whose conversation was a scintillating froth sprinkled with erudite references and obscene jokes; and of the beaming, childlike Henri Rousseau and the legendary banquet Picasso and his mistress Fernande Olivier had thrown for him. That drunken revelry—grown ever more improbable with each retelling by those who were there and those who only imagined they were—was long remembered as the outrageous apotheosis of bohemian Paris.

[*] The original building burned down in 1970. It has since been replaced by a more presentable replica.

They stopped in front of a door near the stairwell. "He put his hand on the doorknob and the other on my arm," Gilot remembered. " 'All we need to do,' he said, 'is open this door and we'll be back in the Blue Period. You were made to live in the Blue Period and you should have met me when I lived here. If we had met then, everything would have been perfect because whatever happened, we would never have gone away from the rue Ravignan. With you, I would never have wanted to leave this place.' He knocked at the door but no one came. He tried to open it but it was locked. The Blue Period remained shut away on the other side of the door."

As Picasso rattled the handle, the weight of years pressed in on him once more. The past, he realized, would lie forever out of reach, just on the other side of an impenetrable barrier. To live is to hear doors slam shut, dark corridors echoing with the regret of alternatives not taken; time's arrow points in only one direction, and memory's capacity to reverse the flow is only an illusion.

They reversed their steps and returned to the deserted square. Gilot could see that Picasso was struggling to contain his emotions. On previous visits, he reminisced, he would often see the concierge's daughter, who used to skip rope outside the window of his studio. "She was so sweet," Picasso sighed, "I would have liked her never to grow up." But of course she did what girls (if not dreams) do and grew and aged, changing from a child into a handsome young woman, then becoming fat, each time shedding a bit of that grace that clings to all things fixed in memory. "In my mind's eye I had kept on seeing that little girl with her jump rope and I realized how fast time was flowing and how far I was away from the rue Ravignan."

With those gloomy reflections, they set out once more, making their way up the hill a few blocks until they reached the rue des Saules, where they stopped in front of a modest house. "He knocked at a door and then walked inside without waiting for an answer," Gilot recalled.

I saw a little old lady, toothless and sick, lying in bed. I stood by the door while Pablo talked quietly with her. After a few minutes he laid some money on her night table. She thanked him

profusely and we went out again. Pablo didn't say anything as we walked down the street. I asked why he had brought me to see the woman.

"I want you to learn about life," he said quietly. But why especially that old woman? I asked him. "That woman's name is Germaine Pichot. She's old and toothless and poor and unfortunate now," he said. "But when she was young she was very pretty and she made a painter friend of mine suffer so much that he committed suicide. She was a young laundress when I first came to Paris. . . . She turned a lot of heads. Now look at her."

This was Picasso's final lesson on their shared journey through time, imparting to his young lover a wisdom that usually comes only through bitter experience. Weeks of instruction that had begun with Picasso leading Françoise Gilot through the conceptual thickets of Cubism now ended at the bedside of that time-ravaged woman.

Arranging a confrontation between his young lover and this unfortunate wreck of a woman was characteristic of Picasso's approach to life and to art, each of which he shaped in light of his own obsessions. Sex and death—Freud's Eros and Thanatos—beauty and hideousness: these opposing forces were the elements that, bound together, gave the world its form. The encounter with Germaine was a flesh-and-blood version of the *vanitas* or *memento mori*, a reminder that even in the midst of life we are in death. The grinning skull, the guttering candle, the fly-specked melon— each of those symbols conjures up the process of decay that is inseparable from the ferment of life.

For Picasso, Pichot was the real-life incarnation of this morbid principle. "[W]omen are suffering machines," he once observed, ignoring the fact that so often it was he who inflicted the pain. It was Pichot's broken form, even more than the aging concierge's daughter, that demonstrated the inexorable passage of years. She was the gatekeeper blocking the way of the hopeful time traveler, the embodiment of the principle of death. Confronting her in the company of his young lover was Picasso's way of evening the odds, showing Françoise that while she might hold a temporary advantage over him, they were both subject to the same grim fate.

Why was Picasso so desperate to turn back the clock, and so bitter when he discovered that the past was denied him? In part it was the promise and the peril of a new love affair, exhilarating and terrifying in equal measure. His passion for Françoise reinvigorated him, but it was also a vampirelike parasitism of age upon youth that conjured shades of mortality in the very act of trying to transcend them.

By 1945, Picasso felt the walls closing in on him; his best years lay in the past, and all he had to look forward to was a long, slow decline. Paradoxically, the Liberation of Paris had actually narrowed his own horizons. His current fame had a valedictory quality, as if he were no longer a living, breathing man but a fossil of something once great and terrible. Of course the Occupation had brought its own peculiar indignities, even if his fame had spared him the worst of its deprivations. Throughout the war he'd been harassed by officials who suspected him of harboring fugitives or, at the very least, sympathizing with the Resistance. But aside from occasional "Kafkaesque" visits from undercover agents of the Gestapo, he was largely left in peace, as fair-weather friends thought twice before allowing themselves to be seen in the company of a known subversive.

All that changed with the arrival of the Allied armies. He'd done little during the years of the Occupation except endure, but to a public yearning for heroes that seemed to be enough. "Oh, I'm not looking for risks to take," he told Françoise during the darkest days of the war when she asked him why he remained in Paris after so many of his colleagues had fled to England or the United States. "I don't care to yield to either force or terror. . . . Staying on isn't really a manifestation of courage; it's just a form of inertia. I suppose it's simply that I prefer to be here. So I'll stay, whatever the cost."

The world, however, insisted on putting a more heroic spin on this mundane tale. In August 1944, when liberation came, Picasso was surprised to find that he was acclaimed as not only the greatest artist of the century but a symbol of resistance to tyranny. On one level he courted the attention, sitting down with journalists and opening his studio to dignitaries and fellow celebrities, but increasingly he saw fame as a trap. "Paris was liberated," he complained, "but I was besieged." Now instead

of visits by the Gestapo he was plagued by a constant stream of tourists, "poets, painters, critics, museum directors, and writers, all wearing the uniform of the Allied armies, officers and ordinary soldiers, thronged up the narrow staircase in a compact mass."* "From that moment on," Gilot observed, "Picasso had stopped being a private citizen and became public property."

Against this well-meaning assault Picasso launched his own campaign of resistance. "Famous," he later grumbled, "of course, I'm famous! . . . What does it all mean? It was at the Bateau-Lavoir that I was famous! When Uhde came from the heart of Germany to see my paintings, when young painters from every country brought me what they were doing and asked for my advice, when I never had a sou—there I was famous, I was a painter! Not a freak." Fame, for him, became as much an enemy as time. Both represented a closing of options, doors slamming shut never to be reopened. As a teenager he'd thirsted for glory and raged at the world that ignored him. In retrospect he could see that it was far better to toil in obscurity than in the public eye; vistas of endless possibility were replaced by the claustrophobic view of a man hunkered down.

Gilot put it best:

> In the light of that I could understand even better the meaning the Bateau Lavoir had for him. It represented the golden age, when everything was fresh and untarnished, before he had conquered the world and then discovered that his conquest was a reciprocal action, and that sometimes it seemed that the world had conquered him. Whenever the irony of that paradox bore in on him strongly enough, he was ready to try anything, to suggest anything, that might possibly return him to that golden age.

* One of them was Ernest Hemingway, who, finding Picasso out, left as his calling card a crate of grenades—presumably a tribute to the artist's gift for exploding convention.

It was a crucial insight, a key to the sadness that clung to this man who appeared to have everything. That intuition allowed her to forgive him his cruelty, since it derived not from strength but from weakness: "I knew by now that although Pablo had been receiving the world's adulation for at least thirty years before I met him, he was the most solitary of men within that inner world that shut him off from the army of admirers and sycophants that surrounded him. 'Of course people like me; they even love me,' he complained one afternoon when I was trying to break the spell of pessimism I found engulfing him when I arrived. 'But in the same way they like chicken. Because I nourish them. But who nourishes me?'"

That role, of course, would fall to Gilot. She would share his life for almost ten years, providing him with the warmth and sympathy he required, tending to his needs, bearing him two children, upon whom he doted and who restored, at least for a time, his zest for life, and fighting an ultimately losing battle against the darkness in his soul.*

As they descended the steep slopes of the Butte in the stilted silence of the limousine—a raft set adrift on time's treacherous currents—Picasso was weary, disconsolate. He had begun the journey in a hopeful mood, convinced that in the company of his young companion he could reverse the tug of entropy, but the journey merely confirmed that the magic he was trying so desperately to recover was inaccessible, locked forever behind a battered door in an old piano factory in Montmartre.

Perhaps it was just as well, since few men were as ill suited as Picasso to the nostalgic role. He'd always been focused on the future, a step or two ahead of his contemporaries, peering ahead to the realm of shadows yet to come while they were still basking in the sunlight. It was this darkness that now made him seem like a prophet. "Picasso believes that art emanates from sadness and pain," wrote Sabartés. "We are passing through an age in which everything is still to be done by everybody, a period of

* Françoise's children with Picasso were Claude, born in 1947, and Paloma, born in 1949. Picasso also had another son, Paulo, born in 1921, from his marriage with Olga, and a daughter, Maya, with Marie-Therese Walter.

uncertainty which everyone considers from the point of view of his own wretchedness, life, with all its torments, constitutes the very foundation of his theory of art."

Had he been a different sort of man and a different sort of artist—less death-haunted, less in touch with the horror that lurked behind the grinning mask of socialized Man—he wouldn't have become the spokesman for an age that excelled in mayhem. Picasso's pessimism struck a chord with a world still reeling from the disaster of war and genocide. His great rival Henri Matisse may have equaled, or even surpassed, him as a magician of paint on canvas, but there was something about the older man's joyous, light-filled art that seemed out of step with the times. The golden age was over, not only for Picasso but for modernity itself; the promise of an incandescent future that had opened with the new century had been reduced to ash as the tools of progress were turned against us. During the very years Picasso was residing at the Bateau Lavoir, giving birth to a revolution in art, a former patent clerk in Bern was radically altering our notions of time and space, contemplating a simple equation whose solution would lead to Hiroshima and Nagasaki.

In retrospect it seemed as if Picasso's work had anticipated the catastrophe: not only in *Guernica* (1937)—perhaps the most vivid evocation of war's horror ever painted—but from the earliest works of his maturity. More than any of his fellow travelers in the avant-garde, he developed a visual language for the dawning age, describing its vertiginous logic in works of art that captured technology's disorienting impact on our senses. But though he embraced modernity, he never succumbed to the illusion (shared by so many of his colleagues) that we were in the process of building paradise on Earth. The fractured mirror he held up reflected an image of our times as harrowing as it was exhilarating.

But Picasso was a reluctant Messiah. Others might recite the gospel they had first learned at his feet, but he himself was an apostate. He turned his back on the world that had failed to nourish him adequately, remembering its slights and then rejecting its honors with a sardonic laugh when he discovered how empty they were.

Or perhaps he didn't actually turn his back on the world because he had never really cared about it in the first place. Despite being anointed the voice of a generation by a public searching for heroes and in need of

a guiding vision, his art was essentially autobiographical, an expression of personal pathologies rather than an exposition of an ideology. He was too much of a nihilist to make a good prophet. He accepted the public's adulation as nothing less than his due but treated those who came to pay homage with either contempt or indifference. In any case, he would have thrown it all away for a chance to start over. Fame had turned out to be a burden, and time had cheated him. The door remained closed, the golden age remained tantalizingly beyond his grasp.

But was it really shut tight? Perhaps another try would do the trick: a more persistent banging or an extra hard twist on the knob. Picasso, in any event, would not let his frustration go to waste. His art thrived on disappointment. Melancholy was always followed by ecstatic fury as he returned to the studio, exorcising his demons by mocking them, making them leap and cavort like demented souls as he wielded his brush. If his art was driven by dark energy, it was energy nonetheless, and he relied on its propulsive power to fuel his creativity.

And even if, like Moses, Picasso was denied entrance to this promised land, might *we* still be permitted to cross the threshold? After all, André Salmon, who was there with Picasso and his friends and was as intimate as anyone with the strange sort of necromancy they practiced, described the rue Ravignan as "a fascinating square of the Fourth Dimension," the kind of place where, employing Einstein's equations, past and future might be bent sufficiently to converge in our present.

It takes a while for our eyes to become accustomed to the gloom, but if we concentrate it becomes apparent that a light still flickers, if only fitfully, from the chink in a darkened hallway, a remnant from the explosion of a distant star that carries messages from a vanished time. . . .

2

The Legendary Hero

*We spoke of him as a legendary hero: "Do you know? . . . He has gone
away . . . Heaven knows when he'll come back!"*

—JAIME SABARTÉS

In art, one must kill one's father.

—PABLO PICASSO

Two young men in matching suits of black corduroy stepped out of
the third-class railway car and onto the crowded platform of the
Gare d'Orsay in Paris. One was tall and thin, with pale, unhealthy
skin, a receding chin, and a poet's distracted gaze. The other was short and
powerfully built, with dark hair, worn long and swept to either side of a
broad forehead, and piercing black eyes. Standing just under five and a half
feet tall, he had a welterweight's frame and a belligerence to match. In a
hopeful attempt to look older, he sported an adolescent's sparse mustache.

Despite the identical outfits, the two were something of an odd cou-
ple. While the taller youth conveyed an air of bemused detachment, his
friend brimmed with confidence, as if ready to take on the world. At least
that was the image he hoped to project. There was something slightly false
about the confident air, a bluster that concealed a nagging doubt—that he
could match up, that he could make it on the big stage.

Pablo Picasso arrived in Paris in late October 1900, a few days before his nineteenth birthday, which fell on the twenty-fifth. It was a year of beginnings, of fresh starts, the first of a century that promised untold innovations and an unprecedented acceleration in the pace of human progress. For an ambitious teenager, to be here—at the very center of the universe, according to Parisians themselves and to the rest of the world that had reluctantly come around to their way of thinking—at this particular moment in time was intoxicating.

Picasso had boarded the train the day before in Barcelona, accompanied by Carles Casagemas, a fellow painter and occasional poet with a small talent, a taste for drugs and alcohol, and a reckless, self-destructive streak. The two young men had been seen off by Picasso's parents, who handed their son what little they could spare. It was a characteristic act of generosity. Don José and his wife, Doña Maria, had invested everything in their only son, and if they had to scrimp in order to further his career they never questioned the sacrifice.

Neither did Picasso. It seemed only natural to him that his parents would dig deep to make sure he fulfilled his genius, a genius they all believed in even as they quarreled over just how he should apply it. In financing their son's Paris trip, Don José and his wife were risking more than their material security. Doña Maria had been easy to convince, but Don José feared that being away on his own would reinforce his son's already worrying independent streak. "Why put obstacles in his way?" she asked her husband after Pablo had approached them with his plan to spend a couple of months in the French capital. "He knows what he has to do."

Don José wasn't so sure. He'd begun to worry that Pablo was squandering his enormous talent by hanging out with scruffy bohemian types and flirting with radical styles rather than attending classes and perfecting the academic technique in which he'd been trained. An extended stay in libertine Paris might teach him all the wrong lessons.

In fact, his fears were justified. Picasso's desire to spend time in Paris reflected a very different conception of his career than the one mapped out by his father. In recent months he'd grown restless, dissatisfied with the smug, self-satisfied provincialism of the Catalan capital and increasingly

impatient with friends whose grandiose plans were never matched by actual achievement. He was also chafing under Don José's close supervision. An extended stay in Paris was just what he needed to get out from under the parental thumb, to strike out on his own and see what he was made of, to test himself in a far more demanding arena.

As the train pulled out of the station, Picasso radiated the nervous energy of a young man setting off on his first great adventure. But behind the flashing eyes, the too-quick laughter, the abrupt gestures was an anxiety he couldn't entirely conceal. After all, he was leaving the nurturing hearth behind to be cast adrift in a world where he would be just another face in the crowd.

Picasso and his family had moved to Barcelona five years earlier, in September 1895. By then, the thirteen-year-old Pablo Ruiz (as he still called himself) was already an accomplished draughtsman, with years of study in the academic art tradition behind him. Unusually for someone from a middle-class family, he never had to fight with his parents to pursue his chosen vocation. His father was the first in the Ruiz clan to make the dubious journey from bourgeois respectability to the slightly disreputable status of artist, which meant that Pablo was, for all practical purposes, born into the profession.

That didn't mean his path was easy. If he was born to be an artist, he and his parents could never agree on exactly what that meant. The fact that Don José was himself a painter meant that Pablo's own journey would take on the fraught, painful quality of an Oedipal struggle as the son sought to surpass the father in the area that most defined him. When he was only sixteen, right around the time he was beginning to assert his independence from Don José, Picasso confided to a friend, "In art, one must kill one's father."

Indeed, Picasso's career involved a headlong flight from everything his father represented. For Don José, achieving success as an artist meant a step-by-step climb up the institutional ladder, producing work calculated to appeal to one's superiors, never deviating from the formula so that, one day, you would be embraced by the establishment. Quality, in

his mind, was defined not by originality but by how well the work conformed to accepted taste. If he never quite achieved the position to which he aspired—an outcome guaranteed by his modest talent and lack of drive—he was convinced his gifted son would succeed where he'd fallen short.

José Ruiz y Blasco's ambition for his son was in sharp contrast to the halfhearted manner in which he pursued his own career. He had confounded the expectations of his proper Málagan relatives when he decided to become a painter, but in every other way he was thoroughly conventional. Possessing a modest gift for drawing, he decided to become a painter not out of any deep-seated compulsion but because it seemed to him a congenial way to make a living without having to work too hard. Tall, fair-haired, indolent, and mild-mannered, the opposite in almost every way of his famous son, Don José was not overburdened with either imagination or ambition. When, at the age of forty-two, he finally decided to settle down and start a family, he took a position as an assistant teacher of drawing at Málaga's provincial art school, the Escuela de Artes y Oficios de San Telmo. To supplement his meager salary, he also served as curator of the municipal museum and part-time conservator. In his spare

Portrait of Don José, 1896. *Album / Art Resource, NY.*

time he made picturesque "fur and feather" paintings, as his son derisively called the humble vignettes that often featured one or more of the pigeons he bred as a hobby.

It was into this world of marginal middle-class respectability that Pablo was born on October 25, 1881, surrounded by numerous aunts and uncles, who tended to regard the feckless artist in their midst with a mixture of pity and indulgence. Picasso could never forgive the condescension with which his father was treated by his more prosperous relatives, a circumstance that provoked a contempt for the bourgeois propriety they embodied.

In the sleepy, sun-drenched seaport of Málaga, on Spain's southern Mediterranean coast, Don José's preferred milieu was the local café, usually the popular Café de Chinitas, which presented a dignified front during the day but offered decidedly more risqué pleasures come nightfall. Here, surrounded by his *tertulia*—the circle of male friends that was the center of a Spanish man's social life—his urbanity and charm earned him the nickname "the Englishman." Picasso, so unlike his father in many ways, would import the custom to Paris, where, even when he lacked for the basic necessities of life, he would spend hours at the local bistro surrounded by his buddies.

Don José's other main source of entertainment was attending the bullfights. He often took his son to those sanguinary spectacles, and they remained among Pablo's fondest memories of childhood. The violence, pathos, and drama of the *corrida* spoke to his instinctive understanding of life's cruelty and to the ways in which cruelty, properly harnessed, could become a powerful creative force. In the ritualized life-and-death struggle between toreador and bull, Picasso discovered a dark beauty that fueled his art. Sometimes he identified himself with the killer, at other times the victim. In either case he was more at home in that bloody arena—peculiarly and profoundly Spanish—where the game is played for ultimate stakes than in the joy-filled landscapes where his future rival, Henri Matisse, would dwell.

For the first decade and a half of his life Picasso accepted his father's instruction and shared his dreams for the future. It seems odd to say that the mild-mannered Don José cast a long shadow on his son's life: he was too diffident to dominate anyone, least of all his headstrong son. But he loomed large in Pablo's imagination. "Every time I draw a man," he told

Brassaï, "it's my father I'm thinking of, involuntarily. For me, a man is Don José, and will be all my life." Far from wishing to emulate him, however, Don José would become a powerful negative example, the embodiment of the provincial dauber with no idea that art could do more than occupy wall space with pleasant scenes or repeat trite formulas. Pablo loved his father dearly, which made it all the more painful when he realized early on what a mediocrity he was.

Physically and temperamentally, Pablo resembled his mother, the stocky, dark-haired Maria Picasso y López. From her he inherited his mercurial temperament and his irrepressible energy, as well as a conviction that hidden forces rule our lives. This affinity, deeper than he ever acknowledged, helps explain why he would ultimately adopt her name. While Don José considered himself a sophisticated man of the world, Doña Maria immersed herself in the superstitious brand of Catholicism that was woven into the fabric of life in southern Spain.* This primitive strain of religiosity left its mark on young Pablo, despite his lifelong insistence that he was an atheist. The demonic transformations of his art are predicated on the assumption that a supernatural dimension lurks just beyond the reach of the ordinary, a mind-set that owes a great deal to the forms, if not the content, of mainstream religion. Picasso's second wife, Jacqueline Roque, claimed that he was "more Catholic than the Pope," but that is misleading. His beliefs ran in darker channels, with roots in the animistic impulses that are older than civilization itself and that were reluctantly adopted by the Church in order to bind the ignorant more firmly to orthodoxy. In the end, Picasso's spirituality owed more to the peasant's faith in the efficacy of amulets and the knucklebones of saints than in sacraments dispensed by priests.

* According to Picasso, while Doña Maria was pregnant she prayed for a son, and his arrival was viewed as an almost miraculous occurrence—made all the more miraculous by the fact that he was born not breathing and saved only by the quick thinking of his uncle Salvador (a physician) who blew cigar smoke into his lungs. Doña Maria was a devotee of the Virgin of Mercy and belonged to the lay sisterhood known as the Hermandad de la Victoria, all signs that she was a typically pious woman.

At home with his mother, sisters, and a couple of unmarried aunts (Elodia and Heliodora), he was the king of his own small domain—or, given the all-female supporting cast, a sultan with his harem. To Pablo, this seemed like the natural state of things. To be waited on and fussed over was his birthright, and it was to that blissful state that he always tried to return, surrounding himself with a devoted coterie that would put his needs before their own. As his friend the poet Guillaume Apollinaire once remarked, Picasso was a "newborn . . . [who] orders the universe in accordance with his requirements." His first mistress, Fernande Olivier, put it in less cosmic terms. She spoke for many of her successors when she shouted at him at one of Gertrude Stein's famous dinner parties, "[Y]our only claim to distinction is that you are a precocious child."

The infantile paradise was shattered when the five-year-old Pablo was packed off to school. In the classroom he was no longer considered special; his talent for drawing counted for little compared to his difficulty with math and his unwillingness to apply himself to his lessons.* He hated school, throwing tantrums and demanding that his father leave some prized possession—his cane, one of his brushes—as a guarantee that he would return for him.

Even as Pablo struggled with school, his father was experiencing his own troubles. First he was passed over for promotion at the institute where he taught, and then, in 1890, the municipal museum closed its doors. No longer able to support his family—which now included two girls, Maria Dolores, known as Lola (age five) and Concepción, known as Conchita (three)—he was forced to look farther afield for employment. Through the influence of his well-connected brother Salvador he found a job as a drawing instructor at the Instituto da Guarda institute in A Coruña, on the northwest Atlantic coast of Spain.

* Picasso exaggerated his academic shortcomings, portraying himself as a kind of idiot savant. When finally unearthed from the archives, his transcript showed him to be a competent, if not brilliant, student. There is no doubt, however, that his lessons bored him and that he much preferred to draw than apply himself to schoolwork.

Picasso with Lola, 1889.

For Don José the move was devastating. A faint whiff of failure followed him to the cold, rainy seaport, so different from sunny Málaga and so far from his family and his customary haunts. Picasso summed up his father's attitude toward their new home in a single phrase: "No Málaga, no bulls, no friends, nothing."

"In Corunna," Picasso continued, "my father did not leave the house, except to get to the Escuela. . . . Upon returning home he amused himself painting, but not so much any more. The rest of the time he spent watching the rain through the windowpanes." No doubt Picasso exaggerated, but even as myth his recollection is revealing, marking the moment he first perceived his father as a failure. All children eventually realize that their parents aren't the omniscient gods they believe them to be, but for Picasso disillusionment came earlier and more thoroughly than for most. That meant additional burdens would be placed on his young shoulders, since, as a man disappointed in life, Don José would come to depend on his son to fulfill his dreams.

The four gloomy years spent in A Coruña contributed another tale to the Picasso mythology. While Pablo was still in his early teens, Don José urged him to add his own touches to the "fur-and-feather" paintings that were his specialty, tacking to the wall a pigeon leg or some other prop

for him to copy. One day, Picasso recalled, Don José came home to discover that he had done the job so well that "he gave me his paints and his brushes, and never went back to painting." It's unlikely that the story is literally true: it follows too neatly the staple great-man biographies where the budding genius surpasses his master, who, conceding defeat, retires from the field. But whether or not it happened exactly as Picasso remembered, it reflects a growing awareness on the part of both parent and child that some invisible barrier had been crossed and that the family's hopes now rested not with the father but with the son.

The transition was marked in more practical ways as well. A year after the move to A Coruña, just before his eleventh birthday, Pablo was accepted as a student in his father's school. Here his training as a professional artist began. At the institute he began making studies from plaster casts and from nude models, honing skills that had been drilled into art students for centuries according to precepts little changed from the Renaissance.

These exercises, though they reveal little of the iconoclast to come, provide the crucial material from which his later innovations spring. Picasso's ambivalence toward this academic training is revealed in a remark made many years later to his wife, Jacqueline: "[M]uch as I despise academic methods, 'Ecole de Dessin' [school of drawing] should be emblazoned on every artist's door. Not, however 'Ecole de Peinture' [school of painting]." This belief that drawing forms the true sinews of art is very much part of the academic tradition. Mastery of this discipline, first acquired in A Coruña and then perfected in Barcelona, allowed Picasso to deconstruct the human body in the most improbable ways without ever losing the underlying coherence that gives even his most monstrous distortions their compelling plausibility. And it's this notion that all painting is based in the rigorous practice of drawing, of delineating form and conjuring space through modeling in light and dark, that gives to his Cubist works their palpability, no matter how far they stray from perceived reality.

The academic tradition provided more than the structural basis of Picasso's later work. He also discovered in this arid territory a mysterious landscape populated with ghosts, reimagining the dusty classrooms of his youth—filled to the rafters with plaster casts of broken classical statues, the remnants of long-dead civilizations—as charnel houses of the mind.

These shattered limbs crop up in paintings from the 1920s and '30s (most famously in the broken arms and legs and detached heads of *Guernica*), giving an ominous, surreal tinge to memories of childhood lessons. In these works the academic tradition that Picasso did so much to destroy makes a haunting reappearance as the mortal remains of a civilization that has already devoured itself.

Picasso will return time and again to this early training, even if it's mostly to subvert the formulas and stand them on their head. From these years in A Coruña emerges a second, equally vital strand of Picasso's art: an irreverent, populist, prurient, even pornographic vein that undermines and pokes fun at the academic lessons peddled by Don José and his colleagues. Instead of proper proportion, Picasso indulges in exaggeration; bored by the pursuit of perfection, he offers up caricature.

The impetus for these early forays into the world of pulp journals and cartoons was the need to keep friends and relatives back in Málaga informed of the family's lives on the far Atlantic shore.* Playing the role of reporter, Pablo sent back a number of illustrated "newspapers," including one he titled *Azul y Blanco* (Blue and White), which he modeled on the popular weekly *Blanco y Negro*. Its humorous vignettes reveal his gift for pithy caricature and a taste for vivid stories of daily life so different from the rigorous discipline he was forced to endure in school. Complete with mock advertisements, including one listing "Pigeons of guaranteed genealogy wanted to buy," (a gentle dig at his father's obsession), these cartoonlike pages demonstrate a precocious awareness of the forms and narrative possibilities of mass media.

In a similar vein are the graffitilike sketches he added to the margins of his lesson books, including one depicting a pair of donkeys humping.† These are just childish diversions, little different from the typical schoolboy

* The Spanish word for such cartoons was *alleluia* (hallelujah) a name derived from the fact that they had originally conveyed religious narratives. Picasso enjoyed deploying the forms of religious art for his own blasphemous purposes.

† Picasso accompanied the drawing with a bit of doggerel: "Without so much as a how-d'ye do,/The she-ass lifts her tail./Without so much as a by-your-leave,/The donkey drives in his nail."

antics, but once Picasso broke down the artificial barriers between the high art he was taught in his father's school and the "low" art that appealed to his puckish nature, a new world was born. Perhaps more than any other artist in history, Picasso deployed crude humor—graffiti, caricature, and sexual puns—in the service of masterpieces. It is in the work of the adolescent boy that we first see the irrepressible id peeking out from behind the curtain. Granted, it's only a cameo appearance, but soon enough this side of his personality will claim center stage, providing the energy and a shape-shifting polyamorousness that pushes the bounds of sexual possibility far beyond the Kama Sutra.

Though Don José never reconciled himself to life in the foggy Atlantic seaport, Pablo reveled in his newfound freedom. Ten years old at the time of the move and with energy to burn, he was no longer under the watchful eyes of his numerous aunts and uncles, while his father, increasingly discouraged, lacked the will to rein in his rambunctious son. For Don José the transfer to A Coruña involved not only dislocation but daily humiliation. His paintings sold poorly, and his salary was barely enough to pay the rent and feed his family. Pablo was well aware of his family's slide down the social ladder. When he was out playing with friends, he was told to keep an eye out for bargains, including one he recalled many decades later advertising "soup, stew and a main course for one peseta and served at home." But rather than embarrassment, Pablo took a perverse pride in his family's shabbiness, adopting the defiant pose (at least with his friends) of a desperado or pirate king.

As Don José withdrew from the world, Pablo's confidence grew. This dynamic manifested itself in increasingly wild behavior. He became the leader of a gang of pint-sized delinquents whose most memorable exploit, he recalled, involved an expedition through the alleyways of the city hunting feral cats with shotguns.

In January 1895, the family suffered a crushing blow when seven-year-old Conchita died of diphtheria. The death of his sister traumatized Pablo and contributed to a morbid obsession that bubbles up time and again in his art. The tragedy plunged the entire family into gloom, but it was hardest on Don José, who had already been depressed. Portraits Picasso made of his father at the time show a man shrinking from life, his energy sapped, his features increasingly haggard. Though Picasso didn't

kill his father, even metaphorically, he was certainly an unsparing witness to his slow disintegration.

The depth of the trauma for Picasso himself is reflected in what he called his "dark secret," which he confided to his wife, Jacqueline, only late in life: that during Conchita's illness he made a vow to God that if she were spared he would never draw again. The fact that he was incapable of sticking to his promise and that she died shortly after he broke his promise gnawed at him, establishing in his mind a profound connection between creation and destruction. God, it seemed, was a vengeful being, a cruel prankster who made a mockery of life and who could be propitiated or perhaps defied, but never loved. That he made this vow in the first place reflects a superstitiousness that was an essential feature of his personality. His certainty that dark forces lay behind the placid surface of life, and the belief that he was at least partly responsible for his sister's death, gave him an appreciation of his own demonic power, a dangerous gift that could be used for good or ill.

Picasso was grief-stricken but not paralyzed. Throughout his life he exhibited a resilience that allowed him to triumph over circumstances that destroyed many of his weaker companions. Instead of succumbing to despair, he put his grief to good use by transforming pain into art. Shortly after Conchita's death, Picasso undertook a series of portraits: one of a beggar, another of a local fishwife, and other assorted characters from the neighborhood. These dramatically lit and vigorously brushed slice-of-life paintings look back not only to the greats of Spain's past—Francisco de Zurbaran and Diego Velázquez in particular—but also ahead to his own Blue Period. Vivid, if uneven, these works earned the thirteen-year-old his first exhibition (in the window of a furniture shop) and his first review in a local newspaper. The anonymous critic noted that the works "are not badly drawn and are forceful in color . . . well-handled, considering the age of the artist." He ended the article with a prediction: "We do not doubt that he has a glorious and brilliant future ahead of him."

But if Pablo was thriving (or, from his parents' perspective, growing wild), the rest of the family was suffering. Don José concluded that the time had come for a change of scenery, and in the spring of 1895 he

La Llotja. *Courtesy of the author.*

accepted a position at the Barcelona School of Fine Arts, commonly known as La Llotja. The new job was a step up for Don José and a modest material boost for the Ruiz family. Located in the pompous neoclassical building near the harbor that also housed the stock exchange (Llotja), it was a more prestigious, though no less hidebound, institution than the one he was leaving in A Coruña. Ultimately, however, prestige was less important than the fact that it offered the chance to put the ghosts of the recent past behind him.*

The arrival of the Ruiz family in Barcelona in the fall of 1895 marked the point at which the future leader of the avant-garde first came into contact with the broader currents of modernism. No matter how provincial by

* Don José owed his new position to the fact that a teacher at La Llotja, a man named Román Navarro whom he knew from Málaga, wanted to return to his hometown of A Coruña.

the standards of Paris, Barcelona was at least open to winds of change that were sweeping across European art and literature: to the mystic strains of Richard Wagner, the disruptive chest-thumping bombast of Friedrich Nietzsche's Superman, to the challenges posed by the hyperrealist Impressionists, who believed that reality was changing every instant, and their rivals, gloom-shrouded Symbolists like Edvard Munch and Gustave Moreau, who believed that deeper truths lay hidden beneath the quicksilver surface. Had he remained in chilly A Coruña or the equally fossilized Málaga, Picasso would never have heard the rumbling thunder from the north that signaled the approach of the cataclysmic twentieth century.

As a child of Málaga, Picasso began life in Barcelona on the outside looking in. Most Spaniards were looked down on by the more "Europeanized" Catalans, and Andalusians were deemed the worst of a backward lot. Jaime Sabartés sums up the disdain of the northerner for his southern compatriot:

> Among Barcelonans of my class, the word Andalusian is . . . never pronounced it without a grimace of repulsion. An Andalusian, to them means a bullfighter, a gipsy, a "wise guy," who drinks and dances . . . all of which, to a middle-class Catalan of Barcelona, is rather alien to our manners and customs. Andalusian? . . . Pants tight at the belt, short vests, Cordobon felt hat and cock-and-bull stories. Ugh!

An Andalusian, in other words, was a rube, the embodiment of all that was wrong with Spain, a country to which Catalonia, according to Catalans, was attached only by accident and whose artificial unity was maintained only through force.

For most of his life, first in Barcelona and later in Paris, Picasso stood apart, never quite one of the locals, welcomed everywhere, nowhere completely at home, thriving by his wits and relying on his charm to gain entrée into circles that would normally be closed to him. He lived with one foot in, the other out—a precarious position that suited his restless spirit and stimulated his imagination.

Shortly after their arrival in the Catalan capital, Don José prevailed

upon his colleagues at La Llotja to allow thirteen-year-old Pablo to take the entrance exam, despite the fact that he was underage. In three surviving drawings, one of a plaster cast made from an antique statue and two of a male model done from life, we can see the results of Don José's instruction and of the long hours of practice at the da Guarda institute. While there is little here that suggests a budding genius, these drawings demonstrate that from an early age Picasso possessed technical skill far beyond the reach of most children his age.*

There's a large element of truth to Picasso's claim, half boastful, half plaintive, that his growth as an artist was somehow stunted by his father's well-meaning interference. "The awkwardness and naïveté of childhood were almost absent from [my drawings]," he told Brassaï. "I outgrew the period of that marvelous vision very rapidly." In fact, Picasso's earliest known drawings, made when he was eight or nine, do display a certain childish awkwardness, but it's clear that the element of fantasy was quickly supressed in the pursuit of competence. His artistic development reverses the usual trajectory. He started by achieving technical proficiency at an early age and only slowly worked his way backward toward that "awkwardness and naïveté of childhood" that he associated with the marvelous. One key to Picasso's urge to storm the edifice of the academic tradition is this premature mastery followed by a long period of disillusionment, made infinitely more painful by the realization that his beloved father was not only second rate but a champion of a dying tradition. For Picasso that tradition was a trap, as comfortable and suffocating as a parental embrace.

By the time Picasso sat for the La Llotja exams, the strains between father and son were beginning to show. Though Pablo still allowed himself to be guided by Don José in artistic matters, he began to assert himself in other ways. He soon attracted an admiring circle of older students who were drawn to the intense young boy who far surpassed them in the

* Picasso's friend and biographer Roland Penrose used the exam to promote the legend of his hero's precocity: "The test, for which one month was prescribed, was completed by him in exactly one day.... There could be no hesitation on the part of the jury. They were at once convinced that they were faced, for the first and perhaps the last time, with a prodigy."

Nude Study. © *RMN-Grand Palais / Art Resource, NY.*

classroom and whose taste for fun outside it was contagious. The fact that he spoke Catalan only haltingly and was unfamiliar with the local landscape and customs did not prevent him from making himself the center of another youthful gang bent on mischief.

Picasso's new companions were mostly fellow students at La Llotja. Their rough-and-tumble fellowship, his first real *tertulia*, included two brothers, Joaquim and Josep Bas, and the nineteen-year-old Manuel Pallarès, who would remain a lifelong friend. For Picasso these confraternities would be as important as female companionship. The *tertulia* was a second family, one that offered an intellectual stimulation that contrasted with the dreary domestic routine. While the women stayed at home, the men hung out at cafés discussing the latest political intrigue or artistic fad, the hours-long bull sessions usually ending in drunken revelry and a visit to the brothel. In a few years Picasso's *tertulia* would include some of the most brilliant minds in Europe, but however subversive the gathering and however abstruse the conversation, it remained rooted in that most reactionary (and chauvinist) of Spanish traditions.

Almost eight decades later, Pallarès described the Picasso he had known as a young boy in Barcelona:

> He had a very strong personality. He was appealing and way ahead of the others, who were all five or six years older . . . he grasped everything very quickly; paid no apparent attention to what the professors were saying. Picasso had no artistic culture, but had extraordinary curiosity . . . took things in the blink of an eye, and remembered them much later. . . . In everything he was different. . . . Sometimes very excited, at other times he could go for hours without saying a word. . . . He could get angry quickly, but calm down just as fast. He was aware of his superiority over us, but never showed it. He often seemed melancholy, as if he had just thought of some sad things. His face would cloud over, his eyes become dark.

Here we can sense for the first time the magnetism that was as critical to Picasso's career as his inventiveness as an artist. Photographs of the fifteen-year-old Pablo Ruiz show the handsome features, strong nose and expressive mouth, the short-cropped hair, almost black. Most remarkable are the dark eyes that seem to devour all they see, the famous *mirada fuerte* that could be so compelling and so disconcerting. Even in middle age Picasso radiated an unsettling power, as a journalist who interviewed him in 1935 discovered: "People said that he had secret powers and could kill a man by looking at him; they said other strange things too. There was something massive and supernatural about him."

Picasso's outsized personality instilled slavish devotion even (or especially) among those victimized by his volatile temper. His appeal only increased as he discovered his power over others, the voltage of his charisma charged by his growing self-confidence. Shifting from moment to moment from light to dark and then back again, from love to anger, laughter to rage, he seemed more alive than those around him—a protean figure, as fascinating to others as he was to himself. "Picasso was a sun all on his own," wrote his lover Geneviève Laporte. "He lit up, burned, consumed and reduced to ashes anyone who approached him, not even sparing himself." A self-portrait from 1896 shows a brooding young man, a

romantic hero, worldly wise, perhaps even a bit jaded. Pallarès concludes his vivid description of the young Picasso: "At fifteen, he neither seemed nor acted like a boy his age."

One sign of his physical, if not his emotional, maturity was that around this time Picasso began his lifelong habit of visiting whorehouses. It was the older Pallarès who introduced him to the seamy side of Barcelona in the Barri Xino, Barcelona's red-light district, located in the warren of alleys near the harbor, but Picasso had no problem keeping up with his older companion. A contemporary poet, Joan Maragall, described the neighborhood, just on the other side of the city's most fashionable boulevard:

> You have one Rambla, a place of delight . . .
> And there, four steps away, feverish with excess,
> broader than the other, the Rambla of the poor
> shudders in the gloom of its hellish lights.

Throughout his life, Picasso would be drawn to the "hellish lights." They seemed more real to him than the staid neighborhoods where proper ladies and gentlemen submitted to the deadening tyranny of respectability.

It was also at this time that Picasso acquired his first steady girlfriend, though his relationship with a circus equestrienne known as Rosita del Oro appears to have been little more than an amusing diversion for both parties. Neither parent, in any case, seems to have been too worried by their son's sexual awakening. Back in his Málaga days Don José had been in the habit of spending his evenings at the high-class brothel Lola la Chata, and Doña Maria had long since resigned herself to the habits of the Andalusian man.

But if Don José and Doña Maria were inclined to turn an indulgent eye on their son's peccadilloes, Pablo's discovery of his own sexuality reinforced his growing rebelliousness, coinciding as it did with his recognition of his father's impotence in artistic matters. For the time being, he agreed to be guided by Don José when it came to his painting, as long as he was allowed free rein in other areas. It was a temporary and uneasy compromise that promised trouble to come.

Pablo had progressed so rapidly that Don José decided it was time to test his skills by submitting a large-scale work to one of the prestigious juried exhibitions. It was the first step along a path that would eventually lead, he assumed, to "traveling scholarships, the Prix de Rome, pensions, contest awards, prizes in exhibitions, a professorship . . ."

If a respectable and financially rewarding career in the Spanish art establishment had been his goal, young Pablo could not have asked for a better instructor than Don José. He himself was only a purveyor of minor still lifes and genre scenes, but he knew that to embark on a distinguished career it was necessary to demonstrate a command of important subjects on a grand scale. To that end he borrowed the studio of a colleague at La Llotja—a specialist in religious themes named José Garnelo y Alda—and helped Pablo prepare a large canvas (65 x 46 inches) upon which to depict a suitably serious-minded theme. For the next few months Pablo applied himself to the task, making numerous sketches of the principal figures and availing himself of the many props lying around the studio. The painting, a re-creation of his sister Lola's First Communion, was submitted to the Exposición de Bellas Artes é Industrias Artísticas, which opened at the Barcelona Palace of Fine Arts on April 23, 1896.

On one level *First Communion*, the first large-scale canvas by the great iconoclast of twentieth-century art, is disappointing, a trite effort remarkable only for its conventionality. The subject was calculated to appeal to the conservative judges, as was its exacting (if somewhat plodding) realism. Pablo reveals his mastery of traditional techniques, rendering the various textures—the sheer gauze of Lola's veil, the leather of the red prie-dieu, and the gleam of candlelight on candlestick—with a skill that would have done credit to an established painter. The mood, as well, has a sobriety in keeping with the pious theme. Everywhere we can feel the guiding presence of Don José, instructing his son in the nuts and bolts of a well-constructed painting. No opportunity for showing off is neglected, no cliché left unattended.

But for all its hackneyed realism, *First Communion* constitutes an important milestone in Picasso's career. The habit of the grand showpiece will endure, even as Picasso transforms it into a subversive assault on the traditions it parodies. The demented harpies of *Les Demoiselles d'Avignon* and the soul-crushing despair of *Guernica* are dark twins of

First Communion. Picasso will never entirely abandon the habit of the big statement, even when he put it to uses that would appall his thoroughly conventional father.

Despite some nice realistic touches, the work lacks conviction. It's more tightly rendered than most of the paintings Picasso was doing at the time, which tend to feature improvised, slashing brushwork; the greater care he lavished on this work contributes to the airless, stilted feel. Even as a boy of fourteen, he must have sensed the hypocrisy involved in such pious expressions. The man who oversaw this work of irreproachable devotion felt none himself. In fact, young Pablo took religion far more seriously than his father did, even if his vision of the universe was more pagan than Christian, haunted by demonic spirits who needed to be propitiated lest they rise up to exact cataclysmic revenge. For Don José, piety was merely habit; for his son, meddling in unseen forces was dangerous business. Indeed, hidden beneath the conventional subject is a darker subtext: of the four candles depicted, two have been snuffed out, perhaps a reference to two dead Ruiz children, Conchita and a stillborn son.* Mortality is intimated as well by the bloodred rose petals strewn on the altar steps. The theme of the *vanitas*, the reminder that death intrudes even in the midst of life to which Picasso often returned, makes its initial appearance in his art in *First Communion*.

Bouyed by this successful debut, the following year Don José upped the ante with an even more ambitious canvas (75 x 98 inches) to be submitted to the country's most prestigious venue for fine arts: the Exposición General de Bellas Artes in Madrid, set to open May 25, 1897. Pablo's lack of enthusiasm for the project is suggested by the fact that Don José had to bribe him with the offer of a studio of his own before he would apply himself. The garret, which Pablo shared with Pallarès, was located at 4 Carrer de la Plata, near both La Llotja and the family apartment. But while it remained close enough for Don José to keep an eye on his son, Pablo saw it as an opportunity to get out from under the parental roof.

* Neither Picasso nor any member of the family ever referred to this birth, but it is recorded in a census of 1885.

Science and Charity [see color insert], which Pablo worked on throughout the month of March 1897, depicts a humble room, based on Picasso's dingy studio, where a stricken woman lies in her sickbed attended by a physician (Science) and a nun (Charity). The theme of the mortally ill young woman comes dangerously close to the tragedy of Conchita's death, a parallel reinforced by the fact that Don José served as the model for the doctor. Not only was *Science and Charity* larger than *First Communion*, but it was intellectually more ambitious. The earlier picture had been a genre scene elevated by its pious subject; the second canvas transformed a humble tableau into allegory, demonstrating the young artist's command of the high-flown rhetoric of "serious" painting.

From Don José's perspective *Science and Charity* was a huge success. Not only was it accepted at the Exposición General de Bellas Artes, but it won an honorable mention, helped by the fact that one of the jurors was an old friend and colleague from Málaga, Antonio Muñoz Degrain. Even a disparaging comment in a Madrid newspaper did little to dampen his triumphant mood.* Encouraged by the official recognition, Don José submitted the painting to the Exposición Provincial in Málaga, where it was awarded a gold medal. It was so well received that when the family returned to Málaga for summer vacation, young Pablo was ceremoniously welcomed into the profession by the city's most prominent painter, Joaquín Martínez de la Vega, who baptized him by pouring champagne over his head.

But *Science and Charity* proved to be one of Don José's last triumphs. From now on whatever success Pablo achieved would be in spite of his father's instruction and often in defiant opposition. Don José presented the painting to his younger brother, the eminent physician Don Salvador, who gave it pride of place in his apartment. The gift was more than a token of his appreciation for all the help his brother had provided over the years. Don José was determined to send Pablo to the prestigious San Fernando Royal Academy of Fine Arts in Madrid, and he needed his wealthier

* The critic, who called himself "the tailor of Campillo," wrote: "Before so much grief I regretfully laugh like a bandit . . . isn't the doctor taking the pulse of a glove?" —all in all a rather fair criticism.

siblings to help with the expenses. The painting, and the accolades it received, helped reassure them that their money would not be wasted.

Picasso, however, felt humiliated by his dependence on his aunts and uncles. The spectacle of Don José begging for crumbs from his brothers and sisters made him more determined than ever to break free. A sign of his growing alienation was that around this time he began signing his works "P. Ruiz Picasso" or "P. R. Picasso," substituting the maternal for the paternal name. This did not go unnoticed by Uncle Salvador, who was dismayed by his rejection of his paternal heritage and who suspected, correctly as it turned out, that it was the first sign of a wholesale rejection of the mainstream values he and his brother represented.

By the time Pablo left for Madrid in October 1897, he was in a mutinous frame of mind. The Royal Academy was hardly the place to explore new artistic ideas, but at least in Madrid he would be on his own, free to find his own way and develop in his own manner.

Ultimately, this first attempt to strike out on his own proved something of a fiasco. Though he was hundreds of miles from his parents, Muñoz Degrain had agreed to keep an eye on him; every time Pablo missed an assignment or cut class, word got back to Don José. Also, the reality of life on his own did not match the fantasy. Decades later Picasso still seethed at what he claimed was Uncle Salvador's stinginess. His allowance, he told Sabartés, was "just a pittance . . . enough to keep me from starving to death, no more." The truth is that the funds he received from his Málagan relatives, in addition to what little his parents could spare, were more than adequate to provide for his basic needs, covering tuition at the academy as well as room and board at a respectable *pensión* in a middle-class neighborhood.

But his relatives' generosity, far from earning his gratitude, stoked Picasso's resentment, particularly toward his uncle Salvador, who came to stand in his mind for all that was worst in the Spanish middle class: narrow-mindedness, bigotry, and a lack of artistic understanding combined with an inflated sense of his own importance. He had no intention of dancing to Uncle Salvador's tune. Picasso claimed that his relatives funded him as they might "an oil well or a mine at a time when it was cheap because nobody wanted it." He would make sure they got no return on their investment.

In Madrid the rebellious side of Picasso's personality emerged in full force. In a letter he wrote to a friend back in Barcelona, he scoffed at the "stupidities" pronounced by his teachers before expressing his dismay at the state of art education in the country as a whole: "But don't be mistaken, here in Spain we are not as stupid as we have always demonstrated, but we are educated very badly. That is why, as I told you, if I had a son who wanted to be a painter, I would not keep him in Spain a moment."

Picasso concludes his letter by informing his friend that he was planning to submit a drawing to the theatrical weekly *Barcelona Comica*, which shows just how far he has already veered from the course set by his father. "Modernist it must be," he boasts in words that would have made Don José weep. He concludes by comparing himself to two of the young stars of the Barcelona avant-garde: "Neither Nonell . . . nor Pichot, or anybody has reached the extravagance that my drawing shall have."

Given his interest in the newest trends, it's not surprising that he rarely set foot in the Royal Academy. Instead of knuckling under to closed-minded professors, he struck out on his own, taking his own artistic journey in hand. An Argentine student named Francisco Bernareggi left an account of his time with Picasso in Madrid: "What times of happiness, work and bohemianism! . . . Because Picasso and I copied El Greco in the Prado, people were scandalized and called us *Modernistes*. . . . We spent our days (eight hours a day) studying and copying in the Prado, and at night we went (for three hours) to draw from nude models at the Círculo de Bellas Artes."

As Bernareggi suggests, adopting El Greco as their hero was a way to declare their allegiance to the progressive movement in art, since the distortions of the seventeenth-century Mannerist were regarded by more conservative types like Don José and Muñoz Degrain as abominations. It was during these months in Madrid that Picasso began his lifelong dialogue with El Greco, whose stylistic quirks—elongated forms, exaggerated emotionalism, and dark religiosity—would serve time and again as a way to pump up the expressive volume of his own work.

Tales of his truancy inevitably got back to Uncle Salvador in Málaga. "You can well imagine," he told Sabartés, "[my relatives] took advantage of the opportunity to stop payments and that was that. My father, who was contributing the major part of it, went on sending me whatever he could—poor fellow!"

Pablo soon felt the pinch. Forced to abandon his comfortable quarters in San Pedro Mártir, he moved to a cramped, shabby studio on Calle Lavapiés. Multiple sketches from that December of a knife fight he witnessed in a tavern provide a preview of tough times ahead. He was rejecting the comfortable path set for him by his father in favor of a bohemian existence. It was a lifestyle that exuded a certain seedy glamour—witness the success of Puccini's opera *La Bohème*, which premiered that same year—but it was also an existance filled with pain and desperation as the artist struggled to survive on the rough-and-tumble margins of civilized society.

In fact, Picasso's first taste of bohemian life proved almost fatal. Trying to scrape by on what little his parents could give him, he grew sickly and malnourished. Neither failing health nor daily discomfort, however, would induce him to relent; he would rather starve than go hat in hand to Uncle Salvador.

To make matters worse, his personal troubles coincided with a particularly difficult moment in Spanish history. Defeat at the hands of the Americans in the Philippines and Cuba marked the final collapse of the once great Spanish Empire, leading to widespread unrest punctuated by occasional outbursts of violence. "[O]ur soldiers came back from the colonies emaciated and crestfallen," recalled one officer. "It was very hard for us to avoid being infected by the *pessimism* of these repatriated comrades . . . the army was suffering from a complex of humiliation, discouragement, impotence and sorrow."

Eventually, humiliation in war and political turmoil would give rise to a cultural rebirth, the so-called Generation of '98, who led a literary and intellectual revolt against *retraso*, the backwardness characteristic of a Spain dominated by a corrupt monarchy and reactionary Church. But in the short run, defeat and loss of empire plunged the country into gloom. Given the fact that all forms of authority had been discredited, Don José's insistence that Pablo seek official honors and position within "the system" seemed particularly misguided. To many in the younger generation, Catalan *Modernisme* and other progressive movements provided the only antidote to Spanish malaise.

In the winter of 1898, underweight, despondent, and plagued by self-doubt, Picasso came down with scarlet fever. Though he eventually

rallied, it was only after a desperate week or two in which family and friends feared for his life. As soon as his quarantine was lifted, Don José and Doña Maria hurried his sister Lola off to Madrid to nurse him back to health. By the time he'd recovered sufficiently to think about the future, he decided he'd had enough of the Spanish capital.

In June 1898, Picasso returned briefly to Barcelona. But within a few days he was off again, traveling with Manuel Pallarès by train and then by mule to Horta d'Ebre,* a small village in the rugged mountains about 120 miles west of the Catalan capital. Here, in Pallarès' ancestral home—a land of olive groves and pine forests, of steep hillsides where shepherds grazed their flocks in meadows fragrant with wild thyme—he hoped to regain his strength and clear his mind.

"All that I know, I learned in Pallarès' village," Picasso told Sabartés. It's an odd claim. During the eight months he spent in the remote mountains, he produced no major paintings, and the town provided little of the intellectual or artistic stimulus he usually needed to make his greatest breakthroughs. In Horta he no longer devoted himself exclusively to art but emptied his mind of all the preoccupations that had weighed him down in Madrid. He lost himself in nature and lived as one of the locals. After spending most of the summer camping in a cave in the high range known as the Ports del Maestrat, hunting rabbits and other small game, washing in a nearby waterfall, and immersing himself in pristine nature, he returned with Pallarès to the village. Here he plunged into a life of vigorous physical labor under the hot sun fueled by hearty country fare. "He wore *espadrilles* like the peasants," Sabartés recounted, "learned to take care of a horse, to cure a hen, to draw water from a well, to deal with people, to tie a solid knot, to balance the load on an ass, to milk a cow, to cook rice properly, to light a fire in the fireplace."

That was hardly the program Don José would have recommended, but it worked wonders to restore Picasso's faith in himself. Mastering practical skills, burying his doubts in the comforting rhythms of mindless toil, he became a new man. He'd been beaten down by his struggles in Madrid and by the rigors of a dreary windswept winter; he needed to warm

* Now called Horta de Sant Joan.

his southern body and clear his troubled mind. Not the least of the skills he acquired in Horta was a fluency in Catalan, which would help ease his way into progressive circles when he returned to Barcelona.

The rustic interlude also steeled his determination to make himself an artist in the *Modernista* mold. A self-portrait in charcoal from the beginning of this rural interlude shows him shirtless, his chest sunken, cheeks hollow, with a bohemian's scruffy beard and mustache. Dangerously thin, he is the very picture of the romantic hero, gaunt yet fearless. The bold contours he employs show a new confidence, their stylized rhythms reflecting his full-throated embrace of Art Nouveau and *Modernisme*. Compared to the stilted realism of *First Communion* and *Science and Charity*, the self-portrait is a work that looks to the future, sounding echos of Munch, Toulouse-Lautrec, Paul Gauguin, and even van Gogh. Once he regained his strength, it was clear he intended to strike out in a new direction.

In the clear mountain air of the *alta terra*, Picasso underwent a physical and psychological rebirth. So powerful were the restorative effects of this retreat that for the rest of his life he would try to duplicate its magic. A summer vacation in some remote spot—the mountains or the seashore—became a habitual, almost ritualistic, aspect of his life. There, far removed from the distractions of the city, he could gather himself, build up vital reserves of physical and spiritual capital that he could spend down upon his return to civilization. Even if he produced little, the vigor he felt often sparked great bursts of creativity in the following months.

When Picasso finally made his way back to Barcelona in February 1899, it was with a new swagger. He slept once more in his old bed and looked up old friends, but he had no intention of simply picking up the pieces of his former life. He was a changed man, eager to face the future.

The city Picasso returned to after an almost eighteen-month absence had changed almost as much as he had, and in many of the same ways. While Madrid shuddered under the blows of military defeat and political turmoil, Barcelona was strangely energized. For centuries Catalans had resisted the central authority of the capital, and the latest debacle struck

them as just retribution for centuries of imperial hubris. National humili-
ation catalyzed Catalans' sense of being a people apart. "We are reappear-
ing in the capital of Catalonia," wrote Miquel Utrillo, one of the leading
Modernistas, "which we consider the true capital of Spain from the artistic
point of view, since a healthy member in a half-destroyed body represents
the best of that body, whether in an individual or in a nation."

Leading this cultural revival were three artists born in the 1860s (and
thus a full generation older than Picasso), who had first conceived their
life's mission while sharing an apartment above the Moulin de la Galette
in Montmartre.* Shuttling back and forth between Paris and Barcelona,
Santiago Rusiñol, Ramon Casas, and Miquel Utrillo preached the gospel
of the Parisian avant-garde to a populace eager to claim its place in the
wider Europe.

If Catalan *Modernisme* never developed into a major school, it was
perhaps because its leading practitioners could never decide exactly what
Catalan modernity was supposed to look like. On the one hand, they
turned to the medieval past to discover the authentic roots of their cul-
tural identity; on the other, they hoped to shake things up by latching on
to the latest international fad: Art Nouveau, Impressionism, Symbolism,
or something else borrowed from the more advanced north. In architec-
ture—in the work of Antoni Gaudí, Josep Puig i Cadafalch, and Lluis
Domènech—this peculiar mix led to some strikingly original forms, but
elsewhere it descended into mere eclecticism.

Still, Barcelona was the center of a vibrant cultural scene that, if it
wasn't quite sure where it was headed, knew at least what it was running
from. At once brash and insecure, determined to assert cultural indepen-
dence but anxious not to appear provincial, Barcelona in the years leading
up to the new century provided a stimulating environment for a young
artist who was also in search of his own identity.

The beating heart of *Modernista* Barcelona was a brand-new tavern
nestled within the narrow streets of the old city named Els 4 Gats (The 4
Cats). Launched on June 12, 1897, it was the brainchild of Rusiñol and

* Rusiñol was born in 1861, Utrillo in 1862, and Casas in 1866.

Els 4 Gats. *Courtesy of the author.*

Casas, along with two other friends from their Montmartre days, Miquel Utrillo and Pere Romeu (the proprietor). Housed in the *Modernista* Casa Martí, designed by Cadafalch—described in a contemporary review as a "mixture of archeology and *modernismo* . . . of love for the old and a passion for the new"—it served as the gathering place for writers and artists of the Catalan renaissance.

Els 4 Gats was a novelty in Barcelona, but it was based on a famous Parisian prototype. Each member of the founding quartet was connected in some way with the Montmartre cabaret Le Chat Noir (The Black Cat), which, until the death of its founder, Rodolphe Salis, earlier that year, was the nerve center of the Parisian avant-garde. Founded in 1881 and located at 12 rue Laval (now one Victor-Massé) at the foot of the Butte Montmartre, Le Chat Noir institutionalized and commodified the love/hate relationship between bohemian artists (with charisma and no money) and the haute bourgeoisie (with plenty of money but no charm). Salis' insight was that the apparently antithetical castes of high society and bohemia were as fascinated with each other as they were appalled, and that there was profit to be made by finding a spot where the two could mingle and check each other out, all in a spirit of good-natured jest.

But though it captured some of the dynamism of the original, Els 4 Gats always took itself more seriously than its Parisian counterpart. The Catalans were a more earnest bunch, less interested in pulling people's legs than in using their tavern to promote a cultural *Renaixença*. As usual, Rusiñol served as spokesman:

> This stopping place is an inn for the disillusioned [he wrote in announcements that were scattered across the city]; it is a corner full of warmth for those who long for home; it is a museum for those who look for illuminations for the soul; it is a tavern and stopping place for those who love the shadow of butterflies, and the essence of a cluster of grapes; it is a gothic beer hall for lovers of the North and an Andalusian patio for lovers of the South; it is a place to cure the ills of our century.

Curing the ills of the century was a tall order for a tavern, no matter how ambitious its intellectual program, but at the very least it could provide a pleasant spot where *Modernistas* and their allies could gather in an atmosphere of mutual congratulation. As part of its program of cultural revival, the café's *sala gran* featured local ceramic and ironwork, traditional Catalan crafts that created an appropriately nativist backdrop for the exhibitions and performances, including concerts by the composers Enrique Granados and Isaac Albéniz. The most popular events were the *ombres xineses* (Chinese shadows), shadow-puppet shows directed by Utrillo and borrowed from a similar program he'd arranged at Le Chat Noir. A large mural painted by Casas of himself and Romeu speeding along on a tandem bicycle (replaced in 1900 by another featuring a more hi-tech motorcar) enlivened this rather fusty collection by injecting an appropriately up-to-the-minute dynamism. Posters for upcoming events designed by the founders and patrons—mostly in a faddish art nouveau idiom that combined the influences of Toulouse-Lautrec, Alphonse Mucha, and Théophile Steinlen—were plastered across the city, so many of them that one visitor described Barcelona as a "springtime of posters . . . which delight the eyes in their festival of lines and colors." Also in imitation of the Paris original the proprietors issued a cultural magazine to publicize the café and promote their ideas. *Quatre Gats*, an illustrated arts journal

written in Catalan, was soon replaced by the more ambitious *Pèl & Ploma* (Brush and Pen), which served as the voice of the *Modernista* movement until it folded in 1903.

One striking difference between the Paris and Barcelona venues was the almost complete absence of women in the Catalan venue. Except for puppet shows, which women and children were encouraged to attend, the atmosphere at Els 4 Gats was exclusively masculine, an extension of the *tertulia* that was a feature of Spanish life. Rather than fashion and flirtation, the Barcelona *café-artistique* specialized in deep conversations about the latest literary and cultural tendencies.

When the seventeen-year-old Picasso returned from Horta in February 1899, he was determined to set his own course, both in his life and in his art. But while for many of his peers joining the avant-garde meant losing the support of friends and family, Picasso never had to sever those ties that were essential to his emotional and financial well-being. He'd long since lost his faith in Don José's tutelage, but it was not his way to climb out on a limb so far that he was unable to clamber back. For at least the next few years he would continue to rely on the support of Don José and Doña Maria. As the treasured only son, he knew he had the upper hand, and he had a keen instinct for just how far he could push things without risking a complete rupture. There was always something calculating in his relations with those closest to him, an affection that was never without its mercenary aspect. He was far more canny than artists like Gauguin and van Gogh, whose dedication to their mission required a complete break from social norms. If Picasso was a revolutionary, he was one with a practical streak.

The one thing he refused to do was to return to La Llotja. He agreed to meet Don José halfway, however, enrolling at the Cercle Artístic, a free-form academy where he could draw from the model without having officious professors looking over his shoulders. He also submitted a painting titled *Aragonese Customs* (now lost) to the *Exposición General* in Madrid, a gesture that helped to reassure his father that he'd gotten over the funk of the past couple of years. Don José remained cautiously optimistic. Despite the fact that Pablo was now working independently,

making drawings in a more up-to-date style with strong, sinuous outlines reminiscent of Toulouse-Lautrec, his latest shift was not so radical as to give offense. Even the archconservative Muñoz Degrain, to whom Don José showed some of his son's latest efforts on a trip to Madrid, was encouraging. "I am pleased to hear that Pablo is working," Don José wrote to his wife back in Barcelona, "and, above all, that he is not missing his lessons. . . . I showed [Degrain] the drawings, which he liked very much, but he told me last year he did nothing useful; however that's all over and done with."

Pablo no longer placed much faith in his father's guidance, but he would still take what he could from the old man. Once again Don José agreed to pay the rent on his studio, hoping his son had gotten over his recent malaise and was ready to apply himself to perfecting his craft and to taking the necessary steps toward launching his career as a respected academician. But Picasso had other ideas. He was now firmly committed to the cause of the avant-garde, to pursuing a course that his father, had he been aware of it, would have regarded as a betrayal of everything he held dear. The studio on the Carrer d'Escudellers Blanc was nothing more than a cramped room that he shared with a student he knew from La Llotja, Santiago Cardona, but it allowed him to live pretty much as he chose. He would often sleep among the littered paint tubes, turpentine-soaked rags, and rolled canvases or in the bed of the vivacious Rosita, though his parents' apartment near the harbor was always available in a pinch.

For the remainder of his time in Barcelona he would rapidly go through studios (and studio partners), a mobility born of restlessness and the fact that he could be a demanding and difficult roommate. Given the run of the city by his indulgent parents, the seventeen-year-old Pablo adopted a lifestyle that he would follow for much of his life, hanging about most of the day and into the evening with his male cronies, visiting the brothels, and working only when everyone else had stumbled home to bed. If he was a far more driven man than his indolent father, he shared Don José's need for conviviality and the distraction provided by chattering friends—a pattern that suggests his obsessive fear of death would close in as soon as the hubbub ceased.

Another pattern that emerges at this time is Picasso's habit of

gathering about him a new group of friends to mark a new phase in his life. He liked to surround himself with new faces whenever he felt that life was growing stale or his art had reached an impasse, but this didn't mean old favorites were cut out entirely. Picasso was a hoarder of both things and people; his studios quickly filled up with junk and his life with emotional entanglements, as old ties were rarely severed to clear the way for new attachments. He preferred to maintain relationships, however tenuous or incongruous (former mistresses, for instance, kept waiting in the wings while he pursued fresh liaisons), in case he was consumed by nostalgia or in need of company; these unfortunates would simply be moved from the center to the periphery, where they would languish in purgatory until summoned once more to the great man's presence.*

This was the fate of Jaime Sabartés, one of the friends he acquired at this time, who spent thirty-five years in the wilderness before Picasso called him back. When he did return, he managed to stick only by making himself indispensable, serving as Picasso's gatekeeper, secretary, and protector until his death in 1968.

"I was the best friend with whom to carry on a conversation," Sabartés wrote of their early days together in Barcelona, explaining how he managed to outlast so many of his rivals,

> because I did not insist on my own point of view; I could take in my stride a long tramp up to the Tibidabo, or wherever it might be, without showing signs of fatigue. The friend with whom one can entertain oneself when one has no money to spend. Others accompanied Picasso to the bullfights, to the café every evening and every night, to the Eden Concert, the bars of the Paralelo, or the

* This was what happened to Marie-Thérèse Walter, who remained available while Picasso pursued Dora Maar, and Dora Maar while he pursued Françoise Gilot. He deployed the same strategy when it came to material things. When he was rich enough to afford multiple residences, whenever he became bored with one, he would simply acquire another, refusing to get rid of the first or any of the piles of junk he had acquired over the years.

brothels. Picasso knows how to distinguish tastes and preferences, and he chooses them as he chooses his colors when painting a picture, each one at its proper time and for a particular purpose. Some friends are good for one thing and others for another.

There was something cold-blooded in Picasso's friendships. Even in this account from someone slavishly devoted to his friend we sense his manipulativeness, the way he deployed people like a general arranging his forces before battle. Reading between the lines, it's apparent that Sabartés was the friend Picasso fell back on when no one better turned up.

Sabartés owed his staying power to his natural subservience, his instant recognition of Picasso's genius, and his willingness to place himself in the service of one he acknowledged to be so much greater than himself. A failed sculptor and dilettantish poet—the son of a successful businessman, he'd inherited enough money not to have to work for a living—Sabartés traveled in the same *Modernista* circles to which Picasso was now drawn. They were first introduced in 1899 by the sculptor Mateo de Soto, a mutual friend. His account of their first meeting reads like that of a disciple for whom the encounter with the Chosen One is a life-altering experience:

> I remember my leave-taking after my first visit to his studio in Escudillers Blancs Street. It was noon. My eyes were still dazzled by what they had seen among his papers and sketchbooks. Picasso, standing in the angle formed by the corridor which ran past his studio and the corridor leading to the front door, intensified my confusion with his fixed stare. On passing before him to go, I implied a kind of obeisance, stunned as I was by his magic power, the marvelous power of a Magi, offering gifts so rich in surprises and hope.

Soon the two were fast friends, though from the beginning Sabartés was relegated to the role of acolyte to the future messiah. While the unobtrusive Sabartés provided the perfect companion for long walks through the city and willingly served as the butt of his jokes, for nights on the town Pablo preferred someone a bit more lively. Accompanying him on

nocturnal romps along the Rambla or in the Barri Xino was Angel Fernández de Soto, "an amusing wastrel," according to Picasso, who toiled by day in a spice shop but made up for the drudgery by wild nights on the town. "Since they wanted to appear chic," Fernande Olivier recorded, "and because between the two of them they had only one pair of gloves, they shared it, making sure to keep the bare hand in the pocket while waving the other ostentatiously. Picasso told me himself how elegant he felt dressed in the green suit he adored and his solitary glove." Picasso's own report on those nocturnal escapades is more succinct. "We used to raise hell together," he said with a laugh.

Another lost soul who found his way into Picasso's orbit at this time was Carles Casagemas, the spoiled youngest son of the US consul in Barcelona. Brilliant and undisciplined, given to impossible dreams and strange obsessions (including an unhealthy fixation on a married niece), to fits of temporary enthusiasm when he could not stop talking followed by periods of black despair when he brooded in silence, he was the first of the many melancholics drawn to Picasso's incandescence. Fancying himself a *poète maudit* in the mold of Paul Verlaine, Charles Baudelaire, or Arthur Rimbaud, taking perhaps too literally the last one's call for a "derangement of all the senses," he was the classic manic-depressive, anesthetizing his pain in drugs and alcohol. In addition to indulging in mind-altering substances, he exhibited a self-destructive streak that, combined with his *anarquista* politics, led him on one occasion to join in a violent antipolice riot in which he beat a constable half to death.

Casagemas was the intellectual among Picasso's new friends, someone who could introduce him to the wonders of Symbolist poetry, to anarchist theory—to all the fashionable tributaries that flowed into the stream of Catalan *Modernisme*. At his parents' well-appointed apartment on the Rambla he hosted Sunday gatherings where radical poets and painters, all of them young and rebellious, plotted revolutions both cultural and political and sang the banned Catalan national anthem, "Els Segadors" (The Reapers), while getting tipsy on coffee spiked with flaming brandy.

It was in social situations like the Sunday get-togethers at Casagemas' apartment that Picasso's real education took place. Here, and in the

smoke-filled rooms of Els 4 Gats, where he would soon become a regular, Picasso, who had little in the way of formal schooling, soaked up the latest intellectual currents. In overheard debates on Peter Kropotkin's political philosophy, Nietzsche's theory of the Superman, Maurice Maeterlinck's mystical literary flights, or the latest provocateur to make a splash at the annual Parisian Salon, Picasso transformed himself from a provincial rube into a sophisticated *Modernista*, conversant with the latest trends and quick to pick up the latest jargon. Later on, friends would marvel at the range of his literary references, but his culture was more broad than deep, his apparent erudition a kind of conjurer's trick enabled by a quick mind that picked out exactly what it needed to spark his own creativity but no more. Gertrude Stein was not far off the mark when—after hearing that Picasso had begun to write his own experimental poetry and thus was muscling in on the territory she claimed for herself (it was in the 1930s, when both had a major reputation to protect)—she grumbled, "it is more offensive than just bad poetry . . . you never read a book in your life that was not written by a friend."

Picasso immersed himself in the lively atmosphere without necessarily committing himself to any particular cause. Despite later claims that he'd always been active in leftist politics, in these early days he was almost exclusively focused on his art. True, he was attracted to the general spirit of rebelliousness fostered by his friends and sympathetic, as the portraits of local down-and-outs he made in A Coruña attest, to the poor and downtrodden, but he was too wrapped up in his own concerns to sacrifice either himself or his art on the altar of some greater principle. The Catalan anarchist Jaume Brossa was dismissive of these café radicals, calling them "neurotic dilettanti, concerned only with being different from the philistines and the bourgeois."

While his younger colleagues took to the streets and even established artists like Casas and Rusiñol made their allegiance clear through sympathetic portrayals of anarchist bombers, Picasso avoided anything that might expose him to potential retaliation from the authorities. Boldness in the artistic arena was accompanied by caution in the political. As his dealer Daniel-Henry Kahnweiler later remarked, Picasso was "the most apolitical man I ever met." Even his commitment to the Communist Party

late in life smacked of opportunism; in the aftermath of the Second World War the Party was fashionable among European intellectuals, and in any case he was by then far too famous to worry about being harassed.

Picasso and his friends naturally gravitated to Els 4 Gats. At first these young men (many of them still adolescents) with no reputation hovered insecurely on the margins of that decidedly more sophisticated company, keeping to their own table and listening wide-eyed to their brilliant and more established colleagues. But they were quickly embraced by the older generation, invited to share in the conversation over steaming plates of *tripa a la Catalana* and *bacalao a la Viscaina* that were the specialties of the house. For all their success Rusiñol, Casas, and Utrillo, were generous hosts, always happy to add fresh recruits to their growing movement of cultural revival.

Picasso was usually a silent observer. He kept his own counsel and let his pencil do his talking for him. Despite this detachment, which could appear either sardonic or merely indifferent, he exuded a quiet magnetism, like the still center at the eye of the storm.

Among the younger generation he was clearly the rising star. At the café, "half cabaret and half chophouse," as Sabartés described it, "Picasso was enthusiastically received and his power of attraction soon made him the leader of the most faithful patrons." Here, the eighteen-year-old Picasso first acquired the aura of the Chosen One. Another acquaintance, Joaquim Folch i Torres, remembers straining to catch sight of the nearly legendary youth at his favorite haunt: "[T]he arches of the café were filled by great leaded panes of glass, across which were hung curtains that concealed those sitting at the tables inside from the view of passers-by. . . . However, by standing on tiptoe in turn on the wooden window-sill, with my brother supporting me from behind, I could also see the group at the corner table. 'That one with the sad eyes is Picasso,' my brother told me."

The remark about the "sad eyes" is suggestive. While everyone who met Picasso talked about the intensity of his gaze, the effect was more often described as hypnotic than sad. Sabartés was not the only one to wilt under a "fixed stare" that "stunned . . . [with] his magic power." But the melancholy Joaquim's brother detected does seem to correspond to a gloomy moment in Picasso's life, or at least in his art. Perhaps he was anxious about his future, perhaps it was the negative energy exuded by his

friend Casagemas. Or perhaps he was simply trying on a fashionable *fin de siècle* world-weariness. Whatever the cause, in the winter of 1899–1900 his art went through a distinctively somber patch that some have dubbed his "black period." Deathbed scenes and interior views lost in shadow were his preferred subjects, as if he were consumed once again by grief and guilt over Conchita's tragic fate.

But it would be a mistake to assume a simple one-to-one correspondence between the mood of his art and his emotional health. Picasso was a master of disguise, trying on humors as he might try on clothes, seeing how they looked on him and what effect they might have on those around him.* His pictorial descent into hell did not necessarily imply that he was consumed by despair. For centuries Spanish art had exhibited a morbid streak, a darkness associated with the term *duende*, a profound melancholy of the soul peculiar to inhabitants of the Iberian Peninsula that contributed to such distinctive cultural expressions as the passionate flamenco and the gory spectacle of the *corrida*. Picasso was well acquainted with that dismal side of life, but he fed off its dark energy, plumbing the nether regions for imagery searing enough to invest his paintings and sculptures with a totemic presence.

It's also true that in the waning hours of the nineteenth century gloom was chic. Or, as Sabartés put it, "Pallor was the order of the day." Aubrey Beardsley's perverse illustrations—even more popular after his death at the age of twenty-five—and Edvard Munch's disturbing paintings were very much in vogue among the Barcelona *Modernistas*. While both Casas and Rusiñol dwelled on scenes of death and violence, two other habitués of the tavern—artists born in the early 1870s and thus halfway in age between the older generation and Picasso—were even more steeped in *fin de siècle* despair.

Ramon Pichot was perhaps the most overtly symbolist of the group at Els 4 Gats, alternating between heavy-handed, death-haunted allegories

* A self-portrait of 1897, for instance, shows him in the powdered wig of an eighteenth-century cavalier—just one of his many attempts to keep people guessing.

and dreamlike nocturnes. Picasso came closest to Pichot in his own morbid allegory, a sketchy watercolor titled *The End of the Road*, a Symbolist fantasy complete with angel of death that recalls Conchita's melancholy funeral and looks forward to the stylized misery of the Blue Period.* Pichot's death in 1925 would inspire one of Picasso's masterpieces, *The Three Dancers*, in which his friend's shadowy profile lurks behind the savage bacchantes whose wild gyrations proclaim the profound connection between the forces of procreation and destruction.

The other artist to make a significant impression on Picasso's art at this time was Isidre Nonell. His brand of gloom, more explicitly tied to the travails of contemporary Spain, would ultimately leave a deeper mark, and his personal generosity toward the younger man would help ease his way into the artistic bohemia of Montmartre. Nonell's depiction of veterans disabled in the recent disastrous war or the blighted victims of rural neglect, as in *Cretins of Boí*, cast their shadow across the marginal figures that haunt Picasso's work over the next few years.

Gloom also permeated the few commercial projects Picasso took on at the time. Unlike many of his struggling colleagues, he refused to prostitute himself by taking on a day job as a commercial illustrator, but playing in the dynamic borderland between fine and commercial art was very much a part of the *Modernista* creed.† The brashness of the commercial poster that must stand out from the busy urban backdrop suggested to Picasso a means to break free from the stuffy conventions that had been drilled into him in the classroom. When *Pèl & Ploma* sponsored a competition for a poster for the Carnival of 1900, Picasso came up with an

* Picasso's sympathy for society's outcasts is revealed by his explanation of this work: "Death waits for all at the end of the road, even though the rich go there in carriages and the poor on foot."

† Another project was a menu design for Els 4 Gats depicting the patrons seated in front of the tavern, rendered in the flat decorative patterns and sinuous whiplash line of Art Nouveau. It was the closest Picasso would come to joining the wildly popular international movement, but distinctive echoes would reverberate throughout his work of the next years. He also did a couple of illustrations for the *Modernista* magazines *Joventut* (Youth) and *Pèl & Ploma*.

image that announced the new century in a form that was more grotesque than celebratory. Featuring a deathly pale Pierrot (who bears more than a passing resemblance to the tormented figure in Munch's *The Scream*) accompanied by a masked woman, it was described by a contemporary critic as "full of style and spontaneity" but, in a bit of understatement, as "[r]ather less cheerful" than the winning entry, the work of an obscure painter named Eliseu Meifrèn i Roig.

Picasso's poster did not win the top prize (it was one of the runners-up, along with an entry by Casagemas), but Rusiñol, Casas, and Utrillo were sufficiently impressed with their young colleague to offer him a one-man show at the tavern. As Sabartés told it, Picasso conceived his show in direct competition with Ramon Casas, who had recently enjoyed a popular triumph with "Una Iconografia Barcelonina," portraits of Barcelona's smart set exhibited at the Sala Parés, the city's only gallery of contemporary art. "If Casas had a corner on the distinguished people of the city," Sabartés noted, "Picasso could dress the leftovers."

Picasso's first important one-man show, held in the *sala gran* of Els 4 Gats for three weeks in February 1900, consisted of an extended riff—half tribute, half parody—on Casas' assembly of Barcelona notables. Unlike that show of fashionable men in a fashionable gallery, Picasso's "group of nonentities, badly dressed," was a slapdash affair. Tacked up on the walls, three or four high, carelessly made and carelessly hung, the show was deliberately rough-and-ready, a pledge of allegiance to the bohemian flag.

For the first time, Picasso demonstrated the breakneck speed that would be a hallmark of his career, tossing off more than 130 portraits in charcoal, pastel, crayon, and watercolor within the space of a few weeks. Compared to Casas' slick portrayals, Picasso's seem deliberately down and dirty. Whatever their position in society—rich banker, politician, or cultural leader—Casas portrayed his subjects as they wished to be seen: suave, debonair, pleased with themselves and with life in general. Picasso's subjects are for the most part younger and still on the outside looking in, scruffy, eager, on the make, uncertain of themselves, and uncomfortable in clothes they seem to have donned for the occasion. Picasso's studies are not caricatures exactly, but they say more with less. In these sketches he demonstrates his capacity to reveal character and status with just a few

well-placed lines. This economy of means, his ability to distill a personality or a pose down to its essential ingredients, will be a key to his art as he discards more of the familiar signposts of normal perception while managing to retain a foothold in reality.

The show was not particularly successful either financially or in terms of public interest. A number of drawings managed to sell for the low price of 1 to 5 pesetas, but mostly to friends and relations. "The most assiduous visitors were ourselves," Sabartés remarked wryly, "since nearly all of us had the time to drop in now and then if only for a cup of coffee and a friendly chat around the table." Nor was Picasso's debut a great critical success, receiving decidedly mixed reviews in the leading journals. The *Diario de Barcelona*, while admitting that "Sr. Picasso has talent and a feeling for art," went on to complain of his "obsession with the most extreme form of Art Nouveau," concluding that the show formed "a gallery of melancholic, taciturn and bored characters, impressing the viewer unfavorably, making him feel sadness and pity for those portrayed." The critic of *La Vanguardia* was more complimentary, praising the artist's "extraordinary facility in pencil and brush-work," particularly from the hand of a "young man, almost a boy," though he too decried "a lack of experience and carelessness" as well as a persistent derivativeness.

But ingratiating himself with the cultural elite was hardly the point. This show was a gauntlet thrown down to the older generation, a signal that the new one had arrived and had found its champion. "Above all," wrote Sabartés, "what we wanted was to put Picasso beside the 'idol of Barcelona' and to infuriate the public—the public and even, it might be, Casas." The combativeness of Sabartés' comment suggests a split within the community that gathered at Els 4 Gats, a rebelliousness born of youth and an impatience with their elders whose art never lived up to their grand pronouncements. They were bored with the "vogue for corkscrews" popularized in the Art Nouveau posters of Alphonse Mucha, tired of "poems featuring fairies and lakes, and designers decorated books, with lilies and such . . . poets [with] long hair, and painters [who] wore their coats buttoned up the neck, regardless of the weather." Picasso made his own disdain crystal clear, poking fun at himself as well as his pretentious colleagues with a drawing of Sabartés in which he mocks the posturing of the *poeta decadente*. He draws his friend in a midnight

graveyard, crowned with a laurel wreath and holding a single lily daintily in his hand.

Fortunately, Casas and the other leading lights of the *Modernista* movement tolerated the malcontents in their midst. After all, wasn't *Modernisme* all about storming the bastions of received wisdom, taking on the pieties of generations past, and replacing them with something fresh? There was nothing really mean-spirited about Picasso's parody, which contained as much reverence as mockery. If the younger man was poking fun at Casas as the successful society portraitist, the older artist had enough distance on himself to appreciate the joke.

When the show came down on February 24, 1900, Picasso found himself at a crossroads in his young career. Though he had not exactly taken Barcelona by storm, he had at least solidified his place as the indisputable star of the under-twenty crowd. But what did it mean to be the most promising teenage artist in Barcelona? Whatever their aspirations, most Barcelonans understood that they were located on the fringe of progressive Europe. Picasso and his cronies were already bored with the pastiche of styles and attitudes that constituted Catalan *Modernisme* and were looking for something to replace it. Barcelona ran a persistent cultural deficit, importing its styles and attitudes from abroad while exporting little that anyone cared about beyond the borders of their own obscure province.

Taking stock over cigarettes and beer at the *cerveseria*, Picasso and his friends mapped the road ahead. If a year or two earlier he had complained that his Málaga relatives looked on him as a joint stock operation in which each could purchase shares, his own *tertulia* was even more heavily invested in his success, though their contribution was more emotional than financial. "In 1900, Picasso was but nineteen years of age," Sabartés wrote, looking back on that momentous year. "He had mingled with Casas, with Rusiñol, with Utrillo and the other figures of the circle of Els 4 Gats, and had even attracted their attention. But while his personal merits might have sufficed to minimize the difference in their ages, there was something more important than years, especially in a milieu like that of these men who ridiculed experience, titles, prejudice, and

tradition. There was Paris. There was Europe. And Picasso had still not crossed the Pyrenees."

It was the journey to Paris that gave an artist the aura of sophistication without which he would be judged irredeemably provincial. A painter like Don José could dispense with a foreign adventure; for a traditionalist, the seductive air of the French capital might actually be detrimental, undermining the soundness of his art with untested techniques and subversive notions. But for anyone looking to give his painting an up-to-date panache or even to speak knowledgably about the latest trends over a glass of beer, the journey to the world capital of art was *de rigueur*. Familiarity with all things Parisian was currency that could be spent back home at a vastly inflated rate of exchange. As Sabartés put it, "Nothing counted except the fashion from Paris. All our intellectuals had been to France."

Before his journey, Picasso was an unpolished gem, a rube (if not a ruby) with untapped potential. After, he glowed with borrowed splendor. As Sabartés wrote years later:

> When he was away, the mere recollection of Picasso entertained us. Our conversations became animated whenever some news about him dispelled our provincial lethargy. He made us think of places unknown to us: of the Galicia which he had seen, of the Andalusia which gave him to us, of the France which had taken him from us, and of the Paris which fascinated us and filled us with feverish curiosity and an anxious longing for developments together with a fear of the struggle for which we were not prepared, nor ready to face, nor strong enough to bear.
>
> From each absence he returned to us with a conquest, and lit up the eyes of our spirit with new surprises.
>
> We spoke of him as a legendary hero:
>
> "Do you know? . . . He has gone away. . . . Heaven knows when he'll come back!"

While it seemed clear to his friends that a trip to Paris was the missing ingredient in Picasso's résumé, Don José resisted. "Why not attend the Academia a little longer?" he asked. "With a little effort [you] could

teach anywhere, either there in Barcelona, or, if he preferred, in Madrid." Picasso had no intention of following his father's advice, but he knew exactly how to play his parents, making defiance look like compliance.

In late July 1899, pamphlets appeared at La Llotja, the Cercle Artístic, the Sala Parés, and Els 4 Gats providing instructions to anyone wishing to be considered for inclusion in the Spanish section of the *Exposition Universelle* in Paris the following year. For Picasso it was the chance of a lifetime. Having a work accepted in the great world's fair would be a signal achievement, especially for an unknown nineteen-year-old. The entire civilized world was about to descend on Paris for the exposition that marked the dawn of a new century, so that instead of being seen by a few dozen close friends his work would be viewed by millions streaming through the various pavilions to gawk at the latest innovations in industry and technology and puzzle over the latest trends in art.

But it was not the prestige or even the publicity that motivated Picasso to apply. He no longer put much stock in that sort of official recognition, which hardly corresponded to the image he was trying to cultivate of a rebel taking on the staid academy. Playing to the judges would require him to trim his sails a bit, to make the very sort of concessions to good taste that were increasingly out of step with his sense of himself as an artist. The fact that Ramon Casas' monumental canvas *La Carga* (The Charge)—which shows officers on horseback trampling a group of protesting workers underfoot—was rejected by the same jury on political grounds would have elevated the older artist in the esteem of the denizens at Els 4 Gats. Practically speaking, however, the inclusion of one of Picasso's paintings in the Spanish Pavilion was such an honor, and of exactly the kind his father understood, that Don José would find it impossible to refuse his son the chance to chase his Parisian dreams.

The painting Picasso submitted was one of those large set pieces like *First Communion* and *Science and Charity* that had been such a success with the judges in the past. The subject was another deathbed scene. Titled *Last Moments*, the painting adhered to the tenebrist mood of other works from the winter of 1899–1900. One of the few oil paintings Picasso included in his one-man show at Els 4 Gats, this large-scale (50 x 78 inches), carefully plotted, ponderously conceived painting, stood out amid the slapdash sketches that surrounded it on the tavern wall. Though the original has

disappeared, painted over by the Blue Period masterpiece *La Vie*, we have a description of it from the review in *La Vanguardia*: "[It] shows a young priest who stands with a prayer-book in hand, looking at a dying woman. An oil-lamp gives out a tenuous light, reflected here and there in the white bed-cover lying over her. The rest of the picture is in the shadows, softening the figures and giving them an indistinct outline." Submerged in Symbolist gloom, *Last Moments* had all the dignity of "serious" art but none of the energy of the sketches that formed the bulk of the show.

On February 24, the same day the exhibition came down, *La Vanguardia* published the names of the artists accepted for the *Exposition Universelle* later that year. "Pablo Ruiz," the paper announced to the cheers of friends and family, would be presenting "pictures in oils."

For Picasso the Parisian trip would be a life-altering experience. Had he remained in Barcelona or, once there, had he not found the French capital so compelling—the exhilarating, infuriating, callous, and thoroughly confusing heart of all that mattered—he would never have vaulted onto the stage of history. His astounding career was the product of a synergy between a man of genius and a city that offered unprecedented opportunities for someone willing to drag the idols from the temples where they'd been worshipped for millennia and send them tumbling into the dust. Of all the cultural capitals throughout history—from fifth-century BCE Athens to Florence in the Renaissance, to New York in the years following the Second World War—Paris at the dawn of the twentieth century was uniquely accommodating to the cultural saboteur, to the man or woman who was willing to attack the very civilization upon which its fame rested. If Paris was the capital of gracious living, of silk stockings and *champagne brut*, of *haute couture* and *haute cuisine*, without that sense of danger lurking just below the surface—an anxiety and exhilaration provoked by the knowledge that sappers were busy undermining the foundations of their impossible, fragile edifice sparkling along the banks of the Seine—the splendor would have felt like mere indulgence.

Having persuaded his parents to fund the trip, Picasso put off his departure for a few months. Don José and Doña Maria still needed time to scrape together sufficient funds, and he needed time to produce a body of work that might appeal to the Parisian galleries. The success in the French

capital of Isidre Nonell and his friend Ricard Canals hawking Hispagno-list scenes to Parisians encouraged Picasso to follow suit. It's ironic that the future leader of the avant-garde hoped to get his foot in the door by confirming French stereotypes of the southern primitive. The sophisti-cated Parisian tended to think of Spain as backward and expected Spanish artists to oblige with quaint scenes full of picturesque brio. The triumph of Bizet's *Carmen* was only the most obvious example of the French taste for tales of fiery Latin passion, but the strategy worked in the fine arts as well. Édouard Manet's early success in the Salon, for instance, was built on Hispagnolist themes and a bravura technique that looked back to the great Spanish painter of the Baroque era, Diego Velázquez.

Picasso spent the time leading up to his departure working up a series of pastels on that most Spanish of themes—the bullfight. These garishly colored works are a radical departure from his recent tenebrism, filled with Andalusian light and a ferocious joy. Whether they were sparked by a cold-eyed assessment of the market or by exhilaration over his impending trip, they constitute one of those abrupt changes in style and mood that will become a hallmark of his career.

His newfound exuberance came in spite of the fact that he was now sharing a studio with the mercurial Casagemas, a loft at 17 Riera Sant Joan near the Santa Caterina market in the old city. To enliven the grim accom-modations, the two friends painted the walls with scenes of plenty that contrasted with their rather straitened circumstances: tables piled high with delicacies and gold coins, and even a buxom maid to serve them. This habit of surrounding himself with images of his own devising, par-ticularly ones that present a hoped-for reality at odds with the inadequate present, is another constant of Picasso's career. It suggests the magical basis of all his art, which invests even the most cobbled-together assem-blage with a totemic presence. Like one of the ancient Egyptian tombs in which the dead dine out for eternity on images carved into stone, these murals represent a kind of magical thinking in which one only need con-jure a particular scenario for it to become manifest in the world. Time and again, Picasso would use his art to manipulate reality, sometimes in a lighthearted vein, as when he showed his friend Max Jacob, a struggling poet, crowned with the victor's laurel, sometimes more seriously, as when

he portrayed Fernande Olivier, still another man's mistress, lying naked in his bed while he watches over her. In each case Picasso demonstrates his deep belief in art's magical efficacy, one that goes back to Conchita's death and the bargain he struck (and broke) with God.

Picasso drew the brightly colored scenes of *the corrida* with an eye toward the French market, but in July he took the opportunity to try them out on the local audience in a hastily assembled exhibition at Els 4 Gats. Unlike his previous show, this one, perhaps because of its pleasing hues, was well received in the press. Particularly glowing was a review in *Las Noticias* that left no doubt that, at least among progressive critics, Picasso was now regarded as the champion of the younger generation: "Let us welcome this youth, who has begun with such talent and courage but is so little appreciated by the establishment. . . . Nobody of that ilk is going to pay any attention to Ruiz Picasso. . . . The last thing these degenerate old sages would do is praise a boy who is achieving more than they are."

But all this was merely marking time until the great day arrived. The *Exposition Universelle* had opened in April, and by the time summer rolled around most of the better-funded artists had gone at least once, bringing back tales of wonder. The announcement that the exhibition would be closing in November made it urgent that preparations be completed. By October everything was ready. Don José and Doña Maria saved enough to buy the train tickets; Picasso himself had also saved a little and, in any case, could always count on a little help from the profligate Casagemas.

The original plan had been that Pallarès would join them and the three youths would travel to Paris together. But Pallarès was delayed in Horta, and they decided they could not wait. Early in the month Picasso and Casagemas visited a tailor near the ancient basilica of Santa Maria del Mar where they ordered identical suits as fashionable as their meager funds would allow. Pallarès, who would shortly have one made for himself in the same black corduroy, described the outfit: "[t]he jacket was very loose, with a round collar buttoned up to the neck so as to hide the waistcoat and, in case of extreme necessity, the absence of a shirt. The trousers were in the same material, narrow and open at the bottom with two buttons to fasten them."

One of the last drawings Picasso made before he set out was a self-portrait on which he scrawled, three times, like a boxer pumping himself up before a big fight, the boast: "*Yo el rey*" (I the king).

Nattily attired, carrying a few clothes and his painting supplies, Picasso set out on a late October morning in the year 1900. Though not exactly the picture of the conquering hero, he was brimming with confidence. Any doubt that he could measure up on the big stage was quickly suppressed. Had he not, at the tender age of eighteen, taken the Barcelona art world by storm? Had he not been anointed the Chosen One, first by his father, Don José, and then by the young men who crowded around him at Els 4 Gats and regarded him as little short of the Messiah?

As the train pulled out of the station amid the screech of metal wheels on metal tracks, as the locomotive emerged from the shed in billowing clouds of smoke and steam, Picasso had every reason to believe that he was bound for glory.

Dirty Arcadia

Well, this is a kind of Eden or dirty Arcadia.

—CARLES CASAGEMAS TO RAMON REVENTÓS, NOVEMBER 11, 1900

Picasso's arrival in Paris on that late October day looms as one of the watersheds of modern history, marking the end of one era and the beginning of the next—the cultural equivalent of Lenin pulling into the Finland Station in 1917 to touch off the century's most radical political revolution. One wishes, then, that the moment the twentieth century's most innovative artist first set foot in the one place on Earth that could unlock his unique talents and enable his unprecedented career was dramatic, but the occasion feels more like a teenage lark than a date with destiny.

To be fair, the line between excess and the serious business of making a life in the avant-garde was somewhat blurry. It was a later generation that coined the phrase "sex, drugs, and rock and roll," but the belief that sexual, spiritual, and aesthetic liberation were all connected, that by throwing off the shackles clamped on them by a disapproving society they would usher in a brave new world, was every bit as potent at the turn of the last century. The pursuit of pleasure was not simply self-indulgence. Self-denial, they contended, was not only a drag—it was the death of creativity. Paris, like Haight-Ashbury, meant freedom, and not

just a chance to hook up and drop out but to proclaim by one's mode of life that a new day was dawning.

Santiago Rusiñol, who had made the same journey a generation earlier, captured the impression left by the City of Lights on the new arrival: "The sympathy Paris inspires as soon as one arrives there does not spring from its movement, which is dizzying, nor from its immense size . . . but from the art-soaked atmosphere which everyone breathes and which spreads to everything, to architecture as much as to women's dresses, to great works and monuments as to little trifles . . . here you feel its harmony, the harmony of a colossal, well-tuned orchestra."

Paris was also a glorious paradox. The French Academy, and the École des Beaux-Arts it sponsored, laid down the rules and enforced a rigid hierarchy of excellence on all aesthetic matters, not only in France but throughout the West. Like a powerful radio beacon, its system of values radiated outward until it permeated the civilized universe. But if Paris was the center of the cultural establishment, it also proved an irresistible magnet to revolutionaries who were drawn to that center in order to storm the bastions of tradition. The city attracted advocates of free love, political agitators, and aesthetic rebels in equal measure. The man who openly

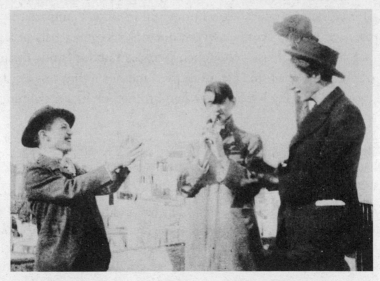

Picasso, Mateu de Soto, and Carles Casagemas, 1900. © *RMN-Grand Palais / Art Resource, NY.*

acknowledged his mistress, or who subscribed to *L'Anarchie*, was a man open to new aesthetic possibilities, disdainful of middle-class propriety and hungry for novelty. The seriousness with which these issues were quarreled over in public fueled an unparalleled creativity and attracted all those who wanted to be where the action was.

To take these radicals at their word, one might imagine that they were engaged in a life-and-death struggle against the bourgeoisie into which most of them were born. But this picture of heroic rejection distorts what was really a far more intimate dance, involving attraction as well as repulsion. Like many of his fellow bohemians, Picasso's marginal lifestyle was at least partially funded by his parents.* If he often experienced deprivation for the sake of his art, he knew that as a last resort he could return to the family home, humiliated perhaps, but saved from starvation.

Bohemia, no matter how low the rent and cheap the food, turned out to be an expensive place to live. Its very existence was predicated on surplus generated by the capitalist, materialistic society it despised. Paris provided plenty of low-cost housing, soup kitchens, and seedy taverns where one could run up a tab—the basic infrastructure of the alternative lifestyle—but for the avant-grade artist, keeping body and soul together was a continual struggle. Pushing aesthetic boundaries usually meant going for years, often decades, without real income. Compared to their classmates who had become lawyers, doctors, or even artists of a more conventional stripe, these young men were a strain on family finances.†
One of the features of this life, from the time of the Impressionists onward, was the begging letter to a father, brother, or friend claiming that

* At that point, probably also Casagemas' parents, since Picasso was always dependent on his better-off companions.

† There were a few women who successfully navigated the macho world of the avant-garde—Berthe Morisot, Mary Cassatt, and Marie Laurencin, to name a few—but they tended to be even more dependent on sympathetic family members or generous lovers. For those young women, the likelihood of earning a living was even slimmer.

only a swift infusion of cash could save the hero from starvation or (even worse) getting a real job. Typical is Cézanne's stormy relationship with his father, a stolidly conventional banker from Aix-en-Provence. "I beseech you," the artist pleaded as he struggled to get a foothold in Paris, "to stop trying to hamper my freedom to come and go. . . . I ask you, Papa, for just two hundred francs a month."

For all its difficulties, this kind of life was possible only in the French capital. As his mistress Fernande Olivier later noted, while Picasso often found himself "without money and without a home, it is a good deal more difficult to live in Barcelona under those conditions than in Paris."

On this initial trip Picasso only intended to stay for a month or two, though his plans seem to have been rather vague. His parents would have insisted on that, and in any case he was still not ready to strike out on his own. There was no question yet of settling permanently abroad: his artistic and emotional life was still in Barcelona. There were, in fact, a number of different models he could draw on as he mapped out his future. Many Catalan artists—Casas, Rusiñol, Utrillo, and Nonell, to name a few of the more prominent—shuttled back and forth between Paris and Barcelona, using their time in France to give their work an up-to-date sparkle that appealed to collectors back home. Some of these same painters could even point to a small success in Paris itself; many exhibited in the numerous salons and galleries and built a market for their work there. Others, however, regarded their Parisian journey as a once-in-a-lifetime splurge, an artistic haj that need not be repeated, while a few were so dazzled by the bright lights that they never went home again. Picasso had no idea which of these options he would pursue. He yearned for fame and fortune but had little sense of where that ambition would take him.

The one course he could not possibly anticipate was the one he eventually embarked on, since it had not yet been invented. His status as an international star, a celebrity as instantly recognizable as any matinee idol, the symbol of the modern world's breakneck innovation and profound deracination, a figure who not only came to embody in the public's imagination what an artist could and should be but transformed the very meaning of art itself—all this was made possible by Paris but was still

unimaginable. As Picasso and Casagemas set out from the Gare d'Orsay, lugging their bags across the boulevard Saint-Germain, past the Jardin du Luxembourg, the prospects were dazzling but indistinct.

Their immediate goal was Montparnasse, where they had been told that rooms were available on the cheap at 8 rue Campagne-Première. When they arrived, a grueling hour later, it turned out to be a no-frills apartment building crowded with artists' studios in what was still a somewhat dingy and unfashionable neighborhood on the Left Bank.*

As soon as they paid their deposit and dropped off their belongings, Picasso and Casagemas headed across the river to Montmartre to pay a visit to their old friend Isidre Nonell, who had a spacious, light-filled studio at 49 rue Gabrielle, in a rough-and-tumble neighborhood near the top of the Butte. Nonell was already a fixture on the Montmartre scene. He had found a market for his morbid paintings among Parisians and was one of the few Spaniards on familiar terms with not only his own compatriots but a number of young French artists as well. They were making a mistake settling in Montparnasse, he told his visitors. Rustic Montmartre, he insisted, was the real heart of bohemian Paris. Here was where the most innovative artists lived and worked and, equally important, here the taverns and cabarets stayed open all night. A few years later, when Modigliani first moved to Paris and was staying in a hotel near the Opera, Picasso advised the young Italian, "Go up to Montmartre. . . . You'll see everything: painting and all the rest of it, women too, if they amuse you." Nonell must have described the charms of the neighborhood in much

* The building was constructed of materials salvaged from the *Exposition Univer-selle* of 1889 (the centerpiece of which was the Eiffel Tower) and was a testa-ment to the abundant accommodations Paris provided at little cost to artists. Montparnasse would become chic only in the years immediately preceding the First World War, when it was Picasso, Modigliani, and their friends, driven from Montmartre by the hordes of tourists, who transformed it into a hub of avant-garde art. It would really come into its own in the 1920s, when writers like Hem-ingway and Fitzgerald linked up with the artists at the various cafés and bars.

Picasso's first studio in Paris (center building, top floor) on rue Gabrielle. *Courtesy of the author.*

the same terms. Always generous to his younger colleagues, he offered to make his own studio available in a few days, as soon as he left for Barcelona.

Finding this a much more attractive proposition, Picasso and Casagemas made yet another crosstown journey, hauling their possessions in a couple of rented handcarts across the river and then up the steep slopes of Montmartre, where, exhausted, they booked a room at the Hôtel Nouveau Hippodrome, a sordid little hotel on the rue Caulaincourt. Here they would remain for the next few days, sharing the communal bathrooms with the prostitutes who rented rooms by the hour, until Nonell left for Barcelona.

One of those who witnessed this midnight caravan was the future Cubist painter Jacques Villon. He had apparently met the two young Spaniards earlier that day in Nonell's studio. Seeing them trudging up the hillside, he burst out laughing, assuming, he later admitted, that they were engaged in that classic bohemian tactic of slipping away in the dead of night to avoid paying the rent. "I think my laughter hurt his Spanish pride," Villon said. "He held it against me for 15 years."

Picasso and Casagemas moved into Nonell's studio on October 25, Picasso's nineteenth birthday. Before their host's departure they composed a letter to Ramon Reventós that Nonell carried back with him to

Barcelona. Written mostly by Casagemas (and illustrated with a few deft sketches by Picasso), the letter exhibits Casagemas' typical overexcited style: breathless, disjointed, filled with half-finished thoughts, pungent observations, and cryptic asides. According to Casagemas, he and Picasso have been keeping up a frenetic pace, mixing equal parts business and pleasure. Despite assurances that "[w]e're working hard," he admits they spent much of their time hanging out with their Catalan cronies in taverns and cabarets, consuming "beer and sandwiches . . . until the early hours of the morning."

The neighborhood, though certainly colorful, was marginal, lively enough during the daytime hours but deserted at night except for the *apaches*, small-time hoodlums who would knife you for the change in your pocket. Initially, at least, Casagemas claimed to be unimpressed with what Paris had to offer, though his air of superiority was mostly a pose to make himself seem less provincial. "Some nights," he told Reventós,

> we go to café-concerts or theaters. . . . It's pretty nice but it usually ends up a mess. . . . The boulevard de Clichy is full of mad places like Le Néant, Le Ciel, L'Enfer, La Fin du Monde, Les 4 z'Arts, Le Cabaret des Arts, Le Cabaret de Bruant and a lot more which don't have the least bit of charm but make lots of money. A "Quatre Gats" he would be a mine of gold. . . . There's nothing as good as that nor anything like it. Here everything is fanfare, full of tinsel and cloth made of cardboard and papier mâché stuffed with sawdust. And above all, it has the other advantage of being of deplorable taste. . . . The Moulin de la Galette has lost all its character and *l'idem* Rouge costs 3 francs to enter and some days five.

As for the main purpose of their Parisian journey: "We have already launched into work," he assured Ramon. "Now we have a model. Tomorrow we'll light the heater and we'll have to work furiously for we're already thinking about the painting we're going to send to the Salon. Also we're painting for exhibitions in Barcelona and Madrid. . . . *So you'll see if we make it!*" He concluded his letter by providing a description of their new accommodations:

One table, one sink, two green chairs, one green armchair, two chairs that aren't green, one bed with extensions, one corner cupboard which isn't in a corner, two wooden horses that make a trunk, one oil lamp, one mat, a persian rug, twelve blankets, one eiderdown, two pillows and a lot of glasses, wine-glasses, bottles, brushes, a screen which just arrived . . . flowerpots, W.C., books and a pile of other things. We even have a mysterious utensil for private use *by ladies only.* I don't know what it's called but I believe it's used to clean oneself where one gets dirty *in coitus* and in addition I believe it's used *to prevent having babies.* . . . In addition we have a kilo of coffee and a can of peas.

The reference to the "mysterious utensil" suggests another feature of their life in Montmartre: Nonell not only had lent them his studio but had introduced them to three local girls, who immediately made themselves at home in the crowded room.

Germaine, Antoinette, and Odette were the kind of young Montmartrois ladies who appear in the paintings of Renoir and Toulouse-Lautrec and who, at least for the almost exclusively male fraternity of artists and writers, gave the neighborhood much of its charm. These young women, usually of obscure parentage—Germaine and Antoinette, for instance, were said to be sisters, though from different fathers—could be found looking for (and providing) company at the nearby dance halls of the Moulin de la Galette or Moulin Rouge. They made their living as artists' models, laundresses, seamstresses, or paid companions, flitting about from one studio to another, trading on their physical charms to save themselves from an even harsher life on the streets. "The young Montmartre girls who posed for Renoir," wrote Renoir's son in an account of his father's life, "were not all models of virtue. The morals of the quarter were far from strict, and scores of youngsters did not know who their fathers were."

The most famous of these grisettes was Suzanne Valadon, who had worked as a trapeze artist before posing for painters like Renoir, Pierre Puvis de Chavannes, and Toulouse-Lautrec. What distinguished Valadon from her peers was her intelligence and artistic talent, nurtured (surprisingly) by the usually misanthropic and misogynist Edgar Degas. A couple

of decades earlier, she had carried on an affair with Picasso's friend Miquel Utrillo; when her son, Maurice, was born the Catalan gallantly offered to adopt him.

How exactly the three young ladies came to live with Picasso and Casagemas at 49 rue Gabrielle is a bit unclear, though the sexual customs of Montmartre were sufficiently relaxed that they seem to have had no difficulty working out an arrangement: Germaine was paired up with Casagemas, Picasso with Odette, and when Pallarès finally arrived a few days later, he was naturally fixed up with Antoinette.*

Picasso immediately took to his new surroundings. For years he had indulged his healthy sexual appetite with prostitutes and with at least one off-and-on girlfriend, but Paris was different from Barcelona and Montmartre different from the rest of Paris. According to Gertrude Stein, being "faithful . . . in the fashion of Montmartre" meant sticking by one's mate "through sickness and health" but "amus[ing one]self by the way." This suited Picasso just fine, and he plunged into the bohemian lifestyle with gusto.

Back in Spain there was a sharp dividing line between respectable young women who remained cloistered in their own homes and were seen in public only if properly chaperoned, and whores who plied their trade behind closed doors in the Barri Xino. In Montmartre, for the first time, Picasso was sharing his bed with a woman as eager for sex as he was. Admittedly, his relationship with Odette was somewhat limited. She spoke no Spanish and he almost no French. In addition, according to Casagemas, she had the "good habit of getting drunk every night." Still, despite these drawbacks, she provided him with the physical release he required, without making any demands on his time or emotional energy. As Picasso wrote to Ramon Reventós about three weeks after moving into Nonell's studio:

All this about women . . . seems or must seem to take all our strength, but no! Not only do we spend our lives "fondling," but

* The three girls were already popular with the Spanish contingent, in part because Germaine (and perhaps Antoinette) spoke Spanish.

I've almost finished a painting—and, to be frank, I think I have it just about sold. Because of this, as lovers of the traditions of our beloved (!) country, which few are, we are saying goodbye to the bachelor life—as of today we are going to bed at 10 and we're not going anymore to [the brothel on] *calle de Londres*. Today Pajar-esco [Pallarès] has written a notice in the studio that we'll get up early and that we'll even try to "fondle" at regular hours.

For the nineteen-year-old Picasso, it was paradise. For Casagemas, however, the arrangement proved catastrophic. At first Casagemas tried to play it cool, referring to their crowded studio as "a kind of Eden or dirty Arcadia." In the same letter he referred to Germaine as "for the time being the woman of my thoughts"—a phrase that hardly suggests the birth of an unhealthy obsession that would ultimately destroy him.

Germaine and Casagemas were mismatched from the beginning. She may have been the woman of his thoughts, but when it came to the physical dimension of their relationship, she seems to have repelled him. Later on, perhaps to assuage his sense of guilt for the tragedy, Picasso

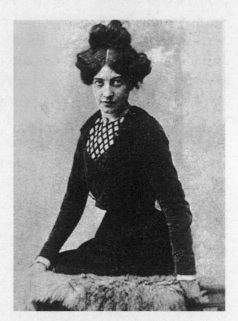

Germaine Pichot.

would claim that Casagemas was impotent and that this disability was confirmed after his death. It's far more likely that Casagemas' inability or unwillingness to consummate his relationship with Germaine was psychological, a manifestation of his conflicted sexuality and morbid personality.

For some time now it had been clear that his interactions with the opposite sex were unusual for a teenage boy, certainly far different from those of Picasso who, at least at this stage of life, preferred his contact with women to be carnal and uncomplicated. Some years earlier, Casagemas had developed an unrequited passion for a married niece, a relationship that apparently existed only in his fevered imagination and over which he had threatened suicide. For Casagemas women were abstractions, never more entrancing than when they were unavailable. He was drawn to them in a romantic and deeply self-dramatizing way, but only as ethereal visions. Their flesh-and-blood counterparts, by contrast, were frightening creatures whose needs appalled him.

This quirk in Casagemas' personality had been apparent to Picasso for some time. Whenever he and his friends headed out for the brothels of the Barri Xino, Casagemas would excuse himself, complaining of a stomachache or some other ailment. The experience of sharing his bed with an attractive woman who exhibited a healthy sexual appetite of her own was excruciating for both parties. This wouldn't have mattered so much had his physical coldness been matched by emotional indifference, but the paradox of Casagemas' personality was that the more he recoiled from physical contact the more his obsession with the Germaine he imagined took hold.

It was an explosive situation that was not helped by the bacchanalian atmosphere of the rue Gabrielle studio. It couldn't have helped that Picasso, in keeping with his need to surround himself with images of magical significance, decorated the walls with a scene of the *Temptation of St. Anthony*. The spectacle of the ascetic holy man beset by demons in the shape of alluring women must have seemed a mockery of Casagemas' own desperate situation. As Picasso and Pallarès happily romped with their willing companions, Germaine and Casagemas were locked in a downward spiral, a descent sped along by copious consumption of drugs

and alcohol. Angry scenes became a regular feature of life in the studio. Germaine, "the heroine of many a strange story," as Gertrude Stein put it, was no demure flower and reproached Casagemas for his ineptitude. For all the use he was to her, she sneered, she might as well return to her husband or make her way down the Butte to the Cirque Medrano, where there were plenty of roustabouts who could get the job done.

Casagemas' dirty Arcadia had devolved into a living hell. A quick study on paper by Picasso titled *Group of Catalans in Montmartre* captures the anxious mood of these months. Depicting the gang congregating on the bleak hillside of the Butte, it shows Casagemas looking particularly spectral. Staring out at the viewer with dark, haunted eyes, his gaunt form seems already to have one foot planted in the grave.

Picasso ignored the situation as long as he could. He had a gift for compartmentalizing that often amounted to callousness, particularly when an emotional entanglement threatened to interfere with his work. As he once told Françoise Gilot, "Everybody has the same energy potential. The average person wastes his in a dozen little ways. I bring mine to bear on one thing only: my painting, and everything else is sacrificed to it— you and everyone else, myself included." In addition to the wine, women, and even the occasional song (Casagemas describes the gang at Ponset's tavern, belting out obscene ballads deep into the night) there was serious work to be done, and he had no intention of allowing his friend's problems to ruin his plans.

These plans included soaking up as much art as possible. For cultural pilgrims, Paris was an artistic Mecca, with unparalleled historic collections in the Louvre and of more recent artists in the Luxembourg, as well as numerous galleries offering for sale both old masters and young unknowns. Ardengo Soffici, the Italian critic and Futurist, recalled, "Picasso would go from museum to museum nourishing himself on good old and modern painting, and since I used to do the same thing, it was not unusual for us to run into each other in the Impressionist room at the Luxembourg or in the Louvre. There Picasso always returned to the ground-floor rooms, where he would pace around and around like

a hound in search of game between the rooms of Egyptian and Phoenician antiquities—among the sphinxes, basalt idols and papyri, and the sarcophagi painted in vivid colors."

In addition to the glories contained in its many museums, Paris hosted a series of temporary exhibitions featuring the latest products from the artists' studios. Each spring the official Salon* was attended by tens of thousands of spectators flocking to see the paintings and sculptures that had received the official seal of approval from the state. Equally popular were the alternative salons, the Salon des Indépendants and, later, the Salon d'Automne, featuring artists rejected by the official venues or unwilling to subject themselves to their judgment.

In 1900, the *Exposition Universelle* added to the already rich offerings, with dozens of national pavilions and three vast surveys dedicated to the fine arts. In two cartoonlike sketches Picasso depicts himself leaving the grounds of the world's fair, arm in arm with his Spanish friends, including Ramon Casas, Pichot, Utrillo, and Casagemas. In one of them Picasso holds hands with Odette; in both, Casagemas clasps Germaine, who is dressed fashionably in a low-cut gown, a stylish hat perched fetchingly on her head. With a caricaturist's gift for concision, Picasso manages to capture their strained relationship in a few quick strokes. While Casagemas peers straight ahead, grim-faced, Germaine swivels her hips and turns her head coquettishly, as if hoping to draw the attention of a handsome passerby.

By the time Picasso arrived in Paris, the exposition had only a few weeks left to run. Since April, more than 30 million visitors had passed through the gates to sample wonders of modern technology and sprawling surveys of cultural excellence. In the national pavilions and great exhibition halls, the popular *Guide Hachette* proclaimed, visitors would witness "the ascent of progress step by step—from the stagecoach to the express train, the messenger to the wireless and the telephone, lithography to the

* That juried show, technically known as the Salon de la Société Nationale des Beaux-Arts, was supposed to represent the highest achievement in French art. By 1900, the rivalry between supporters of the official salon and its competitors was already a well-established feature of the Parisian art scene.

x-ray, from the first studies of carbon in the bowels of the earth to the advent of the airplane." It was, the guide concluded, "the exhibition of the great century, which opens a new era in the history of humanity."

That new era, the exposition made clear, would be characterized by energy and speed. Escalators and moving sidewalks whisking spectators from one exhibit to the next, Bateaux Mouches plying to and fro along the Seine, and a newly completed Métro line, all gave visitors a preview of their kinetic future. It was an exhilarating, if also unsettling, experience enhanced in the various cinemas on the grounds, particularly the popular Phono-Cinéma-Théâtre, one of the first "talkies" where film and sound were successfully synchronized.

The exhibition that defined the *Exposition Universelle* of 1900, and that was meant to capture the excitement of the century just dawning, was the *Palais de l'Électricité*, the Palace of Electricity, where, in words recalling biblical Creation, "a single touch of the finger on a switch" miraculously released a "magic fluid . . . bring[ing] light and life." Impressive during the day, the fair truly came to life at night, when 16,000 incandescent lights and another 300 arc lamps turned both banks of the river into a glittering fairyland, confirming Paris' reputation as the City of Lights.

But for all its glitz, Picasso was less than overwhelmed by the spectacle. Without the drawings and an offhand remark by Casagemas, we would have no record that he even visited the *Exposition*, though the opportunity to see his *Last Moments* in the Spanish Pavilion of the *Grand Palais* had been the ostensible reason for the trip. The fair was simply too superficial, too sunny to appeal to him. A bombastic, self-congratulatory display on the part of a civilization that had convinced itself that we were all gliding happily toward a limitless horizon, it was filled with the kind of pompous boosterism he despised. His Spanish *duende* prevented him from embracing a vision of the coming age based on science, reason, and faith in the perfectibility of Man. As he told Jacqueline Roque, explaining why he'd decided to live in a particularly gloomy medieval chateau, "You forget that I am Spanish and love sadness."

Like the organizers of the exhibition, Picasso was eager to embrace the future, but his version of that future encompassed none of their optimism. No one would do more to take painting and sculpture into

the new century, to create forms that spoke directly to the disorientating impact of technology and new ways of understanding the physical universe. But unlike so many of his colleagues who were seduced by the promise of technology, he understood that so-called progress was a profoundly disruptive force and would not fundamentally alter an existence rooted in cruelty and suffering. In the two drawings he made of the exhibition, he showed himself as morbidly withdrawn as Casagemas, as if he had just witnessed something ominous hidden beneath the electric glare.

Perhaps the most important impact on Picasso of all this wizardry was a vague but profound dissatisfaction with his own profession. In the first place, his own canvas, hung too high in a neglected corner, made little impact. But even if it had been hung more prominently, it wouldn't have mattered; compared to much of what he'd already seen in Paris, the heavy chiaroscuro and maudlin subject matter of *Last Moments* seemed hopelessly out of date, though one critic was kind enough to note that it conveyed "a true sense of grief." He had set out from Barcelona proclaiming *"Yo el rey,"* but a few weeks in Paris taught him how much he still had to learn.

He was not the only painter to feel disappointment. For a sensitive, ambitious artist, the contrast between the dynamism of the sections devoted to technology and those devoted to the arts was dispiriting. To their credit, the organizers of the current fair hadn't stinted on cultural displays, but it was clear to Picasso and his companions that the halls devoted to the fine arts were staid compared with those featuring the latest technologies. Respect for precedent rather than innovation was the organizing principle here. Where was the sculptural equivalent of the Palais de l'Électricité or a painting as hypnotic as the flickering images dancing on a cinema screen?

The cultural portion of the world's fair was housed in two vast structures, the *Grand* and *Petit Palais*: the *Grand Palais* devoted two entire floors to painting and sculpture, the *Décenalle* showing work from the last ten years from all exhibiting nations, and the *Centenale* devoted to French art of the nineteenth century; the *Petit Palais* featured French art of centuries past. Despite the organizers' efforts to put cultural achievements on a par with the industrial, the boldness with which they embraced new

technologies was not matched when it came to the arts. Nowhere was their cautious approach more evident than in their ambivalence toward the Impressionists.

By 1900, after decades of struggle for recognition, the Impressionist painters had achieved a respected status in the collective consciousness, a verdict confirmed by the prices they now commanded at private galleries and auction houses. But despite their recent success, the officials tasked with selecting the art for the *Décennale* still regarded them as suspect. True, Manet's *Le Déjeuner sur l'Herbe*—whose scandalous reception in 1863 is generally credited with launching the modern movement in France—was grudgingly included, as were a handful of paintings by Renoir, Degas, and Monet, but these were swamped by the thousands of academic works rendered in bituminous shades derisively referred to as "tobacco juice" paintings.

To see a more representative sampling of Impressionist paintings Picasso had to head over to the Musée du Luxembourg, where work by living French artists was shown. For the young Spaniard with only a secondhand knowledge of the latest trends, the visit provided an opportunity to study up close the paintings of those former *enfants terribles*. His knowledge of modernism's founding movement was largely through the pseudo-Impressionist school of landscape painting that had flourished in the Catalan port of Sitges under the name of Luminism and through reproductions in the magazines he had pored over at Els 4 Gats. In the Luxembourg, standing in front of these sparkling views of city and countryside rendered in prismatic hues, the products of his native land seemed dull by comparison.

But for all their superficial sparkle, Picasso remained largely unmoved by these canvases. In 1900, Impressionism inhabited a kind of cultural limbo, too radical for traditionalists but no longer really cutting edge. Inclusion in the Luxembourg provided official validation of work that was still regarded by conservatives as a subversion of every academic standard. Only six years earlier, when Gustave Caillebotte had offered the museum his collection of works by his Impressionist colleagues, the academic painter Jean-Léon Gérôme called it "garbage," while a review in *L'Artiste* proclaimed it "a heap of excrement whose exhibition in a

national museum publicly dishonors French art." It took two years and a reduction in the size of the bequest, before the government agreed to display the works.

Two generations separated Picasso from those onetime revolutionaries, and the art world had moved on, setting out in different directions—Neo-Impressionism, Symbolism, Synthetism, the Nabis, to name a few of the movements that grabbed the headlines for a time—guided only by the conviction that academic art was moribund but Impressionism itself had run its course. For decades, the Impressionists had been banging on the door of official acceptance, and now that they'd finally been granted (albeit grudgingly) entrance into the hallowed halls of the establishment, the younger generation had come to regard them as excessively bourgeois.

Those who followed in their wake profited from the Impressionists' struggle with and ultimate victory over the Academy, but they were impatient with an approach that struck most of them as unrigorous and superficial. "In painting as in literature a moment came . . . when we had enough and too much of realism," wrote the critic Téodor de Wyzewa in 1894. "We were struck by a thirst for dreams, for emotions, for poetry." Impressionism, to the extent that it was intended to capture fleeting sensations, evanescent atmospheric effects, the texture of the quotidian, was the ultimate expression of that realist impulse. Symbolism, at least for a while, seemed to be the antidote, a flight from the everyday in search of a world that explored the furthest reaches of the imagination.

More important for Picasso than any of the exhibitions he could see was the spectacle of Paris itself: vast, teeming, forward-looking, self-confident—setting an example for high fashion and fine living but also providing a stage for countless scruffy bohemians whose main goal in life was provoking their stodgier neighbors. Dozens of newspapers and magazines carried tales of the ongoing war between the establishment and the avant-garde. Critics championed their favorites or hurled abuse at their rivals in columns avidly followed by an educated, engaged public. These conversations continued in bars and cafés across the city, many

establishments identified with a particular movement or attitude. In Barcelona, by contrast, the *Modernistas* constituted a cozy club of like-minded painters and literati, an incestuous cultural elite centered around Els 4 Gats and the Sala Parés, the sole venue where progressive artists could show their paintings.

Judging by the works he produced in this first Parisian trip, the art Picasso was studying most closely was not on the museum walls but in the streets—particularly the posters of Toulouse-Lautrec and Théophile-Alexandre Steinlen plastered to walls along the main thoroughfares at the foot of Montmartre. Steinlen, a Swiss-born illustrator who for many years was a fixture at the Chat Noir and one of its most effective publicists, had a particularly marked impact on Picasso. Even before arriving in Paris, Picasso had seen his work in illustrated magazines like *Gil Blas*, *L'Assiette au Beurre*, and *Le Rire*,* and his influence only deepened as he began to explore territory Steinlen had already pioneered. In a series of works, mostly on paper, Picasso chronicles the seamier side of Parisian life, the furtive assignations and desperate gropings on which Steinlen had already turned his unsparing eye, though Picasso is less interested in dissecting society's ills than he is exploring the titillation and pathologies of sexual desire. Paris itself seemed to give off an irresistible erotic charge; in the streets of Montmartre couples embraced openly, though lust was usually not far removed from desperation. Prostitution, illegitimacy, disease, and abandonment were the dark side of sexual liberation. Picasso reveals, and revels in, both. In *The Embrace*, a man and woman hug against the backdrop of Montmartre apartment buildings, their bodies melting together in rapturous abandon; in *Frenzy*, the sexual encounter has become a scene of rape perpetrated in a lonely garret.

Picasso's sexual odyssey culminates in the one major painting from his first Paris trip: *Le Moulin de la Galette* [see color insert]. Measuring almost 3 x 4 feet, *Le Moulin de la Galette* is by far the most ambitious work

* A sheet from 1899 shows him copying Steinlen's signature again and again, a practice that usually indicated an obsession with a particular artist's work—perhaps even a superstitious attempt to steal some of his vital spirit.

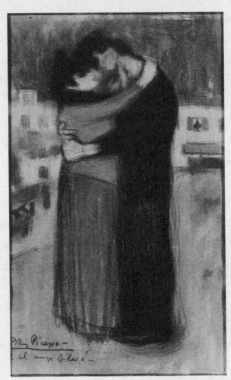

The Kiss, 1900.
Scala / Art Resource, NY.

Picasso produced during these months, the culmination of themes that had been percolating in his mind ever since he had stepped off the train. In painting this famous Montmartre landmark he was deliberately pitting himself against Renoir and Toulouse-Lautrec, both of whom had depicted the famous dance hall. The popular establishment also loomed large in the mythology of the Catalan avant-garde; it was in an apartment overlooking the Moulin de la Galette that Ramon Casas, Santiago Rusiñol, and Miquel Utrillo began their own Parisian adventure.

Picasso was already acquainted with a painting by Casas, depicting the establishment on a sleepy afternoon, that hung in Rusiñol's showcase of *Modernista* art, the Cau Ferrat in Sitges, but his own version has none of the musty realism of his Barcelona rival. His *Le Moulin de la Galette* looks forward rather than back. Picasso has envisioned the working-class dance hall with a fevered sexuality that Toulouse-Lautrec had already discovered in the Moulin Rouge at the base of the hill. He also channels Baudelaire, the Symbolist poet with a taste for the lowlife:

Women who have exaggerated fashion to the point of spoiling its grace and destroying its intention, sweep the floors ostentatiously with the trains of their dresses and the ends of their shawls; they come and go, moving back and forth, with eyes wide and startled like eyes of animals, seeming to see nothing, but watching everything. Against a background of a hellish light or against the background of an aurora borealis, red, orange, sulphur yellow, pink (pink introducing an idea of ecstasy amid frivolity) sometimes violet. . . . It is a good picture of the savagery inside civilization. It has its own beauty, which comes from Evil, always devoid of spirituality but now and then touched with a weariness that seems like melancholy.

In the Moulin Rouge at the foot of Montmartre, *"rendez-vous du high life"* as it promoted itself, show girls, including the famous Jane Avril and *La Golue,* aroused the passions of their male audience in dances meant to show off stockinged calves and thighs glimpsed through a froth of petticoats. The Moulin de la Galette, at the summit of the Butte, offered more wholesome entertainment. Renoir's famous canvases capture the carefree side of Montmartre, depicting the outdoor garden where sturdy young beaux in their Sunday best twirl their dates in sparkling sunshine.

Picasso chooses instead to paint the interior, fitfully illuminated by gaslight that casts a lurid glow over the dancers, who emerge momentarily from the shadows only to be swallowed up again. He manages to combine the tenebrism of his work from the year before with the acid colors of the pastels of the *corrida* he had completed right before he set out for Paris, the jarring contrasts conjuring up an infernal rather than a festive setting. As he did in the pastels of embracing couples, he has blurred his figures so that they seem to meld into a single pulsing organism. Some of Casagemas' desperation and misogyny has rubbed off on Picasso as arousal bleeds into terror. In *Le Moulin de la Galette* the polarities of *Frenzy* are reversed as the women take control. Two heavily made-up coquettes seated in the foreground lean in close, radiating a sexuality both seductive and repulsive. Picasso is offering us Woman as devouring temptress, women as vampires luring young men to their destruction.

The peril of erotic desire is a theme that obsessed Picasso, the pleasure of losing oneself in another bound up in the terror of a loss of self. Desire draws us out, but it also consumes us; the simple carnality of Odette can easily devolve into the predatory sexuality of Germaine. Throughout his career Picasso will ring dizzying changes on this theme. Often one or the other of his wives or mistresses will represent a specific polarity: Marie-Thérèse Walter is almost always evoked through voluptuous curves (even when she herself was almost invisible), while Dora Maar is conceived of as all jagged angles. Sometimes the same woman undergoes a strange metamorphosis, like the slow-motion disintegration of his first wife, Olga, from elegant society belle to pulpy mass of oozing flesh.

In *Le Moulin de la Galette* we see Picasso groping for a more expressive language to convey an emotional truth more powerful than mere fact. He was acquainted with works by both Munch and Gustav Klimt in which sexual passion is conveyed through a merging of male and female forms, but Picasso will take this process of engulfment and dispersal to new extremes, inventing entirely new languages of form to convey his psychic turmoil. The melding of the faces as flesh yearns to merge with flesh that we see in the painting of the Montmartre dance hall, evolves into the fractured forms of Cubism in which solid and void penetrate and open up to each other in a kind of cosmic orgy.

For Picasso the art and spectacle of Paris were creative stimulants. The longer he stayed in the French capital, the more provincial his hometown seemed. From the perspective of the Butte, the boozy get-togethers at Casagemas' apartment on the Rambla and the "deafening discussions" around the table at Els 4 Gats felt like nothing more than adolescent bull sessions. Paris filled his thoughts and fueled his ambition; to return home would seem like defeat.

But if Picasso hoped to make his mark in the French capital and ultimately settle there, he not only had to produce work but also to sell it. In this respect, as in so many others, Paris offered infinitely more opportunities than his native land. While artists like Casas and Rusiñol pursued

successful careers in Barcelona, Picasso wanted something more. The strategy of borrowing a little French chic to dress up otherwise conventional works to sell to the folks back home no longer appealed to him. Now that he was actually there, he realized that in Paris might one not only make a career as a painter or sculptor but that art—pursued with ruthlessness, with a contempt for tradition, and a thirst for innovation— could even change the world.

As late as 1881, Renoir was still grumbling, "There are in Paris scarcely fifteen art-lovers capable of admiring a painting without Salon approval . . . there are eighty thousand who will not buy even an inch of canvas if the painter is not in the Salon." But with each passing year the innovators were gaining ground at the expense of the old guard.

As important to their eventual success as the periodic group shows that garnered all the press attention—most of it negative—was the proliferation of commercial galleries. It was these that sustained the Impressionists during the lean years and ensured their eventual triumph in the marketplace. Paul Durand-Ruel, whose gallery at 16 rue Laffitte lay halfway between the staid Louvre and radical Montmartre, had been the most steadfast champion of the new art, cultivating a widening circle of collectors and providing the artists a vital, if unpredictable, source of income. Many collectors would purchase nothing without the stamp of approval conferred by inclusion in the annual Salon, but Durand-Ruel believed that the growing middle class would eventually demand a new kind of art, whether or not they themselves realized it. A doctor, lawyer, or small-scale merchant—the kind of prosperous bourgeois who rented one of the apartments lining the boulevards created as part of Baron Haussmann's program of urban renewal—did not want to be confronted at the breakfast table by a vast historical tableau or a mythological scene filled with didactic messages and erudite quotations from past masters. Instead, he wanted something pleasant to look at that reminded him of weekend excursions in the countryside, the kind he took with his family whenever he could get out of the office. Once his eyes had become accustomed to the brighter colors and broken brushstrokes that could capture the sparkle of sunlight on water or the mists rising from a summer meadow, he would discover the appeal

of these intimate canvases that evoked the world he knew: a world of bustling streets and quaint suburbs; of dance halls and the opera stage; of Saturday strolls in the Tuileries Garden and Sunday boating on the Seine.

The cracks pried open in the once solid edifice of the art establishment provided unparalleled opportunities not only for artists but for a few entrepreneurs, known as *dénicheurs*, who bought cutting-edge art on the cheap. Speculative fever rose as once worthless canvases became sought-after commodities. Enterprising businessmen jumped into the fray, some motivated by genuine love of art, others in hopes of striking it rich. Ambroise Vollard was among the shrewdest of the new dealers. At his gallery, first at 37 rue Laffitte and later at the more spacious store at number 39, he kept his eye out for the next big thing: he was among the first to champion the works of van Gogh, Vuillard, and especially Cézanne, artists who appeared dangerously radical even to those who'd reconciled themselves to the Impressionist trouble makers. "The Rue Laffitte," Vollard recalled many years later, "was a sort of pilgrims' resort for all the young painters—Derain, Matisse, Picasso, Rouault, Vlaminck, and the rest." Among his other interests was a taste for contemporary Spanish art; in April 1900, he exhibited the work of Picasso's friend (and current landlord) Isidre Nonell.

Speculation in current art soon spread beyond the respectable galleries on the rue Laffitte, infecting many of the local shopkeepers of the Butte who dealt with the bohemians on a daily basis and saw that a painting sold for a pittance by an artist desperate for food or kindling to light his stove might someday be worth a small fortune. It had happened before: Renoir's famous *La Loge* had been unearthed in "Père" Martin's cluttered shop on the rue des Martyrs, where it had been sold by the artist to cover 485 francs of unpaid rent on his Montmartre studio. The occasional discovery of a Manet or a Monet among the used furniture and piles of junk fueled a mini gold rush and stimulated ever greater numbers of tourists to browse the bric-a-brac shops of the Butte.

Typical of these part-time dealers was Clovis Sagot, a former clown from the Cirque Fernando (later renamed Cirque Medrano). Outside his small shop at 46 rue Laffitte, where he sold patent medicines along with an occasional canvas by a local artist, the sign read, "Speculators! Buy

art! What you pay 200 francs for today will be worth 10,000 francs in ten years' time. You'll find young artists at the Clovis Sagot Gallery."

At this lower end, then, where the prices were dirt cheap but the potential profits the greatest, a young unknown was a more attractive prospect than a more established artist. One of those who plied this territory—more a go-between than a dealer himself—was a Catalan named Pere Mañach, the son of a Barcelona locksmith who had gone to Paris to promote the family business but had been seduced by the bohemian lifestyle, remaking himself as a small-time trader in antiques and fine arts. Like many in the Catalan community in Paris, the dandified Mañach harbored anarchist views, and had a taste for the artistic life as well as unconventional sexual leanings that made it difficult to settle into a respectable life back home.* Attuned to the latest currents in painting, he was always on the lookout for fellow Catalans with promising futures.

It was probably Nonell who alerted Mañach to the three young artists currently occupying his rue Gabrielle studio. Casagemas recorded their first meeting in a letter to Reventós dated November 19: "The man we were waiting for has just left. He has a junk shop nearby, where I've seen paintings, and it's certain he's going to buy some from us. Now we are waiting for an answer and the money if he purchases any. This runner is a guy called Mañac and he takes *only* 20%."

It's unclear if Casagemas managed to sell any of his own work, but on a second visit Mañach bought three pastels from Picasso. He immediately sold these bullfight scenes for 100 francs to the art dealer Berthe Weill. She in turn promptly sold them to Adolphe Brisson, publisher of the influential *Annales Politiques et Littéraires*, for an easy 50-franc profit.

Weill, a "funny little squinting near-sighted old lady," as Leo Stein described her, ran a hole-in-the-wall gallery at 25 rue Victor-Massé, near the

* Mañach's sexual orientation has been the subject of intense speculation since it informs our understanding of his relationship with Picasso. Since he ultimately returned to Barcelona to marry and take over the family business, many assume he was always that conventional. But his lifestyle and behavior during his younger days in Paris suggest a more adventurous side.

boulevard de Clichy that formed the southern border of Montmartre at the base of the hill.* "The gallery was of the same dimensions as its proprietor," remembered the painter Pierre Girieud, who exhibited alongside Picasso in one of her early group shows, "that is, very small and low, paintings were displayed from floor to ceiling in order to increase the exhibition space."

Despite its modest dimensions and rudimentary decor, Weill's gallery was one of the most daring in Paris. With her gruff manner and scrupulous honesty, she was one of the few real visionaries among the Parisian dealers. On her business cards she had printed "Make way for the young," a slogan she made good on with pioneering exhibitions of not only Picasso but Matisse, Derain, Utrillo, and Modigliani.

Unfailingly loyal to her artists, her fidelity was not necessarily repaid in kind. (On one occasion she was arrested when she wouldn't take down a Modigliani nude the police deemed obscene.) And unlike most dealers, she didn't take advantage of her artists by forcing prices down when they were desperate for cash, refusing, for instance, to haggle with Utrillo when he was in one of his drunken stupors. Raoul Dufy dubbed her *La Merveille* (The Marvel).

Unfortunately, she didn't possess the business acumen to profit from her artistic courage. Unlike Vollard, Durand-Ruel, and later Kahnweiler, she wouldn't manipulate the market for an artist's work, building demand and hoarding stock until she could unload it at inflated prices. While Picasso and his colleagues appreciated her integrity, they knew she would never make them rich or famous and abandoned her as soon as they began to make a name for themselves. Reflecting on her relationship with her most famous discovery, Weill was philosophical. "He was dead right," she admitted, to move on from "this Montmartre pauper."

Weill played a pivotal role in launching Picasso's career, but she could never satisfy his vaunting ambition. Their professional relationship came to an abrupt end in 1905 after a particularly stormy encounter. One day,

* The 66-year-old Degas, a passionate anti-Dreyfusard and anti-Semite, was one of her neighbors. "When he passed my store," Weill recalled, "and he saw me near the door, his expression became furious, he turned his head away, full of disgust."

frustrated by her continuing inability to pay him what he thought he was owed, Picasso showed up in her gallery unannounced. Casually pulling a revolver from his overcoat and laying it on the table, he demanded his money, at which point Weill, fearing for her life, reached into her purse and threw a hundred francs in his direction. After that, she vowed never to have anything more to do with him.

Despite that unpleasant confrontation, Picasso remembered her fondly. He forgot his frustration with her feckless management and began to look back on their relationship with the wistful longing that tinged anything that reminded him of his early days in Paris. In 1918, the now world-famous artist made a memorable portrait of her, deploying the economical linear style he used to such great effect in his portraits of Igor Stravinsky and Serge Diaghilev. Showing she had no hard feelings herself, she used it to illustrate her own memoirs.

Berthe Weill deserves credit as the first Parisian dealer to take a chance on the young, unknown artist. Daniel-Henry Kahnweiler, renowned as Picasso's principal dealer during the revolutionary Cubist days, dismissed her as little more than an amateur, but there's no doubt that she was a fearless promoter of the avant-garde. Her discerning eye launched the career not only of Picasso but of numerous other artists who went on to make major contributions to the history of modernism.

For Picasso, the sale of three pastels after barely a month in the city was an auspicious start to his Parisian career. Mañach was so pleased that he signed him to a contract on the spot, agreeing to pay him 150 francs a month for the rights to his entire output.* Having easily disposed of those same pastels at a 50 percent profit, Weill herself was anxious to see more work from the artist. A few days later, Mañach, now claiming the role of

* 150 francs was equivalent to the monthly salary of a shop clerk at the Dufayel department store. By that measure, rent, at least in proletarian Montmartre, was comparatively cheap. When Picasso first moved into the Bateau Lavoir in 1904, he paid 15 francs a month.

his manager, arranged to have her visit Picasso in his studio. Arriving at the appointed hour, she knocked on the door but found nobody home. Returning an hour or two later in the company of Mañach, she discovered that Picasso had been hiding in the bed all along.

This childish behavior suggests that Picasso was still out of his element in the big city. He spoke almost no French and was comfortable only in the company of his Spanish and Catalan cronies. It would be years before his command of the language was more than rudimentary, and he never lost his heavy Spanish accent. But for all his homesickness for familiar haunts and faces, he'd been bitten by the bug. Like a young actor dazzled by the lights of Broadway or an ingenue making her way to Hollywood, Picasso knew he was at the center of all that mattered, that however lost he felt and however hard the struggle, this was where he had to be.

This conviction was strengthened by a string of early successes, including the sale of a painting titled *The Blue Dancer*—a scene of Pierrot and a pirouetting Columbine, an early instance of a fascination with the *commedia dell'arte* that will culminate in his Rose Period masterpieces—and, most important, his *Le Moulin de la Galette*. Berthe Weill sold the latter painting for 250 francs to Arthur Huc, a courageous collector who was also an early champion of Toulouse-Lautrec, Pierre Bonnard, and Vuillard.

But even with these small-scale triumphs, life in the rue Gabrielle studio was becoming untenable. The mercurial Casagemas was growing ever more difficult; tormented by Germaine, he was now threatening to kill himself. In late December, fearing for his friend's safety, Picasso decided that the time had come to leave. He had never intended to stay in Paris permanantly, but the crisis came at an inopportune time. He was just beginning to taste success, and in another month or two he might have solidified his position and eased his eventual return. His frustration was lessened somewhat by the 150-franc-a-month stipend Mañach had promised him, a lifeline to the city that had now became the focus of his ambition.

In late December 1900, Picasso packed up the contents of his studio, gave Odette a good-bye kiss, and, with the increasingly erratic Casagemas in tow, set out once more for Spain.

The two young men were back in Barcelona in time for Christmas. To their families the two prodigals appeared wild-eyed and gone to seed, dangerously thin and scruffy; to their friends at Els 4 Gats they emitted that faint phosphorescent glow that radiated from those exposed for any length of time to the crackling air of Paris, the city, as Sabartés wrote, "which fascinated us and filled us with feverish curiosity and an anxious longing" but that also confronted them with "a fear of the struggle for which we were not prepared, nor ready to face, nor strong enough to bear."

If Picasso had withstood the test, it was clear that Casagemas had cracked under the strain. After a few days Picasso could see that the return home had not helped. After two months living on their own in the most vibrant city in the world, they found sleepy Barcelona suffocating. Less than a week after their homecoming, Picasso and Casagemas fled. But not to Paris. "[W]hat concerned him most," Sabartés wrote, "was to restore Casagemas to normalcy. He had decided to take him to Málaga, hoping the sun there would help him."

For Picasso, at least, it was a surprising place in which to recover his peace of mind. Ever since his unhappy visit in the summer of 1897, when he'd fought so bitterly with his uncle Salvador, he had made no attempt to hide his disdain for his birthplace. Málaga was a symbol of backwardness, home to his busybody relatives whose hopes in him had turned to disappointment.

But he had a very practical reason for calling on his relatives. The following October he would turn twenty, which meant that he'd be liable for military service. To obtain the 1,200 pesetas needed to buy him out of that obligation meant making a visit, hat in hand, to Uncle Salvador.

Nothing enraged Picasso more than having to beg favors from his relatives; biting the hand that fed him was the only thing that made the humiliation tolerable. Showing up long-haired, unshaven, and in the same outfits of black corduroy, now worn threadbare, in which they'd set out for Paris three months earlier, Picasso and Casagemas tried to check into the Tres Naciones boardinghouse on the Calle Casas Quemadas. The two looked so disreputable that they were refused a room. Picasso had to send

for his aunt, Maria de la Paz Ruiz Blasco (who lived in the same building), to vouch for them.

The ordeal continued when they called on Uncle Salvador. He was outraged by his nephew's bohemian getup and furious that Picasso refused to wear mourning for his aunt Pepa, who had recently passed away.* Since he still needed his uncle's help, Picasso allowed himself to be dragged to the barber and then to the tailor's, where he was fitted for a new suit.

The trip was made more awkward by what his family perceived as a "broken promise" to his cousin Carmen Blasco. During a visit to his hometown in the summer of 1897, the sixteen-year-old Pablo had paid court to his young cousin, taking her for chaperoned walks, arm in arm, along the Camino de la Caleta. To some of his relatives, and to Carmen herself, it seemed as if they had come to some kind of understanding. But Pablo was no longer Don José's obedient son, about to embark on a respectable career of an academic artist. Instead he was an adolescent in full rebellion against propriety; the idea that he would settle down with a sweet, provincial girl like Carmen was out of the question. Not wishing to endure a painful confrontation, Picasso had written, not to Carmen herself but to her sister Teresita, citing as his excuse for breaking off with her "an unhappy adultery" on his part.

This inconsiderate treatment served to heighten tension between the Ruiz aunts and uncles and their wayward nephew. And despite Picasso's continued dependence on their generosity, he did everything he could to provoke their disapproval. Throughout their stay, he and Casagemas made the rounds of the city's taverns and brothels, making no attempt to hide their outrageous behavior from his family. Casagemas, in any case, was too far gone to care. He stumbled about drunk most of the time while Picasso indulged his own particular vices in Lola la Chata, the bordello once frequented by his father.

Given Casagemas' sexual confusion and addictive tendencies, it was not a regime calculated to restore his equilibrium. Whatever his motives

* He had painted a striking portrait of her in 1896.

for whisking Casagemas off to Málaga, after two weeks Picasso was anxious to get rid of him. So he persuaded Uncle Salvador to use his connections to secure a berth for Casagemas on a ship bound for Barcelona. It was the last Picasso would ever see of his friend, his closest companion for the past two years and the man with whom he had shared his Parisian adventure.

Picasso's trip to Málaga is psychologically revealing. He liked to cast himself in the role of the bohemian rebel, but he was a rebel of a particularly cautious and manipulative sort. However much he despised his conventional family, he could never completely cut them out of his life. Pragmatism certainly played a role. Picasso's dedication to himself and his mission was such that he was fully prepared to exploit anything and anyone who would help him fulfill it. But he also thrived on conflict. Later in life he delighted in fomenting rivalries among his various mistresses, but long before he was in a position to pit one sexual rival against another he derived psychic energy from his confrontations with his relatives. Rebellion was not sufficient in itself; he had to experience conflict viscerally, not only to shock but to witness the anger on the faces of those he disappointed.

With Casagemas out of his life, Picasso could plan his next move. After securing Uncle Salvador's promise to pay the fine that would keep him out of the army, Picasso saw little need to remain in the city of his birth. Fortunately he had just received an offer from an old friend from Els 4 Gats, Francisco de Asís de Soler, the son of a well-to-do Barcelona industrialist who had just moved to Madrid to publish a *Modernista* magazine titled *Arte Joven*. The new magazine would be a Castilian version of the Catalan *Pèl & Ploma*, with Soler playing the role of Utrillo, in charge of the magazine's literary content, while Picasso filled that of Ramon Casas, serving as the journal's art director.

Picasso's second attempt to make a life in the Spanish capital was no more successful than the first. Taking a room first in a boardinghouse on Calle del Caballero de Gracia, he found the rules of the establishment too restrictive after the freedom of the rue Gabrielle studio. After a couple of

weeks he moved into an unfurnished garret at 28 Calle Zurbano, which apparently did double duty as a warehouse for unsold copies of the magazine.

Even as he took up his new role as art director for *Arte Joven*—supplying many of the illustrations himself and begging the rest from his Barcelona friends—Picasso still kept one eye on his Paris career. Mañach was sending him his monthly stipend of 150 francs and expected a supply of marketable works in return. His demands became even more insistent when he secured the promise of an exhibition from Paris' most influential dealer in contemporary art.

In truth, Picasso didn't need much encouragement to abandon his plans. He hated Madrid, which was not only unfriendly but cold and gray compared to Málaga or even Barcelona. A self-portrait from this time shows him in a scarf and heavy overcoat, his hands dug deep into the pockets, his long black hair hanging lank from beneath a broad-brimmed hat. If he had to suffer through a dismal winter, he might as well be in Paris where at least the vitality of the art scene and the general excitement made up for the cold.

It soon became apparent, in any case, that *Arte Joven* was never going to be a success. For all his bombast, Soler proved to be an inept businessman. The family fortune, such as it was, came from a quack remedy, an electric belt invented by Soler's father that was supposed to cure every ill, from digestive problems to sexual dysfunction, and the income he received from the dubious product was enough to launch his literary effort but not enough to sustain it.

Even worse, Soler's high-flown rhetoric, like Rusiñol's a decade earlier, was not matched by any real vision. "To you, young enthusiasts," he wrote in the first issue of *Arte Joven*, "this periodical is dedicated, for you it has been created and from you it hopes to take its nourishment. . . . Come with us, then, into battle, for victory will be ours if we fight with faith. Come with us, and do not forget that *to fight is to win*." What this consisted of in practice was the conventionally unconventional agenda of youthful rebels everywhere: opposition to the establishment, to the bourgeois values of their parents, and to the status quo. Among the "Generation of '98" this agenda took a form that was antigovernment,

and anticlerical, with elements of anarchism thrown in for good measure.

In a tactless (or more likely calculatingly provocative) move, Picasso decided to send a copy to Uncle Salvador asking for a contribution to sustain the venture. The answer was all too predictable. "What on earth are you thinking of!" Salvador demanded of his nephew. "What are you after? What do you take me for? . . . This is not what we expected from you. What ideas! And what friends! . . . Go on this way and you'll see where you land . . ." At least *Arte Joven* provided Picasso with one of the *tertulias* that were an indispensable part of his life, particularly in unfamiliar and uncongenial surroundings. Though he enjoyed the company, he was not above poking fun at the pretensions of these literary figures whose favorite pastime was "to spout reams of poetry at the tombstones." He commemorated this bohemian community in a satirical sketch, showing his colleagues huddled on a gloomy, winter-blasted heath like grotesques in an Edward Gorey cartoon. One of these writers, Ricardo Baroja, recalled evening gatherings at the Café de Madrid.* "Picasso would observe our group and then later from memory draw the fantastic silhouettes of Cornuti, Urbano and Camilio Bargiela, illuminated by the wavering light of a street lamp. He was a boy whose eyes twinkled and in front of them a lock of hair constantly danced."

Artistically, Picasso seemed caught between two worlds. The works he completed during the more than three months he stayed in Madrid were painted largely with an eye to his upcoming Paris exhibition. Many continue the Toulouse Lautrec–inspired low-life scenes of whores and performers he'd begun that autumn in Paris. But he was too steeped in the *duende* of his native land to ever fully embrace the more rationalistic, light-filled traditions of France. To help reconnect with his roots, he took a trip to nearby Toledo to study the altarpieces of El Greco, an artist who haunted Picasso throughout his life and whose tormented soul found a kindred spirit in his own.

* Ricardo was the brother of Pio Baroja, the most talented writer of the Generation of '98.

To no one's surprise, *Arte Joven* failed after only five issues. Picasso headed back to Barcelona with few regrets. In truth, he was more relieved than discouraged by the collapse of the project. Soler's *Modernista* pronouncements already felt stale, and Picasso was not temperamentally suited to journalistic work, resenting anything that took time away from his art.

By the time he returned to Barcelona in May 1901, Picasso was recognized as one of the leading artists in the city. His status was confirmed by an exhibition at the Sala Parés. Now he was given equal billing with Ramon Casas, widely acknowledged to be the city's foremost painter. But if Miquel Utrillo, who organized the show, hoped the honor would encourage the young prodigy to remain in Barcelona, he was soon disappointed. Picasso made it clear that he had set his sights on Paris. "We, his Catalan friends, listened to him open-mouthed," Sabartés recalled. "His stay among us was so brief that we did not have time to grasp what he was telling us; we plied him with questions and hardly begun to realize he was among us when he was gone."

In an article Utrillo wrote for *Pèl & Ploma* shortly after Picasso's departure, he speaks with the voice of experience. After all, he'd made the same pilgrimage two decades earlier. Yes, the journey was difficult, but he was convinced that the young man had the talent and the drive to emerge triumphant. "Picasso, not yet twenty, has even been lucky with the nickname given him in Paris," he noted with a certain paternal pride. "[U]nder that well-worn, large, broad-brimmed Andalusian hat in the rough Montmartre weather, with the lively little eyes of a southerner who is master of himself, his neck wrapped in painted ultra-impressionist cravats, Picasso has inspired in his French colleagues the well-meant name of *Petit Goya.** We hope he lives up to his appearance, and at heart we know he will not let us down."

Along with words of encouragement, Utrillo introduced a note of caution: "Paris, with its bad reputation and feverish life-style, drew him again, not to conquer it with his drive as he had dreamed on making his

* A charcoal portrait by Ramon Casas shows him in exactly that outfit, with Montmartre in the background.

first journey, but eager to learn in that center where, without doubt, all the arts flourished more vigorously." Paris, as Utrillo well knew, devoured more young men than it nourished. Its siren call was hard to resist, but only the strongest could avoid being chewed up and spat out. Paris promised dazzling opportunities, but many of the doors it opened led only to disappointment or despair.

4

Les Misérables

It was thinking about Casagemas's death that started me painting in blue.

<p align="right">—PICASSO</p>

The last time Picasso saw Carles Casagemas he was bundling him onto a ship bound for Barcelona. At the time (early January) he was under no illusion that Casagemas had straightened out his life. Quite the opposite; his drunkenness, dependency, and despondency were getting too much even for Picasso, who usually thrived on turmoil.

At home in Barcelona, without the distraction of Pablo's company, Carles' obsession with Germaine grew. He concocted an imaginary version of his beloved, writing twice-daily letters in which he poured out his heart, pledging his undying devotion and begging her to marry him.

Sometime in the middle of February he mailed postcards to Germaine and Pallarès announcing that he was about to leave for Paris and asking them to meet him at the station. On the appointed day, Germaine and Pallarès bumped into each other on the platform of the Gare d'Orsay, where she warned Pallarès that his friend should expect nothing from her. She was already married, she pointed out. In fact she'd recently moved

back in with her husband—in part, one suspects, to protect herself from her would-be lover. "I'm going to tell Carles," she informed Pallarès, "that if he likes we can still be good friends but nothing else."

Apparently, she did not immediately break the bad news to Casagemas. In his usual manic way, he began to make arrangements without ascertaining first whether they were even in the realm of possibility. He asked Pallarès to put him up temporarily while he looked for an apartment where he and Germaine could settle down as man and wife. At the time Pallarès was renting a cramped two-room apartment at 130 Boulevard de Clichy, at the foot of the Butte near the Moulin Rouge. He'd moved out of the rue Gabrielle when Picasso and Casagemas returned to Barcelona, finding the studio too large for his needs and the neighborhood too rough for comfort. With the addition of Casagemas the third-floor studio was overcrowded, since Pallarès was already hosting a Catalan sculptor by the name of Manolo (Manuel Hugué), a charming rogue who had fled to Paris to avoid military service.

It took Germaine a few days to work up the courage to tell Carles the truth. Much to her relief, he seemed to take the news in stride. In fact he seemed elated, as if a great burden had been lifted. The following day, Sunday, February 17, Casagemas informed Pallarès that he was returning to Barcelona. To mark the occasion he invited him—along with Manolo, a Catalan collector named Alexandre Riera, Germaine, and Odette—to a farewell dinner at a local restaurant.[*]

Throughout the meal everyone drank too much and laughed too loudly. Carles appeared unusually animated. As the party began to wind down, he stood as if to say his good-byes. Reaching into his jacket, he removed a stack of letters he'd written earlier that day. The top one, Germaine noticed with alarm, was addressed to the chief of police, the second to her. At the same moment she noticed the bulge in his jacket pocket. Understanding came in a flash. She dived for cover behind the bulky figure of Pallarès just as Casagemas reached into his pocket and pulled out

[*] The restaurant, named L'Hippodrome, was located at 128 Boulevard de Clichy. It still exists, now under the name of Palace Café.

a revolver. Shouting *"Voilà pour toi!"* he fired at her crouching figure. Pal-larès, who reacted a fraction of a second after Germaine, had thrown up his hands and managed to deflect the shot, but the explosion knocked Germaine to the ground. Believing he had killed her, Casagemas then turned the gun on himself. *"Et voilà pour moi!"* he cried as he pulled the trigger, putting a bullet into his right temple. He collapsed on Manolo, "his face like a crushed strawberry."

After the screams of the fleeing patrons died down and the smoke cleared, Germaine picked herself up. Sobbing, she threw her arms around Pallarès, begging forgiveness for having used him as a shield and thanking him for saving her life. As for Carles, he was still breathing. His friends carried his unconscious body to the nearest pharmacy. From there he was transported to the Hôpital Bichat, where he died two hours later.

Casagemas was buried in the Cimetière de Montmartre; a second memorial service was held at the church of Santa Madrona in Barcelona. Picasso, who was still in Madrid and deeply involved in *Arte Joven*, was

The Death of Casagemas, 1901. © RMN-Grand Palais / Art Resource, NY.

informed of the tragedy in a letter from Ramon Reventós, who asked him not to reveal the true circumstances of his death. Picasso didn't attend the memorial service in Barcelona, but he did contribute a portrait drawing of Carles for the obituary that was printed in *Catalunya Artística* on February 28.

Casagemas' suicide doesn't appear to have had an immediate impact on Picasso's art. Much of the work he completed in Madrid and later in Barcelona has a lugubrious quality, but no more so than the work of 1899, his so-called black period. The only contemporaneous indication we have of Picasso's feelings comes in a letter to Miquel Utrillo. "You must know about poor Carlos," Picasso wrote. "You can imagine the shock this has given me."

This is a perfectly conventional response to a friend's suicide; there's nothing to suggest that the tragedy would provoke a deeper psychic rupture. It's only by looking at Picasso's subsequent behavior and the strange turn his art took later that year that we can detect some unresolved conflict, born of grief and exacerbated by remorse over the role he'd played in his friend's death.

His traveling companion on his second Parisian trip was Jaume Andreu, a casual acquaintance from Els 4 Gats, but to the demon-haunted Picasso it was the ghost of Casagemas sitting beside him on the train. In truth, he seems to have gone to unusual lengths to wallow in the wreckage left behind by his friend's death. Arriving in the French capital on a blustery day in mid-May (Picasso did a sketch showing himself bundled in a heavy overcoat with the collar turned up), he settled into the studio at 130 boulevard de Clichy, where Casagemas had spent the last days of his life. Even more telling is the fact that before long he began an affair with Germaine, the femme fatale whom, even decades later, Picasso blamed for Carles' death. To commemorate his latest conquest, he sent what, under the circumstances, was a rather tasteless *alleluia* to Utrillo: one panel shows Odette discovering them in bed together; another depicts Manolo, who'd been having his own fling with Germaine, being accosted by the police after throwing a jealous tantrum.

As always in Picasso's life, the realms of Eros and Thanatos, love and death, are mutually reinforcing.* The procreative and nihilistic impulses are bound together, as he himself recognized. "My works," he once declared, "are a summary of destruction." For someone as superstitious as he was, making love to the woman who had rejected his best friend in the apartment (perhaps in the same bed) where he had spent his final hours suggests a need to immerse himself, body and soul, in the very womb of the tragedy. Months would pass before he would discover how blood spilled could nourish a new burst of creativity, but from the beginning of his second Paris trip he was determined to wallow, metaphorically at least, in gore.

Six months elapsed between Casagemas' suicide and the first overt reference to the calamity in Picasso's work. It took time for Picasso to assimilate his grief, to discover a way to make it work creatively. But it's also true that during his first couple of months in Paris he was simply too busy for serious reflection.

The show Mañach had arranged was scheduled to open in late June at the gallery of Ambroise Vollard, perhaps the most ambitious of the Parisian dealers in modern art. It was a big step up from Berthe Weill's little shop and just the boost Picasso needed to get his career going in the right direction. Vollard had already established his reputation by showing the work of artists like van Gogh, Gauguin, and Cézanne, as well as fellow Spaniards, including Picasso's friend Isidre Nonell. The show immediately preceding his had featured the work of Émile Bernard, a painter who had worked closely with Gauguin during his breakthrough year at Pont-Aven in Brittany in 1888. To be included in that august company was quite an achievement for a kid from Spain not yet turned twenty.

But for all his daring, Vollard was a businessman. Daniel-Henry

* One of the strangest and most disturbing manifestations is a mural Picasso painted on the walls of Sabartés' studio in 1903. It illustrates a story from the pornographic novel *Gamiani* in which a couple make love beneath a gibbet upon which a Moorish slave has just been hanged, his death throes causing an erection.

Kahnweiler, who called Vollard and Durand-Ruel "[m]y only true masters," says that he learned from the former that "art-dealing was about selling paintings not buying them." Vollard drove a hard bargain even with artists he admired. "Poor Gauguin!" Matisse once remarked. "How he made his tongue hang out, that Vollard. . . . Gauguin would come to him with canvases and Vollard would send him small quantities of paint, small tubes of paint. Yes, Vollard conducted himself shamelessly with Gauguin." Cézanne was even more succinct. "Vollard is a slave trader," he growled. Berthe Weill despised Vollard and all he stood for. One of his tactics, she recounts, was to beat her down to "a rock-bottom price" on a painter she represented "and then tell the artist that he should not sell her any more work: she was ruining his prices by asking too little."

But while Vollard was certainly more cutthroat than Weill, it's unfair to portray him as someone interested only in the bottom line. Gertrude Stein recalls the time she and her brother went to the gallery to look at his Cézannes:

> The first visit to Vollard has left an indelible impression on Gertrude Stein [she wrote, typically referring to herself in the third person]. It was an incredible place. It did not look like a picture gallery. Inside there were a couple of canvases turned to the wall, in one corner was a small pile of big and little canvases thrown pell mell on top of one another, in the centre of the room stood a huge dark man glooming. This was Vollard cheerful. When he was really cheerless he put his huge frame against the glass door that led to the street, his arms above his head, his hands on each upper corner of the portal and gloomed darkly into the street. Nobody thought then of trying to come in.

Vollard, like Picasso, was a hoarder with a passion for collecting beautiful things, someone who parted only reluctantly with the treasures that "he guarded jealously and would show only to a few privileged souls." According to André Salmon, Vollard's shop "was a sort of repository for masterpieces whose artistic value was still under discussion. Here the initiates, or would-be initiates, hastened—only to find there was nothing on view at all. To be allowed to see any of his wares it was first necessary to win over M. Vollard."

Mañach had continued to pay Picasso an allowance of 150 francs a month, but the painter arrived in Paris far short of what he needed to mount a respectable show. He brought only about fifteen to twenty-five paintings, as well as some pastels and drawings, and even though he was sharing the space with a Basque painter named Francisco Iturrino, that was not nearly enough to fill even his half of the gallery.*

It wasn't difficult for Mañach to keep an eye on his protégé, since he was not only his agent but now also his roommate. Pallarès had returned to Spain before Picasso arrived, so the two men set up house together in the boulevard de Clichy apartment, Picasso taking the larger of the two rooms to serve as a combination studio/bedroom while Mañach was stuck with the rent. Judging by the painting *The Blue Room* (*The Tub*), which Picasso painted later that year, it was a pleasant, light-filled space decorated with reproductions of works by Toulouse-Lautrec and Degas, a square of brightly colored carpet, and flowers arranged neatly in a vase on the table. But we shouldn't take his depiction of his atelier too literally. Sabartés' description offers us the more prosaic reality and suggests Picasso's pack-rat mentality, a *horror vacui* manifested in his compulsion to surround himself with objects made precious through personal association:

> The little table placed at varying distances between the bed and the fireplace was completely covered with papers, books and other things which came down to the floor whenever the table was needed for dining purposes, newspapers would then be spread over it for lack of a tablecloth.
>
> Whatever was once put on the floor remained on the floor, and if more things were not piled on top, it was only because Picasso did not want everything to get all mixed up; hence new piles were formed and gradually more and more stacks of odds and ends accumulated, filling up the floor along the walls. Pictures, also on the floor, one on top of the other, all along the walls, occupied the rest of the studio.

* The exhibition ultimately included sixty-four paintings in addition to the drawings and pastels.

The painting, then, represents an ideal, one of those instances of magical thinking in which Picasso conjured up the world as he wished it were, rather than as he found it. The blond nude performing her morning ablutions is both a tribute to Degas, who specialized in this kind of scene, and an allegory of the artist's life, complete with a disrobed muse whose sensuous beauty unlocks his creativity.

The living arrangements suited both men, at least at first. They allowed Mañach to make sure Picasso applied himself while Picasso took advantage of yet another starstruck benefactor willing to pay the bills while he chased his dreams. Of course Mañach's motives were not altruistic. He saw enormous potential in the young Spaniard with the flashing eyes and, like any good investor, hoped to buy low and sell high. He not only pressed Picasso to meet his deadline (for the first couple of months, he was completing two to three paintings a day); he also encouraged him to produce works with an eye to the market. Picasso continued his exploration of the demimonde, portraying the whores, alcoholics, and cabaret performers who had so intrigued him on his previous trip and who had been inspired by Steinlen and Toulouse-Lautrec, but he added to this repertoire of low-life denizens cheerful floral still lifes, Parisian street scenes, rosy-cheeked toddlers, and views of fashionable ladies and gentlemen at the racetrack.

Picasso was not particularly invested in any of it. Taken as a whole, in fact, the exhibition that opened at Vollard's rue Laffitte gallery on June 24 was a rather scattershot affair, the work of a young artist with more brio than discipline. Like the exhibition of portraits at Els 4 Gats the year before, there was something slapdash about it all, as if at this stage of his life he wanted to be everything at once. His willingness to accept Mañach's guidance in terms of subject matter was not simply a concession to commerce: he had not yet discovered the guise in which he wanted to present himself to the world and was trying on a number of different costumes to see which one suited him best.

That chameleonlike quality was noted by the critics. "[I]t is easy to detect numerous likely influences," wrote Félicien Fagus in *La Revue Blanche.* "Delacroix, Manet (clearly indicated with his Spanish connection), Monet, Van Gogh, Pissarro, Toulouse-Lautrec, Degas, Forain, and

Rops perhaps. . . . All those are momentary; he abandons them as easily as he adopts them: he is clearly in such a feverish hurry that he has not yet time to forge his own personal style. . . . For him the danger lies in his very impetuosity, which could easily lead him into facile virtuosity and easy success."

Few doubted, however, that once the young Spaniard harnessed his raw talent, he would be a force to be reckoned with.[*] One exception was Vollard himself. Writing in his memoirs, the pioneering impresario of modernism showed himself less than smitten with his latest discovery. "Towards 1901," he recorded, "I received a visit from a young Spaniard dressed with the most studied elegance. He was brought to me by one of his countrymen whom I knew slightly, a manufacturer from Barcelona called Manache [sic], I fancy, or something like it. . . . Manache's companion was the painter Pablo Picasso, who, though only eighteen [sic], had finished about a hundred paintings, which he was bringing me with a view to an exhibition. This exhibition was not a success, and for a long time after Picasso got no better reception from the public."

Vollard's muted account is surprising since he prided himself on being able to spot talent before his colleagues did. Writing at a time when Picasso was universally acknowledged to be the most important artist of the century, one might expect that he'd want to grab some credit for launching his career. But the truth is that Picasso was one of those who got away. Despite jumping early on the Picasso bandwagon, Vollard almost immediately jumped back off. His insistence that the exhibition was a failure served as an excuse for abandoning him when he was most in need of support. Unlike Berthe Weill, who stuck by her artists through thick and thin, Vollard made no bones that he was in the business of making money, and the potential for profit was the one thing he couldn't find in the young Spaniard's work.

[*] The show was also reviewed by Gustave Coquiot in Le Journal (June 17) and by Pere Coll in La Veu de Catalunya (July 10) and François Charles in L'Ermitage (September). Charles offered the typical criticism that the paintings "are too varied. This does not mean he is without talent, but, for his own good, I would recommend him not to paint a canvas a day."

Picasso himself was quite pleased with his exhibition. "My exhibition in Paris has had some success," Picasso wrote to Joan Vidal i Ventosa back in Barcelona. "Almost all the newspapers have treated it favorably, which is something." And despite Vollard's claim that the show did poorly, more than half the works sold, a more than respectable debut for a young unknown.[*]

In a sense it was just too easy. Picasso's paintings sold because they appealed to every taste. Even Gustave Coquiot, who'd been hired to write the preface to the catalogue (in return for which he received a fine portrait by Picasso), admitted that there was an *"embarras de choix*—everyone could find a subject he liked." Early success can pose a dilemma for a youthful artist. Should he repeat the formulas that won him early acclaim and easy money, flattering well-heeled patrons who can feed his ego and fatten his wallet? Or should he embark on a journey almost certainly entailing years of struggle whose final destination is unknown?

There was no indication at the time which path Picasso would choose, though in retrospect his course never seems in doubt. There was something combative in his character that made it impossible for him to give up with the job only half completed, a dedication to his calling that would never allow him to settle for easy comfort or substitute the opinion of others for his own. The eager-to-please charm of these works remains an aberration in a career marked by artistic courage. There is a kind of facile brilliance to them but little of the ferocious ego that imprints everything it touches with an unforgettable personality and that is at the heart of true genius. In paintings like *The Kept Woman* and *The Morphine Addict* Picasso channels Toulouse-Lautrec and Steinlen to great effect, trawling in the seedy subculture of commercial sex and addiction, heightening the lurid atmosphere through jarring contrasts of acid color borrowed from the divisionism of Georges Seurat and Paul Signac but exploited for his own expressive ends. In his self-portrait *Yo, Picasso*, he adopts a more somber chiaroscuro that recalls the great masters of the Spanish Baroque

[*] The most intriguing purchaser was Käthe Kollwitz, the German Expressionist, who bought a work titled *La Bête* (The Beast), one of the Steinlen-inspired rape scenes Picasso had done on his first trip to Paris.

while updating the idiom with a careless brilliance that owes something to van Gogh's kinetic brushwork.[*]

It is not in any of the individual works that Picasso's personality shines through but in the overall impression of energy, an explosive fury that is itself a form of expression. No artist in history was as protean. He borrows freely from whatever he needs, feeding the art of centuries into his capacious maw, transforming everything he consumes in terms of his own instinctive needs. "They said when I began in Paris," Picasso told an interviewer, "that I copied Toulouse-Lautrec and Steinlen. Possible, but never was a painting by Toulouse-Lautrec or Steinlen taken for mine. It is better to copy a drawing or painting than to try to be inspired by it, to make something similar. In that case, one risks only painting the faults of his model." Ultimately he would learn how to take what he needed without fear of being devoured himself, but at this early stage of his career the sheer variety of influences led to incoherence.[†]

The success of an exhibition, particularly for an artist just starting out, is measured not just in terms of the number of works sold but in terms of publicity and connections forged with potential patrons. In these less tangible areas, as well, Picasso had reason to crow. As he told Vidal, the reviews had been plentiful and largely positive, and for once he even had a little extra money in his pocket. He also attracted a couple of important collectors, including Councilor of State Olivier Sainsère. This powerful

[*] Picasso arrived in Paris too late to see the pioneering exhibition of van Gogh's work held at the Galerie Bernheim-Jeune in March 1901. But this exhibition, which was a revelation to artists like Matisse, Maurice de Vlaminck, and Derain, the future Fauves, was still very much on people's minds when Picasso arrived in May. He could have seen examples of the Dutchman's work at Vollard's gallery.

[†] Shortly after the show closed Picasso tried his hand (for one of the few times in his life) at commercial illustration, making posters for Josep Oller, the owner of the Moulin Rouge, and for an illustrated magazine, *Le Frou-Frou*. The desultory fashion in which he pursued this work is one more sign of his lack of direction.

and well-connected official not only provided him with contacts in high society but on more than one occasion shielded him from French authorities who tended to suspect any young Spaniard of being an anarchist agitator.[*]

Given this promising beginning, what explains the wilderness years that followed? In part, the times were simply not ripe. While *dénicheurs* combed the junk shops and studios in search of bargains, the great collectors who would contribute so much to promoting modern art had yet to make their mark. The Russian patron of both Picasso and Matisse, Serge Shchukin, made his first trip to Paris in 1897, but he was still interested mostly in Impressionism, while Picasso's American promoters, Leo and Gertrude Stein, would not settle in Paris for another couple of years.

Crucially, Picasso himself was not ready. The same superficial sparkle that made his work marketable—*au courant* but not overly demanding, edgy but also reassuringly familiar—also made it somewhat forgettable. There was enormous gusto but little originality.

This was about to change. In a pattern that will repeat itself many times over the course of his career, Picasso was poised to turn in a completely new direction, one that would shock the public and perhaps even surprise himself. "[The Vollard show] went very well," he recalled. "It pleased a lot of people. It was only later, when I set about doing blue paintings, that things went really badly. This lasted for years. It's always been like this with me. Very good and then suddenly very bad." From the chameleon-like artist of the Vollard exhibition, adopting new looks with the ease of a runway model, he will remake himself as a painter of singular focus, obsessively homing in on a private vision that defies conventional taste and makes no concession to the market. A couple of years later, when a friend tried to interest Vollard in his latest work, the dealer drove him out of the gallery, shouting "Your friend has gone mad!" It was this divine madness, this willingness to pursue his own dark path without regard for anyone's

[*] Picasso did have reason for concern. Many years later a secret police dossier was uncovered that showed he had been under surveillance as a possible anarchist sympathizer.

opinion but his own, that transformed Picasso from talented hack into the visionary leader of the avant-garde.

The one vital connection Picasso made as a result of the Vollard exhibition was not with a collector or even a fellow artist. It was with the poet Max Jacob, the first in a roster of distinguished literary figures who would be sucked into his orbit, ultimately including such luminaries as Guillaume Apollinaire, Jean Cocteau, André Breton, and Paul Éluard—writers whose erudition, brilliance, and, above all, devotion to Picasso will provide crucial inspiration over the years.[*] In fact, it was more often writers than fellow artists who provided the essential stimulus Picasso needed to fuel his artistic breakthroughs. Painters and sculptors were either mediocrities or rivals; writers could introduce novel ways of looking at the world without Picasso having to worry about whether he was plagiarizing or being plagiarized. They suggested modes of thought that were not initially pictorial but that when introduced into the pictorial field gave rise to all sorts of fascinating combinations. These writers, in turn, drew on Picasso's endlessly inventive visual and tactile imagination to shake up their own practice, a rare moment of synergy that led to the evolution of strange new life-forms. When Picasso was living in the Bateau Lavoir, struggling with the painting that would send modern art careening off in a startling new direction, the sign scrawled in chalk on the battered door of his studio was not *Au rendez-vous des artistes*, as one might expect, but *Au rendez-vous des poètes*.

Picasso and Jacob were an unlikely pair to strike up an intimate friendship. When the two first met in June 1901, Picasso was a young man on the rise while Max Jacob, though still only twenty-four, seemed well on his way to failure. The son of a prosperous Jewish tailor from Quimper, a provincial capital in Brittany, he was brilliant but also erratic, having quit school to try his hand at writing, dropping that in turn to pursue a career as an artist. As a shy, awkward student at the Académie Julian—one of the most venerable of the *académies libres* that offered an alternative to the

[*] Picasso's biographer John Richardson has aptly described those men as the "poet laureates" of Picasso's life.

Max Jacob. © *RMN-Grand Palais /*
Art Resource, NY.

École des Beaux-Arts—he proved no more accomplished a painter than he had a journalist.* In June 1901 he was barely eking out a living doing odds jobs, sweeping out shops or serving as a part-time lawyer's clerk, and living in a sordid garret on the quai aux Fleurs.

He was also trying his hand at a little art criticism. It was in this capacity that he stopped by Vollard's gallery and found himself dazzled by the brilliance of the unknown Spaniard. "As soon as [Picasso] arrived in Paris," he recalled more than two decades later,

he had an exhibition at Vollard's which was a veritable success. . . . [E]veryone recognized that he had a fire, a real brilliance, a

* Among those who passed through the doors of the Académie Julian were Matisse, Bonnard, Vuillard, and Derain, along with dozens of others who helped shape the course of modern art.

painter's eye. I was an art critic at that time; I expressed my admiration and received an invitation from a certain M. Mañach who spoke French and who managed all the affairs of this eighteen-year-old [sic] boy.

He went on to describe their first meeting:

> I went to see them, Mañach and Picasso; I spent a day looking at piles and piles of paintings! He was making two each day or night, and selling them for 150 francs on the rue Laffitte.
>
> Picasso spoke no more French than I did Spanish, but we looked at each other and shook hands enthusiastically. This happened in a large studio in the place Clichy, where some Spaniards were sitting on the floor, eating and conversing gaily.

This was the beginning of a long, tempestuous friendship characterized by an intimacy forged in shared adversity but also marred by bitter recrimination. If Picasso could be inconsiderate, even cruel—later shutting the poet out of his life when Olga insisted that he abandon his bohemian companions—Jacob took his revenge by spreading gossip about their life together, which Picasso regarded as a betrayal of their friendship. The final act in this tragedy came in 1944, when Picasso failed to speak out on behalf of his old friend after he was arrested and sent to Drancy internment camp, the first stop for French Jews on the way to Auschwitz. Whether or not Picasso's intervention would have made any difference, it was a Judas moment in a relationship marked by many similar denials. Jacob died in Drancy on March 5, 1944, after an illness brought on by deprivation and abuse.*

But in June 1900, it was love at first sight, at least on Jacob's part,

* Jean Cocteau, who had a far less honorable record during the Occupation, wrote two letters to the authorities seeking Jacob's release. When the art dealer Pierre Colle asked Picasso to intervene, Picasso responded, "We don't have to do anything. Max is an elf; he can fly out of there without us." Picasso's failure to act on behalf of his old friend was an unforgivable act of cowardice.

though love of a particularly bitter and conflicted sort. Max was infatuated with Picasso, describing him as "perfectly handsome, a face like ivory, without a wrinkle, in which eyes shone, much larger than they are today [1927], while the crow's wing of hair was like a caress on his low forehead." Among the many torments suffered by this balding, nearsighted waif of a man was his guilt-ridden homosexuality. He called his desires "an atrocious accident, a tear in the robe of humanity," and careened desperately between unrequited longing and shameful consummation.

For Picasso, Jacob's slavish adoration fed his own need for attention. For Max, the bond went even deeper. Looking back on their friendship at a point when they had grown apart, he remarked, "Picasso has been my friend for sixteen years, we have hated each other and we have done each other as much bad as good, but he is indispensable in my life."

In Jacob, Picasso discovered someone who would remain deeply devoted to him no matter how shabbily he was treated. But the poet performed a far more vital service than simply feeding Picasso's insatiable ego. Unlike Sabartés, an even more subservient companion, Max provided him with the education without which he could not have transformed himself into the leader of an avant-garde whose roots were planted as firmly in literary as in visual culture. Max opened a door onto an exciting new world: the great French tradition that included the poetry of Baudelaire and Verlaine, an intellectual legacy whose richness and complexity would find their way into the increasingly sophisticated misdirections of Picasso's art.

Sabartés describes a typical night at the boulevard de Clichy studio shortly after his arrival in Paris in the fall of 1901:

At nightfall Mateo [de Soto] came and shortly afterward Max Jacob, excited, with a book of Verlaine under his arm. Soon the studio was filled with smoke. . . . Max began to read poems from the book he had brought. At first, he adapted the cadence of his voice to the meter of the poetry, reading slowly and softly, accentuating the rhythm with parentheses of silence. . . . In utter darkness, as if he were extracting the verses from the shadows of a very remote remembrance, he began to read the poem "Un grand Sommeil Noir." He must have known it by heart. Now he recited slowly, in

a hollow voice, he stretched out the cadence between alternating vocal spasms and silences which at times gave the impression of leaving the verse in mid-air; ending the last stanza, he smothered the words "silence . . . silence . . ." in a sigh, after which he stretched out supine on the floor.

Picasso was drawing around him a Parisian *tertulia*, one that, crucially, included at least one French intellectual in addition to the Spanish cronies with whom he felt most at home. The truth is that both mismatched halves of this society were equally vital to his development, the one providing a lifeline to his Spanish roots—and a level of comfort in an otherwise alien city—the other opening up breathtaking new vistas. Their mutual incomprehension actually suited Picasso, since, like any tyrant, he knew instinctively that his power depended on his ability to play one courtier off another, never letting any faction gain ascendancy and remaining the still center of a raging storm.

Sabartés' arrival in Paris in October 1901 coincided with a transformation in Picasso's art and, indeed, the entire trajectory of his career. Jaime's initial reaction to the new work was one of dismay:

> This first visit to Picasso's studio was the climax of my bewilderment upon arriving in Paris. Still reeling from the confusion of the trip, still hardly able to believe that I was actually in Paris . . . totally unprepared for this new disturbing emotion, I found myself confronted with this new phase of Picasso's development. What Picasso had done since I had seen him last was far removed from my comprehension. . . . If my previous enthusiasm followed the course of logic, the sight of this gave me the vertiginous sensation of finding myself on the brink of an abyss.

He provides the key to this "abysmal" transformation in a description he gives of Picasso's boulevard de Clichy studio: "The first thing one saw

on entering was the big picture 'El Entierro de Casagemas' [The Burial of Casagemas], which hung, I know not with what or how, slightly away from the wall, as if it were a screen used to conceal something which it were better to keep out of sight."

The words Sabartés uses are telling. In Picasso's universe, art stood as a sentinel guarding the borderland between the material and the spirit world, containing the demonic forces that might otherwise wreak vengeance upon the living. What unmentionable thing lay hidden behind this cenotaph, what secret so dark that the image of Casagemas' funeral cortege would provide blessed relief? Perhaps Picasso hoped to assuage his own guilt by providing Casagemas with a good death. Painting this memorial to his departed friend in the very room where he had spent his last hours (at the same time he was making love to the woman who had lured him to his doom) is a particularly morbid instance of the fetishistic impulse that lies at the heart of Picasso's creative fury.

The large-scale *Evocation* (*The Burial of Casagemas*) was the last in a series of paintings and drawings that he'd been working on in the months following the exhibition at Vollard's gallery. It's hard to imagine a greater contrast with those brightly colored, scattershot sketches of Parisian life than these morbid, highly focused evocations of death. The extrovert, drinking in the world around him and capturing the passing scene, has become the introvert, turning his gaze inward, plumbing the depths of his own turbulent soul. If the Vollard exhibition marked Picasso's bid for public acceptance, his paintings of Casagemas represent his private struggle with the demons of guilt. His abandonment of his friend in his hour of greatest need was one in a long chain of sacrifices he made on the altar of his art that began with Conchita and would end only in his own death. "[T]he sufferings one has inflicted on others, one begins to inflict on oneself equally," he once explained to Françoise Gilot. "[O]ne has to have the courage of the surgeon or the murderer, if you will, and to accept the share of guilt which that gives."

Painting the dead Casagemas was less a matter of achieving catharsis than of entering into the sacred realm that suffering pried open. As Picasso brooded on the meaning of his friend's death, his art began to change. "It was thinking about Casagemas' death that started me painting

in blue," he told a biographer, and if that is an oversimplification, it is one that contains a large element of truth. One can see the transition in two small memento mori: the first, showing Casagemas in his burial shroud illuminated by a candle like a votive saint in his reliquary, is painted in the acid palette of van Gogh, another victim of a self-inflicted gunshot; the second is suffused by winter chill, the colors now those of bruised flesh.

The final work in the series suggests yet another source for the gelid palette that will dominate the next couple of years of Picasso's art. *Evocation* (*The Burial of Casagemas*) is a loose quotation—half tribute, half parody—of El Greco's *The Burial of the Count of Orgaz*, which Picasso had studied intently during his trip to Toledo the year before.* In Picasso's sacrilegious reworking of the Mannerist masterpiece, the angelic host has been replaced by stockinged whores; the forms of piety are harnessed for the purposes of an unabashedly carnal apotheosis, one that is no less moving for its erotic content. Picasso's magical thinking allows Casagemas the consummation and consolation he could never enjoy on Earth, as his heaven-bound soul is embraced by a nude woman (Germaine?) who bids him a fond farewell as he prepares for his ascent.

El Greco was one of the touchstones of Picasso's art, always haunting his imagination but asserting himself more insistently at critical junctures.† "It's probably as a result of [El Greco's] influence that the figures in my paintings of the blue period are elongated as they are," he told Brassaï. Picasso returned to the eccentric master whenever he felt compelled to tap into a vein of ecstatic sorrow that ran deep in his Spanish soul. This mystical strain peculiar to Catholic, and specifically Spanish, art—the language of martyrs and mortification, hallucinatory visions and orgasmic release—drives a shape-shifting imperative at the heart of Picasso's own work, one that crashes through the Cartesian

* Picasso combined elements of this painting with others taken from El Greco's *The Dream of Philip II*.

† He had inscribed a sheet of sketches from 1899 with the bold boast "Yo El Greco."

decorum of the French tradition. Now, meditating like Hamlet on the skull of Yorick, he allows the chill winter light that pervades so many of El Greco's scenes to creep in, a bluish hue steeped in moonlight, melancholy, and madness.

While Casagemas' suicide may have provided a catalyst, the origins of Picasso's so-called Blue Period are as much a product of mind as of heart.* Despite his insistence that his art was merely instinctive, that "the true artist must ignore everything, that knowledge is a hindrance, because it blurs the visions and impedes expression by depriving it of spontaneity," few painters or sculptors were as familiar as Picasso with the great traditions of art and as conscious of his own place within them. Trained by his father and teachers as a painter of religious subjects, Picasso borrowed from not only the mystical visions of El Greco but the Gothic sculptures of Catalonia with their attenuated forms and superstitious piety. If he ultimately deploys the forms of religious art for a far different purpose, he discovers that blasphemy carries its own potent charge.

As if to confirm the cliché that misery loves company, Picasso dealt with his grief by universalizing it. Through the alchemical properties of art, Casagemas' death could be transformed from the senseless act of a confused young man into a redemptive narrative in which the victim sacrifices himself for the sake of humanity at large.† "We are passing through an age in which everything is still to be done by everybody, a period of uncertainty which everyone considers from the point of view of his own wretchedness," wrote Sabartés, paraphrasing conversations he had with Picasso during these critical months. "And since our life is passing through a period of grief, of sadness and wretchedness, life, with all its torments,

* The term "Blue Period" was first coined in 1914 by Gustave Coquiot, the same critic who provided the essay for the Vollard exhibition and a laudatory review in the *Revue Blanche*.

† There was something of a *fin-de-siècle* cult of suicide. It had already claimed at least one of Picasso's friends: the writer and painter Hortensi Güell drowned himself in 1899.

constitutes the very foundation of his theory of art." On the back of one self-portrait Picasso identified himself simply as *"Pictor en misere humane"* (painter of human misery). Grief, in this formulation, is not simply the unwelcome by-product of misfortune that can be mitigated with pills or therapy but something to be cherished as a revelation of deeper truths. Joy is transitory, while sadness is eternal.

To convey these truths, Picasso deploys a stripped-down language, more primitive and more "authentic," tapping into the deep well of spirituality that, at least to the alienated inhabitant of the modern city, seems to belong to an earlier time or distant place. Ironically, this quest for a primitive essence made Picasso very much a man of his times. From at least the 1880s, progressive artists had largely rejected the materialist forms of Impressionism in search of an artistic language that would nourish the soul. Artists as different as Odilon Redon, who dwelt in the land of dreams and nightmares, and Pierre Puvis de Chavannes, whose murals depicting nymphs in classical settings conjured up a lost Arcadia, offered an escape from contemporary world with all its ugliness and uncertainty. As the Symbolist critic Albert Aurier insisted, true art is "fundamentally identical with primitive art, to art as it was defined by the instinctive geniuses of the first ages of humanity."

The profound shift in the zeitgeist—sometimes characterized as the manifestation of a *fin-de-siècle* anxiety or decadence—is embodied in the life of Paul Gauguin. Initially identified with and exhibiting alongside the Impressionists, he quickly grew disillusioned with a movement that he claimed "neglected the mysterious centers of thought." His search for spiritual nourishment drew him first to the rustic villages of Brittany. Then, when he found even these hardy peasants too "civilized" for his taste, he escaped to the South Seas, where he hoped to discover a prelapsarian paradise. By 1901, he was already a legendary figure in avant-garde circles, the embodiment of a life lived in fanatical pursuit of an ideal.[*] According to his friend Maxime Maufra, "[t]he master from Tahiti, the king of Pont-Aven, was worshipped to the point of being a god." Picasso had seen examples of Gauguin's work at Vollard's gallery, but his real initiation into the

[*] Already in failing health, he would die in the Marquesas Islands in 1903.

cult came through the Spanish sculptor Paco Durrio. Durrio, who had befriended the tormented genius during his years in Paris, revered Gauguin and transformed his own Montmartre studio into a kind of shrine to the master. He possessed an unparalleled collection of not only Gauguin's paintings but also his totemlike sculptures, which he shared only with those he deemed worthy of the honor. Sabartés recorded the visit he and Picasso paid to Durrio's studio in October 1901: "At nightfall we went out together, climbed up the Place Ravignan, and entered the 'Bateau Lavoir' to chat with Paco Durrio. The air of the street and the conversation with Durrio pleased Picasso. He showed such interest in what Paco was doing that one might have thought he had just discovered his sculpture. There was much talk about Gauguin, Tahiti, the poem *Noa Noa* . . . and a thousand other such things."

This visit is memorable not only because it was probably the first time Picasso set foot in the ramshackle building that he later made famous as the "Acropolis of Cubism," but also because it marks the occasion on which Picasso first fell under the spell of Gauguin's art and personality. Even more revelatory than the paintings, which were already well known, were the crudely carved and modeled figures that Durrio unveiled. These savage idols seemed to radiate a primal energy more powerful than anything else he could have seen in the galleries. In Gauguin, Picasso discovered a guide to the dark realm of the spirits where he himself hoped to travel.

In some sense, then, Picasso's looking inward is a matter of looking out, of aligning his art with not only history but the most vital strains of contemporary practice. Like Gauguin, he pares down his forms, circumscribing them in unbroken contours that transform the picture into an arrangement of colors on a flat surface. This was very much in the spirit of Symbolism, which stressed the "decorative" at the expense of the illusionic, reversing the five-hundred-year trajectory of art since the early Renaissance. By thinking of painting in terms of decoration, the Symbolist was not promoting an undemanding medium intended merely to please the eye. Quite the opposite; by insisting on the integrity of the two-dimensional picture plane, by rejecting the tricks that conjured a world behind the frame, the artist hoped to foster a more authentic, more expressive pictorial language. "[D]ecorative painting," wrote Aurier, "is

strictly speaking, the true art of painting. Paint can only have been created to *decorate* with thoughts, dreams and ideals the banal walls of human edifices."

This studiously naive approach evokes medieval altarpieces and stained-glass windows, art that seeks to make visible not the world as apprehended by the senses but a higher spiritual dimension visible only to the mind's eye. The gradual submerging of the sun-drenched, multihued world in a vast ocean of blue also marks a rejection of an art based on optical sensation in favor of one filtered through the subjective self. Picasso sloughs off all that is extraneous until only essentials remain. Like a novitiate who sheds his workaday clothes and dons the monk's habit that separates him from his former life, he enters the contemplative penumbra of his solitary cell. He turns his back (in his art, if not in his daily habits) on earthly pleasures, on the boulevards and cabarets; the pulse of life recedes as we are transported to a land outside both space and time.

The transformation does not happen all at once or ever completely. Picasso is too sensitive and intuitive a painter to reduce his art to a sterile formula. One of the transitional works is a portrait of Sabartés called *Le Bock* (The Beer), showing the aspiring poet at a café table staring off into space as he awaits the arrival of his companions.* Sabartés recalled the occasion that provided Picasso the inspiration for this moving work: "One night, I know not for what reason, I found myself alone in the Café La Lorraine.† . . . I was alone and dreadfully bored. Before me, upon the table's top, stood a glass of beer. With my nearsighted eyes I scrutinized the room, trying to penetrate the smoke-laden atmosphere. . . . Just as my sense of desolation was keenest, Picasso appeared—Picasso and the rest. But he came first, led on by the intensity of his gaze."

* Unusually, Picasso insisted on an alternate title for this work, calling it *The Poet Sabartés*. Picasso liked to mock his friend's literary pretentions as he had in an earlier portrait in which he had called him *Poeta Decadente* (see chapter 2).

† The café, in the Latin Quarter, was popular among artists and intellectuals. Picasso and his *tertulia* of the moment met there most days after Sabartés took an apartment across the street.

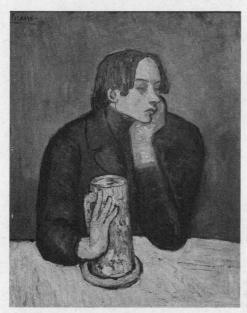

Portrait of Sabartés (Le Bock). Erich Lessing / Art Resource, NY.

Though Sabartés is rather too eager to place himself at the center of this sea change in Picasso's art, he's right to see in what he called "that marvelous blue mirror" a "glimmer of a new horizon." In the completed portrait, which Picasso showed him a few days later in the boulevard de Clichy studio, an unremarkable scene—the kind of urban slice-of-life vignette he had tackled many times before—has been distilled. What remains has the solemnity of an icon.

Over the course of the next few weeks, Sabartés sat for another portrait, which allowed him plenty of time to observe Picasso at work:

> Towards 1901, I generally found him in the middle of the studio, not far from the stove, seated on a dilapidated chair, perhaps lower than an ordinary chair, because discomfort does not bother him and he seems even to prefer it as if he delighted in self-mortification and enjoyed subjecting his spirit to tortures so long as they spur him on. The canvas was placed on the lowest part of the easel, and this compelled him to paint in an almost kneeling position. . . . He surrenders body and soul to the activity which is his *raison d'être,*

dabbing the bristles of the brush in the oily paste of color with a loving gesture, with all his senses focused upon a single aim, as if he were bewitched. So absorbed and so thoroughly wrapped in silence is Picasso when he paints that whoever sees him, whether at close range or from afar, understands and keeps silent. The subdued murmur which the distant street sends into the studio serves as a background to the silence scarcely broken by the creakings of the chair which supports the weight of his body, agitated by his creative fever.

There is something monastic about Picasso's discipline, an indifference to comfort and a concentration that speak of a fanatical devotion to his craft, belying the caricature promoted by some critics of modern art who portrayed him as a charlatan whose only goal was to shock.

Sabartés' account of Picasso painting is particularly precious since he preferred to paint almost exclusively at night, throwing himself wearily into bed at dawn and waking only at midday. Following, perhaps unconsciously, the routines of his father, from noon until late into the evening he would hang out with friends, either at his studio or at a favorite café. These habits are as far removed as one can imagine from those of the typical Impressionist, who set out each morning with his portable easel and paint box, seeking motifs in the countryside and changing canvas with each minuscule change in the light or atmosphere. Working by kerosene lamp or candlelight, Picasso could not have captured these fleeting effects even if he'd wanted to. In any case, he was after something far different. All alone, armed only with images stored in his retentive visual memory and the promptings of his morbid imagination—ignoring what was superficial, changeable—he delved into timeless mysteries.

Ultimately this new phase in his art would involve not only a change in mood and technique but also a transformation in subject matter. In the fall of 1901, Picasso began to visit the women's prison/hospital of Saint-Lazare in search of models and themes. The unfortunate inmates, many of them prostitutes (identified by their distinctive white bonnets) and suffering from venereal disease, not only seemed perfectly cast for the

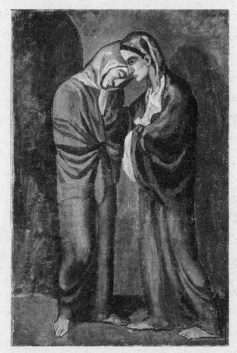

The Two Sisters (The Meeting),
1902. / HIP / Art Resource, NY.

tragic drama Picasso now had in mind, but they were available at no cost, a not-insignificant consideration since he was barely scraping by.

Even before Picasso began to paint there, the prison had achieved a kind of melancholy fame. This grim stone fortress in the Tenth *Arrondissement* was celebrated by, among others, Aristide Bruant, whose sentimental ballad "À Saint-Lazare" was illustrated by Toulouse-Lautrec. Singers and painters who never had to live there tended to romanticize the institution and its residents, but contemporary descriptions point to a more sordid reality of vermin-infested cells and filthy inmates who were discouraged from washing by the nuns, who considered it an *"outrage à la pudeur"* (offense against modesty). According to one observer, Saint-Lazare was "a strange city, in which a many-faceted world lived in sorrow, in blasphemy, in remorse, in prayer, in self-sacrifice."

Picasso was given permission to sketch at the prison by Dr. Louis Jullien, a specialist in venereal diseases who oversaw the inmates' medical care. His name appears in one of Picasso's address books, suggesting,

perhaps, that the artist had first gotten to know him after seeking medical care. Given his lifestyle, it wouldn't be surprising if Picasso had contracted venereal disease, which might also help explain the sudden change in the tenor of his art.* But whether or not illness was the initial catalyst for this new phase, it's always a mistake to reduce aesthetic decisions to autobiography. Whatever Picasso's physical and psychological condition, he transformed the melancholy denizens of Saint-Lazare into suffering Magdalenes whose emaciated forms recall the martyrs of the medieval imagination.

As in his portrait of Sabartés, the paintings he made at Saint-Lazare have undergone a process of radical distillation. In their distinctive white bonnets and blue robes, the women inhabit a timeless realm.† Seen alone with their thoughts or bearing young children in their arms, they carry the burden of all our sins, offering redemption through their stoic acceptance of life's cruelty.

At least one of those who knew him best in those early days, his mistress Fernande Olivier thought she detected a certain lack of sincerity. "What," she asked, "was at the heart of it all? Was the work completely cerebral, as I later thought, or a revelation of a profound and despairing love of human kind as I believed then?" Picasso himself later described the paintings as "nothing but sentiment." He has been accused in his Blue Period works of romanticizing poverty and aestheticizing suffering. Nowhere is this accusation more apt than in the Saint-Lazare paintings, where society's victims have become props in a Symbolist dreamscape, far removed from politics and beyond the reach of social policy.

But this criticism, while containing a grain of truth, largely misses the mark. Even Picasso's later disavowal of these youthful works, made when he was a very public member of the Communist Party, was predicated

* François Gilot said that Picasso admitted to her that he'd contracted venereal disease early in life.

† It's no coincidence that the white bonnets bear a strong resemblance to the white caps worn by Breton peasants that are featured so prominently in the works of Gauguin and Émile Bernard from Pont-Aven. (See, e.g., Gauguin's famous *Vision after the Sermon*.)

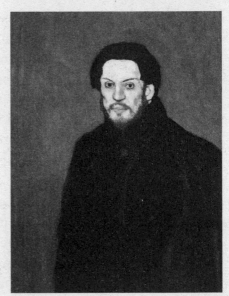

Self-Portrait (1901). © *RMN-Grand Palais / Art Resource, NY.*

on the specious idea that art should be useful, a notion that his own career insistently repudiated.* Even at the height of his commitment to the cause, Picasso was never a crusader, exposing society's ills in order to cure them. He was above all an artist, willing to use everything and everyone to further his aesthetic goals.

Though the Blue Period paintings are now among his most popular and sought-after works, at the time the change in Picasso's art contributed to a decline in his fortunes. After his initial success at Vollard's his career stalled, at least in terms of exhibitions and sales. The morbid intensity of his new work turned off not only the general public but even the more discriminating dealers on the rue Laffitte. That reversal, in turn, placed strains on his relationship with Mañach. In the great self-portrait Picasso painted at the time he depicts himself as a gaunt, almost spectral figure,

* Picasso's refusal to conform to party orthodoxy was a constant source of discomfort to his fellow travelers. Throughout the 1940s and '50s, debate raged within the Party as to whether Picasso was an asset or an embarrassment.

with large, glittering eyes, hollow cheeks, and sparse beard. With his pallid flesh, long hair, hands dug deep into the pockets of his overcoat, he becomes the *poète maudit* of legend, a romantic hero, alienated and haunted, forced to wander the lonely byways and to suffer for his art.

One of the stories Picasso liked to tell of those difficult days came at the expense of the slavishly devoted Sabartés. "Back in their early starvation period in Paris," François Gilot recounted,

Pablo and Max Jacob once gave Sabartés the last few coins they could scrape up and told him to go buy an egg and whatever else he could get the most of for that money. Sabartés shopped around and wound up with a piece of bread, two sausages and, of course, an egg. Since he saw very poorly, he fell on the stairs on the way back. The egg broke and ran in all directions. He picked up the other things and continued up to the room where Pablo and Max were waiting. They were planning to cook the egg over a candle, since there was no other heat. He told them what had happened. Pablo was furious. "You'll never amount to anything," he told him. "We give you our last penny and you can't even get back here with a whole egg. You'll be a failure all your life." He grabbed up a fork and plunged it into one of the sausages. The sausage burst. He tried the other one. The same thing happened. Sabartés with his weak eyesight had bought two sausages so old and rotten that they exploded like a pair of balloons.

These kinds of stories are pleasant to dwell on after fame and fortune have been achieved. Since it turned out all right, it's possible to look back wistfully on the struggles that came before. Such tales become part of the legend without which the hero's journey would lack heroism. Camaraderie made poverty bearable; the knowledge that one belonged to a close-knit circle of friends who were all in it together and would share what little they had gave rise to a kind of communal esprit de corps, and tales of battles long past formed a bond (at least for the survivors) that endured long after these ancient warriors had gone their separate ways.

But at the time poverty and rejection weighed heavily on Picasso, particularly since there was no guarantee that he'd make it in the end.

As his painting grew increasingly introspective and his position in Paris increasingly precarious, Picasso distracted himself by plunging into the bohemian life that had become an essential part of his identity. Perhaps to delay the visits by the demons that plagued him in the lonely hours when he painted by the light of an oil lamp, he spent as much time as possible in the company of friends. The steep hillsides of Montmartre, with their rustic charm, mud-choked alleyways, overgrown gardens, and seedy taverns, provided relief from the claustrophobia of the studio. During these months, when his deteriorating relationship with his roommate made staying home intolerable, Picasso and his *tertulia* discovered a new hangout that perfectly suited their needs and their budget.

Le Zut was located in the place Ravignan, across from the Bateau Lavoir near the summit of the Butte and around the corner from Picasso's old studio on the rue Gabrielle. "In 1901," Sabartés recalled, "this square was a desolate spot; there were no lights, no sidewalks, no cobblestones on the street, and one could see only a few one-story buildings on the right. When there was no trace of moon to light our way, we needed all our determination to penetrate that darkness which, so they said, protected the apaches. In the dead of winter, we were forced to plunge right into that darkness, for icy blasts guarded the entrance to the square with the fury of a hurricane."

Above a rickety gate was a sign with the word *Bière* (Beer) painted in black; a few uneven steps led down to a boisterous room where local painters, sculptors, musicians and poets, along with their girlfriends of the moment, drank cheap brandy and smoked their pipes. A smaller room off the main bar was set aside for Picasso and his Spanish cronies: Sabartés, Manolo, Durrio, Soto, Pichot with his latest girlfriend, Germaine.[*] "The chimney was of little use," Sabartés remembered, "for the cobwebs blocked the light. In the middle of the room, under the light, there was an upright barrel, on which Frédé [Frédéric Gérard, the proprietor] placed a few glasses and hastily filled them with beer. One could not ask for anything else for there was nothing else. Here we felt at home."

[*] Germaine would marry Ramon Pichot in 1906. The two of them set up house in the famous Maison Rose in Montmartre, where they ran a restaurant.

Once they heard a gunshot from the larger room, and another time a quarrel was settled with knives. On that occasion, after the bodies had been dragged out, Frédé rushed in, crying "It's nothing my lads. Nothing to worry about. This doesn't always happen. Let's have another drink." After refilling their glasses, he unslung his guitar from his back and began to belt out one of his rollicking ballads, keeping his Spanish guests entertained until their nerves were settled.

Picasso and his *tertulia* became such a fixture in the dismal back room of Le Zut that they decided to redecorate it themselves. After Frédé whitewashed the crumbling plaster, Pichot and Picasso livened the place up with an impromptu mural. Pichot chose a modern theme, a scene of Paris with the Eiffel Tower and a dirigible. Picasso, in keeping with his obsessions of the moment, chose a religious scene, one whose psychosexual theme appealed to his penchant for mixing the sacred and the profane. "With the tip of his brush dipped in blue," Sabartés wrote, "he drew a few female nudes in one stroke. Then, in a blank area which he had purposely left blank, he drew a hermit. As soon as one of us shouted: 'Temptation of Saint Anthony,' he stopped the composition." This was the third time he had painted a mural of that particular tale; the first two times had been in studios he had shared with the lovesick Casagemas—a sign that, after more than six months, his friend's death continued to haunt him.

Picasso was beset by other worries as well, most of which he kept hidden from even his closest friends. It was during their pilgrimage to Paco Durrio's studio that Picasso shocked Sabartés by telling him that he was planning to leave Paris as soon as possible. In fact, Picasso told him, he'd already written to his father, asking him to send the money for the train fare.

Picasso's hurried decision to leave Paris has never been fully explained. Certainly, a lack of money had something to do with it. His latest works weren't selling, and Mañach was increasingly irritated that he was shelling out 150 francs a month and getting nothing in return.

But there must have been more to Picasso's anxiety than simply a shortage of funds, particularly since he'd already mastered the various expedients of bohemian life: cadging off friends, running up tabs at local

eateries, and generally getting by on very little. As Sabartés described it, Picasso's decision was both sudden and secret:

> Picasso had made up his mind to leave us immediately. Now quite coolly he explained his plan, as if forgetting that he had wished to conceal it. We left Durio's studio very early, for Picasso wanted to get home to see his mail. We went up in single file, like children afraid to face the dangers we imagined lay ahead. But when Picasso opened the door, fear vanished; the letter was on the floor. On the bed, fully dressed, Mañach was lying on his stomach, talking to himself as if delirious:
> "The letter! The letter!"
> Picasso gave him an ugly look, made a scornful grimace and led us into the studio without uttering a word.

Sabartés provides no explanation for this strange scene, and many biographers have assumed that the falling-out between Mañach and Picasso was purely financial. But it's impossible to read Sabartés' account without concluding that the strains in their relationship had an emotional—almost certainly sexual—dimension. This would account for Picasso's desperation to extricate himself from an impossible situation and for the fact that he kept his humiliation from his closest friends.[*] It seems likely that Mañach was using his financial hold over Picasso to force on his roommate an intimacy that repelled him. Picasso was drawn to men who were drawn to him, even sexually. He thrived on being the center of attention, the object of desire, but only as long as he remained in control. Max Jacob (and later Jean Cocteau) were ideal companions in this regard, infatuated but totally under his thumb. In the case of Mañach, however, desire was coupled with dependence, a toxic combination that caused Picasso to flee as fast and as far as he could.

Picasso returned to Barcelona early in January 1902, moving back

[*] This might also explain why Manolo, an incorrigible practical joker, went around introducing Picasso as his "daughter."

into his parents' apartment on the Carrer de la Mercè in the old city. It was a humiliating setback and one that shook his confidence. The last time he left Paris it had been Casagemas' mental breakdown that had forced him home; this time there was no way to pass it off as anything less than a defeat, which was all the more painful given the high hopes with which he'd set out.

Picasso regarded his return to Barcelona as temporary. His hometown, with its petty quarrels and provincial narcissism, offered him little emotional or intellectual sustenance. "I'm showing what I'm doing to the *artists* here," he wrote to Max, "but they think there is too much soul and no form. It's very funny. You know how to talk to people like that; but they write very bad books and they paint idiotic pictures. That's life. That's how it is."

Living under his parents' roof once more, he was forced to endure Don José's daily lectures, but, physically at least, the change of scene did him good. The months in Paris had taken a toll. Now, under Doña Maria's tender ministrations, he put on weight. Not having to face a daily struggle for survival also helped restore his peace of mind.

But he was bored, frustrated, and embarrassed. As Sabartés put it, Picasso continued to have "one foot in Barcelona and the other in Paris." The cultural excitement Barcelona had displayed even a few short years before was ebbing away. Els 4 Gats had gone downhill, Rusiñol and Casas having lost interest, and many of the most ambitious and interesting members of Barcelona's avant-garde were establishing themselves in the city that had just rejected him. "Naturally we went to the Salon Parés," recorded Sabartés, who returned to Barcelona a few months after Picasso, "for there was no other exhibition gallery to go to, but we soon tired of seeing the same things and, at any rate, it seemed to us shallow when compared to our memories of Paris which our imagination endowed with such vivid colors."

As soon as he left Paris, Picasso was thinking only of how to get back. Paris was now the land of his dreams and the sole focus of his ambition. This is confirmed by his painting, which, despite the incomprehension of his friends, continued very much in the same vein as before. The same long-suffering Madonnas populate his Barcelona paintings, though now

perhaps they are even more ethereal, more removed from the grim reality of the prison where they were born. One concession to geography is that the vaults of Saint-Lazare have vanished; now these spectral creatures make their lonely way along the seashore, a twilight realm that, while certainly suggested by Barcelona's Mediterranean setting, remains outside both space and time.

The most resolved of these paintings is *Woman by the Sea*, a work in which the subject's status as a Madonna is emphasized by the child she carries in her arms. There is no hint in Picasso's hushed and meditative work that at the moment of its creation Barcelona was undergoing one of its periodic spasms of political unrest. In February 1902, striking workers were gunned down by General Valeriano Weyler, the so-called Butcher of Cuba, in a violent clash that left ten protestors dead in the streets and many more wounded. Despite later claims that Picasso was politically engaged from the beginning of his career, none of this chaotic reality intrudes on Picasso's timeless reverie, where poverty is more a blessed spiritual state than an economic condition that could (and should) be alleviated through the implementation of progressive policies.

One minor work from this otherwise uneventful period signals momentous things to come: the small *Seated Woman* is his first surviving sculpture, a medium that he would ultimately transform even more radically than the art of painting. This modest work, made under the tutelage of the sculptor Emil Fontbana, who taught him how to model in clay, reveals his continued fascination with Gauguin, whose totemic works had so moved him during his visit to Paco Durrio's. It also reflects his careful study of Auguste Rodin.[*] The influence of the great French sculptor can be detected not only in the sensitively handled surfaces of the modeled figure but in Picasso's paintings as well. Even more than Puvis de Chavannes, Rodin had mastered the trick of seeming up to date while leaning

[*] The influence of Rodin is widely attested at this period in his life. A photograph of Picasso's studio at this time shows a reproduction of Rodin's *The Thinker* taped to the wall, and in August 1903, he made a drawing of Rodin's bust of Jules Dalou for an edition of *El Liberal*.

heavily on the past, a sleight of hand that Picasso exploited for his own revolutionary ends.

On October 20, 1902, *El Liberal*, a progressive newspaper run by his friends Sebastià and Carles Junyer Vidal, announced, "The celebrated artist Pablo Ruiz Picasso, left for Paris on yesterday's express. He was accompanied by the distinguished artists Juli González and Josep Rocarol. Picasso intends to make a long stay in Paris."

Once again Picasso was determined to storm the bastions that had resisted his assault twice before. He had some reason to hope that the repulse of the previous year would not be repeated. During his absence, Mañach had managed to sell most of the work he'd acquired while paying Picasso's monthly stipend, most of it to Berthe Weill. Much to Picasso's annoyance, he made nothing from these sales, but they did suggest the continued viability of his earlier work. The fact that Mañach had returned to Barcelona to take over the family locksmith business upon his father's death also relieved Picasso of the possibility of an awkward confrontation.

But he arrived in Paris almost completely broke, and while his earlier work was apparently still finding buyers, no one seemed to understand his more recent productions. As soon as he arrived in the city he made his way to the rue Laffitte, where he tried to pique the interest of Durand-Ruel, the impresario of Impressionism, but neither he nor Vollard, whose gallery was next door, saw any future for the young Spaniard.

On earlier trips to Paris, Picasso had surrounded himself with friends and adopted a routine that involved making the rounds of cheap taverns and cafés, carousing late into the night before retiring to the studio for serious work. This time was different. Despite his declared intention "to make a long stay," things went badly from the beginning. Picasso was so mortified by his lack of progress that he avoided Montmartre, where he was certain to bump into his old Catalan friends. For the first weeks he stayed with Josep Rocarol, his studiomate from Barcelona, in a cheap hotel in Montparnasse, sleeping on the floor while Rocarol (who was paying the rent) took the bed.

From there he flitted from one cheap room to another, each one

smaller and grimmer than the last, until he found himself without options, unable to work, without hope. Picasso referred to this trip as "those days of misery," and the hardships he suffered left a psychic wound that never fully healed. Despite the frustrations that had cut short his last stay, then he had been sustained by his friends and by the recent memory of his success at Vollard's. Now he was no longer the prodigy who astonished everyone with his youth and vitality. Doors that had once opened at his approach now slammed in his face. Even Berthe Weill, the one dealer in Paris who still believed in him, could do little to help. "I did sell a few Picassos, drawings or paintings, here and there," she recalled, "but was not able to give him the money he needed, and this upset me badly for he held it against me."

Picasso was so desperate that he resorted to an expedient almost unheard of for this most uncompromising of artists, betraying his aesthetic standards in the hope of making a quick buck. In the end even this attempt to sell out proved a failure. "I was living on the rue Champollion," he remembered. "I wanted to do something to make a little money. I'm a little ashamed to admit it, but that's how it was. So I did this pastel [Intimacy]. I rolled it up and carried it to Berthe Weill. She lived in Montmartre, at the other end of Paris. It was snowing. And me with my pastel under my arm. . . . She had no money. . . . So I went away . . . and left the pastel."

Vacating the Hôtel des Écoles on rue Champollion, he found an attic room in the even dingier Hôtel du Maroc on rue de Seine, sharing the squalid space with a sculptor named August Agero. He could barely afford materials and, in any case, the quarters were so cramped that he produced almost no works beyond a few drawings, many of them heads caught in midscream. These anguished souls will find their way, decades later, into the great masterpiece *Guernica*.

For all their misery, these dismal months were crucial to Picasso's development. He was going through an annealing process that burned away much of the carelessness of youth and left him tougher, more resilient. At the time, however, it felt like less like a rite of passage on the path to ultimate triumph than the end of the road. Poverty forced him into desperate expedients. One day he paid a visit to Rocarol at the studio he shared with Mateu de Soto in Montmartre, hoping to borrow a few centimes. No one was home, but he ran into Rocarol on the street a few minutes later. "The

door was open," he confessed. "I found some bread on the table and I ate it. I found some coins, too, and I took them."

The bitterness he felt over his neglect shaped his character in profound ways, fueling his already ferocious ambition and deepening his conviction that life was suffering. It also encouraged a kind of paranoia, or at least mistrust, that made him cynical about human motives long after he'd been showered with riches and become accustomed to adulation.

One day Max Jacob paid him a visit at the Hôtel du Maroc in the company of a young man he was tutoring to earn a few extra francs. Both teacher and pupil were shocked by the squalor. "For the rest of his life," Max remarked, "this nice gentleman will remember having seen misery coupled with genius." Despite the salutary life lesson the scene provided, the kindhearted Jacob was determined to rescue his friend from the depths into which he'd sunk, urging him to come share his slightly more salubrious apartment on rue Voltaire, in the working-class Eleventh *Arrondissement*.

Max was hardly wealthy—barely scraping by as a tutor and later supplementing that with a job as a clerk in his uncle Gimpel's department store—but his neat little apartment was at least a step up from the Hôtel du Maroc. "[Picasso] would draw all night and when I got up in the morning to go off to the store, he would get into the bed and rest," Max recalled. Picasso's own memories of that period are decidedly mixed. "My dear old Max," he reminisced years later, "I think about the room on the boulevard Voltaire and the omelets, the beans and the brie and the fried potatoes. But I also think about those days of misery and that's very sad."

Max said they'd even contemplated committing suicide by throwing themselves off the balcony, a claim that Picasso vehemently denied and that contributed to their estrangement in later years. Picasso always retained a place in his heart for the one man who had shown him kindness in his hour of greatest need, but he also resented his friend's need to expose to the world the most humiliating moments of his life.

In November, Berthe Weill included Picasso in a four-man show at her gallery. Nothing sold. The one positive result of the otherwise disheartening effort was a thoughtful review in the *Mercure de France* by the Symbolist poet Charles Morice. "Picasso who painted before he learned to read seems to have been assigned the mission of expressing with his

brush everything there is," he wrote. "One could talk of a young god who wishes to remake the world. But it is a somber god.... Is not this child with a terrible precocity destined to consecrate with a masterpiece his negative view of life, that sickness which he suffers more than anyone else?"

This writer, to whom Picasso had been introduced by Paco Durrio, was a friend and collaborator of Paul Gauguin; he had played a crucial role in editing and publishing *Noa Noa*, the painter's account of his life and art. As a testament to a young artist whom he believed was poised to inherent the master's mantle, Morice gave Picasso a copy of the book, which Picasso treasured and came to regard as his "talisman." It's a sign of how deeply Picasso had fallen under Gauguin's spell that he signed a charcoal drawing of a nude woman "Paul Picasso" rather than Pablo, as if through this act of identity theft he might acquire a bit of the other artist's shamanistic power.

But not even Morice's fulsome tribute could salvage Picasso's floundering career; the string, he knew, was played out, and it was time to admit defeat. He did manage one sale, the painting *Mother and Child on the Shore*, to Madame Besnard, the wife of the man from whom he purchased his paint, for 200 francs. But even this was more an act of charity than a vote of confidence. With the money Picasso purchased a one-way train ticket to Barcelona. A few months earlier, Max—an adept in the arts of fortune-telling, astrology, and Tarot—had created a chart of Picasso's palm, noting "an ardent temperament" and predicting that "life will grow more peaceful toward the end." In exchange, Picasso—performing his own sort of magic—drew an *alleluia*, one of the cartoon strips in which he depicts the world as it should be. Titled *Histoire Claire et Simple de Max Jacob*, Picasso predicts his friend's certain triumph, with wealth (symbolized by a dinner at Maxim's), fame, and finally a mythical apotheosis as the ample reward for the poet's as-yet-unrecognized talents.

Picasso arrived back at the family apartment sometime around January 15, 1903. That first night, while he slept, his mother cleaned his filthy clothes and polished his shoes. The next morning, discovering her well-meaning interference, Picasso lost his temper, yelling that she had taken his "dust of Paris," an outburst that suggests not only Picasso's superstitious

nature—the soil of Paris resembling a relic of the Holy Land brought back by a crusader to connect him to a blessed realm—but also the hold the city now exerted over his imagination. Despite his recent suffering, or perhaps because of it, Paris had become sacred territory, a Calvary that offered both torment and redemption.

The fifteen months Picasso spent in Barcelona from January 1903 to April 1904 offered a chance to gather his strength and straighten out his mind, to prepare for the struggle to come. He'd been bruised but not beaten. There was work to do, but he no longer doubted that his future lay in Paris. That conviction brought a certain serenity, if not contentment.

Materially, life in Barcelona was less precarious than it was in Paris. His parents provided a roof over his head and three square meals a day, though that didn't stop him from complaining. "I don't have enough 'dough' to do the things I'd like to do," he wrote to Max in August. "I spend days without being able to work, that's very annoying. . . . I'm thinking of doing a painting of three meters of some sailors in a small boat . . . but I have to have the money first. You can't imagine how fed up I've been for some days." His boredom was exacerbated by the collapse of the local cultural scene, which had been so vibrant in the years immediately following the debacle of 1898, when Spain's humiliation had stoked a resurgence of Catalan nationalism: Els 4 Gats would close its doors in July 1903, and *Pèl & Ploma*, the leading journal of *Modernisme*, at the end of the year.

But for all his griping, these were productive months. Many of the most beloved of the Blue Period paintings date to this Barcelona interregnum. Those famous images of destitution—*The Blind Man's Meal, Poor People on the Seashore (The Tragedy), The Old Guitarist*—were produced in relative comfort, at a point when he could contemplate life at the margins with an empathy born of real experience but also from a certain philosophical distance.

The simplest explanation for his renewed productivity was that he once again had room to work, having returned to the studio on the Riera Sant Joan that he had once shared with Casagemas. Though his new studiomate was Angel de Soto, his old companion was there in spirit, an apparition still visible in the mural that he'd once sketched on the wall depicting the Temptation of Saint Anthony and always associated with

his doomed friend. Also confronting him in the studio was the large rolled-up canvas *Last Moments*. That, too, had been implicated in Casagemas' death, since the two of them had set out on that fateful trip to Paris to see the painting hanging in the Spanish section of the *Exposition Universelle*.

Picasso's decision to scrape off the earlier painting and reuse the canvas was partly an attempt to save money; large canvases were expensive, and he was still short of funds. It was also true that he'd grown enormously as an artist over the last four years and probably saw no need to preserve that embarrassing reminder of his more callow self. But it's impossible to believe that expunging this gloomy deathbed scene did not also fulfill a psychological need: to bury the past and finally lay to rest the ghost of a friend whose tragic end still haunted him.

La Vie (Life) [see color insert], the great masterpiece of his Blue Period, was painted over the older image in May 1903 and sold almost immediately, as a puff piece from the June 4 edition of *El Liberal* proclaimed:

> Pablo Ruiz Picasso, the well-known Spanish artist who has had so many successes in Paris, has recently sold to the Parisian collector M. Jean St.-Gaudens for a considerable sum of money one of his latest works, a picture belonging to a new series that this talented Spanish artist has been producing recently, to which we shall shortly be devoting the attention it deserves. . . . The picture acquired by Jean Saint-Gaudens is entitled *Life* and is one of those works which, even when considered separately from the rest of his output, are enough to consolidate any artist's name and reputation. The subject, moreover, is interesting and thought-provoking, and the artist's work so forceful and intense that it may well be asserted that it is one of the few really important works executed in Spain for some time now.

The article, written by Picasso's friend Carles Junyer Vidal, gives no indication of who the mysterious Saint-Gaudens was or how he had found out about this painting by a relatively obscure artist in far-off Barcelona, though it does offer an intriguing suggestion that Picasso's name was becoming known outside a small circle of friends.

La Vie, like *Last Moments*, was one of those large set pieces that Picasso produced at intervals throughout his career. It involved careful planning, including dozens of preparatory sketches in which he tried out various themes and compositions. These more deliberately plotted works stand in contrast to his frequently slapdash efforts, providing an opportunity to take stock after a period of experimentation. Though Don José almost always provided a negative example for Picasso, one of the lessons from his father that he took to heart was the importance of the Grand Statement. In Picasso's hands, however, the authoritative Salon machine usually carries a subversive message that parodies the tradition from which it derived. These monuments—including *Les Demoiselles d'Avignon* and *Guernica*[*]—impart a rhythmic ebb and flow to Picasso's career, as periods of restless searching, of breathless creativity, false starts, and fruitful accidents, all seem to lead inexorably to the climactic statement. Collecting his scattered thoughts, he pauses to sum up; intuition is replaced by more systematic analysis.

Often a more cerebral approach can drain life from an artwork by substituting sterile ideas for the serendipitous meeting of mind, medium, and motif. Picasso was well aware of the danger, warning that too much thought could suffocate spontaneity. For all its undeniable power, for instance, *Guernica* suffers from a kind of airlessness, a sense that by the time he got to work on the enormous canvas, most of his passion was already spent.

La Vie suffers from a similar defect, though Picasso allows enough of his restless searching to show through to keep the work fresh. The handling of paint remains sensitive, seeking out form rather than merely offering up the ashes of a preconceived idea. Rescuing the work from arid philosophy is the fact that the painting remains unresolved, indeed unresolvable, its function as allegory undercut by the impossibility of fitting

[*] In addition to *La Vie*, one could also add to this list *Family of Saltimbanques*, the great Rose Period masterpiece. The series, based on Velázquez's *Las Meninas* of 1656, might also be seen in this light, an extended theme and variation in which Picasso celebrated and satirized the great masterpiece of the Spanish Baroque.

the various elements into a coherent scheme. This places *La Vie* within the wider context of Symbolism, a movement with an affinity for misdirection and mystification.

In fact, the painting is something of a pastiche, a compendium of themes and motifs taken from other contexts: the embracing couple on the left is heir to those Steinlen-inspired couples Picasso depicted on his first trip to Paris, now translated into the less gritty, more idealized, idiom of the Blue Period; the two paintings (or drawings) at the center, one showing a nude couple, the other a crouching figure, both owe a debt to Gauguin's magisterial *Where Do We Come From? What Are We? Where Are We Going?*, which he'd seen in Vollard's gallery; the mother and child at the right are plucked straight off the seashore of his recent works and set down in this new context.

Given this mix-and-match approach, the surprising thing is how well the painting holds together. Unifying the composition is a pervasive sense of mystery, of strange rituals and unfathomable secrets. On the most obvious level, *La Vie* represents the Ages of Man, the journey from birth (embodied in the mother with her infant child) to procreative maturity (in the young couple) and finally to old age (in the crouching figure, who seems bent under the weight of years). But within this obvious narrative lurk more perplexing subtexts. The peculiar pose of the male figure—an idealized portrait of Casagemas—seems fraught with inscrutable significance. He points with his left hand, but at what we cannot tell; the rhetorical gesture seems unmoored, conveying arcane knowledge, perhaps the Secret of the Dead that must remain forever just beyond our grasp. We know from preparatory drawings that Picasso had originally conceived the figure as a self-portrait in the traditional pose of the occult magus Hermes Trismegistus. With his right hand pointing upward, his left down, Hermes embodies in his pose the mystical formula "As above, so below"—that is, Heaven and Earth move in harmony, impelled by the same deep forces, so that one can read one by the light of the other. Or, to put it another way, that our fate does indeed lie in our stars.

This notion appealed to the superstitious Picasso, who, like our Stone Age forebears, saw magic in form and meaning in coincidence. This predisposition had been encouraged by Max Jacob, and over the next few

years many of the poses and gestures Picasso will employ in his paintings owe their potency to the occult and to the Tarot deck that Max always carried with him. What invests these gestures with even greater power is that Picasso does not surrender to simple formulas. In *La Vie*, the male figure hides his right hand behind his lover (Germaine?), creating a deliberate ambiguity. Here, the example of Gauguin looms large. One of the lessons Picasso absorbed by osmosis from the madman of the South Seas was that obfuscation can convey profound truths far more effectively than pat solutions.

The paintings Picasso completed during his final stay in Barcelona possess a noble grandeur at odds with their subject matter, a disjunction that aestheticizes poverty. Deprivation does not provoke our outrage or even our sympathy. These spectral figures inhabit a timeless landscape, forming a sacred tableau in which suffering is the sign of holiness, emaciation the outward manifestation of a retreat into pure spirit. The deliberately artificial poses and spare geometry derive in part from Puvis de Chavannes, whose murals in the Pantheon Picasso copied during his last stay in Paris. From *The Soup* to *The Blind Man's Meal*, from *La Vie* to *Poor People on the Shore (The Tragedy)*, he shows a preference for monumental compositions fashioned from a few figures as solid and imposing as Doric columns. Despite their often emaciated bodies and their austere surroundings, his men and women play their larger-than-life roles with the stoic dignity of actors in a Greek tragedy.

Picasso will tap into this same vein at numerous times throughout his protean career, conjuring up idylls of static perfection, harmonious landscapes dedicated to reason. His most sustained dialogue with the classical mode—in which he pays homage not only to the ancient past but to the great French tradition of Nicolas Poussin, Jacques-Louis David, and Jean-Auguste-Dominique Ingres—occured in the years following the First World War, when the trauma of that catastrophe caused not only Picasso but many of his fellow modernists to fall back on a reassuring vocabulary conveying eternal verities. But each time that Apollonian mode would be rudely interrupted by an even more potent Dionysian impulse, like a riot (or an orgy) breaking out in a Roman piazza, sending columns

tumbling to the ground and exposing the savage forces seething beneath civilization's thin veneer.

In addition to themes of hunger and marginality, in those paintings Picasso explores that most fraught subject for an artist: blindness. Perhaps the theme was suggested to him by the experience of living once again with his father, whose resentment at the world was exacerbated not only by his disappointed hopes but also by his failing eyesight. Indeed, the bearded protagonists of *Old Jew and a Boy* and *The Old Guitarist* both resemble the aging Don José. But it's clear that Picasso, an artist famous for his hypnotic eyes, the *mirada fuerte*, saw himself in these men with empty sockets. In his most famous etching, *Minotauromachy* (1935), Picasso depicts himself in the guise of a blinded Minotaur led across a blighted landscape by a young girl with a candle. Here the powerful beast, at once ferocious and pathetic, is forced to rely on the kindness of those upon whom he once preyed. It's an image of strength reduced to impotence; the loss of sight is equated with the loss of sexual prowess. Picasso once said, "There is in fact only love that matters. Whatever it may be. And they should put out the eyes of painters as they do of bullfinches to make them sing better." Identifying the act of love and the act of looking—a theme he often explored in images of an artist ravaging his model—Picasso paradoxically claims they are in fact polar opposites, that real potency is gained only through loss. The true artist deploys *insight*, the reverse of externally directed sight, which is deceived by superficial appearance.

These paintings are also the product of superstitious dread. By depicting blindness, perhaps he could deflect the anger of the gods, who, as legend teaches us, are jealous of any gift that rivals their own.

After a year in Barcelona, Picasso was ready to move on. Once again, Sabartés, sitting for yet another portrait, is witness to his friend's rebirth:

> From his experiments he had learned what he could do with blue, and now he wanted to discover to what extent he could dispense with it. Evidently, he was on the eve of an evolutionary change. But for this he must change his environment, breathe another air, speak

another tongue, change the conversation, compare his ideas with those of others, see new faces and adopt a new way of life; to begin all over again and to throw himself once more, into the arms of destiny, even if that meant suffering, in order that he might free himself of the burden which oppressed him and to do something else, or even the same thing in a different way.

He must return to Paris; and this time for good.

Writing in *El Liberal* in March 1904, Carles Junyer Vidal gave voice to Picasso's frustration with his native land. "Few, very few," he wrote, "have such honesty in Art. His ability is astonishing and, if he so wishes, he could produce and sell many works. But he sacrifices himself and refuses to please the philistines, unlike all the others who, cynically, consider Art is just a trade or a pastime which anyone can do. Remember that Picasso's work cannot be compared to anything else produced in this country. It stands apart. . . . Picasso will return very shortly to Paris. There he will be properly judged."

Picasso had simply outgrown Barcelona. The city offered comfort and security but not an audience capable of understanding what he was trying to achieve. Worse, it failed to provide the stimulus he needed to grow as an artist. For all his imaginative power, he was not someone who thrived in a vacuum. He needed to be goaded by rivals as hungry for fame as he was himself, brilliant men from other disciplines who could challenge him with ideas drawn from unfamiliar sources and offering unfamiliar perspectives. Most of all, he needed to feed off the excitement of a metropolis that was the vital center of all that was innovative in art and literature.

He'd been contemplating the move for months but sprang into action only when he heard of a studio for rent in Montmartre that would fit his needs. It was the one recently occupied by Paco Durrio. The sculptor was moving to a nearby building with land where he could construct a kiln to fire his ceramics and was always happy to help his fellow Spaniards make a go of it in the French capital. The studio he was vacating was located in the old Maison du Trappeur, where Gauguin had spent some time and that had long been a center of bohemian life.

A year or two later Max Jacob would rename this ramshackle building on the slopes of the Butte the "Bateau Lavoir." Under that name it would go down in history as a holy shrine of the avant-garde, ground zero of that potent, radioactive, disruptive religion known as modernism.

The Square of the Fourth Dimension

Blue-Period Square, Saltimbanque Square, Cubist Square—why not?—even a fascinating square of the Fourth Dimension.

—ANDRÉ SALMON

I n the spring of 1904, the art world in Paris—and in the rest of the world dazzled by the beams radiating outward from the City of Light—seemed set in its ways. Even the clash between the cultural establishment and the avant-garde had settled into a predictable pattern, with conservatives and radicals lobbing rhetorical shells into the opposing trenches, but with few casualties and little hope of advance or retreat.

It's no surprise that the conservative forces were stuck in place; immobility, after all, is the conservative's guiding principle. More surprising is the fact that the avant-garde had made little advance in recent years. One sensitive observer lamented that he was living through "a period of transition . . . in which nothing definitive is being created."

Part of this was simply a matter of being too close to the trees to see the forest, but there was more to the sense of stagnation than a lack of perspective. The great artists who'd come of age in the previous decades were

mostly gone from the scene or pursuing their own courses far removed from the daily tumult of Paris: van Gogh had died in 1890 of a self-inflicted gunshot wound, Seurat a year later of a viral infection; Toulouse-Lautrec had passed away in 1901, at the age of thirty-six, his life cut short by alcoholism; Gauguin had died in May 1903 after many years of self-imposed exile in the South Seas. Of the great quintet lumped under the unhelpful label of Postimpressionism, only Cézanne remained, but the pictorial experiments he was currently engaged in were taking place in far-off Aix-en-Provence, many miles and worlds away from the capital. Rumors that this taciturn and reclusive man was up to something remarkable were whispered whenever progressive critics and artists got together, but his apotheosis was yet to come.

Of course, there were plenty of talented, even brilliant, artists making their careers in Paris, showing in the galleries and the alternative salons, including the chaotic free-for-all of the Salon des Indépendants and, starting in 1903, the more rigorously curated Salon d'Automne. Many of the great Impressionists, including Renoir and Monet, continued to work, transforming the sparkle and dash of their earlier painting into an art that could stand beside the grand monuments of the past. But for the most part progressive artists had moved beyond Impressionism. Many in the next generation, themselves now mostly approaching middle age, were drawn to Symbolism, which was less an organized movement than a sensibility, with roots in literature as well as the visual arts and defined by a preference for the mystical and melancholy that could provide nourishment for the spirit in a materialistic age. Uniquely, Symbolism straddled the worlds of official art—embracing painters like Puvis de Chavanne, Rodin, and Gustave Moreau (Matisse's first teacher)—and the avantgarde, with artists like van Gogh and Gauguin accommodated beneath its broad roof. It's into this context that Picasso's Blue Period works fit most comfortably, with their timelss reveries, their deliberate ambiguity and melancholy cast, their evocation of spirit over matter. But Symbolism was an awkward banner under which to march into the new century: it was too neurotic, too idiosyncratic, too dependent on literary sources, many of which were frankly nostalgic for an earlier time, to speak to the future.

\\\

If one were to magically transport the patrons crowding one of the independent salons in 1904 to a similar venue in, say, 1909, even those who flattered themselves on their ability to spot the latest thing would have been shocked by what they saw. Picasso himself, had he been offered a crystal ball (perhaps by Max Jacob, who dabbled in such occult practices) and glimpsed the work he would be producing five years later as he prepared to leave the Bateau Lavoir, would have been equally perplexed. From the perspective of 1904, the work of 1909 was simply incomprehensible, visual gibberish, an offense against art itself; he might well have sided with those many critics who proclaimed that what he and his colleagues were engaged in was nothing more than an elaborate hoax. There was simply no way to predict a Picasso or Braque Cubist still life of 1909 from the work that preceded it; this was not evolution but revolution, as profound and disturbing a dislocation as has ever occurred in the history of art. As John Golding put it in his classic account of the movement:

> Cubism was perhaps the most important and certainly the most complete and radical artistic revolution since the Renaissance. New forms of society, changing patronage, varying geographic conditions, all these things have gone to produce over the past five hundred years a succession of different schools, different styles, different pictorial idioms. But none of these has so altered the principles, so shaken the foundations of Western painting as did Cubism. Indeed, from a visual point of view it is easier to bridge the three hundred and fifty years separating Impressionism from the High Renaissance than it is to bridge the fifty years that lie between Impressionism and Cubism. If social and historical factors can for a moment be forgotten, a portrait by Renoir will seem closer to a portrait by Raphael than it does to a Cubist portrait by Picasso.

When Picasso arrived in Paris in April 1904, he was still only twenty-two but already a hardened veteran of those struggles with poverty, hunger,

and neglect that test an artist's commitment to his calling. Three times now, he'd been forced back home, defeated, humiliated, questioning himself, and resentful that the world refused to acknowledge the genius he felt certain he possessed. This time his eagerness was tempered by a realistic sense of what he was up against. Dreams of instant fame had given way to grim resolve, a more mature outlook that would allow him to put any setback into perspective.

On this occasion his traveling companion was Sebastià Junyer Vidal, who was embarking on exactly the kind of halfhearted attempt to set himself up as a painter that Picasso must have known was doomed to failure. Picasso's *alleluia* commemorating the voyage shows the flamboyantly mustachioed Sebastià selling a painting to the dealer Paul Durand-Ruel for a sack of money. But this was just a joke on Picasso's part; after only a few weeks, Junyer Vidal was back in Spain, having discovered bohemia a little too rough-and-tumble for his taste.

One sign of Picasso's determination to settle permanently in Paris was that he brought along his dog, a mongrel with the incongruous name Gat (Cat) given to him a few months earlier by Miquel Utrillo. Picasso loved animals and for the rest of his life would surround himself with a menagerie that, like his multiple mistresses (past, current, and future) and his ever-growing accumulation of mementos, bric-a-brac, scraps, and just plain junk, offered a buffer against the demon-haunted world. That faithful companion would provide at least minimal protection against the psychic blows that were sure to come his way.

Moving into the Bateau Lavoir, near the top of the Butte Montmartre, Picasso was ensconcing himself in the heart of bohemian Paris, ground zero of the worldwide avant-garde. At the dawn of the twentieth century, the geographical, economic, and conceptual borders of this world were already fairly well established. From the Latin Quarter to Montparnasse to Montmartre, long-haired artists, poets, and anarchists lived alongside indigents, seamstresses, and day laborers, taking advantage of the low rents, cheap food, and loose morals of these marginal neighborhoods to pursue a lifestyle freed from convention.

The writer Félix Pyat had coined the term "bohemian" seven decades earlier, and in 1849 Henri Murger had given it universal currency with his *Scènes de la vie de bohème*, the basis of Puccini's even more famous opera.* Living by "other ideas and other behavior," Pyat wrote, "isolates them from the world, makes them alien and bizarre, puts them outside the law, beyond the reaches of society. They are the Bohemians of today."

For decades Montmartre had been the preeminent center of bohemian life. "Montmartre the free city," proclaimed Rodolphe Salis, the proprietor of Le Chat Noir, "Montmartre the sacred hill, Montmartre the germ of the earth, navel and brain of the world, the granite breast at which generations in love with an ideal come to slake their thirst." Its reputation for loose living reached back at least to the eighteenth century, when the village lay outside the municipal walls and, thus, just out of reach of the municipal tax collector. The availability of cheap liquor encouraged the proliferation of taverns, along with the associated vices of prostitution, gambling, and petty crime. This seedy underworld coexisted uncomfortably with an even older one, a world of saints and relics, pious monks and cloistered nuns. As the name suggests (Montmartre is the "Mount of Martyrs," the supposed site of Saint Denis' beheading by a pagan mob in the Dark Ages), the hillside was a destination for pilgrims, home to numerous monasteries and abbeys, each with its cache of sacred relics; it was these pious institutions that had erected the windmills that dotted the crest of the hill and gave Montmartre its distinctive silhouette.

The steep slopes that made the village unsuitable for the urban improvement that was transforming the rest of Paris from a medieval city of winding alleys to a modern metropolis of wide boulevards, logically arranged, also gave it a unique place in military and political history. It was in Montmartre that the bloody insurrection known as the Paris

* The term seems to derive from the belief that Bohemia, in eastern Europe, was the ancestral land of the Gypsies and the association of Gypsies with a life outside cultural norms.

Commune began in the spring of 1871. In those delirious weeks the neighborhood's workers formed their own revolutionary government, arming themselves with cannons wrested from the authorities and mounted on the summit to rake the city below. Respectable Paris began to speak of the neighborhood in terms of almost superstitious dread. After arresting "the Red Virgin," Louise Michel, a charismatic leader of the Montmartre Vigilance Committee, the authorities quickly backed down, whispering among themselves that unless they released her, "Montmartre is going to descend on us." Once the insurrection was suppressed, with atrocities on both sides, the forces of reaction hoped to bury that sorry chapter beneath the snow-white vaults of a new pilgrimage church, the Basilica of Sacré-Coeur, a monument intended to atone for the supposed crimes of the godless Commune.

By the turn of the century Montmartre's radical reputation was sustained largely by the neighborhood's anarchists. For the most part, however, these utopian dreamers had renounced the violent propaganda of the deed for the less explosive propaganda of the word. The offices of *L'Anarchie* and *Le Libertaire* were located on the rue d'Orsel, on the southern slope of the Butte, and other fly-by-night publications sprang up nearby, only to disappear just as quickly.

The Bateau Lavoir itself had been a nest of radical conspirators until the police cleared them out in the last years of the nineteenth century. In a sign of the changing times, many of these now-vacant rooms were taken over by Symbolist painters. There was a mutual attraction between avant-garde artists and anarchist agitators, since both hoped to free the individual conscience (or consciousness) from all authority. Many painters and sculptors, including perhaps Picasso himself, were nominal anarchists, while others, like the Fauvist painter Kees van Dongen, actually contributed their talents to anarchist publications.

Not everyone who found a congenial home in Montmartre was a radical. Many of the Impressionists lived and painted in its streets and gardens, attracted by the low rents and a rustic charm unmatched in the rest of Paris: Renoir lived here for many years, painting pretty Montmartrois girls whirling on the floor of the Moulin de la Galette; Cézanne and van Gogh were frequent visitors; and Degas lived at the foot of the hill, across

the street from Berthe Weill's gallery. "Montmartre is a small provincial town at the gates of Paris," wrote the critic Champfleury in 1860, "no traffic, no police, no people in the quiet streets, small houses set in gardens, little shops that smell of the country."

Montmartre's charm drew writers as well as painters. Gérard de Nerval, who lived here in the 1840s, left a detailed description: "There are windmills, cabarets and arbors, rustic paradises and quiet lanes, bordered with cottages, barns and bushy gardens, green fields ending in cliffs where springs filter through the clay, gradually cutting off small islands of green where goats frisk and browse on the thistles that grow out of the rocks; proud, surefooted little girls watch over them, playing amongst themselves. You may even find a vine, last of the famous Montmartre vintage which from Roman times vied with Argenteuil and Suresnes."

There was, in fact, something incongruous about it all, a disjunction between the writers and artists who took refuge here and the rural setting that seemed to belong to an earlier century. The art critic André Warnod, who arrived in Montmartre just as Picasso and his band were leaving, marveled that the most radical art flourished in an environment characterized by old-fashioned charm:

> It is, in fact, entirely paradoxical that, against the ruined backdrop of the Butte's tiny streets, so outdated and trampled with withering tradition, a new spirit burst forth, so new, lucid, and bold that it would animate an entire generation of artists and writers. It is absurd indeed to imagine these young men living within the old walls where little blue forget-me-nots of seamstresses and art students still bloomed. . . .
>
> No land was ever more in contradiction with its inhabitants than was this village, which was half in ruins and steeped in sentimentality, vulgarity, nostalgic love, and languid idlers, when Picasso and Derain, Van Dongen, Dufy, Braque, Modigliani, André Salmon, Pierre MacOrlan, Dorgelès, and Raynal lived there and Apollinaire was a frequent visitor. . . .
>
> This is a fact: for ten years, those who contributed the most to creating the new spirit lived in Montmartre.

By the time Picasso arrived, Montmartre had lost some, but not all, of its countrified air. Cottages with vegetable gardens still populated the narrow lanes, hemmed in by stone walls, ivy-clad and overtopped by flowering wisteria. But these charming byways were slowly being consumed by the encroaching city. The steady advance of urban structures and urban manners had brought about changes that were not only physical but social and moral.

Montmartre, in short, was a world in transition. In 1900, the Funiculaire de Montmartre was opened, making it easier to reach the heights of the Butte. Along with motorized taxicabs, the new technology roused the hamlet from its sleepy isolation, bringing an influx of tourists attracted by the cheap eateries and lively cabarets, as well as the *frisson* of danger that still clung to the hillside.

For foreigners coming to Paris to enjoy diversions unavailable back home, the *Guide Rose* provided an itinerary of illicit pleasures. Many of them clustered in and around the foot of the Montmartre. Enterprising businessmen soon learned how to commodify the vices for which the Butte was already infamous, not only sex and alcohol but also opium, smoked in the privacy of one's home or in one of the neighborhood's dark, drowsy, decadent *fumeries*. At the base of the hill, along the boulevards de Clichy and Rochechouart and in the place Pigalle, was a seething border region, a kind of no-man's-land between the respectable city, given over to commerce and productive work and the heights of the Butte, dedicated to freedom and the indulgence of the senses.

The inhabitants of each zone regarded their counterparts warily, but they knew that neither could survive without the other. Those descending the hill required the money and craved the attention of the respectable businessmen they claimed to despise, while these pillars of society needed a way to blow off steam, a bit of naughty fun to console them for the drudgery of their workaday lives. The two worlds came together in venues like the Moulin Rouge, where the Catalan entrepreneur, Josep Oller, created an atmosphere of fevered sexuality in billowing crinoline and peek-a-boo glimpses of naked flesh. Here "La Goulue" (The Glutton, a favorite subject of Toulouse-Lautrec) was the star attraction. According to the magazine *Gil Blas*, "she allows the spread of her legs to be glimpsed through the froth of pleats and reveals clearly,

just above the garter, a small patch of bare skin." A few doors down was the cabaret L'Enfer (The Inferno), whose entrance was a devil's gaping maw and where the stage show featured scenes of bondage and stylized torment.

Not all the entertainment was equally low-brow, but even the most vulgar display could plant the seeds in the mind of an adventurous artist for a radical breakthrough. The avant-garde flourished at the chaotic intersection of sophistication and crudity, a territory explored imaginatively by Picasso himself who knew that the more esoteric his work became the more he needed to bring it back down to earth with a well-placed scatological joke or sexual pun. The cabarets at the foot of Montmartre were the laboratories where high and low were first brought together like particles careening in a nuclear accelerator, generating unexpected new elements.

Humor was often the catalyst that allowed these incommensurates to merge. The pioneer in this regard was Rodolphe Salis, proprietor of Le Chat Noir. Until his death in 1897, his cabaret provided a space where the *haut monde* and bohemia could mingle in a spirit of gentle mockery. Here avant-garde poets declaimed before audiences more inclined to laugh than to analyze. "People went to that cabaret of Salis's because it was the thing to do," said one cynical observer, "as they might go to the zoo, with the hope of catching a glimpse of a strange beast or two; one felt that the real purpose of those displays of art was business, lucre." The ironic *fumisme* of Le Chat Noir took on a harder edge at Le Mirliton, the cabaret, according to its proprietor and star attraction, Aristide Bruant, "to visit if you want to be insulted." Le Mirliton was the most famous, but there were dozens of other establishments where bankers and clerks could go to listen to ballads of love, loss, and impossible redemption served up in the distinctive patois of the working-class residents.

Another establishment that straddled the world of low and high and created heat from the friction between the two was the Cirque Medrano on the boulevard Rochechouart. This form of entertainment played in the same dangerous territory as the Moulin Rouge, mixing raw physicality, sweat, agility, artistry, and titillation. Its performers, like the high-kicking

cancan dancers, were marginal figures, celebrated for their physical prowess but looked down upon by polite society; they were bohemians of the body, as artists and poets were bohemians of the mind, outlaws and outcasts with a dangerous allure.

And the artists took notice. The circus, like the cabarets and dance halls, offered novel ways of depicting the human body in motion. Many of the leaders of the avant-garde, including Degas, Seurat, and Toulouse-Lautrec, had been regular attendees at the Cirque Medrano (or its predecessor, the Cirque Fernando), reveling in its vulgarity, its brashness, its animal vigor. Picasso went as often as he could afford to, spending many an evening at the bar in the company of the clowns. "He was amused by their odd ways," Fernande Olivier recalled, "their strange accents, their antics." He viewed these antics as an assault on good taste that was similar to his own attack on conventional norms.

The unsavory reputation of the circus made it a natural venue for the newer, but hardly more respectable, art of the cinema. The Medrano capitalized on the popularity of the medium by showing some of the first film reels put out by the Pathé company; another screen was set up in a field in the rue Pigalle. As photography had done more than half a century earlier, movies suggested to artists new ways of seeing, of understanding. Now an image could be conceived in time as well as space. This novel approach posed a threat to traditional modes of representation but an opportunity for those seeking the means to capture the kinetic experience of modern life.

Bohemia always possessed an affinity with vice, even blatant criminality. In fact, the world of the artist, the pimp, and the pickpocket overlapped, since each profession could flourish only in locales where the rules were relaxed but not so remote as to inconvenience potential customers with money in their wallets. At the summit of the Butte, artists staggering back past midnight from their favorite tavern had to contend with the *apaches* lurking in dark doorways, though for the most part their shabbiness discouraged all but the most desperate from attempting a mugging.

While most of Montmartre was poor, there were class distinctions even among the have-nots. Much of the population consisted of day

workers who every morning, unseen by the artists nursing hangovers in their shuttered bedrooms, made their way into the city, the men to the factories or to a variety of odd jobs, the women to the department stores that were a distinctive feature of the modern metropolis. These wage earners constituted the most respectable element. Poor but honest, their work ethic was a reproach (if they were capable of such feelings) to the artists, wastrels, and petty criminals who lived alongside them.

The poorest of the poor were the inhabitants of the Maquis, a wasteland on the northern slopes of the Butte. Here squatters, many of them drunkards and addicts, lived in lean-tos cobbled together with scraps of timber and corrugated metal commandeered from building sites, without heat, running water, or basic sanitation. Rabbits loped among the thistles and were hunted by the locals to supplement their meager diet. Artists too poor to afford even the low rents of Montmartre also found temporary refuge here; Modigliani was among those who made a home for himself in an abandoned shack, to which he imparted an air of culture by decorating it with reproductions of masterpieces and, incongruously, an old piano.

If asked, most of the women of Montmartre referred to themselves as seamstresses or laundresses. Some, like the artist Suzanne Valadon's mother, actually eked out a living plying needle and thread, but many were forced into less respectable lines of work. One option, particularly for the young and attractive, was to hire themselves out as an artist's model. In the place Pigalle at the foot of the Butte, there was a market where painters could hire costumed shepherdesses for their rustic scenes or ladies-in-waiting for a historical tableau. It was here that Puvis de Chavannes met the young Valadon, a former equestrienne at the circus, and hired her to pose as a fetching nymph in one of his Arcadian idylls.

Puvis almost certainly slept with his model, but in this he was no different from his peers.* It was assumed that any woman willing to take off her clothes for a painting was not too squeamish to have sex with the

* There were rumors that Puvis was the real father of Maurice Utrillo.

painter. Picasso himself claimed that he slept with most of his models, and many an artist found himself a mistress or even a wife this way.* The lines between seamstress, artist's model, coquette at one of the neighborhood dance halls, and part-time prostitute were often blurred, a testament not only to Montmartre's liberated mores but also to an exploitive economy that provided few opportunities for young women to make an honest living.

As for the artists themselves, rents were low enough and food sufficiently cheap that it was possible to get by on very little. That may have been the single most important factor in the growth of the avant-garde since it was not absolutely necessary to become a respectable academic painter or take a full-time job just to survive. For those who were not too proud to try their hand at hack work, illustrated magazines like the satiric *Le Rire* and *L'Assiette au Beurre* provided a source of income, as well as a fruitful meeting point between high and low. And despite Picasso's reluctance to pursue this option, doing commercial work was not necessarily viewed as selling out. Honoré Daumier, a hero of the avant-garde, was the foremost cartoonist of his age, and many of the innovative forms that fueled modernism came from the world of advertising. The vigor of Picasso's drawing derived in large part from his talent as a caricaturist, and he was only one of many pioneer modernists inspired by the posters of Mucha, Steinlen, and Toulouse-Lautrec.

On his first trip to Paris, Picasso had often crossed the small, sloping square around the corner from his studio on the rue Gabrielle. Even when he was living at the base of the Butte, on the boulevard de Clichy, he was a frequent visitor since it was there that Frédé opened his grim little watering hole, Le Zut, memorable for its knife fights and the mural Picasso and Pichot had painted on the walls of the cobwebbed room where they congregated. Sabartés described the place Ravignan as a desolate spot

* Renoir's wife, Aline, had begun as his model. When Valadon became his muse, posing for the famous painting *Dance at Bougival,* Aline grew jealous and demanded that he fire her.

where *apaches* lurked in dark corners. Gauguin's friend the artist Maxime Maufra, who moved here in 1892 after abandoning a career in trade to become landscape painter, mapped its irregular contours: "[The place Ravignan]* cuts the street in two and connects the two ends. The difference in levels is such that you can reach it only by climbing a flight of stairs. There are a few benches there and some stunted trees that replaced the beautiful elms that were cut down during the first days of the Commune to make room for the cannons that were set up there."

After the Second World War, when the square was renamed for the poet Émile Goudeau, Picasso's friend André Salmon proposed some alternatives of his own: "But if it hadn't been decided in favor of that, one would have been able to choose: Blue-Period Square, Saltimbanque Square, Cubist Square—why not?—even a fascinating square of the Fourth Dimension." For those who had been there during those heroic days fast slipping into legend, a golden haze hung over the quaint little square, unmoored in time if not in space.

The reality, of course, was made of far grittier stuff than memory: discomfort, anxiety, even terror were the norm for residents who couldn't know what the future held or, too often, where their next meal was coming from. The square itself was little more than a slum, made somewhat more tolerable by the fact that many of its bohemian residents were poor by choice rather than necessity. By the time Picasso came along, the trees had grown, providing welcome shade so that on hot summer days everyone gathered around the fountain, much as they might in a rustic village in his native Spain.

Along the western edge of the square was an inexpensive lodging called the Hôtel du Poirier. Named for the large pear tree in front, to which, according to legend, Napoleon had once tied his horse, it was home to artists who paid 1 franc a day for the privilege of a small room that could serve as both living quarters and studio. Immediately adjacent to the "hotel" was a low facade of rubble and crumbling plaster, lopsided

* In those days, the place where rue Ravignan widened was not even dubbed a square. After being elevated to place Ravignan, it was later designated the place Émile-Goudeau after a poet who had lived there.

like everything else on this lopsided square, that served as the entrance to a bizarre labyrinth of timber and glass.

To the locals, 13 rue Ravignan was known as the Maison du Trappeur (Trapper's House), apparently because its ramshackle appearance conformed to their notion of a log cabin in backwoods Alaska. The name suggests something exotic, as if the building didn't really belong in Europe's most sophisticated city but rather in some remote, uncivilized corner of the world where men and women lived according to barbaric customs and anything was possible. Later dubbed the Bateau Lavoir (Laundry Barge) by Max Jacob (or possibly André Salmon), that more homespun name stuck, indicating perhaps that, no matter how strange the goings-on or how eccentric the inhabitants, this bizarre menagerie was actually characteristic of the local ecosystem.

Originally built as a piano factory, the building had been taken over in the 1860s by a locksmith, whose initials, MFS, were still spelled out in wrought iron over the central doorway. In 1889, as the Butte became a haven for bohemian refugees from the city below, the landlord decided that he could earn more by subdividing the warehouse-sized spaces into smaller units. Since prospective renters were unlikely to be wealthy and

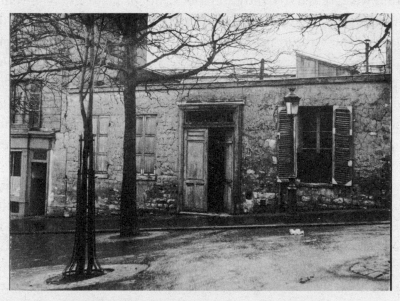

Bateau Lavoir. © *RMN-Grand Palais / Art Resource, NY.*

couldn't afford to be picky, he had done the job on the cheap, ignoring the peculiarities of topography in an effort to maximize usable space.

Entering through a battered door on rue Ravignan, visitors found themselves on the topmost floor. The rest of the building fell away down the hillside, a plunge negotiated via three irregular flights of stairs. At the bottom was another doorway. This one led into a narrow courtyard on the rue Garreau. Here was the building's only bathroom, a filthy hole in the ground with a door that wouldn't lock and banged in the wind, making life miserable for those unfortunate enough to be relegated to one of the basement apartments. Here, too, was the faucet that provided the only source of running water. For those like Picasso with a studio on the top floor, it was usually easier to fetch water for bathing or cooking from the fountain in the square.

The corridors were dark and dank; they ran off at eccentric angles and ended abruptly in stairwells that appeared to lead nowhere in particular. Even with space at a premium, odd gaps remained; alcoves, perhaps meant as air ducts, opened unexpectedly, posing a hazard for the unwary. Shortly before Picasso arrived, one such chasm swallowed up a German painter who fell to his death while trying to shovel snow from his roof.

Despite these peculiar voids, most of the residents in the thirty-odd studios were packed so tightly and the partitions between them were so flimsy that it required little imagination to figure out what was happening in your neighbor's apartment. Violent quarrels and the amorous reconciliations that followed were common property, to be shared at the fountain in the square on a lazy afternoon. And for the price of 15 francs a month (half what it cost to rent a room at the Hôtel du Poirier next door), one could expect few creature comforts. "The studio was a furnace in summer," recalled Fernande Olivier. "In winter, it got so cold that whatever was left in the tea cups would freeze overnight."

In addition to the "painters, sculptors, literary men, humorists, [and] actors," there were members of the laboring class, "washerwomen, tailors and peddlars." One of the residents was a peasant in a peaked Breton hat who styled himself "Sorieul, Farmer." His claim to agricultural expertise consisted of stocking a basement storeroom with carrots, onions, and a few wilted spears of asparagus. From time to time he added to this menu mussels of uncertain provenance rinsed off under the tap by the toilet.

Sorieul, who was older than most of the other inhabitants, shared a room with his alcoholic son, who became a butt of Picasso and his friends and ultimately gained immortality as a character in the avant-garde ballet *Parade*.

Most of the others, however, were young men with some pretension to a higher calling and the various women—a wife or two, assorted mistresses, and models who came and went in rapid succession—who were willing to put up with the squalor in order to be close to genius. The building's legendary status as a home of the muses dated back at least a decade, when Gauguin, just returned from his first trip to Tahiti and paying a call on his friends Maxime Maufra and Paco Durrio, went "knocking on all the doors, bringing the word of the gospel: 'Ye shall be a Symbolist!'"

Renoir had rented a studio here for a brief time, as had the poet Paul Fort, the founder of the experimental Théâtre d'Art. Since his room was inadequate to his professional needs, many of the sets for his productions of Maurice Maeterlinck, Henrik Ibsen, and August Strindberg's plays were painted outside in the square, with the local urchins being given a paintbrush and lending a hand. Shortly before Picasso arrived, Fort abandoned Montmartre for Montparnasse to edit the Symbolist magazine *Vers et Prose* and organize the literary evenings at the Closerie des Lilas that soon became a mainstay of avant-garde Paris.

Presiding over all these comings and goings was the concierge, Mme. Coudray, who lived next door with her husband, a tailor. She looked after her charges with motherly concern, offering a bowl of hot broth to any in her care who had nothing else to eat. "Bent, young and old, harsh, brisk, intelligent—she loved us," remembered Max Jacob. For Picasso, who often worked all night and slept until noon, she performed the additional service of receptionist, screening out anyone she deemed unworthy of his attention. Only if she had determined that the visitor was prepared to buy something would she let him in, shouting "M'sieu' Picasso, M'sieu' Picasso, you can open up, this is a serious visit."

When Picasso moved into the Bateau Lavoir in April 1904, many of the residents were Spanish or Catalan. Ricard Canals, a friend from Els 4 Gats, had a studio there, which he shared with his wife, the beautiful model

Benedetta, as did Joaquim Sunyer, also a native of Barcelona, who would soon begin an affair with another artist's model, a statuesque auburn-haired beauty known about the building as "la belle Fernande."

Paco Durrio's large, run-down studio was almost completely empty when Picasso took possession. The only piece of furniture was a tiny trundle bed, which was claimed by Sebastià Junyer Vidal since he had been stuck with the monthly 15-franc rent. In addition, the always hospitable Durrio had bequeathed them a roommate, a flamenco guitarist named Fabián de Castro, who, for the first few days at least, shared the floor with Picasso.

The studio was located on the top floor at the back, at the end of a long, dark corridor. It consisted of two rooms, one large and well lit with blackened beams, leaky windows, and oozing walls, the other merely an alcove that friends ironically dubbed "the maid's room."

For the first few weeks, three men shared the almost empty studio, Picasso and the flamenco guitarist sleeping on a bit of carpeting Durrio had left behind. By early May, both roommates were gone—Junyer Vidal back to Spain, the guitarist to another apartment in the neighborhood—and Picasso set about furnishing the place with a few items purchased for 8 francs from his friend Pablo Gargallo, who was heading back to Barcelona. Since Gargallo lived in Montparnasse, Picasso hired a handcart and, with the help of the sculptor Manolo and a half-starved street waif they picked up along the way, lugged the furniture across the river and up the steep hill to the rue Ravignan. Picasso promised the youth 5 francs for his efforts, but when they arrived he admitted that this was all he had left in the world. Instead of paying him, Picasso bought the three of them dinner, a small compensation for having cheated the boy out of his fee.

Though hardly a glorious introduction to Montmartre, this little swindle was a fitting entrée onto the stage of bohemian life, which was characterized by expedients lying somewhere between knavery and outright criminality. Murger, in his *Scènes de la vie de bohème*, describes many a daring midnight getaway to skip out on the rent and chronicled the thousand and one deceits to avoid picking up the tab. Manolo (who may well have encouraged Picasso) was already a master of petty larceny. A ruse he employed on numerous occasions was to organize a raffle for a sculpture for which no one ever seemed to draw the winning number. Once he managed

to make off with Max's only pair of pants, returning them when he learned that they were so shabby that even the secondhand clothes dealer refused them. His most daring bit of thievery came at the expense of the trusting Paco Durrio. During one of his extended stays in Spain, Paco hired Manolo to look after his studio. When he returned, he discovered that his prized Gauguins were missing. He confronted the resourceful house sitter, who blandly replied, "I was dying of hunger. . . . I didn't have any choice: it was my death or your Gauguins. I chose your Gauguins."*

If Picasso was less of a con man than Manolo, he was certainly adept at sponging off his friends, many of whom were only too happy to contribute to nurturing the genius in their midst. When desperate, he was not above a little bit of petty theft himself. But it was not only need that drove him to such shady practices. Living by one's wits, skirting both the spirit and the letter of the law, was one of the lures of the bohemian life. There was a rebelliousness in Picasso, an instinctive contempt for propriety, that compelled him to shock the respectable. He was attracted by Manolo's roguish charm and shared his belief that artists shouldn't have to follow the narrow morality of the bourgeoisie. Attending Casagemas' salons back in Barcelona he had been exposed to the writings of Nietzsche, and he subscribed to the philosopher's notion that great men were not obliged to obey laws meant for mere mortals. Once, when all the seats on a bus were taken, he startled his traveling companion with a telling outburst: "This is not the way it ought to be. The strong should go ahead and take what they want." His attitude is characteristic, but so is the fact that it was merely *attitude* and not followed up by action. In theory, at least, almost any expedient was permitted if it allowed one to pursue one's art, the only thing that really mattered. Ultimately, however, Picasso had too strong an instinct for self-preservation to take it to extremes.

Sitting for his latest portrait, shortly before Picasso's departure for Paris, Sabartés thought he detected new notes of color peeking through the

* He'd sold them to Ambroise Vollard, who returned them when he discovered they'd been stolen.

The Frugal Repast, 1904.
Art Resource, NY.

pervasive blue, hints of pink and gold that suggested the first thaw after a long winter of discontent. Despite Sabartés' claim that the portrait marked a new epoch in Picasso's art (like the earlier portrait, which had supposedly ushered in the Blue Period), the work Picasso completed during the first few months in his new home continued in very much the same vein as before. There is the same icy tonality, the same wretched cast—if anything, now more wretched than ever. In August, when Fernande Olivier first had a chance to see his art, she noted the "morbid" tone of the work. "I was struck by one painting in particular," she recalled,* ". . . a cripple leaning on his crutch carrying on his back a basket of flowers. The man, the background, everything was blue except for the flowers, painted in fresh, brilliant tones. The man was pale, thin, miserable, his look one of melancholy resignation. A strange scene, tender, infinitely sad, one steeped in hopelessness, a mournful cry for human pity."

The other work she recalled from that initial visit was the famous etching known as *The Frugal Repast*, depicting an emaciated couple sharing a

* The painting no longer exists. Fernande believed he painted over it, as he often did, since he was too poor to buy additional canvases.

meager meal. Here Picasso has carried the mannerist attenuation of form he learned from El Greco to an extreme; fingers are as long and thin as twigs on a barren tree, cheeks hollow, bodies little more than taut membranes stretched over a bony armature. The empty bowl and half-filled glass before them serve only to heighten the sense of utter destitution. The figures possess a stark beauty that is heightened by the sense of quiet desperation, and the entire image is so impeccably wrought that one is seduced rather than appalled.

The Frugal Repast, only Picasso's second etching, already shows his complete mastery of the graphic medium in which he would create some of his greatest works.* The unusual polish of this work is due in part to the fact that he regarded it as a commercial venture. He sent one version to Sebastià Junyent in Barcelona with the expectation that he would be able to make a few sales. In the end this came to nothing. "It seems to me you will sell many in Paris," Junyent wrote back, "but here it will be more difficult; you know the kind of work they like here" — more proof, had Picasso needed any, that he'd been right to leave his hometown behind.

Close to the *Frugal Repast* in mood and in style is his *Woman Ironing*. The subject came from Degas, who painted numerous versions of the laundresses who were a common sight in Montmartre and other working-class neighborhoods, but while Degas, in keeping with his realistic bent, stressed the tedium of the labor, Picasso invests the mundane chore with timeless dignity. Stoic, oppressed, but ultimately heroic, this gaunt figure is an urban Madonna, standing for the countless millions who toil in obscurity but are sanctified through suffering. Here, perhaps for the first time, we can detect faint glimmers of a new dawn. Though Picasso's working-class martyr is no less undernourished than her Blue Period sisters, his palette has begun to shift from gelid aquatic hues to warmer ochers that suggest a grudging sunlight penetrating the gloom.

* The first, *El Zurdo* from 1899, shows a picador with his lance in his left hand, since he forgot that the image would be reversed in the printing. He acquired the skills he needed with the help of Ricard Canals, his friend from Barcelona and now neighbor in the Bateau Lavoir.

The rest of the work Picasso produced during his first months in Montmartre is interesting mostly for the light it casts on his personal life. A number of paintings and drawings feature a single model, usually an indication that Picasso had found himself a new girlfriend.* A delicate sketch rediscovered only in 1968 (the cardboard had been used as backing for another work) revealed the name of Picasso's latest lover as Madeleine, and it is her wraithlike beauty that determined the type of female protagonist he favored at the time. The brief "Madeleine interlude" is a reminder of the extent to which this unrepentant male chauvinist allowed the woman of the moment to shape the direction of his art, so that at one level those dizzying transformations seem like little more than the chronicle of a complicated love life.

The rediscovery of Madeleine's portrait also elicited from Picasso an admission that he'd gotten her pregnant and had persuaded her to have an abortion. "Can you imagine me with a son sixty-four years old?" he asked, horrified at anything that reminded him he was an old man.† Madeleine's brief presence in his life also inspired a series of paintings and drawings with decidedly Sapphic overtones, a theme that suggests Picasso's fascination with the permissive sexual mores of the French capital. The Butte had a vibrant lesbian scene, an aspect of life already explored by two artists from whom Picasso borrowed heavily early in his career, Toulouse-Lautrec and Georges Bottini, known as the "the Montmartre Goya."

It was not only the women in Picasso's life who determined the twists and turns of his career. To a surprising degree, new directions in painting and sculpture were prompted by the other company he kept. Picasso's art is the product not of a solitary genius but of a highly sociable man, with an

* Picasso was sleeping with at least two other women at the time: Marguerite "Margot" Luc, the stepdaughter of Frédé Gérard, the proprietor of Au Lapin Agile, and Alice Princet, who would go on to marry the painter André Derain. Margot was the model for the well-known *Woman with Raven*.

† At the time his oldest child, Paulo, was forty-seven.

instinctive feel for those who could provide him with exactly the kind of intellectual stimulus he needed. When it came to forging these vital relationships, he was helped immeasurably by his charisma, a brooding intensity that drew people to him, and a faith in his own star that compelled those around him to take up the cause. "He spoke little and seemed neither remote nor intimate—just quite completely there," wrote Leo Stein after his first visit to Picasso's Bateau Lavoir studio. "He seemed more real than other people while doing nothing about it." With his ability to attract talented men and women, Picasso lived like a king amid his courtiers, a sultan with his harem, feeding off their love but also off their petty rivalries, which merely confirmed his status as the cynosure of this quarrelsome, discontented, and thoroughly dependent retinue.

Those who knew him best learned to cope with his many moods. He could be charming one moment, reveling in laughter and good company, but just as quickly withdraw into sullen silence. He bestowed both kindness and cruelty with capricious liberality, and the pattern of his daily life was equally chiaroscuro, alternating between raucous conviviality—long hours in which he seemed to be frittering the day away—followed by intense bouts of concentrated work during which he would lash out at anyone with the temerity to interrupt.

Despite Picasso's stature as the twentieth century's towering artistic genius, the revolution that has come to be associated with his name was to some extent a group project. It involved the meeting of many minds and imaginations—not always in harmony, but just as often in bitter conflict—all brought together in an environment uniquely receptive to radical ideas. As vital as his ambition and indisputable talent was his gift for making himself the dark star around which everything and everyone revolved.

His last trip to Paris had been one of the few times he had made no attempt to establish a *tertulia*, a telling sign that he was in the throes of a depression, assailed by doubts and gloomy about the future. This time he didn't slink into Paris anonymously but made an effort to renew old friendships, looking up his Spanish cronies and reconnecting with Max Jacob, who soon moved next door, into a grim little apartment at 7 rue Ravignan. Lacking money to go to cabarets, they provided their own

entertainment, with Max in the starring role. Fernande Olivier provided a vivid account of Jacob's self-mocking burlesques:

> He always loved making other people laugh, and he could be brilliantly witty and animated when he wanted to be. . . . He used to improvise little plays, in which he was always the main actor. I must have seen him do his imitation of a bare-footed dancer a hundred times, and each time I enjoyed it even more. His trousers were rolled up to his knees to reveal two hairy legs. In shirt-sleeves, his collar wide-open to expose a chest forested with curly black hairs, with his bare-bald head and his pince-nez, he would dance with tiny steps and pointed toe, doing his best to be graceful and making us rock with laughter at his superb over-acting. . . . There was the gay songstress, which he did with a lady's hat on his head and a translucent veil swathed about him, and singing in a heady soprano which was in tune but somehow totally ridiculous.

Max feared that if he ever stopped amusing Picasso he might lose him, fears that only grew as his friend grew more comfortable in his adopted city. "Picasso laughed and played along with us," he recalled, "and his laughter was our reward." He longed to see his friend covered with glory, but that desire was matched by his reluctance to share him with anyone. His anxiety came out in cutting remarks directed at anyone who threatened to break into the tight circle that was beginning to form around the painter. Fernande, for one, felt the sting of Jacob's sharp tongue, simultaneously "biting and flattering," when she first came into Picasso's life, his jealousy of her in particular exacerbated by a fear of women in general.

During the first couple of months at the Bateau Lavoir, most of Picasso's friends continued to be fellow Spaniards, including the Pichots (Ramon and his French fiancée, Germaine); Paco Durrio, who occasionally left tins of sardines, bottles of wine, and other treats on Picasso's doorstep; and the impish Manolo. But that was about to change. Picasso hadn't abandoned the comforts of home simply to re-create its stifling provinciality in a new city. Paris opened up new vistas, but these would remain

closed to him as long as he remained trapped within the insular Spanish and Catalan community.

Max was the key to unlocking the door. Under his tutelage Picasso's French was improving, allowing him to deploy the charm that worked so well on his compatriots to seduce the jaded, cynical members of the Parisian intelligentsia, and Jacob's vast font of literary knowledge rubbed off on him as well, widening his intellectual horizons.

Picasso's first new conquest was the writer André Salmon, a dandi-fied, pipe-smoking poet, described by Fernande Olivier as "[a] dreamer with a keen sensibility, tall, thin, distinguished, eyes full of intelligence set in a too-pale face . . . very young." Salmon was also well connected in the Parisian avant-garde, serving as Paul Fort's editorial secretary at the newly founded *Vers et Prose.* He was introduced to Picasso one evening in October 1904 by Manolo. Ushering the poet into the Bateau Lavoir studio the

André Salmon in front of Picasso's *Three Women.* © *RMN-Grand Palais / Art Resource, NY.*

sculptor announced grandly in his pidgen French: *"Yo te présente Salmon."*

The fact that this intellectual Frenchman was immediately smitten with the largely unschooled Spaniard is a testament to the force of Picasso's personality. "We didn't break up until dawn," Salmon said of their first meeting, "and then only to see each other almost immediately." Salmon was so taken with his new friend that he moved from Montparnasse and found himself a room in the far grubbier Bateau Lavoir, becoming a charter member of that gang of artists, poets, and intellectuals soon to be known as the *bande à Picasso*. Many years later, he set down his initial impression of the man: "The famous lock brushing black-currant eyes. Dressed in blue, his blue jacket open to reveal a white shirt, tied at the waist by a fringed, red belt." Of the studio where so much history was made, Salmon remembered

a wooden paint box. A round table, small, bourgeois, acquired in a second-hand store, an old sofa that doubled as a bed, an easel. Serving as a rudimentary atelier there was a little room in which there was something resembling a bed. . . . Friends called it "the maid's room." We played out many farces there, unbeknownst to the master of the house, but these soon ended with the arrival of Fernande Olivier.

On the bourgeois table with the Napoleon III molding burned an oil lamp. There was no question at number 13 of electricity or even of gas. The oil lamp gave off little enough light. To paint or show his canvases he needed a candle—that trembling candle that Picasso held in front of me as he humanly introduced me to his superhuman world of the starved, the crippled, those mothers without milk—the world-more-real-than-real of his *Misère Bleue*.

Salmon's entry into Picasso's life marks the beginning of the artist's assimilation into the French intellectual avant-garde. Salmon was, as Fernande remembered, an amusing fellow, possessing the kind of cruel wit Picasso appreciated. "A wonderful raconteur," she wrote, "Salmon told the most scabrous stories with the most exquisite style." The poet's

Guillaume Apollinaire.
© *RMN-Grand Palais /*
Art Resource, NY.

admiration was a gratifying confirmation to Picasso that he could hold his own in rarefied company, though the poet was ultimately rather too conventional to stimulate his imagination.* Gertrude Stein, for one, dismissed him as a pretentious bore.

Far more significant was Picasso's introduction, later that same month, to Guillaume Apollinaire, a rising star in the Parisian literary world, and a man whose originality of mind, dazzling conversation, and irreverent wit would provide Picasso with exactly the kind of intellectual push he needed. More than André Salmon or even Max Jacob, Apollinaire opened new imaginative vistas and catalyzed a crucial transformation in his art. In Apollinaire, Picasso found someone whose urge to explore the far horizons of the imagination matched his own restless ambition.

* Picasso and Salmon would fall out over Salmon's support for Franco and his role as a collaborationist in the Second World War.

The introduction was engineered by Jean Mollet, an acquaintance of Manolo who served as Apollinaire's unofficial secretary. In this capacity, one of his jobs was to discover interesting new people to feed Apollinaire's insatiable appetite for good company. Unlike Picasso, who tended to be sullen in large groups when he was not the center of attention, Apollinaire sparkled in situations where he could hold forth, charming everyone with his wit and erudition. "He was an inspired talker if ever there was one," remembered one of his classmates. "I would come away dazzled by the strange, carefully turned sentences that took wing from his lips with the grace of a lyre-bird."

Part of his appeal lay in the fact that he was an inexhaustible font of knowledge, the more obscure the better, that he was always happy to share with anyone who cared to listen. Like Max Jacob, he was fascinated by the occult, but while Jacob took such mystical mumbo jumbo seriously, Apollinaire collected arcana as a scholar and poet rather than as an adept. As another schoolmate recalled, "He lived among legends and all the anecdotes of history. He was fascinating to us, teaching us everything we didn't know: he knew everything already."

When Picasso first met Apollinaire, in October 1904—chaperoned by Mollet, who led him into one of the "English" bars in which he held court every afternoon before taking the train back to his suburban home in Le Vésinet—he was still working a day job as a bank clerk. He'd made his literary debut a year earlier, on April 25, 1903, at one of the soirees held by the magazine *La Plume* in the cellar of the Café au Départ. Here each Saturday night, writers and their groupies gathered to smoke, to drink, to argue, and to recite a little poetry. Before the turn of the century, the *prince des poètes*, Paul Verlaine, had been the presiding deity, but more recently the old guard was being challenged by a new generation increasingly dissatisfied with Symbolism's vaporous confections. André Salmon, who was also reading that night, recalls the singular impression Apollinaire made on the crowd:

Apollinaire stood up, heavily . . . From his mouth he removed a little white clay pipe . . . Looking somber, almost angry, a bit of reddish moustache half-hiding an almost feminine pout, he walked straight to the piano, leaned firmly against it, and began to declaim

vehemently, in an intense, low-pitched voice, the poem "Schinder-hannes,"* from a series then called *Le Vent du Rhin . . .*

If the old-timers were perplexed by his disturbing imagery—including lines from *L'Ermite* (The Hermit): "By thunder Smirking at the sex of popesses/ And titless lady saints I am off to the city . . ." —Salmon and Mollet were won over, "ready to defend those lines from those in the audience . . . turning up their noses."

Like Picasso, Apollinaire was a foreigner, and while by 1904 he was better integrated into the Parisian cultural milieu—fluent in French where Picasso was still halting, at ease in brilliant company while Picasso was all too aware of his own awkwardness—he was less comfortable in his own skin. As one of his close friends noted, "Guillaume Apollinaire never gave me the impression of being completely natural. . . . As I remember him, he seemed always to be playing the parts of several characters simultaneously."

If Apollinaire was constantly reinventing himself it was to mask a deep void at the center of his being. His ancestry, even his name, was a source of mystery. According to his baptismal record, he was born Guglielmo Alberto on August 26, 1880, in the Roman neighborhood of Trastevere. His mother was the "daughter of Apollinaris, of St Petersburg," a minor nobleman of Polish descent who served as one of the papal chamberlains. Though records indicate that her legal name was Angelika Kostrowicka, she called herself Olga, one of many obfuscations in this family united by little more than their own internal contradictions. The boy's father was listed as unknown, a blank that Guillaume was only too happy to fill with outlandish speculation, including that he had been sired by Napoleon's heir or (more plausibly) by some high official of the Church.† This fluid and aspirational sense of identity was extended to others in Apollinaire's

* Schinderhannes was the nickname of a notorious eighteenth-century bandit.

† The rumor of his Napoleonic origins gave rise to one of his most haunting stories, "The Hunting of the Eagle." (Napoleon's son was known as *L'Aiglon*, the Eaglet.) Picasso played on the clerical connection in one of his many caricatures of Apollinaire, showing him in one topped by the distinctive papal tiara.

circle, including Mollet, whom he dubbed "Baron," a fictitious pedigree that helped create the impression of a Versailles of the imagination with Apollinaire in the role of a bohemian *Roi Soleil.*

Unlike Picasso, who fled from the suffocating embrace of a supportive family, Apollinaire never really had a family to begin with, at least not in the normal sense of the word. His mother earned her living as a *entraineuse* or *femme galante,* that is, an escort hired by a casino to entice men into the establishment, distracting them with her charm while they proceeded to lose their shirts. Guillaume spent a peripatetic childhood with Olga and her lover as they made the rounds of the spas of Europe one step ahead of the law, before finally settling in Paris in 1899. The disquiet instilled in him by his peculiar upbringing, as well as the sense of mystery and adventure, are captured in the famous line from his poem "Le Larron" (The Thief): "A sphinx was your father and your mother a night."

Eying each other across the crowded bar that October afternoon, Picasso and Apollinaire established an immediate rapport, the poet—as always in mid-oration—bestowing on the painter "a malicious wink" as he entered. A few days later, Picasso returned, this time accompanied by Max Jacob, who provided a vivid account of the scene:

> Apollinaire was smoking a short-stemmed pipe and expatiating on Petronius and Nero to some rather vulgar-looking people whom I took to be jobbers of some kind or travelling salesmen. He was wearing a stained light-colored suit, and a tiny straw hat was perched atop his famous pear-shaped head. He had hazel eyes, terrible and gleaming, a bit of curly blond hair fell over his forehead, his mouth looked like a little pimento, he had strong limbs, a broad chest looped across by a platinum watch-chain, and a ruby on his finger. The poor boy was always being taken for a rich man because his mother—an adventuress, to put it politely—clothed him from head to toe. She never gave him anything else. He was a clerk in a bank in the Rue Lepeletier. Without interrupting his talk he stretched out a hand that was like a tiger's paw over the marble-topped table. He stayed in his seat until he was finished.

Then the three of us went out, and we began that life of three-cornered friendship which lasted until the war, never leaving one another whether for work, meals, or fun.

That three-cornered friendship (Max conveniently left Salmon out of the equation) would prove immensely fruitful, each member of the trio picking the others' pockets in a game of intellectual larceny that worked to the advantage of all. "You've heard of La Fontaine and Molière and Racine," Max gushed, "well now that's us!" For the insecure Jacob, his friends' encouragement allowed him to begin thinking of himself as a serious writer. "Live like a poet," Picasso told him, urging him to quit his day job at the department store and plunge with both feet into the bohemian lifestyle. Apollinaire, for his part, profited from his friendship with Picasso to launch his career as an art critic.* Most important, mutual admiration as well as mutual competitiveness pushed each one farther than he was able to go on his own.

The alchemical combination of Apollinaire's quicksilver intellect and Picasso's brooding intensity touched off unpredictable reactions. Picasso profited from Apollinaire's immense font of knowledge, from esoterica to erotica—including the Marquis de Sade, whom Guillaume pronounced "the freest spirit that has ever existed"—providing imagery and attitudes that soon found their way into Picasso's paintings.† Apollinaire's poem "Mardi-gras," written five years before they met, features "pierrots wreathed in roses/pale ghosts who prowl the night. . . . Harlequin,

* Shortly before meeting Picasso, Apollinaire had made the acquaintance of two young painters who lived in Chatou, close to his home in Le Vésinet. They were Maurice de Vlaminck and André Derain, soon to vault to fame as leaders, along with Henri Matisse, of the Fauves.

† Apollinaire soon replaced his job in the bank by hiring out his services as an editor, translator, journalist, and writer of anonymous pornography. He translated and edited a series of pornographic works, sneaked out of the locked vaults of the National Library, for the publisher Briffault under the innocuous title *Les Maîtres de l'amour.*

Columbines and Punchinellos with crooked noses," characters who will soon populate Picasso's Rose Period canvases. For Apollinaire, Picasso's formal inventiveness transformed his own poetic voice, dispelling once and for all the mists of the Symbolist dreamworld and providing him with a jarring, jagged syntax that spoke in the staccato rhythms of modernity.

Another figure not included in Jacob's trinity, but who served as a potent catalyst for both Picasso and Apollinaire, was the writer and provocateur Alfred Jarry. Jacob's oversight is understandable. Despite many attempts to establish a relationship, there is no evidence that Picasso ever actually met Jarry, though they traveled in the same circles (including the gatherings at the Closerie des Lilas that would soon become a center of intellectual life in the city) and had many friends in common. Jarry occupied a position similar to the one Gauguin had held a few years back—the presiding spirit of the new age, a visionary who captured not only in his art but in his very being the suppressed id of the moment.

Both provided inspiration for a new generation not only through their work but through a total commitment to a life in art, a commitment so fierce as to approach madness. Like the master of Tahiti, whose pursuit of authenticity led him to flee civilization itself, Jarry was dedicated to his own peculiar course to the point of self-destruction. He drank excessively, dosed himself on ether (a favorite intoxicant of Max's as well), exercised maniacally—riding his bicycle furiously around the streets of Paris, sometimes with his face painted green—and, just to liven things up, occasionally fired his revolver at random strangers. Despite his fame, he lived in abject poverty, ultimately starring in his own greatest work, which consisted in nothing less than the slow dismantling of a brilliant life lived at the bleeding edge of the possible.

Jarry's rise marked a profound shift in sensibility over the course of a few short years, though, like most prophets, he was regarded by his contemporaries as merely an eccentric. Instead of Symbolist preciousness, Jarry offered absurdity; instead of reaching for the sublime, he preferred to wallow in the grotesque. His taste for scatological and sophomoric sexual humor appealed to Picasso's own irreverence, contributing to his

repertoire of tricks as well as supplying some of his most memorable images. The long shadow cast by the writer is revealed by the fact that Picasso's most explicitly Jarry-esque creation was made decades after the writer's death. In a series of etchings from 1937 titled *The Dream and Lie of Franco*, Picasso imparted to the Fascist *generalissimo* the misshapen contours of Jarry's monstrous creation Ubu. Above all, Picasso learned from Jarry's example how an assault on good taste could open up new aesthetic vistas.

Picasso was not the only convert to the cult of Jarry. Apollinaire was an early disciple of the addled prankster of the avant-garde; it was Jarry who initially encouraged his shift from Symbolist fantasy into something far more pungent. Indeed, much of the iconoclastic impulse of modernism and pop culture draws inspiration from Jarry's example. His play *Ubu Roi*, with its famous opening salvo—"*Merdre!*"*—touched off a near riot in the audience at its premiere in 1896, setting a precedent for countless acts of modernist provocation, from Futurist outrages to Stravinsky's *Rite of Spring*, from Dada happenings to punk rock mayhem.

After Jarry's premature death in 1907, Apollinaire bequeathed to Picasso the great man's Browning revolver, an acknowledgment that the painter had taken over from the writer as the most daring exponent of the avant-garde. Since the facts seemed a little too prosaic, Max improved them with an entirely invented account of this symbolic torch passing:

> At the end of a supper, Alfred Jarry gave up his revolver to Picasso and made a gift of it to him.
> . . . At that time it was recognized:
>
> 1. That the tiara of the psychic Pope Jarry was loaded in [the] revolver, [the] new distinguishing mark of [the] papacy.
> 2. That the gift of this emblem was the enthronement of the new psychic Picasso.

* The nonsense word "merdre" was close to the French word for shit, "merde."

3. That the revolver sought its natural owner.
4. That the revolver was really the harbinger comet of the century.

With the admission of Salmon and Apollinaire into Picasso's inner circle, the famous *bande à Picasso* was launched. Mostly artists and poets, they preferred to think of themselves as outlaws. They were aesthetes and intellectuals disguising themselves as hooligans, men of hyperrefined sensibility who refused to live solely in the mind, believing instead that the sincere pursuit of art allowed—in fact, demanded—that they test boundaries in every arena of life.

They were nothing if not snobbish, though their snobbery was aesthetic and intellectual rather than based on class or breeding. "As a group of young men all anxious to astonish the world and dazzle by our theories and talents," Salmon remembered, "we were inclined to discuss the quirks and failings of others." They scorned money, though they were constantly on the lookout for someone who actually had any so that he could treat them all to a meal or a few drinks at the bar. The true currency among them was audacity, which was admired far more than conventional success: Who would make the next move, create a splash, upset the status quo? Who would cause an uproar that would get his name into the paper, setting off one of those furors that would pit the old guard against the new?

Most afternoons they gathered in Picasso's studio—the door of which was now inscribed in blue chalk with the words *"Rendez-vous des poètes"*—or in the back rooms of seedy taverns, in opium dens and soup kitchens, to plot their revolution. Recalling Max's Monday get-togethers in his dark room off a trash-filled courtyard, Fernande Olivier evoked the fevered mood of a Bolshevik cell in tsarist Russia: "Here one came across the unknowns, the mutes, the immobile, huddled in the darkest corners. Indeed, there were many people of every sort, which rendered the atmosphere oppressive, suffocating, and mysterious. It seemed a gathering of fellow conspirators. And why not? Weren't they plotting against everything that was established in the arts?"

Cooking facilities in the Bateau Lavoir were rudimentary, which

meant that, despite their poverty, the residents were usually forced to dine out. They naturally favored establishments that extended credit to penurious artists and poets, the grimy Azon's or Vernin's on rue Cavallotti, "a small, hot cellar" where a dinner costing 90 centimes included a glass of wine but where "the smell of the cooking and bad wine mingled disagreeably."

Part of what attracted them to this grubby little eatery was the fact that it was located near a pawnshop and that the proprietor, who was in any case a soft touch when it came to "real" artists, was also somewhat forgetful and so was apt to lose track of even the largest tabs. When even he lost patience, Picasso was forced to walk across town to Montparnasse, where there was still one restaurant that had not caught on to his mooching. On the return journey he would raid garbage cans to find scraps to feed his dogs. Lacking the necessities to sustain even the human residents of the studio, he still continued to add to his menagerie, training a white mouse he kept in a drawer and taking on an enterprising cat who justified her existence by her resourcefulness. One time she earned her keep by dragging in from a neighboring apartment some sausages that she generously shared with her owner.

Another expedient, though one that could be resorted to only infrequently, was to order out from the *pâtissier* on the place des Abbesses and then pretend not to be home when the delivery boy showed up, forcing him to leave the basket on the doorstep. After Fernande moved in, the coal man proved susceptible to her charm, which allowed them to keep the stove going in the depth of winter even when they couldn't pay. There were times, however, when even his charity was not sufficient. On the coldest nights it was dangerous to poke one's head out from beneath the covers.

Despite his poverty, Picasso never learned the habits of frugality. Pinching pennies was not the bohemian way. A sudden windfall—from the sale of a painting or a few drawings—was cause for celebration. Perhaps out of necessity, a kind of communism prevailed, in which everyone shared what little he had. Once, Picasso's longtime patron Olivier Sansière showed up at the Bateau Lavoir, walking away with drawings for which he paid 300 francs, cash. "[Picasso] bought me cakes, candy and fruit and

got into bed with me," recalled Fernande. "Max and Guillaume came at around six in the evening, and a little later André Salmon and Manolo turned up. Then we all went to an Italian restaurant on the boulevard de Clichy and afterwards on to the Médrano Circus. After that we climbed up to the Lapin [Agile], where Berthe gave us onion soup. We laughed, sang and talked, and Pablo didn't even get jealous, so I was able to be unreservedly happy. But when everyone eventually left to go to bed our 300 francs were sorely depleted. We've just got 70 left."

The members of the *bande à Picasso* loved one another in their own way, but that didn't prevent them from engaging in their favorite sport—character assassination. The taunting was bad enough when they were in the same room, but woe to anyone who turned his back, even for a moment! "I often noticed that despite the solid affection which appeared to unite them," said Fernande, "no sooner had one friend left—almost before he'd gone through the door—than the others would begin to tear him apart. . . . They were wittily malicious even about their best friends."

Bruised feelings were common, as were tearful reconciliations, emotional swings exaggerated by the liberal use of intoxicants. Fernande Olivier describes a typical evening in one of the local *fumeries*—Baron Pigeard's in the Maquis, Paulette Philippi's on the rue de Douai, or Dr. Alexandre's *pavillon* on the rue du Delta—or in Picasso's own studio, where grudges were temporarily forgotten in a benevolent opium fog:

> Friends, a few more or less but always loyal, sat on straw mats, sharing delightful hours marked by intelligence and subtlety. We drank cold tea with lemon. We conversed, we were happy; everything was ennobled; we loved all of humanity, bathed in the muted glow of the kerosene lamp, the only source of light in the house. Sometimes the light went out, and only the furtive glimmer of the opium pipe illuminated the tired faces. . . . The nights passed in warm intimacy, devoid of all hard feeling. We spoke of painting, of literature, with perfect clarity of spirit, with an intelligence more refined. . . . Waking up the next day, all fellowship was forgotten and sniping started up again, since there was never an artistic community more given to mockery, to cruel words, where to wound was to triumph.

There was often a communion of spirit, of art, of ideas, but rarely a communion of the heart, or any generosity of feeling.

For all their mutual jealousies, the *bande* was even more hostile to outsiders and contemptuous of the general public, regarding, in typical bohemian fashion, any disturbance of the peace as yet another victory in the ongoing struggle with the bourgeoisie. "They would return home at night, very often drunk," recalled Fernande Olivier, "shouting, singing, quarreling, and declaiming in the little square that, no doubt, had been home to many similar scenes. They would wake up the neighbors by firing off the revolver: Picasso loved this. He always carried his Browning." They became so notorious that when André Salmon was relocating to the Bateau Lavoir, the movers warned him, "If you're settling up there, watch out for those who you shouldn't associate with—I mean Picasso's gang."

When they weren't getting stoned at one of the various *fumeries*, Picasso and his associates liked to take their ease at the Lapin Agile, a tavern run by Frédé, their former host from Le Zut.* The ivy-covered farmhouse with a shaded terrace that, legend had it, had once served as a hunting lodge for Henry IV, was a distinct improvement on Frédé's old hostlery. With its rough wooden tables and stone floor, the moldering room "dimly lit by two kerosene lamps . . . which smoked under their pleated red paper shades" was still gritty enough to appeal to Picasso and his gang, though Frédé, hoping to attract a better class of customer, had pompously inscribed the words "Cabaret Artistique" on an exterior wall. He tried to make good on the promise by encouraging poets to recite their verses, crooners to croon, and local artists to decorate the rooms. Picasso and his friends came despite these pretensions, not because of them, preferring

* The name came from its former owner, the illustrator André Gill, who painted the sign outside the door showing a rabbit leaping out of a frying pan while balancing a bottle of wine on his foot. "Au Lapin à Gill" soon became Au Lapin Agile (Nimble Rabbit's). The tavern is the setting of Steve Martin's play *Picasso at the Lapin Agile*, which revolves around an imagined conversation between the artist and Albert Einstein in 1904.

The Lapin Agile. *Courtesy of the author.*

the company of the dwindling number of local *apaches* to the increasing number of tourists enthralled by its seedy allure.

Originally known as the Cabaret des Assassins (not, as some contended, because of the cutthroats who still occasionally congregated there but because the former owner had decorated the walls with images of notorious serial killers), Frédé's tavern remained true, at least for a while, to its bohemian origins. Located at the corner of the rue des Saules and rue Saint-Vincent, on the northern flank of the Butte, the Lapin Agile was the heir to establishments like Le Chat Noir and Le Mirliton, saloons where the colorful patrons were as much of a draw as the performers. At the Lapin Agile they were often one and the same, since Frédé encouraged his clients to work for their booze, usually in the form of the house cocktail, a mixture of white wine and grenadine with "perhaps a drop of straight alcohol," added.

> We did not feel the want of money so very badly then, [wrote Francis Carco in his memoir *The Last Bohemia*] for we could always

find something to eat at Frédé's, the Lapin Agile, and a drink in exchange for a song, which we did not begin till our glasses had been refilled. Frédé was not stupid and he loved artists of all kinds, so that one met at his place, poets, painters and writers. The amiable ladies who shared our destinies at that time were not hard to please. They always answered when asked what they wanted to drink: "The cheapest there is!"

Like Rodolphe Salis before him, Frédé understood that the local bohemians who came for the cheap liquor and raucous company created exactly the right sort of atmosphere to attract better-heeled clients, allowing the respectable to dream for an hour or two that they, too, might live without responsibilities. If Salis was the first to discover how the attractions of bohemia might be monetized, Frédé was not far behind.

The Lapin Agile has become legendary in the annals of cultural history as the classic bohemian hangout, but it was merely the latest in a long line of similar establishments that were the nerve centers of the avant-garde. Ever since the Impressionist revolution, cafés, cabarets, and saloons had played a vital role in promoting a sense of community among artists who otherwise had few opportunities to share insights and pursue common agendas. Each generation had its favorite haunts and preferred neighborhoods; sudden shifts of allegiance were subject to the whims of fashion and the clash of personalities. The Impressionists originally favored the Café Guerbois at the foot of the Butte, before moving on to the Nouvelle Athènes in the place Pigalle, where two tables were set aside for Manet, Degas, and their guests. It was here that Cézanne famously snubbed Manet. "I haven't washed for a week, Monsieur Manet," he proclaimed on walking into the café, "so I am not going to offer you my hand."

The café replaced the discredited institutions of official culture—the French Academy, the École des Beaux-Arts, and the Salon—as centers of artistic life, encouraging an informal exchange of ideas, often lubricated by ample quantities of *mominette*, the favored variety of absinthe for the down-and-out, or cheap red wine. Monet revealed how important these informal get-togethers were for artists groping

toward a new vision in the face of universal incomprehension. "Nothing could have been more interesting than these talks, with their perpetual clashes of opinion," he said. "You always left the café feeling hardened for the struggle, with a stronger will, a sharpened purpose, and a clearer head."

The humble Lapin Agile more than holds its own in this distinguished company. It had its own distinctive flavor, lying somewhere between a seedy neighborhood dive and a literary salon, exuding a rough-and-ready bonhomie that characterized this particular moment in history.

The place took on the character of the good-natured if somewhat disreputable Frédé, heavily bearded and dressed in a brown corduroy suit, wooden clogs, and "a crimson scarf knotted around his head like an Italian bandit." When the entertainment petered out, he would regale the crowd with one of his own songs, always prefacing his performance with the announcement "Now we'll have a little art."

Adding to the homey atmosphere were Frédé's wife, Berthe, who served as cook, and her daughter Margot, with whom Picasso had a brief affair, along with Margot's trained raven and a donkey named Lolo, who was usually tethered to a post beside the outdoor terrace.* The decor suggested the cultural melting pot of a Montmartre on the cusp of an aesthetic revolution, featuring an eclectic hodgepodge of exotic influences that included a plaster cast of a Buddhist deity, another of Apollo, and a huge crucifix. These mismatched pieces shared the walls with paintings by some of the locals, including Suzanne Valadon and her alcoholic son Maurice Utrillo, Steinlen and, ultimately, Picasso himself.

* Lolo figured in an elaborate prank staged in 1910 by the journalist Roland Dorgelès. Tying a paintbrush to the beast's tail, which he proceeded to dip into various pots of paint, he composed three pictures that were submitted to the Salon des Indépendants under the name of Joachim Raphael Boronali (an anagram of *aliboron*, i.e., jackass or ignoramus). Since that Salon had no jury, the paintings—with titles such as *And the Sun Went to Sleep* and *On the Adriatic*—were accepted without question. In keeping with the times, the display was accompanied by a suitable manifesto in the paper *Le Matin*.

Picasso's contribution was little more than a large oil sketch boldly daubed in earth tones enlivened by splashes of yellow, red, and green (anything more refined would have been lost in the smoke-filled gloom), but it exudes a distinctive mood of dissipated melancholy. *Au Lapin Agile* depicts the artist himself, glass in hand, dressed incongruously in a harlequin costume and, next to him at the bar, Germaine Pichot in a fashionable feathered hat. The former lovers look their separate ways, each absorbed in melancholy thoughts, while in the background Frédé strums away on his guitar. Picasso donated the work to Frédé, no doubt in return for extending his already generous tab.

Ultimately, and perhaps inevitably, the Lapin Agile became a parody of itself; ersatz authenticity replaced the real thing as soon as Frédé learned how to market that ineffable quality to the professional men and their wives who made the trek from lower Paris. As Picasso's fame grew and the fame of his favorite hostelry along with it, the painter began to find the atmosphere oppressive.

> Picasso was beginning to be worshiped, surrounded by admirers, [writes Fernande Olivier] sincere or not. He quickly tired of them. Though he liked to be flattered, he was naturally uncomfortable with over-the-top displays. One evening at the Lapin à Gill he was honored by a party where he was acclaimed and carried out the door in triumph by some Germans. Later, he was seized by a desire to be alone. He was on the Butte, in the Place du Tertre. All of a sudden, he pulled out his revolver, which he always had with him, and fired in the air. In an instant the square was deserted. The Germans scattered, disappeared, and did not soon return.

The fate of the Lapin Agile mirrored the fate of Montmartre itself, transformed from an artists' haven into a tourist trap. By the time Picasso drove off the impertinent Germans, he realized it was time to move on.

Hanging out most of the day and into the evening with his all-male *tertulia,* Picasso also never lacked for female companionship, though from

the equestrienne Rosita in Barcelona to Odette in his first autumn in Paris—not to mention an on-again-off-again liaison with the dangerously alluring Germaine, as well as flings with Madeleine, Margot, and various one-night stands—none of these women ever made a large claim on his feelings. But his carefree bachelor's existence was about to change.

He'd noticed the tall, auburn-haired beauty long before he ever met her. She lived in the Bateau Lavoir, in one of the studios on the lower floors, apparently the mistress of a sculptor by the name of Gaston de Labaume. She was much in demand as a model for the local painters and sculptors, who appreciated her statuesque form and distinctive almond-shaped eyes of an alluring, catlike shade of green. When she wasn't posing, she liked to sit out in the square on one of the peeling benches by the fountain reading.

Fernande had also noticed the unkempt Spanish painter with long hair and slightly dangerous air. Indeed, she could hardly help noticing him since he would stare at her as she crossed the square with "his huge deep eyes, sharp but brooding, full of suppressed fire."

"I don't find him particularly attractive," she confesses in her diary, "but his strangely intense gaze forces me to look at him in return, although I've never answered him when he tries to make conversation."*

From the beginning it was Picasso who pursued Fernande. At the time, though her relationship with Labaume was ending, she wasn't looking for another entanglement. In fact she was disenchanted with men in general, Labaume being only the latest in a string of unsuitable or abusive lovers who had made her young life a misery.

Fernande Olivier was born Amélie Lang in 1881. Her parents, whom

* Fernande Olivier's *Loving Picasso* was her second memoir, published in 1988, more than twenty years after her death. Though it purports to be based on a diary she kept during the years she lived with Picasso, she almost certainly reworked many passages at a later date. She did not publish it in her (or Picasso's) lifetime, since her former lover hated any intrusion into his private life. She agreed to suppress it in return for one million francs.

she barely knew, were never married, and she was raised by her aunt and uncle.* After a lonely childhood, reading books and dreaming of something better, she ran off with and soon married a clerk in her uncle's firm by the name of Paul-Émile Percheron. As with most decisions made in desperation, this one proved disastrous. Percheron turned out to be abusive, and when his young wife proved less accomodating than he expected, he raped her—repeatedly and with increasing violence. "I'm living in hell," she cried a week after she was taken away by Percheron. "Is this really what love is? This cruel, brutal possession, this madness where a man satisfies his passion for a woman in a bestial frenzy?" After one particularly vicious attack Amélie took the desperate step of leaving her husband, setting out for a new life in the city with only 1 franc, 15 centimes in her pocket.

Later that day—hungry, frightened, contemplating her bleak prospects—she was approached by a young man who took her to a café and bought her hot chocolate and brioches. He told her his name was Gaston de Labaume and that he was a sculptor.† Instead of seeking work as a secretary, which was as far as her plans had gotten, why not come sit for him? Working as an artist's model, he insisted, was far easier and paid better than any office job she could possibly land. Fernande did not take much convincing, since, as she said, artists "seemed to me to inhabit an enchanted world."

Thus began her life as an artist's model earning 10 francs a day, first in Montparnasse and, later that year, in Montmartre, after Labaume found himself a studio in the ramshackle Bateau Lavoir. Not surprisingly, Fernande allowed herself to become Labaume's mistress. Though less brutal than her husband, the sculptor proved to be an unsatisfactory lover,

* No one, least of all Fernande herself, ever explained the origin of the name by which she was known in Montmartre. As was the case with Guillaume Apollinaire, the change seems to have been part of an effort to remake herself anew after an unhappy childhood.

† Throughout her memoir she calls him Laurent Debienne, probably to protect his reputation.

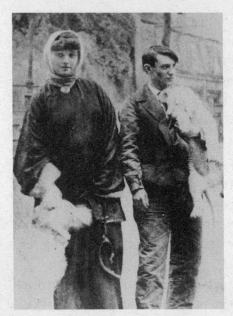

Fernande, Picasso, and their dogs. ©
RMN-Grand Palais / Art Resource, NY.

self-absorbed, petulant, and unambitious. Not only did she earn most of the money, to which he felt free to help himself, but he expected her to do all the housework, a chore for which she had little interest or aptitude.

Despite these disappointments, Fernande was thrilled to belong to the picturesque world of Montmartre, with its artists and poets, foreign anarchists and local *apaches*, eccentrics, drug addicts, and alcoholics, a world of dreams and dreamers, of daily want but eternal hopefulness, all of it so different from the crabbed respectability of her childhood home. "Here," she exulted, "life is preserved by hope, love and intellect. Here the law is made by youth." She found steady work, posing mostly for academic artists like the sculptors François-Léon Sicard and Fernand Cormon, in the nude or dressing up as a peasant girl, an Egyptian dancer, or a grand Spanish lady in a lace mantilla. An aspiring painter herself, Fernande tried to make up her mind where her loyalties lay—with the Salon painters and sculptors who provided her with steady work or with the scruffy radicals among whom she lived. The successful academician Cormon used to tease her: " 'What are your heroes of the future doing at the moment, then?' And I would answer him with my own impressions or with ideas I had picked up here and there. I would find arguments to

defend and justify them, and he would listen seriously to this twenty-year-old girl who idolized everything that seemed new, rejected the familiar and looked toward the future."

Academic artists, with their "grand machines," provided a more reliable source of income, but Fernande also posed for many of the more bohemian sorts, many of them her neighbors. Two of them were Catalan painters living in the Bateau Lavoir, Picasso's friend Ricard Canals, and Joaquim Sunyer, who soon became his rival for Fernande's affections.*

Though Picasso and Fernande saw each other almost every day, in the dark stairwells of the Bateau Lavoir or out on the place Ravignan, his early attempts to woo her were clumsy and only served to put her on her guard. "He seemed to spend all his time on the little Montmartre square," she recalled, "and I asked myself: 'When does he work?' Later, I learned that he preferred to paint at night so as not to be disturbed. During the day his studio was filled with a continual procession of Spaniards."

Fernande finally succumbed to Picasso's advances one evening in August 1904, though she immediately regretted her impulsiveness. It was, she feared, "another stupid adventure":

> Yesterday afternoon the atmosphere was really oppressive before the storm. The sky was black, and when the clouds suddenly broke we had to rush for shelter. The Spanish painter had a little kitten in his arms which he held out to me, laughing and preventing me from going past. I laughed with him. He seemed to give off a radiance, an inner fire, and I couldn't resist his magnetism. I went with him to his studio, which is full of large unfinished canvases—he must work so hard, but what a mess! Dear God! His paintings are astonishing. I find something morbid in them, which is quite disturbing, but I also feel drawn to them.

They apparently slept together on that occasion, but that didn't mean she was ready to commit to him. For months they engaged in a

* Picasso and Sunyer never got along. Sunyer resented his success in finally winning Fernande. Years later he retaliated by becoming a forger of Picasso's work.

surreptitious on-again, off-again affair, sneaking around behind the back of her lover and driving Picasso to distraction with jealousy and frustration. "I've been back to see my Spanish painter," she writes. "He adores me with real sincerity, which I find touching, but I have to conceal my destination when I go visit him, as I don't want Laurent to find out. . . . Picasso is sweet, intelligent, very dedicated to his art, and he drops everything for me. His eyes plead with me, and he keeps anything I leave behind as if it were a holy relic. If I fall asleep, he's beside the bed when I wake up, his eyes anxiously fixed on me."

Picasso commemorated this painful courtship, which lasted more than a year, in two delicate watercolors that seem to show the dilemma facing his beloved. They depict Fernande asleep; in one she is watched over by the gaunt form of Labaume, in the other by Picasso himself. In both she remains blissfully unaware of the men who contemplate her naked form, each of them tormented by the thought that she will give herself to his rival when she awakes. A third drawing reveals Picasso's fondest wish: it shows Labaume hurling himself in despair from a tall building.

In the real world, as opposed to the fantasy of his art where he can shape the course of events, things were not that simple. Determined to end the relationship with Labaume, Fernande was not ready to move in with Picasso. In fact, in the meantime she had begun a torrid affair with Sunyer. She admitted that he pleased her physically, "show[ing] me a side of life I've never known," but in every other way he left her cold. As for her other Spanish lover, "I can't go and live with Pablo. He's jealous, he has no money at all, and he doesn't want me to work. It's ridiculous!"

Desperate to escape the increasingly fraught atmosphere of the Bateau Lavoir, where at least three temperamental artists were vying for her affection, she escaped with a friend to the seaside resort of Berck. When she returned to the Bateau Lavoir in September, it was to stay not with Labaume but in the studio of Ricard Canals, who lived with his wife, Benedetta, a beautiful, hot-tempered Italian. Having gotten rid of Labaume and informed Picasso that she only wanted to be friends, she enjoyed a rare interlude of peace. "In the evenings there's a lot of merriment here," she writes, "five or six friends come over, they play their guitars and sing Spanish songs after dinner. This simply consists of an enormous dish of spaghetti. Madame Benedetta is Italian and this is one of her specialties;

it feeds us all and we can afford it. The men are all artists and talk among themselves about their work. Benedetta and I stretch ourselves out on the couch and are happy to be the focus of admiration."

Picasso was a man obsessed. "Poor Pablo is very unhappy," Fernande writes, "but I can't do anything about it. He writes me desperate letters in a French that is highly imaginative and quite barbaric." She continued to hold out, put off by the squalor of his existence and his lack of prospects. Worst of all, he was already exhibiting possessive traits that frightened her; she had suffered at the hands of too many jealous and abusive men to throw herself into the arms of another.

It was opium that finally brought them together, a drug that instills in even the most quarrelsome a universal benevolence. "Everything seems beautiful, bright and good," she wrote after one nightlong session. "It's probably thanks to opium that I've discovered the true meaning of the word 'love,' love in general. I've discovered that at last I understand Pablo, I 'sense' him better. It seems as if I have been waiting all my twenty-three years for him."

According to her journal, she finally moved in with Picasso on September 3, 1905, a scorching Sunday afternoon during which Labaume was conveniently out of town for military service. The logistics were managed easily enough: she shoved all her worldly possessions into a little black trunk, and Picasso dragged it across the corridor and into his studio.

The distance traveled in the more elastic realm of the psyche— perhaps the stuff of André Salmon's mysterious fourth dimension—was immense. For Fernande Olivier the years that followed were the happiest of her life, as the mistress of the only man she ever loved. For Picasso the change was equally dramatic. Self-centered and egotistical, inclined to regard women as objects to gratify his pleasure, the discovery that he could actually devote himself to another person, to be consumed by her, to care not only about his own needs but about hers, was a revelation.

Infatuation didn't necessarily make him easier to get along with. She hesitated for months before succumbing in part because she understood that being with Picasso meant giving up her independence, and she'd seen enough of his jealous nature to be concerned. His Andalusian possessiveness meant that, despite his poverty, he would not allow her to work. She tried to get him to change his mind, but when the sculptor Sicard offered

to let him accompany her while he finished the monument he'd been working on, Picasso snapped, "Well I don't give a f—!"

But for all his macho bluster, Picasso was devoted to Fernande, doing everything he could to please her (short of sharing her with another man), buying her little treats, candy, or vials of the perfume she loved. When she moved in, she was surprised to discover he'd built a shrine, dedicated, he told her, "to the memory of a young woman I used to know and hope will return to me." The tribute was both flattering and alarming. Taking up most of the so-called maid's room, it consisted of a pen-and-ink drawing of Fernande, framed by a white blouse she'd once worn, behind a table set with two vases of artificial flowers. "What inspired him to create this shrine dedicated to unrequited love?" she asked, providing her own answer in the next sentence: "As well as nostalgia, a mocking self-irony and humor, I think it showed a kind of mysticism that Pablo must have inherited from his Italian ancestors, though he himself is Spanish. He pretends to laugh at this 'votive' chapel, but he won't allow me to touch it."

Fernande was right to dismiss his mocking laughter as a strategy of concealment. This makeshift shrine offers a profound insight into the nature of Picasso's art, revealing the extent to which he believed that objects, suitably arranged, could be imbued with magical powers. This was why African sculpture appealed to him and why he made much more profound use of it than any of his colleagues. For Picasso, art was not primarily a visual language but a method of manipulating unseen forces. Cubism was an attempt to invest the image with a potency greater than mere illusion, and when he began to make his collages, incorporating found objects into the pictorial matrix—or his even more revolutionary sculptures made from scraps picked up on his daily walks or studio detritus—they functioned very much like this altar to his lady love, as powerful totems exerting an influence on the world of the living.

This voodoolike display having done the trick, Picasso basked in the glow of consummation, a young man in love with his mistress and in love with life. Day-to-day existence in the Bateau Lavoir continued to be a constant struggle against hunger and cold, an anxious search for just enough cash to work another day, to eat, and, perhaps, to find a little extra to go out on

the town. "We don't have any money," Fernande writes, "so we hardly ever go out, except somewhere in Montmartre where we can have dinner on credit. After we've eaten we often go for a walk and observe Paris asleep from the top of the Butte near the Sacré-Coeur. Then Picasso seems to be less anxious, less ferociously silent, less wrapped up in the one thing he cares about, his painting." Love, to dredge up an old cliché, made the hardships easier to bear—love and the belief that he, that they, were working toward some great purpose.

With Fernande safely ensconced beneath his own roof, reading or sleeping while he painted, often late into the night, at the center of a community of brilliant and amusing friends who regarded him as the undiscovered genius in their midst, Picasso could return to his art with renewed dedication, renewed confidence. If Apollinaire's febrile imagination supplied much of the imagery for the next stage in his development, la Belle Fernande supplied much of the matter, her sensuous form and grace and the contentment she brought him ushering in a new era. He put the struggles of the past few years behind him, banishing winter's chill and setting out for lands unknown.

6

La Vie en Rose

But tell me, who are they, these wanderers, even more transient than we ourselves.

—RAINER MARIA RILKE, "FIFTH DUINO ELEGY"

Henri Matisse once said, "If there were no public, there would be no artists. . . . Painting is a way of communicating, a language. An artist is an exhibitionist. If you took away his audience, the exhibitionist would slink off too, with his hands in his pockets. . . . The artist is an actor: he's the little man with the wheedling voice who needs to tell stories."

It was an attitude completely at odds with Picasso's way of thinking. He needed no audience to give his work meaning and made little effort to ingratiate himself with the public. Once, when his dealer informed him that their best customer did not like his latest work, Picasso wrote back, "That's fine. I'm glad he doesn't like it! At this rate we'll disgust the whole world." It's not that he painted to please himself—in fact, he was rarely pleased with his own work—and there's no doubt that he craved recognition. But rather than play to the crowd, he worked to survive, to negotiate the demon-haunted world that threatened to consume him. For Picasso, art existed on a plane deeper than mere communication: it existed for its own sake; it had meaning regardless of whether anyone ever saw it. In fact,

invisibility enhanced its power, like a statue of a god kept in a niche where only the high priest can ever approach, ritually purified, eyes averted. Here in the shadows the fetish would conserve its awesome authority unsullied by contact with the dross of ordinary life.

Picasso was determined to make a life for himself in art, but he found the actual process of earning a living, exhibiting, and cultivating buyers a dispiriting chore. "[H]e was always distraught when he had to sell a painting," Fernande revealed. "After the business had been concluded, the canvases taken away, he was despondent and wouldn't be able to work for several days. All this exhausted him: pressure from the buyer, the haggling, and the prolonged uncertainty. By the end he would be so fed up that, if it had been up to him and there was no one around to help him, he would have given it all away for nothing or thrown the dealer out the door just to be done with it."

Given the fact that he was determined to chart his own course—unconventionally, quixotically, even belligerently—Paris was his natural habitat. Indeed, it was the only place on Earth where such a journey was even possible. Much as he loathed the humiliating process of shopping his works around to the handful of dealers who might take a chance on a young unknown, he owed them more than he was willing to acknowledge. These risk-taking entrepreneurs, some of them mercenary, some idealistic, were vital to his success.

Indeed, for a bohemian artist living in Montmartre around 1905, there were numerous opportunities for achieving fame. This was a world that rewarded audacity. Here the bias was toward novelty, toward daring work that upset the status quo, and any artist willing to thumb his nose at convention could expect to win the applause of his peers. No one was striking it rich, but someone with sufficient drive, ambition, and a bit of originality could count on getting his work before the public and, at the very least, being taken seriously.

The most important venues were the two large-scale exhibitions that served as alternatives to the officially sanctioned Salon de la Société Nationale des Beaux-Arts. The Salon des Indépendants was founded in 1883, to be joined twenty years later by the more prestigious, less chaotic Salon d'Automne. André Level, one of the *dénicheurs* (speculators) who would establish the market for modern art, recalled the impact of seeing

the work of the future Fauves (Derain, Matisse, Vlaminck) in the 1903 Salon d'Automne: "It was a revelation to me. . . . There was a boldness and youthfulness there which cut through the monotony and predictability of the grand annual salons. . . . I saw canvases there which seemed to me, without the slightest shadow of a doubt, to be the authentic art of our own age, and of the immediate future. I believed in it, I had faith."

These exhibitions were where radical artists could make a splash and where dealers like Ambroise Vollard and Berthe Weill often discovered new talent by mingling with the crowds to overhear which names were on everyone's lips. Picasso, unlike Matisse, never made any attempt to show at either, an odd choice for someone wishing to claim his place as a leader of a new generation but perfectly in keeping with his skeptical attitude toward all forms of publicity. In part it was an instinctive reaction against the regimen his father had once imposed on him and that he associated with the worst kind of academic careerism. Putting his work in front of the vulgar crowd, begging for their affirmation, struck him as a kind of moral prostitution. But there was more to it than that: throughout his career he had a love/hate relationship with his potential audience, craving recognition while at the same time despising the compromises necessary to make it possible. If he were ever to become famous, it would be on his own terms, making no concessions and without doing anything to cultivate a public he despised.

There was, in fact, something mysterious about the way his reputation began to grow even as he shunned the limelight. Amedeo Modigliani, a penniless Italian seduced by the romance of bohemia who came to Paris in 1906, was witness to the early evolution of the legend. "Modigliani had his first glimpse of Picasso one day near the Place Clichy," André Salmon recorded, "when two passers-by had turned to stare at a little man dressed in a pair of plumber's blue jeans, his open short coat flapping over a flame-colored sweater, his trousers held in place by a red flannel sash, the traditional waist-band worn by carpenters in those days. He had extraordinary eyes, like currants, and he sported an English cap from under which a lock of hair hung down over his forehead. With him on a lead was a large white dog. Modigliani heard one of the passers-by say to the other: 'Did you see Picasso with his cur?'"

That Picasso would have been regarded with almost superstitious awe by someone as besotted with the threadbare glamour of the avant-garde as Modigliani is not entirely surprising, but that two passing strangers would turn to stare at this impoverished painter with his mangy dog is testament to the caste system of Montmartre, which measured status by its own inscrutable formulas. Even before Picasso was able to sell his art on a regular basis, before he was a familiar name in the newspapers, there was an aura about him, a dangerous charisma, that caused people to stop and take notice.

Further evidence of this strange phenomenon comes in a preface to a collection of essays published in 1906 by the novelist and critic Eugène Marsan. It contains an almost certainly fictitious—but nonetheless illuminating—account of a conversation at the Lapin Agile:

> If you are tempted to think me paradoxical, I would ask you to observe the eloquent décor of this café which is frequented only, for I discount the curious, by the young men who pay with poverty for the leisure of their unlimited dreaming. . . . With his finger, M. Sandricourt pointed out to me a compelling picture done in colors that were flat, as if burnt. He remarked of it: "This Harlequin and Columbine are hungry (notice the eyes), but they don't have twenty sous and, not being able to eat, they drink. They are not looking at each other at all; but I can tell that they care for each other. The young artist who painted that in two hours will become a genius, if Paris does not destroy him." I objected, for I had at once recognized the hand that had fitted the yellow, red, green lozenges of their tights to the thin bodies of Harlequin and Columbine. "The painter of this Harlequin," I said, "Monsieur, already has a reputation. . . . He is an Andalusian, and one who paints, as only a Spaniard could, the look and the rags. You might call him, to help you remember, The Callot of the saltimbanques, but you'd do better to remember his name: Picasso."

This was the kind of tribute that really mattered. Picasso craved the respect of his peers far more than adulation of the multitude and directed his efforts at winning over those few whom he respected. Rather than

riches, what sustained him and his comrades in arms was the esprit de corps that came from sharing hardships and the validation that could be bestowed only by one's fellow combatants. "How little poverty mattered amidst all that spirit, all that gaiety!" Fernande reminisced, forgetting for a moment the daily struggle to keep body and soul together. "Life was lived for life's sake, for everything was young, fresh, and spontaneous."

Au Lapin Agile, the painting that so intrigued Eugène Marsan, is one of the first works in what has come to be known as Picasso's Rose Period.* It is not the tonality of the painting—which is rendered in neither the chilly blues of the recent past nor the pinks and ochers still to come— but the costume in which he depicts himself that announces a new phase in his art. Dressed in Harlequin's diamond-patterned leotard and an extravagant bicorn hat, Picasso portrays himself as an intruder in the bleak passion play he has been directing for the past few years, a wry observer of a scene that can no longer be taken at face value. The presence of the comic hero inevitably transforms the masque from tragedy into something at once more playful and more ambiguous. It's not that Picasso has suddenly abandoned gritty realism for artifice, the here and now for the historical pastiche of the *Commedia dell'Arte*.† After all, there was always something stagey about Picasso's Blue Period paintings, in which misery was presented not in the coarse vernacular of Steinlen or Émile Zola but as a timeless pantomime, a ritual of suffering and redemption that had its roots in the religious narratives of the middle ages.

But with the arrival of Harlequin, artifice itself becomes the theme,

* Like the label "Blue Period," it was coined by the critic Gustave Coquiot, the man who wrote the review for Picasso's first show at Vollard's and would continue to promote Picasso until the Cubist period, when, like so many, he broke with the artist.

† Harlequin, like Columbine, Pierrot, and other stock characters, derives from the popular entertainment known as *Commedia dell'Arte*, which originated in Italy as far back as the sixteenth century.

as if to warn us that all is make-believe, that art is an illusion, and that we would be wise to question everything. Picasso takes on the role of the wily trickster, untrustworthy, sardonic, a man of masks and deceptions—in Verlaine's nimble verse,

> The sly
> Harlequin too—that oh
> So cunning domino,
> Whose eyes
> Shine through that mask that is
> So odd a part of his
> Disguise . . .

To follow him is to enter a realm where nothing is certain and the boundaries between the performer and the performance have become confused. The terrain of the Rose Period is a parched plateau on an unknown continent of indeterminate horizons, where the greatest navigational challenge is distinguishing what is real from what is merely imagined.

Picasso drew on multiple sources for the acrobats and tumblers, jugglers and jesters, that populate his work for the next year or so. He himself remembered an afternoon when he came across a troupe of acrobats in the place des Invalides. Another source was almost certainly the Cirque Medrano, a favorite destination whenever he had a little money in his pocket.

But itinerant performers were a staple of Symbolist iconography, their tatterdemalion providing just the right degree of piquant alienation, the contrast between their antic performances and the difficulty of their everyday lives a source of ready-made pathos. This is the theme of Ruggero Leoncavallo's 1892 opera *Pagliacci*, with its famous tear-jerking aria "Vesti la Giubba" (Put On the Motley), in which the hero must entertain the crowd even as his heart is breaking. In the opera's prologue Tonio sings:

> Mark well, therefore, our souls,
> rather than the poor player's garb

> *we wear, for we are men*
> *of flesh and bone, like you, breathing*
> *the same air of this orphan world.*

Also rattling somewhere in the back of Picasso's mind was the play by his Barcelona friend Santiago Rusiñol, *L'Alegria que Passa* (The Happiness That Fades), another drama featuring a band of wandering performers. The verses "Whether we weep or suffer,/We must still make people laugh. /We must sing for our supper" perfectly capture this strange ecosystem where the strident good cheer of the performer masks a world of hurt.

Apollinaire had already mined this imaginative vein in his poem "Mardi-gras" (1899) with its "pierrots wreathed in roses/pale ghosts who prowl the night . . . Harlequin, Columbines and Punchinellos with crooked noses . . ." and he will be among the first to write seriously about the new turn in Picasso's art. Covering the artist's 1906 show at the Serrurier Gallery for his latest literary endeavor, *La Revue Immoraliste*, Apollinaire noted that they "are the kind of creatures who would enchant Picasso. Beneath the tawdry finery of his slender clowns, one feels the presence of real young men of the people—versatile, shrewd, clever, poor, deceitful. The tension Apollinaire discerns between the role and the player, between the streetwise tough and the amiable buffoon who struts before the public, surely reflects Picasso's thinking at the time, which the writer gleaned in daily conversations at the Bateau Lavoir or on long walks through the streets of Montmartre.

The shift from blue to pink as the dominant hue in Picasso's art is usually attributed to his improving circumstances, from the despair and disappointment of 1902–3 to the contentment that came with Fernande's arrival in his life. This perspective almost certainly contains a grain of truth, but as an interpretive tool it is far too simplistic. Both modes are in a sense literary, artificial, expressions of the wider zeitgeist rather than purely autobiographical. And while the Rose Period paintings do not wallow in misery to quite the same degree as their predecessors, they hardly evoke earthly bliss. Apollinaire, who provided much of the inspiration for and was in turn inspired by Picasso's work at this time, captures the ambiguous associations of this most treacherous of

hues, the color of flush and fever, and the deracinated lives of the wandering players:

> *The oldest wore tights of that purplish pink one finds*
> *On the cheeks of certain fresh young girls close to death*

> *A pink that often nestles in the dimples near the mouth*
> *Or around the nostrils*
> *A pink full of betrayal.*

There is a lyricism in these paintings, a new element of tenderness, but also a cynicism that seems to mock the maudlin tone of the works that preceded them. They are jaded, enervated, suffused with a sense of futility, disillusionment, and alienation, a recognition, perhaps, that he'd been playacting all along. One of the earliest works on this new theme is a painting titled *The Actor*, from late 1904.* The figure is as gaunt and hollow-cheeked as any of his immediate predecessors; his fingers as he gestures toward the invisible audience are as twiglike as those of the couple in *The Frugal Repast*. But the mannerisms read differently in this new context. The actor has little of the dignity of the emaciated couple. He is a hapless figure, noble only to the extent that anyone who perseveres in the face of ridicule is deserving of our sympathy, if not our respect. If, as Matisse insisted, the artist is nothing but an actor, a "little man with the wheedling voice," Picasso reveals him to be a pathetic creature, his need for applause a hopeless, and soul-crushing quest. Significantly, he depicts the performance at the very moment it breaks down: at the bottom of the picture, he shows us the prompter's box, with two disembodied hands frantically riffling through the script to see where the actor has flubbed his lines.

* Like *Au Lapin Agile*, the work is in New York's Metropolitan Museum of Art. It's possible to date *The Actor* precisely to late 1904 since the sheet on which he made a preliminary sketch of the figure also contains two drawings of Fernande Olivier, the first he made of his future mistress.

Though it's often a mistake to assume the mood of an artwork reflects the mood of the artist, on one level Picasso's obsession with performers is clearly autobiographical. It conveys, at best, an ambivalence about the artist's role as performer; at worst, a bitter realization that he's little better than a whore, selling his talent to the highest bidder. But the alienation Picasso captures is more conceptual than personal. Like all art about art, the Rose Period works are self-conscious, both reflective and reflexive, turning back on themselves in ways that privilege irony over sincerity. They are not simply theatrical but investigations of theatrically, probing the mechanics by which illusion is produced. Artistic representation is a conjurer's trick, Picasso seems to say, and nothing is what it seems.

The Actor undermines the seamless illusion by which drama normally functions, short-circuiting the suspension of disbelief that is at the core of traditional theater and, indeed, all forms of representation. Even when he isn't explicitly showing us the moment when the illusion fails, most of the Rose Period works still evoke this treacherous terrain. Picasso normally depicts his performers offstage, practicing their craft, as in *Young Acrobat on a Ball*, or in mundane domestic settings, as in the touching *Harlequin's Family*. Usually they remain in costume, half themselves and half the roles they play. Like Degas in his depictions of ballerinas, Picasso takes us behind the scenes, but unlike those tough, muscular little gym rats, Picasso's players are mythical creatures, inhabiting the realm of metaphysical uncertainty that lies between real life and the stage. His acrobats and clowns inhabit a state of quantum uncertainty, neither wholly one thing nor another. This is their predicament, and it is this predicament that gives them their poignancy. They are, in an almost literal sense, disillusioned, with one foot in the world of make-believe, the other precariously perched on shifting sand.

Picasso's itinerant players are stand-ins for the bohemian painters and poets who make up his own community. Living a hand-to-mouth existence in shabby clothes and in shabbier rooms, free spirits haunting the margins of a society that romanticizes them even as it hold them at arm's length, they are the *bande à Picasso* plucked from Montmartre and sent wandering in the desert. One of the few sculptures he made during these months transforms Max Jacob into a court jester, and the portly figure who reappears in many of the Rose Period works, originally based on one

of the clowns from the Cirque Medrano, comes in time to be identified with Apollinaire.* Picasso's attitude toward these characters is at once ironic and affectionate, respectful of their dedication to their craft but also skeptical that they will achieve anything lasting.

The mood of these works—dreamy, languid, tender, and addled—no doubt owes something to the opium habit Picasso and Fernande acquired at this time. Under its influence, Fernande said, "[f]riendship would become more intimate, more tender, indulgent." The sweetness of paintings like *Harlequin's Family with an Ape* may owe something to the drug, which by Fernande's own account induced a temporary feeling of benevolence in the usually contentious group. But there is also a more sinister undercurrent to all this decadence. This comes through in paintings like *Young Girl with a Basket of Flowers* and *Boy with a Pipe*. In each work there is a suggestion of unnatural dissipation, an incongruity between the youth of the model and a knowledge inappropriate to their tender years. In *Young Girl with a Basket of Flowers*, the subject is an adolescent flower seller who plied her trade outside the Moulin Rouge nicknamed "Linda la Bouquetière" who also worked as a part-time prostitute. Picasso painted her in the nude, her still developing body making an uncomfortable contrast to the surly-seductive gaze she fixes on us.

Boy with a Pipe is a portrait of a local delinquent, "an atrocious and gracious little criminal, an unashamed friend of evil," Salmon remembered. P'tit Louis, as he was known around the neighborhood, was one of those dangerous sorts to whom Picasso was instinctively drawn. Salmon goes on to narrate how Picasso finally resolved this image of his young friend, which had been giving him trouble: "One night Picasso deserted the group of friends deep in intellectual discussion: he went back to his studio and, taking up this picture, which he had left untouched for a month, gave the young artisan in it a crown of roses. By a sublime stroke of caprice he had turned his picture into a masterpiece." The contrast

* The clown, as he noted in one of his sketchbooks, was named Tio Pepe. Picasso made the link to Apollinaire explicit in a watercolor dedicated to the poet showing him as a corpulent king stuffing his face at a banquet. This is a dig at his friend's notorious gourmandizing.

Harlequin's Family with an Ape, 1905. *Erich Lessing / Art Resource, NY.*

between the tough, knowing features, the hooded eyes—the addict's far-away gaze—and the floral crown evokes a world of corrupted innocence and moral depravity reminiscent of Baudelaire and Rimbaud.

Intended as a summing up of this particular moment in his art, and playing a role in the Rose Period equivalent to *La Vie* in the Blue, is the monumental *Family of Saltimbanques* [see color insert]. It's not only the painting's vast size—measuring 83 ¾ x 90 ⅜ inches, it was the largest painting he had yet attempted—that qualifies it as a masterpiece. Like *La Vie*, it was a grand summation, the painting toward which all the other work of the period pointed. Picasso devoted a great deal of time and labor to it, elaborating the composition in numerous studies, sketches, and related paintings. It's synthetic rather than improvisational, magisterial rather than spontaneous, timeless rather than ephemeral. Here the strolling players seem to have strolled right off the edge of the earth. Performers adrift in a landscape without an audience to cheer them on, they are wanderers in search of a context that will give them meaning, unmoored, bewildered, and unmourned.

It wasn't Apollinaire but the Austrian poet Rainer Maria Rilke who

best captured the mood of this painting. Exiled from his beloved Paris, by the outbreak of the First World War, Rilke stayed for a time in the Munich apartment of the writer and art collector Hertha Koenig, where the painting now hung. Communing day after day with this melancholy masterpiece, he dedicated to his patroness (and the work's current owner) the fifth of his Duino Elegies:[*]

> *But tell me, who are they, these wanderers, even more*
> *transient than we ourselves, who from their earliest days*
> *are savagely wrung out*
> *by a never-satisfied will (for whose sake)? Yet it wrings them,*
> *bends them, twists them, swings them and flings them*
> *and catches them again; and falling as if through oiled*
> *slippery air, they land*
> *on the threadbare carpet, worn constantly thinner*
> *by their perpetual leaping, this carpet that is lost*
> *in infinite space.*

Shortly before Fernande moved into his studio, Picasso took a trip to Holland in the company of a Dutch writer and musician, Tom Schilperoot, "an eccentric," according to Olivier, "who became the epitome of the bohemian when he squandered all his money in Paris." Since Picasso couldn't afford the train fare, the equally impoverished (but more resourceful) Max Jacob managed to come up with the funds. "[Max] went to the concierge and returned with twenty francs," Picasso recalled. "I had a satchel . . . and I'd put my paints in, but my brushes wouldn't fit. So I broke them in half and was on my way."

The summer Picasso spent in the rustic village of Schoorl, nestled in the coastal dunes along the North Sea, forms a peculiar interlude in his life and work. At least for the moment, the etiolated waifs of recent

* Duino is the name of a castle near Trieste where Rilke began the series of poems. In 1931, Hertha Koenig sold the painting to the American collector Chester Dale, who bequeathed it to the National Gallery of Art in 1963.

months vanish, replaced by women as voluptuous and fully rounded as his circus players are emaciated. "In Holland, Picasso was startled by the size of the Dutch girls," Fernande noted. "These 'little girls' towered over him, kissing him while they sat on his knee."

Returning to Paris, he returned as well to the skinny androgynous types that dominate the Rose Period, but the memory of those hulking Amazons lingered; along with Fernande's own more curvaceous form, they will make their mark on the next phase of his art. The stark beauty of the North Sea landscape may well have had a more immediate impact, merging in his mind with the barren plains of his native Spain to conjure up the desert setting for many of the Rose Period scenes.

In early 1906, Picasso bid farewell to the players who had kept him company for more than a year in a gouache titled *The Death of Harlequin*.* Killing off his alter ego was an attempt to move beyond the sentiment and late-Symbolist affectation that still characterized the Rose Period works. But while he was ready to move on, he was still too attached to his alter ego to abandon him completely. Apparently dead and buried, Harlequin's ghost makes frequent appearances in his art, including in Cubist master-pieces like *Harlequin* (1915) and *Three Musicians* (1923), among the most moving and disquieting of all his paintings.† Indeed, whenever Picasso in-troduces a diamond pattern into even the most abstract context, one can be sure that Harlequin's mischievous spirit hovers somewhere close by.

\\\

* Gouache was Picasso's preferred medium at the time: he used it for *Harlequin's Family*, *Two Acrobats with a Dog*, and *Harlequin's Family with an Ape*, among oth-ers. The glue-and-water-based medium allowed him to paint on heavy paper or cardboard, making it a cheaper and more convenient alternative to oil painting. It also leant itself to the sketchy, improvisational style he often favored. The matte finish of gouache also seems to have influenced the look of oil paintings like *Family of Saltimbanques* and *Young Acrobat on a Ball*, suggesting a chalky, dusty appearance appropriate to the desert setting.

† Picasso will reengage with the *Commedia dell'Arte* at various points during his collaboration with Serge Diaghilev and the Ballets Russes.

When he returned from Holland late in the summer of 1905, Picasso was, materially speaking, hardly better off than he'd been when he'd struck rock bottom in the fall and early winter of 1903. Psychologically, however, he was in a far better place. Happily in love and surrounded by an admiring coterie of brilliant and engaging friends, he was as close to contentment as his naturally discontented soul would allow.

For Fernande, as well, the years she spent with Picasso were the happiest of her life, despite the fact that he turned out to be every bit as possessive and controlling as she'd feared. He was so jealous, she remembered, that and he locked her into the studio whenever he went out shopping (which he insisted on doing himself). For the time being she put up with his paranoia, seeing it as a testament of his devotion. It was the first time in years she wasn't forced to work, and she luxuriated in her role as the sensuous odalisque of the Bateau Lavoir.

Leisure, however, was about the only luxury Picasso could provide her—that and an occasional bottle of perfume when he'd made an unexpected sale. One of the few diversions they could afford was the open-air market in the place Saint-Pierre. Waking early (at 11:00) on Sunday mornings, the two of them would head a few blocks east, in the direction of Sacré-Coeur, Picasso dressed in the workman's overalls he preferred, and Fernande in whatever secondhand finery she'd been able to acquire on a previous expedition. By the time they arrived the place Saint-Pierre would already be mobbed with bargain hunters combing through the "most incongruous miscellany of wares . . . on tarpaulins, or just strewn on the ground . . .

> ladies' hats of every stripe, trimmed with flowers, feathers and ribbons, a little dented and tired, but so well stiffened they could easily be brought back to life; there are stylish ostrich feathers and parrot feathers, not too badly bent; shoes, from heavy soldiers' boots to delicate satin ballroom slippers trimmed with buckles, but often you can only find a single one and have to search forever to find its partner; there are long underpants, white or with blue stripes; sheets and pillowcases; dusters; towels; suits for little boys and dresses for little girls; flounced petticoats; women's dresses and coats; working clothes for men; trimmings; innumerable packets

of artificial flowers; remnants of cloth, from buttons to brocades and lamés; purses; umbrellas; shopping bags; beaded handbags for going dancing; carpenters' trousers in rough canvas or corduroy; blankets; baby clothes; even saucepans and toys.

Even after he became rich, Picasso had a taste for castoffs, bringing home peculiar objects he'd discovered in flea markets or pawnshops, the grubbier and more scuffed up, the better. No modernist had less of an affinity for the sleek lines and gleaming chrome usually associated with the modernist aesthetic. Picasso had a pack-rat mentality and much preferred to surround himself with wounded hand-me-downs that evoked the lives of past owners. His belief that even the most humble scraps were imbued with magic potency would ultimately shift the course of Western art when this most superstitious of men began incorporating these redolent odds and ends into his paintings and sculptures.

Even amid the daily struggles there were hints that interest in Picasso's art was at last beginning to pick up. Collectors who'd supported him in the past, including Gustave Coquiot and Olivier Sansière, continued to buy an occasional work, though the prices they paid remained laughably small. Coquiot even tried to help him out by drumming up commissions for commercial work, though Picasso continued to balk at selling himself so cheap. He was so determined to make it on his own terms that he spurned opportunities that sustained many of his colleagues. Offered a chance to earn 800 francs to do some drawings for the satirical magazine L'Assiette au Beurre, he asked Fernande her opinion. "I'll do it for you," Picasso offered. "No," Fernande replied, "really you mustn't do anything you don't want to do." Whether or not he was being sincere, she knew her lover well enough to realize that such a sacrifice would only make him miserable.

That stubbornness meant he had to resort to even more humiliating expedients to earn a few extra sous. Most of the letters he sent to his Barcelona friends during these years contain solicitations for loans, a task made all the more distressing by the fact that his pleas fell on deaf ears. Kees van Dongen, a Dutch painter who'd just moved into the Bateau Lavoir, recalled, "Several other artists such as Picasso and myself tried selling in the area around the Cirque Medrano. We would spread out our canvases on the ground and sell them for five or ten francs apiece." But van Dongen,

who had a wife and young child to support, couldn't afford to be as high-minded as Picasso; in addition to hawking his canvases on the streets, he took as much commercial work as he could get.

In some ways the various dealers and *dénicheurs* Picasso had to deal with at this stage of his career exacted a higher toll on his self-regard than peddling his art to passersby on the boulevard Rochechouart. At least strangers simply ignored him. With the exception of the scrupulous Berthe Weill, most of the dealers who were willing to take a chance on a young unknown were little better than extortionists, taking advantage of his desperation to force his prices even lower. Later in life he compared these predators to the Roman soldiers playing dice at the foot of the Cross, and once he was famous he liked nothing better than to play one dealer against another to punish them for their greed.

Perhaps the worst of them was Louis Libaude (aka Louis Lormel), described by Berthe Weill as "a hyena that preyed on carrion." Alfred Jarry, who dealt with him as his editor, was even blunter, naming him "the Isle of Cack in the sea of Shit."* Libaude was among the new breed of speculators in modern art who had watched the rise of the Impressionists and their successors and decided that this rags-to-riches formula might form the basis of a lucrative business. Weill's contempt stemmed in part from the fact that Libaude skirted the law by pretending he was merely an avid collector, thereby avoiding the onerous dealer's license. Fernande, who refers to him as a "horse dealer," says that his modus operandi was to "speculate on certain paintings when he could get them very cheap." His hard-sell tactics made him so despised in Montmartre that he never went anywhere without his revolver, fearing an attack by one of the artists he'd cheated.

A more important (and certainly more honest) collector was André Level, who in 1904 established a consortium of speculators in contemporary art called Le Peau de l'Ours.† With an annual budget of 2,750 francs,

* Under his pseudonym Louis Lormel, Libaude was a literary editor. He and Jarry had quarreled after the failure of Lormel's magazine *L'Art Littéraire*.

† The name, meaning "The Bear's Paw," comes from a fable by La Fontaine in which hunters sell shares in a bear they haven't yet caught, leading to the inevitable misunderstandings.

Level was tasked with amassing a collection that, according to the group's bylaws, was to be sold at the end of ten years, hopefully for a healthy profit. With a deep love of art and a keen eye for the latest thing, Level was soon a fixture at the various alternative salons and in the galleries of respectable dealers like Vollard and Weill, as well as in the lower-end shops. His first great coup was discovering the work of the Fauves, but he also had the foresight to purchase two works by Picasso from Weill's group show in November 1904 for 200 francs, "[a] rare event in that epoch," she noted. Though Level was as much an investor as an art lover, the sight of such pragmatic men of business haunting the studios and pawnshops of Montmartre was an encouraging sign for modern art in general and for Picasso in particular. "Me," Libaude admitted, "I buy Picassos not because I like them, but because they'll be worth a lot someday." Many, including Picasso, found this attitude disgusting, but the fact that vultures like Libaude were circling meant they'd sniffed a change in the air.

Typical of the dealers who sprang up at this period near the Butte Montmartre was Père Soulié, a hard-drinking former wrestler who opened a shop in the rue des Martyrs. Once, when he was particularly desperate, Picasso sold him a pile of drawings for 10 sous, a paltry sum that didn't even cover the cost of the materials. Dealing in art was not Souliér's real business; his shop stocked bedding, housewares, and other necessities of life. Since many of his clients were poor painters, he began to accept paintings in lieu of cash, hoping he might someday strike it rich by stumbling upon the next Manet or Renoir. If he ever did hit the jackpot, it would have to be by accident, since he had no eye for art, modern or otherwise. In 1908, Picasso came across a striking portrait by Henri Rousseau (who had yet to make his reputation as the self-taught genius of the age) among the stacks of canvases that cluttered Souliér's shop. When Souliér sold him *Portrait of a Woman* for 5 francs he thought he was driving a shrewd bargain, pointing out that the canvas alone was worth that much and that if Picasso didn't like it he could simply paint over it.

Slightly more professional was Clovis Sagot, a former clown who opened his gallery at 46 rue Laffitte, down the street from the galleries of Vollard, Durand-Ruel, and Bernheim-Jeune. "Art dealer," Picasso snorted many years later, "that's saying a bit too much. . . . Clovis Sagot was really a junk dealer who also sold paintings. . . . He was a hard man, Clovis Sagot,

very hard—almost a usurer. But sometimes when I was broke, I put a few canvases under my arm and sold them to him." Sagot also ran a side business dispensing quack remedies. His gallery was located in an old pharmacy, and his "cures" were based not on any diagnosis but on whatever he happened to have lying about. Fernande recalled one occasion when he attempted to treat her chest cold with diabetes medicine.

But for all Sagot's eccentricities and hard bargaining, he, unlike Souliér, had a real eye for modern art, taking on consignment paintings not only by Picasso but by Juan Gris, Maurice Utrillo, Albert Gleizes, Jean Metzinger, Fernand Leger, and others. For all his unscrupulousness, his hardball tactics meant he'd made a shrewd calculation that there was something to bargain for. Olivier recalled a scene shortly after Picasso returned from Holland and was in desperate need of money:

Sagot arrives at the studio with Picasso and settles on three studies: a gouache on cardboard, quite large, showing two seated acrobats; a canvas depicting two girls holding a tall basket filled with flowers, and another whose subject escapes me. Sagot offers 700 francs. Picasso refuses. The dealer walks out and doesn't return. A few days pass, and the painter decides to call on him. He's still willing to buy, but this time he'll only give him 500 francs for the three studies. Picasso, furious, returns home.

The same comedy plays out a little while later. This time, Sagot will offer only 300 francs. Now desperate, Picasso is forced to accept.

On another occasion she caught Sagot slipping a few extra drawings into his portfolio. Not the least embarrassed about being caught red-handed, he simply returned the stolen items with an impudent grin.

Another promising sign was that whenever Picasso did manage to exhibit his work there were now a few members of the press who were ready to take up his cause in print. Charles Morice, the Symbolist poet and correspondent for the influential *Mercure de France*, organized a group show at the Serrurier Gallery in February 1905 that included a number of Picasso's recent works. Despite this high-profile booster, Picasso struck a pessimistic note in a letter to his friend Jacinto Reventós in Barcelona (perhaps because he wished to borrow money from him):

Dear friend Jacinto, You cannot imagine the happiness you gave me yesterday when I read your letter, because I have thought of you often and it has been a consolation for me to talk with you—you already know how lonely I am, always in the middle of a commotion and in the midst of a crowd which irritates me, but I am forced to deal with them because of interest and necessity—one has to eat—but if it were only that!... [I]t's terrible to be obliged to waste so much time, sometimes scrounging for the last *peseta* to pay for the studio or restaurant—and believe me all those struggles and all this trouble isn't worth it—it's wasted time. This only teaches you a practical and stupid moral, identical in everything to that of the last bourgeois of Barcelona. But, anyway, I continue working and in a few days I'm going to have a small exhibition. God willing people will like it and I'll sell all I'm sending. Charles Morice is in charge of organizing it. He tries to cover whatever is in his hands in the *Mercure de France*—we'll see about the results of all this.

In the end Picasso's pessimism was justified. He sold next to nothing, though, as promised, Morice did publish a laudatory article in his journal.

All this activity barely provided the minimum Picasso and Fernande needed to keep from starving, but it was vital nonetheless. Even the small-time dealers and speculators were laying the foundation for future success. Looking back on it all, Picasso was as surprised as anyone at what took place. "When we were twenty we were sure that painting meant us,—sooner or later—" he told André Malraux, "but that we wouldn't be acknowledged until we were dead. Like Cézanne. Like Van Gogh, who had sold one canvas—only one!—for a louis d'or. Then he committed suicide." Picasso was not being disingenuous; there was simply no precedent for the kind of success he, and to a lesser extent his colleagues, would ultimately enjoy. Fabulous wealth and international celebrity were not the goals artists aspired to at the time, particularly not those who had set out to defy the establishment and had rejected the dull if comfortable lives being a successful academician guaranteed. They hoped to avoid

the fate of van Gogh—impoverished, unknown, and with a bullet in his head—but in their wildest dreams they could not have anticipated the worldwide explosion of interest, attention, scandal, and celebrity their efforts would ultimately bring about. In 1969, when André Malraux, as Minister of Culture, declared the Bateau Lavoir a national monument, Picasso responded with a chuckle, "Heavens! If anyone had told us when we were there!"

In October 1905, there sounded one of those violent salvos that from time to time jolted the art world out of its complacency, announcing the end of one era and the beginning of a new. Such events, reports of which quickly spread from the Parisian salons to the capitals of Europe and beyond, were sometimes followed by consensus as everyone agreed that a novel vision, so startling at first, was just what was needed to crystallize the inarticulate yearnings of the age. Such a moment occurred in 1785, when Jacques-Louis David first exhibited his *Oath of the Horatii*, a painting that signaled not only a new aesthetic but a new ethic on the eve of revolution.

More often such bursts of insight were followed by years, even decades, of turmoil as the shock of the new was met by the resistance of the old. Not surprisingly, these cultural controversies largely followed the contours of the wider political debate. As radicals rallied around the innovators, traditionalists inevitably decried the assault on sacred values. Such was the case in 1865 when outrage over Manet's *Olympia* set off a decades-long battle between admirers of the new painting and its detractors. And again in 1874 when the Impressionists, Manet's spiritual disciples, launched their own attack on decorum.

By the dawn of the twentieth century the pattern had been largely set. Assaults on officially sanctioned art were even institutionalized, through alternative salons like the Salon des Indépendants and the Salon d'Automne. Journalists who covered the cultural scene tended to divide along party lines, defining themselves as either conservatives, opposed to every novelty, or progressives, indiscriminately attracted to the next bright, shiny thing. To a large extent the public that showed up at these

alternative venues were drawn by the lure of scandal; many came to scoff, to jeer, to insist that this time "they" had simply gone too far—this despite the fact that at each prior staging of this now-hallowed ritual the progressives had ended up looking like prophets and the rest like fools. These periodic spasms provided the necessary pulse to animate the avant-garde. Without regular eruptions of strife the entire organism would wither and die. And given the fact that with each cycle it became more difficult to shock a public that had come to expect the unexpected, many artists knew they had to up the ante even to get noticed. The bombastic manifestos of the Futurists and the aggressive stagecraft of the Dadaists were a self-conscious effort to provoke the kinds of responses that in earlier decades had grown up organically when artists pursuing their own idiosyncratic course had placed their works in front of an uncomprehending public.

Leading the charge in October 1905 was the most unlikely of revolutionaries. At the time, Henri Matisse was a thirty-five-year-old painter, trim, dapper, red-bearded, and bespectacled. Shy and a bit standoffish, his few close friends referred to him as "the doctor" or "the professor," nicknames that suggest a dignity and reserve that set him apart from his bohemian colleagues. The son of a well-to-do dry goods merchant from Bohain, in the far north of France, as a young man he tried desperately to conform to his family's expectations for him. He even trained for a time as a lawyer, and an air of bourgeois respectability continued to cling to him even during his years of penury. Unlike Picasso, for whom a career in art was set from the beginning, Matisse's journey was a perpetual struggle against his origins. He was not a born rebel like his Spanish rival; had he been able to pursue his singular vision while simultaneously remaining true to his conventional upbringing, he would almost certainly have hewed to this less tortuous path. But his attempts to play the dutiful son and pursue a respectable career approved of by his dour, hardworking father always foundered, the strains revealing themselves in bouts of psychosomatic illness that left him incapacitated, often for months at a time.

At the age of twenty-two he gave up this losing battle and went to Paris to pursue the life of a painter, studying first at the Académie Julian and later with the Symbolist painter Gustave Moreau. Matisse was a conventional man with a radically unconventional talent, a tension that showed through all his life but particularly in his early years as painter, where his

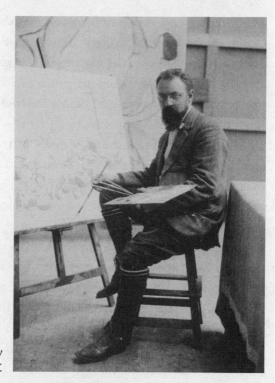

Henri Matisse. *The Morgan Library & Museum / Art Resource, NY.*

natural conservatism was undermined by the compulsion to pursue his own vision of what art could be. He often seemed his own worst enemy, enraging his teachers by his stubborn refusal to take instruction and instead following his own quixotic course.

The same pattern emerged outside the classroom. Early on he had won distinction at the official Salon with genre scenes in muted tones. One of his friends had even dubbed him "the master of the arts of grey." But what pleased the Academy failed to please him. Despite the fact that even a dealer as adventurous as Ambroise Vollard preferred his low-key paintings—on the sensible notion that "they appealed strongly to the customers" —Matisse rejected this easy success. Over the next few years he set about radically remaking his art, stripping his painting down to first principles and starting afresh.

He paid a steep personal as well as professional cost for his willfulness. Most painfully, his rejection of commercial rewards led to a rupture with his live-in mistress, Caroline Joblau, the mother of his daughter,

Marguerite. Soon, however, he found the perfect mate, one who believed in him unconditionally (often far more than he believed in himself) and was prepared to support him come what may. In 1898, he married Amélie Parayre, a woman of enormous generosity of spirit who not only raised her stepdaughter as her own but insisted that her husband pursue his own star whatever the consequences.

This star led him to the far fringes of the Parisian avant-garde. A honeymoon with Amélie on the Mediterranean island of Corsica opened the eyes of this child of the gloomy north to the possibilities of dazzling color, and the canvases from that idyllic time explode with vivid greens, orange, and purple. Following the example of, first, the Impressionists, and then the even more radical work of van Gogh, Gauguin, and Cézanne, Matisse endured a decade of poverty, scorn, and self-doubt. His career reached rock bottom in 1900, when he was forced to take a job in a sweatshop on the rue Sacrestan, painting backdrops for the upcoming *Exposition Universelle*.

Thus, while Picasso and Casagemas were preparing to set out on their Parisian junket, Matisse was trying to support his growing family by grinding out paintings by the yard, nine hours a day, "as if [we] were breaking stones." Now over thirty—a graybeard in the youth-centered world of the avant-garde—Matisse saw his career stall, while the eighteen-year-old prodigy Picasso was heading to the City of Lights in pursuit of what he fully expected would be a brilliant career. Indeed, there is a tortoise-and-hare quality to their rivalry and friendship, pitting the plodding striver against the facile genius, the introvert against the extroverted gadfly.

It's surprising, then, that Matisse was first off the mark. While Picasso was shuttling back and forth between Barcelona and Paris, alternating between exultation and despair, Matisse was working out, slowly but surely, the principles of a revolutionary approach to the art of painting. Despite his continued poverty, he was beginning to establish a reputation in the world of the Parisian avant-garde as a serious man and serious thinker. His integrity as well as his quietly subversive approach attracted younger painters inspired by his vision of an art liberated from a slavish adherence to appearances. Among those who shared his goals were a pair of friends from the Parisian suburb of Chatou. André Derain and Maurice

de Vlaminck.* Matisse met Derain in 1900, when they were both students at Académie Camillo in Montparnasse, where, in his typically self-improving way, the thirty-year-old Matisse was working from the model alongside youths barely half his age. He had, observed Leo Stein, "the temper of the eternal pupil: he is always willing to learn anyhow, anywhere, and from anyone." Derain, nineteen at the time, was won over by Matisse's earnestness and his quest to push the boundaries of his art. The following year Derain introduced Matisse to Vlaminck at a small exhibition of van Gogh's work held at the Galerie Bernheim-Jeune, and the three men instantly bonded over their mutual admiration of the visionary Dutchman who used color to evoke psychic and spiritual states rather than for naturalistic ends.

Each of these artists was groping toward a new kind of expression, one based on a more elemental, more intuitive approach. "I believe the realist period is over," Derain wrote to Vlaminck that same year. "[W]e have only just begun. . . . Apart from Van Gogh's abstract pictures, I believe lines and color are enough . . . to enable us to discover a simpler composition."

Though Matisse was growing more confident in his own powers and gaining a following in the younger generation, commercial success continued to elude him. Berthe Weill took an interest and Vollard offered him a one-man show in his gallery in June 1904 but then dropped him again after almost nothing sold. In his review of the show for *Mercure de France*, Charles Morice discerns an evident talent but also a certain hesitancy: "Matisse's paintings bear witness to the pleasure he finds in colors, in tones, in their relationships; but those relationships stand for themselves alone. This artist unquestionably has the taste, the passion, for the *techniques* of his art, but he perhaps has not grasped the full meaning *of his art.*"

* Chatou is located just east of Le Vésinet, where Guillaume Apollinaire lived with his mother, and the poet may have met the two young painters on the train he took home each evening. He met them shortly before his famous meeting with Picasso. His friendship with these three painters launched his career as an art critic.

Matisse's exploration of color harmonies had by now drawn him into the circle of Paul Signac. Since the death of Georges Seurat in 1891 at the age of thirty-one, Signac had led the so-called Divisionist or Neoimpressionist school. These artists were attempting to place the ad hoc optical experiments of the Impressionists on a scientific footing, creating paintings from thousands of dots of pure, usually complementary, colors that blended in the eye of the viewer, capturing light and form without the traditional expedient of modeling in shades of black and gray. In the hands of a master designer like Seurat it could lead to magnificent tableaux that shimmered and sparkled like a medieval mosaic; in lesser hands it led to sterile formalism.

For Matisse the scientific certainty espoused by Signac provided reassurance in a time of doubt. Signac, for his part, was happy to take on the new convert to the Divisionist gospel. But despite Signac's reputation as an anarchist in politics, he was something of a tyrant when it came to artistic matters. And much as Matisse wanted to toe the party line, he found Divisionist strictures as difficult to follow as those of his more academic teachers. His *Luxe, Calme et Volupté*, completed in 1904 and exhibited at the Salon des Indépendants in 1905, a vision of a sensual paradise based on a poem by Charles Baudelaire, features Neo-Impressionism's distinctive dots of pure color. But he breaks with orthodoxy by enlarging and separating them so that they no longer blend in the eye. Instead, the blobs of high-keyed color take on a life of their own, evoking the landscape while never losing their integrity as marks on a flat surface. Also radical is the way Matisse liberates line from its purely descriptive function. Instead of slavishly following the contours of figures, mountains, and boats, his brush traces graceful arabesques across the canvas that bear only the most general resemblance to the forms they describe. To a degree unprecedented even in the art of Cézanne, Gauguin, and van Gogh, line and color exist for their own sake.

Critics began to take notice. Reviewing this and other submissions to the Salon des Indépendants in the spring of 1905, the influential Louis Vauxcelles, writing for the magazine *Gil Blas*, declared that Matisse "is assuming, willingly or not, the position of leader of a school."

In early July 1905, Matisse invited Derain to spend the summer with him at the remote Mediterranean fishing village of Collioure, near the

Basque country and Picasso's own Catalonia. As had happened a few years earlier in Corsica, the blazing sun and vibrant colors of the south both galvanized and unsettled him. "[T]here are great hampers of cherries," wrote one of the town's residents, describing Collioure's central market in almost orgiastic tones,

> pyramids of pears, tumbled masses of apricots; the sharp red of tomatoes and the pale yellow of cucumbers and their brilliant notes. . . . Carts full of oranges pour their contents out into baskets of every shape, and the golden globes that roll free mingle with white and purple aubergines, like mighty eggs of some unknown bird.

Arriving a few days later, Derain, too, was overwhelmed, writing to Vlaminck, "it's the light, a pale golden light that devours shadow. To capture it is a labor of enchantment. All that I've done to this point seems stupid." The blazing summer light bleached out shadows and dissolved form. The sun-drenched south induced a sensory overload that made the silver-toned work of Matisse's early Salon success and even his more daring Corsican works appear dull by comparison. On the European shores of the Mediterranean and later in Africa, Matisse and his followers reveled in a Dionysian explosion of light and color, ecstatic to the point of madness. "The night is radiant," wrote Derain, "the day powerful. Light rises all around us a vast, clamorous cry of victory."

The 1905 Salon d'Automne opened on October 18 at the *Grand Palais*, where Picasso's *Last Moments* had hung in the *Exposition Universelle* five years earlier. As always the galleries were crowded, not only with progressive artists and their supporters but also with fashionable Parisians who enjoyed the spectacle and who came to laugh at the antics of the long-haired sorts. These shows had become social occasions where "one saw . . . everybody who was anybody." The ritual, in truth, had grown predictable through repetition, settling into a kind of stalemate in which positions and attitudes hardly budged.

In any case, there was plenty for traditionalists to approve of, including a gallery devoted to Ingres, the great neoclassical painter, and another

to Manet, who by now, two decades after his death, had been grudgingly accepted by the establishment that had once spurned him. In fact the Salon d'Automne, unlike the unjuried Salon des Indépendants, was the forum in which the latest art was given a stamp of respectability. As Gertrude Stein observed with her usual cynicism, it was the place where "those outlaws were to be shown . . . who had succeeded enough so that they began to be sold in important picture shops."

But despite attempts by the exhibition's organizers to sell the avant-garde to society's respectable elements, for the first time in years, even decades, the art on display infuriated a public that many assumed had lost its capacity for surprise. "A tempest raged at the Salon d'Automne," Leo Stein reported. "The visitors howled and jeered." The ire of the "commonsense" public (and the mainstream media that catered to their prejudices) was reserved for one group of paintings in particular, the work of an apparently deranged confraternity that had banded together with the sole purpose of thumbing their noses at all that was sacred and good in the nation. The angry and bemused mobs crowding into Room VII recalled the days of Manet and the Salon des Refusés, when the fate of civilization seemed to hang in the balance.

Typical of mainstream reaction was an article by a critic writing in *Le Journal de Rouen*: "We come to the most astounding room of the Salon. . . . We are presented with something that—apart from the materials employed—has absolutely no relation to painting. The pictures are made up of shapeless masses of color—blues, reds, yellows, greens, spots of crude color happily juxtaposed as in the barbaric and naïve games children like to play with the paint boxes they receive for Christmas. Let us be satisfied with simply mentioning the names of these performers, whose art—at least for us commoners—seems to have originated from nothing but pure folly and jest: Camoin, Derain, Manguin, Matisse."

On the basis of the ten works he showed in Room VII, Matisse was singled out as the ringleader of this dangerous new movement mocked in the press as either the "incoherents" or the "invertebrates." "This is madness!" was the repeated cry heard in front of one painting in particular, a portrait by Matisse of his wife in a fancy hat scrawled in acid colors that reminded viewers of nothing they could find in nature and drawn in a manner that seemed at once careless and belligerent. Like Manet's *Le Déjeuner*

sur l'Herbe four decades earlier, *Woman with a Hat* was always surrounded by visitors, most of whom came to see what all the fuss was about. Those who didn't see the painting in person could get an impression nonetheless from a spread in the magazine *L'Illustration*, which reproduced not only the offending *Woman with a Hat* but the hardly less disturbing *Open Window, Collioure*. Even the normally sympathetic Vauxcelles was taken aback. It was he who provided the most memorable line and the name by which the group would be known to history. Noticing a rather academic sculpture at the center of the room, a bust of a child by Albert Marque, he exclaimed, "Look! A Donatello surrounded by wild beasts."

The term "wild beast," or *fauve*, stuck and became the name under which Matisse and his followers became famous. The label seems particularly inapt for this most mild-mannered of men and does not reflect the tenor of a career characterized by the search for grace and harmony. Indeed, it seems much more fitting for his Spanish rival, a man who projected both savagery and violence and took positive delight in shocking the public.

But for all Matisse's outward calm there *was* something ferocious about the way he and his colleagues attacked the foundations of the Western representational tradition; they were anarchists of the brush, as disruptive in their way as the political variety, who believed that tossing a bomb into a crowded café was the best way to stir things up. One politician dubbed Matisse "the incarnation of Disorder." Many years later Derain reflected on their attitude at the time. "For us, Fauvism was a trial by fire," he said. "Colors became cartridges filled with dynamite to be exploded through contact with light."

Matisse, like Manet before him, was a reserved man uncomfortable in the role of *enfant terrible*. He was appalled when a group of academic painters hired a model to parade in front of his house "painted with chrome oxide green stripes from forehead to chin," and after facing down the derisive crowds at the opening of the exhibition, he refused to return. The president of the Salon d'Automne, Frantz Jourdain, had tried to spare him the ordeal, urging the jury to reject his submissions for his own good. "Poor Matisse!" he sighed when he heard that the jury had overruled him. "I thought we were all his friends here."

Whether he liked it or not, Matisse now found himself the leader of

the most radical, pugnacious, and controversial group of artists France had seen in many a decade. His notoriety only increased when the president of the republic, Émile Loubet, refused to pay the customary visit and lend his prestige to "such daubs." But the flip side of all this ridicule—indeed, its almost mathematical reciprocal—was a triumph in progressive circles, where there was no success admired as much a *succès de scandale*. If upstanding citizens came to jeer, bohemians came to applaud. One of the curators noted that the exhibition was "invaded every evening by long lines of revolutionaries, pouring down from Montmartre . . . much as a century earlier rioters from the faubourg Antoine descended on the National Convention." The comparison to events leading up to the French Revolution was only a bit of an exaggeration. Parisians took their art seriously, and the violence of the quarrels between the old guard and the new was due in large part to the belief that what was at stake was nothing less than the soul of the nation.

If Matisse was made uneasy by his sudden notoriety, he was compensated for the ordeal by the material benefits that came with it. On the strength of his earlier exhibition at the Salon des Indépendants, he had already won over the collector André Level, who visited his studio in the Latin Quarter and purchased two paintings for 400 francs. "I found myself holding four bills for one hundred francs in my hand!" Matisse recalled decades later. "I couldn't get over it."

The clamor surrounding the Salon d'Automne brought still greater dividends. A week before the exhibition closed, Matisse received a startling telegram: an offer of 300 francs to purchase the portrait of his wife that had been singled out by conservative critics as the very worst of the worst. Amélie told her husband he should refuse the offer, urging him to hold out instead for the 500-franc asking price. After an excruciating week a second telegram arrived: the buyers had agreed to the higher sum. "I was so moved," Matisse remembered, "I could not speak."

For Matisse, the 1905 Salon d'Automne meant an end to the years of struggle. He was now famous, or at least notorious, the recognized leader of the new wave in French art, a man who had paid his dues and was now reaping the rewards. His position as the leader of the avant-garde was cemented the following March with a single monumental canvas that

summed up a decade of striving for a new way of painting, a new way of seeing. Like *Luxe, Calme et Volupté, Joy of Life* [see color insert] is an Arcadian idyll based on a poem by Mallarmé. But now Matisse paints with a newfound boldness. He had discarded the remnants of his Divisionist technique in favor of broad swathes of pure color, shimmering veils that capture light without describing any particular feature of the landscape or reproducing any known atmospheric effect. Orchestrating subtle harmonies in a manner that is deceptively naive—based on his profound study of non-Western and children's art—he conjures a universe of sensual delight while employing only the most basic tools in the painter's kit. Without fuss, without apology, he invites us to fling aside our inhibitions, to leave civilization and its discontents behind and revel in a world of Dionysian ecstasy. Not everyone, even within avant-garde circles, was pleased. His old master Paul Signac wrote sorrowfully, "Matisse . . . seems to have gone to the dogs." Others were more open-minded. Charles Morice, who earlier had praised Picasso as "a young god who wishes to remake the world," now turned his eyes to Matisse. *Joy of Life*, he said, was *"la question du Salon,"* masterful, challenging, and, most of all, talked about.

Picasso and his allies regarded the triumph of the Fauves with dismay. For the better part of the year his friends had been positioning him as the rising star of the avant-garde, and even after Matisse and his colleagues had sucked out most of the oxygen, they tried valiantly to pump him up. André Salmon's review of the Salon d'Automne contains a rather gratuitous plug for his friend's work:

Picasso, with whom we meet, is not in the exhibition, doubtless with very good reason, but we regret not seeing here his visionary harlequins, his prophetic children, his breathless flowers and dolorous mothers. Vollard and Sagot more happily are exhibiting some of his incomparably poignant canvases. Painters and poets are duty-bound to go down rue Laffitte. People know too well the boulevard and not enough rue Laffitte, so nearby, where there are ten canvases by Picasso, which are the newest contribution to painting for ten years.

Picasso himself almost certainly didn't regret his absence from the circus surrounding the Salon d'Automne. However competitive he was, and however grudging in his praise for his colleagues, he was not prone to self-deception. Far from being "the newest contribution to painting for ten years," he would have seen immediately that the older artist had stolen the march on him. Side by side with the explosively dynamic canvases on display in Room VII, his delicately tinted acrobats and pathetic waifs would have faded into oblivion. Worse still, they would have been exposed as backward-looking, sentimental, the anemic last gasp of a dying Symbolism rather than harbingers of a new age. Even the monumental *Family of Saltimbanques* was no match for Matisse's expansive painting. Great as Picasso's painting is, it feels like a monument of the late nineteenth century rather than a beacon lighting the way to the future.

To challenge Matisse he would have to radically rethink his art once more, to build it—as the older artist had through years of slow, grinding toil—from first principles. It would be overstating the case to claim that Picasso transformed himself into the twentieth century's most protean and revolutionary artist simply to spite Matisse, but jealousy of Matisse's success goaded him to greater heights than he would have achieved on his own. The same, of course, could be said for Matisse.

Picasso came to regard Matisse as his one true rival, the only living artist who could challenge him on nearly equal terms. They competed for more than half a century, stealing from and one-upping each other, poking, prodding, and measuring themselves in the light of the other's achievement, ultimately engaging in one of the most complex and fruitful dialogues between any two artists of any age. "You've got to be able to picture side by side everything Matisse and I were doing at that time," Picasso said late in life. "No one has ever looked at Matisse's painting more carefully than I; and no one has looked at mine more carefully than he."

The process of deep looking began in 1905 and would not stop until both artists were in their graves.

Friends and Enemies

Matisse and Picasso then being introduced to each other by Gertrude Stein and her brother became friends but they were enemies.

—GERTRUDE STEIN, *THE AUTOBIOGRAPHY OF ALICE B. TOKLAS*

I f Picasso and Matisse were rivals from almost the first moment each knew of the other's existence, the contest was driven as much by those cheering from the sidelines as by their own considerable egos. It was Montmartre versus the Latin Quarter, the *bande à Picasso* versus the Fauves, the dark voodoo of the Spaniard versus the Apollonian grace of the Frenchman. For the most part the competition was respectful, but it could occasionally devolve into childish stunts. Shortly after the exhibition of *Joy of Life*, a few members of Picasso's gang went around Montmartre altering posters warning of the dangers of lead paint to read " 'Painters stay away from Matisse!' . . . 'Matisse drives you mad!'" And while Matisse generally tried to rise above the fray, on more than one occasion he was overheard making disparaging remarks about Picasso's art that found their way into the newspapers.

Much of the blame for the fraught situation belongs to an American family recently settled in Paris, three siblings and one spouse from Oakland, California, who were about to establish themselves as the world's foremost patrons of the avant-garde. The ambitions and peculiar internal

dynamics of this clan drew the two artists together, but also thrust them into direct competition. "[Leo] Stein can see at the moment only through the eyes of two painters, Matisse and Picasso," wrote Apollinaire of those early days, a situation that guaranteed the two leaders of the avant-garde would regard each other with a certain wariness. This was true even before harmony in the Stein family gave way to bickering and mutual recrimination. Then, like children in a messy divorce, the artists were pitted against each other, caught up in a tug of war that made aesthetic judgment a test of personal loyalty.

The Steins—Michael and his wife, Sarah (or Sally), Leo, and Gertrude—were Americans of German Jewish extraction. As children they had enjoyed a peripatetic existence, moving from Baltimore to Vienna to Paris and then back again, finally landing on the far western fringes of the continent in the still frontierlike town of Oakland, California. Here their father, Daniel, appeared to prosper for a time as an executive of the Omnibus cable car company. But when Daniel died unexpectedly, the eldest brother, Michael, discovered that their father was deeply in debt. Taking it

Leo, Gertrude, and Michael Stein. *Claribel Cone and Etta Cone Papers, Archives and Manuscripts Collections, The Baltimore Museum of Art.*

upon himself to retrieve the family fortune, he worked his way up to an executive position in the Central Pacific Railroad, raising his brilliant but impractical younger siblings and providing them the means to pursue their own idiosyncratic destinies.

Growing up, Leo and his younger sister Gertrude were inseparable. Physically they were opposites—he spare and willowy, she squat and massive—but when it came to the life of the mind they were kindred spirits. Smarter and more cosmopolitan than their unsophisticated schoolmates, they were thrown back on each other's company, living in their own world far removed from the concerns of their neighbors. Their sense of isolation was exacerbated by their Jewish heritage, which made them seem exotic and in Leo's case contributed to a lifelong defensiveness that showed through in verbal torrents that were intended to overwhelm listeners with his brilliance. "Had it not been for the shadow of himself, his constant need of feeling superior to all others," wrote his friend Hutchins Hapgood, "he would have been a great man."

When Leo headed to Harvard in 1893, Gertrude followed, enrolling the following year in the Harvard Annex (later renamed Radcliffe, sister school to the all-male university). There she studied with, among others, William James, the foremost philosopher and psychologist of the age. She was much taken with the charismatic professor and he with her, impressed by her intelligence and originality of mind. James' exploration of the "stream of consciousness" influenced the distinctive prose style Gertrude invented to capture the fleeting perceptions of an eternal present, and his belief in her gifts contributed to her growing conviction that she was destined for greatness.

Like Leo, Gertrude was bright but undisciplined. She pursued intellectual enthusiasms but dropped them when the initial impetus was lost. After a somewhat uneven career at Harvard, she followed Leo to Johns Hopkins, where she enrolled in the medical school, only to lose interest after a few months. When one of her fellow students urged her to apply herself, not only for her own sake but for the cause of women's rights, Gertrude sighed, "You don't know what it is to be bored."

By this time Leo had left Johns Hopkins to study art in Florence. The two Stein siblings were well on their way to becoming professional

dilettantes, gifted but erratic, decidedly unconventional, and indulged in their eccentricities by their older brother, who was willing to fund their somewhat aimless intellectual journey. For Gertrude, the discovery of her unconventional sexuality further distanced her from more straitlaced peers, leaving her ever more determined to chart her own course. An early short story, "Q.E.D.," unpublished during her lifetime, is based on her unhappy affair with the feminist editor Mary "May" Bookstaver.

In the wake of this failed romance, Gertrude rejoined Leo, first in Florence and then in England. By this time Leo had come under the influence of a scholar and fellow Harvard alum, Bernard Berenson, who encouraged him to apply his talents to art history. He briefly contemplated a book on the Renaissance artist Andrea Mantegna but dropped the project when he discovered that two other scholars were already preparing works on the painter.

In the summer of 1903, Leo moved to Paris, renting an apartment at 27 rue de Fleurus in Montparnasse, a couple of blocks west of the Jardin du Luxembourg. Gertrude joined him later that fall. Here in this middle-class neighborhood, in an apartment decorated with Renaissance furniture acquired in Florence and the Japanese prints that Leo had begun to collect, brother and sister set up their household together, each of them casting about for some purpose in life commensurate with their scatter-shot abilities.

Now thirty-one, Leo had yet to find direction. His latest ambition to become a painter fared no better than his previous enthusiasms. "Art," he complained to his friend Mabel Weeks, "is having its revenge on me." Gertrude was only a bit more focused; she'd decided that becoming a writer was the surest route to *la gloire*, as she called it, but had yet to discover the singular approach to language that would make her one of the distinctive literary voices of the twentieth century.

While Gertrude was finding her vocation, her older brother was discovering the one area in which his peculiar combination of talents—a keen but unfocused mind, strong opinions pugnaciously expressed, aesthetic insight unredeemed by any actual talent, and a need to prove himself smarter than anyone else in the room—could flourish. Oddly, it was Berenson, the world's foremost authority on Renaissance art, who

introduced Leo to the painting of Cézanne and set him on the path to becoming a collector of modern art.* "Do you know Cézanne?" Berenson asked him after Leo complained that there was nothing to see in Paris. "I said I did not. Where did one see him? He said, 'At Vollard's'; so I went to Vollard's and I was launched."

One reason Leo Stein decided to collect modern art was that he simply couldn't afford to buy the old masters. The Steins were prosperous compared to the artists they would soon be collecting, but comfortably middle class rather than wealthy.† Buying art, Leo had always assumed, was a hobby for the rich, but when he realized he could afford work created by his contemporaries, he claimed he felt "a bit like a desperado. . . . One could actually own paintings even if one were not a millionaire." Vollard, for his part, enjoyed doing business with the Steins, since, as he explained to Leo, he was one of the few who bought pictures not *because* he was rich but despite the fact that he wasn't.

Cézanne was the artist who first got Leo excited about modern art, and he and Gertrude spent hours rummaging through the dusty old stacks that Vollard stowed away in his cluttered gallery.‡ In these early days of their collecting it was Leo who led the way, with Gertrude deferring to her brother's discerning eye and greater knowledge.

By that time Michael and Sally had also arrived in Paris. Though not a born bohemian like Leo and Gertrude, Michael, encouraged by Sally, who wanted to study art, had apparently decided that the carefree lifestyle

* In his typically cranky fashion, Leo claimed, "In 'modern art' I was never interested. I don't even know what it is." By modern, he apparently meant most art made after 1910 or so, when Cubism and abstraction dominated.

† Leo and Gertrude each had about $150 per month to spend on art or other luxuries. Once, when Michael announced that there was a windfall of 8,000 francs (at an exchange rate of about 5 francs to the dollar) they hurried off to Vollard's and bought two Cézannes, two Renoirs, and two works by Gauguin.

‡ Leo spent the summer of 1904 in Fiesole and Florence, where he studied the collection of Cézannes amassed by Charles Loeser, the heir to the Macy's fortune. Leo called that summer his "Cézanne debauch."

of his two younger siblings was far more attractive than his plodding nose-to-the-grindstone existence. The couple, along with their young son, Allan, took an apartment on the rue Madame, around the corner from Leo and Gertrude, and the reunited Stein family prepared to sample all the intellectual and aesthetic delights the City of Light had to offer.

It would be difficult to overestimate the audacity of the Stein family when they decided to purchase Matisse's portrait of his wife, listed in the catalogue as *Woman with a Hat*. It was not simply a matter of buying a particular work—which, after all, was not that expensive—but of placing a bet on the future of art, one made in the face of widespread ridicule and in defiance of conventional wisdom. For the family as a whole, and for Leo in particular, this was part of the attraction. They reveled in the thrill that comes from doing something illicit. By purchasing the notorious canvas, they would be bringing into their home not an object of timeless beauty but something that pulsed with an almost toxic energy, insidious, radioactive, transformative.

It's not entirely clear which member of the Stein family deserves the credit for "discovering" Matisse. According to Leo's account, he'd had his eye on the artist since the Salon d'Automne of 1904, when Matisse's *Luxe, Calme et Volupté* made on him "the strongest impression, though not the most agreeable." Around that time he stopped by Berthe Weill's gallery, where the proprietor tried to interest him in the painter's work. Leo declined, and Weill herself later admitted "the paintings weren't ripe yet." It was only the following year, when, in the company of his sister, brother, and sister-in-law, he saw *Woman with a Hat*, that he realized he was in the presence of "something that was decisive." Recalling the impact of the work on him decades later, after he had largely given up on modern art and the rest of the Stein clan had chosen sides—Michael and Sally opting for Matisse, Gertrude faithful to Picasso, Leo deciding he'd had enough of both—he managed to pat himself on the back for his perspicacity while at the same time revealing an ambivalence and the infuriating condescension that was an essential part of his nature. "It was a tremendous effort on his part," Leo wrote, "a thing brilliant and powerful, but the nastiest smear of paint I had ever seen. It was what I was unknowingly waiting for, and I

would have snatched it at once if I had not needed a few days to get over the unpleasantness of the putting on of the paint."

Thérèse Jelenko, a family friend, suggested that it was in fact Michael and Sally Stein who first perceived the brilliance of the much reviled canvas. "I still can see Frenchmen doubled up with laughter before it," Jelenko recalled, "and Sarah [Sally] saying 'it's superb' and Mike couldn't tear himself away." Matisse later confirmed Sally Stein's vital role, claiming she was the one "who had the instinct in that group." Whoever made the first move, what is beyond dispute is that these peculiar Americans had a far keener appreciation of the most radical art than their French peers. While Parisians jeered, the Steins pooled their resources and snatched up the painting.

Matisse, who'd been shaken by the almost universal condemnation, was almost equally shocked when he heard the painting had found a prospective buyer. Soon *Woman with a Hat* was hanging in the pavilion at 27 rue de Fleurus, the large room in the courtyard that had served as Leo's atelier until he concluded he was too neurotic to make it as a painter. Alongside his Renaissance furniture, his Japanese prints, and even his Cézannes, the Matisse struck a decidedly dissonant note. But its power to shock was exactly what appealed to Leo. Matisse was now the most talked about artist in Paris, widely scorned as the demented leader of a band of anarchists who wished to tear down everything good Frenchmen held sacred. By backing this subversive, Leo made sure he was part of the conversation.

In purchasing the work Leo was staking his own claim to originality. What distinction was there in collecting a work that consensus had already anointed a masterpiece? Only by seeing what others couldn't, by singling out for praise what the great mass of men and women despised, could he fulfill his ambition. As his collection grew, and as its fame spread, Leo was in his element, bestowing enlightenment like a Buddhist sage on those who made the pilgrimage to the temple dedicated to the adventurous spirit of modernism he was building. "People came," he said, "and so I explained, because it was my nature to explain."

Ultimately the artists would disappoint him: he purchased his last Matisse in 1908, his last Picasso two years later. Neither of his most important discoveries would allow himself to be led by his theories, so he

abandoned them; and once they became household names, there was no longer any credit in singing their praises. He retreated into cranky old age, outliving his gifts and his courage, grumbling that the world no longer listened to him.

But for a few crucial years he was the most daring prophet of the new. His eventual apostasy should not diminish the pioneering role he played in these early years in promoting art that most still regarded as a threat to the established order. If Leo was dogmatic, pompous, and perhaps even a bit deranged, no one could deny that he had courage and that his financial and rhetorical support came at a critical time for the modernist movement, when powerful forces were determined to smother the dangerous new tendencies in the cradle.

Indeed, Leo Stein saw himself as more than simply a collector: he was a patron in the mold of the great Renaissance princes—the d'Este, the Medici, the Montefeltri—who acquired immortal fame through their enlightened support of the greatest talents of the age. In addition to Matisse, Leo cast about for other worthy souls to champion. His search inevitably took him to Montmartre and to the various junk shops–cum–galleries that clustered in the vicinity of the Butte. "It was a queer thing in those days that one could live in Montparnasse and be entirely unaware of what was going on in the livelier world of Montmartre," he said. "I was a Columbus setting sail for a world beyond the world."

Before long he found his way to the old pharmacy a few doors down from Vollard's that Clovis Sagot had turned into a gallery offering the latest products from the Montmartre studios:

> I had known for some time in the Rue Lafitte [sic] a little dealer, an ex-clown with a pointed beard and bright eyes and a hat pushed back on his head, who twinkled with enthusiasm whatever was the subject, but especially when that subject was Zan or current painting. Zan was a particular brand of licorice which was different from any other and the only one that had the properties of a life-preserver. He would interrupt the talk on modern art to put a bit of Zan between his teeth and commend its virtues; then we were back again on the latest show, the latest artistic scandal, the prospects for the future.

Once, Sagot talked him into buying a small watercolor by a Spanish painter, which Leo immediately regretted since he realized it was a trivial work. "[W]hen he recommended another Spaniard, I balked. 'But this is the real thing,' he said. So I went to the exhibition, and in fact this was the real thing. . . . When, a few days later, I dropped in at Sagot's to talk about Picasso, he had a picture by him, which I bought." That painting was *Harlequin's Family with an Ape*, one of the most tender of the Rose Period works.

A few days later Leo brought along his sister Gertrude, who, though she still had almost no understanding of modern art, was putting up half the money for Leo's burgeoning collection. This time Sagot showed them another work by Picasso, the haunting *Young Girl with a Basket of Flowers*. "Gertrude Stein did not like the picture," she wrote in the guise of Alice Toklas, "she found something appalling in the drawing of the legs and feet, something that repelled and shocked her. She and her brother almost quarreled about this picture. He wanted it and she did not want it in the house. Sagot gathering a little of the discussion said, but that is alright if you do not like the legs and feet it is very easy to guillotine her and only take the head. No that would not do, everyone agreed, and nothing was decided."

Leo bought it anyway, and when Gertrude saw the disquieting painting hanging above the dinner table, she pushed her food aside and claimed she'd lost her appetite.* A few years later, the situation was reversed. When the two had a falling-out in 1913 and were forced to divide the collection, Leo insisted on taking the Cézannes while Gertrude was equally adamant about holding on to the Picassos. By that time Picasso was already acknowledged to be the most revolutionary artist of the age, and Gertrude's attachment had as much to do with her self-image as the leader of the literary avant-garde as a genuine appreciation for his achievement. And at the very moment Gertrude was embracing modernist painting in order to promote her own modernist literary credentials, Leo was losing his nerve

* Leo bought the painting for 150 francs, twice what Sagot had paid Picasso but 350 francs less than Leo had paid for Matisse's *Woman with a Hat*—a good indication of the relative status of the two artists at the time.

and dismissing Cubism as a cheap stunt. In one of many score-settling accounts aimed at his estranged sister, Leo Stein recalled bumping into Picasso on a Paris street. " 'By the way,' " Picasso said:

"I saw Gertrude recently. She said to me, 'There are two geniuses in art today, you in painting and I in literature.' Picasso shrugged his shoulders. "What do I know about it? I can't read English. What does she write?"

I said she used words cubistically, and that most people couldn't understand at all.

"That sounds rather silly to me. With lines and colors, one can make patterns, but if one doesn't use words according to their meanings, they aren't words at all."

By the time Leo wrote this, rewriting history had become a full-time occupation on the part not only of the Steins but of many survivors of the heroic days, brother and sister taking potshots in their respective memoirs and the artists pushing back at the writers who wanted to turn the spotlight on themselves. Picasso's memory was as selective and self-serving as that of the rest. Once he no longer needed their support, he even complained, "Ah those Steins, how they did exploit me!"

Picasso's ungrateful comment is as deceptive as anything penned by Gertrude or Leo. Leo's initial purchases in the fall and winter of 1905–6 were a godsend to the artist and his mistress, who were still barely managing to scrape by. But Picasso resented the humiliation of his dependence, railing against the dealers who took advantage of him and the collectors who treated him with such condescension. He would take their money and exploit their connections, but that didn't mean he had to thank them for it.

Another source of resentment was the fact that the sponsorship of the Stein siblings meant that he was thrown into direct competition with Matisse at a time when he wasn't adequately armed for the battle. Leo relished his newfound role as patron of the arts and enjoyed making invidious comparisons between the artists he considered his personal property. Picasso was shrewd enough to know that, at least in the short run, the juxtaposition would not work to his advantage.

A modern-day Maecenas, Leo Stein had found a mission suited to his peculiar tastes and particular gifts. After years of drift he took to his new role with gusto, not only purchasing the artists' work but observing them in their natural habitats and generally involving himself in their lives, the better to explain to them the meaning of paintings that, according to Leo's way of thinking, they but dimly understood themselves. Shortly after purchasing *Woman with a Hat*, he paid a visit to Matisse in his studio on the top floor of an apartment house on the quai Saint-Michel, where he was introduced by his fellow Fauve, Henri Manguin. Matisse greeted his new patron warmly, while Leo bestowed his blessing on the scholarly artist, calling him "really intelligent . . . also witty, and capable of saying exactly what he meant when talking about art"—a quality, he asserted, "rare with painters."

Tracking down the elusive Spaniard proved slightly more difficult. At this stage Picasso was still a somewhat marginal figure in the Parisian art world. He didn't show at the various Salons where artists, collectors, and critics made connections. He balked at self-promotion and in any case was too self-conscious about his imperfect command of French to be a natural networker. True, he had widened his circle of friends in recent months, but, as Leo pointed out, Montmartre remained terra incognita.

The Steins were eventually introduced to Picasso by a mutual acquaintance, Henri-Pierre Roché, a journalist who supplemented his income as an agent buying modern art for rich Americans.[*] They had met Roché in the studio of a sculptor named Kathleen Bruce who was working on a bust of their nephew Allan. Gertrude described Roché as "one of those characters that are always to be found in Paris . . . very earnest, very noble, devoted, very faithful and [a] very enthusiastic man who was a general introducer." He was one of those people who made it his business to know everyone who mattered, ingratiating himself with the various expat communities among whom many of his best clients lived. His ease in that multilingual world elicited one of those witty, acerbic remarks from Picasso, who had so little of that capacity himself. "Roché is very nice," he told Gertrude, "but he is only a translation."

[*] Roché would achieve fame as the author of the autobiographical novel *Jules et Jim*, later made into a film by François Truffaut.

One day in Bruce's studio Gertrude happened to mention the fact that they had just bought a painting by Picasso. "Good good excellent, said Roché, he is a very interesting fellow, I know him. Oh do you, said Gertrude Stein, well enough to take somebody to see him. Why certainly, said Roché. Very well, said Gertrude Stein, my brother I know is very anxious to make his acquaintance."

A few days later Leo and Roché made the crosstown journey, climbed the steep hill of the Butte, and knocked on the door of Picasso's Bateau Lavoir studio. "One could not see Picasso without getting an indelible impression," Leo said of this initial encounter. "His short, solid but somehow graceful figure, his firm head with the hair falling forward, careless but not slovenly, emphasized his extraordinary seeing eyes. I used to say that when Picasso had looked at a drawing or a print, I was surprised that anything was left on the paper, so absorbing was his gaze." Leo was less impressed with the grubby surroundings, which he described as "a mess," with "a heap of cinders beside the round cast-iron stove . . . some crippled furniture; a dirty palette; dirty brushes; and more or less sloppy pictures."

Leo's mania for explaining, for classifying, for demonstrating his superior understanding, led to an immediate appraisal of the two artists he now considered his protégés:

> The homes, persons and minds of Picasso and Matisse were extreme contrasts. Matisse—bearded, but with propriety; spectacled neatly; intelligent; freely spoken, but a little shy—in an immaculate room, a place for everything and everything in its place, both within his head and without. Picasso—with nothing to say except an occasional sparkle, his work developing with no plan, but with the immediate outpourings of an intuition which kept on to exhaustion, after which there was nothing till another came.

Shortly after this visit the Steins invited Picasso and Fernande for dinner at the rue de Fleurus. "Picasso in those days," Gertrude recalled, "[resembled] a good-looking bootblack. He was thin dark, alive with big pools of eyes and a violent but not rough way. He was sitting next to Gertrude Stein at dinner and she took up a piece of bread. This, said

Picasso, snatching it back with violence, this piece of bread is mine. She laughed and he looked sheepish. That was the beginning of their intimacy."

Picasso's peculiar behavior reveals not only his social awkwardness but the gnawing hunger that was never far away in those days of struggle. If he accepted various invitations to dine, it was as much to help himself to the free food as to make the connections he needed to succeed. As it turned out, dinners at the Steins proved rewarding on both material and personal levels. The friendship between the eccentric American lesbian and the sardonic, womanizing Spaniard was an attraction of opposites, helped, rather than hurt, by the fact that they were both less than proficient in the one language they had in common. Picasso rarely regarded women as equals, but then he hardly seemed to regard Gertrude as a woman at all, at least not in the conventional sense. Her masculinity and complete lack of coquettishness allowed him to conceive of her as almost a different species entirely. He found her physically, but not sexually, charismatic. Gertrude's unapologetic girth (she was one of the few women in Paris who refused to wear a girdle) inspired in him a kind of awe, reminding him of one of those Paleolithic fertility fetish that throbbed with a savage energy. He was so captivated by her powerful presence that shortly after they met, he asked her to sit for her portrait.

Gertrude, who considered herself a personage worthy of being immortalized, happily accepted. Every afternoon during the winter and spring of 1905–6, she took the horse-drawn omnibus to the foot of the Butte and climbed the hill to the Bateau Lavoir, making the return journey on foot. In her billowing skirt of brown velvet corduroy and leather sandals she cut a bizarre figure striding along the boulevards of Paris, completely unself-conscious about the stares she received from passersby.* She sat for Picasso eighty or ninety times, she claimed, leisurely hours during which

* When she and Leo, who favored a similar outfit of brown corduroy and sandals (designed by their former Oakland neighbor Raymond Duncan, the brother of Isadora), tried to order drinks at a fashionable café, they were often denied service on the assumption that people dressed so unfashionably would be unable to pay the bill.

she composed in her head the novel she would eventually publish under the title *Three Lives*. When she wasn't composing, Fernande, "very large, very beautiful and very gracious," read to her from the fables of Jean de La Fontaine. Like everyone else who had the privilege of watching him at work, Gertrude was struck by the artist's single-minded focus. "Picasso sat very tight on his chair and very close to his canvas," she wrote, "and on a very small palette which was of a uniform brown grey color, mixed some more brown gray and the painting began."

The *Portrait of Gertrude Stein* [see color insert], now in the Metropolitan Museum of Art in New York, represents yet another seismic shift in Picasso's young career. She herself said as much, and while it is usually best to view her pronouncements with a healthy skepticism, for once she is on the mark: "In the long struggle with the portrait of Gertrude Stein, Picasso passed from the Harlequin, the charming early italian period to the intensive struggle which was to end in cubism." For the past year or so he'd been portraying wistful harlequins and lithe acrobats; before that his cast consisted of cadaverous beggars and sorrowful Madonnas: in each case their disembodiment signaled a withdrawal from the world, the triumph of spirit over gross matter. The Blue Period and Rose Period work achieved a kind of melancholy poetry, evoking states of consciousness far removed from mere physicality. Instead of confronting the here and now, Picasso invited us to lose ourselves in a land of dreams.

With the portrait of Gertrude Stein the material world—the substance of paint and canvas, as well as the hulking, fleshy, sculptural presence of the sitter—reasserts itself. This sensitivity to surface, to the tactile and textural qualities of pigment laid down roughly or caressingly on a flat surface, had always been there, but these elements had been subordinated to a narrative that appealed directly to our emotions. As Picasso himself later perceived when he dismissed these early works as sentimental, there was a separation between the meaning of the work and the forms through which those meanings were conveyed. This chasm between form and content constituted the fatal flaw of academic art, where the subject matter was everything and the means of representation counted only to the extent that it helped tell a story, preferably an edifying one.

Gertrude Stein at the rue de Fleurus, below her portrait. *Library of Congress.*

Like the banal canvases hung floor to ceiling at the official Salon, Picasso's work, as he himself seemed vaguely aware, came dangerously close to illustration. If his meanings were ambiguous rather than didactic, poetic rather than allegorical, they were nonetheless infected by a kind of false consciousness: one might even accuse them of insincerity. The trick, he was now beginning to realize, was to convey meaning *through* form, not to rely on external associations to invest the artwork with a spurious significance. He was never one of the formalists who believed that art should be stripped of all connection to our emotional life (and thus was never seduced by abstract art, in which form was an end in itself). Quite the opposite: without those deeper connections, art ceased to have any meaning at all. Somehow meaning had to emerge from the building blocks of painting (and later sculpture) itself, from line and plane, light and shade, mark and texture. The artist who could imbue those basic forms with the emotional power of a Crucifixion or the universal appeal of a mother and child would have achieved something remarkable—he (or she) would

spark a revolution in art as profound as that set off more than half a millennium earlier when Giotto reimagined the static icon as a stage upon which real men and women might enact their sacred dramas.

Beginning with the *Portrait of Gertrude Stein* and the related works of 1906, Picasso began to remove overtly narrative elements from his work while simultaneously attempting to invest the image with a totemic presence. Like many of his colleagues he looked to so-called primitive and archaic art, to medieval icons, Egyptian tomb reliefs, non-Western fetishes, even the art of children, hoping to recover the direct, unmediated expression of a primal instinct that had been lost to the eye-deceiving tricks of the Renaissance.* In search of this more authentic vision he wandered the less visited parts of the museums—the pre-Classical galleries of the Louvre and, later, the even more obscure venues devoted to African and Oceanic art—hoping to unlock the secrets that made these works capable of reaching directly into the dark corners of the psyche. Instead of being diluted by the preposition *of*—a depiction *of* a figure, *of* a landscape— these objects simply *were*, which gave them a power unavailable to the Western representational tradition.

It would be overstating the case to say that Gertrude Stein's forceful personality *caused* Picasso to rethink the direction of his art, but her presence in his life and in front of his devouring gaze helped catalyze a shift that was already beginning to take place. Even before he met the formidable American, the women Picasso had depicted during his summer in Schoorl were far more imposing than the anemic waifs typical of the Rose Period; it's also apparent that Fernande's voluptuous form was beginning to take over from the undernourished types he had preferred up to that point.

* This primitivizing trend took many different forms and looked to many different traditions. Some relatively sophisticated painters, like the Pre-Raphaelites in England or Puvis de Chavannes, looked to the early Renaissance, the so-called Italian primitives; others looked to folk art, children's art, or non-Western cultures that were viewed as "savage" and therefore in closer touch with something fundamental in human nature. There was an almost universal sense that civilization had taken a wrong turn. In each case the goal was to discover a more honest, more truthful form of expression.

He'd not yet discovered an aesthetic suited to this more assertive physicality, but he was clearly searching for a new, more robust mode of expression.

Crucially, Picasso was growing dissatisfied with the Symbolist vocabulary that had served him so well in breaking free of the academic discipline in which he'd been trained. If its exhaustion had not been apparent earlier, the bombshell lobbed by Matisse and his fellow Fauves was more than sufficient to kill off a movement that had clung to life too long. For Picasso, as for many artists and writers of his generation, purging himself of those habits of thought proved difficult. Fortunately, his poet friends were suffering through the same kind of withdrawal. If he ever succumbed to easy sentiment, Max Jacob was on hand to set him straight, crying out in front of the offending image, "Still too Symbolist!" Room VII of the 1905 Salon d'Automne had revealed to anyone with eyes to see that the new century would call for a more aggressive approach, something tougher, more in your face. The opium-scented dreams of Symbolism felt enervated in the face of the delirium unleashed by Matisse, Derain, Vlaminck, and their Fauve colleagues. Picasso had no wish—and, he knew, no ability—to best these rainbow warriors at their own game. He was not an instinctive colorist; he thought in terms of light and shade, form and substance. It was clear to him that Matisse was supremely gifted in the one area where he was least endowed. If he were to beat Matisse, or even to equal him, it would be in very different terms, employing very different tools. The months he spent struggling with Gertrude Stein's portrait—comparing what he'd done with Matisse's portrait of his wife, which he saw during the weekly soirees held in the Steins' pavilion—he not only purged himself of the last vestiges of Symbolist sentiment but forged his way, inch by grudging inch, toward a revolutionary kind of expression.

Leo Stein's "discovery" of Picasso marks a new phase in the artist's life, the beginning of his climb to fame and fortune that in retrospect feels preordained but at the time felt tenuous and easily reversed. After years of neglect, grinding poverty, and bouts of despair, the market for his work was finally solidifying.

Leo Stein deserves a lot, but not all, of the credit; he was as much a sign of the change as its agent. With allies like Charles Morice, Apollinaire,

and Salmon determined to promote Picasso in the journals and a handful of galleries willing to take a chance on his work, his name was becoming familiar to anyone following the progressive art scene. Crucially, Leo was willing to put his money where his mouth was, providing an infusion of cash to go along with an increasing number of moral victories. And once the eccentric American had placed his bet on the artist, others followed— slowly at first but then in increasing numbers. From now on, Picasso and Fernande would not have to cheat the local *pâtissier* in order to eat. They could dine at one of the cheap bistros that sustained life in bohemian Montmartre and could even spring for regular nights out at the Cirque Medrano or the Lapin Agile. There was ample coal for the stove—blazing away during Gertrude's many sittings—and Picasso was even able to buy Fernande the little treats she craved: a stylish hat from the place Saint-Pierre or a bottle of Essence de Chypre, her favorite perfume.

Leo took the first step, but it was Gertrude who ultimately embraced the role of Picasso's champion in the Stein clan, perhaps because his obsession with her portrait confirmed her sense of herself as an object of fascination. Promoting the young Spaniard became her pet project, while Leo gave the nod to Matisse, a more thoughtful artist, he believed, and more congenial company. "I often said that I had complete confidence in Matisse," wrote Leo, "who would give all that was possible for him to give, but that the future of Picasso was unpredictable, as there was no center."

Centered or not, collectors were beginning to pay attention to the mercurial Spaniard. Gertrude's esteem paid immediate dividends. On numerous occasions while sitting for her portrait, she brought along two of her friends from Baltimore, Claribel and Etta Cone. With Gertrude's encouragement, and despite their own reservations about this bohemian savage—Etta found the Picassos "appalling but romantic"—the sisters began to purchase drawings straight off the studio floor. Later they would favor Matisse over Picasso, but even these modest purchases made a difference.[*]

[*] On November 2, 1905, Etta bought "1 picture and 1 etching" for 120 francs, and a few months later the sisters bought "11 drawings 7 etchings" for 175 francs. They later donated their collection to the Baltimore Museum of Art, the basis of the famed Cone Collection.

Picasso, for his part, was much taken with his new acquaintances, who provided him a glimpse of a hitherto unsuspected dimension of womanhood. "They are not men," he remarked, "they are not women. They are Americans." Their gruff, no-nonsense presence confirmed the new direction his art was taking, providing a model for those Amazons— sometimes goofy, often ferocious—that crop up time and again in his art.

A curious feature of Picasso's rise to prominence was that while it took place in Paris it was engineered largely by foreigners. Even his "French" friends were for the most part outsiders: Apollinaire was an Italian of Polish extraction; Salmon, though of French parentage, had spent much of his childhood in Saint Petersburg; and Jacob was Jewish and a homosexual, which meant he was doubly marginalized. Like all great cultural centers, Paris was cosmopolitan, a magnet for creative and restless souls from across the globe. Picasso himself had been drawn to the French capital by its polyglot creative ferment, which he found so much more stimulating than the parochialism of his native Barcelona. Many of those responsible for the triumph of the avant-garde were similarly peripatetic. At its best Paris accommodated misfits of all sorts, whose disparate talents seeded the indigenous culture, giving rise to all sorts of unexpected hybrids. From time to time, however, tolerance gave way to jingoist reaction. In the nationalist fervor leading up to the First World War, Picasso's art—and Cubism in general—was denounced as *bosch*, a foreign organism infecting the pure body of *la patrie*.

Lending superficial plausibility to the slander that Picasso had subversive tendencies was the fact that so many of his early admirers came from a country that France regarded as its mortal enemy. Among the most fervent was Wilhelm Uhde, the descendant of a respectable Prussian family, who had come to Paris in 1904 to deal in the decidedly unrespectable area of modern French art. One of his first acquisitions was Picasso's early Blue Period work *The Blue Room (Le Tub)*, which he purchased from the Montmartre junk dealer Père Soulié for ten francs. A few days later he made his way to the Lapin Agile. "In the low smoky room were gathered the young artists of the rue Gabrielle and the Place Ravignan," he remembered. "Someone was reciting the poems of Verlaine. I ordered wine to be served at the big table in the center of the room. In the course of the evening I learned that the young man who had

painted the canvas was called Picasso and that he was sitting at my right."
The two men soon struck up a friendship that would prove profitable to
both.

Uhde was the earliest of the German dealers to promote Picasso's
work in Paris and abroad, paving the way a few years later for the even
more successful Daniel-Henry Kahnweiler, the "impresario of Cubism."
More of a businessman than the Steins, Uhde not only loved modern art
but hoped to earn a living from his passion. He conducted much of that
business on Sundays, when he kept an "open house" at his apartment, in-
viting Picasso, Braque, Robert Delaunay, and others on his roster to come
mingle with potential buyers.

Like many who found their way into Picasso's charmed circle, Uhde
was gay, his adventurous eye no doubt conditioned in part by his out-
sider status. Unusually for this era, he made no attempt to conceal his
unconventional lifestyle. "Uhde used often to come Saturday evening,"
Gertrude Stein recalled, "accompanied by very tall blond good-looking
men who clicked their heels and bowed and then all evening stood sol-
emnly at attention. They made a very effective background to the rest of
the crowd." Uhde's support and friendship were helpful to getting Picas-
so's name known outside the narrow confines of Montmartre. In addition
to cultivating a growing market for his work, he introduced the artist to
the small but influential circle of German writers and intellectuals who
congregated at the Café du Dôme in Montparnasse.

Also contributing to Picasso's rising fortunes was the Russian collec-
tor Serge Shchukin, a rich textile manufacturer who assuaged his grief at
the death of his son by going to Paris and bingeing on modern art.* De-
spite the fact that Russia lay on the far fringes of European civilization,
Shchukin proved a quick study. He began, as had so many others, with
Impressionism, soon working his way up to the more challenging work of
Cézanne and Gauguin. Importing the most radical French art to Moscow,
Shchukin was deliberately provoking a clash of cultures. While showing

* There is some uncertainty about when Shchukin first met Picasso. Fernande
implies sometime in 1909, but Picasso's caricature of the Russian as a pig (see
following page) almost certainly dates from 1905 or 1906.

one of his prized Gauguins to a friend, he joked, "A madman painted it, and a madman bought it."

Like Leo Stein, Shchukin was overwhelmed by his encounter with Matisse and the rest of the Fauves at the 1905 Salon d'Automne. Soon he found himself in direct competition with the Americans for the best new works from the Paris studios and galleries, which he shipped east by the crateload.* His purchases were so prolific and so discerning that an artist wishing to bone up on the latest trends had almost as many opportunities for enlightenment in the Russian capital as in the French.† In 1909, Shchukin opened his Moscow palace to visitors on Sunday morning, allowing a new generation of Russian artists to experience the French avant-garde at first hand and sparking an aesthetic revolution every bit as disorienting as the political cataclysm that would arrive a decade later.

Though Shchukin was a rapid convert to Matisse's art, it took him another year to come around to Picasso. The artist himself never seems to have warmed to the awkward Russian. In a grotesque caricature of "Stschoukin" he depicts him with a piglike snout and ears, perhaps a testament to a clash of personalities or perhaps just another instance of Picasso biting the hand that fed him. Fernande's description of the "important collector from Moscow" was equally unflattering:

> [A] Russian Jew [Shchukin was not in fact Jewish.], very rich, and an afficionado of modern art. He was a small, pale man, with an enormous head like a pig's mask. Afflicted with a horrible stutter,

* Shchukin was considerably richer than the Steins, but they had the advantage of living in Paris year-round. They were rivals but respected each other's acumen, often comparing notes on their latest acquisitions. Shchukin commissioned some of Matisse's greatest masterpieces for his Moscow palace, including the vast murals *The Dance* and *Music*.

† Ivan Morozov also played an important role in introducing Russia to the art of the French avant-garde. His collection was particularly strong in Impressionist and Postimpressionist work. He bought only three Picassos, including the Rose Period *Young Acrobat on a Ball* and the Cubist *Portrait of Ambroise Vollard*.

he could make himself understood with only the greatest difficulty, which merely added to the pathetic impression left by his physical appearance.

Picasso's painting was a revelation to the Russian. He bought, at a high price for those days, two paintings, one of which, *Femme à l'Éventail* [Woman with a Fan], was among the most beautiful. From that point he was one of his most loyal collectors.

One interesting fact to emerge from Fernande's account is that it was Matisse who first brought Shchukin to the Bateau Lavoir and introduced him to Picasso. Unfortunately, she has nothing to say about the initial meeting between the two giants of modernism, which must have taken place some months before Shchukin's own visit. Picasso himself confirmed that he had met Matisse in March 1906. The date stuck in his mind because it coincided with the opening of the Salon des Indépendants, when Matisse scored his triumph with *Joy of Life*.

The epochal encounter was arranged by the Steins, who ceremoniously escorted Matisse and his daughter, Marguerite, up the winding streets of the Butte to the rue Ravignan. In Leo's and Gertrude's minds, at least, this was a trek up Mount Olympus to anoint the twin gods of the avant-garde. "I had recognized the value of Picasso the first time I saw his work," Leo congratulated himself in later years, "and for a while was the only person that bought his pictures. I was the only person anywhere, so far as I know, who in those early days recognized Picasso *and* Matisse. Picasso had some admirers, and Matisse had some, but I was alone in recognizing these two as the two most important men."

"I remember it as if it were yesterday," Marguerite Matisse told the photographer Brassaï when he asked her about the famous meeting, though apparently what had made the biggest impression on the twelve-year-old girl was Picasso's "big St. Bernard dog" and the peculiar getup of their American chaperones. "[W]e did not go unnoticed!" she reminisced half a century later. "On the avenue de l'Opéra everyone turned around and stared at us."

Gertrude provides a second eyewitness account, though her testimony is hardly any more informative and, while characteristically amusing, is also characteristically self-serving:

[T]he Matisses were back and they had to meet the Picassos and to be enthusiastic about each other, but not to like each other very well. . . .

It may seem very strange to every one nowadays that before this time Matisse had never heard of Picasso and Picasso had never heard of Matisse. But at that time every little crowd lived its own life and knew practically nothing of any other crowd. Matisse on the Quai Saint Michel and in the independant did not know anything of Picasso and Montmartre and Sagot.

Gertrude's claim that Matisse and Picasso had never heard of each other before she introduced them is simply not believable. Both artists kept a close eye on what was being shown in the various progressive galleries and exhibitions; both had already shown at Vollard's and Berthe Weill's; and both had already earned at least modicum of critical praise in the enlightened press. The fact that they traveled in different circles, lived and worked in different parts of town, did not mean that they were unaware of each other's work. They were both poor artists on the cusp of fame, both struggling to get a toehold in the competitive world of the Parisian avant-garde. They were not yet rivals but rather combatants mustered under the same flag and engaged in a common fight for recognition and acceptance.

All that changed in the fall of 1905. Picasso and his Montmartre friends attended the notorious Salon d'Automne and certainly discussed the uproar caused by Matisse and his colleagues. In the aftermath of that epochal exhibition Matisse was widely acknowledged the most daring and most dangerous painter in Paris, and the change in status forced Picasso to reassess his strategy. Rather than viewing him as a potential comrade in arms, he now envied the older man. And if Picasso did not yet loom as large in the Frenchman's consciousness, his reputation in avant-garde circles had grown sufficiently over the course of the past year or so that Matisse would certainly have known about him, at least in a superficial way. As is often the case in her memoir, Gertrude has altered the facts to give herself a more prominent role.*

* When *The Autobiography of Alice B. Toklas* was first published in 1933, many artists (though significantly not Picasso himself) contributed to a "Testimony

In any case, the exaggerations were completely unnecessary since even without them Gertrude Stein played a critical part in laying the foundations for Picasso's rise to fame. While Leo, Michael, and Sarah all tended to favor Matisse, Gertrude—precisely because of this fact— hitched her wagon to Picasso's star, which allowed her to step out from under her brother's shadow.*

Gertrude Stein and Picasso grew closer over the winter and spring of 1905–6 during afternoons at the Bateau Lavoir studio while she sat for her portrait. "She had come to like posing," she said, "the long still hours followed by a long dark walk intensified the concentration with which she was creating her sentences."

On Saturdays she would make the return journey accompanied by Picasso and Fernande. It was during these months that she and Leo began hosting their famous soirées, and the Picassos were almost always among the privileged guests. "Little by little people began to come to the rue de Fleurus to see the Matisses and the Cézannes," she wrote. "Matisse brought people, everybody brought somebody, and they came at any time and it began to be a nuisance, and it was in this way that Saturday evenings began."

At these gatherings of artists and intellectuals Leo was in his element. Sandaled feet propped up in front of him to aid his digestion, he would hold forth for hours on end, explaining the daring new art he had acquired to the artists themselves and to anyone else who cared to listen

Against Gertrude Stein" in the literary magazine *Transition*. Both Matisse and Braque protested the slighting of their roles, with Matisse stating that "she has presented the epoch 'without taste and without relation to reality.'"

* An anecdote she recounted sheds light on the way Picasso and Gertrude made common cause against Leo. "That evening Gertrude Stein's brother took out portfolio after portfolio of japanese prints to show Picasso, Gertrude Stein's brother was fond of japanese prints. Picasso solemnly and obediently looked at print after print and listened to the descriptions. He said under his breath to Gertrude Stein, he is very nice, your brother, but like all americans . . . he shows you japanese prints. Moi j'aime pas ça, no I don't care for it. As I say Gertrude Stein and Pablo Picasso immediately understood each other."

(and to many who didn't but could find no means of escape). The dinner parties quickly became a fixture of the Parisian scene to go along with the Tuesday-night gatherings at the Closerie des Lilas, an essential stop on the itinerary of anyone interested in contemporary art. American, Hungarian, Russian, and German tourists flocked to the rue de Fleurus, as did all the major figures of the Parisian art world. "Our collection became in time one of the sights of Paris for everyone who was curious to know modern art," Leo boasted. No one profited more from the opportunity than the artists themselves, who came not only to study the work of their colleagues but to measure themselves against masterpieces of the previous generation.

At least one discerning guest concluded that the race had already been won. Walter Pach—who would go on to do so much for modern art in America as a tireless champion of the new and as one of the principal organizers of the groundbreaking Armory Show of 1913—had no trouble assimilating Picasso's work, placing him at the end of a tradition that included van Gogh and Cézanne (both hung nearby on the crowded walls). "All three men were therefore easily connected with what I already knew," he said. "Matisse was of the present, and I fought it in my mind."

The "difficulty" of Matisse's art was a mark in his favor, a testament to his originality and a sure sign that he had leapt ahead of the competition. Picasso reluctantly arrived at the same conclusion; he envied the notoriety that to the professorial Matisse was as much a curse as a blessing, but had to admit that the older artist had gotten the better of him. Picasso's irritation was exacerbated by the fact that they were opposites in almost every way. "Matisse was a social person rather than a convivial one," Leo Stein observed. "Picasso was more convivial than social. Matisse felt himself to be one of many, and Picasso stood apart, alone."

They were "the North Pole and the South," Matisse told Fernande, summing up his attitude toward the young man nipping at his heels. Picasso despised the social niceties that Matisse clung to with a tenacity unusual in an artist of such daring. "Bourgeois, bourgeois, bourgeois!" he sneered when he talked of his father, an epithet he might well have applied as well to the tweedy Frenchman. Like many bohemians, Picasso wore his scruffiness as a badge of honor. It was around this time that he began to dress in a worker's blue overalls and spotted shirt he'd picked up in a flea

market, deliberately throwing in his lot with the laboring classes. It was not so much a political statement as a psychological prop. He associated respectability with mediocrity and his own narrow-minded family and fled its suffocating embrace at the earliest opportunity. Matisse, by contrast, believed that one could remain true to one's art while still maintaining a dignified front: he would not betray his ideals in order to conform, but he would also not go out of his way to offend.

Picasso was a born rebel, Matisse a rebel through circumstance, and a reluctant one at that. He annoyed Picasso with his pomposity. Unlike Apollinaire, who deployed his conversational gifts to flatter and amuse, Matisse used his intellect to pronounce on aesthetic matters in a way that brooked no contradiction.* During an exhibition at Durand-Ruel's gallery dedicated to Manet and the Symbolist painter Odilon Redon, Matisse cornered Picasso and insisted on explaining to him why Redon was the greater painter. Later that day, Leo Stein recalled, Matisse told him about their conversation, and he in turn confronted Picasso with his own words. "Picasso burst out almost angrily. 'But that is nonsense. Redon is an interesting painter, certainly, but Manet, Manet is a giant.' I answered, 'Matisse told me you agreed with him.' Picasso more angrily: 'Of course I agreed with him. Matisse talks and talks. I can't talk, so I just said *oui oui oui*. But it's damned nonsense all the same.'"

Saturday evenings at the rue de Fleurus began at nine, to allow guests time for a predinner drop-in at the apartment of Michael and Sally around the corner, where the couple were adding to their already impressive collection of Matisses. At Leo and Gertrude's soirees the food was good and plentiful, prepared by the faithful Hélène, who took pride in her employers' growing celebrity. As Gertrude Stein herself admitted, Hélène's skills were part of the draw: "She was a most excellent cook and she made a very good soufflé. In those days most of the guests were living more or

* Matisse and Leo Stein were too alike to remain friendly for long. On a disastrous trip through Italy in 1906, Stein spent so much time lecturing Matisse on what he should and should not admire that the artist was soon fed up with his self-appointed guide.

less precariously, no one starved, some one always helped but still most of them did not live in abundance." Years later Hélène would beam whenever she heard one of their former guests mentioned in public. "[I]sn't it extraordinary," she said, "all those people whom I knew when they were nobody are now always mentioned in the newspapers, and the other night over the radio they mentioned the name of Monsieur Picasso."

For Picasso, Saturdays at the Steins were something of an ordeal. "During these evenings," Fernande remembered, "Picasso would remain sulky and morose for the most part. He was irritated, not wanting to have to explain himself, which he found difficult, especially in French, believing that one shouldn't have to explain what needed no explanation."

To shield himself from encounters with pushy or tedious guests he brought along members of the *bande à Picasso*. Gertrude Stein was intrigued by the seedy Montmartre contingent. She found Salmon a bore, but she was amused by Jacob's antics and charmed by Apollinaire's eloquence. "Guillaume was extraordinarily brilliant," she wrote, "and no matter what subject was started, if he knew anything about it or not, he quickly saw the whole meaning of the thing and elaborated it by his wit and fancy carrying it further than anybody knowing anything about it could have done, and oddly enough generally correctly."

Matisse's greater ease in this bright company was due in part to his more courtly nature but also to the fact that he knew he had the upper hand. "Matisse was then at the top of his game," Fernande noted, "a fierce proselytizer for his own style, which he defended jealously against Picasso's muted attacks. He always had a clear, intelligent way of expressing himself and a compulsion to convince those around him. Picasso rarely made the effort. Always sardonic, I believe he rather despised those who couldn't understand him."

The only thing that kept them from quarreling openly was a certain wary respect, artist to artist. Each recognized in the other a strength appreciated all the more since his rival was strongest where he himself was lacking. While Matisse was a magician of color, Picasso possessed a supreme gift for sculptural form; while the Frenchman aspired to an effortless grace, the Spaniard plumbed the darker reaches of the soul.

Picasso used his weekly visits to the Steins' apartment to take the

measure of his rival, testing the portrait of his host he was struggling to complete in his Bateau Lavoir studio against the celebrated *Woman with a Hat*. If Matisse's portrait of his wife proved challenging, even more daunting was the monumental *Joy of Life*, which Leo added to his collection in the spring of 1906. These two powerful works haunted Picasso's imagination, showing him what was possible and how far he had to go if he were to claim his place as the leader of the avant-garde.

The mood of these gatherings was superficially collegial but also fraught, involving much smiling through gritted teeth and snide remarks made behind one another's backs. Every artist came to the Steins' to determine where he stood with his hosts and how he stacked up in the larger world of the Parisian avant-garde. Leo and Gertrude basked in their role as kingmakers. "The hosts wander amiably from group to group," said Fernande, "but are particularly attached to their two great men: Matisse and Picasso." Naturally competitive themselves, the brother and sister relished the intrigue stirred up by this game of thrones. "Matisse and Picasso then being introduced to each other by Gertrude Stein and her brother," Gertrude wrote, "became friends but they were enemies. Now they are neither friends nor enemies. At that time they were both." On one occasion she even rearranged the artwork so that each guest was forced to sit beneath his own paintings, like a merchant in the casbah surrounded by his wares and trying to attract customers to his stall. These invidious comparisons were problematic for Picasso, who felt destined for a greatness he had yet to achieve.

One incident in particular illustrates the complexity of a relationship marked by both mutual respect and petty spite. In 1907 the two men exchanged paintings, "as was the habit in those days." According to Gertrude's mischievous account, "Matisse and Picasso chose each one of the other one the picture that was undoubtedly the least interesting either of them had done." As usual she missed the far richer subtext in her desire to portray it as an exercise in one-upmanship. Picasso selected from Matisse's studio what at first glance appears to be one of the artist's more slapdash efforts. But Picasso, who had an uncanny ability to discern value in what other people considered junk, realized that there was something more there than met the eye. The painting was a portrait of Matisse's daughter, Marguerite, done in a deliberately naive manner that derived

from his deep study of the art of children. It was a precocious instance of a modern artist reimagining his art through the eyes of the unschooled and a device to which Picasso himself would have recourse on numerous occasions. As Baudelaire declared in his essay "The Painter of Modern Life," "genius is nothing more than the ability to recover childhood at will." Matisse, for his part, selected a proto-Cubist still life of fruit and dishes that recalls (and pays homage to) their mutual admiration for Cézanne and Matisse's own very different exploration of the time-honored theme.

Still, if Gertrude was a little too anxious to stir the pot, she was not wrong in discerning tensions seething just beneath the surface. By the time the two exchanged paintings Picasso had already completed *Les Demoiselles d'Avignon*, a work Matisse considered not only a crime against art but a personal affront. His irritation only grew as the radical direction signaled by the monumental canvas began to win over artists who had earlier rallied under the Fauve banner. Their changing relationship is chronicled by Fernande Olivier: "Picasso and Matisse, who were quite close at one time, fell out over the birth of Cubism, which disturbed Matisse's usual calm. He lost his temper. He said he'd 'get back' at Picasso, make him beg for mercy." In retaliation the *bande à Picasso* took to using Matisse's portrait of his daughter as a target for rubber darts, shouting "A hit! One in the eye for Marguerite!" every time one of them came near the mark.

Over the years their relationship would have its ups and downs. Never less than stimulating, it was almost always productive, pushing each artist further and in directions in which he might never have gone on his own. This was certainly true in the first years of their acquaintance, when Picasso knew he had to equal Matisse's breakthrough with one of his own. After the Cubist revolution their roles would be reversed, and then it was the older artist who was forced to take stock and beat back the challenge of the younger man.

The Village Above the Clouds

Pablo is quite different in Spain. He's more cheerful, not so wild, more sparkling and animated, and he takes a calmer, more balanced view of things. He seems at ease. He glows with happiness.

—FERNANDE OLIVIER

I n retrospect, it's clear that 1906 was a transitional year for Picasso: a year dividing youth from maturity, promise from fulfillment. During these months of intense work a painter of late-nineteenth-century sensibility was reborn as a prophet of modernity, one whose utterances seemed to ring with both the promise and the peril of the new age.

The transformation was largely invisible, not least to Picasso himself. He took the crucial steps on the path to an artistic revolution with no clear destination in mind. All he knew for certain was that he had to take his art in new directions if he hoped to rise to the challenge posed by Matisse and his Fauve colleagues. With the benefit of hindsight his progress seems purposeful, the outcome inevitable, as if he knew where he was headed all along. But this is a misreading of history caused by our need to weave a coherent narrative out of events that were contingent, unpredictable, and unforeseen. As the distinguished art historian Robert Rosenblum noted, the very magnitude of the change Picasso brought about in the collective consciousness distorts perception, "warp[ing] our approach to the 'BC'

Picasso, whose life presumably came to an end in 1906 before the curtain came up on the twentieth century."

The dawning of a new age was announced in a single monumental work, as shocking as any in the history of art. To quote Robert Rosenblum once more: "Like the apocalyptic visions by El Greco that helped spark its flickering, hallucinatory intensity, *Les Demoiselles d'Avignon* seems to proclaim, together with the Lord in the Book of Revelation, 'I am the Alpha and Omega.' Carrying the destructive force of an earthquake, the *Demoiselles* splits art historical time into an old and new epoch, BC and AD, as if in 1907 Picasso and, with him, all of art were reborn. What he did before this watershed year might belong to another era." The story of how he arrived at this breakthrough is no less fascinating for being a tale of false starts and circuitous detours, more a case of a man feeling his way tentatively in the dark than of a hero striding boldly toward the light.

In the spring of 1906, Picasso had never been more confident in his own powers. This confidence was well earned. He'd grown considerably as an artist in the two years he'd been in Paris, weaning himself from the sentimentality of the Blue Period to compose works that were thematically complex and crafted with a more supple touch. His achievements were ratified by the small circle of men and women whose judgment he valued. He was gaining recognition as a leader of the avant-garde, and increasing numbers of collectors were making the trek to the summit of the Butte to purchase his work, relieving some anxiety about his immediate prospects and many of the day-to-day hardships. Surrounded by admiring friends and happy in love, he felt an emotional security he'd never before experienced outside of the unconditional embrace of his family.

But he wasn't satisfied. His complacency had been shattered by the sudden notoriety of Matisse and his Fauve colleagues. "He felt himself a man apart," wrote Leo Stein of Picasso at this time, "what the story books call a man of genius, though not pretentiously so. But in those days he was not sure."

Whether he would have pushed himself to become the twentieth century's most celebrated, imitated, revered, and reviled artist without the example of Matisse to goad him is an open question. The older man certainly offered a rebuke to caution. Beneath his tweedy exterior

he possessed a steely courage, a recklessness even, that compelled him to pursue his vision whatever the cost. Picasso had not yet dared as much, and the gap only grew wider after each subsequent exhibition in which Matisse seemed to break through one aesthetic barrier after another. For all of Picasso's ambivalence about fame and indifference to luxury (though not to money), he thirsted for recognition and could never be satisfied as long as he thought that someone else had trumped him.

Picasso's sense of mission was encouraged by the fact that so many friends shared a belief in his star. Of course their adulation was as much a burden as a blessing: failure to live up to their lofty expectations would make the humiliation harder to bear. Crucially, Picasso had internalized the ethic of the avant-garde, which placed its highest value on originality and awarded its accolades to the man or woman who set the world on fire. Matisse was only the latest in a long line of modernist rebels who were revered by their peers only to the extent that they were reviled by the public at large. Once his status as the world's foremost artist became unassailable, he refused to be governed by this imperative, a refusal that, paradoxically, made him much more innovative than his younger colleagues, who were always chasing the latest fashion. But before Picasso was allowed to do as he pleased, he first had to show himself the great iconoclast, a man capable of overturning all the rules and creating forms never before seen.

Neither the thirst for fame nor the cult of the new can entirely explain the aesthetic transformation Picasso would effect over the course of the next few years. Like one of those "paradigm shifts" that the physicist Thomas Kuhn identified as forming the basis of most scientific innovation, the Cubist revolution came after a period of uncertainty filled with an inchoate yearning for something as yet unnamed, as yet unnamable. Cubism—the movement that originated in the formal inventions of *Les Demoiselles* [see color insert], whether or not one chooses to include the painting within the strict definition of the term*—offered answers to

* Debate about *Les Demoiselles'* status as the "first Cubist painting" has preoccupied generations of scholars but is of little more than academic interest, if that. Such designations are necessarily arbitrary. Many of Cubism's most startling innovations exist in embryonic form in Picasso's 1907 masterpiece, but the work

questions no one had even thought to ask before. It presented an entirely new way of seeing the world that could not have been predicted before the fact, even by those most responsible for bringing it about, and it opened up imaginative vistas that have yet to be fully explored or exhausted.

In the first years of the twentieth century there was a growing sense that the disorienting changes wrought by the technological and social innovations associated with modernity had passed beyond the capacity of traditional forms to contain them. This disconnect was nowhere more evident than in world's fairs like the *Exposition Universelle* of 1900, where the excitement of the galleries devoted to the latest technological marvels could not be matched by those devoted to painting and sculpture. The same crowds that were entranced by the futuristic innovations in electric gadgetry, movies, or automobiles seemed content, indeed reassured, when they contemplated canvases that looked hardly any different from those painted centuries earlier.

A crucial task for the avant-garde was to match the sense of endless possibility that technology seemed to offer using techniques and materials little changed since the time of Leonardo and Michelangelo. Matisse and the other Fauves offered one alternative for those seeking a way forward. Never before in the history of art—at least since the Renaissance, five centuries earlier—had painters taken such liberties with perception. Instead of simply reproducing what the eye saw, their acid color harmonies created their own reality on the surface of the canvas, a reality more vivid than and bearing only the most cursory resemblance to anything found in nature. They were condemned by most respectable citizens as a crude assault on good taste and on any notion of craftsmanship, but a few more perceptive viewers saw something else. Above all, these more adventurous souls claimed, this was an art of pleasure, of sensuous delight: barbaric, yes, but filled with the savage joy that comes from throwing off the fetters of civilization and wallowing in primal bliss. Matisse's titles offered a clue—*Luxe, Calme et Volupté; Joy of Life*—a promise of lush plenty of the kind that

would prove an almost endless source of pictorial ideas, some of which were built on over the next few years in the Cubist revolution, some of which would be exploited only later.

must have lured the crew of the HMS *Bounty* into rising up against the harsh discipline of Captain Bligh. Matisse reinforced the identification of his art with sensual pleasure in his "Notes of a Painter," published in 1908, in which he set out his famous ideal. "What I dream of," he wrote, "is an art of balance, of purity and serenity, devoid of troubling or depressing subject matter, an art which could be for every mental worker, for the businessman as well as the man of letters, for example, a soothing, calming influence on the mind, something like a good armchair which provides relaxation from physical fatigue." This is hardly a revolutionary battle cry, but rather a plea to expand our notions of what constitutes beauty.

Thus, for all the radicalism of its means, Fauvism's ends were fairly conventional. Matisse and his colleagues sought to delight the eyes and satisfy the mind's quest for harmony.* Faced with the anxieties of modern life, they did not seek the safe haven of academic formulas. Instead they invited us on a riskier venture but one that was in its own way equally escapist: to embark for a lost paradise, where heart, mind, and body were no longer alienated from one another.

For Picasso and the other artists who would ultimately be associated with Cubism, what the Fauves promised was not so much misguided as insufficient. An art of joy, of sensual indulgence, was all very well, but it seemed somehow *unrigorous.* Despite Matisse's professorial air, his art struck many as intellectually vacuous. And some of the accusations the Symbolists leveled against Impressionism—that, in Gauguin's eloquent phrase, it "neglected the mysterious centers of thought"—could be charged against Fauvism as well. Even if they didn't yet know it, the future Cubists would answer the Fauvist approach to *color* with a new approach to *form*, placing art once again "in the service of the mind."†

* In other hands, like those of the Norwegian Edvard Munch and German Expressionists like Ernst Ludwig Kirchner and Emil Nolde, the high-keyed colors of Fauvism could be used to probe more extreme psychological or metaphysical states, but these concerns were far removed from those of Matisse and his colleagues.

† The phrase is Marcel Duchamp's. Duchamp is widely considered the father of conceptual art, a movement that pursued certain elements of Cubism to their logical conclusion.

For Picasso in particular, Fauvism could not offer a way forward, in part because the position as leader of the school was already firmly occupied by someone else. More important, it did not satisfy the imperatives of his troubled soul. For Picasso art was, at its deepest level, a shamanistic practice concerned with managing the hidden forces that rule our fates. It was impossible to exorcise the ghosts of a dead sister or a despairing friend with soaring harmonies evoking sundrenched Shangri-las. Not for him an art of relaxation or sensual bliss. "His instinct," as Fernande noted, "pushed him toward all that was tormented." Whatever pleasure was to be derived from *his* art would be of a more violent sort, with suggestions of rape and dismemberment never far from the surface. "One really has to be masochistic to like my painting," he once confessed, an observation that would never have passed the lips of Matisse, who wished to seduce his audience. If Picasso was ever tempted to dwell in Eden, it was Paradise after the serpent's arrival, a place that offered suffering in return for wisdom.

So far he had pursued this course only tentatively, without knowing exactly what he was seeking. As was often the case in the modern movement, the key to discovering an artistic language capable of reflecting the jarring, jagged realities of contemporary life would come through channeling modes that seemed to issue from the remotest past, before civilization interposed the multiple layers of refinement that alienated us from our true selves. Picasso's breakthrough came when he discovered the tools to tap into the magic that was at the savage heart of all artistic creation but that was embodied most fully in the "naive" art of children and so-called primitives. Once he internalized these potent forces, he would convey meaning not through sentimental storytelling, as he had during the Blue and Rose periods, but in terms of pure form, investing painting and, later, sculpture with a totemic *presence* that made mere image seem superficial by comparison.

Given the fact that he was a master of form rather than color, it's ironic that the two periods that preceded Picasso's Cubist revolution were defined by specific hues. But in a sense this is a confirmation of the ancillary role color plays in Picasso's art. In fact when a single color dominates a painting it ceases to act as color. Whether blue or dusty pink, an overall hue defines form in terms of light and dark, like a cyanotype photograph that

reads as essentially black and white. Just how superfluous color is to Picasso's approach at the time is confirmed by the paintings of 1906 through early 1907, when his compositions were rendered in shades of brown, and even more emphatically in the Cubist works of 1910–11, when color was almost completely absent.*

In this regard, as in so many others, *Portrait of Gertrude Stein* will prove pivotal. Here, the wistful pastel hues of recent months have been replaced by a deliberately monochromatic, uningratiating palette, sober and unrelieved by any grace notes. The painting's power emerges through form alone: through the bulk of the sitter leaning forward in her chair, the strength of her personality conveyed through the aggressiveness of her pose. It's the antithesis of Matisse's *Woman with a Hat*, dour where the other is sparkling, reaching for eternal verities rather than evanescent effects. For all the deliberate crudeness of the drawing, Madame Matisse remains something of a society belle, at least compared to the hulking Gertrude Stein, who looms as a chthonic deity from the dawn of time.

The months he spent working on this modestly sized canvas demonstrate the difficulties Picasso faced in giving birth to his new conception. He was feeling his way forward, clutching at something just beyond his reach. In May 1906 he finally gave up. "I can't see you any longer when I look," he grumbled, painting out her face in frustration. He would return to the portrait only after a transformative summer in Spain, when he finished it in a single inspired session and without the model in front of him.

In seeking an alternative to the chromatic profligacy of Matisse, Picasso steeped himself in the art of the past. Initially his course paralleled the one taken a couple of decades earlier by Cézanne, when he had tried to impose geometric structure on the amorphous clouds of Impressionism by studying the art of the great seventeenth-century Classicist Nicolas Poussin. In Picasso's case, the search for a more rigorous approach led him to the art of Jean-Auguste-Dominique Ingres, the great neoclassical

* When color returned, as it did with a vengeance in Picasso's so-called Synthetic Cubist phase (after 1911), it came in swatches of "local color", that is, discrete patches, rather than the atmospheric veils mastered by the Impressionists and Matisse that seem to capture light on canvas.

painter of the early nineteenth century who had set himself in opposition to Eugène Delacroix, leader of the Romantics.

At first glance Ingres might seem an odd source of inspiration for an artist determined to change the course of history. For generations, progressive painters had shunned Ingres as the great reactionary, a fossil propping up the discredited ideology of a moribund system. But by 1905 the master was being embraced by a new generation. "Ingres may have died," wrote Gauguin, "but he was badly buried, for today he is very much alive." Beneath the impeccable academic technique, and despite appointing himself the upholder of a tradition that stretched from ancient Athens through the art of Raphael—the same tradition, that is, that served as the model for all students at the École des Beaux-Arts—there was something unsettling about Ingres' work. In his paintings the chilly classical ideal is carried to such perverse extremes that it begins to suggest something else, an obsessiveness that a later generation will term Surrealist.

Symbolist painters like Gustave Moreau luxuriated in Ingres' morbid eroticism; Matisse adopted his sinuous line to impart to the nudes of *Joy of Life* and *The Dance* a voluptuous rhythm, both primal and seductive. Ingres' rehabilitation at the hands of the avant-garde was consolidated at the Salon d'Automne of 1905, where a retrospective of his work was held a few doors down from the infamous Salle des Fauves. Many of those who had come to cheer on the rebels discovered an affinity with this stalwart of the old regime.

Picasso's *Portrait of Gertrude Stein* is actually based on Ingres' famous portrait of the journalist Louis-François Bertin.[*] Rendered in shades of brown and black, hunched forward, clawlike hands gripping meaty thighs, Bertin provides just the air of authority Picasso was seeking to evoke his own patron's powerful presence. Picasso has distilled the earlier image down to essentials so that Stein seems to thrust from the shallow space like a sumo wrestler stomping into the ring.

In a more general sense, Ingres' influence on Picasso's work can be detected in a renewed emphasis on contour, though Picasso translates his predecessor's delicacy into a language of deliberate awkwardness that

[*] Picasso disguised the similarity by reversing the pose.

owes as much to Gauguin and folk idioms. Many of Picasso's paintings from these months exhibit the same forward push as the Gertrude Stein portrait, as if his figures can barely be contained by the space they are forced to inhabit. In works from the Blue and Rose periods his cast of characters behave like actors on a stage, playing out their dramas comfortably behind a proscenium that separates their world from ours. But in paintings like the *Portrait of Gertrude Stein* and *Boy Leading a Horse*, the figures press more forcefully against the picture plane; space itself is shallower, airless, inducing a claustrophobia that can be relieved only by allowing the protagonists to advance dangerously close to our world, as in those avant-garde theaters where the players breach the imaginary "fourth wall" of the theater and harass the audience.

The revival of Ingres' reputation coincided with a reappraisal of the entire classical idiom, which had earned the scorn of progressive artists since the beginning of the nineteenth century when it was their rivals, the Romantics, who were seen as leading the revolt against the establishment. The embrace of Puvis de Chavannes by the avant-garde was one manifestation of this change of heart. He gave voice to a particular strain within the polyphonic Symbolist choir, a wistful air played on a pan-pipe that conjured a lost golden age of nymphs and temples nestled in sylvan glades.

Puvis' embrace by unconventional artists like Gauguin signaled a wider shift in the zeitgeist. The poet Jean Moréas (born Iannis Pappa-diamontopoulos), a charismatic presence at those Tuesday evenings at the Cloiserie des Lilas, was one of the leading propagandists of a pan-Mediterraneanism, whose gospel he preached through what he called the *École Romane* (founded in the 1890s) and through which he hoped to build a literary and artistic rebirth with roots firmly planted in the Hellenic world. In this formulation, the Greco-Roman south was seen as the spiritual antithesis of the Gothic north, a home-grown alternative to the foreign cult of Wagner and Nietzsche. According to one of its chief exponents, Ernest Raynaud, who set out his thoughts in the *Mercure de France* in May 1895, the members of the *Ecole Romane* wished to "return in thought and style to balance and harmony . . .

We have undertaken to defend the heritage of the Latin muses, using our own native taste for order, measure and harmony to

oppose the freakish inventions, the inconceivable chaos of foreigners, to fight with all our strength for the health of the French spirit and the reign of beauty.

The work of these neo-Neoclassicists, whose devotees included sculptors like Aristide Maillol* and at least two of Picasso's Spanish friends, Manolo and Enric Casanovas, strived for a purity of form, an idealized beauty, and a return those virtues supposedly characteristic of ancient art—its "noble simplicity and quiet grandeur" to borrow the words of the eighteenth-century scholar Johann Winckelmann.† The movement was widespread, making at least a temporary convert of Matisse himself: *Luxe, Calme et Volupté* and *Joy of Life* embody a Dionysian version of a classical world moving to savage rhythms and devoted to hedonistic pleasure.

An art predicated on a distinctly Mediterranean culture had an obvious appeal for a child of Málaga and Barcelona living in France; it offered reassurance that he shared a common heritage with his adopted land. In fact the movement was perhaps most vibrant in Picasso's native Catalonia, where an enthusiasm for an art rooted in native soil was in the process of sweeping away the last vestiges of Art Nouveau and *Modernisme*. "Beautiful forms are glorified once again," wrote the Catalan critic Eugenio d'Ors in 1904:

And everything we do along these lines will give us significance in history tomorrow; a significance morally demanded by the

* One of Maillol's best-known sculptures is an image of a reclining woman titled *The Mediterranean*, which was one of the hits of the 1905 Salon d'Automne. Maillol was a French Catalonian, born in Banyuls-sur-mer, just up the coast from the Spanish border and close to Barcelona. Like many from that part of the world he embraced Classicism as the authentic idiom of his native land.

† Winckelmann employed the famous phrase in his "Thoughts on the Imitation of Greek Works in Painting and Sculpture" (1755). That a German art historian was smitten with the art of ancient Greece is reason enough to be skeptical of any aesthetic theory based on ethnic or racial lines.

conditions in which nature has placed us. For I believe that our position as Mediterraneans not only gives us rights but also imposes duties on us. And at the present moment one of the principal duties is to collaborate in the *Mediterreanization of all contemporary life.*

These eternal values of balance, harmony, and reason, often wedded to specifically classical imagery, will find expression time and again in Picasso's art, a bright counterpoint to (or perhaps only a brief respite from) the dark, tormented side of his personality. This lyrical mode had its first full flowering in the works of 1906, most notably in studies for an ambitious scene titled *The Watering Place* that he intended as the grand summation of this period in his art. Though the contemplated masterpiece was never executed, a beautiful sketch in gouache survives depicting a group of nude young men with their horses in a desert setting, a composition that owes as much to the Elgin marbles as it does to Puvis de Chavannes. Like many of Picasso's "grand machines," *The Watering Place* served as an incubator of many pictorial ideas that he will realize in more modest form. Perhaps the finest of these is *Boy Leading a Horse*, whose composition is taken directly from the central group of the intended larger canvas. In this fragment Picasso conveys that longing for a lost Arcadia that lies at the heart of classicism's periodic resurrection.

Though the classical impulse returns time and again over the course of Western art, it's never the same twice. The search for order, for timeless truths that rise above the messy contingency of life, may answer one of the deepest longings of the human soul, but perhaps because it is lodged so firmly in the collective psyche, it can be couched in multiple different forms and take on new meanings in new contexts. The "Mediterraneanism" that gripped the intellectuals of southern Europe in the early years of the twentieth century participated in that perennial nostalgia for a lost golden age, but it was very different from the classicism of Poussin, of David, or even of Ingres. Less refined, less learned, and more earthy, it was in a sense another expression of the primitivism that was so potent a force in avant-garde practice throughout these years—which helps explain why Gauguin could find inspiration in an artist like Puvis de

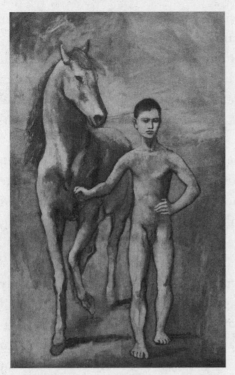

Boy Leading a Horse. © *The Museum of Modern Art/Licensed by SCALA / Art Resource, NY.*

Chavannes. Picasso's classicism, like Gauguin's, is not delicate or sophisticated—not an evocation of civilization's acme but an expression of childlike innocence.

For all that they point to the future, Picasso's works of this period reek of the museums whose galleries he combed in search of alternatives to the Western pictorial tradition. He continued to haunt the stately old Louvre, where the Futurist Ardengo Soffici remembered bumping into him on numerous occasions in the rooms of Egyptian and Phoenician antiquities. Centuries of imperialist plundering had filled this former palace of kings chock-full of treasures from the farthest reaches of the globe and reaching into the most distant past. For the most part it was these older works that absorbed him. He studied closely the sculpture of the classical era, but even more closely those from the Archaic era that preceded it. *Boy Leading a Horse* shows the

results of that twin legacy, drawing from both the Parthenon frieze and the Archaic Greek youths known as *kouroi* that were carved before the refinements of the Athenian golden age robbed them of their expressive rigidity. Like many of his contemporaries, Picasso regarded their stilted formality as an aesthetic virtue, conveying a powerful mystical presence far more effectively than the suave athletes of Athens' golden age.

Picasso's highly stylized *Woman with a Fan* is indebted to even older forms: the carved reliefs of ancient Egypt or Assyria.* Unlike *Boy Leading a Horse*, she does not press forward into our world, but the space Picasso allows her to inhabit is shallower still—nonexistent, in fact—as if she has been carved onto the façade of a temple wall. Her face is in strict profile, but her torso turns slightly toward us, a distortion deployed by the ancients that offered a more conceptually complete image of the sacred figure than any one vantage point could supply. Her status as a modern-day priestess is emphasized by the stylized pose, promising, like the Casagemas figure in *La Vie*, the key to ancient mysteries.† *Woman with a Fan* is yet one more rebuke to that other fan-wielding woman, Matisse's *Woman with a Hat*; in Picasso's version the fashionable accoutrement has become a signifier of timeless truths, an indication that she belongs not to the ephemeral *now* but to the ages.

It's significant that, with the exception of Ingres, the work that engaged Picasso most deeply at this time was sculptural, either in relief or in the round. This impacts not only his own sculptural practice—which

* Another source for the haunting pose is Ingres' *Tu Marcellus Eris*. Picasso has taken the pose of the emperor Augustus gesturing to the poet Virgil out of context, giving it a quality of mystery.

† Both *Boy Leading a Horse* and *Woman with a Fan* would end up in Gertrude Stein's collection. She regarded the latter painting as a good-luck charm, and when she was thinking of selling it in order to raise money for a publishing venture she first organized a council, including Picasso himself, to give their blessing to a venture that might otherwise come to grief.

he picks up again at this time, if only tentatively—but, more important, his approach to the pictorial surface. What he seems to be seeking in his painting is the solidity, palpability, and presence normally associated with work in three dimensions. In his quest for pictorial *presence*, he reverses the trajectory of art history since the Renaissance invention of one-point perspective. Of course this revolt against the illusionism that had been so carefully built up over the centuries had itself been brewing for the past few decades. Efforts to call attention to the painting as a flat surface covered with pigment—that is, to the process of conjuring the illusion rather than to the illusion itself—had been a potent element in the modernist project from at least the time of Manet, who offended traditionalists not only by the supposed vulgarity of his subjects but by his refusal to maintain the fiction that the canvas was a transparent window onto a world beyond. The mark of the brush on the surface—in Manet's case a stroke applied with supreme verve and elegance—became as important to the experience of the painting as the image it described. As Maurice Denis, a follower of Gauguin, pronounced, "Remember that a picture—before being a war horse, a nude woman or some anecdote—is essentially a plane surface covered with colors assembled in a certain order." This declaration became a rallying cry of the avant-garde and a justification, before the fact, of abstract art.

Ultimately, this impulse would lead not only to abstract art but to the blurring of lines between painting and sculpture, along with much sterile theorizing about the "integrity of the picture plane." At its most basic level, however, it was all about increasing the impact of the painting, whose surface no longer dissolves into nothingness but becomes a charged field, a membrane as taut as the surface of a drum upon whose tactile surface a sensitive artist can summon a myriad of savage rhythms.

In the paintings of 1906 Picasso transfers the drama of the Rose Period works onto a different conceptual plane. If the earlier works were all about artifice—the performer behind the scenes, without the footlights and special effects—the paintings that follow also play in that ambiguous terrain where illusion breaks down, offering us a glimpse of the artifice that underlies all forms of representation. Looking at *Portrait of Gertrude*

Stein, Boy Leading a Horse, or any of the other paintings Picasso worked on during these crucial months, we see him searching for a more direct means of representation, one that aggressively asserts solid, relieflike elements at the expense of illusion.

This was not merely intellectual exercise. There was a sense among all avant-garde painters that the Western tradition was spent, and each in his own way tried to revitalize artistic practice by tapping into something more primal, more authentic. For an artist like Matisse, Persian miniatures, the art of so-called primitive peoples (whatever that meant), medieval icons, and even the daubs of children, provided alternative modes that, when combined with his delirious palette, gave rise to unprecedented forms. In many cases what passed for novelty was simply a looping back to forgotten traditions, plucked out of context and combined in unexpected ways.

Picasso was setting out on a similar journey, though, in keeping with his different temperament and needs, both the sources he looked to and the destination at which he hoped to arrive were vastly different. Picasso's artistic path veered in a new direction when, in the spring of 1906, the Louvre put on view a group of sculptures excavated a few years earlier at Osuna, in southern Spain. Dating largely to the fourth century BCE, the so-called Iberian statues reflected the art of the peninsula before the "civilizing" impact of Greece and Rome. To most eyes these heads appeared irredeemably crude, but to Picasso they were a revelation. Far from being put off by their clumsiness, he cherished their raw power. This was exactly what he was seeking in his own art—a naive approach to form unrelieved by any refinement or notions of good taste. The fact that they had been unearthed in his native land gave them even greater resonance in his eyes, allowing him to embrace his roots and distinguish himself from the cerebral traditions of his adopted land.

Picasso's embrace of Iberian sculpture reveals the extent to which he clung to his Spanish identity even as he built a life for himself in a foreign country. There's no need to subscribe to a spurious notion that ethnic traits are inborn to admit that Picasso looked to his own origins when fashioning his artistic personality. Unlike his French peers he was steeped in Spanish *duende*, the dark, mystical strain that infuses not only the folk

art form of flamenco but also the high art of El Greco and Goya. This was a matter not only of his personality, which was drawn to the crueler aspects of existence, but also of background, a return to his roots that was part atavistic, part self-conscious branding.

In the spring of 1906 the revelation of an ancient Spanish idiom helped catalyze the shift that was already taking place in Picasso's art, encouraging his search for a more primal, sculptural form of expression. Ironically, that shift was occurring just as his previous style was finding favor with collectors, providing him with a sudden windfall that allowed him to pursue this more difficult direction unimpeded by the daily struggle for existence.

That May, an unexpected visitor arrived at the Bateau Lavoir. It was Ambriose Vollard, the dealer who had initially taken a chance on the young unknown before deciding that there was little market for the melancholy paintings of the Blue Period. Now he was taking a second look. His change of heart was encouraged by Apollinaire, who convinced him that the harlequins and acrobats of the Rose Period were sure to please the buying public. By the time Vollard showed up in the rue Ravignan he'd already been converted.

On hand for the great occasion were André Salmon and Max Jacob. Watching as Vollard's horse-drawn cab pulled away, crammed with so many paintings that Vollard was forced to sit outside with the driver, Picasso's friends were overcome, taking it as a sign that he'd finally arrived. "Max and I gaped at the sight," Salmon recalled. "[He] clasped my hand, without saying a word, without looking at me, utterly content, his eyes like seascapes, full of tears."

For Picasso, the two thousand francs Vollard peeled off the wad of banknotes he kept in his coat pocket meant at least a temporary respite from anxiety, as well as a gratifying confirmation that he was on his way. He celebrated this stroke of good fortune by preparing for a long-overdue trip home to Barcelona. This time he would not slink back with his tail between his legs but return as a certifiable success, a young man who was finally living up to the high expectations set for him by those he'd left behind two years earlier.

One reason for visiting his family in Barcelona was to show off the woman he was now presenting as his fiancée.* To have a beautiful, fashionable French woman on his arm was one more sign that he'd made it, and Picasso was not above exploiting Fernande's striking good looks to prop up his fragile vanity. Fernande, for her part, seemed perfectly content to play the role of Picasso's prized possession. She purchased a stylish new dress and hat to show herself to best effect and looked forward to conquering a new batch of admirers.

They spent the next two weeks in Barcelona, fussed over by Doña Maria, while Don José, now nearly blind, brooded in silence. In addition to showing off his beautiful fiancée to his parents and sister, Picasso took the opportunity to catch up with his old cronies: Ricard Canals and his wife, Benedetta, both of whom Fernande knew from the Bateau Lavoir, along with Miquel Utrillo, Enric Casanovas, Pablo Gargallo, and Mateu de Soto. Picasso was happy enough to bask in their fawning adulation, but he couldn't take them too seriously, ridiculing anyone who had as high an opinion of him as he had himself. For all his obvious pleasure at reconnecting with old friends, he found nothing in Barcelona that caused him to regret his decision to leave. In the two years since he'd said good-bye to his hometown, the expectation of cultural renewal that energized the city at the turn of the century had largely dissipated. Els 4 Gats was defunct, and the once tight-knit *Modernista* community had lost its sense of common purpose, divided between those who looked to a wider Europe for inspiration and those who preferred to retreat into a provincial variant of an already backward-looking Mediterraneanism.

But for all its drawbacks as a place from which to launch a brilliant career, Picasso was more at ease there than he was in the French capital. Fernande marveled at the change that came over her lover after only a few days back in his native land. "Pablo is quite different in Spain," she observed. "He's more cheerful, not so wild, more sparkling and animated, and he takes a calmer, more balanced view of things. He seems at ease. He glows with happiness, so unlike the kind of person he is in Paris, where he

* Marriage was never an option since Fernande was still the wife of the abusive Paul-Émile Percheron, who had no intention of granting her a divorce.

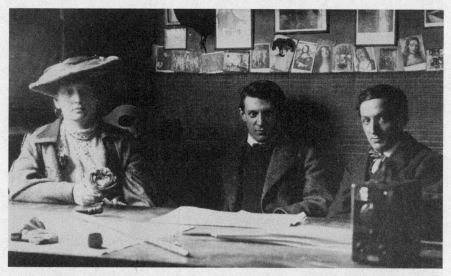

Fernande, Picasso, and de Soto in Barcelona, 1906. © *RMN-Grand Palais / Art Resource, NY.*

seems shy and inhibited, as if the atmosphere is alien to him. I've never met anyone less suited to life in Paris."

Is it possible, then, that Picasso was not the tormented genius he appeared to be but simply a lonely boy, cast upon a distant shore and forced to struggle in a hostile environment? There's some truth in this. Picasso's life might well have been more contented—and certainly more placid—had he been willing to follow the path set out for him by his father, building a successful career as a pillar of the establishment, surrounded by a loving family and showered with honors by a grateful nation. But settling for such comfortable mediocrity was not in his nature. He felt himself destined for greatness, and greatness in his mind demanded suffering, not only for himself but for those around him. He subscribed to the Nietzschean belief that those destined to change the world were not bound by rules meant for mere mortals. In pursuit of a great cause, he told Françoise Gilot, while attempting to justify his cruelty to his former mistress Dora Maar, "one accepts for oneself a share of tragedy, one steps outside the usual laws and has the right to act as one should not act under ordinary conditions. . . . At a time like that, the sufferings one has inflicted on others, one begins to inflict on oneself equally. . . . It's a question of the recognition of one's destiny and not a matter of unkindness or insensitivity."

Picasso, living in self-imposed exile and having sacrificed his own happiness on the altar of his art, was not prepared to spare the feelings of those he loved, all of whom were, sooner or later, tossed upon the pyre of his ambition.

After a couple of weeks spent soaking up the warmth of family and friends, Picasso and Fernande set out for Gósol, a remote village in the Pyrenees. The spot had been recommended by his sculptor friend Enric Casanovas, as well as by Cinto Reventós, the brother of the writer Ramon, a physician who sent his patients to the mountains to convalesce. "[G]ood air, good water, good milk and good meat" was how the doctor summed up the virtues of this rustic hamlet.

In making the journey to Gósol, Picasso was hoping to reprise one of the happiest periods of his life. During his six months of convalescence in Horta d'Ebre, he felt he had tapped into an elemental life force. "All that I know, I learned in Pallarès' village," he insisted. Heading once more into the heart of the Pyrenees, he thought he could recover the magic of that earlier time.

Fernande was less thrilled with the prospect. Her Parisian fashions had been a hit in Barcelona, but the villagers who were to be her neighbors for the next few months were sure to be less easily impressed. Not only did this child of the city have nothing in common with the goatherds and housewives of Gósol (she found their custom of eating separately from their husbands, standing in corners while the men folk sat at the table and talked, demeaning), but she couldn't speak a word of Catalan and they not a word of French.

The couple left from the Plaça d'Espanya station, taking the train some fifty miles north to Guardiola de Berga, in the foothills of the Pyrenees. From there, Gósol was another fifteen miles, at the end of a steep mountain path. The daylong journey proved harrowing. "You have to ride a mule for several hours," Fernande wrote in her diary, "and the paths are bordered on one side by walls that scrape your knees and hands, while on the other side the drop is so sheer I had to shut my eyes to prevent vertigo."

Once they settled in, however, Fernande found unexpected joy in the mountains. The two months she spent in this remote village were among the most contented of her life, and certainly among the most blissful during the years she was with Picasso:

The village is up in the mountains above the clouds, where the air is incredibly pure, and the villagers—almost all of whom are smugglers—are friendly, hospitable and unselfish. We have found true happiness here. There is no one here for Pablo to be jealous of, and all his anxieties seem to have vanished, so that nothing casts a shadow on our relationship.

Indeed, the transformation was remarkable. If Picasso felt at home in Barcelona, he was reborn in the stark beauty of the mountains. "A tenor who reaches a note higher than any in the score" reads a triumphant inscription he made in one of his sketchbooks from this summer. Just as he had in Horta eight years earlier, he felt connected to the land and to the people, adopting the clothes and habits of the country folk he admired. Their simplicity restored his faith in life and in himself. He signed his letters from Gósol "Your friend, Pau," as if he hoped to capture a little of the natives' vitality by referring to himself in their dialect. A pencil self-portrait from this summer shows him with his hair cropped short—a remedy against lice and the heat but also a look that conveys a tougher, more confident self, as if he's been possessed by the spirit of one of the bandits who gave this mountainous region its air of dangerous romance.

The peasants of Gósol, like the clowns of the Cirque Medrano, seemed to him a finer race than the jaded denizens of the city, more rooted, in touch with the deepest mysteries of the universe. Though he didn't share their simple piety, he did share their conviction that mysterious forces govern our lives. One image in particular captured the primitive faith of these peasants and stayed with him long after he had returned to civilization: a Romanesque statue of a Virgin and Child (the so-called *Virgin of Gósol*) venerated in the church of Santa Maria, whose impassive face and wide, staring eyes haunt the work of the next few months and beyond.

To replace the mercurial Apollinaire and gossipy Max, Picasso bonded with Josep Fontdevila, the ninety-year-old proprietor of the inn where they were staying, the Cal Tampanada [House with the Sloping Roof]. "[A] fierce old fellow, a former smuggler with a strange wild beauty," as Fernande described him, Josep formed an immediate rapport with the artist. "He's difficult and cantankerous with everyone else but always good-humored with Pablo," she observed. For all their differences

in education and background, they saw themselves as kindred spirits, fellow outlaws who despised convention and set themselves in opposition to polite society. The two men grew so attached to each other that when it came time to leave Josep tried to accompany the couple back to Paris, a rash act forestalled only by the last-minute intervention of his children. If Fontdevila had earned his living by slipping back and forth across the border and evading the police, Picasso trafficked in another kind of contraband, one that was no less dangerous for violating only aesthetic norms. He portrayed the innkeeper numerous times over the course of the summer, each time paring down his fine-boned features a little more, until his skull and shoulders were reduced to a simple geometry of stacked planes. In distilling the essence of this sly old fox, Picasso was heading down the road toward Cubism.

Life in Gósol was spartan, but at least Picasso was free from the worries that plagued him in Paris: over money, the state of his career, the conniving of dealers and petty quarrels of friends. Almost a mile above sea level, hemmed in on one side by the Cadí range and on the other by the high peaks of the Pedraforca, Gósol had a spectacular if austere beauty. The "new" village was located below the medieval ruins of the old town, enhancing an impression of a deep rapport between Man and Mountain, stone and bone. Though Picasso painted very few scenic views, Gósol's palette of pale stucco and terra-cotta, gray soil and bleached rock, found their way into the paintings he made there.

He and Fernande dined at the communal table in the Cal Tampanada, filling up on *cocido*, a stew of sausage and beans, occasionally supplemented with rabbit or deer that Picasso hunted himself. When he wasn't working in his room or hiking through the forests to hunt with the locals, Picasso spent his time with the blacksmith who had a shop across from the inn, fascinated as always by craftsmen who shaped their materials with an artistry born in function rather than high-flown theory.* At night, particularly during the religious feasts that were a regular feature of village

* Picasso always had a fondness for craftsmen and their trades. The time he spent with the village blacksmith may well have born fruit decades later, when he made his revolutionary welded-metal sculptures.

life, he joined in the all-male dances around the bonfire, reveling in customs barely changed over the centuries that summoned spirits older than Christianity itself.

The two months Picasso spent in Gósol were crucial for the development of his new aesthetic. Rustic retreats like Gósol and Horta—and, later, places like Céret, Avignon, and the Riviera—were essential to restoring his peace of mind, but they were usually periods of consolidation and reflection rather than of innovation. They formed necessary interludes between extended stays in Paris where, plunging into the roiling cross-currents of that most intellectually stimulating environment, he was exposed to new ideas, new modes of thought. It was there that the real creative breakthroughs were made.*

Gósol did not so much alter the trajectory of Picasso's art as confirm and solidify changes that were already taking place. The primitivizing classicism he'd been exploring in Paris was embodied in the rugged terrain and equally rugged people of this timeless land. Just as Gauguin and his followers found inspiration in the peasants of Brittany or van Gogh in the provincial charms of sun-drenched Arles, Picasso discovered in Gósol a cure for the discontent and alienation of modern life. The figures he painted in the summer of 1906 are at one with their environment, so much a part of the landscape that they might have grown from the soil like gnarled cypresses clinging to rocky slopes.

In *Woman with Loaves* we see a simple peasant girl carrying a baker's bounty upon her head, just as her mother had and *her* mother before that, countless generations living in harmony with the rhythms of the seasons. She shares a quiet dignity with her Blue Period sisters, but she is no longer

* Many artists, including Cézanne, Braque, and Matisse, followed a similar pattern, alternating between time spent in the city and in the country. For the Impressionists and their followers it was often necessary to leave central Paris to discover motifs to paint, but for Picasso, who rarely painted pure landscapes, time spent far from the city was a means of clearing his mind of accumulated clutter and to escape the constant social demands imposed by his many friends.

the eternal victim. Instead, she has become symbol of the land's bounty, a source of sustenance and pillar of strength as enduring as the caryatids who support the porch of the Erechtheion on the Acropolis. An even more explicit classical reference comes in *Two Youths*, where the seated boy is taken directly from the ancient bronze known as the *Spinario*, depicting a youth pulling a thorn from his foot.

For the first time in Picasso's art, Fernande's face and figure feature prominently. Her sturdy, voluptuous form suited the mood of these works, which are sensual, reassuring, exuding well-being and the promise of plenty. Like the peasant girl carrying bread, Fernande is engaged in timeless rituals, though Picasso also invests these erotic images with her particular mix of indolence, vanity, and languorous sexuality. In *La Toilette*, Fernande serves as the model for both figures, the nude coiling her long tresses and her maidservant who holds up the mirror. Though modeled on Fernande, the pose of the nude—arms raised above her head in a gesture that is both self-absorbed and inviting—goes back thousands of

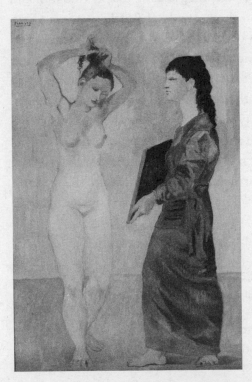

La Toilette. Albright-Knox Art Gallery / Art Resource, NY.

years, to ancient depictions of Aphrodite, the source as well for Ingres' many depictions of the goddess of love.

The erotic strain in these works culminated in a large, unfinished canvas called *The Harem*, a half-parodic tribute to Ingres' *The Turkish Bath*, which Picasso had admired at the 1905 Salon d'Automne retrospective. Though Picasso's work is unresolved, the harem (or its modern-day cousin—the whorehouse) will continue to obsess him. On some level, of course, such scenes are a form of erotic wish fulfillment, in which a bevy of beautiful and compliant women, each of them based on Fernande, tends to the needs of the lone male figure. But even here, Picasso acknowledges, pleasure is never uncomplicated. The reclining figure at the center—perhaps the artist's alter ego—seems strangely impotent, as if he were not the sultan but merely a eunuch, incapable of taking advantage of the bounty so temptingly arrayed before him. Far more virile than the ineffectual giant is the phallic *porrón* (a Spanish wine vessel with an "erect" spout) he grasps in his left hand, a sexual pun that suggests, along with the nearby melons and sausages, an underlying masturbatory theme. The comic frustrations of *The Harem* will be transformed a year later into the far more harrowing emotions of predatory lust and thwarted desire in *Les Demoiselles d'Avignon.*[*]

The sensuality of these paintings is not limited to subject matter. Picasso treats the surface of the canvas with the tenderness of a potter kneading clay. This is true whether he is depicting local peasants, young boys who seem to have walked straight out of an ancient fresco, or Fernande exhibiting her charms. His palette consists of warm ochers, terra-cottas, and cool slate, with very little contrast between light and dark. Everything is bathed in a golden afternoon light that envelops his figures and fuses them with the surrounding architecture, which is itself reduced to the most basic of geometric forms. Space has been all but eliminated. As in *Boy Leading a Horse* or *Portrait of Gertrude Stein*, everything is pressed up against the surface, which has become a tumescent membrane, pulsing with life. Now that he has discovered how to invest the surface of the

[*] Some of the preparatory drawings for *Les Demoiselles d'Avignon* also include a *porrón*, though it would be eliminated in the final painting.

canvas with an erotic charge, Picasso can subject the medium of painting itself to all the strange transformations that sexual appetite—desire *and* repulsion—work on the object of its fascination. This activation of the surface will have momentous consequences for the course of modern art, shifting the dramatic action from the fictive depths of a painting to its fleshy surface, as if one were to perform Shakespeare's *King Lear* on a stage of only a millimeter's depth.

One of the final works from this summer, completed only on his return to Paris, is *The Blind Flower Seller.* This large-scale painting in a vertical format, shows a blind man hawking his garlands accompanied by two bulls, the procession led by a young girl—motifs he will recycle to different effect throughout his career.* Unlike most of the works of this period, whose sculptural solidity derives from classical or Iberian sources, here Picasso channels an artist of a very different sensibility: El Greco, the eccentric Mannerist who haunts his works like a melancholy spirit, always hovering somewhere in the background. His renewed interest in this most expressive and idiosyncratic painter may have been sparked by a book just published by his friend Miquel Utrillo, the first monograph on a painter who was one of the heroes of the *Modernista* movement. For Picasso, El Greco's bizarre distortions offered yet another means to animate the picture plane, this time in terms of pleated sheets, as if the figures were origami birds laid atop an origami landscape. By treating the canvas as a continuous faceted surface and making the figures appear as if they're not only pressed against the picture plain but tumbling forward into our space, Picasso (though he could not yet have known it) is setting off on the road that will ultimately lead to Cubism.

* Blindness was a major theme of the Blue Period works, while the young guide carrying a bouquet would reappear in his most famous etching, *Minotauromachy* of 1935. The idea for the bulls seems to come not only from local customs in Gósol, where the beasts were led down from the high pastures garlanded with flowers, but perhaps also from classical mythology, where Zeus would appear in the form of a bull to ravish beautiful maidens. The composition seems to derive, in part, from El Greco's *Saint Joseph and the Christ Child*, which Utrillo had reproduced in his monograph on the artist.

The summer in Gósol also saw a revival of Picasso's interest in sculpture, which is not surprising, given the fact that his paintings of the time aspire to a kind of sculptural presence. On June 27 he wrote to Casanovas in Barcelona, asking him to send him some chisels so he could begin carving in wood. The chisels never arrived, forcing Picasso to make due with the penknife he had acquired in Horta. This helps explain the crudeness of the one sculpture to have survived from the summer, a figure of a woman (modeled by Fernande) known as the *Bois de Gósol*. Rather than allowing the inadequacy of his means to limit his expressive power, Picasso has made a virtue of necessity. Simplicity actually enhances the fetishistic power of this phallic figurine that combines in a single form the male and female principles, recalling the roughly hacked sculptures of Gauguin that he'd seen in Paco Durrio's studio and that had remained seared in his imagination.

Picasso and Fernande's rustic idyll was cut short in mid-August when it was discovered that Fontdevila's daughter had come down with typhoid fever. Ever since Conchita's death from diphtheria and his own near-death experience from scarlet fever, Picasso was afflicted by an almost pathological terror of infection. As soon as he got the news he began packing up his things. Not wanting to pass through Barcelona, where he would have to explain his panicked flight to friends and family, he insisted they take the far more difficult route north across the mountains.

Setting out on muleback at five in the morning, Picasso clutching the little fox terrier Fernande had been given by the villagers, they headed east and then north across the rugged mountain passes, reaching the border town of Puigcerda at six in the evening. The next morning they hired a coach to take them to Bourg-Madame in France, where they caught the train for Paris. They arrived at 13 rue Ravignan exhausted, relieved to be home after their chaotic journey but dismayed at having to exchange their mountain retreat for the sweltering heat of the Parisian summer.

The Chief

Picasso was more than ever as Gertrude Stein said the little bullfighter followed by his squadron of four, or as later in her portrait of him, she called him, Napoleon followed by his four enormous grenadiers. Derain and Braque were great big men, so was Guillaume [Apollinaire] a heavy set man and Salmon was not small. Picasso was every inch a chief.

—GERTRUDE STEIN, *THE AUTOBIOGRAPHY OF ALICE B. TOKLAS*

Adjusting to life back in the Bateau Lavoir was difficult at first. The studio was "like an oven," Fernande recalled, "[and] the mice had returned in full force and had gnawed at everything in their path." To make matters worse, bedbugs had infested both the bed and the couch, forcing them to sleep on the floor until they could fumigate the room with sulfur. Still, after the typhoid scare and the precipitous flight across the mountains, she admitted that they were glad to be back.

The return to the Bateau Lavoir did nothing to slow Picasso. When he was in one of his creative furies he paid no attention to bodily discomfort, and he'd built up such momentum over the course of the last few months that it carried him through the rest of the summer and into the fall. First, he put the finishing touches on *The Blind Flower Seller*,

updating his progress in letters to Leo Stein, who was summering in Fiesole and was now paying him a small stipend in return for getting the pick of the studio.

Picasso also returned to the portrait of Leo's sister. He'd rubbed out her face the previous spring, but now, with his vision sharpened after months in the limpid Pyrennean air, he could "see" her once again. According to Gertrude he completed the painting on the day of his return, in a single session and at a time when she was still hundreds of miles away in Italy with her brother. Of course this may simply be one of her many exaggerations, but it's obvious that his time in Spain had solidified his conception. The startling, masklike face he created for his patron is at odds with the more painterly chiaroscuro with which he modeled her body. It's more schematic, even cartoonlike. He imparts an aggressive, thrusting quality to her likeness so that she seems more totem than image, as if she were impatient with the shallow depth she's forced to inhabit and can will herself to the status of sculpture.

But this hard-won magic has come at a cost in terms of straightforward realism and even coherence. Rendered in simplified contours that recall the medieval *Virgin of Gósol*—as well as the brutality of Iberian sculpture and the stripped-down geometry of his portraits of Fontdevila—Picasso departs from literal description to better convey his sitter's forceful personality. "[E]verybody thinks she is not all like her portrait but never mind," he said, "in the end she will manage to look just like it." This notion of a truth deeper than mere appearance was echoed by Stein herself: "[F]or me it is I, and it is the only reproduction of me which is always I, for me."

For all its undeniable power, *Portrait of Gertrude Stein* feels disjointed, as if frozen in midthought. Though Picasso achieves the almost supernatural presence that made so-called primitive and non-Western art so compelling, he makes no attempt to resolve the dissonance between the face and the rest of the canvas that reflects two different stages of the difficult journey he'd embarked on. Another artist might have gone back and reworked the earlier passages in terms of the more rigid geometry of the final phase, but Picasso allows us instead to see the conceptual seams, regarding them as integral to the meaning of the work.

This lack of resolution is a feature of much of Picasso's best work,

often most evident during moments of maximum creativity. It reflects an ambivalence about his role as an artist that is part psychological, part conceptual. He often worked in great haste, heading off in a new direction before he'd completed the old, which gives his works a slapdash, provisional quality that can be mistaken for carelessness. This derives in part from his disdain for the kind of polish that was prized by academic painters like his father; all his life he'd had to fight against his own mastery, afraid that his art would descend into mere glibness. But there was an even more crucial psychological dimension. To declare a work of art unalterable was to succumb to a kind of slow death. "[Pablo] can't bear to sell works he considers unfinished," Fernande noted, going on to reveal that, according to him, "a painting is never finished, something could always be added. He resigns himself to parting with his pictures because he's forced to, as he wouldn't have the materials to work with, but he always complains about it and feels resentful for days afterwards."

Allowing the seams to show provides a means for an artist to enter his creation, haunting the work like a restless ghost, forever mourning paths not taken. In *Portrait of Gertrude Stein*—and even more startlingly in *Les Demoiselles d'Avignon*—the clash of incommensurates provides a paradoxical sense of fullness. In depicting his formidable patron Picasso acknowledges that no single viewpoint, no one approach, suffices, that there is too much to say to allow coherence to get in the way. He provides a surfeit of information, as in those ancient Egyptian reliefs where Pharaoh is depicted simultaneously from both the front and the side in order to capture his full authority. In Gertrude Stein's masklike visage we see these shifts in microcosm, subtly contradictory points of view, inconsistencies of shading and perspective, that will become ever more pronounced over the next couple of years, evolving into the visual conundrums of Cubism.

Less dissonant is the self-portrait Picasso completed at almost the same time. Depicting himself with the short-cropped haircut he'd adopted in Gósol and holding a palette in his left hand, he turns away from the viewer, self-contained, enraptured, his gaze directed toward some unseen vision, like one of those ancient Sumerian worshippers whose eyes are wide with the apprehension of divinity. His right hand, which would

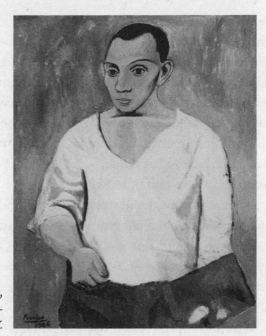

Self-Portrait with Palette,
1906. *The Philadelphia Museum of Art / Art Resource, NY.*

normally be holding the brush, is empty, creating one of those enigmatic signs (as in *La Vie* or *Woman with a Fan*) that imparts a sense of mystery to what would otherwise be a conventional gesture.

More of a piece than his portrait of Gertrude Stein, *Self-Portrait with Palette* delves even further into the pictorial ambiguities that give the former work its unsettling power. Picasso outlines his face and body with the simplicity of a medieval icon or stained-glass window, but these graphic elements coexist uneasily with passages of subtle shading—especially in the sleeve of his right arm and the left side of his torso—that draw on a different perceptual mode. The jarring shifts that came about in the Stein portrait as a result of his inability to settle on a single approach are woven into this composition from the outset. The tricks of the trade by which a painter suggests a three-dimensional form on a two-dimensional surface are all present, but deployed in such a way as to undercut any consistent reading, like a mutually incomprehensible conversation carried out in two or three different languages. The dark shadow beneath his chin, for example, suggests a projection into space that is belied by the paper-thin

treatment of the neck and much of his body below. The clavicle on top of which the firmly modeled skull rests is not merely flat but as structurally unreliable as an optical illusion, nothing more than a T of slightly lighter pigment that makes pictorial but not anatomical sense. Nowhere is this perceptual play more evident than in the way Picasso has depicted the thumb of his left hand. Wedged through the hole of the palette, the thumb is, logically speaking, the element that should project furthest into our space. But Picasso has rendered it as merely a smudge of lighter paint, as insubstantial as a puff of smoke.

Here we have entered strange territory indeed. Picasso is pushing his painting in two conflicting directions: stressing an iconic flatness while at the same maximizing sculptural solidity. Over the course of the next few months and years Picasso will see how far he can go in pushing these perceptual puzzles without having the work collapse under the weight of its own contradictions. As it turned out, he could go much further than anyone (including Picasso himself) thought possible, inventing in the process an entirely new language of form.

On one level this tug-of-war between two and three dimensions might seem like a triumph of theory over sensuality, intellect over heart. But for Picasso what was at stake was nothing less than the soul of painting. Like so many of his colleagues in the avant-garde, he was seeking a way of restoring a lost sense of wholeness, to wrest painting in particular from the tricksters, the frauds, and the purveyors of cheap effects who produced nothing but empty tours de force. In Picasso's hands, at least, such perceptual gamesmanship is anything but sterile. In fact it is almost uncomfortably carnal, a tribute to the voyeuristic pleasure of seeing and the intimacy of touch. Picasso has not abandoned his obsessions; he has simply transcribed them into the coded language of painting itself.

By divesting his work of overt narrative elements he gives free rein to his libido. The paintings he made over the course of the next few months are eroticized, even when their ostensible subject matter is relatively chaste. Most of them focus on one or two figures, most of them women and always unclothed—a respectable enough subject given the Western canon's obsession with female beauty. Indeed, his nudes are far less provocative than the morbidly voluptuous odalisques conjured up by

Ingres. Massive, hulking creatures, they are not exactly androgynous, but they are hardly ideals of femininity either—their type inspired, no doubt, by Gertrude Stein and the Cone sisters, as well as the generously proportioned Dutch women he'd encountered the previous summer.

His *Seated Nude* is a behemoth, squat and heavy-limbed—Fernande reimagined as an earth goddess—plunked down on a simple cube so that the painting appears to be a takeoff on the standard life-drawing exercise. Her mute presence offers a rebuke to her Rose Period sisters; Picasso deliberately suppresses narrative the better to concentrate on form itself. In *Two Nudes* [see color insert] he allows the faintest suggestion of a story to creep back in, a possibility suggested by the fact that the woman on the left holds open a curtain, as if inviting her companion to a tryst. The folded drapery offers a visual pun on the female anatomy while extending the play of advance and retreat, solid and void, that forms the real subject of these paintings.

In *Two Nudes* Picasso plunges headlong into visual paradox, modeling breasts, thighs, and buttocks as if he had viewed each part at a different time of day from a different point of view. Rather than provide us with a snapshot, he has stretched the temporal dimension, lingering over his figures like a lover tracing his fingers along every bump and hollow of his beloved's body. These massive women expand in every possible direction, bulking large in time as well as space.

In this world of Alice-in-Wonderland perplexity figures can appear as massive as stone monoliths and as insubstantial as pleated paper. The process of stretching time causes deformations in the three spatial dimensions as well, forms apparently receding and projecting at the same instant, locking figure and ground into a single, perceptually undulating field. This projection and recession, in turn, embodies in plastic terms the repulsion and attraction that form the yin and yang of sexual desire.

These paintings are hermetic, self-referential—that is, concerned with the rules of their own making—but also rooted in the needs of the body, responsive to the urgent promptings of the flesh. They are rude, bumptious, assertive, making a claim on our attention while making no concession to beauty. They seem both ancient and ahead of their time, Paleolithic fetishes stomping into the twentieth century and subject to quantum fluctuations.

To explore this strange new territory, to play Virgil to his Dante—or perhaps John the Baptist to his Jesus—there was only one artist who could offer any real guidance. Picasso had already looked closely at ancient sculptures by anonymous craftsmen and the work of long-dead masters; and he borrowed freely from his immediate predecessors and near contemporaries, trying on for size the nostalgic classicism of Puvis de Chavannes, the primitivism of Gauguin, and the urban *verismo* of Steinlen. None of them, however, could take him where he needed to go, to that treacherous realm where two and three dimensions meet on the surface of the canvas. Now for the first time, and like many so of his contemporaries, Picasso's voracious gaze turned to the difficult, maddening, and deeply nourishing art of Paul Cézanne.

Of all the artists who grew to maturity in the wake of the Impressionist revolution, Cézanne had proved to be the most enigmatic and difficult to assimilate. Van Gogh, who sold only one work in his lifetime, had been rediscovered in the years since his untimely death in 1890, with exhibitions at Vollard's in 1895 and 1896 and a major retrospective at Bernheim-Jeune in 1901, while Gauguin's influence only grew during his years of self-imposed exile in the South Seas. Following his death in 1903, he was acknowledged as the leading voice of his generation, a prophet whose life was as inspirational as his art; his true apotheosis came in 1906 with a reverential display at the Salon d'Automne. Seurat, too, after facing initial incomprehension, had built a loyal following. Carrying on his legacy after his early death in 1891, disciples like Paul Signac, Camille Pissarro, and Matisse's friend Henri-Edmond Cross continued to preach the Divisionist gospel, extending the optical theories of the Impressionists into the twentieth century.

Cézanne, however, remained something of an outsider, misunderstood by his colleagues and ridiculed by the popular press, for whom he came to symbolize the worst excesses of contemporary art. A year older than Monet and two years older than Renoir, Cézanne was of the same generation as the founders of Impressionism. A slow starter, he'd been encouraged by the fatherly Pissarro, who saw in him an earnestness that

others, put off by his awkward drawing and brooding temperament, failed to appreciate. His early scenes of sexual violence and heavily worked portraits in bituminous shades were almost the polar opposites of Impressionist lightness, and to the general public his heavy-handed approach looked like mere incompetence.

But, as with many of the most original artists, Cézanne turned his faults into virtues, exploiting his lack of facility to dig deeper, transforming each canvas into a meditation on the nature of seeing and an investigation into the way the material world can take on new life on the two-dimensional surface of the canvas. As Georges Braque, an artist of very similar gifts, limitations, and sensibility, observed: "Progress in art consists not in extending one's limits, but in knowing them better." Or, as he put it in another context, "Cézanne is great . . . for his clumsiness as for his genius."

By the turn of the century, Cézanne was spending most of his time in his native city of Aix-en-Provence. Before 1895, when Vollard announced what would become a lifelong passion with his one-man show of the artist's work, Cézanne was almost invisible on the Parisian scene. Far removed from the art capital and its polemics, he pursued his own idiosyncratic course, attempting to translate the light-filled palette of his contemporaries into an art as authoritative as that of the great masters he admired in the Louvre. "What I wanted was to make of Impressionism something solid and durable, like the art of the museums," he said near the end of his life.

Everything Cézanne painted possesses paradoxical qualities of both weight and transience, stasis and dynamism, lumpish materiality and divine transcendence. While Impressionism's broken brushwork and vivid hues tended to dissolve form, Cézanne had an affinity for what could be held in the hand and grasped by the mind. Artists at the École des Beaux-Arts were trained to make the painting itself disappear and to give each substance they depicted its own particular quality—the liquid sparkle of dew on a leaf; the sheen of metal; the gossamer translucence of silk caught in the breeze—but Cézanne never lets the viewer forget the material properties of the oily paste and canvas out of which the image emerges. What looked like incompetence to the general public was in fact a conscious effort to give painting its due, not only as image but as a physical presence

in the world. Next to a painting by one of his contemporaries trained in the Beaux-Arts manner, a work by Cézanne is assertive, confrontational, fully present, like a rude guest at a dinner party whose too-loud voice and shabby clothes make him unforgettable. He renders torsos rotund as oil tanks, cotton tablecloths as monumental as mountain ranges, mountain ranges as treacherous as mirages. Even his skies, which he tends to reduce to a minimal strip at the top so that his landscapes seem to tilt forward until they touch the picture plane, are abrasive enough to scrape one's shins on. [See color insert]

Cézanne never seems to begin with a preconceived notion but to discover the composition in the process of painting. Each canvas or sheet of paper is merely a proposition, offering clues to alternative solutions and an admission that no single approach can do justice to the complexity of the subject. Each possesses its own distinctive architecture. But that architecture is dynamic rather than static, balancing force with counterforce, even when an angle or contour defies logic: light and shadow are deliberately inconsistent, undercutting the illusion of real space; the edge of a tabletop disappears behind a bowl of fruit, only to reemerge on the other side at a different height; ceramic pitchers deform in response to the structural needs of the painting; areas of built-up pigment abut patches of bare canvas, so that a peach or apple seems at one moment ripe enough to bite into and the next to dissolve into thin air. Cézanne's willingness to bend reality to the formal requirements of the painting, and to allow the viewer to share in the process of discovery, opened up new vistas that generations of artists could not fully explore.

"He who understands Cézanne is close to Cubism," wrote Albert Gleizes and Jean Metzinger in their 1911 manifesto, *Cubism*, with only a bit of hyperbole. There is nothing complacent about Cézanne's art. His quest for an art of grandeur and harmony—a quest he felt had been abandoned by the Impressionists in favor of fleeting effects—forced him to discard plausibility itself. His paintings are tentative because he perceived so much more than mere vision could encompass. Each stroke of the brush was fraught since so much was at stake in the losing battle to apprehend the fullness of Creation. For Cézanne, Braque insisted, "painting was a matter of life or death." His vision was both exhilarating and

tragic, liberating the artist from a slavish adherence to the visible world while acknowledging that the search for wholeness was ultimately futile. As Picasso himself explained, "Cézanne's anxiety is what interests us. That is his lesson."

Another way to put it is that Cézanne's art revealed (and reveled in) the insufficiency of any one representational system to capture the full range of experience: tactile and temporal, perhaps even moral, as well as visual. This anxiety—manifested by an unprecedented willingness to depart from what the eye sees and logic dictates—gave license to future generations to create their own reality on the canvas.

For all its cerebral quality, Cézanne's art is deeply sensual. His anxiety was a form of sublimation in which the sexual ferocity so evident in his early work is replaced (or disguised) by an approach in which vision itself is eroticized, so that the pulpy feel of ripe fruit and the tumescent swell of a mountain rising over fertile fields substitute for passions he would rather not acknowledge. Picasso, by contrast, rarely felt the need to suppress his appetites. In fact, he was one of the most confessional artists of all time, charging his art with both rage and longing. But he understood that Cézanne's investigation of form, itself the result in part of repression or sublimation, was the key to a more expressive, more capacious, vocabulary, one undreamt of by the Master of Aix himself. Picasso's willingness to acknowledge the central role Cézanne played in his own formation is in stark contrast to his usual caginess when it came to his sources. "[Cézanne] was my one and only master!" he told Brassaï. "It was the same with all of us—he was like our father. It was he who protected us."

Though Cézanne continued to avoid the Parisian art world, his reputation began to grow in the last five years of the nineteenth century. Vollard embarked on his own lifelong love affair with the artist's work in 1895, and from that time on any artist or collector who wished to see what the reclusive Master of Aix was up to had only to stop by the gallery at 6 rue Laffitte. One of those who did and fell under Cezanne's spell was Matisse, who purchased his *Three Bathers* from Vollard in 1899. It was an extravagance he could ill afford, but the small canvas remained a kind of

talisman all his life, the embodiment of the magic of painting at its mysterious best.*

In addition, a few of Cézanne's paintings, more with each passing year, began to be exhibited, first in the Salon des Indépendants (1899, 1901, and 1902) and then in the Salon d'Automne, where, in 1904, thirty of his paintings were on view. Picasso's appreciation of Cézanne's work came slowly, though in the end his engagement with the Master of Aix would be more intense and bear greater fruit than anyone else's, with the possible exception of Braque, his partner in the creation of Cubism. It's only in 1905, with the work of the Rose Period, that we see the first hints that Picasso was beginning to grapple seriously with the old man's art. This engagement shows itself in a renewed focus on the conceptual arena of the canvas surface, to the subtle push/pull of space and form that we see in paintings like *Boy Leading a Horse*.† Significantly, only when Picasso had purged the last vestiges of Symbolist poetry from his work did he began to appreciate how Cézanne imparted to even the most mundane subjects a totemic power, not primarily through literary interest but by investing form itself with dramatic narrative.

Cézanne's death in October 1906 made it easier for Picasso to acknowledge his debt since he was now effectively removed as a rival for leadership of the avant-garde. The solidly rendered nudes from this period draw heavily on Cézanne's figure paintings, the massive card players and the giantesses of his late *Bathers*. As Cézanne had in his final paintings, Picasso's depicts behemoths who embody visual paradox, appearing

* In order to raise the money to purchase the painting, Matisse was forced to pawn his wife, Amélie's, treasured emerald ring. When he returned to redeem the pledge, he discovered that the ring had already been sold.

† This painting in particular bears more than a passing resemblance to Cézanne's *The Bather* (now in the Museum of Modern Art in New York), which Picasso probably saw at Vollard's gallery. Like the bather, Picasso's boy strides purposefully forward into our space. But most of his paintings from this period show that he was looking carefully at the way Cézanne handled paint, using hatched, overlapping brush marks as a means of giving greater structural coherence to the canvas and emphasizing the solidity of the picture plane.

simultaneously as hefty as sumo wrestlers and translucent as air. Picasso's *Self-Portrait with Palette* is an explicit homage to the Master of Aix, down to the smudge of paint to indicate his thumb, a visual joke he borrowed from Cézanne's own self-portrait.

Cézanne's legacy was rich enough for artists as different as Matisse and Picasso to base their radical innovations on foundations he'd laid. Even Paul Sérusier, who began as a follower of Gauguin, concluded: "If a tradition is to be born in our time, it is from Cézanne that it will come . . . not a new art, but a resurrection of purity, solidity, *classicism*, in all the arts." Picasso's principal dealer during the Cubist years, Daniel-Henry Kahnweiler, noted: "Paul Cézanne [is] the point of departure for all painting of today."

Kahnweiler also noted that it was André Derain "more than any other . . . [who] communicated to his colleagues, through his paintings and in his words, the lessons of Cézanne." This forceful, cultured, but mercurial man—"a dictator at once humorous and tragic" as one friend described him—was, after Matisse himself, perhaps the most accomplished of the Fauve painters. But by 1906 he was already restless. "Doubt is everywhere and everything," he wrote to his friend and fellow Fauve Maurice de Vlaminck, a doubt that marked the beginning of a journey that would eventually alienate him from his colleagues and lead him into the camp of the reactionary critics of the modernist movement.

Derain's most full-throated tribute to the Master of Aix came in the spring of 1907 with his monumental *Bathers* exhibited at the Salon des Indépendants. *Bathers* represents a heroic but not altogether successful attempt to contain Fauvist chromatic flights of fancy within a more rigorous armature. While the critic Louis Vauxcelles condemned its "revolutionary" and "barbaric simplifications," it remains something of a pastiche in which the two approaches, coloristic and structural, undercut rather than reinforce each other.

Far more successful was Matisse's *Blue Nude (Memory of Biskra)*, also shown at the 1907 Salon des Indépendants; the two paintings, in fact, were products of an informal competition on the part of the artists to see who could paint the better "blue nude." While Derain attempted to

stiffen his flaccid forms with a bit of Cézannesque starch, Matisse managed to capture an architectonic equivalent in a work that nowhere resembles its model. In *Blue Nude*, very un-Cézanne-like arabesques recall the arches of a Moorish castle, weaving together figure and ground in an ecstatic dance that conjures the pulsing rhythms and intoxicating smells of the Casbah.* With barely a tropical motif in sight, save for a few palm fronds that echo the provocative thrust of hip, the painting conjures up a hot summer night of sensual overload and carnal delight. Here for the first time Matisse demonstrates himself to be more than simply a consummate painter of landscapes. The nude, while crudely, even brutally, drawn, is a force of nature, as ferociously "present" in her own way as Picasso's Amazons.

Whether or not Matisse was deliberately trying to beat Picasso at his own game, the Spaniard certainly took it as a provocation, particularly after the widespread attention it received in the press cemented Matisse's position as the leading light of the progressive movement. Picasso was further irritated when Leo Stein snatched it up as soon at the Salon closed and hung it on the wall of his pavilion. Each Saturday evening at the rue de Fleurus, Picasso could contemplate at leisure Matisse's latest masterpiece, one, moreover, that challenged him in the one area where, until now, he felt he had the advantage. As always when he felt threatened, he sulked. When another guest told him he couldn't understand what Matisse was up to, Picasso replied: "Neither do I. If he wants to make a woman, let him make a woman. If he wants to make a design, let him make a design. This is between the two."

But Picasso understood more than he would admit; Matisse had raised the stakes once again, and he would have to respond. Even as he claimed to be baffled, he studied the painting closely, learning just how far he could go in distorting the human figure, flouting conventional notions of decorum and good taste, how even ugliness could be a source of barbaric beauty.

If Matisse's latest triumph seemed to propel him into the lead, there

* The Biskra of the title is the Algerian city where Matisse spent the spring of 1906.

were other signs that Picasso was closing the gap—at least in the estimation of his colleagues, if not with the general public. Partly this had to do with the fact that Fauvism was losing steam as many of the principals, Matisse included, began to pursue their own courses. In truth, Fauvism was never really an organized movement but rather a temporary alliance of disparate talents driven together as much by outside criticism as by a common vision. Derain, who had trouble playing second fiddle to anyone, was chafing under Matisse's well-meaning but heavy-handed tutelage. He referred to Matisse derisively as "the dyer" and concluded: "I don't see any future . . . in our tendencies."

One sign of shifting allegiances was that when Derain finally left his parents' house in the summer of 1906 and moved into the city, he did not settle in Montparnasse (where the Fauvist leader could keep a close eye on him) but on the rue Tourlaque in Montmartre, only a few blocks from Picasso's studio. "Poor, patient Matisse," wrote the American journalist Gelett Burgess, "breaking his way through this jungle of art, sees his followers go whooping off in vagrom paths to right and left. He hears his own speculative words distorted, misinterpreted, inciting innumerable vagaries. . . . What wonder Matisse shakes his head and does not smile!"

In fact, Derain and Picasso already knew each other; they'd been introduced by Apollinaire, who had been friendly with both Vlaminck and Derain since 1904. Derain now joined the *bande à Picasso*, his wit and erudition adding to the already lively conversations at Azon's or in the Bateau Lavoir studio. For Gertrude Stein, who had already placed her bet on the Spaniard and was exquisitely attuned to power dynamics if not to artistic subtleties, it was clear that Picasso's star was on the rise. "Matisse was back and there was excitement in the air," she wrote in *The Autobiography of Alice B. Toklas*.

> Derain, and Braque with him, had gone Montmartre. . . . Braque had done rather geographical pictures, rounded hills and very much under the color influence of Matisse's independent painting. He had come to know Derain, I am not sure but that they had known each other while doing their military service, and now they knew Picasso. It was an exciting moment.

They began to spend their days up there and they always ate together at a little restaurant opposite, and Picasso was more than ever as Gertrude Stein said the little bullfighter followed by his squadron of four, or as later in her portrait of him, she called him, Napoleon followed by his four enormous grenadiers. Derain and Braque were great big men, so was Guillaume a heavy set man and Salmon was not small. Picasso was every inch a chief.

Though Derain's "defection" to the *bande à Picasso* was the betrayal Matisse felt most deeply, Braque's apostasy would prove far more consequential, the beginning of one of the closest and most creative collaborations in the history of art and one that would knock Matisse, at least temporarily, from his perch atop the leadership of the avant-garde.

Georges Braque was born May 13, 1882, the son of a building contractor and decorator from Argenteuil, a town on the Seine made famous by the Impressionists, whom the young Georges used to watch, spellbound, as they painted scenes of life along the river in veils of sparkling color. He grew up in an atmosphere that valued art but also saw it as a useful trade. His father, Charles, was both a housepainter and an accomplished amateur artist with progressive notions. He was a cofounder of the *Cercle de l'Art Moderne* in Le Havre, the bustling port on the English Channel to which the family moved when Georges was eight. Unlike Picasso, who came to despise Don José's bourgeois pretensions, Braque had a blessedly uncomplicated relationship with both his father and his chosen profession. "I no more made up my mind to become a painter than to go on breathing," he said.

Young Georges, handsome, athletic—he was an avid cyclist and accomplished boxer, as well as a musician and dancer—learned the family business, eventually becoming an apprentice in the decorating firm of Rupalay and Rosney. There he learned the tricks of the trade: how to imitate wood graining by dragging a comb through wet paint; to create trompe l'oeil moldings and mock marble; how to stencil letters for signs. Such skills would prove critical when he applied these eye-deceiving techniques to impart perceptual and conceptual depth to his Cubist collages. Perhaps even more important, this early training gave him a

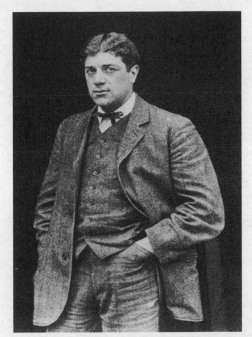

Georges Braque.

profound respect for the materials from which paintings were made, for the grain of canvas and the tactile properties of the pigments themselves. While Picasso would paint on anything with anything, Braque was exquisitely sensitive to texture, mixing sawdust, sand, and even coffee grounds into his pigments to provide a varied surface that was tactile as well as visual.

Reserved, modest, dogged rather than brilliant, he was the opposite of Picasso in almost every way. While Picasso spent his entire career fighting his own virtuosity, Braque, like Cézanne, spent *his* seeking to discover an approach commensurate with a deep but limited talent. Cubism, he confessed, allowed him "above all to put painting within reach of my own gifts."

After completing his military service in 1902, Braque decided to remake himself as a fine rather than a commercial artist. With the support of his family, Braque moved to Montmartre, renting a studio in rue d'Orsel, and enrolled in the independent Académie Humbert on the boulevard de Clichy, where he could pursue his own course without interference. "He always had a beefsteak in his stomach and some money in his pocket,"

complained one of his less fortunate neighbors, who resented his comfortable circumstances and untroubled outlook.

Like Matisse, Braque was an unlikely revolutionary, an apparently bourgeois personality with a stubborn, rebellious streak that showed up only in his art. Since two of his friends from Le Havre, Othon Friesz and Raoul Dufy, had already joined the Fauves, it seemed natural for Braque to do the same, though he was temperamentally unsuited to its wild-man aesthetic. Braque met Matisse in 1906 when the Fauve leader was included in the inaugural exhibit of the *Cercle de l'Art Moderne* in Le Havre, which his father helped organize. Though Matisse seems to have had little interest in his new disciple, Braque was seduced for a time by the heady sense of freedom this new kind of painting promised. In the summer of 1906 Braque and Friesz traveled to Antwerp, where they painted Fauvist canvases side by side.

Braque was a naturally collegial man, able to suppress his own ego in order to progress as an artist. "Braque [was] perpetually in quest of a comrade with whom to work out seductive solutions," observed André Salmon. That fall he headed to the Mediterranean coast, to the town of L'Estaque, made famous by Cézanne, who painted there memorable views of red-roofed buildings and ocher hills tumbling down to an azure sea. Like Matisse and Derain before him, this northerner was initially transfixed by the brilliant hues of the south: "It's there that I felt all the elation, all the joy, welling up inside me. Just imagine, I left the drab, gloomy Paris studios where you were still working in bitumen. There, by contrast, what a revelation, what blossoming!" But one can live on delirium for only so long. "[O]ne became accustomed to it," he remarked. "With time the enchantment faded and it was then that I realized that one had to find something more profound, more lasting."

In the end, Braque realized that Fauvism was not an approach that fit his particular gifts, which were more subdued, more architectonic than coloristic. Still, the shock of Matisse's Dionysian painting had opened his eyes to art's revolutionary potential. It also brought him his first success. Showing his vividly colored scenes from L'Estaque at the Salon des Indépendants of 1907, he came to the attention of Wilhelm Uhde, who purchased five of his canvases, and sparked the interest of a young German dealer named Daniel-Henry Kahnweiler who'd just set up a tiny gallery on

the rue Vignon. "At that moment," Braque said, "I understood that I was a painter. Until then I had not believed it."

But by then Braque was already looking for another mentor, another approach to painting more in keeping with his reserved personality and instinct for order. It was during this moment of doubt that Braque began to seek out the young Spanish painter who lived a few blocks from him on the rue Ravignan. He already knew Picasso by reputation since he'd spent the summer of 1905 in the company of two of his closest friends, the sculptor Manolo and the critic Maurice Raynal, who'd traveled with him to his hometown of Le Havre. He was also acquainted with Apollinaire from Paulette Philippi's opium den on the rue de Douai (which Picasso and Fernande also attended on occasion).*

On the basis of Uhde's recommendation, Picasso had agreed to meet with the young painter, despite the fact that he had grown more reclusive after his return from Gósol. He jotted down two separate notations in the sketchbook he was using at the time: one read, "Write to Braque"; the other, "Braque Friday." Braque visited the Bateau Lavoir at least two times in March 1907, leaving his calling card when he found no one home. On one of them he wrote, "Anticipated memories," words that seem prophetic in light of subsequent events.

Surprisingly, neither of them could remember whether they actually succeeded in getting together during the few weeks Braque was in town. He'd returned to Paris for the Salon but was soon off again, painting in Le Havre and then in the Mediterranean ports of La Ciotat and L'Estaque. Given the momentous consequences of their partnership, it seems as though fate were toying with them, deferring the consummation until precisely the right moment, when each was able to profit from the very different but complementary gifts of the other.

Part of the problem may have been that Braque was intimidated at the thought of making the acquaintance of the formidable Spaniard.

* Kahnweiler says that it was Apollinaire who introduced Braque and Picasso. Perhaps surprisingly given Braque's diffident personality, he was currently having an affair with Paulette, a blond, faded beauty and one of the neighborhood's notorious decadents.

Already a legend in Montmartre, Picasso was surrounded by a posse of accomplished men and had a well-earned reputation for inflicting his biting wit on those he didn't respect. Braque, by contrast, was getting his first taste of success after years of toiling in obscurity. He was diffident, still unsure of himself, looking for another partner with whom he could explore the far reaches of the aesthetic universe. For his part, Picasso was probably intrigued by the possibility of adding another former disciple of Matisse to the Montmartre contingent, but not enough to pursue the matter.

As it turned out, Braque's tentative overtures came at exactly the wrong time. In fact, he was not the only one having trouble connecting with Picasso these days. Over the last few months Picasso had grown increasingly testy and withdrawn. Even Fernande felt the chill. Much to her dismay, the joy of Gósol had evaporated in the gray Parisian winter. Over the summer she had blossomed in the role of her lover's muse, posing for some of his most sensuous and life-affirming paintings, but now she was either ignored or, worse, subject to those jealous rages that were the dark side of his passion.

"Picasso's group became more subdued," she recalled, "and as the intervals between bouts of wild socializing grew longer, our existence became more reclusive. Work was the only thing that really mattered, and it dominated everything." Part of this was provoked by sheer exhaustion; it was the inevitable let-down after an unprecedented burst of creativity. But Picasso's state of mind was certainly not improved by the success of Matisse's *Blue Nude* at the Salon des Indépendants, which showed him just how far he still had to go. André Salmon witnessed the transformation. In the first months of 1907, he said, "[Picasso] experienced anxiety. He turned his canvases to the wall and threw away his paintbrushes."

Picasso's current discontent was far different from those months of despair in the winter of 1902, when he had felt that his career had reached an impasse. This time he was more sure of himself. He was no longer a penniless nobody but a force to be reckoned with in the Parisian avant-garde. After the progress of the past six months, he felt certain he was on the verge of some great discovery. His ill temper was a sign not of depression but of concentration, a withdrawal from the world that signaled

a gathering of all his forces for one supreme effort. His anxiety was the fierce apprehension of an athlete before the big game or an explorer heading out beyond known horizons. "For many long days and nights he did nothing but draw," Salmon recorded. "Never was hard work less rewarded with joy, and it was quite without his usual youthful enthusiasm that Picasso undertook the large canvas that was intended to be the first fruit of his experiments."

Exorcism

All alone in that awful museum, with masks, dolls made by the redskins, dusty manikins. Les Demoiselles d'Avignon must have come to me that very day, but not at all because of the forms; because it was my first exorcism painting—yes absolutely!

—PICASSO TO ANDRÉ MALRAUX

P icasso purchased the large canvas on which he hoped to realize "the first fruit of his experiments" sometime in the early spring of 1907. He was usually rather careless about the quality of his materials, but this time he chose a particularly expensive, fine-grained cotton, one sign of how much he was investing, materially and emotionally, in the project.* For all its primal fury, the painting that would come to be known as *Les Demoiselles d'Avignon* was the most deliberate, the most carefully plotted, of his entire career. [See color insert]

* That would actually prove to be a drawback. The material proved too flimsy for such a large expanse and he had to have it strengthened by adding a lining in back. Leo Stein misinterpreted this practical adjustment as a sign of Picasso's pretentiousness, an indication that "he would have one of his pictures treated like a classic."

Even before picking up his brushes, he began to work out the composition in a number of sketchbooks—they would eventually number sixteen in all—that he filled with hundreds of preparatory drawings. These notebooks contain everything from rapid compositional sketches to precise studies of individual components. So consumed was he by this process that he wrote on one of them, *"Je suis le cahier"* (I am the notebook). Some drawings were tossed off in a few seconds, others were marked by hard labor as he struggled to find exactly the right placement of a contour or the essence of a pose; some represented dead ends, and others are seared by sudden flashes of insight. Since he was evolving an entirely new pictorial language, nothing could be taken for granted. The notebooks chronicle a period of intense struggle, even anguish, and represent the most sustained effort he ever devoted to a single work, perhaps the most exhaustive (and exhausting) exploration any artist ever devoted to a painting of comparable scope.

In the spring of 1907, then, Picasso was setting out very deliberately to create a masterpiece, a work that would cause the world to sit up and take notice, that would vault him ahead of Matisse and into the lead of the avant-garde. The one lesson he had learned from his father and that remained with him throughout his life was to make his mark with a *grande machine*, a canvas whose careful craft and vast dimensions signaled its importance. He clung to that approach despite his disdain for the Salons, the only venues where such show-stopping tours de force really made sense. His latest masterpiece would deploy the grand rhetoric of a public pronouncement while making no concession to the public; it would not speak the comforting language of consensus, but instead embody anarchy and disruption.

There is something paradoxical, even perverse, about the entire enterprise. When at the age of fourteen he had created his earliest "masterpiece," *First Communion*, exhibited at the Exposición de Bellas Artes è Industrias Artísticas in Barcelona, or the following year, when he exhibited the even more ambitious *Science and Charity* in Madrid, Picasso was working within a system in which art was treated as a form of public address: rhetorical, morally uplifting, and a confirmation of the status quo. But even after he had committed himself to the cause of modernism, he continued to embrace the form, if not the substance, of the system. *La Vie*,

for instance, encapsulated the Blue Period, as did the magisterial *Family of Saltimbanques* for the Rose. Each was a salon-sized canvas whose audience consisted only of his fellow rebels in the avant-garde.

This latest chef d'oeuvre would go far beyond those earlier efforts in its attack on the foundations of Western art, as Picasso deployed the enemy's own weapons against him. In works like *Joy of Life*, Matisse had tested canons of beauty, but his paean to hedonistic pleasure expanded without fundamentally threatening a tradition that had grown ossified and unresponsive to new impulses. Matisse, in short, wished to be accepted into the club, not burn it down.

Accommodation was not Picasso's way. More pugnacious than his rival, he intended not to broaden the Western tradition but to destroy it root and branch, creating a work so belligerent, so defiant, that neither side could give up the fight until victory had been won.

Leo and Gertrude Stein put up the money for the rent on a second studio in the Bateau Lavoir, a small, dark room just below Picasso's living quarters that was just large enough to accommodate the painting. Crucially, this second studio assured him the peace he needed to concentrate. It was impossible to conjure up the spirits that now obsessed him with Fernande only inches away, lounging about reading her novels, and with constant interruptions from well-meaning friends, who continued to drop in at all hours of the day and night. As always, Picasso was torn between his need for sociability, to keep up a constant hum that would drown out the demonic voices whispering in his ear, and his recognition that it was precisely these denizens of the deep places who were the source of his creative energy.

Even as he spent his nights plumbing the depths of his troubled soul, the *bande à Picasso* continued to grow. Picasso was now a leading figure in the Parisian avant-garde, and the most creative men and women in Paris were drawn to him. His inner circle included not only the usual Spanish and Catalan cronies, supplemented by the established trio of French poets, but had recently been reinforced by Derain and other defectors from the *bande à Matisse*. Typically, Picasso liked to have his former lovers

around, which added to the volatility of the social arrangements. One frequent guest was Ramon Pichot, accompanied by his wife, Germaine, Casagemas' femme fatale, as well as the mathematician Maurice Princet, who showed up with his wife, Alice Géry, with whom Picasso had conducted a brief affair in 1904. Soon she and Derain would fall madly in love and Princet's jealous rages would add fuel to an already combustible atmosphere. Princet would later exploit his friendship with Picasso to claim his place as the "intellectual" of the movement. Painters like Albert Gleizes and Jean Metzinger, the so-called Salon Cubists, put great stock in Princet's pseudoscientific pontificating, but Picasso scoffed. "All this," he sneered, "has been pure literature, not to say nonsense, which has only succeeded in blinding people with theories."

Others drawn into Picasso's vortex were the progressive critic Maurice Raynal, a friend from the weekly gatherings at the Closerie des Lilas, and the painter André Deniker, who led nighttime expeditions to the Jardin des Plantes, where his father served as librarian, to sketch the animals in the zoo. The ostensible reason for these excursions was for Picasso to gather material to illustrate a bestiary Apollinaire was writing, but when combined with the group's habitual indulgence in opium and other intoxicants, they served to heighten the general "derangement of all the senses" that Rimbaud preached as the key to unlocking the creative potential. "Everything seemed mysterious and terrifying," Fernande recalled of these nocturnal escapades. "At every step I expected to see a wild animal leap out, a ravening beast or a reptile that had been lying await in the bushes."

It seems to have been part of Picasso's compulsion at this time to push the boundaries in his life in order to push the boundaries of his art. That was particularly true in his personal relationships. He liked to stir the pot, to prod, to provoke, to come up with new combinations. Though his *tertulia* was almost exclusively male, a few women were grudgingly admitted into the charmed circle. The most intriguing was Marie Laurencin, a talented painter and friend of Braque from the Académie Humbert, described by their mutual friend Georges Lepape as "bubbly, witty, ironic, caustic, discriminating, unpredictable, and charming."

After stumbling into the quirky, dark-haired exotic at Sagot's gallery in

January 1907, Picasso immediately told Guillaume Apollinaire that he'd just met Apollinaire's future wife. In the short term, Picasso's matchmaking proved effective. In the end, however, his meddling was unfortunate as the relationship devolved into bitter recriminations on both sides. In Apollinaire's autobiographical fable "Le Poète assassiné," Picasso—thinly disguised as the "the Benin Bird"—announces, "I have seen your wife, I tell you, she is ugliness and beauty; she is everything we love today." But, he warns, "She has the somber and childlike face of women destined to make men suffer."

Fernande, for one, was not impressed. "She took a great deal of trouble to appear to be just as simply naive as she actually was," she wrote dismissively. "It was impossible to unravel the real personality, the real intelligence, of this pretentious little person." Still, Braque found her charming and Apollinaire, at least for a time, irresistible. Her two faux-naive paintings, *Group of Artists* (1908) and *Réunion à la Campagne (Apollinaire et Ses Amis)* (1909), are among the most charming mementos from that momentous time. Each of those group portraits included Picasso, Fernande, Apollinaire, and Laurencin herself, along with various minor players. In the end, like so many men and women of talent, Laurencin failed to thrive in that strutting, hypercompetitive world. "If I did not become a cubist painter," she said, "it is because I never could. . . . If I feel so far removed from the painters it is because they are men. . . . Their discussions, their researches, their genius have always astonished me . . . the genius of men intimidates me."

Picasso, as so often in the past, signaled a new phase in his life and in his art by scrutinizing his own features and subjecting them to the kinds of transformations he was engineering in the rest of his art, as if he could validate the changes only by testing how he appeared in this distorting mirror. In *Self-Portrait with Palette* from a few months earlier he had shown himself in the grip of an almost religious ecstasy, "a *bonze*, a simple worshipper of the eternal Buddha," as van Gogh said of his own self-portrait, in which he depicted himself with a similarly shaved head. In the later version the seasons have changed. Instead of the simple white shirt open at the neck and with the sleeves rolled up, Picasso wears a heavy coat;

the close-cropped hair of the summer has grown back, and he sports the familiar fringe of black hair sweeping across his right eye.

But more has changed than the temperature. In the second image, painted in the early spring of 1907, Picasso's wide eyes have grown even wider, black pupils rimmed in black like Egyptian hieroglyphs, the rest of his features drawn schematically in a few slashing lines as if he wished to reduce his face to a cipher, a sign as immediate, but also as distant and inscrutable, as something carved on the walls of an ancient temple. He abandons for the moment the subtle push/pull of solid and void that had characterized the self-portrait of 1906 for an approach that is completely flat, almost calligraphic. Subtlety is banished in order to provide the most direct, unmediated confrontation between the viewer and the image, as in a Byzantine icon.

If the self-portrait of 1906 portrays a man in a state of heightened awareness, that of 1907 suggests a man on the brink of madness. Indeed there were indications that during these months Picasso was under almost unbearable stress. Some of this was a matter of overwork as he struggled to bring his conception to life, but not all of the pressure was directly related to his painting. The personal and the professional had a way of

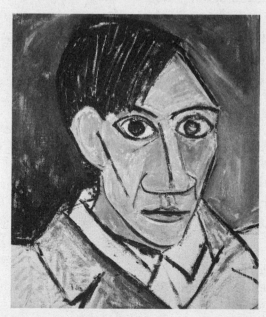

Self-Portrait (1907). *Nimatallah / Art Resource, NY.*

bleeding one into the other, the frustrations and exaltation of the studio shaping his relationships and the psychodrama of his daily life inflecting the forms emerging on the page. One has the sense that during these months Picasso's life was close to running off the rails. He seemed to court danger, as if this might help stimulate his imagination, opening up fissures to the infernal regions that were the key to his inspiration. Even at the best of times he was drawn to unstable types and perilous situations. Now more than ever he needed to feel he was teetering on the edge of the precipice.

The one friend who could be counted on to provide more than his share of mayhem was Guillaume Apollinaire. He was currently in the process of publishing, under a pseudonym, a pornographic novel, *Les Onze Mille Verges* (the eleven thousand virgins), a cruel farce based on the writings of the Marquis de Sade—a work that Picasso, perhaps facetiously, called his masterpiece—and otherwise exploring the far reaches of his own fluid sexuality. In February, Apollinaire renewed his friendship with a young Belgian con man named Géry Pieret, a charming sociopath with a long trail of blackmail and larceny behind him.[*] This "mad, spiritual, intelligent, bohemian," as Fernande described him, was currently serving as Guillaume's secretary, and, despite the fact that Picasso had recently fixed him up with Marie Laurencin, his sometime lover.

On February 27, Apollinaire and Pieret stopped by the Bateau Lavoir studio. "Evening, dinner with Picasso," Guillaume recorded in his diary; "saw his new painting; even colors, pinks of flowers, of flesh, etc., women's heads similar and simple heads of men too. Wonderful language that no literature can do justice to, for our words are preordained. Alas!" This is the earliest reference we have to *Les Demoiselles d'Avignon*, though what Apollinaire must have seen at that time was not the canvas itself, which had yet to be started, but one of the preliminary studies. Even in this rudimentary form, however, it was clear to Apollinaire that Picasso was seeking something so new as to defy language itself.

[*] According to one account, Apollinaire had picked up Pieret on one of his late-night prowls of Paris' seedier districts. Pieret, Apollinaire, and Marie Laurencin all had a taste for sadomasochistic sex.

At the time Picasso was still in thrall to the brute power of the Iberian sculptures he'd seen the previous year in the Louvre. Though he was usually careful to conceal the sources of his inspiration, on this occasion he must have discussed his passion with his guests, a conversation that apparently inspired Pieret to attempt some grand gesture that would elicit admiring gasps from his new friends. He pursued a life of crime, he explained, not for personal gain (for that he relied on friends like Guillaume, who were constantly called upon to get him out of his latest scrape) but "to accomplish something rare and difficult, which required courage, psychological acumen, imagination and the strength of mind to kill if need be or to jump from a third story." This was a vulgarization of the fashionable Nietzschean philosophy of the Superman to which Picasso and many of his bohemian colleagues subscribed. Whether or not Picasso suspected what Pieret was capable of, he was hardly the innocent dupe he later pretended to be.

Sometime in early March, Pieret walked into the Louvre in a heavy overcoat, making his way to what was then referred to as the Gallery of Phoenician Antiquities:

> Being absolutely alone [he later confessed] and hearing no sounds whatever, I took the time to examine some fifty heads that were there, and I chose one of a woman with, as I recall, conical forms on each side. I put the statue under my arm, pulled up the collar of my overcoat with my left hand, and calmly walked out, asking my way of the guard, who was still completely motionless.
>
> I sold the statue to a Parisian painter friend of mine. He gave me a little money—fifty francs I think, which I lost the same night in a billiard parlor. What of it, I said to myself. All Phoenicia is there for the taking.

That friend, of course, was Picasso. The story came to light only four years later, when, in a bid for publicity, Pieret implicated himself in the far more spectacular theft of the *Mona Lisa*. That immediately threw suspicion on his friend Apollinaire and on *his* friend Picasso. It was only then, with the law closing in, that Picasso tried to rid himself of the stolen property, concocting a half-baked scheme with Apollinaire to toss

the statues, which he'd concealed in a suitcase, into the Seine. In the end, the two would-be desperados lost their nerve, reduced to "scared, contrite children," as Fernande described them. "They had wandered about without finding the right moment or simply lacked the courage to unload the package. They thought they were being followed. Their imaginations dreamed up a thousand possibilities, each one more fantastic than the last." Ultimately they hit upon a less desperate expedient, contacting André Salmon, who arranged the return of the statues anonymously through the magazine *Paris-Journal*.*

In 1907, however, Picasso was delighted with his new acquisitions, studying them closely before squirreling them away in the back of a cupboard. As always, he was less interested in the way the sculptures looked than in their aura, the sense that they were connected to some deep current from the dawn of time. That aura was only magnified by their dubious provenance. Like all magic charms, their power was enhanced rather than diminished by being hidden away where no one could see them.

If trafficking in stolen goods excited Picasso, contributing to his own sense of himself as outside the law, another incident, infinitely more painful, helped create the mood of psychological dislocation from which his masterpiece emerged.

That spring Fernande talked Picasso into letting her adopt a child from a local orphanage. Many years earlier she had suffered a miscarriage

* The so-called *Affaire des Statuettes* created a sensation in 1911. In the end it was Apollinaire who suffered the most. While Pieret fled the country, Apollinaire was arrested on suspicion of complicity in the *Mona Lisa* theft and held in prison for a number of days. When questioned by the authorities, Picasso not only denied any knowledge of the theft but even denied knowing Apollinaire at all, a betrayal that soured their friendship for a number of years. As it turned out, neither Pieret nor Apollinaire (or Picasso) had anything to do with the theft of the *Mona Lisa*. It was taken by an Italian named Vincenzo Peruggia, who was angry that that piece of his national patrimony was residing in a French museum.

that left her unable to bear children of her own, a misfortune that cast a pall on her life and put limits on relations with her lover. For a man brought up in a patriarchal culture, the notion that he would attach himself permanently to someone who could not supply him with heirs was unthinkable. Perhaps she thought that a child in their life would bring them closer together, or perhaps she simply wanted a companion during the long, lonely hours when Picasso shut himself away in his studio. The glow from the summer in Spain had long since faded, and she was already beginning to feel the pain—suffered by most of her successors—of tumbling off the pedestal to be trodden underfoot.

Picasso reluctantly agreed to her ill-conceived plan, believing, perhaps, that a child would occupy Fernande, a woman for whom he could now spare little time or thought. Motherhood would allow her to channel her energies in ways that would leave him more time to himself.

For Picasso fatherhood would always prove a mixed blessing. He genuinely liked little children and enjoyed playing with them, showing an instinctive understanding of their world. Dolly, the daughter of his neighbor in the Bateau Lavoir, the Fauve painter Kees van Dongen, was one of his favorites and often romped about the studio calling for the man she called "Tablo." Something of an overgrown child himself, he had an ability rare in an adult to capture a child's sense of play. This is one of the keys to his artistic genius. Some of his most delightful works were based on children's toys, cobbled together with a sense of whimsy that, like much of the best children's literature, contained strong elements of the uncanny.

But Picasso treated children like he treated his many pets—as entertaining playthings, subservient to his will, whom he could banish whenever he had more important things to do. The full-time responsibility of caring for a child, particularly in the close quarters of a squalid Montmartre tenement, was more than he—or Fernande, for that matter—was prepared to deal with.

On April 9, 1907, Fernande and Picasso made their way to the orphanage on rue Caulaincourt at the foot of the Butte, where the mother superior told them they could take their pick of the young girls there. The girl they chose, Raymonde, was about thirteen, "intelligent and poor,

sensuous and gentle." She was the daughter of a Tunisian prostitute, taken in by foster parents and then abandoned a second time after she failed to live up to their unrealistic expectations.* Picasso and Fernande offered a final chance at a stable home life for a girl who had known little love and little happiness.

Like Raymonde, Fernande had suffered through a neglected and unhappy childhood, and she lavished all her frustrated affection on the girl, spending hours putting ribbons in her hair and dressing her up in frilly clothes. Picasso played the role of doting father, at least for a while, making charming little drawings and helping her with her homework. But the experiment was doomed from the start. Fernande's attentions had an element of overcompensation, while Picasso's feelings soon veered dangerously far from the paternal. A quick sketch titled *Raymonde Examining Her Foot* is disturbingly revealing as she spreads her legs to his devouring gaze, and a list of spelling words scrawled in Raymonde's hand in one of the notebooks also hints at painful cross-currents: *"Fernande/Raymonde/ Pableaux/Mimiche/rouquin/asphyxie."* (Fernande/Raymonde/Pableaux/ tit/redhead/asphyxia.)

There's no indication that Picasso ever abused Raymonde, but it's clear that she aroused feelings in him that might have led to disaster. His attraction to adolescent girls, at least later in life, is well documented, and if Raymonde was younger than those lovers, the difference amounted to only a year or two.† Tensions were exacerbated by the fact that there was almost no privacy in the cramped studio; on more than one occasion

* Much of our information about this sad interlude comes from André Salmon's autobiographical novel *La Négresse du Sacré-Coeur.* In the novel Raymonde is called Léontine, while Picasso is the painter named Sorgue.

† Fernande had reason to be wary. She had left her former lover, Gaston de Labaume, after discovering him in bed with an underage model and had earlier escaped from an abusive relationship. It's also true that turn-of-the-century Parisians took a much more lenient view of such matters than we do now. The exploitation of both women and girls was commonplace, particularly in the poorer neighborhoods, where they were forced into desperate expedients.

Fernande kicked Picasso out of the room while Raymonde tried on the new underwear Fernande had bought her. Despite her initial hope that a child would bring them together, it soon became clear that Raymonde's presence in their life was putting unbearable strains on an already strained situation.

After four fraught months, the crucial period of gestation for *Les Demoiselles d'Avignon*, Fernande decided to terminate the experiment. Abandoned once more, Raymonde packed up her dolls and clothes and, escorted by Max Jacob, made her way back to the orphanage on the rue Caulaincourt. Significantly, Fernande fails to mention this painful episode in either of her two memoirs. Nor, indeed, does she make any mention of the epochal painting whose birth she witnessed, as if that, too, was an episode so painful that it was better to simply ignore it. Her silence on both matters suggests that the two were linked, at least in her own mind. For Picasso, this excruciating melodrama helped create the fevered conditions that made *Les Demoiselles d'Avignon* possible, shaping a narrative of illicit desire and repulsion, love and rage, jealousy and betrayal.

The origins of this epochal painting, "the incandescent crater from which emerged the fire of present art," as André Salmon described it, actually lie in a happier time, the first glimmers appearing at the end of the Dionysian summer when Picasso and Fernande had enjoyed a period of unclouded bliss in Gósol. There he had portrayed his lover as an indolent goddess, as Venus admiring her own reflection, as an odalisque primping in the sultan's bedchamber, as a young peasant girl proffering the fruits of a bounteous harvest. Her classic features and voluptuous body evoke sensual and emotional contentment; she is both mother and lover, the incarnation of fullness, of plenty.

But it never took long for Picasso's lovers to go from goddess to doormat. Sooner or later the flame of desire would peter out, leaving only the ash of contempt. Love and hate were the same thing viewed from a slightly different point of view or at a slightly different time. Elevated to a cosmic principle, this suggested that effulgent life must share the world with ravening death. Indeed, the dynamic interplay between the constructive and

destructive principles, Freud's Eros and Thanatos, was the key to Picasso's creativity. An urge to build up, but even more to tear down, drove his protean inventiveness. "In my case," he said, "a picture is a sum of destructions." One impulse or the other could be suppressed for a while, but it always returned, often in more ferocious form and usually in response to the ecstatic beginning or painful end of a sexual relationship.

Picasso was in a buoyant frame of mind when he first began to contemplate the great painting that would answer the challenge posed by Matisse's magisterial *Joy of Life*. During the final weeks of his stay in Gósol he sketched out a composition based on Ingres' *The Turkish Bath*—the odd, unresolved painting known as *The Harem*, in which all the nudes are variations on Fernande. Picasso made another gouache, *Three Nudes*, a few weeks later, updating the exotic theme by transforming the sultan's bedchamber into a modern-day whorehouse. Though this particular composition went nowhere, it was the germ that would eventually bear fruit in Picasso's disruptive, transformative canvas.

Even before Picasso unleashed *Les Demoiselles d'Avignon* on an unsuspecting world, the brothel was perhaps *the* paradigmatic subject of modern art. Many of the early modernists had already tackled the theme, from Manet (whose *Olympia* was obviously meant to be a courtesan) to Degas, Toulouse-Lautrec, and Steinlen, all of whom discovered in its tawdry appeal the means to distinguish themselves from the Salon hacks peddling erotica disguised as high-toned allegory or ancient myth. What shocked the public about *Olympia* was not its explicit sexuality—after all, it's far less erotic than Alexandre Cabanel's *The Birth of Venus*, which was deemed perfectly acceptable—but the fact that Manet replaced the coy, flirtatious goddess with the frank, knowing professional who brashly confronts the viewer and thus implicates him in the sordid transaction.

For Baudelaire, whose essay "The Painter of Modern Life" (1863) was one of the early manifestos of the modernist movement, the whore was the emblematic figure of the age,

> the perfect image of the savagery that lurks in the midst of civilization. She has her own sort of beauty, which comes to her from Evil

always devoid of spirituality, but sometimes tinged with a weariness which imitates true melancholy. . . . In a foggy, gilded chaos, whose very existence is unsuspected by the chaste and the poor, we assist at the Dervish dances of the macabre nymphs and living dolls whose childish eyes betray a sinister glitter.

The whore might be physically and morally repulsive, but she possesses the beauty that can come only from truth.

What makes the brothel such a distinctly modern subject is not sexuality per se, which is a theme, after all, as old as art itself, but the fact that it is the site where this basic human drive is reduced to just another commodity. In the whorehouse sexuality can no longer be shrouded in romantic pieties but is revealed as simply another transaction among the many that characterize contemporary life. Manet, Degas, and Toulouse-Lautrec turn the same dispassionate eyes on whores and whorehouses as they do on cafés, racetracks, and crowded boulevards. They don't judge; they don't moralize. In an age of capitalist triumph, they imply, even the most profound human passions are reduced to an exchange of cash for services rendered. Artists in particular identified with the whore's predicament. Like them, they were forced to sell what was most intimate on the open market, putting a price on the sacred stuff of life and exchanging transcendence for a few greasy francs.

Picasso's initial conception was in some ways a reversal of that modernist vision, a return to the discredited allegorical mode favored by the École des Beaux-Arts. Despite his familiarity with whorehouses, he doesn't treat his subject with the objective eye of Degas or Toulouse-Lautrec, who focused on hard-bitten working girls and conjured an atmosphere of dispiriting boredom. In fact, Picasso had little use for the kind of just-the-facts reportage that animated many of the early modernists, from Courbet and Daumier to the Impressionists. By taking up Baudelaire's challenge, he was setting up a deliberate contrast, proposing an alternate version of modernism that would not simply substitute a cramped naturalism for the tired formulas of the Academy. His bordello scene would have all the metaphysical ambition of a Salon set piece while delivering its message in a language that was completely

new: iconoclastic rather than conventional; radical rather than conservative; subversive rather than reassuring. *His* whorehouse was not set in Barcelona, Paris, or even Avignon. It was not even a whorehouse in the normal sense of the word. Instead, it was to be the great battlefield of the human soul, an Armageddon of lust and loathing but also of liberation, the site where our conflicted nature reveals itself in all its anarchic violence.

As it turned out, the process of giving birth to a modernist masterpiece proved more difficult than Picasso had anticipated, pushing him to the limits of his physical and emotional endurance and cutting him off from friends who had little comprehension of what he was doing. It consumed him for more than eight months, months of unremitting labor, personal hardship, and spiritual anguish.* "Yes, I was alone," he remembered, "very much alone." Working mostly at night in the cramped, filthy, ill-lit studio, this man, who thrived on conviviality, was forced to become a solitary pilgrim to a goal he could not see and could barely even imagine. "[A]rtist friends began to distance themselves," Salmon tells us, revealing the disquiet the strange new picture evoked in even the most shock-proof audience. "[T]he human image seemed to us so inhuman . . . the monsters of his imagination put us in despair." For weeks on end, these

* Establishing a chronology for the evolution of *Les Demoiselles d'Avignon* is notoriously difficult, since Picasso was secretive—never more than about his most revolutionary work—and firsthand accounts are conflicting. He was unsystematic, picking up whatever sketchbook happened to be near at hand and filling up any available surface with his latest thoughts. The first tentative sketches for the composition probably date to the very end of 1906 or the first weeks of 1907. He spent the winter and early spring of 1907 working out the composition in the notebooks and began painting on the canvas itself only in mid- to late spring. The process of actual painting seems to have taken place in two main campaigns in the spring and summer of that year. The painting would receive its final form by late summer 1907. Many crucial dates, such as his visit—or, more likely, visits—to the Trocadéro Museum remain speculative.

"monsters" were practically Picasso's only companions as his friends fled and his domestic life spiraled downward.

One can follow his struggle in the many sketchbooks that chronicle both the creative fecundity and confusion of those months. If in retrospect the destination seems preordained, the record of the journey shows that it was anything but. Time and again he would set out boldly in directions that would turn out to be frustrating detours, forcing him to double back and start over. His notebooks show multiple cul de sacs and blind alleys, with only occasional moments of clarity as the mists clear for an instant and the panorama lies spread out before him. Like the *Portrait of Gertrude Stein*, labored over for unrewarding months and then finally resolved in a sudden epiphany, many of the most revolutionary elements can be found nowhere in the notebooks but were set down in a flash of inspiration on the canvas itself.

Early sketches show that Picasso conceived his whorehouse not only allegorically but in surprisingly pious tones. Unable to free himself entirely from nineteenth-century modes and his own academic training, he relied at first on time-tested props to give his painting the required conceptual weight. In addition to the whores themselves, most early studies include a medical student—sometimes holding a skull, sometimes a book, but in each case an emblem of the wages of sin and the link between sex and disease—and a sailor. This is the traditional theme of the *vanitas* or *memento mori*, a reminder that flesh is subject to corruption; it addresses as well the ancient dichotomy between the intellectual life (the medical student) and the sensual life (the sailor).

As he labored over the composition, he slowly purged it of these overt narrative and moralistic elements, though not entirely of its Symbolist overtones: woman as both temptress and destroyer was a common Symbolist theme and one that was too central to Picasso's own psychology for him ever to abandon. The medical student was first to go, and then the sailor, so that instead of seven figures of both sexes we are left with five, all of them female.* In Picasso's original conception most of the figures

* The medical student entering on the left changed genders and became another prostitute, while the seated figure adjacent to her was removed altogether.

turn to watch the entering student; in the final version they face outward, replacing a self-sufficient narrative with one in which we, the viewers, are required to complete its meaning. The whores display themselves for *us*, both alluring and horrifying at the same time; they fix *us* in their accusatory stare, creating, in Leo Steinberg's memorable phrase, "the startled consciousness of a viewer who sees himself seen." Here Picasso adopts the strategy Manet deployed to such disconcerting effect in masterpieces like *Olympia* and *A Bar at the Folies-Bergère*, though now the confrontation between the female protagonist and us, the presumably male client, is even more problematic.[*]

At the same time Picasso changed the orientation of the painting, opting for an almost square (even slightly vertical) format to replace the horizontal one that had suited his original conception. While the horizontal format permitted the figures to interact with one another, the square format squeezes them outward, into our space.[†] This crucial change happened sometime in early spring, when Picasso cut the canvas to size and set it up in the small, dark studio beneath the living quarters where he, Fernande, and now Raymonde slept and ate their meals. The lateral compression creates a feeling of claustrophobia, of unbearable stresses

[*] No doubt Picasso also had, somewhere in the back of his mind, the masterpiece by Diego Velázquez *Las Meninas*, which he knew well from his days prowling the Prado Museum. Picasso was fascinated by that painting, in which the figures also turn to confront the viewer. He painted numerous variations on this famous composition.

[†] The transformation reverses the trend of late medieval painting in which the square, "iconic" format gave way to the horizontal, discursive narrative type associated with the Renaissance. (See, e.g., Sixten Ringbom *Icon to Narrative: The Rise of the Dramatic Close-Up in Fifteenth-Century Devotional Painting*.) The inspiration for this change in format may well have been an opportunity to study up close a masterpiece by El Greco that had recently come into the possession of a friend and neighbor in Montmartre, the academic painter Ignacio Zuloaga. Known at the time as *The Opening of the Fifth Seal*, it owed its unusual, nearly square dimensions to the fact that over the centuries it had been cut down from a larger altarpiece. And, in fact, *Les Demoiselles d'Avignon* (at 96 x 92 inches) is almost exactly the same size as the El Greco (88.5 x 78.5 inches).

building up as walls close in. In the final version narrative is suppressed but not erased; the student with his skull and book, the sailor with animal lusts are no longer visible, but they are very much present. Like it or not, it is we who have taken on their roles, forced to confront these vampires unarmed, transfixed by their Medusa stare.

When Picasso first explored the theme of prostitution, during his Blue Period, sex was the furthest thing from his mind. In these melancholy works he transformed the syphilitic denizens of Saint-Lazare into long-suffering Madonnas, ascetic, ennobled, chaste. *Les Demoiselles d'Avignon*, by contrast, is all about sex. The whores he summons for his modernist masterpiece are Baudelaire's "macabre nymphs" and more: sluts, harridans, harpies, ravening, devouring, heroic in scale and shameless in stance, unapologetic, unabashed, fearsome but unafraid. Like their Blue Period sisters they stand as archetypes but no longer models of self-abnegation. They are creatures much more to Picasso's taste and closer to his heart, vessels of cruelty, loathing, and unbridled libido. If in those earlier canvases Picasso hewed to a conventional image of womanhood, now he felt liberated, even compelled, to transgress, since only transgression would take him where he needed to go.

Les Demoiselles d'Avignon is the first painting in which Picasso seems truly himself. If he later dismissed his Blue and Rose period paintings as mere sentimentality, this was long after he learned how success could be achieved by launching a sustained attack on decorum. The fact is that he had been holding back. Even such early masterpieces as *La Vie* and *Family of Saltimbanques* suffer from a kind of false consciousness. One senses that he was trying to make the paintings others expected of him. With *Les Demoiselles*, the scatological, irreverent side of his personality—which had always been there, lurking in the margins of his notebooks, bursting forth in crude jokes and in his taste for low dives—now becomes central to his artistic persona. *Les Demoiselles* marks the moment when the censors he'd deployed to check his basest instincts pack it up and go home, leaving the unshackled id triumphant.

In one sense it's the son's ultimate revenge on his father. Don José, like many of his peers (and just like his son), was a habitué of bordellos.

Lewd in private life, he was prim and proper in public. Such hypocrisy infuriated Picasso. It was not so much a moral failing as it was a failure of artistic courage that led to aesthetic sterility. "Art is never chaste," he said long after he'd achieved unprecedented fame as an aesthetic bomb thrower. "Yes, art is dangerous. And, if it's chaste, it isn't art." For Picasso, the whore, least chaste of women, was the vehicle for aesthetic subversion and social revolution. *Les Demoiselles* was the pictorial equivalent of Alfred Jarry's *Ubu Roi*, which began with a shouted obscenity and ended in riot.

The fact is that he was somewhat late to the game. Matisse's boldness gave Picasso license to explore the darker reaches of his psyche. He had spent too much time suppressing his own delinquent nature, only to find himself leapfrogged by a painter in spectacles and tweed jacket. Behaving himself had decidedly not paid off. Now he was determined to turn his back on those long-suffering Madonnas who embodied self-denial; he would also disavow those ethereal dreamers of the Rose Period who seemed even less creatures of flesh and blood. Matisse's sensuous nymphs cavorting in sylvan glades were too well adjusted to suit his darker nature, and though the galumphing nudes he painted in the latter part of 1906 were nobody's idea of grace or beauty, they only hinted at a savagery yet to come. When Picasso finally found his muse she was a figure drawn from the shadowy caverns of the night, lascivious, malevolent, and disruptive.

Les Demoiselles is a cathartic painting, a great cry of lust, anger, anguish, and release—a form of black magic in which Picasso summons his demons in order to vanquish them. As he explained to André Malraux, "If we give spirits a form, we become independent." Picasso had a rare ability to harness not only desire but pain in the service of his art, as when he latched on to his grief over Casagemas' suicide to propel the breakthrough of his Blue Period. Indeed, he often seemed to court disaster as a means of goading his creativity. Now it was his deteriorating relationship with Fernande that fed the frenzy of rage and dread that shaped *Les Demoiselles*.

Unlike the rest of his paintings, which were propped up against the walls of his studio, *Les Demoiselles* remained largely inaccessible. Wrestling

with his tormentors in the lonely hours of the night, Picasso shut himself off from the usual give-and-take with his poet and painter friends. Dealers like Sagot and Vollard occasionally stopped by to scoop up the more marketable works, and Shchukin continued to purchase canvases to ship them off to his palace in Moscow. Even Matisse offered his advice, whether Picasso wanted it or not, as the two men established a routine of visiting each other's studios.

But with *Les Demoiselles d'Avignon* Picasso knew he was going where few were willing to follow. As Salmon noted, he was not only obsessed but uncertain. Picasso's confidence was shaken, his famous facility stymied by the insuperable problems he set for himself. "In early 1907," Wilhelm Uhde recalled, "I received a desperate note from Picasso asking me to come see him at once. He was troubled about the new work; Vollard and Fénéon* had paid him a visit but left without understanding a thing." Even Uhde himself, usually so open-minded, was initially lost. "Weeks would go by," he admitted "before I realized what had prompted Picasso to take this new approach."

Picasso received no more sympathy from his fellow painters. "Derain told me himself," said Kahnweiler, "that one day we would find that Picasso had hanged himself behind his great picture, so desperate did this enterprise seem." Incomprehension and outright hostility would be the almost universal reaction in those early days in the life of *Les Demoiselles.* "The regulars at the strange studio on the rue Ravignan, who had put their trust in the young master, were generally disappointed when he allowed them to assess the first state of his new work," Salmon remembered. Kahnweiler himself spoke of a "spiritual solitude . . . truly terrifying."

Still, Picasso continued to reach out, hoping for a sympathetic eye and a glimmer of understanding. On April 27, he sent a postcard to Leo and Gertrude Stein: "My dear friends, would you like to come tomorrow, Sunday, to see the painting?" There was little reason expect that the

* The anarchist journalist Félix Fénéon was one of the most perceptive and influential figures in the Parisian avant-garde. He had been a friend and promoter of Georges Seurat; now he was serving as the head of modern art for Bernheim-Jeune, where he would sign Henri Matisse to a contract.

Americans would prove any more perceptive than Vollard and Fénéon, but since they were paying the rent on the studio he had to at least try to coax them along.

This overture was no more successful than any of the others. In fact, Leo Stein "brayed" with laughter upon first viewing the painting. Later he would go on to describe it as a "horrible mess." His dislike of *Les Demoiselles* was the beginning of his disenchantment with Picasso and with modern art in general. Gertrude would eventually come around to Cubism, but even she never showed any inclination to acquire this work, which seemed to break every rule.

We can still get a good idea of how the painting looked to early visitors by focusing on the second and third figures from the left, who retain the "Iberian" form of his original conception. These figures, in contrast to the one entering from the left and their two companions on the right—the most radically distorted and the ones that give the painting its distinctive ferocity—build on the direction pursued throughout the second half of 1906 and that culminated in the masklike face of the Gertrude Stein portrait. Streamlined and rendered with a renewed linear assurance, these figures are schematic rather than contorted, cartoonlike but not yet grotesque. Fénéon picked up on this aspect, telling Picasso, "You ought to do caricatures," an intended put-down that the artist admitted contained a grain of truth. Caricature—as Picasso knew well, being an expert practitioner who used his skills to poke fun at his friends and skewer his enemies—was the art of simplification and exaggeration, approaches that could be used to shock as well as to mock.

This aspect of the work was less disturbing than the bizarre space the creatures inhabit, an Alice-in-Wonderland interior in which two and three dimensions have been jumbled together. In one sense this merely continues a trend as old as modernism, in which the perspectival space perfected in the Renaissance was giving way to a renewed emphasis on the integrity of the picture plane. This "iconic" mode—typical of medieval altarpieces and stained-glass windows and taken up by artists like Gauguin and Matisse to give their works a naive immediacy—was characteristic as well of Picasso's Blue Period canvases. But in *Les Demoiselles* Picasso has revolutionized this ancient pictorial mode, squeezing the maximum amount of back-and-forth agitation into the smallest available space. The

tools invented five centuries earlier for creating a convincing illusion are not discarded but deployed in a deliberately disruptive way. A comparison between *Les Demoiselles* and Matisse's nearly contemporary *Portrait of Marguerite* (the painting Picasso acquired in exchange for his own *Pitcher, Bowl and Lemon*) is instructive. Matisse, adopting the naive vision of the child, paints an image that is almost completely flat; the only concession he makes to a third dimension is to show Marguerite's nose in profile, an inconsistency typical of both archaic art and children's drawings that provides a more conceptually satisfying, more complete, understanding of form than is possible from any single point of view.

But how much more disorienting is Picasso's approach! Instead of presenting his whores with the frozen majesty of a Gothic *Madonna and Saints*, he introduces multiple and mutually contradictory perspectives as if they had been carved, Mount Rushmore–like, onto a faceted cliff face, one moreover, experiencing seismic disturbance. Planes overlap and interpenetrate, tilting this way and that in vertiginous cascades. It's impossible to determine what is in front and what lies behind; shading is not only inconsistent but paradoxical, so that forms seem to protrude and recede simultaneously. The second figure from the left, whose pose ultimately derives from Michelangelo's *Dying Slave*, tucks her leg beneath her in such a way as to undercut any notion that she is actually standing. The only way to make sense of this figure is to assume she is reclining, thus introducing a perspective completely at odds with the rest of the painting. The curtain, which shifts position and even color as it slithers across the surface of the canvas like a Chinese dragon, highlights this game of penetration and projection, inside and out, forward and back. Void is as palpable as solid; figure and ground become part of a single, accordionlike membrane.

Perhaps the most radical passage in this regard is his treatment of the torso belonging to the figure parting the curtain on the right. Picasso renders her chest as a diamond shape perplexingly shaded on one side. Neither fully two- nor three-dimensional, she steps forward aggressively while simultaneously dematerializing before our eyes. The sexual come-on of the whore's bared breasts has been denied us by rendering soft flesh as angular geometry, swelling concavity as ambiguous convexity.

The women themselves may be singularly unsexy, but the rhythmic push and pull to which space is subjected diffuses the erotic charge across

the entire surface of the canvas—an instance of what Freud would term polymorphous perversity, i.e., the childish impulse to seek gratification in all sensation. The seduction/repulsion that is the thematic heart of the painting encompasses not only the whores but the world they inhabit, every square of which seems to be simultaneously tilting forward and back. Picasso offers up a lingering perceptual tease that arouses and frustrates in equal measure. Spatial compression replicates tumescence, a swelling outward, creating an experience more haptic than visual; everything is put within reach of our greedy hands, while at the same time eluding our grasp. The possessive sense of touch has replaced the dispassionate sense of sight as the primary means of apprehending the world, as if Picasso were seeking (paradoxically) a kind of Braille for the eyeballs. The age-old identification of looking with violation has been made almost literal, though now the ogled turn the tables on the oglers, spearing us with their gimlet stares.*

The dissection of the human figure and the destruction of perspectival space were both strategies to increase the immediacy of these grotesque apparitions, who are not so much depicted as they are extruded, caught in the very act of stepping out of the demon-haunted world and into our own. All of this thrusting urgency comes to a point at the bottom of the canvas. This is the portion of the scene that presumably projects farthest into our space, a kind of way station between *here* and *there.* At this critical juncture Picasso places a table to serve as fulcrum or perceptual pivot. Precariously perched on the canted surface are a wedge of melon, grapes, and peaches, carnal temptations that invite us to imagine the greater pleasures—and greater dangers—that lie beyond.

But like everything else in this topsy-turvy world, what is proffered is also withheld; what appears easiest to grasp—the most "realistic" portion of the painting—also proves the most treacherous. Picasso's little still life is a pun on the Christian mythology of forbidden fruit; it is Eve's apple

* The inherent voyeurism of the artist's gaze has made such scenes perennially popular. One need only think of Rembrandt's famous painting *Susanna and the Elders* and the many changes Picasso himself rang on the theme of the artist and his model, ranging from the tender to the frankly violent.

served up for our delectation and our edification. The unease engendered by this spatial ambiguity is reinforced by the sinister forms of the fruit themselves, the baited promise of the grapes and peaches impaled on the scythe blade of the melon wedge. If we are tempted to reach for these succulent morsels, we'd better watch our fingers!

The painting as a whole embodies paradox: it is both in your face and intangible, belligerent and evasive, like a boxer who bobs and weaves in order to pummel his more lead-footed opponent. Picasso's radical approach to space, which builds on Cézanne's "anxiety" and pumps it up to the level of existential crisis, paves the way for the temporal and spatial displacements that he will explore with Georges Braque over the next few years. Whether or not *Les Demoiselles d'Avignon* was in fact "the beginning of Cubism," as Kahnweiler (and many others) insisted, in this one area, at least, it provided the essential road map for those later explorations, offering a revolutionary alternative to both the iconic flatness of archaic art and the one-point perspective that had dominated Western art since the Renaissance.

Ultimately, *Les Demoiselles* is too desperate, too restless, too multivalent, to serve as the manifesto of any movement, even one as notoriously slippery as Cubism. It won't wear any label comfortably, since discomfort—the anarchic, barrier-destroying fury of our most basic instincts—may be said to be its true subject. As surely as it spawned the cerebral investigations of Cubism, it was also father to a no-holds-barred expressionism that eschewed intellectuality, even objectivity itself, in order to give full vent to the urgent promptings of the id. On its fractured surface one can discover the origins of the geometric abstraction pioneered by artists like Kazimir Malevich and Piet Mondrian, as well as the paranoid dreamscapes of Salvador Dalí and the Surrealists.

Given the almost universal incomprehension with which the earlier version of *Les Demoiselles* was met, Picasso might have been expected to return to his painting in a chastened mood. But rather than pull his punches, he lashed out. If people found his figures monstrous, he would subject them to even greater contortions; if they complained of incomprehensible spatial confusion, he would add multiple layers of visual paradox.

Here for the first time we encounter the Picasso of history, willful, pugnacious, fearless, defiant. Kahnweiler spoke of his "incredible heroism," but it was the heroism of a wounded animal raging at the world, a Samson willing to bring the temple crashing down around him.

For all the dismay expressed by even his closest associates, the painting that visitors to the Bateau Lavoir saw in the early spring of 1907 was far more sedate, more conventional, than the one that now hangs on the walls of the Museum of Modern Art in New York. The work we see today was the product of a final, furious campaign that Picasso conducted in late June or early July, over the course of which he repainted at least two of the five figures in a style without precedent in the Western tradition and in a form so novel, so aggressively defiant of any canons of beauty or proportion, that more than a century later they still give off a malevolent energy.*

The two most startling figures in the painting, the "curtain raiser" who enters from the right and her squatting companion just below, were transformed at some point after Picasso had put aside the canvas for weeks or perhaps months, discontented, depressed, wondering whether he would ever be able to complete the work into which he'd sunk so much of his time, energy, and burning ambition. In these two figures he has upped the ante, deliberately shattering the unity of the painting. X-rays show that before being subjected to the bizarre makeover we see today, they resembled the two "Iberian" figures at the center. Following this last-minute intervention they looked nothing like their companions; they belong to a different species entirely, intruders from an alien world.

What intervened between the first campaign and the final version, transforming the distorted yet still coherent nudes of the spring into the leering, disjointed she-devils of the summer? "The large canvas with

* The figure entering on the left, who replaced the medical student in the original composition, was also repainted some time after the initial campaign. In some ways the most enigmatic figure, she is darker than her companions and rendered in a more painterly style. She seems in many ways to be a tribute to Gauguin's particular brand of primitivism. Her incongruity adds another layer of uncertainty to this already uncertain scene.

African mask. © *RMN-Grand Palais / Art Resource, NY.*

the severe figures and no lighting did not long remain in its first state," recorded André Salmon, who had a front-row seat to the drama. "Soon Picasso attacked the faces, most of whose noses were rendered from the front, in the form of isosceles triangles. The sorcerer's apprentice continued to consult the Oceanic and African enchanters."

Picasso himself recalled his revelatory encounter with these "enchanters" in the dusty basement of the old ethnographic museum in Paris:

When I went to the old Trocadero,* it was disgusting. The Flea Market. The smell. I was all alone. I wanted to get away. But I didn't

* This ethnological and anthropological museum, now called the Musée de l'Homme (Museum of Mankind), is located on the Right Bank in Paris, across the river from the Eiffel Tower. Visitors can still see some of the masks that inspired Picasso in 1907.

leave. I stayed. I stayed. I understood that it was very important: something was happening to me, right?

The masks weren't just like any other pieces of sculpture. Not at all. They were magic things. But why weren't the Egyptian pieces or the Chaldean? We hadn't realized it. Those were primitives, not magic things. The Negro pieces were *intercesseurs*, mediators; ever since then I've known the word in French. They were against everything. . . . I too believe that everything is unknown, that everything is an enemy! Everything! . . . I understood what the Negroes used their sculpture for. Why sculpt like that and not some other way? After all, they weren't Cubists! Since Cubism didn't exist. . . . But all the fetishes were used for the same thing. They were weapons. To help people avoid coming under the influence of spirits again, to help them become independent. They're tools. If we give spirits a form, we become independent. . . . I understood why I was a painter. All alone in that awful museum, with masks, dolls made by the redskins, dusty manikins. *Les Demoiselles d'Avignon* must have come to me that very day, but not at all because of the forms; because it was my first exorcism painting—yes absolutely!

Picasso's testimony, then, confirms the crucial role African art played in the evolution of *Les Demoiselles d'Avignon*. The significance of that visit would not have been questioned at all but for the fact that at various times Picasso went out of his way to discount the impact that tribal, specifically African, art had on the painting. "The artist has assured me," wrote Christian Zervos in 1942, "that at the time he was painting *Les Demoiselles d'Avignon*, he was unaware of the art of black Africa. It was only somewhat later that he had the revelation."

Why did Picasso go to such lengths to deny the obvious? His caginess reflects his natural secretiveness. He preferred to speak in riddles, to cover his tracks, to obfuscate and deflect. Flashes of insight and moments of heartfelt confession are interspersed with false leads, like a detective novelist who hides key clues amid red herrings. "You must not always believe what I say," Picasso warned those who asked him

to explain himself. "Questions tempt you to tell lies, particularly when there is no answer."

His need to deflect, to conceal, was most pronounced when a revelation threatened to expose the mysterious wellsprings of his art. The more potent the magic, the more fiercely he guarded the formula that would lose its efficacy if shared with any but his fellow adepts. Far from marginalizing the importance of these fetishes to his new conception, his attempts to cover his tracks reveal that they lay somewhere very close to the heart of things; they were talismans whose enchantment could be maintained only by shielding them from the glare of day.

Another reason for Picasso's disavowal of African influence was that to admit he was inspired by those newly fashionable objects would have undermined his claims to originality. Around the time he was painting *Les Demoiselles* there was a vogue for so-called primitive (especially African) art, examples of which had for years been finding their way to bric-a-brac shops in Paris from far reaches of the French colonial empire. He was reluctant to admit that the key to his own most revolutionary work could be found in objects that were becoming something of a cliché in bohemian circles.

In fact, the "discovery" of tribal art by the avant-garde constitutes a turning point in modern art, in large part because it marked a turning point in Picasso's own artistic practice. Of course the urge to reinvigorate stale traditions by tapping into the vital energy of the "less civilized" peoples of the globe was as old as modernism itself.* Decades earlier, Japanese prints had been all the rage, contributing a non-Western sense of space to Impressionist canvases. A taste for a more primal, more authentic, experience was behind not only Gauguin's escape to the South Seas but also the Pre-Raphaelites' infatuation with medieval legends and even

* Needless to say, the appropriation of non-Western styles by artists in Europe and America was based on misunderstanding, imperialist attitudes of superiority, and often overt racism. It was part of a history that dates back at least to the time of the Enlightenment, when distant cultures were often typecast as either noble savages or brutish cannibals.

Puvis de Chavanne's brand of archaic classicism. But the discovery of African—and, to a lesser extent, Oceanic and Native American—sculpture in the early years of the twentieth century constituted the most aggressive assault yet on the assumptions that had governed European art for centuries.

Picasso's initial introduction to the art of Africa probably came through Henri Matisse, one more reason he may have wished to cover his tracks. The sculptural presence and aggressive deformations of Matisse's *Blue Nude (Memory of Biskra)*, made shortly after his Algerian trip, owe everything to the plastic inventiveness of African artists. Picasso would have been sensitive to any notion that he was following in his rival's footsteps. Gertrude Stein summed up the complex dynamics of this critical moment:

> Derain and Braque became followers of Picasso about six months after Picasso had, through Gertrude Stein and her brother, met Matisse. Matisse had in the meantime introduced Picasso to negro sculpture.
>
> At that time negro sculpture had been well known to curio hunters but not to artists. Who first recognized the potential value for the modern artist I am sure I do not know. Perhaps it was Maillol who came from the Perpignan region and knew Matisse in the south and called his attention to it. There is a tradition it was Derain. It is also very possible it was Matisse himself because for many years there was a curio-dealer in the rue de Rennes who always had a great many things of this kind in his window and Matisse often went to the rue de Rennes to go to one of the sketch classes.
>
> In any case it was Matisse who first was influenced, not so much in his painting but in his sculpture, by the african statues and it was Matisse who drew Picasso's attention to it just after Picasso had finished painting Gertrude Stein's portrait.

Matisse confirmed Stein's account, recalling the time he purchased a small figurine in a shop named Le Père Sauvage for 50 francs: "I went to Gertrude Stein's house on the rue de Fleurus. I showed her the statue,

then Picasso arrived. We chatted. It was then that Picasso became aware of Negro sculpture." Max Jacob offered a somewhat different version of events:

We were dining one Thursday evening at Matisse's on the quai Saint-Michel—Salmon, Apollinaire, Picasso, and myself. Matisse took a black, wooden statuette from a table and showed it to Picasso. It was the first piece of Negro wooden art. Picasso held onto it all evening. The next morning, when I arrived at the studio, the floor was strewn with sheets of paper, and on each sheet was drawn the head of a woman; all of them were more or less the same: one eye, an oversized nose attached to the mouth, and a lock of hair on the shoulders. Cubism was thus born. This same woman appeared in his paintings, instead of only one woman, there were two or three. Then there was *Les Demoiselles d'Avignon*, a canvas as large as the wall itself.

For all their inconsistencies, these accounts make a few things abundantly clear: that an admiration for African sculpture was widespread at this time; that Matisse was an early devotee and communicated his passion to Picasso; and that Picasso, for all his obfuscations, was an enthusiastic convert.

If Picasso's assertion that he was unaware of African art when he painted *Les Demoiselles d'Avignon* is obviously false, it's also obvious that his solitary pilgrimage to the Trocadéro was not the first time he'd ever laid eyes on those fascinating objects. Touring the dusty basement of the ethnographic museum, he was overcome by a spiritual revelation:

Men had made those masks [he told Françoise Gilot] and other objects for a sacred purpose, a magic purpose, as a kind of mediation between themselves and the unknown hostile forces that surrounded them, in order to overcome their fear and horror by giving it a form and an image. At that moment I realized that this was what painting was all about. Painting isn't an aesthetic operation; it's a form of magic designed as a mediator between this strange, hostile

world and us, a way of seizing the power by giving form to our terrors as well as our desires. When I came to that realization, I knew I had found my way.

Picasso's insight that art, at its deepest level, is a form of dark magic to ward off the horrors of the night was aided by the context in which he viewed these tribal artifacts. In the ethnographic museum they took on a new life, suggesting a purpose and a history far removed from Western conceptions. Rather than being treated solely as objects of aesthetic delectation, as they would be in a gallery or studio, they became tools to achieve very specific tasks. At the Trocadéro, masks, statuettes, and other objects were often displayed on mannequins in ceremonial regalia and given helpful labels such as "Protects against the sorcerer," "Cures ailments caused by the deceased," "Cures the insane," "Cures gonorrhea"—labels that emphasized function over form.

This last "cure" may have been particularly important to Picasso, who almost certainly suffered from venereal disease at some point in his life and whose great painting enshrines not only desire but the dread of contagion. The "fearful and grimacing nudes" he conjured up, with their features at least vaguely based on what he saw in the Trocadéro, now shoulder the burden once carried by the medical student with his skull, simultaneously embodying and protecting against the corruption that comes from sin.*

Picasso said that he was interested in tribal works because he found them *raisonnables*, by which he meant not so much *reasonable* as *conceptual*. They were based on ideas rather than perception. "I paint objects as I think them, not as I see them," he explained. Those who had carved the fetishes were concerned with efficacy, not with making a plausible

* Picasso's association of Africa with sexuality was in keeping with racist attitudes of his time, which equated the supposedly primitive state of the inhabitants with animal appetite. Such racist tropes were disseminated by images of half-naked Africans. Picasso, like many of his colleagues, collected erotic postcards depicting bare-breasted natives.

facsimile of what the eye could see, to "overcome their fear and horror by giving it a form." The relationship between the depiction and the thing depicted paralleled the abstract system of written or spoken language, rather than the mimetic system of pictorial representation. They were spells cast in three dimensions, cryptic incantations obeying inscrutable laws. An eye or a nose, for instance, was its own discrete unit of meaning, not an organ of a certain size and shape that had to be rendered in correct relation to the body as a whole. What appeared to be arbitrary distortions of the human form were actually practical accommodations to ritual functions, in which certain features were given prominence over those deemed superfluous. These vital elements were then conventionalized in such a way as to provide maximum conceptual clarity. In this supernatural lexicon an eye could as easily be represented as a concavity as a convexity; elements might be exaggerated or eliminated altogether if they did not fulfill a magic purpose. Abstraction, stylization, the treatment of each element as a symbol that played a role in a complex grammar of form lifted the objects onto another plane, where the deeper affinities that lay hidden beneath the surface of the visible became manifest.

Picasso was uniquely receptive among his colleagues in the avant-garde to such messages. "That's also what separated me from Braque," Picasso said. "He loved the Negro pieces, but . . . because they were good sculptures. He was never at all afraid of them. Exorcism didn't interest him. Because he wasn't affected by what I called 'the whole of it,' or life, or—I don't know—the earth?—everything that surrounds us, everything that is not us—he didn't find all of that hostile. And imagine—not even foreign to him! He was always at home. . . . Even now. . . . He doesn't understand these things at all: he's not superstitious!"

Picasso's superstitiousness, his pathological dread of disease, made him take the original function of these otherwise perplexing works seriously.* Understanding their potency allowed him to exploit his own particular gift. He had a heightened sense that the miraculous resided in even in the most mundane things, particularly those worn, rubbed, threadbare

* Françoise Gilot noted, "Beginning on the day I went to live with Pablo, I got my indoctrination in how to live—with superstition."

objects that carry the marks of human usage. He exploited these proper-ties to the fullest in his Cubist collages and assemblages, in which, with a few deft manipulations, he transformed junk into works of mysterious power. One has only to think of sculptures like the magical *Bull's Head*, made of a rusted bicycle seat and handlebars, to appreciate his uncanny ability to turn castoffs into powerful totems.

His struggle to complete *Les Demoiselles d'Avignon* precipitated a cri-sis that made him peculiarly susceptible to the whispered blandishments of these savage idols. What, after all, was his great canvas if not a mediator, an *intercesseur*? As such it could not simply depict a squadron of guard-ian demons. After all, the artifacts he saw in the Trocadéro were never intended to be placed inside a museum, cut off from the rest of the world. They had participated in the communal life of the villages where they were made; they had been dressed up and danced with, hacked at and caressed, bowed down to and cursed at. They were apprehended not by the eye alone but with both body and spirit.

Discovering a pictorial equivalent to that sorcery would be the key to transforming his own painting. For hundreds of years in the West the trend had been to divest the artwork of its magic, to separate it from real life in pristine galleries surrounded by gilded frames, to aestheticize it, to render it available to the eyes alone. Worshippers were transformed into connoisseurs, detached, dispassionate, disengaged. Picasso wanted to re-verse this trend, reclaiming art's totemic status. "Painting is not made to decorate apartments," he insisted. "It is an instrument of offensive and defensive war against the enemy."

To be sure, he could not escape the habits and assumptions of the culture into which he had been born. After all, he didn't live in an Afri-can village but in the world's most cosmopolitan city, and his audience was sophisticated about not only the latest avant-garde maneuver but also the centuries-old tradition that the avant-garde was attacking. He was an artist, not a shaman, a producer of images and forms, not a spiritual me-dium. But he did want to steal a bit of that sacred fire for his own—to become, in Salmon's phrase, the sorcerer's apprentice. More than any of his contemporaries, he had a feeling for the uncanny dimension of art and for the ways in which modernist innovations could restore the lost sense of connection with the occult forces that govern the world. If his team of

Gorgons were to fulfill the task he'd assigned he would have to summon them, to give them the awesome presence associated with those three-dimensional fetishes scarred by the marks of ritual use and abuse. It was not enough to make a picture of a sculpture, as his colleagues were inclined to do when captivated by an exotic relic; he had to make the painting itself sculptural. To give the image even greater potency, he trawled the unstable borderland between two and three dimensions that seethed and crackled in response to invisible pressures.

Picasso presents his demon-whores with the authoritative frontality of an icon but then subjects the icon's placid surface to destabilizing forces, as if these monsters are not simply present but in a state of perpetual materialization. For centuries, the history of art had played out between two alternatives: the iconic mode, which was serene, abstract, a vision of a perfected world beyond our ken, and the illusionistic space of Renaissance art, which was logical and fundamentally materialistic. Picasso invented a third way: a mode of representation with all the magical potency of the one, the palpable physical presence of the other, and a nervous energy that belongs to neither. We catch his hags in midspell, at the very instant of their greatest imminence *and* immanence. They wink into and out of existence as befits creatures caught between two worlds.

The spatial ambiguities he had been exploring over the past year and that culminated in the vertiginous conundrums of the great painting itself had served to give his work greater *presence*, transforming image into substance, illusion into icon. Internalizing the far greater plastic liberties taken by the makers of the tribal masks and figurines, Picasso saw that he could push his own work further in a direction he'd been pursuing all along. Repainting the two right-hand figures of *Les Demoiselles* in light of the revelation he'd experienced in the ethnographic museum, Picasso untethers them from perception itself. They are contorted, distorted, the human form under maximum metaphysical duress, channeling the disturbances already latent in the painting like Bacchantes whose wild gyrations have the power to siphon off evil humors.

It's important to stress that Picasso was not simply illustrating exotic tales of voodoo and black magic. Those themes, after all, had already been touched on by Gauguin and many of the Symbolists. Picasso's genius, his compulsion, was to discover pictorial equivalents of the uncanny power

radiated by these fetishes. It would have been simple enough to include one or more of those exotic objects in an otherwise conventional still-life arrangement, as many of his contemporaries did, or to give his European figures a primitivist makeover. But that would have robbed them of their power. It was not the stylistic quirks that intrigued him but the piercing insight that art was, fundamentally, not an aesthetic practice at all but a system for manipulating the hidden forces of the universe.

In fact, neither of the two right-hand figures in *Les Demoiselles* actually reproduces anything he could have seen at the Trocadéro that summer—one of the reasons his evasions had a certain plausibility.[*] Their ferociousness, their air of savage menace, echoes not only the African art but the Oceanic masks he'd seen in the museum, but the affinity is conceptual rather than based on specific morphological similarities. Like his African or Pacific Islander colleagues, Picasso treats each element—nose, eye, limb—as an independent unit, a sign that can be rearranged at will. There is no organic or logical connection among them; each component can be shifted like a word in a sentence without losing the essential meaning. These more or less arbitrary signs make sense only in relation to one another, not because of any resemblance to something found in nature. He emphasizes the disjointed nature of this syntax by painting the heads of the two figures on the right in a completely different palette and with a completely different grammar of form, than the rest of the canvas, a shift probably inspired by the highly colored masks from the New Hebrides he'd seen at the Trocadéro. Making no attempt to integrate them into a coherent whole, he emphasizes their status as independent units; meaning is constructed as a play of differences rather than a seamless narrative.[†] As André Salmon wrote, paraphrasing Picasso himself, "The great law that

[*] Many articles have suggested various sources for the two right-hand figures, but none of them convincing. In various sketches from the same period, including one in oil titled simply *Head* and a pencil drawing titled *Two Antelopes*, Picasso made far more literal copies of specific African works.

[†] There is a large body of literature on Cubism as a system of signs, in other words, as semiotics. Much of it is tough going for the general audience and not necessary for an appreciation of the work.

dominates the new aesthetic is the following: conception overrides perception."

Of course for Picasso the *expressive* potential was as important as the conceptual. There is a brutality to his reshaping of the human form that was perhaps never intended by the makers of the idols, who were participating in a highly ritualized system. Picasso was superstitious but not religious. His reconfiguring of the human form was idiosyncratic, based on his own anxieties rather than the conventions of shared belief. He explained his methods thus: "To displace. To put eyes between the legs, or sex organs on the face. To contradict. To show one eye full face and one in profile. Nature does many things the way I do, but she hides them! My painting is a series of non-sequiturs." The needs his art served, the terrors it guarded against, were personal rather than communal: he was concerned with lust rather than fertility, the extinction of his own consciousness rather than the survival of the community.

What made Picasso receptive to this more conceptual mode is that he'd been groping toward exactly the same end without knowing it. Progressive moves away from illusionistic space and naturalistic form had already taken him halfway there, providing a context in which these more radically altered figures made sense. Once Picasso conceived the head of the squatting woman on the right as a completely separate element from her body—an ideograph or pictograph rather than a picture—he could snap it around 180 degrees like the possessed teenager in *The Exorcist*. One can read the head as an independent sign (a *signifier* in scholarly jargon), but that should not inure us to its shocking violence. The squatter's boomerang-shaped hand, with which she cups her disarticulated skull, bears no relation to human anatomy, as if Picasso were trying to see how far he could deform nature and still have it read as a human limb engaged in an all-too-human gesture. Freed from any obligation to imitate what the eye perceives, Picasso radically expanded the expressive and pictorial range of his figures. The "curtain raiser," a Jenga-like tower of tumbling blocks, and the squatting figure, a monster slapped together by a particularly cruel and careless Dr. Moreau, are mothers of the anguished mix-and-match race that Picasso will spend the next seven decades unleashing upon the world.

The conceptual approach of the tribal artist provided Picasso with a

key to unlocking the potential of his own work. It revealed to him what he'd been seeking all along: an art based not on an appearance but on a repressed grammar of the reptilian mind, capable of conveying the things that mere sensation fails to grasp. The two intruders who break through the curtain are like jesters in a Shakespearean tragedy whose antic hijinks clarify the action; their disjointed appearance reveals how out of joint everything already is. So clearly defying logic themselves, they embody the topsy-turvy world they inhabit.

Les Demoiselles d'Avignon is the scene of a riot or a war zone in which contradictory systems collide. The perceptual collides with the conceptual; the expressive with the cerebral; the very arena in which the incommensurates battle appears to be in the process of collapsing in on itself, destabilized by the fury of the contestants.

Having unleashed this final salvo, Picasso turned away from the canvas, this time for good. Over the course of eight anguished months, he had finally succeeded in creating a work as paradoxical, disquieting, and ultimately powerful as any in the history of art. He could do no more.

11

Drinking Kerosene, Spitting Fire

[I]t was if someone was drinking kerosene so he could spit fire.

—GEORGES BRAQUE

When Picasso put down his brushes in late June or early July 1907, no one, least of all the artist himself, seemed to know whether the work that would come to be known as *Les Demoiselles d'Avignon* was actually finished.* Selling a painting always left a little void, reminding him of the inexorable progress of ravening time and of his own mortality. "Have you ever seen a finished picture?" he once demanded of Jaime Sabartés. "A picture or anything else? Woe unto you the day it is said that you are finished! To finish a work? To finish a picture? What nonsense! To finish it means to be through with it, to kill it, to rid it of its soul, to give it the final blow: the most unfortunate

* Some scholars argue that Picasso continued to work on the painting up to, and even after, the fall of 1908, when it was photographed as part of an article for Gelett Burgess' article "The Wild Men of Paris." But that seems unlikely. As far as one can tell, the photograph shows the painting in its current form.

one for the painter as well as the picture." If this was true for even the most casual sketch, how much more painful for the work that had consumed him for the better part of a year and cost him so much in, sweat and tears!

The notion that *Les Demoiselles* is fundamentally unresolved was promoted by his dealer Daniel-Henry Kahnweiler. "Picasso regarded it as unfinished," he claimed, "but it has remained exactly as it was, with its two different halves." The artist himself wasn't so sure, acknowledging the dissonance but suggesting that people would simply have to get used to it. "I had done half the painting," he told his biographer Antonina Vallentin. "And I felt: It's not right! I did the other [half]; I wondered if perhaps I should redo the whole thing. Then I said to myself: 'No, people will understand what I was trying to do.'"

That hope proved wildly optimistic, at least in the short run. In a repeat of the spring fiasco, the reworked painting was greeted with bafflement, suspicion, and outright hostility. No dealer or collector showed the least interest in purchasing the vast and vastly difficult work. After paying a visit to the Bateau Lavoir, Serge Shchukin left, practically in tears, telling the Steins, "What a loss for French art!"

Matisse responded with anger rather than sadness. He seemed to think that the whole thing was an elaborate hoax—one specifically aimed at him. He swore he'd "get back" at Picasso, "make him beg for mercy."

The hostile reception took a toll on Picasso. "A short period of exhaustion followed," Kahnweiler recorded, describing his spirit as "battered." Old friendships were strained; those who had once shared his vision and championed his cause were left behind on the platform while he sped off into the future. New alliances would soon take their place, but the old camaraderie, the sense of a shared mission, was shattered.

The most immediate casualty was his relationship with Fernande. "Do you want to hear some important news?" she wrote to Gertrude Stein on August 24. "Picasso and I are ending our life together. We are parting for good next month. He's waiting for the money Vollard owes him so as to be able to give me something. . . . What a disappointment! But don't imagine for a minute that matters will sort themselves out again. No, Pablo 'has had *enough*.'"

The news couldn't have come as a total shock to her. Things had been going downhill since their return from the idyllic summer in Gósol, with Picasso ever more consumed by problems for which Fernande could provide no relief and even less understanding. The savage depiction of womanhood in *Les Demoiselles* was ominous; this was not the vision of a man happily in love. The experiment with Raymonde had proven disastrous, but it was a symptom, not the cause, of a deeper estrangement. Giving birth to his revolutionary masterpiece had changed Picasso, cutting him off from even his most sympathetic friends. Exhausted, frustrated, and upset, he simply lost patience with what he called "her little ways."

As always, Picasso was reluctant to make a clean break. Just as he hated to part with his paintings, he hated to cut himself off from people who'd been important to him. He used the second installment from Vollard's purchase earlier that year to set up Fernande in an apartment on rue Girardon, only a few blocks from rue Ravignan. Here, to supplement her income, she gave French lessons, her only client consisting of Alice B. Toklas, Gertrude Stein's new companion, who'd recently arrived in Paris from her native San Francisco. If Picasso now found Fernande irritating and shallow, he still needed to have her around, like a sultan exchanging one favorite for another but keeping the demoted concubine close at hand. Fernande reconciled herself to the new situation. After only a couple of weeks, she was writing to Gertrude Stein, reassuring her that while she was still "very disoriented," she was "in much better spirits than when I last wrote."

As it turned out, the separation lasted only a few months. The reconciliation was engineered by Stein, who invited them both to dinner at the neutral ground of the rue de Fleurus in late September. Fernande moved back into the Bateau Lavoir studio shortly thereafter, and the two of them settled down as if nothing had happened. But the ties that once bound them together had weakened. As if to guard against being cast off once more, Fernande began to style herself "Mme. Picasso," and friends remarked that they seemed like an old married couple, companionable enough but no longer passionately in love.

Picasso never felt more isolated or more misunderstood than in the

weeks and months following the completion of *Les Demoiselles*. The painting "unleashed universal anger," Salmon wrote. The old gang continued to congregate at Azon's or the Lapin Agile, but the quarrels grew louder and the reconciliations more tentative. The sign labeling Picasso's studio the *rendez-vous des poètes* was removed, and he sought kindred spirits among the painters who had at least some chance of appreciating what he was trying to do. "Despite everything," Fernande wrote, "he seemed ever more preoccupied," his ill temper brought on by "exhaustion from constant work."

This was the price he had to pay for traveling down a road where few could follow. Many years later, standing in front of a painting by Cézanne, another revolutionary shunned by his contemporaries, he mused on what it meant to be ahead of one's time: "[T]hose men lived in unbelievable solitude which was perhaps a blessing to them, even if it was their misfortune too. Is there anything more dangerous than sympathetic understanding? Especially as it doesn't exist. It's almost always wrong. You think you aren't alone. And really you're more alone than you were before."

Only Georges Braque seemed to have a glimmer of understanding, and even he—at least until he had time to absorb what he'd seen—was more shaken than inspired. "He said it was as if someone was drinking kerosene so he could spit fire," wrote Kahnweiler of Braque's first reaction upon seeing *Les Demoiselles*.

That startling turn of phrase has often been characterized as just one more jab in an already long sequence of blows aimed at Picasso by friends and rivals alike.* But it was more than that. Braque was like a bystander momentarily stunned by an explosion, a sudden jarring thunderclap that rattled his teeth and jolted him out of his complacency. Once the initial

* Fernande, for instance, reported the line as "But in spite of your explanation . . . you paint as if you wanted to force us to eat rope or drink paraffin." Salmon has it as, "It's as if you were drinking kerosene and eating flaming tow." Whichever version one chooses, the sense of shock comes through.

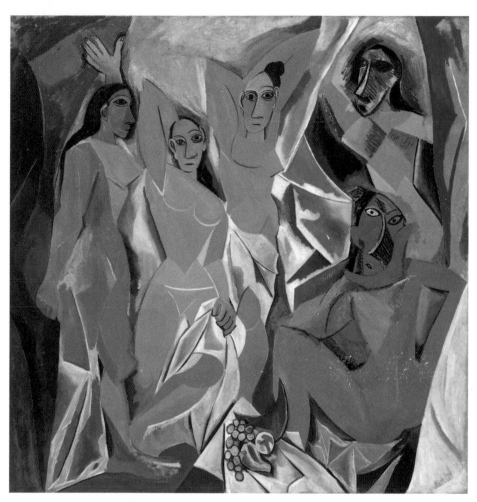

Picasso, *Les Demoiselles d'Avignon*, 1907. © *The Museum of Modern Art/Licensed by SCALA / Art Resource, NY. Artwork © 2017 Estate of Pablo Picasso / Artists Rights Society (ARS), New York.*

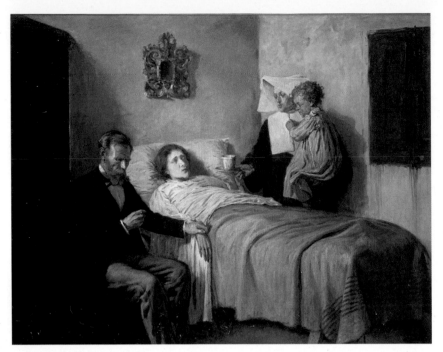

Picasso, *Science and Charity*, 1897. *Album / Art Resource, NY. Artwork © 2017 Estate of Pablo Picasso / Artists Rights Society (ARS), New York.*

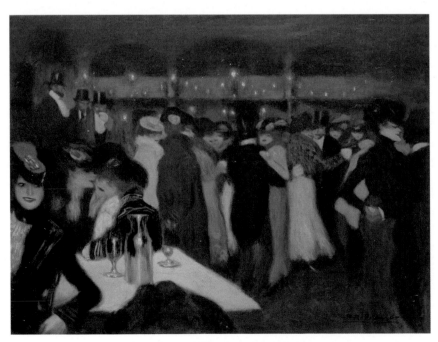

Picasso, *Le Moulin de la Galette*, 1900. *The Solomon R. Guggenheim Foundation / Art Resource, NY. Artwork © 2017 Estate of Pablo Picasso / Artists Rights Society (ARS), New York.*

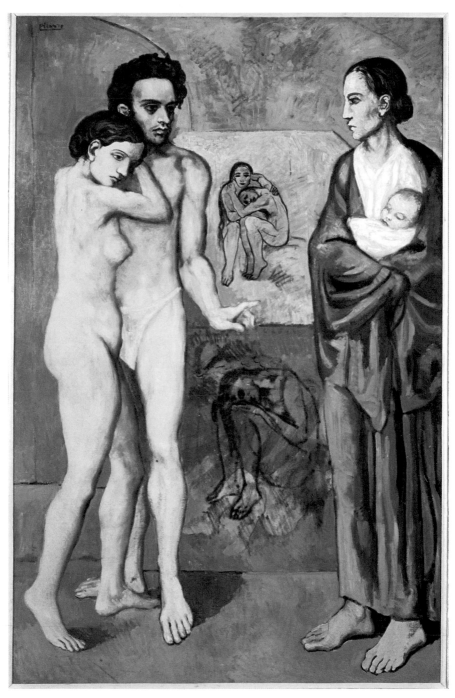

Picasso, *La Vie*, 1903. *Scala / Art Resource, NY. Artwork © 2017 Estate of Pablo Picasso / Artists Rights Society (ARS), New York.*

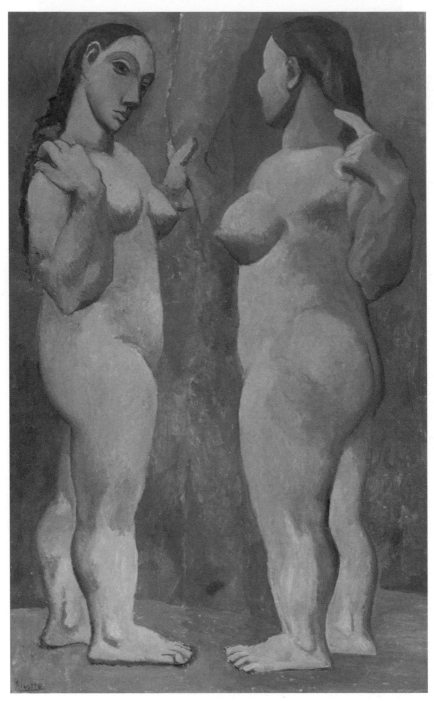

Picasso, *Two Nudes*, 1906. © *The Museum of Modern Art/Licensed by SCALA / Art Resource, NY. Artwork* © *2017 Estate of Pablo Picasso / Artists Rights Society (ARS), New York.*

Cézanne, *Mont Sainte-Victoire*, 1904–1906. *Scala / Art Resource, NY.*

Picasso, *Factory at Horta de Ebro*, 1909. *Erich Lessing / Art Resource, NY. Artwork © 2017 Estate of Pablo Picasso / Artists Rights Society (ARS), New York.*

Braque, *Houses at L'Estaque*, 1908. *Bridgeman-Giraudon / Art Resource, NY.*

shock had passed, however, he experienced a great sense of liberation, of exaltation, sensing that barriers had been broken and new possibilities were pouring through the breach. "My true meeting with [Picasso] was in his studio in the Bateau Lavoir, in front of *Les Demoiselles d'Avignon*," he recalled, ignoring their brief introduction six months earlier. "There at once I knew the artist and the man, the adventurer, in the work he set down in spite of everything, as it seemed. People have talked about provocation. For my part, I found in it an unswerving determination, an extraordinary yearning for freedom asserted with a daring, one might almost say a calm fieriness, already sure of itself."

But for all Picasso's boldness, Braque sensed a profound uncertainty. "Picasso was very anxious, watching for my reaction," he added.

It's not surprising that Picasso should have felt some lingering doubt. After all, he'd just fired the opening salvo in a revolution of consciousness. It would take some getting used to, but, once internalized, it would change the world. Braque could not take it in all at once or altogether. Such violence was foreign to his nature. He was methodical, cerebral, cautious. But he was also perceptive, not beholden to any tradition or a slave to fashion. Perhaps most importantly, he never let his ego get in the way of artistic growth. In this, as in so many other ways, he was the exact opposite of Picasso. He was perfectly happy to give credit where credit was due, particularly if it allowed him to learn from a colleague. Of all the visitors to Picasso's studio in those weeks, Braque alone seemed willing to follow the road the Spaniard had opened up to see where it might lead.

Admittedly, his first attempts were clumsy. Over the following months he would try to harness Picasso's fury, with only mixed success: fury did not come naturally to him, any more than Matisse's delirious hedonism had earlier. In thrall to the voodoo of Picasso's great painting he turned for almost the first and almost the last time in his life to portraying the female nude. Only one of the two paintings he submitted to the 1908 Salon des Indépendants survives. His *Large Nude* was his most ambitious attempt to come to grips with not only the savage primitivism of *Les Demoiselles* but also its radical treatment of space. In Fernande's account, Braque kept the painting hidden from Picasso. "He told no one, not even Picasso, who had inspired it. Did he wish to be the first to harvest the fruits of this new formula? It was worth a try, since Picasso never exhibited."

Large Nude (Georges Braque), 1908.
© CNAC/MNAM/Dist. RMN-Grand
Palais / Art Resource, NY.

But Fernande misjudged Braque. Instead of an attempt to steal the limelight, his secrecy was a sign that he was too unsure of himself and his command of the new pictorial language to risk Picasso's ridicule. And far from resenting Braque's bid for recognition, Picasso was perfectly happy to let his new disciple bear the brunt of the public outcry.

As it turned out, Braque had cause for concern. Hoping to replicate the complex integration of figure and ground in *Les Demoiselles*, he surrounds his galumphing Amazon with random arcs that fly off her like a frantic stripper tossing off all her clothes at once.* The result is not so much complexity as incoherence. He approximates Picasso's technique of providing more information about a form than could be apprehended from a single viewpoint, but with such clumsiness that both the woman's

* Many critics have cited the influence on both Braque's nude and Picasso's *Nude with Raised Arm and Drapery* (1907) of the "Dance of the Veils" by the American dancer Loie Fuller, which Picasso had seen at the *Exposition Universelle* of 1900.

buttocks, for instance, appear attached to a single leg. More successful was a second painting he exhibited called *La Femme*, a composition with three nudes that were all variations on a single figure. As he explained to the American journalist Gelett Burgess, "To portray every physical aspect of such a subject required three figures, much as the representation of a house requires a plan, an elevation and a section." Though the painting was later destroyed, Braque gave a pen-and-ink study to Burgess that was later reproduced for his article "The Wild Men of Paris." Unlike the ham-fisted *Large Nude*, it shows a far more sophisticated understanding of how to integrate figure and ground into a single dynamic surface.

By that time Derain had also fallen under the spell of *Les Demoiselles*. After earlier declaring that Picasso would one day be found hanged behind his failed masterpiece, he, too, tried to steal a bit of its magic. *La Toilette*, like Braque's *Large Nude*—the two paintings were exhibited side by side in the Salon—was an attempt to harness the savage power of Picasso's nudes, but Derain's maidens come off as ponderous rather than frightful. It's an early sign of his declining powers and eventual retreat into a banal, reactionary primitivism.

Since Picasso himself refused to show at the Salons, this was the public's only opportunity to experience the latest outrage issuing from the studios of Montmartre. As Gertrude Stein put it, "The first time that . . . [Picasso] had ever shown at a public show was when Derain and Braque, completely influenced by his recent work, showed theirs." A seismic shift had taken place within the avant-garde. "The feeling between the Picassoites and the Matisseites became bitter," Stein said. ". . . I sat without being aware of it under the two pictures which first publicly showed that Derain and Braque had become Picassoites and were definitely not Matisseites."

To many, the eclipse of the Fauves by the new barbarians was a case of going from bad to worse. Burgess himself described the room where Braque and Derain were exhibiting their Picasso-inspired canvases as "a universe of ugliness" and recalled being accosted by "a party of well-dressed Parisians in a paroxysm of merriment."

For the first time since the notorious Salon des Fauves three years earlier, the public had discovered a fresh target for its wrath. Sharpening his satiric wit, the critic from *Le Rire* even renamed Braque's three nudes: "I

particularly recommend the painting *Hunger, Thirst, Sensuality*, in which a woman—if one may call her such—is eating her right leg, drinking her blood, and with her left hand. . . . No, I could never tell you where her left hand is wandering." Louis Vauxcelles opted for the more direct approach, condemning Braque's "savage, resolutely, aggressively unintelligible art."

The bolts aimed at Derain and Braque confirmed to Picasso the wisdom of staying away from the Salons, and it increased his distaste for the kind of spectacle that was the usual road to fame in the avant-garde. Ambitious as he was, he didn't crave the notoriety that came from being the butt of ridicule in the newspapers. And since he didn't have to worry about what was said about him, he could pursue his own course without distraction.

Left to his own devices, Picasso was free to explore some of the pathways opened up by *Les Demoiselles*. Many of the problems raised in the struggle to realize his vision generated solutions in the form of independent works. The most innovative paintings and drawings from these months, sometimes labeled his "Negro" or "African" period, take as a point of departure the two figures on the right-hand side of *Les Demoiselles*. One of the most successful—more resolved if less volcanic than the large painting—is his *Nude with Drapery*. The pose actually comes from the second figure on the left, one of those left in the original "Iberian" style, but now reconceived in the more conceptual mode of the tribal figures. It is this work, rather than *Les Demoiselles* itself, that likely provided the model for Braque's *Large Nude*, but the comparison serves only to demonstrate how much more sophisticated and radical Picasso's approach was at this stage. While Braque tries to integrate figure and ground by fudging contours, hiding his imperfect grasp of the new language by taking refuge in murky scumbles of paint that stand for nothing in particular, Picasso inscribes his within a web of razor-sharp lines that radiate outward, as if the figure and the space around her form a continuous whole. He deploys the parallel hatchings that carve out the masklike faces of the two "tribal" figures of *Les Demoiselles* (and that derive ultimately from the scarification marks on African sculptures) across the entire surface of the canvas, to produce a steady back-and-forth rhythm while still maintaining the linear, two-dimensional integrity of the picture plane. There is no front or back, solid

or void, only a continuous faceted membrane thrusting and receding in a great barbaric dance.

An entirely predictable consequence of Picasso's radical departure was that, once again, he'd outpaced his market. Vollard had finally come around to the Blue and Rose period work but drew the line at *Les Demoiselles*. Leo Stein made his disapproval known, and his sister was not yet confident enough in her own judgment to forge ahead on her own. Shchukin's despair over the wrong turn Picasso had taken summed up the general feeling that a once promising career had gone off the rails. The one major sale Picasso did manage to engineer merely underscored the change in his fortunes. "It's always been like this with me," he grumbled. "Very good and then suddenly very bad. The acrobats pleased. What I did after that didn't please anymore!"

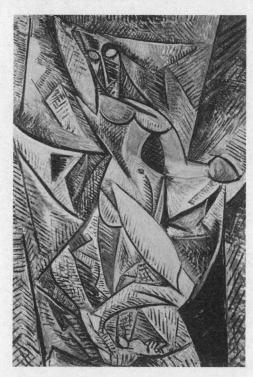

Nude with Drapery. Erich Lessing / Art Resource, NY.

The acrobats in this case were the itinerant troupe of *The Family of Saltimbanques*, the great masterpiece of his Rose Period to which he'd bid a fond farewell two years earlier. At first he had offered the canvas to Vollard, but the dealer had balked at the asking price. Desperately short of cash, Picasso reluctantly accepted an offer of 1,000 francs from André Level, the head of Le Peau de l'Ours, which specialized in buying young artists cheap and (hopefully) selling them at a large profit.

Fortunately, just as Picasso's career seemed to have stalled, a new figure entered his life, a man who would do more than anyone to build a market for his work, nurturing his reputation and eventually establishing him as *the* preeminent artist of his generation.

Daniel-Henry Kahnweiler was born into a German-Jewish family of bankers. In February 1907, at the age of twenty-two, he moved to Paris from London, where he'd been working in an uncle's firm as a stockbroker, determined to make a career as a dealer in modern art. His relatives agreed to let him try his hand at this peculiar business, loaning him £1,000 with the promise that he would return to his old job if, as they surely expected, he failed to make a success of it.

This ultimatum gave him little time, so he plunged in with both feet. After only a few weeks in the city, he opened a tiny gallery at 28 rue Vignon, close to the contemporary annex of Bernheim-Jeune and the Galerie Druet, which he rented from a Polish tailor for 200 francs a month. After laying carpet and covering the walls with burlap, he headed off to the Salon des Indépendants, where he snapped up works by Derain, Vlaminck, van Dongen, and Braque—all the significant Fauves with the exception of Matisse, who'd already signed a lucrative contract with Bernheim-Jeune.

Unlike his friend and compatriot Wilhelm Uhde, Kahnweiler pursued the buying and selling of art as a business, using his background in finance to set up operations on a professional basis. He had a keen eye for the next new thing and would take risks for artists he believed in. But he also suspected that there was money to be made by dealing in the most radical art and was smart enough to figure out how to turn his passion to profit. He had the aesthetic courage of Berthe Weill but

Daniel-Henry Kahnweiler. ©
RMN-Grand Palais / Art Resource, NY.

gave the artists he represented the confidence that he would maximize their mutual profits; the discerning eye of Vollard but without his penchant for underhanded tricks. Picasso grumbled about Kahnweiler's stinginess, but even he had to admit that he was the first dealer who could provide him with the financial security he needed to pursue his art in peace. "[M]y role," Kahnweiler insisted, "was to fight for those my own age."

In 1907, even in Paris, the world of contemporary art was an intimate affair. Only a handful of venues dealt in the work of living artists, so the opening of a new gallery was big news. Before long, most of the artists from Montmartre and Montparnasse came to check out the newcomer. The dealers, too, stopped by, if only to size up the competition. "One day I was in my shop when a young man came in whom I found remarkable," Kahnweiler recalled. "He had raven-black hair, he was short, squat, badly dressed, with dirty, worn-out shoes, but his eyes were magnificent.

Without a word, this young man began looking at the pictures." He left without introducing himself.

"[I]t was [Uhde] who first told me about a strange picture that the painter Picasso was working on," Kahnweiler explained. "A picture, he said, that looked Assyrian, something utterly strange." Intrigued, Kahnweiler headed off to Montmartre and 13 rue Ravignan:

> I knocked at the door; a young man, bare-legged, with his shirt flapping open, came to the door, took me by the hand and asked me to come inside. It was the young man who'd come a few days earlier. . . . Thus I found myself in Picasso's studio. No one has any idea of the poverty, the disgraceful misery of those studios in the Rue Ravignan. . . . The wallpaper hung in ragged strips from the planks of the walls. There was dust covering the drawings, and rolled-up canvases on the sagging sofa. Next to the stove a volcanic mountain of ashes. It was frightful. It was there that he lived with a very beautiful woman, Fernande, and a great big dog named Fricka.

As for the painting he'd come to see, "I was overwhelmed." In front of *Les Demoiselles* he imagined "the point of departure for a new art."

By the time Kahnweiler set down his reminiscences, *Les Demoiselles* was almost universally regarded as the most important painting of the twentieth century, and his account of how he felt standing before this immense canvas may well have been colored by its subsequent fame. The fact is that he made no attempt to acquire the painting, though he was sufficiently impressed with what he'd seen to make a modest investment in the young Spaniard. He bought some minor works for next to nothing since, as he pointed out, "no one else was buying from him any more."

Fernande depicts Kahnweiler as a grasping businessman who took advantage of Picasso's desperate straits. "Kahnweiler haggled for hours until, now at the end of his rope, the painter would agree to cut the price. Kahnweiler was well aware of how much he could profit by wearing Picasso down."

Still, even Fernande admitted that after Kahnweiler came into their lives things changed for the better. Picasso's new dealer understood how to cultivate clients, slowly building a market for an artist and raising his prices year by year. "Picasso later told me," Kahnweiler noted, " 'If you want paintings to fetch a high price, you must first sell them cheap.' Well, like most, I sold Picasso's pictures very cheaply, but I also bought them very cheaply. That is to say, he wasn't living in poverty any more, but he wasn't exactly rich, either."

If Picasso and his strange painting were the driving force behind the radical new art, the other crucial influence among the younger generation was Paul Cézanne. For Picasso, Braque, and the other painters of the Parisian avant-garde, the retrospective of Cézanne's painting at the Salon d'Automne of 1907 had been revelatory; almost as influential was a simultaneous exhibition of his watercolors at Bernheim-Jeune. Robert Delaunay, himself a future Cubist, was exaggerating only slightly when he claimed: "The watercolors of Cézanne announce cubism." These deceptively simple works, made from a few stray pencil marks and thin washes of opalescent color that leave large patches of paper bare, raise doubt to the level of a principle (Cézanne's "anxiety," as Picasso called it), revealing that to *really* see is not a simple thing but involves a process of constant questioning, of making tentative propositions, none of which can possibly capture the whole.

To make Cézanne's apotheosis complete, the *Mercure de France* published selections from the correspondence between the Master of Aix and the painter Émile Bernard, containing such prophetic utterances as "Treat nature by means of the cylinder, the sphere, the cone" and "The real and immense study to be undertaken is the manifold picture of nature." These oracular pronouncements became almost as famous as the paintings themselves, inspiring generations of abstract geometricians who painted with a formulaic rigidity that was the opposite of Cézanne's open-ended approach.

For both Braque and Picasso, the Cézanne retrospective in the fall of 1907 came at exactly the right time. It gave them a crucial toehold in

the yawning chasm opened up by *Les Demoiselles d'Avignon*. That painting came as an earthquake, leaving no certain ground upon which to stand. Cézanne's art, so radical but also somehow reassuring, pointing to the future while deeply embedded in the past, served as a fixed point from which to explore the altered landscape, an oasis amid the rubble and the aftershocks.

This was no less true for Picasso than for Braque. Perhaps no one was more disoriented by his creation than he was himself. The howls of protest that greeted his masterpiece, coming not only from the ill-informed public but from those he respected, left him shaken. He was not the kind to back down in the face of criticism, but he was also emotionally vulnerable. For a man who needed constant adulation, the lack of sympathy from those closest to him was disturbing.

It was here that Braque played a crucial role. Getting over his initial shock, he acknowledged that the rules of the game had been changed forever. He could not breathe fire like Picasso, but he had a subtle pictorial intelligence, a natural feel for the architecture of painting. When you stripped away all the expressionist angst from *Les Demoiselles d'Avignon*—a rage foreign to Braque's placid nature—what was left was a radically new conception of form and space, one that built on Cézanne but pushed far beyond anything achieved, or even proposed, by the Master of Aix. The elimination of centuries-old pictorial conventions, that for Picasso had served primarily to heighten the work's expressive impact and magical efficacy, provided him with a treasure trove of pictorial devices that, as Braque himself declared, would "put painting within range of my own gifts."

That gift, as he would soon demonstrate to the world, was an exquisite feel for material and texture, for the pictorial drama that could be amped up by squeezing it into a shallow space, where everything was pushed toward the surface of the canvas so that it could be caressed in the mind, rolled in the fingertips. "It is not enough to let people see what one paints," Braque said. "You have to let them touch it."

Temperamentally, Braque was much closer to Cézanne than he was to his new collaborator. He was a man of depth rather than range. He was, above all, *grounded.* Introverted, at peace with himself, infinitely subtle,

a man uncomfortable with overt displays of emotion, he would find his expressive outlet in form itself, the matter of ordinary life apprehended with extraordinary subtlety. While Picasso went to extremes, Braque was drawn to the mundane, discovering material enough in the sights, sounds, and smells he encountered every day. As Uhde explained it: "Braque's temperament was limpid, precise and bourgeois; Picasso's somber, excessive and revolutionary. To the spiritual marriage which they then contracted, one brought a great sensitivity, the other a great plastic gift."

He was just the man Picasso needed at this moment, a still center, the eye of the whirlwind. Their collaboration over the next few years, perhaps the most surprising and productive partnership in the history of art, was an attraction of opposites, but it couldn't have happened at any other time. For once, Picasso was desperately in need of a collaborator, somebody who could tame his anarchic impulses, who could steady him and keep him on the straight and narrow. He'd gone so far out on a limb that he needed someone to coax him back, someone who was sympathetic and understood what he was trying to do but could channel his excess energies to constructive ends. Their shared admiration for Cézanne became the tie that bound them, drawing them together to scale heights that neither could have climbed alone. "We were," Braque said, "like two mountain climbers roped together." Unlike Matisse, whom Picasso saw as a rival, Braque was his "pard," borrowing the nickname from the Buffalo Bill stories he loved to read.

The closeness of their relationship, with its secret language, its hidden codes, and its almost telepathic understanding, tended to shut out everything and everyone else, even Fernande, who resented Braque as an interloper. The origins of Picasso's paintings during the Rose Period were as much literary as artistic, a vision shared with his poet friends, conjuring up opium-infused dreamscapes steeped in Symbolist melancholy. But beginning in late 1906, Picasso began to move away from an art based on imagery and narrative toward one focused on pictorial problems that had no literary equivalent. Then came *Les Demoiselles d'Avignon*, a work of savage fury whose chief casualty was representation itself. It would be

years before the literary world caught up and turned its weapons on the structure of language. By the time the poets and the painters were once again on the same page, it was the writers who took their cues from the visual artists, seeking a Cubism of words that would be as compelling as a Cubism of forms.*

The dissolution of the *bande à Picasso* was not deliberate and not always apparent. Old habits died hard, even as former comrades drifted apart. Much as he wanted to follow where his friend led, Apollinaire never really understood Cubism. "Apollinaire was a great poet and a man to whom I was deeply attached," said Braque, "but let's face it, he couldn't tell the difference between a Raphael and a Rubens." He would remain a loyal champion, but his critical writings show no real understanding of what the artists were up to. He took refuge in vague analogy and meaningless hyperbole. "He expresses a beauty full of tenderness," he wrote of Braque's 1908 show at Kahnweiler's gallery, "and the mother-of-pearl of his paintings gives iridescence to our understanding." Salmon, too, never caught up, mischaracterizing *Les Demoiselles* as nothing more than a pictorial experiment, "white equations on a black-board . . . the first appearance of painting as algebra." Max Jacob was the most honest. Reflecting on the change that had come over the *bande à Picasso*, he wrote wistfully: "I didn't do Cubism . . . because Picasso chose as his pupil not me but Braque."

In his isolation Picasso sought new allies, and these alliances were soon reflected in his social life. As Derain and Braque became the public faces of the new art, the painters were drawn together, a band of brothers staring down the world. "They often went out, the four of them [Picasso, Braque, Derain, Vlaminck]," Fernande remembered, "Picasso looking very small beside them. But being stocky, he gave a false impression of strength. He was pleased, surrounded by his three friends, to be mistaken for a boxer." Particularly after the hysterical response to Braque's and

* Apollinaire's *Calligrammes*, published in 1918—the year before his death—consisted of poems where the words form images on the page. It was an attempt to give language a *pictorial* dimension, but the results are more gimmicky than profound.

Derain's submissions to the 1908 Salon des Indépendants, the pugilistic stance perfectly suited their collective mood: belligerent, defensive, defiant.

Typically, Picasso tried to bind his new friends more firmly to him by procuring female companions for them. It was one manifestation of his need to control those around him, ensuring that he would remain the indispensible center of life and love. "I can't have friends if they're not capable of sleeping with me," he once remarked. "Not that I require it of the women or want it from the men—but there should be at least that feeling of warmth and intimacy one experiences in sleeping with someone." If he couldn't hold them through his own sexual magnetism—as he had with Max Jacob, most obviously, but also Mañach, Uhde, and, almost certainly, Casagemas—the next best thing was, like a king of old, to fix up his favorites with suitable mates. After introducing Apollinaire to Marie Laurencin, he facilitated an affair between André Derain and his own former mistress Alice Géry—despite the fact that she was still married to Maurice Princet. Now he tried to do the same for Braque, hoping to wean him from the decadent Paulette Philippi. Initially he decided on an attractive cousin of Max Jacob, the daughter of the owner of a Montmartre club called Cabaret du Néant (Cabaret of Nothingness). The plan backfired when the gang showed up, attired in rented evening clothes complete with top hats, but also drunk and disorderly. After making a scene and being asked to leave, they compounded their offense by making off with coats and canes of the other patrons.

Picasso's second attempt proved more successful when he introduced Braque to a friend of Fernande, Marcelle Lapré, a former model who had posed for van Dongen and Modigliani, among others. "[A] small, serious woman, with extraordinarily tender, perceptive blue eyes," as a friend described the future Mme. Braque, she would prove a perfect mate for her stolid husband, tending to his needs and running his household, like so many of the women in this male-dominated world, while he got on with the business of making himself famous.

Another of Picasso's conquests at this time was a young German painter named Karl-Heinz Wiegels, a strange, sensitive soul with a shaved head, "hard, piercing eyes," and an irrepressible wild streak. He was a friend of Wilhelm Uhde and a member of the circle of German aesthetes

who congregated at the Café du Dôme in Montparnasse. He was also, like many of his fellow *dômiers*, what Fernande describes as being of "eccentric" moral standards, that is, gay.

Picasso persuaded the impressionable Wiegels, who had just endured a difficult breakup with his lover—a pupil of Matisse named Rudolf Levy—to exchange Montparnasse for the Bateau Lavoir, pleased to add one more disciple to the charmed circle. Unfortunately, Wiegels' move to Montmartre coincided with his psychological collapse, for which the *dômiers*, with some justification, blamed Picasso. "After an eventful evening," wrote Fernande, "during which he took ether, hashish and opium in succession, he never regained his senses, and several days later, despite our efforts to care for him, he hanged himself. For some time the studio where he had died became a place of terror for us, and the poor man appeared to us everywhere, hanging as he had been the last time we ever saw him."

Picasso was shaken by Wiegels' suicide, a painful echo of Casagemas' death seven years earlier. One consequence was that it abruptly ended their indulgence in opium, which had been such an integral part of the Rose Period and had fostered an artificial benevolence among people who, when sober, tended to bicker and backbite. "The whole business drove Pablo into a state of nervous depression," Fernande wrote in her diary. "He was unable to work and he couldn't bear to be alone, so I had to be at his side the whole time." He memorialized the painful episode with a painting titled *Still Life with Skull*, a view of an artist's atelier painted in acid colors, with a grim symbol of Death sharing the tabletop with brushes and a palette, reminding us of the toll a creative life takes on those caught up in the maelstrom.

Still Life with Skull stands out as the one painting from this period that contains a faint whiff of *Les Demoiselles'* brimstone. For the most part Picasso eschewed overtly expressive elements in favor of subdued themes and dispassionate analysis. Once the destructive fury of his great painting had run its course, he was content to build on the ruins. To guide him through that blasted territory he grasped the firm, steady hand of Cézanne.

One sign of his preoccupation with the Master of Aix was the emergence of still life as a major factor in his art. Before 1908, he had rarely engaged this time-honored theme, and only on those rare occasions when he needed to make a quick buck. Of all the traditional genres, still life is the one that least appealed to his taste for drama and life in extremis. It is the most reticent, most insular of subjects, ideally suited to exploring purely pictorial problems—which is exactly why both Cézanne and Braque were drawn to it.

While continuing to explore the female nude, Picasso now began a series of paintings featuring Cézannesque tabletop arrangements—ceramic jugs, a few apples, a couple of swivel-hipped pears playing off the conical form of a wineglass—painted in chunky brushstrokes that emphasize solidity of form. Like Cézanne, he makes no attempt to distinguish between the transparent sheen of glass and the mottled skin of a pear, giving to each the same meaty opacity, so we can never forget that what we're looking at is pigment on canvas.

In keeping with his new sobriety and dedication to purely pictorial problems, even the figure paintings are more subdued, showing little of the savagery of *Les Demoiselles*. In *Friendship* and *Three Women*,[*] the figures are fragmented and merge with their surroundings in the manner of *Les Demoiselles*, but the unsustainable paroxysm of the earlier work has receded. They still radiate a kind of barbaric energy—Picasso's version of jungle tom-toms and primal release—but the rhythm has slowed. This is primitivism as life-affirming carnality rather than destructive, death-driven fury.

A marked characteristic of both the still lifes and the figure paintings is their reductive geometry. This builds on a distinctive feature of Cézanne's painting in which he tends to depict rounded forms in terms of faceted planes; hence his boxy apples and chunky vases, whose rims are flattened

[*] *Three Women*, the most ambitious painting of that period, seems to have evolved over time. The more faceted, Cubist look of the final work derived from a second campaign and to be a response to Braque's work from the summer of 1908.

to emphasize the orthogonals of the rectangular frame. Cézanne's dictum "To see in nature the cone, the sphere, the cylinder" is a call to discover beneath the apparent chaos of visual experience an underlying order, the kind imposed by the great classical painters of the past but hidden behind the slick, eye-deceiving surface.* In the wake of the Impressionist discovery of the ever-changing kaleidoscope of sensory perception, any attempt to impose order was something of a fool's errand. For Cézanne, then, the desire to provide solid architectural underpinning to his landscapes and still lifes necessarily involved peculiar perceptual distortions as he sought to reconcile the irreconcilable: chaos with order, the experience of three-dimensional space with the two-dimensional reality of the painted surface. In his still lifes, tabletops are viewed from above and tilted forward so that they press up against the picture plane; in his landscapes, empty sky is minimized and the most distant objects brought forward so that near and far form a single surface—more bas-relief than window.

These anomalies are exaggerated by Picasso; almost all sense of space is lost as figure and ground both swell outward, almost bursting through the fictive wall that separates the space depicted from the world we inhabit. Even as he compresses space, he paradoxically stresses the solidity of his forms through emphatic (though deliberately inconsistent) chiaroscuro. His forms don't lie flat on the surface, as in a Byzantine icon, but protrude and buckle as illusion bumps up against reality, creating a feeling of tectonic plates shifting under pressure. In *Les Demoiselles* these devices contribute to a sense of claustrophobia, of metaphysical terror as creatures seem to leap from one dimension to the next. In the work of late 1907 and 1908 Picasso suppresses these more disruptive elements, sublimating psychic dissonance in structural tension.

For Picasso, purging his art of the narrative, psychological content of his earlier work involved a monastic discipline foreign to his nature. "Picasso

* Cézanne himself stressed the continuity by saying that he "wished to do Poussin after nature."

and I were engaged in what we felt was a search for the anonymous personality," Braque explained. "We were prepared to efface our personalities in order to find originality." Such modesty, of course, came far more easily to Braque than to Picasso, but this was the one time in his life when Picasso was ready, even anxious, to suppress his ego. *Les Demoiselles* had left him feeling unmoored. It would take discipline, hard work, and even a certain loss of identity to restore his equilibrium.

He could not have asked for a better partner in this project than Georges Braque. With the stolid Norman he never had to worry that he would be overshadowed or taken advantage of. Braque was a patient builder, someone who could direct Picasso's destructive impulses into more constructive channels, who could impose order on anarchy.

In the summer of 1908 Braque headed once more to L'Estaque to gather his thoughts after the shock of *Les Demoiselles* and to see what use he might make of the lessons he'd learned at the Cézanne retrospective the previous fall. He was no longer dazzled by the vivid hues of the south, which had once sent him into ecstasies and had released an unsuspected sensualist in him. He banished the prismatic hues favored by Matisse, replacing them with a Cézannesque palette of ochers, greens, and grays. What he was seeking now was an art of measure, of sobriety, of intellectual heft, rather than seductive color.

He returned to Paris in late September, where he submitted six of his L'Estaque views to the jury of the Salon d'Automne. This meant submitting them to the judgment of his former comrade in arms, Henri Matisse, the dominant figure on the panel. Much to his disgust, the jury initially rejected them all. By the time two of the jurors (Albert Marquet and Charles Guérin, but not Matisse) had a change of heart, Braque had withdrawn all his works from consideration.

Kahnweiler sensed an opportunity. Using the oldest trick in the avant-garde playbook, he signed Braque to an exhibition in his gallery, exploiting the controversy to get attention, knowing that the rejection of the former Fauve by his erstwhile colleagues would only add to the public's interest.

His timing was perfect. The quarrel caught the attention of the press, which was always drawn to conflict, particularly when it involved a kind of

civil war among former comrades in the avant-garde. Among those writing up the show was Louis Vauxcelles, who'd already gained a measure of immortality by christening Matisse and his followers the Fauves at their debut at the 1905 Salon des Indépendants. Two years on, and Matisse was once again at the eye of the storm, this time not as the barbarian at the gates but as the voice of reaction putting the upstarts in their place. According to Vauxcelles, Matisse told him: "Braque has just sent a painting made of small cubes." He continued: "In order to make himself better understood (for I was dumbfounded . . .) he [Matisse] took a piece of paper and in three seconds he drew two ascending and converging lines between which the small cubes were set, depicting an Estaque of Georges Braque, who, incidentally, withdrew it from the Grand Palais on the eve of the opening."

Thus *Cubism*, like *Impressionism* and *Fauvism* before it, was a term that began in mockery. And as on those earlier occasions, the artists themselves tried mightily to escape the label, only to concede defeat after it had become such a part of the vernacular that further resistance was futile. "[I]t was Braque who made the first Cubist painting," Matisse declared. "He brought back from the South a Mediterranean landscape that represented a seaside village seen from above. . . . [H]e had continued the signs that represented the roofs on into the sky and had painted them throughout the sky. This is really the first picture constituting the origin of Cubism and we considered it as something quite new about which there were many discussions."

Describing Braque's views of L'Estaque as a series of "little cubes" is more caricature than description; it's certainly not subtle analysis. True, Braque emphasized the boxy form of houses—the ocher walls and red-tiled roofs—using repeated rectilinear modules to provide unity to a scene that might otherwise dissolve into illegible veils of color. Relieving the repetitive rectilinear forms of the houses are fan-shaped patches of green suggesting foliage peeking out from behind the walls. Sky is eliminated altogether, giving the painting a sense of fullness or overcrowding, with no gaps or empty spaces to poke perceptual holes in the canvas. Like Picasso, Braque absorbed the lessons of Cézanne, tilting everything forward so that even the most distant elements seem contiguous with the

picture plane. "It's as if the artist were behind rather than in front of the canvas," Braque said, "pushing everything outwards."

If Braque conceives his Mediterranean landscape as a checkerboard of tilting cubes, they are cubes of a most unusual sort—not the geometric solids imagined by Euclid but deceptive forms that, like quantum particles, elude any sort of precise measurement. In *Houses at L'Estaque* [see color insert], Braque exploits the Cézannesque technique of *passage*, shading each side of the right angle in the building at the center to create a form that simultaneously projects and recedes in space.* The contours separating one object from another are opened up so that structures bleed into each other. The trunk of the tree firmly anchored on the bottom edge of the canvas sprouts branches that merge with the houses in the background, locking near and far into a single faceted surface. Space is not so much eliminated as it is deconstructed.

One-point perspective, invented in the Renaissance to create a convincing illusion of three dimensions, has been replaced by a system that accommodates and even demands multiple points of view, as if the same scene were being examined over time and from different vantages. The vanishing point has completely vanished, eliminating the basic organizing principle of space that prevailed for centuries. "[T]he whole Renaissance tradition is antipathetic to me," Braque said.

> The hard-and-fast rules of perspective which it succeeded in imposing on art were a ghastly mistake which it has taken four centuries to redress: Cézanne and, after him, Picasso and myself can take a lot of the credit for this. Scientific perspective is nothing but eye-fooling illusionism; it is simply a trick—a bad trick—which makes it impossible for an artist to convey a full experience of space, since it forces the objects in a picture to disappear away from the beholder instead of bringing them within his reach, as painting should.

* Alfred Barr defines *passage* as "the breaking of a contour so that the form seems to merge with space."

In Braque's L'Estaque landscapes the new conception of space introduced in *Les Demoiselles* as a means of heightening the experience of disorientation is presented as an end in itself, without the distraction of those savage Furies leering back at us.

While Braque was warming himself on the Mediterranean coast, Picasso was trying to put the trauma of Wiegels' suicide behind him. Haunted, spiritually depleted, emotionally exhausted, he and Fernande decided to leave Paris for the month of August. The place they chose was a tiny village on the Oise River, forty miles north of Paris, called La Rue des Bois. While Fernande was charmed by this remote hamlet tucked along the edge of the Halatte Forest, Picasso compared it unfavorably to the sun-drenched south, summing up his feelings with a single dismissive sentence: "It smells of mushrooms."

Shortly after their arrival he wrote to the Steins, who as usual were summering in Fiesole: "I have been ill, very nervous . . . and the doctor told me to get away and spend some time here. I worked so hard last winter in Paris. This summer in the studio with the heat and so much work to do finally made me ill. I have been here for a few days and already feel much better."

Despite his dislike of the gloomy northern climate, the month he spent in La Rue des Bois was productive. Like Braque, he now turned to landscape, subjecting the trees and farmhouses of northern France to the same kind of geometric reduction that Braque was imposing on the hillsides of the south. Even before his departure, he was aware of the direction Braque's art was headed. "Have you noticed that for some time now," Max Jacob asked Picasso, "Braque has been introducing cubes into his painting?"

Picasso's approach, like Braque's, is conceptual. That is, he is less interested in capturing the particulars of a given scene than he is in presenting an idealized version of the landscape, one that is immediately recognizable but also iconic. But while Braque's paintings exude a kind of cerebral sophistication, Picasso's are a hybrid of Cézannesque geometry and deliberate naïveté. Like so many in the avant-garde, Picasso was drawn to the childlike and the primitive, those wellsprings of supposedly authentic feeling that had been buried beneath thousands of years of civilization. For all their proto-Cubist faceting, there is

something toylike about these trees and houses. Hovering somewhere in the background is the spirit of Henri Rousseau, an outsider artist who was just beginning to be taken seriously by those in Picasso's circle. Rousseau's visions of exotic jungles, fantasies rendered with almost supernatural precision, find an echo in Picasso's fairy-tale views of the Oise valley.

Another contrast to Braque's work from the summer of 1908 was Picasso's continuing engagement with the human figure. For Picasso, trained in the academic tradition he would help destroy, the human form remained the touchstone of "important" art, its source of drama and meaning. Even during his Cubist years he continued to do nudes and portraits alongside the still lifes and landscapes that were its natural subjects.* In La Rue des Bois he was particularly taken with the hulking form of their landlady, a woman of mythic proportions over six feet tall and weighing almost three hundred pounds known as the Widow Putnam. He painted her multiple times, subjecting her to a process of geometric reduction similar to the one he had imposed on the features of the old smuggler Josep Fontdevila two summers earlier. With each successive reconfiguration she becomes less an individual and more an earth goddess, Ur-mother to us all.

By September, both Braque and Picasso were back in Paris, comparing notes and checking on each other's progress. The autumn of 1908 marked the real beginning of their partnership. "Almost every evening, either I went to Braque's studio or Braque came to mine," Picasso recalled. "Each of us *had* to see what the other had done during the day." Perhaps the most surprising thing about their collaboration was Picasso's willingness to suppress his own ego for the sake of a common goal. Matisse remembered seeing Braque's *Houses at L'Estaque* at Picasso's Bateau Lavoir studio, noting with some amusement (or perhaps dismay) that the same

* Braque, too, did occasional Cubist figures, including his masterful *Le Portugais* from 1911. But the figure was always more central to Picasso's art than to Braque's.

work he'd rejected from the Salon d'Automne was now the subject of excited discussions by Picasso and his friends.

The avant-garde was splitting between the "Picassoites and Matisseites," as Gertrude Stein called them. Loyalties were tested and sides chosen. Nowhere were these divisions felt more acutely than in the Stein family itself, with Gertrude championing the Spaniard while Michael and Sally placed their bets on the Frenchman. Leo, once the most daring of all, was turning against both, now that it was becoming clear that his protégés were not inclined to listen to his advice. On one occasion Leo took Picasso into his study to harangue him about where he'd gone wrong. Picasso emerged some minutes later, furious. "He does not leave me alone," he shouted. "It was he who said my drawings were more important than Raphael's. Why can he not leave me alone then with what I am doing now?"

The differences between the two factions were accentuated by Matisse's growing respectability. He'd always been dismissed by his more bohemian colleagues as "the Professor," and now he seemed to be doing everything in his power to live up to this caricature. In 1908, Michael and Sally Stein helped Matisse set up a school in his Montparnasse home where he could propound his theories. At the same time he published his *Notes of a Painter*, in which he tried to distill his intuitive approach into something resembling a philosophy of art. Gertrude Stein, always in competition with her oldest brother and sister-in-law, began taunting the artist by referring to him as *le cher maître*, "in derision of course."

To many in the avant-garde, Matisse's bid for acceptance in mainstream society was a betrayal of his radical past. While he regarded *Les Demoiselles* as a hoax and belittled Braque's paintings of "little cubes," friends of Picasso, led by Apollinaire, began scrawling graffiti around Montmartre that read, "Matisse induces madness! Matisse has done more harm than war!"

While Matisse was reaching for respectability, Picasso was moving decidedly in the opposite direction. To the public at large it was clear that something ominous was brewing in Montmartre, a radically new art form that owed nothing to the great traditions, that seemed deliberately indecipherable, irredeemably ugly, an affront to good taste and to common sense. For decades Montmartre had been a breeding ground

for dangerous ideas, from violent anarchism to the decadent hedonism of drugs and free love. The public hardly knew what to make of the newly minted Cubists, but the one thing that seemed certain was that they were subversives, launching a covert attack on all that was sacred in *la patrie*.

Like Picasso, Braque largely stopped exhibiting at the Salons, still bitter about his treatment at the hands of Matisse and his cronies. Fortunately, controversy generated interest, which enticed the more daring collectors to the rue Vignon. In truth, Kahnweiler had to do very little to cultivate a clientele for this difficult work. Among his conquests was Serge Shchukin, who'd gotten over his initial dismay to become an enthusiastic convert to the new movement.

Kahnweiler's low-key methods defied conventional wisdom, but they perfectly suited the publicity-shy Picasso. Instead of hawking his painters at the various Salons, the dealer would keep a selection of their work on the walls of his gallery and wait for the curious to beat a path to his door. "All I did was hang their pictures," Kahnweiler said.

> You understand, the painters worked in peace: I advanced them the money so that they could live. They brought pictures, we kept the books, we hung the canvases, and the people who were interested in them came to see them. I must say that after a certain point the few people interested in these painters—for there were five or six—came immediately to see the new paintings, and painters and art lovers unable to buy came too; but we never again exhibited publicly, which shows you the absolute contempt in which we held not only the critics, but also the general public . . . In the old days, people went to the Indépendants to get mad or to laugh. In front of certain pictures, there would be groups of people writhing with laughter or howling with rage. We had no desire to expose ourselves either to their rage or to their laughter, so we stopped showing the pictures.

Kahnweiler's methods worked. Soon Picasso and Braque cemented their position as the most radical of the radicals, always a badge of honor in the avant-garde and a selling point to the small cadre of collectors

who made it a point of pride to hang only the most provocative art on their walls.

The very difficulty of this work gave it a dangerous allure. Cubism looked like nothing else and did not belong to any known tradition. With the Fauves one could draw a line from Manet to the Impressionists, through Gauguin and van Gogh, arriving ultimately at the oversaturated canvases of Matisse. But Cubism seemed to come out of nowhere. Of course, those well versed in recent art history could point to the influence of Cézanne on these younger artists, but by late 1908, Picasso and Braque had moved so far and so fast that they had left their master, and indeed the whole Western tradition, far behind.

Kahnweiler's approach provided Picasso much needed stability. For the first time since leaving his parents' home he felt financially secure. "We were beginning to find life easier," Fernande wrote. Among the little luxuries they could now afford was a cleaning woman hired for an hour a day at 20 centimes, though Fernande complained that the woman spent most of her time reading the paper and drinking coffee.

Picasso's rising income also brought other changes to his life. Unlike the scruffy bunch who'd hung around the studio in years past, the new crowd was less cultured but better dressed. "More new faces were appearing now at Picasso's studio," Fernande remembered, "people who were curious about the new school of painting. . . . Picasso was surrounded by admirers, not all of them with the best of motives, and was occasionally taken in by flattery, or by his own self-esteem, but although he enjoyed these devotees, he soon tired of them." One of those attracted by Picasso's rising fame was the fashion designer Paul Poiret, who hosted lavish parties on his boat, *Le Nomad*, which he kept moored in the Seine. Picasso hated these swank affairs but had a hard time turning anyone down.

Crucially, Kahnweiler's unquestioning faith and business acumen provided Braque and Picasso with the space required to explore new pathways without having to make concessions to public taste. Even the imperative to shock was absent. Ironically, this made Cubism far more revolutionary than any of the more deliberately "shocking" movements that followed in its footsteps, since its inventors were intent on digging ever deeper, not worrying about whether anybody "got it." They didn't

publish theoretical tracts like the so-called Salon Cubists, or belligerent manifestos like the Futurists. They didn't set out to provoke. In fact, the most provocative thing about them was their indifference to what the public thought of them. Cubism proved to be so arcane that it could thrive only under very special circumstances, far removed from the spectacle and polemic on which the Parisian art world depended. The critic Vauxcelles, for one, complained about their tactics: "I'm afraid that the mystery with which Picasso surrounds himself only serves his legend. . . . Let him hold an exhibition, simple as that, and then we'll judge it."

Vauxcelles' comments reflected frustration over artists who refused to play by the rules that even the avant-garde had always followed. Other artistic movements had been equally misunderstood and had elicited the same amount of public outcry. But few were less ingratiating. Perhaps no one was less interested in courting public opinion than Braque and Picasso during the early years of Cubism. "At that time our work was a kind of laboratory research from which every tension or individual vanity was excluded," Picasso explained. Cubism was the most hermetic of art forms, a coded language developed by two men who were each other's only real audience. "At that period," he insisted, "I was doing painting for its own sake. It was really pure painting."

From the moment he exposed *Les Demoiselles d'Avignon* to the ridicule of his friends, Picasso largely turned his back on any potential audience. If the most radical and aesthetically adventurous men and women in Paris couldn't comprehend what he was doing, what chance did he have putting his work in front of the ignorant masses? His disdain was encouraged by a sympathetic dealer who knew that such Apollonian indifference exerted its own fascination. Picasso was grateful when Braque decided to join him, but having a fellow traveler share his pilgrimage only emboldened him to stray farther from the beaten path. Reflecting on their seven-year partnership, Braque mused, "Things were said with Picasso during those years that no one will ever say again, things that no one could ever understand . . . things that would be incomprehensible and which gave us such joy . . . and that will end with us." In a tribute to their shared adventure as a team pushing the frontiers of the possible, Picasso began to address his letters to Braque with the heading *"Mon vieux Wilbourg"*

(My old Wilbur) likening their partnership to the brothers who first conquered the air.* They did not lack for champions who tried to make their case in the wider forum—Jacob, Salmon, and, most of all, Apollinaire—but all of them were on the outside looking in, and their well-meaning attempts did as much to obscure as to enlighten.

Throughout the remainder of 1908 and over the course of the next few years, the trajectory of Braque's and Picasso's art was toward ever-greater obscurity, even abstraction, though Picasso always insisted that abstract art was boring. "Nonfigurative painting is never subversive," he said, subversiveness being a good indicator of legitimacy in his eyes. "It's always a kind of bag into which the viewer can throw anything he wants to get rid of." Even the most indecipherable Cubist still life begins with a real subject. However far it strays from normal perception, it is always rooted in that reality, a reality it recovers not on the level of superficial appearance but through some deeper affinity.

To some extent Cubism evolved as an alternative not only to academic art but also to the "decorative" strain in modern art as practiced by the Symbolists and later by the Fauves. "Composition," Matisse declared in "Notes of a Painter," "is the art of arranging in a decorative manner the diverse elements at the painter's command to express his feelings." By "decorative" Matisse did not mean devoid of content but rather work that emulated more archaic forms like folk art, medieval tapestries, or the pre-Renaissance fresco tradition that emphasized the surface of the wall at the expense of an illusion of a third dimension. This mode was iconic: flat, frontal, hieratic, suitable for conveying eternal spiritual truths rather than fleeting impressions. Braque and Picasso, while agreeing with Matisse that the illusionistic space achieved through one-point perspective was a fraud, equated decoration with blandness. It was too simplistic, lacking those tensions, anxieties, and ambiguities that were an essential

* Braque and Picasso were fascinated by airplanes, as they were with movies and any other new technology, and went as often as they could to the air shows at Issy-les-Moulineaux, an aerodrome on the outskirts of Paris.

component of modern life. Cubism offered an alternative to the age-old dualism between the iconic and illusionistic modes, one that can only be called conceptual.* *Les Demoiselles* demonstrated how much more pictorial drama, how much more psychic, intellectual, and perceptual data, could be elicited by squeezing a maximum amount of sculptural plasticity into the least available space.

The characteristic Cubist strategy, at least in this so-called analytic phase, was to split up solid objects as a means of more fully integrating them into their surroundings.† Picasso and Braque reduce forms to geometric solids and then shatter them, like mad jewelers who facet precious gemstones to give them definition, only to hurl them onto the floor in order to explore their interior as well. In the process they reduce color to a bare minimum, allowing the viewer to concentrate on the complexities that emerge when form and space interpenetrate.

One can see the process clearly by comparing three Picasso still lifes from early 1908 through late 1909. In *Carafe and Three Bowls* from the summer of 1908, the forms have an exaggerated solidity; light and shade, though inconsistently rendered, play crucial role in establishing a sculptural presence. In *Bread and Fruit Dish on a Table* from early 1909, the forms still maintain their physical integrity, but now Picasso has pushed even further the spatial contradiction between the sculptural solidity of the loaves, the fruit, and the ceramic vessel and the insubstantial, two-dimensional table upon which these forms sit. By the time we get to *Le*

* This should not be confused with what we today call conceptual art—art based on ideas without physical form—though this contemporary mode ultimately derives from Cubism. In this sense conceptual art was not entirely an invention of the twentieth century. It is a conceptual approach that gives ancient Egyptian art, for example, its distinctive form, in which multiple views of the figure are combined in a single image.

† Art historians tend to divide Braque's and Picasso's Cubist years into the earlier "analytic" phase, from about 1908 to 1910, and a "synthetic" phase, lasting from about 1911 to the beginning of the First World War in 1914. The analytic phase is associated with a progressive fracturing of visible reality into its constituent parts. Synthetic Cubism involves putting the objects back together in conceptual ways, often using the techniques of collage and *papier collé*.

Bock (The Beer), painted in the fall of 1909, the contradictory elements—solid and void, recession and projection—have so deracinated the entire image that each object, and even space itself, exhibits the uncertainty of quantum particles existing in multiple states simultaneously.

The further Cubism dissolved into visual obscurity and the deeper it plunged into conceptual thickets, the more Picasso and Braque tried to ground their work in the mundane. It was difficult enough to decipher a Cubist painting without wandering off into abstruse allegory. The café table with a bottle of cheap spirits, a newspaper, and a few random objects was the classic Cubist subject, something solid enough to withstand ever more elaborate conceptual gymnastics.

For Braque in particular, the process was all about making the image more palpable, more tactile. "[I wish] to touch the object and not merely to see it," he said. "Fragmentation gave me a way to establish space, and movement in space, and I could only introduce the object after making a space for it." Every square inch of the canvas had to be as active as every other so that there were no "holes" piercing the picture plane; space asserted itself as forcefully as the forms that occupied it, void becoming ever more palpable as form began to dissolve.

The function of Cubist fragmentation and Cubist faceting can be explained in the negative by looking at Picasso's difficulty in providing a fuller sense of sculptural form without it. Among the more curious paintings he ever made (and among the ugliest) are a series of female nudes from the spring of 1909. Half art mannequin, half robot, these bathers are bizarrely articulated and misjointed. In *Bather* (now at the Museum of Modern Art) Picasso has twisted the right leg and arm around at impossible angles; her torso broadens, her buttocks multiply, as he combines a number of views in a single form. In these experimental works we can see him groping for a new pictorial language that will allow him to evoke the experience of a three-dimensional form viewed over time and fully integrated into the space around it. Though ultimately unsuccessful, they demonstrate a refreshing capacity to push an idea to an extreme, without worrying that the result will defy conventional standards of beauty.

Cubism can seem the most cerebral of forms, an arid intellectual exercise akin to the most abstruse philosophical debate, but for both

Braque and Picasso it fulfilled a deeper psychological need. The academic painting they despised was all about absence; the artist's enormous skill was deployed for the sake of making the painting disappear so that the illusion might come alive. Cubism, by contrast, was all about *presence*. In *Les Demoiselles*, Picasso had thrust his grotesque harridans forward onto the picture plane and beyond. Without an illusionistic space of their own to inhabit, they were forced into *our* space, where they were both more unnerving but also more effective as *intercesseurs*. For Braque the stakes were different, if equally compelling. He was not superstitious like Picasso; he was possessed by no demons in need of exorcising. Instead, what he sought from painting was a certain sensual satisfaction, a reassuring manifestation of solidity. Traditional one-point perspective, Braque complained, "doesn't allow you to possess things fully." Like Cézanne, he wished to make his landscapes and still lifes more real than real, not illusions of something else but objects in their own right. "The aim is not to *reconstitute* an anecdotal fact but to *constitute* a pictorial fact," he wrote. Picasso, explaining his Cubist portrait of Kahnweiler (1910) to Françoise Gilot, put it this way: "In its original form it looked to me as though it were about to go up in smoke. But when I paint smoke, I want you to be able to drive a nail into it. So I added the attributes—a suggestion of eyes, the wave of the hair, an ear lobe, the clasped hands—and now you can." As the image dissolves under the weight of its own contradictions, the subject is recovered through a system of signs, another set of references that have nothing to do with appearance but that engage other, more conceptual, systems of meaning.*

When he provided this explanation to his mistress, Picasso may well have had at the back of his mind Braque's seminal *Violin and Palette* from 1909, a barely decipherable cascade of faceted forms that is pinned at the very top by a trompe l'oeil nail (complete with cast shadow) that appears

* This process will continue so that in a few years, during the phase known as Synthetic Cubism, the subject would be conjured primarily through linguistic means or other referential systems: collage, stenciled lettering, found objects, etc.

to fix the palette to the painting's surface. The most deceptive element in the painting, the nail testifies to the materiality of the painted surface. Here for the first time we see one of those visual puns that are such an integral part of the Cubist project and a natural by-product of the switch from a perceptual to a conceptual language that Picasso learned from African art. "We didn't any longer want to fool the eye; we wanted to fool the mind," he explained.

Cubism takes to its logical conclusion an insight, already present in the late nineteenth century, that there are different ways to apprehend reality: one is fundamentally perceptual, the other conceptual. Impressionism exploited this insight by wallowing in pure perception—raw sensory data uninformed by any actual experience of the world. To many artists, including Picasso and Braque, this approach was superficial because it left out most of what we actually know about the world. True knowledge required multiple viewings, perhaps even physical and psychological interaction. The nineteenth-century physiologist Hermann von Helmholtz wrote, "The idea of a body in space, of a table, for instance, involves a quantity of separate observations. It comprises a whole series of images which this table would present to me in looking at it from different sides and at different distances." Thus a Cubist still life incorporates multiple views to give depth and substance to perception: the same vase seen from the side and from above, a violin shown schematically to reveal its constituent parts, but also in the round, as if we had not merely observed it but nestled it between neck and shoulder and coaxed from it a few melancholy notes. As Helmholtz understood, to truly know something one has to observe it over time and experience it not only through the sense of sight but also through touch and, finally, in the theater of memory.

It was easy to ridicule this kind of painting as pretentious drivel, which was one more reason Picasso and Braque kept their thoughts to themselves. They were suspicious of theory, working intuitively toward profound concepts that in the hands of lesser practitioners became empty demonstrations. "I remember one day when I was in the middle of it [*The Three Women*]," Picasso wrote to Kahnweiler, "Matisse and [Leo] Stein came to see me and they laughed in my face. Stein told me (I was telling him something to try to explain it to him) but it's the fourth

dimension and at this very moment he starts laughing." Indeed, talk of the fourth dimension, or Henri Bergson's *élan vital,* was the stock in trade of the Salon Cubists who disguised the shallowness of their art by couching it in pseudoscientific jargon. Picasso and Braque largely avoided these pitfalls, but there is no doubt that their painting touched on issues that struck a baffled public as far removed from everyday reality.

As Picasso and Braque pursued their quixotic course, the old camaraderie began to fray. Intellectually and artistically Picasso needed only Braque and Braque, Picasso—the two of them shielded from the rest of the world by Kahnweiler, who paid them a regular stipend so that they could work in peace. Cubism was both a new aesthetic *and* a new ethic, one characterized not by the wistful dreams of poets but by the nuts-and-bolts tinkering of the mechanic. They were Wilbur and Orville men exploring the frontiers of knowledge, embracing the future and keen to experience novel points of view. For years now Picasso's "uniform" had been the workman's blue overalls, an outfit that set him apart from the long-haired bohemians with their romantic illusions. Braque, for his part, adopted a style of proletarian chic, a boxer who strode around the streets of Montmartre in faded denim and secondhand American suits showing just the right amount of wear and tear.

With Braque as his partner, Picasso abandoned for good the pose of the aesthete, as if to rescue art from the ivory tower and proclaim its continuity with the rest of life. His identification with the working class—which ultimately drew him into the Communist Party—was never really political. Rather, it reflected his contempt for the bourgeoisie into which he'd been born and that he associated with his narrow-minded relatives. The role of the artist in the new century was to be different—tougher, grittier, more science and less poetry. Instead of reading Verlaine and Rimbaud, they bought cheap paperbacks that Picasso kept in an old tin tub in his studio: tales of the Wild West like *The Vulture of the Sierra;* novels featuring the American detective Nick Carter or Fantômas, the master thief who prowls the streets of Paris. They preferred cinema to opera, the circus to the theater, and billboards to the walls of the Louvre. One day

walking through the streets of Montmartre, Vlaminck recalled, Picasso halted in front of a cheap poster: " 'Could it be that this is better than Cézanne?' And the second time to affirm: 'It's better than Cézanne!'"

Of course this was largely a pose, but the pose mattered. As rarefied as their art was in terms of its intellectual content, the material from which it was made—both conceptually and physically—was down and dirty. Braque, trained as a housepainter, and Picasso, who had fled from the Beaux-Arts tradition of his youth, disdained anything that smacked of preciousness. The two men played their newfound role to the hilt, mocking the pretensions of the *artiste*. On one occasion, Kahnweiler relates, "[t]hey arrived [at the gallery], imitating laborers, turning their caps in their hands: 'Boss, we've come for our pay.'"

This charade had a serious purpose. It reflected a different conception of the artist's relationship to society: not that of a respectable academician but also not that of a bohemian dropout. The artist of the new century would be a man or woman who could make art out of the gritty stuff of ordinary existence. Refinement, learned references, and high-minded themes: all these were banished in favor of imagery drawn from the streets and cafés, posters and advertisements, cheap mass-produced goods and the flotsam of urban life. Cubism was far too arcane to appeal to the masses, but its subjects were familiar to everybody.

Ironically, at the same time that Picasso was reconceiving himself in the role of proletarian hero, he was beginning to travel in more refined circles. Fame, financial success, and the frisson of danger that attached itself to this most hard-core radical made him an attractive ornament in any society gathering. Fernande noted the changes and the strains it placed both on old friendships and on Picasso's peace of mind.

In retrospect it's clear that an era was coming to an end. The real fissure between then and now opened up when Picasso first shut himself away in his dark studio to began the crushing labor that would lead to *Les Demoiselles d'Avignon*. It was the work that would ultimately define him and define the age to come. His friends had proclaimed him the leader of the new generation before he'd done anything to earn the title. But now that he'd made their prophecies come true, his flock abandoned him. Instead of anointing him the new Messiah, they turned away in embarrassed silence.

The *bande à Picasso* tried to act as if nothing had changed, but the old sense of common purpose was gone. Picasso's great iconoclastic painting marked the beginning of the end. Though it remained out of sight, rolled up and tucked away in a cluttered corner of his Bateau Lavoir studio, it had already done its work: dividing the nineteenth century from the twentieth, defining both past and future, "[c]arrying the destructive force of an earthquake" and "split[ting] art historical time into an old and new epoch . . . as if in 1907 Picasso and, with him, all of art were reborn."

12

Bohemia's Last Stand

What a colorful evening that was!

—FERNANDE OLIVIER

The men and women weaving their erratic course up the hill toward 13 rue Ravignan on the evening of November 21, 1908, came both to celebrate and to mourn. The mood was raucous, even a bit hysterical, as if laughter and delirium could slow down time, could halt, at least for a few hours, the steady, anxious crawl that some called progress. This was bohemia's last stand, a bleary toast to a passing age and a drunken revelry to steel the nerves for what was to come.

At least it seemed that way long after the night's events had passed into legend, for those who were there and even for those who weren't but pretended they were, since to have been among that bleary company meant that you had touched the very heart of things, that you still glowed with the reflected light of a world long since vanished.

The banquet marked the end of innocence and the beginning of something else, something harder-edged and more ferocious: the end of an age of horse-drawn carriages and mellow gaslight, the beginning of a world dominated by the internal combustion engine and the harsh glare of the electric lightbulb. The emblem of the dying age was the hot-air balloon, a craft of transcendence, of dizzying lightness and infinite possibility but

also somehow aimless—more poetic than practical. Some years earlier the photographer Nadar had made himself famous by taking photographs of Parisian rooftops from the gondola of *Le Géant* (The Giant), which had made his studio on the boulevard des Capucines the appropriate venue for the first Impressionist exhibition in 1874. Now the two most radical artists of the new century modeled themselves on the inventors of the airplane, a far more efficient and lethal machine.

The party captured the spirit of jest, of *blague* or *fumisme*, that was one of the most characteristic attitudes of bohemia, a humor that was equal parts laughter and scorn. "[I]t was to be very rigolo," said Gertrude Stein of the night's festivity, "a favorite Montmartre word meaning a jokeful amusement." That attitude had been captured perfectly at Le Chat Noir, the antic cabaret that drew high society and bohemia together on the edge of Montmartre and thrived on the friction between two worlds: between the haut monde of top-hatted gentlemen and their bejeweled consorts, and the patchwork bohemians with their capes and extravagant manners. They had their differences, of course, but in the end they could enjoy each other's company and profit from their disagreements. The artists liked to shock, and the bourgeois liked to be shocked. It was a mutually beneficial arrangement in which each side kept fit through good-natured sparring in which much energy was expended but no one really got hurt.

But on that November evening there were signs of change in the air, which gave to the festivities an almost desperate intensity, as if everyone sensed they were bidding farewell not only to an era but to youth itself. Or perhaps it only appeared that way through the wrong end of the telescope, after years of loss and pain, of triumph and defeat, years in which old friends became estranged and the past transformed into a battleground contested by soldiers who had once marched under the same banner.

Appropriately enough, the man at the center of it all was himself a riddle. Depending on your point of view, Henri Rousseau, the sixty-four-year-old painter known as "Le Douanier" (the customs inspector), was an impostor or the genuine article, an ironic joke or a creature of inexplicable magic. The trick was to hold both views simultaneously. That was the very essence of *blague*, the gesture that pointed in two directions at once.

Henri Rousseau. © *RMN-Grand Palais / Art Resource, NY.*

Rousseau was the guest of honor at the gala Picasso and Fernande were hosting at the Bateau Lavoir. Or perhaps he was the butt of the joke. The host and hostess could never quite make up their minds, and their guests were equally divided, if not confused. That, in the end, was very much the point. If the avant-garde stood for anything, it stood for breaking down barriers, lifting up the despised and tearing down the sacred. The old standards drawing a bright line between good and bad had been erased; the arbiters of quality had been exposed as frauds and the tricksters turned into heroes. In bohemia, high and low, refinement and vulgarity, collided; praise and derision were not mutually exclusive but signs of an energy that was to be cherished as an end in itself. From the time of Manet and the *Salon des Refusés*, the more advanced artists had been held up for ridicule, until, finally, the former outcasts were accepted into the pantheon. Who were they to judge?

There's no doubt that Rousseau was an enigma. A Sunday painter turned visionary, he'd captured the imagination of both the public and the avant-garde. A holy fool to some, merely a fool to others, no one

could deny that, whether through happy accident or through unsuspected cunning, he had produced some of the most remarkable works of the age.

Rousseau's cause had initially been taken up by that unrivaled provocateur Alfred Jarry. And if it was unclear whether Le Douanier was just another one of his absurd creations, like Père Ubu or Dr. Faustroll, he soon acquired a following among more sober observers of the current scene. Among his early boosters were Gustave Coquiot, the man who had written so eloquently about Picasso's first Parisian show; Ambroise Vollard; and Wilhelm Uhde, who had written the first book on him. But there were also some who refused to jump on the bandwagon. The Fauve painter Raoul Dufy called him "an old idiot," recounting his ecstasy in front of a painting by Ernest Meissonier, one of the most successful of the academic painters: "Look at that, my friend; *that's* beautiful. Everything is there—the buttons on the gaiters and the coats, the gold braid on the epaulettes—he even tells you the number of the regiment." What could be done with such a man?

Since 1886, Rousseau had been showing regularly at the Salon des Indépendants, an artist out of step with his times but also somehow distinctly of it. Works like *The Dream* (1910) and *The Snake Charmer* (1907) hold their own next to paintings by his more sophisticated colleagues. His awkwardly drawn portraits have both charm and a surreal intensity. And his haunting landscapes, whether scenes of Paris complete with Eiffel Tower or exotic jungle locales, home to man-eating tigers (most of them inspired by nothing more arduous than day trips to the Jardin des Plantes), were painted with a preternatural clarity that was later employed by Dalí and Magritte to similar ends.

Part of his popularity was due to the fact that his straightforward, even simplistic, approach reassured a public disoriented by the willfully barbaric canvases of subversive radicals. But those same radicals could find here a kindred spirit, someone who came naturally by the innocent vision it had taken them all their lives to achieve. At the Salon des Indépendants of 1890, Gauguin stood before one of Rousseau's works and proclaimed, in his typically oracular fashion, "Now that is painting! It's the only thing that can be looked at here."

Whether Rousseau was in fact an innocent or a sly old fox also depended on your point of view. Apollinaire was happy to stoke the legend, inventing a biography for him that included a fictitious journey to Mexico with the French Army that, the poet claimed, had served as inspiration for his tropical visions. The less romantic truth is that his military career was spent entirely within France and was forced on him after he was convicted of petty theft. There was, in fact, something conniving beneath the innocent mask. After Rousseau learned that he had received the *Ordre des Palmes Académiques* only because he'd been mistaken for someone with a similar name, he continued to wear the violet rosette in his lapel, exploiting the prestige it conferred on him to obtain portrait commissions. Late in life, when he was put on trial for fraud, his lawyer played up his simplicity to win the sympathy of the jury.

Despite his growing renown in avant-garde circles, Rousseau remained poor all his life, inhabiting a wretched one-room apartment near the rue Vercingétorix, where he supplemented his meager government pension by giving lessons in painting and on the violin, an instrument he played with more enthusiasm than skill. As a painter his technique was so painstaking, so labor-intensive, that even at the height of his fame he sold little and then for a price that barely covered the cost of his materials.

Rousseau was a bundle of contradictions, which allowed those who knew him to construct their own plausible version of the man. Even his nickname, "Le Douanier," was off the mark; he had spent most of his life not as a customs officer but in the humble job of a *gabelou*, an inspector who patrolled the banks of the Seine and the areas around the city gates, on the lookout for smugglers.

His personality was even harder to pin down. Many were drawn to his apparent simplicity and good nature. But Fernande also noted a different side to his personality. "His bewildered face radiated kindness," she remarked, "though he would go purple in the face if he was opposed or thwarted. He generally agreed with all that was said, but one felt he was merely holding back and didn't dare to say what he really thought." Coquiot admitted that "he could sometimes be as conceited and disagreeable as anyone." And for all his apparent guilelessness, he had an inflated sense

of his place in history, telling Picasso, "We are the two greatest painters of the age, you in the 'Egyptian' manner, and I in the modern."

The deepest mystery of all is what he thought he was doing when he painted his eerily compelling canvases. His admiration for Gérôme, Meissonier, and other academic painters was unfeigned, and indeed their precision and high finish had something in common with his own approach. This is what he seems to have meant when he called himself the greatest painter in the "modern" idiom. Even more difficult to say is what he made of Picasso and his ilk, though he was certainly flattered by their attention. But there are suggestions that, deep down, he knew his limitations. In 1910, a few months before his death, he wrote to a critic: "I cannot now change my style, which I acquired, as you can imagine, by dint of hard labor. . . . If I have kept my naiveté, it is because Monsieur Gérôme . . . as well and Monsieur Clément . . . always told me to keep it." Innocence is the one quality that is impossible to cultivate deliberately. It was just one of Rousseau's many paradoxes that he seems to have achieved this impossible task.

The idea to pay tribute to Le Douanier originated with Picasso's chance discovery of a portrait by him in a pile at the odds-and-ends shop of Père Soulié, the dealer to whom he himself had resorted when he was in dire straits. The proprietor offered to let him have it for 5 francs, pointing out that if he didn't like it he could always paint over it. Unlike the clueless Soulié, Picasso knew exactly what he'd laid his hands on, later calling it, perhaps with just a hint of *blague*, "one of the most revealing French psychological portraits."

No doubt there was an element of mockery from the very beginning. Of all the artists in Paris, Rousseau was the only one who could be granted an apotheosis without the whole thing seeming pompous and self-congratulatory. What they were celebrating was not so much Rousseau as themselves, men and women with such lively imaginations and lightness of spirit that they could see the drollness of the occasion. Had the object of their attention been worthy of such adulation the affair would have appeared pedantic, but if he'd been merely a fraud it

would have been a pointless waste of time. With his simplicity and inflated ego, Rousseau was an easy man to mock. But as Picasso knew, he was also an artist of great power. In the best tradition of *fumerie*, Rousseau's banquet played in those in-between spaces where true creativity dwelled.

From the beginning it was a chaotic affair. Picasso's studio had been cleared of most of the discarded paint tubes, ash heaps, rags, and assorted debris. The beams and columns were decorated with leafy branches, and the ceiling hung with Chinese lanterns. A large trestle table was set up, with chairs, plates, glasses, and cutlery supplied by Azon's. Van Dongen's studio next door was also cleared out to serve as a coatroom. Propped up at one end of the table stood the Rousseau portrait Picasso had recently acquired, draped in wreaths and banners like a patriotic relic. At the far end, Picasso erected a makeshift throne from a chair and a packing crate, over which he had pinned the banner *"Honneur à Rousseau!"*

The food was to be supplied by the grocer Félix Potin and by Fernande herself. She had spent the previous day making an enormous pot of *riz à la Valencienne* (a type of paella) that she had learned to cook during the summer in Gósol. It was prepared in Max Jacob's studio next door, though Max himself, who'd had a recent falling-out with Picasso, insisted he wouldn't come.

As for the great man himself, he was to be escorted to the Bateau Lavoir by Apollinaire after the other guests had already assembled. Early in the evening, the thirty or so invitees—many without invitations would also find their way to the Bateau Lavoir—began to gather at a nearby bar. It was then that Fernande discovered that the grocer had failed to deliver the order. (It would arrive at noon the following day.) In a panic, she, Gertrude Stein, and Alice Toklas rushed out to see what could be scrounged from the shops in the neighborhood.

In the meantime the guests, who were not expected at rue Ravignan until eight, began the party early. Marie Laurencin, egged on by the men who wanted to see how this proper young lady would handle her liquor, began to down one aperitif after another. By the time they were ready to make their way to the Bateau Lavoir, she was so thoroughly drunk that she

had to be held up by the Steins as she staggered along the cobblestoned streets. Walking through the door of the studio, she promptly fell into a tray of jam tarts that Fernande had managed to get hold of at the last minute. "Her hands and dressed covered with jam," Fernande recalled with evident relish, "she started kissing everyone."

Just then Apollinaire arrived with the guest of honor. "At the sight of Guillaume," Gertrude Stein recalled, "Marie who had become comparatively calm . . . broke out again in wild movements and outcries. Guillaume got her out of the door and downstairs and after a decent interval they came back Marie a little bruised but sober."

As soon as Apollinaire returned, the guests launched into a series of poetic tributes to Le Douanier, who received them, smiling benevolently, on his throne. After Apollinaire chanted his eulogy, André Salmon jumped onto the rickety table, "seized a big glass and drank what was in it, then promptly went off his head, being completely drunk, and began to fight." Gertrude Stein was appalled by the sudden eruption of violence, but Fernande claimed that the entire scene had been staged by Salmon and his fellow poet Maurice Cremnitz, who faked an attack of delirium tremens by chewing a bar of soap and frothing at the mouth.

In the meantime the already crowded room was swollen by passersby—most of Montmartre showed up at one point or another, according to Fernande—including some well-dressed Americans "a bit out of their element," who could barely suppress their laughter, and some locals who began to stuff *petits fours* and other delicacies into their pockets. At one point Frédé wandered in, leading his pet donkey, Lolo, who had to be shooed from the premises before she consumed what was left of the food.

Picasso himself remained largely in the background. According to Gertrude Stein, he was among those who dragged Salmon off after he began swinging wildly at the other guests, while Braque protected Picasso's African sculptures from damage. For the most part Picasso just watched the scene unfold, enjoying the spectacle like a Roman emperor at a gladiatorial combat.

As for the great man himself, Rousseau was overcome by emotion. He received the songs and poems composed specially for the occasion with tearful gratitude:

He beamed with pleasure. He was so happy that all evening he stoically endured the wax tears dripping from a large lantern above him. They formed a small mound like a clown's hat on his head that remained there until the lantern caught fire. We persuaded Rousseau that this was his ultimate apotheosis. Then Rousseau, who had brought his violin, favored us with a little tune.

Fernande concludes with a bit of understatement, "What a colorful evening that was!"

It was indeed that, but so much more. It marked the end of an era, a final outburst of joy, of silliness, before the serious work began. As the guests began to leave, stumbling back down the Butte as the first faint glimmers of the new day began to brush the dome of Sacré-Coeur, many must have sensed it. This explains why so many of them remembered the event years, even decades, later and those who were fortunate enough to have been there racked their liquor-clouded memories for any telling anecdote that might have escaped the memoirists who got there first. None of the firsthand accounts is exactly the same, but each is valuable in its own way, a precious relic of a vanished time preserved in amber.

As for the hosts, their memories were as fallible as their guests'. Fernande stated unequivocally that the whole thing was nothing but a great farce. Picasso told his mistress Geneviève Laporte: "That was a jest you know. No one believed his talent. But he took it seriously and wept for joy." Of course there's an element of truth in this, but Picasso often directed his cruelest jibes at those he loved the most. There's no doubt that he admired Rousseau as an artist, an admiration he demonstrated by the way he treasured the portrait he'd acquired at Soulié's shop, but that was all the more reason to convince historians that his elaborate tribute was meant to ridicule, not to praise.

The Rousseau banquet was not quite the final act. Picasso wouldn't leave the Bateau Lavoir for almost another year, and he would spend much of that time in Horta, where he returned for three months in the summer of 1909. But even before then, the old joy had vanished. Though

he had gotten back together with Fernande, things were never really the same after their breakup. He was no longer infatuated and stayed with Fernande mostly out of habit.

Wiegels' suicide had been another blow. Picasso was haunted by visions of his body dangling before the window and shuddered every time he passed the door that might open at any time upon new horrors. His death put an end to the opium-clouded evenings that had been the key to his courtship of Fernande, kindling her love and prompting her vow "to bind my life to his, for better or worse."

The new sobriety coincided with a shift in Picasso's work, confirming a vision that was tough-minded, less pleasing, one that was the very antithesis of poetic. The future, Picasso now saw, lay not in escapist dreams but in something grittier. Most vanguard movements, from Symbolism to Primitivism, even the wild frenzy of the Fauves, had been backward-looking, nostalgic, responding to the anxieties of contemporary life by seeking refuge from its brutalities. Cubism was the first progressive movement, at least since Impressionism, to fully embrace modernity. Its founders were artists who dressed in denim and mechanics' overalls, ready to face up to the deracinated, disorienting tumult of the young century. Fernande is our best witness to the passing of an era:

> Despite the gaiety, the friendly atmosphere, the shouts, the laughing and the arguments; despite Apollinaire's frequent recitals of his poems or reading of his articles; despite Max's flights of fancy, the majestic vastness of Gertrude Stein and Van Dongen's beard (in which lay all his hopes for worldly success); despite the wise, imposing bearing of Matisse, Braque's rather coarse chatterings and the charmless stupidity of Olin; despite Salmon's whimsy and Picasso's biting wit (which could, for an instant, wipe out the lines drawn by work and worry on his face); despite the youth which still lent its animation to them all, I could already feel something like a premature aging, an imperceptible flagging in their friendships, an occasional unwonted harshness (quickly repressed), an exhaustion at seeing the same old faces every day, at thrashing out the same ideas, at criticizing the same talents and envying the same successes.

In fact, beneath the surface and unnoticed yet, a gradual process of disintegration was bringing with it, very slowly it's true, a split between these artists who had once been so united which they now try in vain to disguise.

While Fernande continued to share Picasso's bed, it was Braque who was the center of Picasso's world. Everyone but the stolid Norman was shut out as the two men tinkered away in their laboratory. Over the course of the next few months, Fernande would continue to serve as an occasional model but never as his muse. She was no longer the voluptuous goddess of Gósol. The paintings and sculptures Picasso now made of her are clinical, even cruel, flayed, dissected—a process Stein likened to being "put through the mincing machine" —analyzed with the intellect that the Cubist projected onto everything that met his pitiless, probing gaze.

In the summer of 1909, Picasso returned to Horta d'Ebre, the hometown of his friend Pallarès, where he had recuperated from scarlet fever in 1898, while Braque spent the summer north of Paris, in La Roche-Guyon and then in Carrières-Saint-Denis with Derain. Despite the physical distance between them, the work from that summer shows them still joined at the hip. Or, to use the metaphor Braque preferred, they were like two mountain climbers roped together, their fate determined by the efficiency with which they worked toward a common goal. They were by now so in sync as to have developed an almost telepathic bond.

Form continues to break down under their relentless assault, becoming ever more fragmented, ever more transparent, until objects and the space that contains them form a continuum. Like radiologists studying bones and muscles under a shower of X-rays, they demonstrate that the harder one looks, the more rigorously one probes, the more things slip through one's grasp.* Yes, knowledge is gained, but only at the expense of

* There are indications that Picasso, for one, was fascinated by X-ray images. The question of how Cubism related to contemporaneous scientific discoveries—quantum physics, relativity—remains controversial. It is safe to say that the artists and scientists were steeped in the same conceptual atmosphere in which commonsense notions of what constituted reality were under assault.

exposing everyday reality as a sham. For centuries art and science had run on parallel tracks, applying rational thought to material reality and bringing the mysterious within reach of the mind. Cubism marks the great reversal of that trajectory, demonstrating that, when pursued to the nth degree, the world becomes strange once more, that logic bears the seeds of its own destruction.

For Picasso, the summer of 1909 was enormously productive. His views of the mountains and rooftops of Horta d'Ebre pushed the language of Cubism in bold new directions [see color insert]. For Fernande, however, it was a miserable time. She felt more isolated than ever, cut off from her friends and native land. She also suffered from a chronic kidney infection that incapacitated her for weeks at a time. While she lay in bed, Picasso was too absorbed in his work to spare her any thought.

After a forced layover in Barcelona while Fernande recuperated sufficiently to make the arduous journey to the mountains, they remained in Horta for almost four months, returning to Paris in early September. By then Picasso was determined to leave the Bateau Lavoir. "It was a great wrench," Fernande recalled, "and it affected him deeply, as he associated the Bateau Lavoir with the happiest times of his life. It is certainly true, as people often say, that once artists become successful they look back with regret on the days when they were poor. They leave behind the best of themselves in the places where their life was such a struggle, a struggle so essential to their artistic development. But above all they abandon their youth."

Late in September 1909, Picasso and Fernande bade farewell to the Bateau Lavoir. They did not abandon Montmartre entirely. The new apartment was located at 11 boulevard de Clichy, at the base of the Butte and close to the apartment where Casagemas had spent his final hours and where Picasso had lived in the spring of 1901. The new apartment was a drastic improvement over the squalid tenement they'd occupied for the past three years. Picasso's studio, with large, north-facing windows opening onto a tree-lined street, quickly devolved into a chaotic mess, but everything else was marked by bourgeois propriety. "Picasso took his meals in a dining room furnished with old mahogany furniture, waited on by a maid in a white apron," Fernande recalled. "He slept in a real bedchamber, on a low bed with heavy brass end posts." So great was the contrast that

the moving men who carted their few pathetic scraps down from the rue Ravignan commented, "Surely these folks must have won the lottery!"

Of course there was no jackpot, but the change in material circumstances was remarkable. Kahnweiler, the Steins (particularly Gertrude; Leo had all but given up), Shchukin, and Vollard now provided Picasso with a steady income. Crucially, he didn't need to worry that his paintings might prove so outlandish that they'd never find a buyer. Not so many years before he had betrayed his ideals by making a pastel on a sentimental theme that he thought he could easily sell. But after trudging for miles through the snow in his threadbare overcoat he had discovered that his dealer had no money to give him. Now he could pursue work of utmost difficulty and still find himself handsomely rewarded. It was a lesson he took to heart: Selling out would get him nowhere; integrity, even belligerence, was, in the long run, a far more effective strategy.

This was the beginning of Picasso's *embourgeoisement*, the steady climb toward first respectability and ultimately unimaginable wealth and fame. "Life was improving," Fernande said, noting the procession of foreigners—Austrians, Spaniards, Hungarians, Swedes, Japanese, and

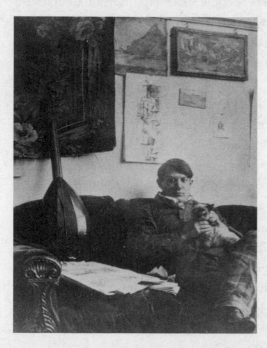

Picasso, Boulevard de Clichy, 1910.
© *RMN-Grand Palais / Art Resource, NY.*

others—streaming through the door and testifying to his growing international celebrity, cultivated by the astute Kahnweiler. But success came at a price. "Little by little the gang split up, dispersed," she recalled. "This group of artists, whose unity of purpose had been its greatest strength, no longer enjoyed the same intimacy. A sort of mutual mistrust pushed them apart."

Fernande was one more victim of the changes taking place in Picasso's life. In truth, things had not been the same since the autumn of 1907, when, in the aftermath of *Les Demoiselles*, Picasso had decided he'd had enough of Fernande. Once again Gertrude Stein was a witness to the slow disintegration: "Things were not in those days going any too well between them, it was just about the time they were quitting the rue Ravignan to live in an apartment in the boulevard Clichy, where they were to have a servant and to be prosperous." It was at one of her Saturday soirees that the couple had a fight that ended with Fernande shaking Picasso so vigorously that he lost a button off his shirt and shouting at him: "[Y]our only claim to distinction is that you are a precocious child"—a verdict that, if it short-changed his genius, provided a pretty fair assessment of his faults.

They would continue on, as many old married couples do, far longer than was healthy for either of them, to the point that causing each other pain proved more compelling than giving each other pleasure. The cold war went on until the winter of 1911–12, when Picasso fell in love again, this time with a friend of Fernande's, a pale, delicate beauty named Eva Goulet.* Even then, though Fernande was carrying on an affair with an Italian painter named Ubaldo Oppi—facilitated by Eva, who saw it as a means of driving a wedge between her and Picasso—he was reluctant to make a clean break. The new mistress appears in Picasso's life in coded form, smuggled into the almost abstract matrix of his Cubist paintings through refrain of a popular song, "Ma Jolie" (My Pretty).

* When he met her, Eva was going under the name Marcelle Humbert. Like many in this bohemian demimonde—Germaine, for instance, and Fernande—she treated her name as a somewhat fluid signifier, no doubt to cover up past associations she preferred not to acknowledge.

If this subterfuge allowed him to pay tribute to his new love right under the nose of his live-in companion, others were not so easily fooled. "One day we went to see him [in his new studio]," said Stein. "He was not in and Gertrude Stein as a joke left her visiting card. In a few days we went again and Picasso was at work on a picture on which was written ma jolie and at the lower corner painted in was Gertrude Stein's visiting card. As we went away Gertrude Stein said, Fernande is certainly not ma jolie, I wonder who it is. In a few days we knew. Pablo had gone off with Eve."

For those who had once gathered under the sign *Rendez-vous des poètes*, the process of estrangement dragged out longer, leading to betrayals, recriminations, and hurt feelings, the embers of affection cooling but never dying out completely. Even after the *Affaire des Statuettes*, when Picasso had refused to acknowledge Apollinaire during his brief imprisonment, the two men continued to be friends, though the poet could not conceal his hurt. To the extent that Apollinaire sought revenge, it was only indirectly, by writing articles praising one or another of the Salon Cubists at Picasso's expense.* But he always came back to Picasso, an artist whose genius continued to exert a powerful hold on him even when he could no longer follow its twists and turns. Picasso's reaction upon learning of Apollinaire's untimely death in November 1918, at the age of thirty-eight, was heartfelt but typically self-centered. At the moment he received the telephone call with the bad news, he was staring at his own face in the mirror, drawing a self-portrait—a portent, he feared, of his own impending doom.

Max Jacob's grief was just as intense but less complicated. "We have spent enough hours laughing together," he said, preparing to stand vigil at Apollinaire's coffin, "for me to spend a few hours weeping by his side." For

* After Picasso refused to lift a finger, Apollinaire would be exonerated with the help of, among others, Albert Gleizes, who wrote in 1946: "Didn't one of his dearest friends deny him when they were brought face to face, losing his head so completely as to declare that he did not know him? Apollinaire spoke to me about this with bitterness, and without hiding his dismay."

some years now, Jacob had been a practicing Christian. Almost the same day that Picasso moved from the Bateau Lavoir, Christ appeared to Jacob on the wall of his tenement at 7 rue Ravignan, as if, with Picasso gone, he needed to replace one god with another. It took a number of years before the Church would allow this Jewish mystic with unconventional habits to convert. He was finally baptized on February 18, 1915, with Picasso standing as godfather; Jacob took as his patron Saint Cyprian, after rejecting Picasso's suggestion of Saint Fiacre, the patron saint of cab drivers. In the end, neither Christianity nor Picasso could save him; he died in 1944 at Drancy internment camp while awaiting transfer to Auschwitz, after Picasso failed to intervene on behalf of his old friend.

If most of Picasso's old friendships devolved into bickering and recrimination, the fault was not always his. As his fame grew, many of the old gang—including Jacob and Fernande—tried to profit by trading in stories of the old days, often betraying confidences or stretching the truth. Often politics intervened, particularly during the 1930s, when the Spanish Civil War and the rise of Fascism forced everyone to choose sides. As Picasso moved to the left, many of his old comrades, including André Salmon, veered right, opening up irreparable breaches.

The two living artists most responsible for Picasso's rise to fame— one his most bitter rival, the other his brother in arms—continued to play an important role in his life. After Picasso dethroned Matisse as the undisputed leader of the avant-garde, his admiration for the older man grew. It was lonely at the top, and as his own sense of isolation grew he craved contact with those few who had been there at the beginning and who had some concept of what it was like to be trapped by fame. Secure in his position, Picasso could afford to acknowledge his admiration.

With Braque the trajectory was reversed. From 1908 onward, he and Picasso had been engaged in an artistic partnership of unprecedented richness and depth, a bond so deep that the women in their lives were often jealous. Once, when Braque was hospitalized, the nurse refused to let Picasso into his room. "She said Madame Braque was with him," he groused. "She didn't realize that I am Madame Braque." That remarkable partnership came to an end in August 1914. When war was declared, the two of them—along with André Derain—were in the south of France. Picasso, who as a foreign national was not liable for service, escorted the

new conscripts to the station. "On August 2 1914 I took Braque and Derain to the station at Avignon. I never saw them again."

That was not literally true, but the war created a chasm that could never be bridged, dividing those who served from those who remained behind. By then Derain had already lost his artistic nerve, retreating, like so many others in those uncertain times, to safer ground. After being wounded in battle in May 1915 Braque returned to civilian life, building on his prewar years as one of the greatest innovators of the century to create a body of work that, if not as startling or wildly inventive as his former partner's, rivaled it in terms of depth of feeling. With the exception of the years he spent as Picasso's collaborator, Braque proved to be a minor master, but a master nonetheless.

Unlike many of those who had shared the poverty of those early days in Montmartre, Braque didn't begrudge Picasso his unmatched fame. Jealousy was not part of his nature, which sometimes enraged Picasso, who was never happy unless he could spark an intense response in someone, good or bad. They continued to see each other from time to time, but, like many a divorced couple, their relationship was marked by a mixture of affection, nostalgia, and occasional spite. Françoise Gilot relates an amusing encounter sometime in the late 1940s, when she and Picasso showed up at the Braques' unannounced:

> The house was filled with the aromatic bouquet of roasting lamb. I could see Pablo mentally adding up . . . the very appetizing kitchen odors plus his lifelong friendship with Braque to get the desired result: an invitation to lunch. But if Pablo knew his Braque by heart, Braque knew his Picasso just as well. . . . Had he made the gesture and invited us for lunch, he could well imagine Pablo having a good laugh about it later, telling everyone, "Oh you know Braque has no mind of his own. I get there at noon, he knows I want lunch so he sits me down and serves me. I push him around and he only smiles."

After Braque politely escorted them from the premises without inviting them to dine, Picasso was furious. But, Gilot concludes, "it became very clear that Braque had risen considerably in his esteem."

For Kahnweiler the arrival of war in 1914 was a disaster. At the outbreak of hostilities he was in Switzerland, and as a citizen of a hostile power he was not allowed to return to France. Much of his stock was confiscated and sold off in bulk, hurting both the dealer and his artists, who saw the value of their work plummet.

Even before the war Cubism was facing a nationalist backlash in the land where it was born. The great auction held at the Hôtel Drouot on March 2, 1914, by André Level and the consortium Le Peau de l'Ours marked in many ways modern art's coming of age. With works by Matisse and Picasso, Gauguin and van Gogh, the star-studded event attracted headlines in the press. Having laid out 27,500 francs, the investors reaped 116,545 francs, an almost fourfold return on their investment. The star of the show was Picasso's *Family of Saltimbanques*, which Level had purchased in 1907 for 1,000 francs and which now sold for 12,650. But the very success of the auction provoked outrage among French patriots. Under the headline "Avant l'Invasion" (Before the Invasion) the right-wing journalist Maurice Delcourt thought he had discovered "[a] new proof of German meddling," concluding that bidders from a hostile nation had deliberately set out to undermine the "measure and order of our national art."

But by this time Picasso was already regarded as the leading artist of his generation, the public face of modernism. Jingoist hysteria could temporarily tarnish his reputation, but he was too firmly established to be dislodged by the forces of reaction. For the rest of his life he would be a lightning rod, the target of those who viewed modernism as the enemy, but he would never lose his status as the embodiment of the avant-garde, scourge of the traditionalists, and a hero to the young at heart. For better or worse he had become the face of the new century.

What of the disruptive painting that had started it all, "the incandescent crater from which emerged the fire of present art"? After showing *Les Demoiselles d'Avignon* to a few friends and collectors in the fall of 1907, Picasso removed the canvas from its stretchers, rolled it up, and tucked it away in a dusty corner of his studio. When he moved from the Bateau Lavoir to the airy rooms of the boulevard de Clichy, it was somewhere

among the other meager belongings carted down the Butte. Fernande, as usual, was silent about the work she associated with the worst period in their relationship. "[T]here was not much worth taking from the old studio besides some canvases, easels, and some books" was her laconic remark.

She always hated *Les Demoiselles*. Or maybe she feared it. The "maidens of Avignon" were her rivals, more than Eva or any of the other mistresses or one-night stands, responsible for her alienation from the one man with whom she had "experienced happiness, the true penetrating warmth of a heart that is in love." Her silence is a tribute to their frightful power. Their siren song had seduced her lover, giving voice to his rage and luring him to the dark places where she dared not follow.

For Picasso himself it was a source he returned to time and again, a deep, dark well that nourished the roots of his creative impulse. In any case, it had cost him too much simply to discard it, to shrug it off as a failed experiment and then move on. The bargain he had struck on his sister's deathbed was now consummated; the forces of both life and death gathered for a midnight rendezvous. Whether or not anyone else understood its true significance, the one incontrovertible fact was that the painting had changed *him*, and in changing him it had changed the world.

In the seven years between the painting of *Les Demoiselles d'Avignon* and the eruption of the greatest man-made cataclysm in history thus far (a title held for a scant twenty-five years), the arts were transformed beyond all recognition, as if to condition men and women for what was to come: the killing fields of Verdun and the Somme, the new threat rising in the east, where a red tide was sweeping all before it. The giddy optimism about the latest technological miracle that had made the *Expositions Universelles* of 1889 and 1900 sparkle turned to ash as the same technologies were weaponized in armored tanks and clouds of mustard gas. Picasso, it turned out, would be the prophet of this new age. As the critic Waldemar George wrote on the occasion of the artist's fiftieth birthday, his art was "the clearest expression of modern disquiet." Looking back to a happier time, seeking ground zero of the grim age dawning, all lines of force seemed to converge on a single spot, on a single work—on a ramshackle

tenement on a neglected square in Montmartre and a painting so disturbing, of such disruptive power, that even its maker kept it hidden from view.

Two years after "the maidens" made their brief turn on stage and a little more than half a decade before the outbreak of the First World War, Matisse still believed he dwelled in Arcadia. "What I dream of is an art of balance, of purity and serenity, devoid of troubling or depressing subject matter," he'd written in "Notes of a Painter," "something like a good armchair which provides relaxation from fatigue." This was not an art that could speak to the new age, no matter how much men and women longed for such reassurance. The world now belonged to a different crowd—tougher, noisier, more belligerent. It belonged to those who refused to turn their backs on the disruptive technologies and instead embraced them, artists with X-ray eyes and atom-smashing fists who didn't provide false comfort but turned their faces to the cacophonous rapture of the future.

The world, in short, belonged to the Cubists and their spawn. Among those misbegotten children were the bellicose Futurists, who proclaimed in the pages of *Le Figaro* on February 20, 1909: "We intend to sing the love of danger, the habit of energy and fearlessness. . . . We affirm that the world's magnificence has been enriched by a new beauty: the beauty of speed. A racing car whose hood is adorned with great pipe, like serpents of explosive breath—a roaring car that seems to ride on grapeshot is more beautiful than the *Victory of Samothrace*." Umberto Boccioni, probably the finest artist among these professional agitators, created his first Futurist sculptures immediately after seeing Picasso's Cubist *Head of a Woman (Fernande)* at Vollard's gallery in 1912. For him, as for most of his colleagues, the interpenetration of solid and void at the heart of both Cubist painting and sculpture was the perfect metaphor for the dynamism of modern life.

More frightening still were visitors from the east, where artists were in the forefront of the revolution, harnessing Cubist geometry as the emblem of their own soulless utopia. They had been nosing around the studios and galleries of Paris for years, looking for anything that might help catalyze a conflagration in their backward land. In 1914, Vladimir Tatlin made the pilgrimage to Paris, during which he saw, among other things,

the cobbled-together assemblages Braque had stuck into the corners of his studio. Five years later these modest constructions had mutated to gargantuan proportions (if only in Tatlin's imagination) in the monstrosity of a kinetic 400-meter tower reaching to the sky and beaming Vladimir Lenin's latest harangue to the expectant masses.*

Kazimir Malevich had been to Paris in 1912 where he, too, had discovered the future in the work of Picasso, Braque, and their Cubist followers. Three years later he published his pamphlet "From Cubism and Futurism to Suprematism: The New Realism in Painting." "I have transformed myself *in the zero of form*," he exulted, capturing an impulse in the modernist project that was as much nihilistic as idealistic.

Picasso had no patience with either the braggarts or the utopian dreamers. He was not an artist of theories or manifestos.† He lit the fuse but didn't stick around to watch the explosion. In the end, it was left to others to pick up the pieces, to comb through the rubble to see what might serve in building something new. Picasso, though he eventually (and reluctantly) became a public figure, was ill suited to the role.‡ His work was too personal, made in response to deep anguish and serving no one beyond himself. Even the minimum requirement to place his art in the public arena ran against the grain of his self-involvement.

If this was true of his art in general, it was particularly true of *Les Demoiselles d'Avignon*, perhaps the most deeply personal and misunderstood painting he ever made. Nine years after it was painted, at the height of

* Tatlin's *Monument to the Third International* was never built, and never really intended to be built. The nascent Soviet Union never had the capacity to erect such a structure, but it reflected the utopian aspirations of the Revolution in its early days.

† Braque's terse putdown of the Salon Cubists was that "[t]hey made ideas instead of paintings," a view shared by Picasso, who had an even stronger aversion to theoretical constructs.

‡ He changed his attitude during the Spanish Civil War, committing himself openly to the socialist cause. *Guernica*, unlike *Les Demoiselles*, was intended from the beginning to address the wider public.

the Great War, *Les Demoiselles d'Avignon* made its public debut at an exhibition titled *L'Art Moderne en France*. Organized by André Salmon, the show was held in a gallery located in a building owned by Paul Poiret, one sign that, whatever the general public thought of it, modernism still had cachet in certain circles. For the sophisticated, the Cubists and their heirs represented the sleek promise of a future untarnished by horrors still to come. Among those attending the posh event was Poiret's fellow high-end couturier Jacques Doucet.

The embrace of Cubism by the smart set merely provoked the critics, who sensed something unpatriotic in the display. The show opened to hostile reviews from journalists, who decried not only the subversive art but the large number of foreigners on the roster. Typical is a piece in the *Le Cri de Paris* from July 23:

> The Cubists are not waiting for the war to end to recommence their hostilities against good sense. They are exhibiting at the Galerie Poiret naked women whose scattered parts are represented in all four corners of the canvas; here an eye, there an ear, over there a hand, a foot on top, a mouth below. M. Picasso, their leader, is possibly the least disheveled of the lot. He has painted, or rather daubed, five women who are, if the truth be told, all hacked up, and yet their limbs somehow manage to hold together.

It was at the 1916 exhibition that the painting acquired its name. Given the mood of wartime Paris, puritanical as well as xenophobic, Salmon tried to cover up the fact that what viewers were looking at was the interior of a bordello, transforming whores into maidens. This bowdlerization of his great masterpiece was one of many sins Picasso held against his old friend.

Following this cameo appearance, *Les Demoiselles* went underground once more. Appropriately enough, the man who would rescue the revolutionary work from the obscurity into which had fallen was André Breton, the founder and chief propagandist of Surrealism, the movement that would come to dominate the postwar years and that was second only to Cubism in establishing the main lines of modernist aesthetics. Breton was

then working as an art adviser to Jacques Doucet. As part of his efforts to find paintings and sculptures to decorate Doucet's home,* Breton wrote to his employer in December 1921, "I somewhat regret the fact that you have not acquired one of Picasso's major works (by this I mean something whose historical importance is absolutely undeniable, such as, for example those *Demoiselles d'Avignon* which mark the origin of Cubism and which it would be a shame to see end up abroad)."

For Breton, Picasso remained a touchstone, the lone figure from the older generation who could still speak to the younger. Recruiting him to the Surrealist cause, he knew, would confer instant legitimacy. "My admiration for you is so great," he wrote him in October 1923, "that I can't always find words to express it."

Crucially, Breton did not see Picasso simply as the inventor of Cubism, nor did he see Cubism as a movement devoted exclusively to the arid intellectual analysis of form. In Breton's eyes, Cubism, and Picasso's work in particular, foreshadowed his own fascination with the subconscious, probing beneath the surface to discover the irrational wellsprings of human behavior. In 1924, when the ballet *Mercure*—for which Picasso had designed the sets and costumes—was disrupted by Dadaists, Breton and the other Surrealists penned "Hommage à Pablo Picasso." Far from being the out-of-touch fossil the Dadaists portrayed, "Picasso . . . defies consecration and goes on creating a troubling modernity at the highest level of expression. . . . [He] is today the eternal personification of youth and the absolute master of the situation."

Nothing made his case as convincingly as *Les Demoiselles d'Avignon*, a work that spoke directly to the irrational side of life and that for the Surrealists represented something "deeper and more real than the real." Doucet was not easily convinced, and two years later Breton was still pleading his case:

* Among the masterpieces Breton convinced Jacques Doucet to purchase, in addition to *Les Demoiselles d'Avignon*, were Rousseau's *The Snake Charmer*, Giorgio de Chirico's *Disquieting Muses*, and a sketch for Seurat's *Circus*. *Les Demoiselles* would ultimately be located at the top of a sleek iron staircase in his new home at 33 rue Saint-James in Neuilly, a western suburb of Paris.

One sure thing [is] *Les Demoiselles d'Avignon*, because through it one penetrates right to the core of Picasso's laboratory and because it is at the crux of the drama, the center of all conflicts that Picasso has given rise to and that will last forever in my opinion. It is a work that to my mind transcends painting; it is the theater of everything that has happened in the last fifty years. . . . If it were to disappear, it would take with it the largest part of our secret.

Doucet finally took the plunge in February 1924, agreeing to purchase the painting for 30,000 francs. Picasso knew that this was far below its market value. The only reason he agreed was that Doucet promised to bequeath the work, along with the rest of his collection, to the Louvre.*

Instead, after Doucet's death in 1929, the painting was sold by his widow to the dealer Jacques Seligmann. That same year a group of New York philanthropists, led by the Rockefeller family, opened the world's first museum of modern art, hiring as its director a young Harvard-trained scholar named Alfred Barr. For Barr, Picasso was "the greatest living artist," and *Les Demoiselles* was the key work of his protean career.

For decades, the Museum of Modern Art and its influential directors—most of all Barr himself and his successor, William Rubin—more or less wrote the official history of art in the twentieth century, and from the beginning they placed Picasso at the center of that narrative. Even before the museum opened in November 1929, Barr was planning a major retrospective of Picasso's work. In the end his plans fell through, in large part because of the artist's reluctance to lose control of the display and dissemination of his work. As it turned out, the first major Picasso retrospective in the United States took place not at the Museum of Modern Art but at the Wadsworth Atheneum in Hartford, Connecticut, in February 1934. The New York museum would have to wait until 1936 for the historic exhibition *Cubism and Abstract Art* to see a large sampling of Picasso's work, and another three for the long-awaited retrospective, *Picasso: Forty Years of his Art.*

* In 1916, Picasso had rejected an offer of 20,000 francs, and shortly after the sale it was appraised at 200,000–300,000 francs, ten times what Doucet had paid.

In 1937 Seligmann's firm shipped *Les Demoiselles* across the Atlantic, where the economic and political situation was far more favorable for the art market. From the moment it arrived, Barr launched a campaign to acquire the work he called "the most important painting of the twentieth century." It took two years before it actually entered the museum's collection. In order to raise the $28,000 asking price, the museum solicited an anonymous $10,000 gift and then took the rare step of deaccessioning another masterpiece from its permanent collection, putting Degas' *The Race Track* on the market. From that moment, *Les Demoiselles d'Avignon* has been viewed as the foundational work of the museum's incomparable holdings and, indeed, the key work in the entire modernist project.

But while its importance is now almost universally accepted, the terms under which it has gained its foundational status have been contested. Writing for the catalogue of the 1939 exhibition, Barr called *Les Demoiselles* "the first cubist picture," but also "a transitional picture, a laboratory or, better, a battlefield of trial and experiment . . . a work of formidable, dynamic power unsurpassed in European art of its time." In large part because of Barr's authority and the authority his museum conferred, the intellectual frame placed around *Les Demoiselles* was that of a precursor, a liminal work whose chief importance lay in its role as the progenitor of Cubism. In the famous diagram Barr created for the 1936 exhibition *Cubism and Abstract Art*, one can fit *Les Demoiselles* neatly on the right-hand side, at the junction of Cubism and "Negro Sculpture" that flows into the great stream that leads to Suprematism, Constructivism, Bauhaus, and De Stijl—all emptying into the vast ocean labeled "Geometrical Abstract Art."*

* Barr traces "two main currents" of abstract art. "The first and more important current finds its sources in the art and theories of Cézanne and Seurat, passes through the widening stream of Cubism and finds its delta in the various geometrical and Constructivist movements which developed in Russia and Holland. . . . This current may be described as intellectual, structural, architectonic, geometrical, rectilinear and classical in its austerity and dependence upon logic and calculation. The second—and, until recently, secondary—current has its principal source in the art and theories of Gauguin and his circle, flows through the *Fauvisme* of Matisse to the Abstract Expressionism of Kandinsky. . . . This

This "formalist" interpretation came despite the fact that no less a figure than André Breton—by then perhaps the dominant personality in the avant-garde—had discovered another, buried narrative, one in which the painting was not the origin of geometric abstraction but a revelation of the great psychic rupture at the heart of civilization. That view was more likely to be held by laymen, who saw in Picasso's shredded forms the signs of a deeper disturbance. Carl Jung spoke for many when he claimed he saw in it the hallmarks of a deep psychotic breakdown. In 1932, after attending an exhibition of Picasso's paintings in Zurich, he compared Picasso to a schizophrenic, describing "the journey to Hades, the descent into unconscious. . . . I mean that personality in Picasso which suffers the underworld fate—the man in him who does not turn towards the day-world, but is fatefully drawn into the dark; who follows not the accepted ideals of goodness and beauty, but demoniacal attraction of ugliness and evil."

The debate about the meaning of *Les Demoiselles d'Avignon* is largely a battle about the meaning of modern art itself. While modernism remained a dynamic force, with an almost Bolshevik confidence that we were standing at the end of history, the painting was rationalized, reduced, in Salmon's phrase, to "white chalk ciphers on a blackboard." Clement Greenberg, the most important American critic in the two decades after the Second World War, defined this formalist approach. Writing in *Partisan Review* in 1948, Greenberg insisted:

> Cubism remains the epoch-making feat of twentieth-century art, a style that has changed and determined the complexion of western art as radically as Renaissance naturalism once did. . . .
>
> [B]y its rejection of illusionist effects in painting or sculpture and its insistence on the physical nature of the two-dimensional picture plane . . . [it] expressed the positivist or empirical state of mind with its refusal to refer to anything outside the concrete

tradition . . . is intuitional and emotional rather than intellectual; organic or biomorphic rather than geometrical in its forms; curvilinear rather than rectilinear, decorative rather than structural, and romantic rather than classical."

experience of the particular discipline, field or medium in which one worked; and it also expressed the empiricist's faith in the supreme reality of concrete experience.

It was only when modernist hubris was collapsing into postmodern doubt that those long-suppressed elements were allowed back into the discourse. Of course they were always there, hiding in plain sight—the rage, the misogyny, the unbridled libido. But they weren't spoken of in polite company. They were embarrassing excesses that could be ignored without distorting the central message, rather than the message itself.*

Picasso hated all of this. If he scoffed at scholars who wrapped his work in obscure theories, he resented even more anyone who tried to psychoanalyze him. He was a deeply private man who found himself the most famous artist in the world. He never sought the role of a public figure, and only on rare occasions did he make art specifically for public consumption. He had clawed his way to the top, but once there he felt exposed. "Picasso withdraws into himself," a critic observed on the occasion of his fiftieth birthday, "pays heed to his voices, listens to the familiar demons that haunt him." For the most part he worked only for himself. And not for pleasure but out of necessity, to provide an army of his own to combat the legions of the night. "How can anyone enter into my dreams, my intentions, my desires, my thoughts," he once asked, "which have taken a long time to mature and to come out into daylight?"

In the end, neither fame, nor wealth, nor love or even art could protect him from his most implacable foe: devouring Time and His snarling companion Death. The nearer he approached to the end of his long life, the more he looked back on the years he spent on the rue Ravignan as the golden age, infinitely precious but forever just beyond his reach. He had achieved everything he thought he wanted, but it was never enough. "It

* The key moment in that shift came in 1972 with the publication of Leo Steinberg's "The Philosophical Brothel," which refocused attention on the painting's repressed sexual content. This narrative was also shaped by the new feminist scholarship, which was rightfully suspicious of any history that ignored the personal dimension.

was at the Bateau Lavoir that I was famous!" he cried, "when I never had a sou—there I was famous, I was a painter! Not a freak."

By the time he uttered this plaintive cry, the world had changed along with him. It had grown disillusioned. The hope of those years, the faith in progress—that humankind would move forever onward and upward until we had reached a perfected future—died in the trenches on the western front, in the gas chambers of Auschwitz, at Hiroshima and Nagasaki, and in the Twin Towers in lower Manhattan. Remembering the promise with which the new century had begun made the betrayal seem all the more bitter. For Picasso, and for all who have lived through these troubled times, the myth of a lost golden age has grown more powerful with each passing year, its distant glow casting ever-longer shadows on the age to come.

Acknowledgments

Writing is one of the most solitary of endeavors, but books are, ultimately, collaborative efforts. The current volume would not have been possible without the thoughtful guidance provided by my editor, Bob Bender, and the tireless work of Johanna Li and the rest of the team at Simon & Schuster. I also owe a debt of gratitude to my agent, Jim Levine, who believed in this project before anyone else and helped see it through to completion. Also essential was the team of reference librarians at Winchester Public Library who tracked down every book and article I requested, no matter how obscure.

Like most narrative biographies, *Picasso and the Painting That Shocked the World* is built on a vast body of original documents and scholarship. Every Picasso biographer, the present author included, owes a debt to the artist's friends and lovers, many of whom left first-hand accounts that must form the basis for any fully rounded portrait of this complicated man and the fascinating world that shaped his art. Each of us owes a particular debt to one friend in particular, the art historian John Richardson, whose multivolume biography of the artist remains the one against which all others will be judged. Since its founding in 1929, the Museum of Modern Art in New York has been a vital center for Picasso studies, contributing in incalculable ways to our understanding and appreciation of his work. I'm grateful as well to the people of Barcelona and Paris, who continue to treat their own storied past with the reverence it deserves.

Finally, I'd like to thank my wife Jody for her patience and support, as well as her many insightful comments on the evolving manuscript. Her companionship made every research trip a pleasure and the process of writing a bit less solitary.

—Miles J. Unger
February, 2018

Notes

1: IN SEARCH OF LOST TIME

1 "whose folds had long since given up the struggle for form": Françoise Gilot, *Life with Picasso* (New York: McGraw-Hill, 1964), 78.

2 "One has to be able to afford luxury": Pierre Cabanne, *Picasso: His Life and Times* (New York: William Morrow, 1977), 411.

2 "Those who thought that he had put his youth behind once and for all": Brassaï, *Picasso and Company* (Garden City, NY: Doubleday, 1966), 41.

3 "raw state of his nerves": Ibid., 102.

3 "When I see Picasso": Ibid.

4 "You're too complicated for me": Gilot, *Life with Picasso*, 24.

4 "I thought you weren't coming back": Ibid., 91.

5 "Over the weeks that followed": Ibid., 78.

5 shut out the world: Ibid., 47.

5 "You mind your business": Ibid., 46.

6 "I could admire him": Ibid., 84.

6 "the intelligent one": Ibid., 14.

6 "That's the funniest thing": Ibid., 15.

6 "You're very gifted": Ibid., 21.

6 "two peaches": Ibid., 26.

7 "You do everything you can": Arianna Huffington, *Picasso: Creator and Destroyer* (New York: Simon & Schuster, 1988), 279.

7 "English reserve": Gilot, *Life with Picasso*, 25.

7 "there are only two kinds of women": Ibid., 84.

7 "[H]e was very moody": Ibid., 83.

8 "I'm going to take you to see the Bateau Lavoir": Ibid., 78.

9 "[I]t is good to walk": Fernande Olivier, *Picasso et ses amis* (Paris: Stock, 1973), 47.

10 "I would have thought": Gilot, *Life with Picasso*, 78.

12 "There's where Modigliani lived": Ibid.

12 "That was my first studio": Ibid.

12 "A little farther along": Ibid., 79.

13 "We will all return to the Bateau Lavoir": Jean-Paul Crespelle, *La vie quotidienne à Montmartre* (Greenwich, CT: New York Graphic Society, 1962), 11.

16 "He put his hand on the doorknob": Gilot, *Life with Picasso*, 80–81.

16 "She was so sweet": Ibid., 81.

16 "He knocked at a door": Ibid., 82.

17 "[W]omen are suffering machines": André Malraux, *Picasso's Mask* (New York: Da Capo, 1976), 138.

18 "Kafkaesque": Gilot, *Life with Picasso*, 45.

18 "I don't care to yield": Ibid., 46.

18 "Paris was liberated": Brassaï, *Picasso and Company*, 150.

19 "poets, painters, critics": Ibid., 149.

19 "From that moment on": Gilot, *Life with Picasso*, 64.

19 "Famous . . . of course I'm famous": Malraux, *Picasso's Mask*, 48–49.

19 "In the light of that": Gilot, *Life with Picasso*, 81–82.

20 "I knew by now": Ibid., 109.

20 "Picasso believes that art": Jaime Sabartés, *Picasso: An Intimate Portrait* (New York: Prentice-Hall, 1948), 65.

22 "a fascinating square of the Fourth Dimension": Jeanine Warnod, *Washboat Days* (New York: Grossman, 1972), 3.

2: THE LEGENDARY HERO

24 "Why put obstacles in his way?": Jaime Sabartés, *Picasso: An Intimate Portrait* (New York: Prentice-Hall, 1948), 47.

25 "In art, one must kill one's father": John Richardson, *A Life of Picasso*, vol. 1, *The Prodigy, 1881–1906* (New York: Alfred A. Knopf, 1991), 95.

27 "fur and feather": Sabartés, *Picasso: An Intimate Portrait*, 7.

27 decidedly more risqué pleasures: Richardson, *A Life of Picasso*, I:20.

27 "Every time I draw a man": Brassaï, *Picasso and Company* (Garden City, NY: Doubleday, 1966), 56.

28 "more Catholic than the Pope": Richardson, *A Life of Picasso*, I:75.

29 "a newborn . . . [who] orders the universe": Mark Antliff and Patricia Leighten, *Cubism and Culture* (London: Thames & Hudson, 2001), 130.

29 "[Y]our only claim to distinction": Gertrude Stein, *The Autobiography of Alice B. Toklas* (New York: Vintage Books, 1990), 96.

30 "No Málaga": Sabartés, *Picasso: An Intimate Portrait*, 9.

31 "he gave me his paints": Ibid., 30.

31 "[M]uch as I despise academic methods": Richardson, *A Life of Picasso*, I:49.

32 "Pigeons of guaranteed genealogy": Ibid., I:46.

32 "Without so much as a how-d'ye do": Joseph Palau i Fabre, *Picasso: The Early Years, 1881–1907* (Barcelona: Ediciones Polígrafa, 1985), 41.

33 "soup, stew and a main course": Richardson, *A Life of Picasso*, I:40.

33 hunting feral cats: Ibid., I:41.

34 he would never draw again: Ibid., I:49.

34 "are not badly drawn": Ibid., I:55.

36 "Among Barcelonans of my class": Sabartés, *Picasso: An Intimate Portrait*, 17.

37 "The awkwardness and naïveté": Brassaï, *Picasso and Company*, 86.

37 "The test, for which one month was prescribed": Roland Penrose, *Picasso: His Life and Work* (Berkeley: University of California Press, 1981), 32–33.

39 "He had a very strong personality": Pierre Cabanne, *Picasso: His Life and Times* (New York: William Morrow, 1977), 33.

39 "People said that he had secret powers": Axel Salto, quoted in Arianna Huffington, *Picasso: Creator and Destroyer* (New York: Simon & Schuster, 1988), 143.

39 "Picasso was a sun all on his own": Geneviève Laporte, *Sunshine at Midnight: Memories of Picasso and Cocteau* (New York: Macmillan, 1975), 25.

40 "At fifteen": Cabanne, *Picasso: His Life and Times*, 33.

40 "*You have one Rambla*": Robert Hughes, *Barcelona* (New York: Random House, 1992), 446.

41 "traveling scholarships": Sabartés, *Picasso: An Intimate Portrait*, 41.

42 bloodred rose petals: Richardson, *A Life of Picasso*, I:72.

43 "Before so much grief": Ibid., 84.

44 "just a pittance": Sabartés, *Picasso: An Intimate Portrait*, 40.

44 "an oil well or a mine": Ibid.

45 "But don't be mistaken": Xavier de Salas, "Some Notes on a Letter of Picasso," *The Burlington Magazine* 102, no. 692 (November 1960): 483.

45 "Modernist it must be": Ibid.

45 "What times of happiness": Richardson, *A Life of Picasso*, I:95.

45 "You can well imagine": Sabartés, *Picasso: An Intimate Portrait*, 41.

46 "[O]ur soldiers came back from the colonies": Palau, *Picasso: The Early Years*, 141.

47 "All that I know": Sabartés, *Picasso: An Intimate Portrait*, 43.

47 "He wore *espadrilles*": Ibid., 42–43.

49 "We are reappearing in the capital of Catalonia": Palau, *Picasso: The Early Years*, 157.

50 "mixture of archeology and *modernismo*": Marilyn McCully, *Els Quatre Gats: Art in Barcelona Around 1900* (Princeton, NJ: Art Museum, Princeton University, 1978), 16.

51 "This stopping place": Ibid., 18.

51 "springtime of posters": Ibid., 23.

53 "I am pleased to hear": Palau, *Picasso: The Early Years*, 155.

54 "I was the best friend with whom to carry on a conversation": Sabartés, *Picasso: An Intimate Portrait*, 19.

55 "I remember my leave-taking": Ibid., 18.

56 "an amusing wastrel": Richardson, *A Life of Picasso*, I:115.

56 "Since they wanted to appear chic": Fernande Olivier, *Picasso et ses amis* (Paris: Stock, 1973), 17.

56 "We used to raise hell together": Richardson, *A Life of Picasso*, I:116.

56 coffee spiked with flaming brandy: Ibid., 119.

57 "it is more offensive": Cabanne, *Picasso: His Life and Times*, 278.

57 "neurotic dilettanti": Richardson, *A Life of Picasso*, I:237.

57 "the most apolitical man I ever met": Ibid., 171.

58 "half cabaret and half chophouse": Sabartés, *Picasso: An Intimate Portrait*, 18.

58 "[T]he arches of the café": Palau, *Picasso: The Early Years*, 175.

59 "black period": Ibid., 167ff.

59 "Pallor was the order of the day": Sabartés, *Picasso: An Intimate Portrait*, 56.

60 "Death waits for all": McCully, *Els Quatre Gats*, 37.

61 "full of style and spontaneity": Richardson, *A Life of Picasso*, I:127.

61 "If Casas had a corner": Sabartés, *Picasso: An Intimate Portrait*, 53.

61 "group of nonentities": Ibid., 55.

62 "The most assiduous visitors": Ibid.

62 "Sr. Picasso has talent": Palau, *Picasso: The Early Years*, 513.

62 "young man, almost a boy": Ibid., 512–13.

62 "Above all . . . what we wanted": Sabartés, *Picasso: An Intimate Portrait*, 55.

62 "poems featuring fairies": Ibid., 56.

63 "In 1900": Ibid., 52.

64 "Nothing counted except the fashion from Paris": Ibid.

64 "When he was away": Ibid., 19–20.

64 "Why not attend the Academia a little longer?": Ibid., 47.

66 "[It] shows a young priest": Palau, *Picasso: The Early Years*, 512.

66 "pictures in oils": Ibid., 162.

68 "Let us welcome this youth": Richardson, *A Life of Picasso*, I:154.

68 "[t]he jacket was very loose": Palau, *Picasso: The Early Years*, 199.

69 "*Yo el rey*": Richardson, *A Life of Picasso*, I:157.

3: DIRTY ARCADIA

71 "The sympathy Paris inspires": Robert Hughes, *Barcelona* (New York: Random House, 1972), 432.

73 "I beseech you": Sue Roe, *The Private Life of the Impressionists* (New York: HarperCollins, 2006), 131.

73 "without money and without a home": Fernande Olivier, *Picasso et ses amis* (Paris: Stock, 1973), 30.

74 "Go up to Montmartre": André Salmon, *Modigliani: A Memoir* (New York: Putnam, 1961), 44.

75 "I think my laughter": Jean-Paul Crespelle, *La vie quotidienne à Montmartre* (Paris: Hachette, 1978), 142.

76 "[w]e're working hard": Casagemas to Ramón Reventós, October 25, 1900, in *A Picasso Anthology: Documents, Criticism, Reminiscences,* ed. Marilyn McCully (Princeton, NJ: Princeton University Press, 1981), 28.

76 "Some nights . . . we go to café-concerts": Ibid.

76 "We have already launched into work": Ibid., 27.

77 "One table, one sink": Ibid., 30.

77 "The young Montmartre girls": Jean Renoir, *Renoir, My Father* (Boston: Little, Brown, 1962), 206.

78 "faithful . . . in the fashion of Montmartre": Gertrude Stein, *The Autobiography of Alice B. Toklas* (New York: Vintage Books, 1990), 24.

78 "good habit of getting drunk every night": Casagemas to Ramón Reventós, November 11, 1900, in McCully, *A Picasso Anthology*, 31.

78 "All this about women": Picasso to Ramón Reventós, November 11, 1900, in McCully, *A Picasso Anthology*, 30.

79 "a kind of Eden": Casagemas to Ramón Reventós, November 11, 1900, in McCully, *A Picasso Anthology*, 31.

81 "the heroine of many a strange story": Stein, *The Autobiography of Alice B. Toklas*, 25.

81 "Everybody has the same energy potential": Françoise Gilot, *Life with Picasso* (New York: McGraw-Hill, 1964), 348.

81 "Picasso would go from museum to museum": Marilyn McCully, *Picasso in Paris: 1900–1907* (New York: Vendome Press, 2011), 119.

82 "the ascent of progress": Jeanine Warnod, *Washboat Days* (New York: Grossman, 1972), 50.

83 "a single touch of the finger": John Allwood, *The Great Exhibitions* (London: Studio Vista, 1977), 102.

83 City of Lights: Ibid.

83 "You forget that I am Spanish": Pierre Cabanne, *Picasso: His Life and Times* (New York: William Morrow, 1977), 491.

84 "a true sense of grief": McCully, *Picasso in Paris*, 18.

85 "a heap of excrement": Mary McAuliffe, *Dawn of the Belle Époque: The Paris of Monet, Zola, Bernhardt, Eiffel, Debussy, Clemenceau, and Their Friends* (Lanham, MD: Rowman & Littlefield, 2014), 246.

86 "In painting as in literature": Robert Goldwater, *Symbolism* (New York: Harper & Row, 1979), 156.

89 "Women who have exaggerated fashion": Philippe Jullian, *Montmartre* (Oxford: Phaidon, 1977), 43.

89 *"rendez-vous du high life"*: June Rose, *Suzanne Valadon: Mistress of Montmartre* (New York: St. Martin's Press, 1998), 90.

91 "There are in Paris scarcely fifteen art-lovers": Ibid., 65.

92 "The Rue Laffitte": Ambrose Vollard, *Recollections of a Picture Dealer* (Mineola, NY: Dover Publications, 2002), 71.

92 "Speculators! Buy art!": Dan Franck, *Bohemian Paris: Picasso, Modigliani, Matisse, and the Birth of Modern Art* (New York: Grove Press, 2001), 13.

93 "The man we were waiting for": McCully, *Picasso in Paris*, 20.

93 "funny little squinting near-sighted old lady": Leo Stein, *Appreciation: Painting, Poetry and Prose* (Lincoln: University of Nebraska Press, 1996), 159.

94 "The gallery was of the same dimensions": McCully, *Picasso in Paris*, 117.

94 "Make way for the young": Warnod, *Washboat Days*, 66.

94 *La Merveille*: John Richardson, *A Life of Picasso*, I: 163.

94 "He was dead right": Ibid., 164.

94 "When he passed my store": Ezra Mendelsohn, "Should We Take Notice of Berthe Weill? Reflections on the Domain of Jewish History": *Jewish Social Studies* (New Series) 1, no. 1 (Autumn 1994): 33.

95 she vowed never to have anything more to do with him: Crespelle, *La vie quotidienne à Montmartre*, 33.

95 150 francs: Ibid., 21.

97 "which fascinated us": Jaime Sabartés, *Picasso: An Intimate Portrait* (New York: Prentice-Hall, 1948), 20.

97 "[W]hat concerned him most": Ibid., 48.

98 "an unhappy adultery": Richardson, *A Life of Picasso*, I:124.

100 "To you, young enthusiasts": Josep Palau i Fabre, *Picasso: The Early Years, 1881–1907* (Barcelona: Ediciones Polígrafa, 1985), 216.

101 "What on earth are you thinking of!": Sabartés, *Picasso: An Intimate Portrait*, 45–46.

101 "to spout reams of poetry": Richardson, *A Life of Picasso*, I:189.

101 "Picasso would observe our group": Ibid.

102 "We, his Catalan friends": Sabartés, *Picasso: An Intimate Portrait*, 50.

102 "Picasso, not yet twenty": Palau, *Picasso: The Early Years*, 514.

102 "Paris, with its bad reputation": Ibid.

4: LES MISÉRABLES

105 "I'm going to tell Carles": Richardson, *A Life of Picasso*, I: 180.

106 "*Voilà pour toi!*": Josep Palau i Fabre, *Picasso: The Early Years, 1881–1907* (Barcelona: Ediciones Polígrafa, 1985), 212.

106 "*Et voilà per moi!*": Ibid.

106 "his face like a crushed strawberry": Richardson, *A Life of Picasso,* I:181.

107 "You must know about poor Carlos": Picasso to Miquel Utrillo, 1901, in *A Picasso Anthology: Documents, Criticism, Reminiscences,* ed. Marilyn McCully (Princeton: Princeton University Press, 1981), 32.

108 "My works . . . are a summary of destruction": Roland Penrose, *Picasso: His Life and Work* (Berkeley: University of California Press, 1981), 49.

108 One of the strangest and most disturbing manifestations: Jaime Sebartés, *Picasso: An Intimate Portrait* (New York: Prentice-Hall, 1948), 94.

109 "[m]y only true masters": Richardson, *A Life of Picasso*, I:194.

109 "Poor Gauguin!": Jeanine Warnod, *Washboat Days* (New York: Grossman, 1972), 64.

109 "Vollard is a slave trader": Ibid.

109 "a rock-bottom price": Richardson, *A Life of Picasso*, I:194.

109 "The first visit to Vollard": Gertrude Stein, *Autobiography of Alice B. Toklas* (New York: Vintage Books, 1990), 30.

109 "he guarded jealously": Fernande Olivier, *Picasso et ses amis* (Paris: Stock, 1973), 59.

109 "was a sort of repository": André Salmon, *Modigliani: A Memoir* (New York: Putnam, 1961), 38.

110 "The little table placed at varying distances": Sabartés, *Picasso: An Intimate Portrait,* 70–71.

111 "[I]t is easy to detect numerous likely influences": Palau, *Picasso: The Early Years,* 514–15.

112 "Towards 1901": Ambrose Vollard, *Recollections of a Picture Dealer* (Mineola, NY: Dover Publications, 2002), 219–20.

112 "are too varied": Ibid., 515.

113 "My exhibition in Paris has had some success": Picasso to Joan Vidal i Ventosa, July 13, 1901, in McCully, *A Picasso Anthology*, 35.

113 "*embarras de choix*": Ibid., I:194.

113 The most intriguing purchaser: Richardson, *A Life of Picasso*, I:20.

114 "They said when I began in Paris": Marilyn McCully, *Picasso in Paris: 1900–1907* (New York: Vendome Press, 2011), 50.

115 "[The Vollard show] went very well": Richardson, *A Life of Picasso*, I:199.

115 "Your friend has gone mad!": Max Jacob, "Picasso, Apollinaire, Salmon and Jacob" in McCully, *A Picasso Anthology*, 54.

116 *Au rendez-vous des poètes*: Jean-Paul Crespelle, *La vie quotidienne à Montmartre* (Paris: Hachette, 1978), 105.

116 "poet laureates" of Picasso's life: Richardson, *A Life of Picasso*, I:205.

117 "As soon as [Picasso] arrived in Paris": Max Jacob, "Souvenirs sur Picasso contés par Max Jacob" in McCully, *A Picasso Anthology*, 38.

118 "I went to see them": Ibid.

118 "We don't have to do anything": Pierre Cabanne, *Picasso: His Life and Times* (New York: William Morrow, 1977), 358.

119 "perfectly handsome": Ibid., 76.

119 "an atrocious accident": Arianna Huffington, *Picasso: Creator and Destroyer* (New York: Simon & Schuster, 1988), 58.

119 "Picasso has been my friend for sixteen years": Ibid., 143–44.

119 "At nightfall Mateo [de Soto]": Sabartés, *Picasso: An Intimate Portrait*, 71–72.

120 "This first visit to Picasso's studio": Ibid., 59.

120 "The first thing one saw": Ibid., 70.

121 "[T]he sufferings one has inflicted on others": Françoise Gilot, *Life with Picasso* (New York: McGraw-Hill, 1965), 101.

121 "It was thinking about Casagemas's death": Pierre Daix, *Picasso: Life and Art* (New York: Icon Editions, 1993), 87.

122 "It's probably as a result of [El Greco's] influence": Brassaï, *Picasso and Company* (Garden City, NY: Doubleday), 143.

123 "the true artist must ignore everything": Sabartés, *Picasso: An Intimate Portrait*, 65.

123 "We are passing through an age": Ibid.

124 *"Pictor en misere humane"*: Richardson, *A Life of Picasso*, I:219.

124 "fundamentally identical with primitive art": Robert Goldwater, *Symbolism* (New York: Harper & Row, 1979), 184.

124 "neglected the mysterious centers of thought": Ibid., 1.

124 "[t]he master from Tahiti": Warnod, *Washboat Days*, 40.

125 "At nightfall we went out together": Sabartés, *Picasso: An Intimate Portrait*, 80.

125 "[D]ecorative painting": Goldwater, *Symbolism*, 184.

126 "One night, I know not for what reason": Sabartés, *Picasso: An Intimate Portrait*, 62.

127 "that marvelous blue mirror": Ibid., 63–64.

127 "Towards 1901": Ibid., 78–79.

129 "*outrage à la pudeur*": Richardson, *A Life of Picasso*, I:221.

129 "a strange city": Ibid., 219.

130 "What . . . was at the heart of it all": Olivier, *Picasso et ses amis*, 27.

130 "nothing but sentiment": Richardson, *A Life of Picasso*, I:277.

130 Picasso admitted to her that he'd contracted venereal disease: Ibid., 218.

132 "Back in their early starvation period in Paris": Gilot, *Life with Picasso*, 166.

133 "In 1901 . . . this square was a desolate spot": Sabartés, *Picasso: An Intimate Portrait*, 72–73.

133 "The chimney was of little use": Ibid., 74.

134 "It's nothing my lads": Ibid., 75.

134 "With the tip of his brush dipped in blue": Ibid., 77.

135 "Picasso had made up his mind to leave us": Ibid., 82.

136 "I'm showing what I'm doing": Picasso to Max Jacob, July 13, 1902, in McCully, *A Picasso Anthology*, 38.

136 "one foot in Barcelona": Sabartés, *Picasso: An Intimate Portrait*, 90.

136 "Naturally we went to the Salon Parés": Ibid., 87.

138 "The celebrated artist Pablo Ruiz Picasso": Palau, *Picasso: The Early Years*, 310.

139 "those days of misery": Picasso to Max Jacob, 1903, in McCully, *A Picasso Anthology*, 41.

139 "I did sell a few Picassos": Cabanne, *Picasso: His Life and Times*, 80.

139 "I was living on the rue Champollion": Michael FitzGerald, *Making Modernism: Picasso and the Creation of the Market for Twentieth Century Art* (New York: Farrar, Straus and Giroux, 1995), 28.

139 "The door was open": Huffington, *Picasso: Creator and Destroyer*, 67.

140 "For the rest of his life": Richardson, *A Life of Picasso*, I:259.

140 "[Picasso] would draw all night": Huffington, *Picasso: Creator and Destroyer*, 67.

140 "My dear old Max": Picasso to Max Jacob, in McCully, *A Picasso Anthology*, 41.

140 "Picasso who painted before he learned to read": McCully, *Picasso in Paris*, 235.

141 "talisman": Richardson, *A Life of Picasso*, I:264.

141 "an ardent temperament": Ibid., I:267.

141 "dust of Paris": Geneviève Laporte, *Sunshine at Midnight: Memories of Picasso and Cocteau* (New York: Macmillan, 1975), 19.

142 "I don't have enough 'dough'": Richardson, *A Life of Picasso*, I:276.

143 "Pablo Ruiz Picasso": Palau, *Picasso: The Early Years*, 342.

147 "There is in fact only love that matters": Penrose, *Picasso: His Life and Work*, 89.

147 "From his experiments": Sabartés, *Picasso: An Intimate Portrait*, 98–99.

148 "Few, very few": McCully, *Picasso in Paris*, 129.

5: THE SQUARE OF THE FOURTH DIMENSION

150 "a period of transition": Francis Steegmuller, *Apollinaire: Poet Among the Painters* (New York: Penguin, 1986), 73.

152 "Cubism was perhaps the most important": John Golding, *Cubism: A History and Analysis 1907–14* (New York: Faber and Faber, 1968), 15.

154 "other ideas and other behavior": Jerrold Seigel, *Bohemian Paris: Culture, Politics, and the Boundaries of Bourgeois Life, 1830–1930* (Baltimore, MD: Johns Hopkins University, 1986), 17.

154 "Montmartre the free city": Philippe Jullian, *Montmartre* (Oxford: Phaidon, 1977), 82.

155 "Montmartre is going to descend on us": Louise Michel, *The Red Virgin: The Memoirs of Louise Michel* (Tuscaloosa, AL: University of Alabama, 1981), 61.

156 "Montmartre is a small provincial town": Jullian, *Montmartre*, 34.

156 "There are windmills": Ibid., 21.

156 "It is, in fact, entirely paradoxical": Jeanine Warnod, *Washboat Days* (New York: Grossman, 1972), 11–12.

157 "she allows the spread of her legs": Alex Danchev, *Georges Braque: A Life* (New York: Arcade, 2012), 14.

158 "People went to that cabaret": Steegmuller, *Apollinaire*, 71.

158 "to visit if you want to be insulted": June Rose, *Suzanne Valadon: Mistress of Montmartre* (New York: St. Martins Press, 1999), 69.

159 "He was amused by their odd ways": Fernande Olivier, *Picasso et ses amis* (Paris: Stock, 1973), 155.

162 "[The place Ravignan] cuts the street in two": Warnod, *Washboat Days*, 38.

162 "But if it hadn't been decided in favor of that": Ibid., 3.

164 "The studio was a furnace": Olivier, *Picasso et ses amis*, 53–54.

164 "painters, sculptors, literary men": Ibid., 24.

165 " 'Ye shall be a Symbolist!' ": Warnod, *Washboat Days*, 40.

165 "Bent, young and old": Ibid., 12.

165 "M'sieu' Picasso": Olivier, *Picasso et ses amis*, 90.

167 "I was dying of hunger": Richardson, *A Life of Picasso*, I:210.

167 "This is not the way it ought to be": Leo Stein, *Appreciation: Painting, Poetry and Prose* (Lincoln: University of Nebraska Press, 1996), 172.

168 "I was struck by one painting": Olivier, *Picasso et ses amis*, 26–27.

169 "It seems to me you will sell many in Paris": Marilyn McCully, *Picasso in Paris: 1900–1907* (New York: Vendome Press, 2011), 140.

170 "Can you imagine me": Richardson, *A Life of Picasso*, I:304.

171 "He spoke little": Stein, *Appreciation*, 170.

172 "He always loved making other people laugh": Fernande Olivier, *Picasso and his Friends* (New York: Appleton-Century, 1964), 59–60.

172 "Picasso laughed and played along": Warnod, *Washboat Days*, 19.

172 "biting and flattering": Olivier, *Picasso et ses amis*, 33.

173 "[a] dreamer with a keen sensibility": Ibid., 92.

174 "*Yo te présente Salmon*": André Salmon, *Souvenirs sans fin: Première Époque (1903–1908)* (Paris: Gallimard, 1955), 169.

174 "We didn't break up until dawn": Richardson, *A Life of Picasso*, I:319.

174 "The famous lock": Salmon, *Souvenirs sans fin*, 170.

174 "a wooden paint box": Ibid.

174 "A wonderful raconteur": Olivier, *Picasso et ses amis*, 92.

176 "He was an inspired talker": Steegmuller, *Apollinaire*, 35.

176 "He lived among legends": Ibid., 36.

176 the *prince des poètes*: Richardson, *A Life of Picasso*, I:332.

176 "Apollinaire stood up": Steegmuller, *Apollinaire*, 75.

177 "By thunder Smirking": Guilliame Apollinaire, *Alcools* (Berkeley: University of California Press, 1965), 123.

177 "ready to defend": Steegmuller, *Apollinaire*, 76.

177 "Guillaume Apollinaire never gave me the impression": Ibid., 153.

177 "daughter of Apollinaris": Ibid., 15.

178 "A sphinx was your father": Apollinaire, *Alcools*, 103.

178 "a malicious wink": Steegmuller, *Apollinaire*, 125.

178 "Apollinaire was smoking": Ibid.

179 "You've heard of La Fontaine": Richardson, *A Life of Picasso*, I:327.

179 "Live like a poet": McCully, *Picasso in Paris*, 156.

179 "the freest spirit": Richardson, *A Life of Picasso*, I:334.

179 "pierrots wreathed in roses": Ibid., I:330.

181 "At the end of a supper": William Rubin, Hélène Seckel, and Judith Cousins, *Les Demoiselles d'Avignon* (New York: Museum of Modern Art, 1994), 128.

182 "As a group of young men": André Salmon, *Modigliani: A Memoir* (Putnam, 1961), 47.

182 "Here one came across": Olivier, *Picasso et ses amis*, 65–66.

183 "a small, hot cellar": Ibid., 41.

183 "[Picasso] bought me cakes": Fernande Olivier, *Loving Picasso: The Private Journal of Fernande Olivier* (New York: Harry N. Abrams, 2001), 173–74.

184 "I often noticed that despite the solid affection": Olivier, *Picasso and his Friends*, 116–17.

184 "Friends, a few more or less": Olivier, *Picasso et ses amis*, 56–57.

185 "They would return home at night": Ibid., 38.

185 "If you're settling up there": Jean-Paul Crespelle, *La vie quotidienne à Montmartre* (Paris: Hachette, 1978), 79.

185 "dimly lit by two kerosene lamps": Olivier, *Loving Picasso*, 173.

186 "We did not feel the want of money": Francis Carco, *The Last Bohemia: From Montmartre to the Latin Quarter* (New York: Henry Holt & Company, 1928), 27.

187 two tables were set aside for Manet, Degas, and their guests: George Moore, *Reminiscences of the Impressionist Painters* (Dublin: Maunsel, 1906), 13.

187 "I haven't washed for a week": Rose, *Suzanne Valadon*, 27.

188 "Nothing could have been more interesting": Sebastian Smee, *The Art of Rivalry: Four Friendships, Betrayals, and Breakthroughs in Modern Art* (New York: Random House, 2016), 130.

188 "a crimson scarf": Olivier, *Loving Picasso*, 172.

188 "Now we'll have a little art": Josep Palau i Fabre, *Picasso: The Early Years, 1881–1907* (Barcelona: Ediciones Polígrafa, 1985), 374.

189 "Picasso was beginning to be worshiped": Olivier, *Picasso et ses amis*, 113.

190 "his huge deep eyes": Olivier, *Loving Picasso*, 137–39.

190 one million francs: Ibid., 286.

191 "I'm living in hell": Ibid., 53.

191 hot chocolate and brioches: Ibid., 74.

191 "seemed to me to inhabit": Ibid., 75.

192 "Here . . . life is preserved by hope": Ibid., 158.

192 "'What are your heroes of the future'": Ibid., 121.

193 "He seemed to spend all his time": Olivier, *Picasso et ses amis*, 25.

193 "another stupid adventure": Olivier, *Loving Picasso*, 137.

193 "Yesterday afternoon": Ibid., 139.

194 "I've been back to see my Spanish painter": Ibid., 140.

194 "show[ing] me a side of life": Ibid., 152.

194 "I can't go and live with Pablo": Ibid., 141.

194 "In the evenings there's a lot of merriment": Ibid., 148.

195 "Poor Pablo is very unhappy": Ibid., 142.

195 "Everything seems beautiful": Ibid., 156.

196 "Well I don't give a f—!" Ibid., 161.

196 "to the memory of a young woman": Ibid., 161.

196 "What inspired him to create": Ibid., 162.

197 "We don't have any money": Ibid., 165.

6: LA VIE EN ROSE

198 "If there were no public": Hilary Spurling, *Matisse: The Life* (London: Hamish Hamilton, 2009), 10.

198 "That's fine. I'm glad he doesn't like it!" Daniel-Henry Kahnweiler, *My Galleries and Painters* (Boston: MFA Publications, 2003), 43.

199 "[H]e was always distraught when he had to sell": Fernande Olivier, *Picasso et ses amis* (Paris: Stock, 1973), 144.

200 "It was a revelation to me": Spurling, *Matisse: The Life*, 104.

200 "Modigliani had his first glimpse of Picasso": André Salmon, *Modigliani: A Memoir* (New York: Putnam, 1961), 41.

201 "If you are tempted to think me paradoxical": Marilyn McCully, *Picasso in Paris: 1900–1907* (New York: Vendome Press, 2011), 235.

202 "How little poverty mattered": Olivier, *Picasso et ses amis*, 70.

203 "The sly Harlequin": Paul Verlaine, *one hundred and one poems* (Chicago: University of Chicago Press, 1999), 55.

203 place des Invalides: Josep Palau i Fabre, *Picasso: The Early Years, 1881–1907* (Barcelona: Ediciones Polígrafa, 1985), 398.

204 "Whether we weep or suffer": Ibid., 399.

204 "are the kind of creatures": Apollinaire, *Apollinaire on Art: Essays and Reviews, 1902–1918* (Boston: ArtWorks, 1960), 13.

205 "The oldest wore tights": Richardson, *A Life of Picasso*, I: 336.

207 "[f]riendship would become more intimate": Olivier, *Picasso et ses amis*, 57.

207 "an atrocious and gracious little criminal": McCully, *Picasso in Paris*, 171.

207 "One night Picasso deserted the group of friends": André Salmon, "On *Les Demoiselles d'Avignon*" in *A Picasso Anthology: Documents, Criticism, Reminiscences,* ed. Marilyn McCully (Princeton, NJ: Princeton University Press, 1981), 55–57.

209 "But tell me, who *are* they": Rainer Maria Rilke, *The Selected Poetry of Rainer Maria Rilke* (London: Picador, 2014), 175.

209 "an eccentric . . . who became the epitome": Olivier, *Picasso et ses amis*, 43.

209 "[Max] went to the concierge": Richardson, *A Life of Picasso*, I:378.

210 "In Holland, Picasso was startled": Olivier, *Picasso et ses amis*, 43.

211 "most incongruous miscellany": Fernande Olivier, *Loving Picasso: The Private Journal of Fernande Olivier* (New York: Harry N. Abrams, 2001), 179.

212 "I'll do it for you": Ibid.

212 "Several other artists": Jeanine Warnod, *Washboat Days* (New York: Grossman, 1972), 69–70.

213 "a hyena": Richardson, *A Life of Picasso*, I:352.

213 "the Isle of Cack": Ibid.

213 "horse dealer": Olivier, *Picasso et ses amis*, 63.

214 "[a] rare event in that epoch": Michael FitzGerald, *Making Modernism: Picasso and the Creation of the Market for Twentieth Century Art* (New York: Farrar, Straus and Giroux, 1995), 26.

214 "Me . . . I buy Picassos": Jean-Paul Crespelle, *La vie quotidienne à Montmartre* (Paris: Hachette, 1978), 230.

214 "Art dealer": Brassaï, *Picasso and Company* (Garden City, NY: Doubleday, 1966), 21.

215 diabetes medicine: Olivier, *Picasso et ses amis*, 45.

215 "Sagot arrives at the studio": Ibid., 44–45.

216 "Dear friend Jacinto": Picasso to Reventós in McCully, *A Picasso Anthology*, 51.

216 "When we were twenty": André Malraux, *Picasso's Mask* (New York: Da Capo, 1976), 49.

217 "Heavens!" Ibid.

219 "the master of the arts of grey": Spurling, *Matisse: The Life*, 45.

219 "they appealed strongly to the customers": Ibid., 107.

220 "as if [we] were breaking stones": Ibid., 80.

221 "the temper of the eternal pupil": Janet Hobhouse, *Everybody Who Was Anybody: A Biography of Gertrude Stein* (New York: Anchor Books, 1989), 41.

221 "I believe the realist period is over": Gaston Diehl, *Derain* (Paris: Flammarion, 1991), 25.

221 "Matisse's paintings bear witness": Jack Flam, ed., *Matisse: A Retrospective* (New York: Park Lane, 1988), 45.

222 "is assuming, willingly or not,": Ibid., 45–46.

223 "[T]here are great hampers of cherries": Spurling, *Matisse: The Life*, 117.

223 "it's the light": André Derain, *Lettres à Vlaminck* (Paris: Flammarion, 1955), 159.

223 "The night is radiant": Ibid., 167.

223 "one saw . . . everybody who was anybody": Leo Stein, *Appreciation: Painting, Poetry and Prose* (Lincoln: University of Nebraska Press, 1996), 152.

224 "those outlaws were to be shown": Gertrude Stein, *Autobiography of Alice B. Toklas* (New York: Vintage Books, 1990), 34.

224 "A tempest raged": Leo Stein, *Appreciation*, 158.

224 "We come to the most astounding room": Warnod, *Washboat Days*, 110.

224 "This is madness!": Flam, *Matisse: A Retrospective*, 50.

225 "Look! A Donatello": Richardson, *A Life of Picasso*, I:413.

225 "the incarnation of Disorder": Sebastian Smee, *The Art of Rivalry: Four Friendships, Betrayals, and Breakthroughs in Modern Art* (New York: Random House, 2016), 184.

225 "For us, Fauvism was a trial by fire": Diehl, *Derain*, 33.

225 "painted with chrome oxide green stripes": Jack Flam, *Matisse and Picasso: The Story of their Rivalry and Friendship* (Cambridge, MA: Westview Press, 2003), 11.

225 "Poor Matisse!": Sue Roe, *In Montmartre: Picasso, Matisse and Modernism in Paris, 1900–1910* (London: Fig Tree, 2014), 128.

226 "such daubs": Richardson, *A Life of Picasso*, II: 72.

226 "invaded every evening": Spurling, *Matisse: The Life*, 132.

226 "I found myself holding four bills": Ibid., 106.

226 "I was so moved": Ibid.

227 "Matisse . . . seems to have gone to the dogs": Ibid., 136.

227 "*la question du Salon*": Richardson, *A Life of Picasso*, I:414.

227 "Picasso, with whom we meet": McCully, *Picasso in Paris*, 159–60.

228 "You've got to be able to picture": Pierre Daix, *Picasso: Life and Art* (New York: Icon Editions, 1993), 64.

7: FRIENDS AND ENEMIES

229 "'Painters stay away from Matisse!'": Hilary Spurling, *Matisse: The Life* (London: Hamish Hamilton, 2009), 137.

230 "[Leo] Stein can see at the moment": Ibid., 142.

231 "Had it not been for the shadow of himself": Richardson, *A Life of Picasso*, I: 396.

231 "You don't know what it is to be bored": Janet Hobhouse, *Everybody Who Was Anybody: A Biography of Gertrude Stein* (New York: Anchor Books, 1989), 24.

232 "Art . . . is having its revenge on me": Ibid., 37.

232 *la gloire:* Ibid., 30.

233 "Do you know Cézanne?": Ibid., 154.

233 "a bit like a desperado": Ibid., 150.

233 despite the fact that he wasn't: Ibid., 170.

233 "In 'modern art' I was never interested": Leo Stein, *Appreciation: Poetry, Painting and Prose* (Lincoln: University of Nebraska Press), 202.

233 "Cézanne debauch": Ibid., 156.

234 "the strongest impression": Ibid., 157.

234 "the paintings weren't ripe yet": Spurling, *Matisse: The Life*, 133.

234 "something that was decisive": Leo Stein, *Appreciation*, 158.

234 "It was a tremendous effort": Ibid.

235 "I still can see Frenchmen": Hobhouse, *Everybody Who Was Anybody*, 41.

235 "who had the instinct in that group": Spurling, *Matisse: The Life*, 140.

235 "People came . . . and so I explained": Leo Stein, *Appreciation*, 201.

236 "It was a queer thing in those days": Ibid., 156 and 157.

236 "I had known for some time": Ibid., 169.

237 "[W]hen he recommended another Spaniard": Ibid.

237 "Gertrude Stein did not like the picture": Gertrude Stein, *The Autobiography of Alice B. Toklas* (New York: Vintage Books, 1990), 43.

238 "'By the way'": Leo Stein, *Appreciation*, 190.

238 "Ah those Steins": Hobhouse, *Everybody Who Was Anybody*, 48.

239 "really intelligent": Leo Stein, *Appreciation*, 159.

239 "one of those characters": Gertrude Stein, *The Autobiography of Alice B. Toklas*, 44.

239 "Roché is very nice": Ibid., 44.

240 "Good good excellent": Ibid., 45.

240 "One could not see Picasso": Leo Stein, *Appreciation*, 170.

240 "a mess": Ibid.

240 "The homes, persons and minds": Ibid., 170–71.

240 "Picasso in those days": Gertrude Stein, *The Autobiography of Alice B. Toklas*, 46.

241 often denied service on the assumption: L. C. Breunig, Jr., *Apollinaire on Art* (Boston: ArtWorks, 2001), 29.

242 "very large, very beautiful": Gertrude Stein, *The Autobiography of Alice B. Toklas*, 46–47.

242 "In the long struggle": Ibid., 54.

245 "Still too Symbolist!": Francis Steegmuller, *Apollinaire: Poet Among the Painters* (New York: Penguin, 1986), 127.

246 "I often said that I had complete confidence": Leo Stein, *Appreciation*, 175.

246 "appalling but romantic": Gertrude Stein, *The Autobiography of Alice B. Toklas*, 52.

246 Etta bought "1 picture and 1 etching": Richardson, *A Life of Picasso*, I:514, note.

247 "They are not men": Gertrude Stein, *The Autobiography of Alice B. Toklas*, 49.

247 "In the low smoky room": Wilhelm Uhde, *Picasso and the French Tradition* (Paris: Éditions des Quatre Chemins, 1929), 20.

248 "Uhde used often to come Saturday evening": Gertrude Stein, *The Autobiography of Alice B. Toklas*, 96.

249 "A madman painted it": Spurling, *Matisse: The Life*, 138.

249 "important collector from Moscow": Fernande Olivier, *Picasso et ses amis* (Paris: Stock, 1973), 143.

250 "I had recognized the value of Picasso": Leo Stein, *Appreciation*, 188.

250 "I remember it as if it were yesterday": Brassaï, *Picasso and Company* (Garden City, NY: Doubleday, 1966), 252.

251 "[T]he Matisses were back": Gertrude Stein, *The Autobiography of Alice B. Toklas*, 53.

252 "She had come to like posing": Ibid., 50.

252 "Little by little": Ibid., 41.

252 "she has presented the epoch": Hobhouse, *Everybody Who Was Anybody*, 140.

252 "That evening Gertrude Stein's brother": Gertrude Stein, *The Autobiography of Alice B. Toklas*, 46.

253 "Our collection became in time": Leo Stein, *Appreciation*, 195.

253 "All three men": Spurling, *Matisse: The Life*, 154.

253 "Matisse was a social person": Leo Stein, *Appreciation*, 171.

253 "the North Pole and the South": Olivier, *Picasso et ses amis*, 103.

253 "Bourgeois, bourgeois, bourgeois!": Richardson, *A Life of Picasso*, I:433.

254 "Picasso burst out": Leo Stein, *Appreciation*, 171.

254 "She was a most excellent cook": Gertrude Stein, *The Autobiography of Alice B. Toklas*, 7.

255 "[I]sn't it extraordinary": Ibid., 8.

255 "During these evenings": Olivier, *Picasso et ses amis*, 173.

255 "Guillaume was extraordinarily brilliant": Gertrude Stein, *The Autobiography of Alice B. Toklas*, 59.

255 "Matisse was then at the top of his game": Olivier, *Picasso et ses amis*, 173.

256 "The hosts wander amiably": Ibid.

256 "Matisse and Picasso then being introduced": Gertrude Stein, *The Autobiography of Alice B. Toklas*, 64.

256 "as was the habit in those days": Ibid.

257 "genius is nothing more": Sebastian Smee, *The Art of Rivalry: Four Friends, Betrayals, and Breakthroughs in Modern Art* (New York: Random House, 2016), 83.

257 "Picasso and Matisse, who were quite close": Olivier, *Picasso et ses amis*, 108.

257 "A hit!" Spurling, *Matisse: The Life*, 155.

8: THE VILLAGE ABOVE THE CLOUDS

258 "warp[ing] our approach": Robert Rosenblum, "Picasso in Gósol: The Calm before the Storm" in Marilyn McCully, *Picasso: The Early Years: 1892–1906* (Washington, DC: National Gallery of Art, 1997), 263.

259 "Like the apocalyptic visions by El Greco": Ibid.

259 "He felt himself a man apart": Leo Stein, *Appreciation: Painting, Poetry and Prose* (Lincoln: University of Nebraska Press, 1996), 172.

262 "What I dream of": Henri Matisse, "Notes on a Painter" [1908], in *Art in Theory, 1900–1990*, ed. Charles Harrison and Paul Wood (Oxford, UK: Blackwell, 1993), 76.

263 "His instinct . . . pushed him toward all that was tormented": Fernande Olivier, *Picasso et ses amis* (Paris: Stock, 1973), 117.

263 "One really has to be masochistic": Geneviève Laporte, *Sunshine at Midnight: Memories of Picasso and Cocteau* (New York: Macmillan, 1975), 38.

264 "I can't see you any longer": Gertrude Stein, *The Autobiography of Alice B. Toklas* (New York: Vintage Books, 1990), 53.

265 "Ingres may have died": Richardson, *A Life of Picasso,* I:, 421.

266 "return in thought and style": Elizabeth Cowling and Jennifer Mundy, *On Classic Ground: Picasso, Léger, de Chirico, and the New Classicism 1910–1930* (London: Tate Gallery, 1990), 325.

267 Manolo and Enric Casanovas: Richardson, *A Life of Picasso,* I:423ff.

267 "Beautiful forms are glorified": Josep Palau i Fabre, *Picasso: The Early Years, 1881–1907* (Barcelona: Ediciones Polígrafa, 1985), 440.

271 "Remember that a picture": Robert Goldwater, *Symbolism* (New York: Harper & Row, 1979), 18.

273 "Max and I gaped at the sight": Jean-Paul Crespelle, *Picasso and His Women* (New York: Coward-McCann, 1969), 68.

274 "Pablo is quite different in Spain": Fernande Olivier, *Loving Picasso: The Private Journal of Fernande Olivier* (New York: Harry N. Abrams, 2001), 182.

275 "one accepts for oneself": Françoise Gilot, *Life with Picasso* (New York: McGraw-Hill, 1964), 101.

276 "[G]ood air, good water": Palau, *Picasso: The Early Years,* 440.

276 "All that I know": Jaime Sabartés, *Picasso: An Intimate Portrait* (New York: Prentice-Hall, 1948), 43.

276 "You have to ride a mule": Olivier, *Loving Picasso,* 182–83.

277 "The village is up in the mountains": Ibid., 183.

277 "A tenor who reaches a note": Richardson, *A Life of Picasso,* I:451.

277 "[A] fierce old fellow": Olivier, *Loving Picasso,* 184.

278 last-minute intervention of his children: Ibid., 185.

9: THE CHIEF

284 "like an oven": Fernande Olivier, *Loving Picasso: The Private Journal of Fernande Olivier* (New York: Henry N. Abrams, 2001), 185.

285 still hundreds of miles away: Gertrude Stein, *The Autobiography of Alice B. Toklas* (New York: Vintage Books, 1990), 57.

285 "[E]verybody thinks she is not at all like": Roland Penrose, *Picasso: His Life and Work* (Berkeley: University of California Press, 1981), 118.

285 "[F]or me it is I": Gertrude Stein, *Picasso* (New York: Dover Publications, 1984), 8.

286 "[Pablo] can't bear to sell works": Olivier, *Loving Picasso,* 168.

291 "Progress in art": William Rubin, "Cézanne and the Beginnings of Cubism," in *Cézanne: The Late Work: Essays* (New York: Museum of Modern Art, 1977), 169.

291 "Cézanne is great": Ibid., 167.

291 "What I wanted was to make": Maurice Denis, "Cézanne" [1907], in *Art*

in Theory, 1900–1990, ed. Charles Harrison and Paul Wood (Oxford, UK: Blackwell, 1993), 42–43.

292 "He who understands Cézanne": Albert Gliezes and Jean Metzinger, "From *Cubism*" [1912], in Harrison and Wood, *Art in Theory,* 188.

292 "painting was a matter of life or death": Richardson, *A Life of Picasso,* II: 68.

293 "Cézanne's anxiety": William Rubin, "From Narrative to 'Iconic' in Picasso: The Buried Allegory in *Bread and Fruit Dish on a Table* and the Role of *Les Demoiselles d'Avignon,*" *The Art Bulletin* 65, no. 4 (December 1983): 620.

293 "[Cézanne] was my one and only master": Brassaï, *Picasso and Company* (Garden City, NY: Doubleday, 1966), 79.

295 "If a tradition is to be born": David Cottington, *Cubism and Its Histories* (Manchester, UK: Manchester University Press, 2004), 33.

295 "Paul Cézanne [is] the point of departure": Daniel-Henry Kahnweiler, *The Rise of Cubism* (San Francisco: Wittenborn Art Books, 2008), 3.

295 "more than any other": Rubin, "Cézanne and the Beginnings of Cubism," 156.

295 "a dictator": Richardson, *A Life of Picasso,* II:70.

295 "Doubt is everywhere": Ibid.

295 "revolutionary . . . barbaric simplifications": Rubin, "Cézanne and the Beginnings of Cubism," 157.

296 "Neither do I": Hillary Spurling, *Matisse: The Life* (London: Hamish Hamilton, 2009), 153.

297 "I don't see any future": Richardson, *A Life of Picasso,* II:74.

297 "Poor, patient Matisse": Alex Danchev, *Georges Braque: A Life* (New York: Arcade, 2012), 75.

297 "Matisse was back": Gertrude Stein, *Autobiography of Alice B. Toklas,* 57–58.

298 "I no more made up my mind": Richardson, *A Life of Picasso,* II:60.

298 stencil letters for signs: Danchev, *Georges Braque,* 18.

299 "above all to put painting": William Rubin, *Picasso and Braque: Pioneering Cubism* (New York: Museum of Modern Art, 1989), 17.

299 "He always had a beefsteak": Danchev, *Georges Braque,* 23.

300 "Braque [was] perpetually in quest": Richardson, *A Life of Picasso,* II:67.

300 "It's there that I felt": Danchev, *Georges Braque,* 41.

300 "[O]ne became accustomed": Roger Fry, "Cubism 1907–1908: An Early Eyewitness Account," *The Art Bulletin* 48, no. 1 (March 1966): 72.

301 "At that moment": Danchev, *Georges Braque,* 42.

301 "Write to Braque": William Rubin, Hélène Seckel, and Judith Cousins, *Les Demoiselles d'Avignon* (New York: Museum of Modern Art, 1994), 150.

301 "Anticipated memories": Richardson, *A Life of Picasso,* II:68.

302 "Picasso's group became more subdued": Olivier, *Loving Picasso*, 199–200.

302 "[Picasso] experienced anxiety": Rubin et al., *Les Demoiselles d'Avignon*, 21.

303 "For many long days": Ibid.

10: EXORCISM

304 "he would have one of his pictures": Leo Stein, *Appreciation: Painting, Poetry and Prose* (Lincoln: University of Nebraska Press, 1996), 175.

305 "*Je suis le cahier*": William Rubin, Hélène Seckel, and Judith Cousins, *Les Demoiselles d'Avignon* (New York: Museum of Modern Art, 1994), 17.

307 "All this . . . has been pure literature": Richardson, *A Life of Picasso*, II: 103.

307 "Everything seemed mysterious": Fernande Olivier, *Loving Picasso: The Private Journal of Fernande Olivier* (New York: Harry N. Abrams, 2001), 202.

307 "bubbly, witty": Alex Danchev, *Georges Braque: A Life* (New York: Arcade, 2012), 27.

308 Apollinaire's future wife: Richardson, *A Life of Picasso*, II:63.

308 "I have seen your wife": Ibid., II:64.

308 "She took a great deal of trouble": Fernande Olivier, *Picasso et ses amis* (Paris: Stock, 1973), 106.

308 "If I did not become a cubist": David Cottington, *Cubism and Its Histories* (Manchester, UK: Manchester University Press, 2004), 98–99.

308 "a *bonze*": Van Gogh to Paul Gauguin, October 3, 1888, in Vangoghletters .org, letter 695.

310 "mad, spiritual, intelligent": Olivier, *Picasso et ses amis*, 183.

310 "Evening, dinner with Picasso": Richardson, *A Life of Picasso*, II:20.

311 "to accomplish something rare": Ibid., II:21.

311 "Being absolutely alone": Francis Steegmuller, *Apollinaire: Poet Among the Painters* (New York: Penguin, 1986), 169.

312 "scared, contrite children": Olivier, *Picasso et ses amis*, 184.

312 in the back of a cupboard: Ibid., 183.

313 "intelligent and poor": André Salmon, *The Black Venus* (New York: Re Macaulay Company, 1929), 112.

314 "*Fernande/Raymonde*": Richardson, *A Life of Picasso*, II:32.

315 "the incandescent crater": Rubin et al., *Les Demoiselles d'Avignon*, 16.

316 "In my case": Hélène Parmelin, *Picasso Says* (South Brunswick, NJ: A. S. Barnes, 1969), 38.

316 "the perfect image of the savagery": Charles Baudelaire, *The Painter of Modern Life and Other Essays* (London: Phaidon, 2001), 36–38.

318 "Yes, I was alone": Ibid., 224.

318 "[T]he human image seemed to us": Ibid., 21.

318 Many crucial dates: The best discussion of these crucial issues is provided in Rubin et al., *Les Demoiselles d'Avignon*, especially the chapter on chronology, 145ff.

320 "the startled consciousness": Leo Steinberg, "The Philosophical Brothel," reprinted in *October* 44 (Spring 1988): 12.

322 "Art is never chaste": Picasso to Antonina Vallentin, "Art and Eroticism," in Picasso, *Picasso on Art: A Selection of his Views*, ed. Dore Ashton (New York: Viking Press, 1971), 15.

322 "If we give spirits a form": André Malraux, *Picasso's Mask* (New York: Da Capo, 1976), 11.

323 "In early 1907": Rubin et al., *Les Demoiselles d'Avignon*, 148.

323 "Weeks would go by": Richardson, *A Life of Picasso*, II:34.

323 "Derain told me himself": Daniel-Henry Kahnweiler, *Mes galeries et mes peintres: Entretiens avec Francis Crémieux* (Paris: Gallimard, 1982), 45–46.

323 "The regulars at the strange studio": Rubin et al., *Les Demoiselles d'Avignon*, 245.

323 "spiritual solitude": Daniel-Henry Kahnweiler, *My Galleries and Painters* (Boston: MFA Publications, 2003), 38.

323 "My dear friends": John Golding, "The 'Demoiselles d'Avignon,'" *The Burlington Magazine* 100, no. 662 (May 1958): 160. Golding is in error when he claims the date as March 27, which was a Wednesday.

324 "brayed": Richardson, *A Life of Picasso*, II:45.

324 "horrible mess": Leo Stein, *Appreciation*, 175.

324 "You ought to do caricatures": Parmelin, *Picasso Says*, 36.

327 "the beginning of Cubism": Daniel-Henry Kahnweiler, *The Rise of Cubism* (San Francisco: Wittenborn Art Books, 2008), 7.

328 "incredible heroism": Kahnweiler, *My Galleries and Painters*, 38.

328 "The large canvas": Rubin et al., *Les Demoiselles d'Avignon*, 245.

329 "When I went to the old Trocadero": Malraux, *Picasso's Mask*, 10–11.

330 Picasso went out of his way: Picasso's assertion to Pierre Daix led Daix to write an article titled "Il n'ya pas d'art nère dans Les Demoiselles d'Avignon" (There Is No Negro Art in *Les Demoiselles d'Avignon*), published in *Gazette de Beaux Arts* (Paris), ser. 6, 76, 1221 (October 1970): 247–70.

330 "The artist has assured me": Rubin et al., *Les Demoiselles d'Avignon*, 216.

330 "You must not always believe what I say": Richardson, *A Life of Picasso*, II:11.

332 "Derain and Braque became followers": Gertrude Stein, *The Autobiography of Alice B. Toklas* (New York: Vintage Books, 1990), 63.

332 "I went to Gertrude Stein's house": William Rubin, *"Primitivism" in Twentieth-Century Art: Affinity of the Tribal and Modern* (New York: Museum of Modern Art, 1984), I:217.

333 "We were dining one Thursday": Jeanine Warnod, *Washboat Days* (New York: Grossman, 1972), 128.

333 "Men had made those masks": Françoise Gilot, *Life with Picasso* (New York: McGraw-Hill, 1964), 266.

334 "Protects against the sorcerer": Rubin et al., *Les Demoiselles d'Avignon*, 141.

334 "fearful and grimacing nudes": Ibid., 114.

334 *raisonables*: Golding, "The 'Demoiselles d'Avignon,'" 162.

334 "I paint objects": Ibid., 162.

335 "That's also what separated me": Malraux, *Picasso's Mask*, 11–13.

335 "Beginning on the day:" Gilot, *Life with Picasso*, 230.

336 "It is an instrument": Danchev, *Georges Braque*, 86.

338 "The great law that dominates": Rubin et. al., *Primitivism in Twentieth-Century Art*, I:247.

338 There is a large body of literature on Cubism: See, e.g., "Art and Semiotics" in *Primitivism, Cubism, Abstraction: The Early Twentieth Century*, ed. Charles Harrison, Francis Frascina, and Gill Perry (New Haven, CT: Yale University Press, 1993), or Mieke Bal and Norman Bryson, "Semiotics and Art History," *The Art Bulletin* 73, no. 2 (June 1991): 174–208.

339 "To displace": Pierre Cabanne, *Picasso: His Life and Times* (New York: William Morrow, 1977), 268.

11: DRINKING KEROSENE, SPITTING FIRE

341 "Have you ever seen a finished picture?": Pierre Cabanne, *Picasso: His Life and Times* (New York: William Morrow, 1977), 319.

341 "The Wild Men of Paris": Britta Martensen-Larsen, "When Did Picasso Complete 'Les Demoiselles d'Avignon'?" *Zeitschrift für Kunstgeschichte* 48, no. 2 (1985): 48.

342 "Picasso regarded it as unfinished": Daniel-Henry Kahnweiler, *My Galleries and Painters* (Boston: MFA Publications, 2003), 39.

342 "I had done half the painting": William Rubin, Hélène Seckel, and Judith Cousins, *Les Demoiselles d'Avignon* (New York: Museum of Modern Art, 1994), 224.

342 "What a loss": Marilyn McCully, *Picasso in Paris: 1900–1907* (New York: Vendome Press, 2011), 221.

342 "get back": Fernande Olivier, *Picasso et ses amis* (Paris: Stock, 1973), 108.

342 "battered": Daniel-Henry Kahnweiler, *The Rise of Cubism* (San Francisco: Wittenborn Art Books, 2008), 7.

342 "Do you want to hear some important news?": Fernande Olivier, *Loving Picasso: The Private Journal of Fernande Olivier* (New York: Harry N. Abrams, 2001), 191.

343 "her little ways": Alice B. Toklas, *What Is Remembered* (London: Michael Joseph, 1963), 40.

343 "very disoriented": Olivier, *Loving Picasso*, 191.

344 "unleashed universal anger": Rubin et al., *Les Demoiselles d'Avignon*, 114.

344 "Despite everything": Olivier, *Picasso et ses amis*, 157.

344 "[T]hose men lived": Hélène Parmelin, *Picasso Says* (South Brunswick, NJ: A. S. Barnes, 1969), 114.

344 "He said it was as if": The French original read: "avait déclaré qu'il semblait que c'était comme si quelqu' un buvait du pétrol pour cracher du feu . . ." Daniel-Henry Kahnweiler, *Mes galeries et mes peintres: Entretiens avec Francis Crémieux* (Paris: Gallimard, 1982), 45.

344 "But in spite of your explanation": Fernande Olivier, *Picasso and His Friends* (New York: Appleton-Century, 1964), 97.

344 "It's as if you were drinking": Alex Danchev, *Georges Braque: A Life* (New York: Arcade, 2012), 52.

345 "My true meeting": Ibid., 51.

345 "Picasso was very anxious": Ibid.

345 "He told no one": Olivier, *Picasso et ses amis*, 120.

347 "To portray every physical aspect": John Richardson, *A Life of Picasso*, II: 85.

347 "The first time that": Gertrude Stein, *The Autobiography of Alice B. Toklas* (New York: Vintage Books, 1990), 65.

347 "The feeling between the Picassoites": Ibid., 64–65.

347 "a universe of ugliness": Richardson, *A Life of Picasso*, II:84.

347 "I particularly recommend": William Rubin, *Picasso and Braque: Pioneering Cubism* (New York: Museum of Modern Art, 1989), 351.

348 "savage, resolutely, aggressively": Ibid.

349 "It's always been like this": Richardson, *A Life of Picasso*, I:199.

351 "[M]y role . . . was to fight": Kahnweiler, *Mes galeries et mes peintres*, 25.

351 "One day I was in my shop": Ibid., 39.

352 "[I]t was [Uhde]": Kahnweiler, *My Galleries and Painters*, 37–38.

352 "I knocked at the door": Kahnweiler, *Mes galeries et mes peintres*, 45.

352 "I was overwhelmed": Ibid., 47.

352 "no one else was buying": Ibid.

352 "Kahnweiler haggled for hours": Olivier, *Picasso et ses amis*, 144.

353 things changed for the better: Ibid., 143.

353 "Picasso later told me": Kahnweiler, *Mes galeries et mes peintres*, 47.

353 "The watercolors of Cézanne": Richardson, *A Life of Picasso*, I:50.

353 "Treat nature by means": Paul Cézanne, "Letters to Emile Bernard" [1904–1906], in *Art in Theory, 1900–1990*, ed. Charles Harrison and Paul Wood (Oxford, UK: Blackwell, 1993), 37–40.

354 "put painting within range": Rubin, *Picasso and Braque*, 17.

354 "It is not enough": Danchev, *George Braque*, 76.

355 "Braque's temperament was limpid": John Golding, *Cubism: A History and Analysis, 1907–14* (New York: Faber and Faber, 1968), 21.

355 "We were . . . like two mountain climbers": William Rubin, "Cézannisme and the Beginnings of Cubism," in Theodore Reff and William Rubin, *Cézanne: The Late Work: Essays* (New York: Museum of Modern Art, 1977), 194.

355 "pard": Danchev, *George Braque*, 67.

356 "Apollinaire was a great poet": Richardson, *A Life of Picasso*, II:101.

356 "He expresses a beauty": Guillaume Apollinaire, "Georges Braque" (1908), in Appollinaire, *Apollinaire on Art: Essays and Reviews, 1902–1918* (Boston: ArtWorks, 1960), 51.

356 "white equations on a black-board": Golding, *Cubism: A History and Analysis*, 47.

356 "I didn't do Cubism": Danchev, *George Braque*, 51.

356 "They often went out": Olivier, *Picasso et ses amis*, 127.

357 "I can't have friends": Arianna Huffington, *Picasso: Creator and Destroyer* (New York: Simon & Schuster, 1988), 108.

357 "[A] small, serious woman": Danchev, *George Braque*, 98.

357 "hard, piercing eyes": Olivier, *Loving Picasso*, 213.

358 "After an eventful evening": Ibid., 216.

358 "The whole business": Ibid.

360 "Picasso and I were engaged": Rubin, *Picasso and Braque*, 19.

360 "wished to do Poussin": Theodore Reff, "Cézanne and Poussin," in *Journal of the Warburg and Courtauld Institutes* 23, no. 1–2 (January–June 1960), 50.

362 "Braque has just sent a painting": Ibid., 354–55.

362 "[I]t was Braque who made the first Cubist painting": Rubin, "Cézannisme and the Beginnings of Cubism," in Theodore Reff and William Rubin, *Cezanne: The Late Work: Essays*, 199.

363 "It's as if the artist were behind": Danchev, *George Braque*, 88.

363 "[T]he whole Renaissance tradition": Danchev, *George Braque*, 73.

363 Alfred Barr defines *passage* as "the breaking of a contour": Alfred H. Barr Jr., *Cubism and Abstract Art* (New York: Museum of Modern Art, 1966), 31.

364 "It smells of mushrooms": Olivier, *Loving Picasso*, 216.

364 "I have been ill": Richardson, *A Life of Picasso*, II:93.

364 "Have you noticed": Golding, *Cubism: A History and Analysis*, 69.

365 "Almost every evening": Pepe Karmel, *Picasso and the Invention of Cubism* (New Haven, CT: Yale University Press, 2003), 10.

366 excited discussions by Picasso: Danchev, *George Braque*, 79.

366 "He does not leave me alone": Toklas, *What Is Remembered*, 70.

366 "in derision of course": Ibid., 43.

366 "Matisse induces madness!": Jack Flam, *Matisse and Picasso: The Story of Their Rivalry and Friendship* (Cambridge, MA: Westview Press, 2003), 46.

367 "All I did was hang their pictures": Kahnweiler, *My Galleries and Painters*, 41.

368 "We were beginning to find life easier": Olivier, *Loving Picasso*, 209.

368 "More new faces were appearing": Ibid., 211.

369 "I'm afraid that the mystery": David Cottington, *Cubism and Its Histories* (Manchester, UK: Manchester University Press, 2004), 17.

369 "At that time our work": Françoise Gilot, *Life with Picasso* (New York: Mc-Graw-Hill, 1964), 77.

369 "At that period": Ibid., 72.

369 "Things were said with Picasso": Danchev, *George Braque*, 60.

369 "*Mon vieux Wilbourg*": Ibid., 68.

370 most of all, Apollinaire: Kahnweiler, *My Galleries and Painters*, 44.

370 "Nonfigurative painting is never subversive": Gilot, *Life with Picasso*, 72.

370 "Composition . . . is the art of arranging": Henri Matisse, "Notes on a Painter" [1908], in *Art in Theory, 1900–1990*, ed. Charles Harrison and Paul Wood (Oxford, UK: Blackwell, 1993), 73.

372 "[I wish] to touch the object": Karmel, *Picasso and the Invention of Cubism*, 13.

373 "doesn't allow you to possess things fully": Ibid.

373 "The aim is not to *reconstitute*": Georges Braque, "Thoughts on Painting" [1917], in Harrison and Wood, *Art in Theory*, 209.

373 "In its original form": Gilot, *Life with Picasso*, 73.

374 "We didn't any longer": Ibid., 77.

374 "The idea of a body in space": Karmel, *Picasso and the Invention of Cubism*, 6.

374 "I remember one day": Huffington, *Picasso: Creator and Destroyer*, 122.

376 " 'Could it be that this is better' ": Jean-Paul Crespelle, *La vie quotidienne à Montmartre* (Paris: Hachette, 1978), 115.

376 "[t]hey arrived [at the gallery]": Kahnweiler, *My Galleries and Painters*, 45.

377 "[c]arrying the destructive force": Robert Rosenblum, "Picasso in Gósol: The Calm before the Storm," in Marilyn McCully, *Picasso: The Early Years: 1892–1906* (Washington, DC: National Gallery of Art, 1997), 263.

12: BOHEMIA'S LAST STAND

379 "[I]t was to be very rigolo": Gertrude Stein, *The Autobiography of Alice B. Toklas* (New York: Vintage Books, 1990), 103.

381 "an old idiot": Francis Steegmuller, *Apollinaire: Poet Among the Painters* (New York: Penguin, 1986), 156.

381 "Now that is painting!": Roger Shattuck, *Henri Rousseau* (New York: Museum of Modern Art, 1985), 40.

382 "His bewildered face": Fernande Olivier, *Picasso et ses amis* (Paris: Stock, 1973), 76.

382 "he could sometimes be as conceited": Shattuck, *Henri Rousseau*, 16.

383 "We are the two greatest painters": Olivier, *Picasso et ses amis*, 113.

383 "I cannot now change my style": Shattuck, *Henri Rousseau*, 35.

383 "one of the most revealing": Richardson, *A Life of Picasso*, II: 110

385 "Her hands and dress covered with jam": Olivier, *Picasso et ses amis*, 79.

385 "At the sight of Guillaume": Stein, *The Autobiography of Alice B. Toklas*, 106.

385 "seized a big glass": Ibid., 107.

385 "a bit out of their element": Fernande Olivier, *Picasso and His Friends* (New York: Appleton-Century, 1964), 69.

386 "He beamed with pleasure": Olivier, *Picasso et ses amis*, 80.

386 "That was a jest you know": Geneviève Laporte, *Sunshine at Midnight: Memories of Picasso and Cocteau* (New York: Macmillan, 1975), 23.

387 "to bind my life to his": Olivier, *Loving Picasso*, 157.

387 "Despite the gaiety": Olivier, *Picasso and His Friends*, 153–54.

388 "put through the mincing machine": Roy MacGregor-Hastie, *Picasso's Women* (Luton, UK: Lennard, 1988), 67.

389 "It was a great wrench": Olivier, *Loving Picasso*, 251.

389 "Picasso took his meals": Olivier, *Picasso et ses amis*, 167–68.

390 *embourgeoisement*: Ibid., 167–70.

390 "Life was improving": Ibid., 189.

391 "Little by little the gang split up": Ibid., 230.

391 "[Y]our only claim to distinction": Stein, *The Autobiography of Alice B. Toklas*, 96.

392 "One day we went to see him": Ibid., 111.

392 "We have spent enough hours laughing together": John Richardson, *A Life of Picasso*, vol. 3, *The Triumphant Years, 1917–1932* (New York: Alfred A. Knopf, 2010), 100.

392 "Didn't one of his dearest friends": Steegmuller, *Apollinaire*, 187.

393 "She said Madame Braque was with him": Alex Danchev, *Georges Braque: A Life* (New York: Arcade, 2012), 108.

394 "On August 2 1914": Ibid., 121.

394 "The house was filled with the aromatic bouquet": Françoise Gilot, *Life with Picasso* (New York: McGraw-Hill, 1964), 140.

394 "it became very clear": Ibid.

395 "[a] new proof of German meddling": Michael FitzGerald, *Making Modernism: Picasso and the Creation of the Market for Twentieth Century Art* (New York: Farrar, Straus and Giroux, 1995), 41.

395 "the incandescent crater": William Rubin, Hélène Seckel, and Judith Cousins, *Les Demoiselles d'Avignon* (New York: Museum of Modern Art, 1994), 16.

396 "[T]here was not much worth taking": Olivier, *Picasso et ses amis*, 163–64.

396 "experienced happiness": Olivier, *Loving Picasso*, 21.

396 "the clearest expression of modern disquiet": Huffington, *Picasso: Creator and Destroyer*, 201.

397 "What I dream of": Henri Matisse, "Notes on a Painter," in *Art in Theory, 1900–1990*, ed. Charles Harrison and Paul Wood (Oxford, UK: Blackwell, 1993), 76.

397 "We intend to sing the love of danger": Filippo Tommaso Marinetti, "The Foundation and Manifesto of Futurism" [1909], in Harrison and Wood, *Art in Theory*, 147.

398 "I have transformed myself": Kasemir Malevich, "From *Cubism and Futurism to Suprematism: The New Realism in Painting*" [1915–16], in Harrison and Wood, *Art in Theory*, 166.

398 "[t]hey made ideas instead of paintings": Jeanine Warnod, *Washboat Days* (New York: Grossman, 1972), 223–24.

399 "The Cubists are not waiting": Rubin et al., *Les Demoiselles d'Avignon*, 168.

400 "I somewhat regret the fact": Ibid., 175.

400 "My admiration for you is so great": Richardson, *A Life of Picasso, The Triumphant Years, 1917–1932*, 243.

400 "Picasso . . . defies consecration": FitzGerald, *Making Modernism*, 141.

400 "deeper and more real": Richardson, *A Life of Picasso, The Triumphant Years, 1917–1932*, 349.

401 "One sure thing": Rubin et al., *Les Demoiselles d'Avignon*, 177.

401 "the greatest living artist": FitzGerald, *Making Modernism*, 244.

402 "the most important painting of the twentieth century": Christopher Green, ed., *Picasso's Les Demoiselles d'Avignon* (Cambridge, UK: Cambridge University Press, 2001), 18.

402 "the first cubist picture": Alfred H. Barr Jr., *Picasso: Forty Years of His Art* (New York: Museum of Modern Art, 1946), 70.

402 all emptying into the vast ocean: Alfred H. Barr Jr., *Cubism and Abstract Art* (New York: Museum of Modern Art, 1966), frontispiece.

402 "The first and most important current": Ibid., 19.

403 "the journey to Hades": Carl Jung, "Picasso" [November 13, 1932], in *A Picasso Anthology: Documents, Critism, Reminiscences,* ed. Marilyn McCully (Princeton, NJ: Princeton University Press, 1981), 183–84.

403 "Cubism remains the epoch-making": David Cottington, *Cubism and Its Histories* (Manchester, UK: Manchester University Press, 2004), 188.

404 "Picasso withdraws into himself": Waldemar George, "Les cinquante ans des Picasso et la mort de la nature-morte," in McCully, *A Picasso Anthology*, 180.

404 "How can anyone enter into my dreams": Phoebe Pool, "Sources and Background of Picasso's Art 1900–6," *The Burlington Magazine* 101, no. 674 (May 1959): 176.

404 "It was at the Bateau Lavoir that I was famous": André Malraux, *Picasso's Mask* (New York: Da Capo, 1976), 48–49.

Bibliography

PRIMARY

Acton, Harold. *Memoirs of an Aesthete.* London: Faber & Faber, 2008.

Apollinaire, Guillaume. *Alcools.* Berkeley: University of California Press, 1965.

———. *Apollinaire on Art: Essays and Reviews, 1902–1918.* Boston: ArtWorks, 1960.

———. "From *The Cubist Painters*" [1912]. In Harrison and Wood, *Art in Theory.*

———. "The Cubists" [1911]. In Harrison and Wood, *Art in Theory.*

———. "The New Painting: Art Notes" [1912]. In Harrison and Wood, *Art in Theory.*

———. "On the Subject in Modern Painting" [1912]. In Harrison and Wood, *Art in Theory.*

———. *Les Onze Mille Verges: Or, the Amorous Adventures of Prince Mony Vibescu.* London: Peter Owen, 1976.

———. "Picasso and the *Papiers Collés.*" In Schiff, *Picasso in Perspective.*

———. "The Young: Picasso, Painter" [1905]. In McCully, *A Picasso Anthology.*

Balzac, Honoré de. *The Unknown Masterpiece.* Middletown, Del: CreateSpace Independent Publishing Platform, 2015.

Baroja, Pio. *Red Dawn.* New York: A.A. Knopf, 1924.

Baudelaire, Charles. "Correspondances." In MacIntyre, *French Symbolist Poetry.*

———. *The Painter of Modern Life and Other Essays.* London: Phaidon, 2001.

Beauvoir, Simone de. *Wartime Diary.* Urbana, IL: University of Illinois, 2009.

Bell, Clive. *Since Cézanne.* Memphis: General Books, 2010.

Bergson, Henri. "From *Creative Evolution*" [1907]. In Harrison and Wood, *Art in Theory.*

———. *The Creative Mind: An Introduction to Metaphysics.* New York, 1946.

Boccioni, Umberto, et al. "Futurist Painting: Technical Manifesto" [1910]. In Harrison and Wood, *Art in Theory.*

————. "Futurist Sculpture." In *Modern Artists on Art*. Mineola, NY: Dover Publications, 2000.

Braque, Georges. "Response to Gertrude Stein." In McCully, *A Picasso Anthology*.

————. "Thoughts on Painting" [1917]. In Harrison and Wood, *Art in Theory*.

Brassaï. *Conversations with Picasso*. Chicago: University of Chicago Press, 1999.

————. *Picasso and Company*. Garden City, NY: Doubleday, 1966.

Breton, André. *Manifestos of Surrealism*. Ann Arbor, MI: University of Michigan Press, 1969.

————. "Picasso and Surrealism." In McCully, *A Picasso Anthology*.

Burgess, Gelett. "Picasso Is a Devil" from "The Wild Men of Paris," *Architectural Record*, May 1910. In Schiff, *Picasso in Perspective*.

Carco, Francis. *The Last Bohemia: From Montmartre to the Latin Quarter*. New York: Henry Holt & Company, 1928.

Casagemas, Carles. "Letter from Paris" (October 25, 1900). In McCully, *A Picasso Anthology*.

Cézanne, Paul. "Letters to Émile Bernard" [1904–1906]. In Harrison and Wood, *Art in Theory*. Cambridge, UK: Blackwell, 1993.

Cocteau, Jean. *The Journals of Jean Cocteau*. Bloomington, IN: Indiana University Press, 1964.

Codola, Manuel Rodriguez. "Els IV Gats: Ruiz Picazzo Exhibition" [1900]. In McCully, *A Picasso Anthology*.

Coll, Pere. "Review of the Exhibition at Vollard's Gallery" [1901]. In McCully, *A Picasso Anthology*.

Coquiot, Gustave. "Review of the Exhibition at Vollard's Gallery" [1901]. In McCully, *A Picasso Anthology*.

Croce, Benedetto. "What Is Art?" [1913]. In Harrison and Wood, *Art in Theory*.

Daix, Pierre. "There Is No African in *Les Demoiselles d'Avignon*." In Schiff, *Picasso in Perspective*.

Delaunay, Robert. "On the Construction of Reality in Pure Painting" [1912]. In Harrison and Wood, *Art in Theory*.

Denis, Maurice. "Cézanne" [1907]. In Harrison and Wood, *Art in Theory*.

————. "From Gauguin and Van Gogh to Neo-Classicism" [1909]. In Harrison and Wood, *Art in Theory*.

Derain, André. "Letters to Vlaminck" [c. 1905–1909]. In Harrison and Wood, *Art in Theory*.

————. *Lettres à Vlaminck*. Paris: Flammarion, 1955.

Douglas, Charles. *Artist Quarter: Reminiscences of Montmartre and Montparnasse in the First Two Decades of the Twentieth Century*. London, 1941.

El Liberal. "On *La Vie*." In McCully, *A Picasso Anthology*.

Émile-Bayard, Jean. *Montmartre Past and Present*. New York: Brentano's, 1929.

Fagus, Félicien. "The Spanish Invasion" from *Revue Blanche* [1901]. In Schiff, *Picasso in Perspective*.

Fénéon, Felix. *Novels in Three Lines.* New York: New York Review of Books Classics, 2007.

Fry, Roger. *Vision and Design.* Mineola, NY: Dover Publications, 2012.

Gauguin, Paul. *Gauguin's Intimate Journals.* Mineola, NY: Dover Publications, 1997.

———. "Letter to Fontainas" [1899]. In Harrison and Wood, *Art in Theory.*

———. *Noa Noa.* Paris: G. Cres, 1929.

Gilot, Françoise. *Life with Picasso.* New York: McGraw-Hill, 1964.

Gleizes, Albert, and Jean Metzinger. "From *Cubism*" [1912]. In Harrison and Wood, *Art in Theory.*

———. "Cubism" [1912]. In Herbert, *Modern Artists on Art.*

Goncourt, Edmond and Jules. *Pages from the Goncourt Journals.* New York: ___, 1962.

———. *Paris and the Arts, 1851–1896: From the Goncourt Journal.* Ithaca, NY: Cornell University Press, 1971.

Hemingway, Ernest. *A Movable Feast.* New York: Scribner, 2010.

Herbert, Robert L., ed. and trans. *Modern Artists on Art.* Mineola, NY: Dover Publications, 1964.

Jacob, Max. *Hesitant Fire: Selected Prose of Max Jacob.* Lincoln, NE: University of Nebraska Press, 1992.

———. "Meeting Picasso in Paris" [1901]. In McCully, *A Picasso Anthology.*

———. "Picasso, Apollinaire, Salmon and Jacob" (1905–7). In McCully, *A Picasso Anthology.*

Jarry, Alfred. *Selected Works of Alfred Jarry.* New York: Grove Press, 1980.

Juner-Vidal, Carlos. "Picasso and his Work." In McCully, *A Picasso Anthology.*

Jung, Carl G. "Picasso." In McCully, *A Picasso Anthology.*

Kahnweiler, Daniel-Henry. *Juan Gris: His Life and Work.* London: Thames & Hudson, 1969.

———. *Mes galeries et mes peintres: Entretiens avec Francis Crémieux.* Paris: Gallimard, 1982.

———. *My Galleries and Painters.* Boston: MFA Publications, 2003.

———. *The Rise of Cubism.* San Francisco: Wittenborn Art Books, 2008.

———. "From *The Rise of Cubism*" [1916–20]. In Harrison and Wood, *Art in Theory.*

Kandinsky, Wassily. "From *Concerning the Spiritual in Art*" [1911]. In Harrison and Wood, *Art in Theory.*

Laporte, Geneviève. *Sunshine at Midnight: Memories of Picasso and Cocteau.* New York: Macmillan, 1975.

Laurencin, Marie. *Marie Laurencin*. New York: Rizzoli, 1977.

Léger, Fernand. "Contemporary Achievements in Painting" [1914]. In Harrison and Wood, *Art in Theory*.

———. "The Origins of Painting and Its Representational Value" [1913]. In Harrison and Wood, *Art in Theory*.

MacIntyre, C. F., trans. *French Symbolist Poetry*. Berkeley: University of California Press, 1964.

Malevich, Kasimir. "From *Cubism and Futurism to Suprematism: The New Realism in Painting*" [1915–16]. In Harrison and Wood, *Art in Theory*.

———. "Suprematism." In Herbert, *Modern Artists on Art*.

Mallarmé, Stéphane. "L'Après-midi d'un Faune." In MacIntyre, *French Symbolist Poetry*.

Malraux, André. *Picasso's Mask*. New York: Da Capo, 1976.

Marinetti, Filippo Tommaso. "The Foundation and Manifesto of Futurism" [1909]. In Harrison and Wood, *Art in Theory*.

Matisse, Henri. "Notes of a Painter" [1908]. In Harrison and Wood, *Art in Theory*.

McCully, Marilyn, ed. *A Picasso Anthology: Documents, Criticism, Reminiscences*. London, 1981.

Metzinger, Jean. "Note on Painting" [1910]. In Harrison and Wood, *Art in Theory*.

Michel, Louise. *The Red Virgin: The Memoirs of Louise Michel*. Tuscaloosa, Ala.: University of Alabama Press, 1981.

Moore, George. *Reminiscences of the Impressionist Painters*. Dublin: Maunsel, 1906.

Moore, Henry. "Primitive Art." In Herbert, *Modern Artists on Art*.

Murger, Henri. *The Bohemians of the Latin Quarter: Scènes de la Vie de Bohème*. New York: Fertig, 1984.

Olivier, Fernande. *Loving Picasso: The Private Journal of Fernande Olivier*. New York: Harry N. Abrams, 2001.

———. *Picasso and His Friends*. New York: Appleton-Century, 1964.

———. *Picasso et ses amis*. Paris: Stock, 1973.

Picasso, Pablo. "Letter from Barcelona to Max Jacob" (July 13, 1902). In McCully, *A Picasso Anthology*.

———. "Letter from Madrid to Miquel Utrillo" (1901). In McCully, *A Picasso Anthology*.

———. "Letter from Paris to Jacinto Reventós" (February 22, 1905). In McCully, *A Picasso Anthology*.

———. "Letter from Paris to Vidal Ventosa" (July 13, 1901). In McCully, *A Picasso Anthology*.

———. *Picasso on Art: A Selection of Views*. Edited by Dore Ashton. New York: Viking Press, 1972.

————, and Carles Casagemas. "Letter from Paris" (November 11, 1900). In Mc-Cully, *A Picasso Anthology*.

Poiret, Paul. *King of Fashion: The Autobiography of Paul Poiret*. London: Victoria & Albert, 2009.

Raynal, Maurice. *History of Modern Painting*. Geneva: A. Skira, 1949.

————. *Picasso*. Geneva: A. Skira, 1950.

Renoir, Jean. *Renoir, My Father*. Boston: Little, Brown, 1962.

Rilke, Rainer Maria. *Letters on Cézanne*, edited by Clara Rilke. New York: North Point Press, 1983.

————. *The Selected Poetry of Rainer Maria Rilke*. London: Picador, 2014.

Sabartés, Jaime. "On *Science and Charity*" [1897]. In McCully, *A Picasso Anthology*.

————. *Picasso: An Intimate Portrait*. New York: Prentice-Hall, 1948.

Salmon, André. *André Salmon on French Modern Art*. Cambridge: Cambridge University Press, 2005.

————. *The Black Venus*. New York: Re Macaulay Co., 1929.

————. *Le Manuscrit trouvé dans un chapeau*. Montpellier, France: Fata Morgana, 1983.

————. *Modigliani: A Memoir*. New York: Putnam, 1961.

————. "On *Les Demoiselles d'Avignon*" [1907]. In McCully, *A Picasso Anthology*.

————. "Response to Gertrude Stein." In McCully, *A Picasso Anthology*.

————. *Rousseau*. New York: H. N. Abrams, 1963.

————. *Souvenirs sans fin: Première Époque (1903–1908)*. Paris: Gallimard, 1955.

Schiff, Gert, ed. *Picasso in Perspective*. Englewood Cliffs, NJ: Prentice-Hall, 1976.

Severini, Gino. *The Life of a Painter*. Princeton: Princeton University Press, 1995.

————. "On *Souvenirs du Havre*." In McCully, *A Picasso Anthology*.

Shevchenko, Alexander. "Neo-Primitivism" [1913]. In Harrison and Wood, *Art in Theory*.

Signac, Paul. "From *Eugène Delacroix to Neo-Impressionism*" [1899]. In Harrison and Wood, *Art in Theory*.

Stein, Gertrude. *The Autobiography of Alice B. Toklas*. New York: Vintage Books, 1990.

————. *Picasso*. New York: Dover Publications, 1984.

————. *Wars I Have Seen*. New York: Random House, 2013.

Stein, Leo. *Appreciation: Painting, Poetry and Prose*. Lincoln: University of Nebraska Press, 1996.

Toklas, Alice B. *What Is Remembered*. London: Michael Joseph, 1963.

Uhde, Wilhelm. *Picasso and the French Tradition*. Paris: Éditions des Quatre Chemins, 1929.

Verlaine, Paul. *101 Poems*. Chicago: University of Chicago, 1999.

Vollard, Ambroise. *Recollections of a Picture Dealer.* Mineola, NY: Dover Publications, 2002.

Weill, Berthe. *Pan! Dans l'oeil! Ou trente ans dans les coulisses de la peinture contemporaine, 1900–1930.* Dijon, France: L'Echelle de Jacob, 2009.

Zola, Emile. *The Masterpiece.* Oxford: Oxford University Press, 2008.

SECONDARY

Allwood, John. *The Great Exhibitions.* London: Studio Vista, 1977.

Andersen, Wayne V. *Picasso's Brothel.* New York: Other Press, 2002.

Antliff, Robert Mark. "Bergson and Cubism: A Reassessment." *Art Journal* 47, no. 4, "Revising Cubism" (Winter 1988): 341–9.

———. "Cubism, Celtism, and the Body Politic." *The Art Bulletin* 74, no. 4 (December 1992): 655–8.

———. "Cubism, Futurism, Anarchism: The 'Aestheticism' of the 'Action d'art' Group, 1906–1920." *Oxford Art Journal* 21, no. 2 (1998): 101–20.

———. "The Fourth Dimension and Futurism: A Politicized Space." *The Art Bulletin* 82, no. 4 (December 2000): 720–33.

———, and Patricia Leighten. *Cubism and Culture.* London: Thames & Hudson, 2001.

Arnason, Hjørvardur Harvard. *History of Modern Art: Painting, Sculpture, Architecture, Photography.* Englewood Cliffs, NJ: Prentice-Hall, 1986.

Assouline, Pierre. *An Artful Life: A Biography of D. H. Kahnweiler.* New York: Fromm International Pub, 1991.

Barr, Alfred H., Jr. *Cubism and Abstract Art.* New York: Museum of Modern Art, 1966.

———. *Matisse, His Art and His Public.* New York: Museum of Modern Art, 1966.

———. *Painting and Sculpture in the Museum of Modern Art, 1929–1967.* New York: Museum of Modern Art, 1977.

———. *Picasso: Fifty Years of His Art.* New York: Museum of Modern Art, 1966.

———. *Picasso: Forty Years of His Art.* New York: Museum of Modern Art, 1946.

Bassani, Ezio. "Paris and London: Modigliani." In Rubin, *"Primitivism" in 20th Century Art.*

Boggs, Jean Sutherland, Douglas W. Druick, Henri Loyrette, Michael Pantazzi, and Gary Tinterow. *Degas.* New York: Metropolitan Museum of Art, 1988.

Bohn, Willard. *The Rise of Surrealism: Cubism, Dada, and the Pursuit of the Marvellous.* Albany, NY: SUNY Press, 2002.

Boime, Albert. *Art in an Age of Bonapartism, 1800–1815.* Chicago: University of Chicago, 1990.

———. *Art in an Age of Revolution: 1750–1800.* Chicago: University of Chicago, 1987.

Bois, Yve-Alain, and Katharine Streip. "Kahnweiler's Lesson." *Representations* 18 (Spring 1987): 33–68.

Bowlt, John E., and Matthew Drutt, eds. *Amazons of the Avant-Garde.* London: Thames & Hudson, 1999.

Breunig, L. C., Jr. "Studies on Picasso, 1902–1905." *College Art Journal* 17, no. 2 (Winter 1958): 188–95.

Brookner, Anita. *The Genius of the Future: Essays in French Art Criticism.* Ithaca, NY: Cornell University Press, 1971.

Cabanne, Pierre. *Picasso: His Life and Times.* New York: William Morrow, 1977.

Canaday, John. *Mainstreams of Modern Art.* New York: Holt, Rinehart & Winston, 1981.

Chave, Anna C. "New Encounters with *Les Demoiselles d'Avignon*: Gender, Race, and the Origins of Cubism." *The Art Bulletin* 76, no. 4 (December 1994): 596–611.

Clark, T. J. *Farewell to an Idea: Episodes from a History of Modernism.* New Haven, CT: Yale University Press, 1999.

Cobb, Matthew. *Eleven Days in August: The Liberation of Paris in 1944.* London: Simon & Schuster, 2013.

Cooke, Cristina Scassellati. "The Ideal of History Painting: Georges Rouault and Other Students of Gustave Moreau at the École des Beaux-Arts, Paris, 1892–98." *Burlington Magazine,* May 2006: cxlviii.

Cooper, Douglas. *The Cubist Epoch.* London: Phaidon, 1994.

Cottington, David. *Cubism and Its Histories.* Manchester, UK: Manchester University Press, 2004.

———. *Cubism in the Shadow of War.* New Haven: Yale University Press, 1998.

Cousins, Judith, and Hélène Seckel. "Chronology of *Les Demoiselles d'Avignon,* 1907 to 1939." In Rubin et al., *Les Demoiselles d'Avignon.*

Cowling, Elizabeth. *Interpreting Matisse Picasso.* London: Tate, 2002.

Cowling, Elizabeth, and Jennifer Mundy. *On Classic Ground: Picasso, Léger, de Chirico, and the New Classicism, 1910–1930.* London: Tate Gallery, 1990.

Crespelle, Jean-Paul. *The Fauves.* Greenwich, CT: New York Graphic Society, 1962.

———. *Picasso and His Women.* New York: Coward-McCann, 1969.

———. *La vie quotidienne à Montmartre.* Paris: Hachette, 1978.

Crow, Thomas E. *Modern Art in the Common Culture.* New Haven, CT: Yale University Press, 1996.

———. *Painters and Public Life in Eighteenth-Century Paris.* New Haven, CT: Yale University Press, 1985.

———, and Stephen Eisenman. *Nineteenth Century Art: A Critical History.* London: Thames and Hudson, 1994.

Daix, Pierre. *Picasso: Life and Art.* New York: Icon Editions, 1993.

Daix, P., and J. Rosselet. *Picasso: The Cubist Years, 1907–16.* London: Thames & Hudson, 1979.

Danchev, Alex. *Cézanne: A Life.* London: Profile Books, 2013.

———. *Georges Braque: A Life*. New York: Arcade, 2012.

DeJean, Joan. *How Paris Became Paris: The Invention of the Modern City*. New York: Bloomsbury, 2014.

Diehl, Gaston. *Derain*. Paris: Flammarion, 1991.

Donne, J. B. "African Art and Paris Studios." in *Art in Society: Studies in Style, Culture and Aesthetics*, edited by Michael Greenhalgh and Vincent Megaw. London: Duckworth, 1978.

Douglas, Charles. *Artist Quarter: Reminscences of Montmartre and Montparnasse in the First Two Decades of the Twentieth Century*. London: Faber & Faber, 1941.

Duncan, Carole. "Virility and Domination in Early Twentieth Century Vanguard Painting." *Artforum* (December 1973): 30–39.

Faille, J.-B. de la. *The Works of Vincent van Gogh: His Paintings and Drawings*. Amsterdam: Meulenhoff, 1970.

Feest, Christian F. "The Arrival of Tribal Objects in the West: From North America." In Rubin, *"Primitivism" in 20th Century Art*, vol. 1.

Fer, Briony, David Batchelor, and Paul Wood. *Realism, Rationalism, Surrealism: Art Between the Wars*. New Haven, CT: Yale University Press, 1993.

Ferrier, Jean-Louis. *The Fauves: The Reign of Color*. Paris: Terrail, 2001.

FitzGerald, Michael C. *Making Modernism: Picasso and the Creation of the Market for Twentieth Century Art*. New York: Farrar, Straus and Giroux, 1995.

Flam, Jack. "Matisse and the Fauves." In Rubin, *"Primitivism" in 20th Century Art*, vol. 1.

———. *Matisse and Picasso: The Story of Their Rivalry and Friendship*. Cambridge, MA: Westview Press, 2003.

———, ed. *Matisse: A Retrospective*. New York: Park Lane, 1988.

Franck, Dan. *Bohemian Paris: Picasso, Modigliani, Matisse, and the Birth of Modern Art*. New York: Grove Press, 2001.

Friedlaender, Walter. *David to Delacroix*. Cambridge, MA: Harvard University Press, 1980.

Fry, Edward F. "Cubism 1907–1908: An Early Eyewitness Account." *The Art Bulletin* 48, no. 1 (March 1966): 70–3.

Geist, Sidney. "Brancusi." In Rubin, *"Primitivism" in 20th Century Art*, vol. 2.

Gleizes, Albert, and Daniel Robbins. *Albert Gleizes: 1881–1953*. New York: Guggenheim Museum,

Golding, John. *Cubism: A History and an Analysis, 1907–14*. New York: Faber and Faber, 1968.

———. "The 'Demoiselles d'Avignon.'" *Burlington Magazine* 100, no. 662 (May 1958): 154–63.

Goldwater, Robert. *Symbolism*. New York: Harper & Row, 1979.

Gopnik, Adam. "High and Low: Caricature, Primitivism, and the Cubist Portrait." *Art Journal* 43, no. 4 (1983): 371–6.

Gordon, Donald E. *Modern Art Exhibitions, 1900–1916*. Munich: Prestel, 1974.

Gray, Camilla. *The Russian Experiment in Art: 1863–1922*. New York: Thames & Hudson, 1986.

Green, Christopher. *Art in France, 1900–1940*. New Haven, CT: Yale University Press, 2000.

———. *Cubism and Its Enemies: Modern Movements and Reactions in French Art, 1916–28*. New Haven, CT: Yale University Press, 1987.

———. *Léger and the Avant-Garde*. New Haven: Yale University Press, 1976.

———. *Picasso: Architecture and Vertigo*. New Haven: Yale University Press, 2005.

———. *Picasso's* Les Demoiselles d'Avignon. Cambridge: Cambridge University Press, 2002.

Greenberg, Clement. *Art and Culture: Critical Essays*. Boston: Beacon Press, 2006.

———. *Homemade Esthetics: Observations on Art and Taste*. New York: Oxford University Press, 2006.

Greenhalgh, Paul. *Ephemeral Vistas: The Expositions Universelles, Great Exhibitions and World's Fairs*. Manchester, UK: Manchester University Press, 1988.

Hamilton, George Heard. *Painting and Sculpture in Europe: 1880–1940*. Englewood Cliffs, NJ: Prentice-Hall, 1972.

Harrison, Charles, Francis Fascina, and Gill Perry, *Primitivism, Cubism, Abstraction: The Early Twentieth Century*. New Haven, CT: Yale University Press, 1993.

Harrison, Charles, and Paul Wood, eds. *Art in Theory, 1900–1990*. Oxford, UK: Blackwell, 1993.

Henderson, Linda Dalrymple. *The Fourth Dimension and Non-Euclidean Geometry in Modern Art*. Cambridge, NJ: MIT Press, 2013.

Higonnet, Patrice. *Paris: Capital of the World*. Cambridge: Harvard University Press, 2002.

Hobhouse, Janet. *Everybody Who Was Anybody: A Biography of Gertrude Stein*. New York: Anchor Books, 1989.

Hoffman, Edith. "Cubism and Futurism in Paris." *The Burlington Magazine* 115, no. 849 (December 1973): 837–9.

House, John. *Impressions of France: Monet, Renoir, Pissarro, and Their Rivals*. Boston: Museum of Fine Arts, 1995.

Hubert, Étienne-Alain. "Was *Les Demoiselles d'Avignon* Exhibited in 1918?" In Rubin et al., *Les Demoiselles d'Avignon*.

Huffington, Arianna. *Picasso: Creator and Destroyer*. New York: Simon and Schuster, 1988.

Hughes, Robert. *Barcelona*. New York: Vintage Books, 1993.

———. *The Shock of the New*. New York: Knopf, 1980.

Jullian, Philippe. *Montmartre*. Oxford: Phaidon, 1977.

———. *The Triumph of Art Nouveau: The Paris Exhibition 1900*. New York: Carousse, 1974.

Kahng, Eik. *Picasso and Braque: The Cubist Experiment, 1910–1912*. Santa Barbara, CA: Santa Barbara Museum of Art, 2011.

Karmel, Pepe. *Picasso and the Invention of Cubism.* New Haven, CT: Yale University Press, 2003.

King, Ross. *The Judgment of Paris: The Revolutionary Decade That Gave the World Impressionism.* New York: Walker Books, 2009.

Költzsch, George-Wilhelm. *Morozov and Shchukin: The Russian Collectors: Monet to Picasso.* Cologne: Dumont, 1993.

Krauss, Rosalind. *The Originality of the Avant Garde and other Modernist Myths.* Cambridge, MA: MIT Press, 2010.

———. *The Picasso Papers.* Cambridge, MA: MIT Press, 1998.

Lambourne, Lionel. *Victorian Painting.* London: Phaidon, 1999.

Leighten, Patricia. *Cubism and Culture.* London: Thames & Hudson, 2001, Mark Antliff.

———. *Re-Ordering the Universe: Picasso and Anarchism.* Princeton, NJ: Princeton Press, 1989.

———. "Revising Cubism." *Art Journal* 47, no. 4, "Revising Cubism" (Winter 1988): 269–76.

———. "The White Peril and *L'Art nègre*: Picasso, Primitivism, and Anticolonialism." *The Art Bulletin* 72, no. 4 (December 1990): 609–30.

Leja, Michael. "'Le Vieux Marcheur' and 'Les Deux Risques': Picasso, Prostitution, Venereal Disease, and Maternity, 1899–1907." *Art History* 8, no. 1 (March 1985): 66–81.

Leymarie, Jean. *Georges Braque.* New York: Solomon R. Guggenheim, 1988.

Lincoln, Bruce W. *Between Heaven and Hell: The Story of a Thousand Years of Artistic Life in Russia.* New York: Penguin, 1999.

Lubar, Robert S. "Review: *Re-Ordering the Universe: Picasso and Anarchism, 1897–1914 by Patricia Leighten.*" *The Art Bulletin* 72, no. 3 (September 1990): 505–10.

MacGregor-Hastie, Roy. *Picasso's Women.* Luton, UK: Lennard, 1988.

Mailer, Norman. *Portrait of Picasso as a Young Man.* New York: ____, 1995.

Martin, Marianne W. "Futurism, Unanimism and Apollinaire," *Art Journal* 28, no. 3 (Spring 1969): 258–68.

Maurer, Evan. "Dada and Surrealism." In Rubin, *"Primitivism" in 20th Century Art,* vol. 1.

McAuliffe, Mary. *Dawn of the Belle Époque: The Paris of Monet, Zola, Bernhardt, Eiffel, Debussy, Clemenceau, and Their Friends.* Lanham, MD: Rowman & Littlefield, 2014.

———. *Twilight of the Belle Époque: The Paris of Picasso, Stravinsky, Proust, Renault, Marie Curie, Gertrude Stein, and Their Friends Through the Great War.* Lanham, MD: Rowman & Littlefield, 2014.

McCullough, David. *The Greater Journey: Americans in Paris.* New York: Simon & Schuster, 2011.

McCully, Marilyn. *Els Quatre Gats: Art in Barcelona Around 1900.* Princeton, NJ: Art Museum, Princeton University, 1978.

———. *Homage to Barcelona*. London: Thames & Hudson, 1986.

———, ed. *A Picasso Anthology: Documents, Criticisms, Reminiscences*. Princeton, NJ: Princeton University Press, 1981.

———. *Picasso in Paris: 1900–1907*. New York: Vendome Press, 2011.

———. *Picasso: The Early Years: 1892–1906*. Washington, DC: National Gallery of Art, 1997.

Mendelsohn, Ezra. "Should We Take Notice of Berthe Weill? Reflections on the Domain of Jewish History." *Jewish Social Studies* (New Series) 1, no. 1 (Autumn 1994): 22–39.

Miller, Arthur I. *Einstein, Picasso: Space, Time, and the Beauty That Causes Havoc*. New York: Basic Books, 2001.

Milner, John. *The Studios of Paris: The Capital of Art in the Late Nineteenth Century*. New Haven, CT: Yale University Press, 1988.

Moffett, Charles S., et al. *The New Painting: Impressionism 1874–1886*. Geneva: Burton, 1986.

Moffitt, John F. *The Arts in Spain*. London: Thames & Hudson, 1999.

Moser, Joann, ed. *Jean Metzinger in Retrospect*. Iowa City, IA: University of Iowa, 1985.

Mucha, Jiri. *Alphonse Maria Mucha: His Life and Art*. London: Academy, 1989.

Mundy, Jennifer, ed. *Surrealism: Desire Unbound*. Princeton, NJ: Princeton University Press, 2005.

Nadeau, Maurice. *The History of Surrealism*. New York: MacMillan, 1965.

Naifeh, Steven, and Gregory White Smith. *Van Gogh: The Life*. New York: Random House, 2011.

Newhall, Beaumont. *The History of Photography*. New York: MOMA, 1982.

Oberthür, Mariel. *Cafés and Cabarets of Montmartre*. Salt Lake City, UT: Gibbs M. Smith, 1984.

O'Brian, Patrick. *Pablo Ruiz Picasso: A Biography*. London: HarperCollins, 1976.

Orwicz, Michael R., ed. *Art Criticism and Its Institutions in Nineteenth-Century France*. Manchester, UK: Manchester University Press, 1994.

Palau i Fabre, Josep. *Picasso: The Early Years, 1881–1907*. Barcelona: Ediciones Polígrafa, 1985.

Parmelin, Hélène. *Picasso Says*. South Brunswick, NJ: A. S. Barnes, 1969.

Paudrat, Jean-Louis. "The Arrival of Tribal Objects in the West: From Africa." In Rubin, *"Primitivism" in 20th Century Art*, vol. 1.

Peltier, Philippe. "The Arrival of Tribal Objects in the West: From Oceania." In Rubin, *"Primitivism" in 20th Century Art*, vol. 1.

Penrose, Roland. *Picasso: His Life and Work*. Berkeley: University of California Press, 1981.

Perloff, Marjorie. *The Futurist Moment: Avant-Garde, Avant Guerre, and the Language of Rupture*. Chicago: 1986.

Pickvance, Ronald. *Gauguin and the School of Pont-Aven*. London: Apollo, 1994.

Platt, Susan Noyes. "Modernism, Formalism, and Politics: The 'Cubism and Abstract Art' Exhibition of 1936 at the Museum of Modern Art." *Art Journal* 47, no. 4, "Revising Cubism" (Winter 1988): 284–95.

Poggioli, Renato. *The Theory of the Avant-Garde*. Cambridge, UK: BellKnap Press, 1968.

Pollock, Griselda. *Avant-Garde Gambits: Gender and the Colour of Art History*. London: Thames & Hudson, 1992.

Pool, Phoebe. *Impressionism*. London: Thames & Hudson, 1974.

———. "Sources and Background of Picasso's Art 1900–6." *The Burlington Magazine* 101, no. 674 (May 1959): 176–82.

Read, Herbert. *A Concise History of Modern Painting*. London: Thames & Hudson, 1974.

———. *The Philosophy of Modern Art*. London: Faber & Faker, 1964.

Reff, Theodore, and William Rubin. *Cézanne: The Late Work: Essays*. New York: Museum of Modern Art, 1977.

Rewald, John. *Cézanne: A Biography*. London: Thames & Hudson, 1986.

———. *The History of Impressionism*. New York: Museum of Modern Art, 1987.

Richardson, John. *A Life of Picasso*. Vol. 1, *The Prodigy, 1881–1906*. New York: Alfred A. Knopf, 1991.

———. *A Life of Picasso*. Vol. 2, *The Cubist Rebel, 1907–1917*. New York: Alfred A. Knopf, 1996.

———. *A Life of Picasso*. Vol. 3, *The Triumphant Years, 1917–1932*. New York: Alfred A. Knopf, 2010.

Ringbom, Sixten. *Icon to Narrative: The Rise of the Dramatic Close-up in Fifteenth-Century Devotional Painting*. Doornspijk, Netherlands: Davaco, 1984.

Robbins, Daniel. "Abbreviated Historiography of Cubism." *Art Journal* 47, no. 4, "Revising Cubism" (Winter 1988): 277–83.

———. "From Symbolism to Cubism: The Abbaye of Créteil." *Art Journal* 23, no. 2 (Winter 1963–4): 111–16.

Roe, Sue. *In Montmartre: Picasso, Matisse and Modernism in Paris, 1900–1910*. London: Fig Tree, 2014.

———. *The Private Lives of the Impressionists*. New York: HarperCollins, 2006.

Rosbottom, Ronald C. *When Paris Went Dark: The City of Light Under German Occupation: 1940–44*. New York: Back Bay Books, 2015.

Rose, June. *Suzanne Valadon: Mistress of Montmartre*. New York: St. Martins Press, 1999.

Rosenblum, Robert. *Cubism and Twentieth-Century Art*. New York: Abrams, 2001.

———. "Picasso and the Typography of Cubism." In *Picasso, 1881–1973*, edited by Roland Penrose and John Golding. London: Elek, 1973.

———. *Transformations in Late Eighteenth Century Art*. Princeton, NJ: Princeton University Press, 1967.

———. and H. W. Janson. *Nineteenth-Century Art*. Upper Saddle River NJ: Prentice-Hall, 2005.

Rubin, William. "From Narrative to 'Iconic' in Picasso: The Buried Allegory in *Bread and Fruitdish on a Table* and the role of *Les Demoiselles d'Avignon.*" *The Art Bulletin* 65, no. 4 (December 1983): 615–49.

———. "The Genesis of *Les Demoiselles d'Avignon.*" In Rubin et al., *Les Demoiselles d'Avignon*.

———. ed. *Pablo Picasso: A Retrospective*. New York: Museum of Modern Art, 1980.

———. "Picasso." In Flam, *Matisse: A Retrospective*.

———. *Picasso and Braque: Pioneering Cubism*. New York: Museum of Modern Art, 1989.

———. *"Primitivism" in 20th Century Art: Affinity of the Tribal and the Modern* (2 vols.). New York: Museum of Modern Art, 1984.

———. Hélène Seckel, and Judith Cousins. *Les Demoiselles d'Avignon*. New York: Museum of Modern Art, 1994.

———, and Lynn Zelevansky, eds. *Picasso and Braque: A Symposium*. New York: Museum of Modern Art, 1992.

Salas, Xavier de. "Some Notes on a Letter of Picasso." *The Burlington Magazine* 102, no. 692 (November 1960): 482–4.

Schapiro, Meyer. *Modern Art: 19th and 20th Centuries*. New York: George Braziller, 2011.

Schroth, Sarah, and Ronni Baer. *El Greco to Velázquez: Art During the Reign of Philip III*. Boston: Thames & Hudson, 2008.

Seckel, Hélène. "Anthology of Early Commentary on *Les Demoiselles d'Avignon.*" In Rubin et al., *Les Demoiselles d'Avignon*.

———. ed. *Les Demoiselles d'Avignon*. Paris: Editions de la Réunion des musées nationaux, 1988.

Segel, Harold B. *Turn-of-the-Century Cabaret: Paris, Barcelona, Berlin, Munich, Vienna, Cracow, Moscow, St. Petersburg, Zurich*. New York: Columbia University Press, 1987.

Segy, Ladislas. "African Sculpture and Cubism." *Criticism* 4 (Fall 1962): 273–301.

Seigel, Jerrold. *Bohemian Paris: Culture, Politics, and the Boundaries of Bourgeois Life, 1830–1930*. Baltimore, MD: Johns Hopkins University Press, 1986.

Shattuck, Roger. *The Banquet Years: The Origins of the Avant-Garde in France, 1885 to World War I*. London: Faber & Faber, 1959.

Shattuck, Roger, et al. *Henri Rousseau*. New York: Museum of Modern Art, 1985.

Shipman, David. *The Story of Cinema*. New York: St. Martin's Press, 1986.

Sloane, Joseph C. *French Painting: Artists, Critics, and Traditions from 1848 to 1870*. Princeton, NJ: Princeton University Press, 1973.

Smee, Sebastian. *The Art of Rivalry: Four Friendships, Betrayals, and Breakthroughs in Modern Art.* New York: Random House, 2016.

Spate, Virginia. *Orphism: The Evolution of Non-figurative Painting in Paris, 1910–1914.* Oxford: Clarendon Press, 1979.

Sprigge, Elizabeth. *Gertrude Stein: Her Life and Work.* New York: Harper, 1957.

Spurling, Hilary. *Matisse: The Life.* London: Hamish Hamilton, 2009.

———. *The Unknown Matisse.* New York: A. A. Knopf, 2008.

Staller, Elena. *A Sum of Destructions: Picasso's Cultures and the Creation of Cubism.* New Haven, CT: Yale University Press, 2001.

Steegmuller, Francis. *Apollinaire: Poet Among the Painters.* New York: Penguin, 1986.

Steinberg, Leo. *Other Criteria: Confrontations with Twentieth-Century Art.* Chicago University of Chicago Press, 2007.

———. "The Philosophical Brothel." *October* 44 (Spring 1988): 7–74.

———. "Resisting Cézanne: Picasso's 'Three Women.'" *Art in America* 66, no. 6 (November–December 1978): 115–33.

Suleiman, Susan. *Subversive Intent: Gender, Politics and the Avant-Garde.* Cambridge, Harvard University Press, 2012.

Sutton, Denys. *André Derain.* London: Phaidon, 1959.

Temkin, Ann, Anne Umland, Virginie Perdrisot, Luise Mahler, and Nancy Li. *Picasso Sculpture.* New York: Museum of Modern Art, 2015.

Tuchman, Barbara W. *The Proud Tower: A Portrait of the World Before the War, 1890–1914.* New York: Random House, 1966.

Tuchman, Maurice, Judi Freeman, and Carel Blotkamp. *The Spiritual in Art: Abstract Painting, 1890–1985.* New York: Abbeville Press, 1986.

Tucker, Paul Hayes. *Monet in the '90s.* Boston: Museum of Fine Arts, 1989.

Turner, Elizabeth Hutton. "Who Is in the Brothel of Avignon? A Case for Context." *Artibus et Historiae* 5, no. 9 (1984): 139–57.

Varnedoe, Kirk. *A Fine Disregard.* New York: H. N. Abrams, 1989.

———. "Gauguin." In Rubin, *"Primitivism" in 20th Century Art*, vol. 1.

———, and Adam Gopnik. *High and Low: Modern Art, Popular Culture.* New York: Museum of Modern Art, 1991.

Vriesen, Gustav, and Max Imdahl. *Robert Delaunay: Light and Color*, New York: Harry N. Abrams, 1967.

Warnod, Jeanine. *Washboat Days.* New York: Grossman, 1972.

Weiss, Jeffrey. *The Popular Culture of Modern Art: Picasso, Duchamp and Avant-Gardism.* New Haven, CT: Yale University Press, 1994.

White, Harrison C. and Cynthia. *Canvases and Careers: Institutional Change in the French Painting World.* Chicago: University of Chicago Press, 1993.

Williams, Ellen. *Picasso's Paris: Walking Tours of the Artist's Life in the City.* New York: Little Bookroom, 1999.

Willett, Frank. *African Art.* New York: Thames & Hudson, 2002.

Wissman, Fronia E., and George T. M. Shackelford. *Impressions of Light: The French Landscape from Corot to Monet.* Boston: Museum of Fine Arts, 2002.

Zervos, Christian. *Picasso.* Paris: Cahiers d'Art, 1936.

WEBSITES AND ELECTRONIC MEDIA

Baltimore Museum of Art, The Cone Collection: https://artbma.org/collections/cone.html.

The Barnes Foundation, Philadelphia, Art Collection: http://www.barnesfoundation.org/collections/.

The Metropolitan Museum of Art, New York, Collection: http://www.metmuseum.org/art/collection.

Musée National Picasso-Paris: *The Life of Pablo Picasso:* http://www.museepicassoparis.fr/en/biography/.

Museu Picasso, Barcelona, Chronology: http://www.bcn.cat/museupicasso/en/collection/chronology.html.

———, Search: http://colleccio.museupicasso.bcn.cat/.

The Museum of Modern Art, New York, The Collection: https://www.moma.org/collection/.

———, *Les Demoiselles d'Avignon: Conserving a Modern Masterpiece:* http://www.moma.org/explore/conservation/demoiselles/analysis.html.

Vangogh letters.org

Index

Page numbers in *italics* refer to illustrations.